PIETRO NOBILE

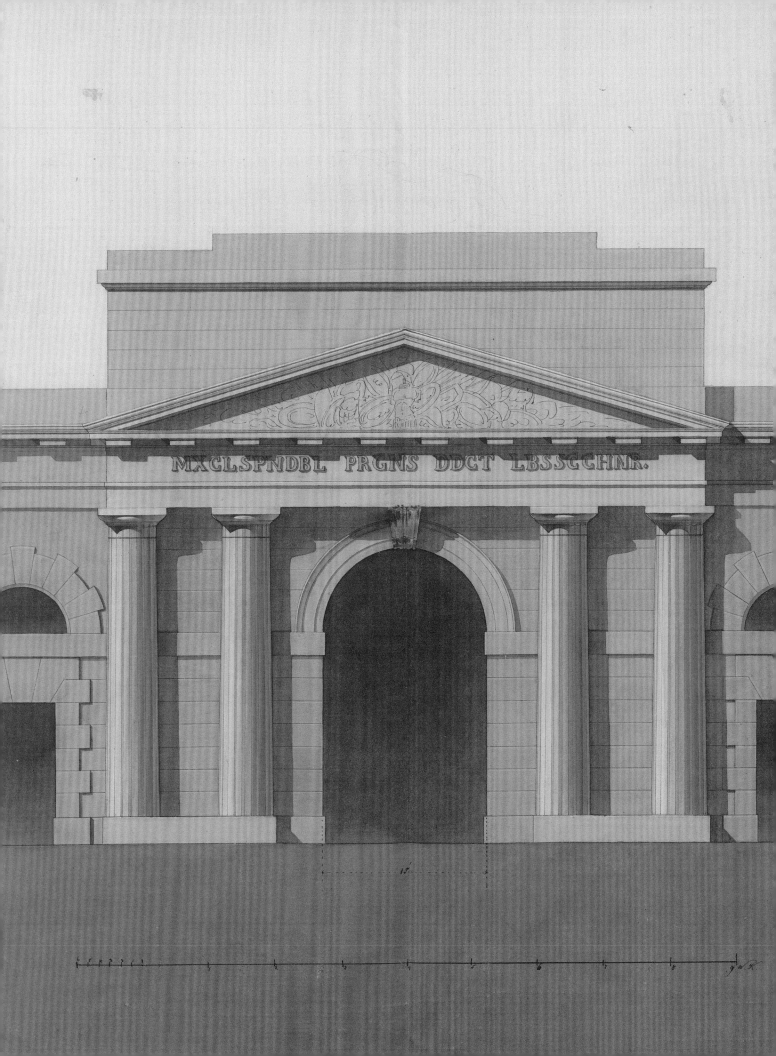

Taťána Petrasová (Ed.)
With contributions by Rossella Fabiani
and Richard Kurdiovsky

PIETRO
1776—1854
NOBILE

Neoclassicism between Technique and Beauty

DE GRUYTER

CONTENTS

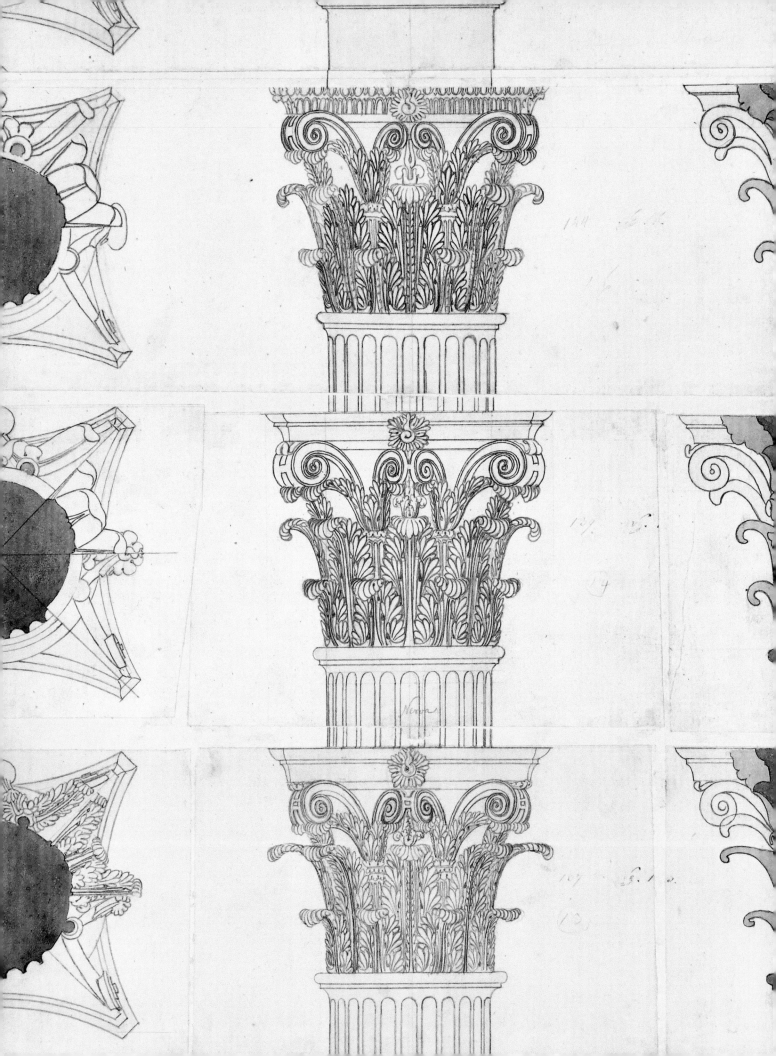

INTRODUCTION

Taťána Petrasová

The position occupied by neoclassical architecture is a topic that can be discussed endlessly. As there is no single origin point for this phase in the history of European architecture and thought, our approach to it depends on the time and place we choose to focus on. For Britain, Neoclassicism began with the return of six architects – Nicholas Revett, Matthew Brettingham, Robert Mylne, James Stuart, William Chambers, and Robert Adam – from Italy and Greece in July 1759.[1] By contrast, the prominent German representative of continental Neoclassicism Friedrich Wilhelm von Erdmannsdorff travelled to England with his patron in 1763/64 in order to draw inspiration there from Palladianism, propagated since the 1720s by Lord Burlington and "his" architect William Kent. Regardless, at the heart of neoclassical architecture is a return to the Renaissance and a particular way of rediscovering antiquity, along with a balancing of forces between architect and engineer, between artist and technician. Sigfried Giedion, in searching for the origins of this new concept of construction in his book *Bauen in Frankreich: Eisen, Eisenbeton* (1928), wrote: "Art, it is said, is a presentiment [...] Architecture, which, we can agree, has not always deserved to be called the art of construction, has led us round in circles for a century now, leading us from one failure to another."[2] Given the need to oppose this critique with new knowledge of architecture designed in the 19th century and at the same time driven by the desire to explore one moment of this presentiment, we have decided to examine in this book the telling historical case of Pietro Nobile. An architect trained both as an engineer and academically, Nobile reformed teaching at the School of Architecture of the Academy of Fine Arts Vienna by reacting to the design methods introduced at the École Polytechnique in Paris and making academic drawing compulsory for engineers. Around 1830, neoclassical architecture gained strong new impulses that made it possible to work with the classical theory of the five orders as a tool for technological innovation, whereas technological progress and classical architecture still used the traditional language (Fig. 1).

Architects

In the second half of the eighteenth century, the insights gained from the architecture and texts of Andrea Palladio, who devoted himself to the study of the monuments of ancient Rome and to the interpretation of Vitruvius's texts, brought about a division in what until then had been a unified architectural tradition. While Palladio makes frequent use in his texts of phrases such as "according to Vitruvius" or "as Vitruvius teaches us," some neoclassical authors accepted Palladio but called into question Vitruvius's canonical text because of its concept of architecture as an imitation of the primitive hut; others subjected the latter's passages on the orders of columns, in particular, to merciless polemics. In a reaction against the traditionalism of French theorists such as Jacques-François Blondel, and before him Vitruvius's translator Claude Perrault, the Jesuit and brilliant essayist Marc-Antoine Laugier in his *Essai sur l'architecture* (1753, first illustrated edition 1755) questioned Vitruvius's less theoretical approach to architecture.[3] According to Laugier, who based his argument on the importance of the theory and the generally accepted doctrine of art as imitating nature, it is not possible to derive the origin of architecture from stone elements, one reason being that contemporary architecture had degraded these elements into ornament. He believed that contemporary architecture should restore the constructional function to these parts of buildings. The basis for this function was the simple structure of the primitive hut, made without any knowledge of the arch from only

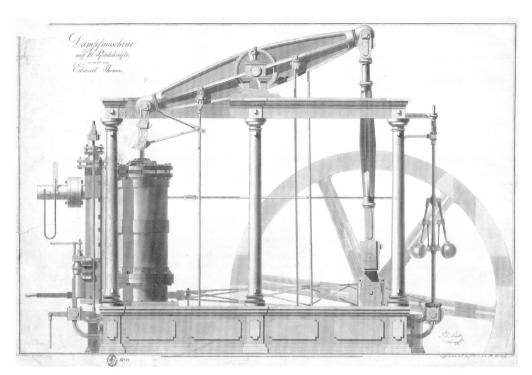

the materials available, namely the trunks of trees.[4] On the other side, the theorist of revolutionary architecture and later a professor at the École des Beaux-Arts Étienne-Louis Boullée added his voice to the critics of Vitruvian praxis. He also accused Vitruvius of reducing architecture to pragmatic engineering. Boullée opened his text *L'architecture. Essai sur l'art* (1790–1799) – which was unpublished but was certainly used for teaching, e.g. in the form of architect's in-studio discussions of the drawings included in this *Essai* – with the suggestive question: "Would I define architecture with Vitruvius as the art of building? No [...]. First it is necessary to reflect, and then to act. Our forefathers did not start building their hut until they had an idea of what it would look like. And this creative process is the basis of architecture."[5]

This parable of the architect who, out of nothing, creates an image of a future building reflects the status of architects as no longer mere craftsmen, but it did not in itself help people to understand what came after the primitive hut and formed the basis for the architecture of antiquity. The architects who, once again, began measuring the ancient buildings that had survived were following in Palladio's footsteps. They no longer travelled only to Rome but also to Athens, Palmyra, Baalbek, and Paestum. And even their journeys to

Rome acquired a new character. In France, the new era of study tours to Italy was launched by the Marquis de Marigny (1727–1781), destined through the adroitness of his sister Madame de Pompadour for the future post of General Director of the King's Works. The young architect Jacques-Germain Soufflot accompanied him on his journey to Rome in 1750. They were thus able to become familiar with the setting where the French Academy in Rome had, since 1720, been established. Its students were selected for three-year stays in Rome from the annual competition held by the Académie d'architecture in Paris. The work done by the *pensionnaires* (scholarship recipients) in Rome was sent by the director of the French Academy to the General Director of the King's Works in Paris. While in Rome, the first French adepts at Neoclassicism, Jean-Laurent Legeay and Charles-Louis Clérisseau, came into contact with leading figures of the international artistic community, such as the Englishmen Robert Adam and William Chambers and the Germans Friedrich Wilhelm von Erdmannsdorff and Johann Joachim Winckelmann. They also got to know Giovanni Battista Piranesi, who created prints and texts on the theme of ancient Rome and opened a shop selling prints right next to the French Academy. Because of this proximity, the ideas cap-

tured in Piranesi's cycles of prints *Prima parte di architetture e prospettive* (1743), *Carceri* (1745), and *Antichità romane* (1748) began circulating among the French scholarship recipients at the academy.[6] The spread of ideas from Rome to the centres of the new style was dependent on networks of artists, patrons, schools, and leading officials. In the case of Paris, this network took the form of the system linking the French Academy and the General Director of the King's Works, as is shown in the Petit Trianon pavilion (1762–1764) (Fig. 2), which is strikingly similar to the theme of the "pavilion on top of a terrace by a riverbank" announced for the Prix de Rome competition in 1758. The winning drawing by Mathurin Cherpitel (1736–1809) and Jean-François-Thérèse Chalgrin (1739–1811) contained all the elements to be found in the architect Ange-Jacques Gabriel's final design for the Petit Trianon pavilion: a diverging double staircase leading to a building raised on a terrace, with the entrance emphasized by a columned portico with no gable. The high-ranking royal official Marquis de Marigny evidently made a copy of the winning drawing from the school for his own (and for state) purposes.[7]

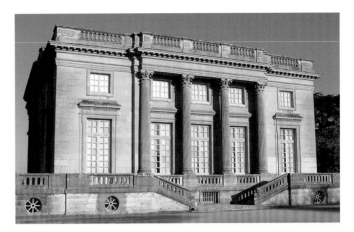

Fig. 2 Ange-Jacques Gabriel, Petit Trianon, Versailles, 1762–1764, photo 2008.

Technicians and Constructors

Neoclassical architecture was not only designed by architects, however. One of the key theses on this period is that of Sigfried Giedion in his book *Space, Time and Architecture* (1941). He contended that we cannot gain insight into the development of modern architecture from the monumental public buildings of the nineteenth century, as its primary influence comes instead from the "modest," utilitarian architecture that resulted from the development of new technologies and materials in the eighteenth century.[8] Giedion's thesis can be understood as stemming from his constructivist concept of architecture, evident in the above-mentioned *Bauen in Frankreich*. He first published on this concept in 1928, calling into question the impact of nineteenth-century, traditional stone architecture and of the concepts arising from it, which clashed sharply with modern construction systems.[9] In support of his contention about the conservative nature of stone architecture, Giedion assembled examples of the oldest cast-iron constructions in France and England, from the second half of the eighteenth century. He started with a setback, the unsuccessful attempt to build a cast-iron bridge across the Rhône in 1755, but the examples that followed were all successful: the use of industrially produced cast iron by John Smeaton in 1755, the production of large iron sections for railway lines in 1767, and the first cast-iron bridge, built across the River Severn by Abraham Darby in 1775–1779, which still stands today.[10] A further revolutionary innovation was Thomas Paine's designing of a metal frame for stone arches in 1783, which in Giedion's view represented the origin of later steel frames.[11] He also showed how improvements in the design of the steam engine (1763–1775) facilitated James Watt's design for the first textile mill with a metal structure (1801) in Salford, today a part of Greater Manchester. Already at that time, the factory hall was supported by cast-iron pillars and beams, and the textile factory was illuminated by light passing through a continuous glass wall fortified with a grid of cast-iron members.[12] Almost at the same time as the erection of the textile mill in Salford, standardization became part of the concept for both monumental and residential architecture, although this was unconnected to English engineering. This took place thanks to the École Polytechnique in Paris, where Jean-Nicolas-Louis Durand (1760–1834) was appointed professor of architecture in 1796. A graduate in academic architecture under Étienne-Louis Boullée (1728–1799) at the École des Beaux-Arts, he implemented a reform in the way architecture was taught, consisting in a new approach to design that

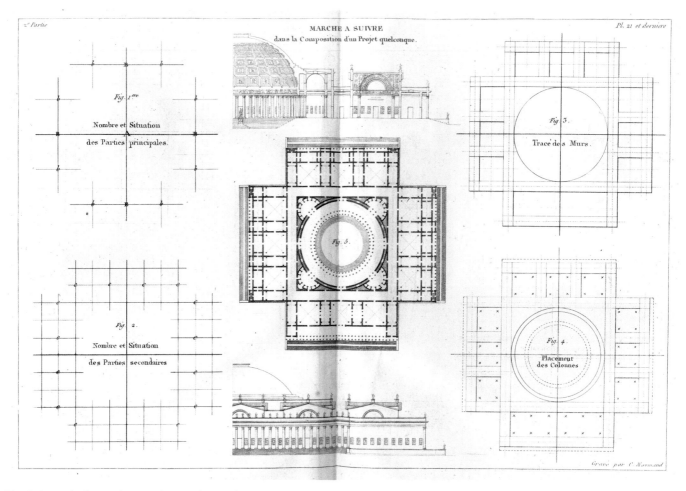

Fig. 3 Jean-Nicolas-Louis Durand, Procedure in the Composition, engraving from *Précis des leçons d'architecture* (Paris: Chez l'Auteur et Bernard, 1805), second part, plate 21, Kroměříž, Archdiocesan Museum.

placed great emphasis on the standardization of spatial, and thus also constructional, arrangement. Building typology cultivated a feel for the regular and repeated use of construction elements, similar to the way that Watt worked with them in his textile halls. Durand's analysis of historical and contemporary typological layouts (spas, basilicas, schools) led his pupils towards functionality and economy of design, especially as he, as an assiduous reader of Perrault, saw Vitruvius's *utilitas* as based on convenience (*convenance*) and frugality (*économie*). This quality of *utilitas* explains why architects continued to look to models from antiquity on account of tradition but, at the same time, helped to redefine functionality, which once again became a basis for beauty (Fig. 3). Giedion was therefore inclined to see Durand as a constructor and not an architect. However, the expression "appearance of the construction" means something different than the display of the construction on the exterior of a building. As Boullée's pupil, Durand worked with the idea of an architecture that manifests itself outwardly through a symbolic language.[13] Werner Szambien, based on Durand's texts – *Précis des leçons d'architecture* (first written 1801–1803) and *Recueil et parallèle des édifices de tout genre, anciens et modernes* (the first edition 1800) – and on his pupils' drawings, argued that Durand continued to see the role of training in engineering within the development of neoclassical architecture from the perspective of the polarity between the academy and the polytechnic, between imitation and method. The change towards method did not consist simply in abandoning the Vitruvian tradition.[14] It was connected with the rejection of the role of the

orders of columns, but it also meant departing from the theory of imitating nature, as expounded by Laugier. During this time, architecture emancipated itself both from art and from the natural sciences.[15]

Antoine Picon, by contrast, has argued that the transformation in architectural thinking would not have taken place without changes in the natural sciences.[16] In his view, the fundamental step was the introduction of the analytical method to the textbooks of the École Polytechnique in Paris starting in the 1790s, across various disciplines. This linked architecture not only to the natural sciences (such as chemistry) but also to the linguistics of Jean-Baptiste Maudru, the author of *Nouveau système de lecture applicable à toutes les langues* (1799–1800). In order to adapt the analytical method to architecture, it was necessary to overcome "an unbridgeable gulf [that] continues to separate our sensations from the complex judgements of the human mind," in Picon's words.[17] And Durand bridged this gulf by approaching design through the innovative teaching of architectural drawing. He expressed its basic principle as follows: "In science you can recognise a thing if you reflect on it properly just once, but in art you can only do something well if you have repeated it many times."[18]

For both architects and "constructors" of that time, the concept of naturalness remained indispensable. A contemporary definition of it was:

> the general and permanent principles of visible objects, not disfigured by accident or distempered by disease, not modified by fashion or local habits. Nature is a collective idea, and, though its essence exists in each individual of the species, can never in its perfection inhabit a single object.[19]

The concept of naturalness influenced one of the most widely discussed practices of trained architects, for imitation remained the doctrine of academic architectural drawing. Imitation certainly did not mean unthinking repetition. It was the creative process of choosing the correct forms, imitating the true Creator. The naturalness of nature and the naturalness of art "was to be imitated: it was not to be copied," for, as Winckelmann wrote, the opposite of independent thought is not imitation, but copying.[20]

Officials and the Public

One of the most obvious preconditions for the development of Neoclassicism was the involvement of state institutions, which trained and then recruited into the service of the state graduates from the academies and polytechnics (Fig. 4). The integration of the academies into economic policy enabled the French minister of finance Jean-Baptiste Colbert to build up a universal academic system in the years 1661–1683, whereby the Académie des Inscriptions et Belles-Lettres (founded 1663), the Académie des sciences (1666), the Académie Royale de Musique (1669), and the Académie d'architecture (1671) became instruments of royal policy. However, the cornerstone of the system was the Académie Royale de Peinture et de Sculpture (1663), which from 1666 organized a competition for a scholarship to Rome. The doctrine of mercantilism, according to which it was the sovereign duty of the state to create a prosperous manufacturing system in order to stimulate the circulation of money and to strengthen export and the influx of finance, integrated the artistic academies into its concept of economic utilitarianism.[21] However, the role and the degree of involvement of state policy in establishing European Neoclassicism varied widely. The buildings with which the architects Stuart, Chambers, and Adam introduced Neoclassicism to England in the 1750s and 1760s were private ones, with the exception of Chambers's buildings for King George III. From 1720 onwards, however, a steering institution was gradually created in England, which contributed to a "standardization" of style. This institution, called the Office of the King's Works, made it compulsory for its employees to enter their accounts into account books every month. These data, in Barbara Arciszewska's view, helped bring about a formal standardization of the vocabulary of Neoclassicism. After the death of the royal architect John Vanbrugh in 1726, the Office of Works underwent so many changes that it practically ceased to exist, but its successor became "a modern institution created to deploy Palladian Classicism as a state idiom."[22]

Looking at educational institutions in France, we consistently find pupils trained in the state style being assigned to high official posts. For one, only people with state diplomas could enter the state service, which applied, for example, to

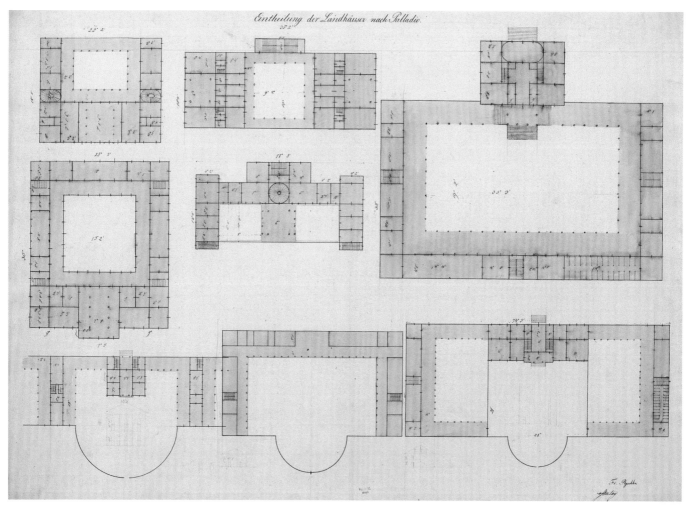

Fig. 4 Franz Ryschka, Study of villas after Palladio, pen and ink with watercolour, ca. 1823–1829, Vienna, Academy of Fine Arts, Kupferstichkabinett.

graduates of the Académie Royale d'architecture (founded 1671), the École Royale des Ponts et Chaussées (1747), the École Royale du Génie (1748), and the École Polytechnique (1794). The directorships of these institutions were held by architects who came from the highest levels of officialdom. The first director of the prestigious Académie Royale to be appointed (in 1742) during the period of the rise of Neoclassicism was Ange-Jacques Gabriel (1698–1782), who "climbed the ladder of advancement in the *Bâtiments du Roi*, where his father had trained and systematically promoted him."[23] A further example is that of Soufflot, capable as both a practitioner and a theorist of Neoclassicism, who acquired state commissions in his capacity as Inspector of Royal Buildings in the Department of Paris, having been summoned to Paris

by Marigny to take up this official position.[24] Likewise, Claude Nicolas Ledoux (1736–1806) held the office of Inspector of the Saltworks in the Franche-Comté while also acting as an official architect to the king and the French court. Around the year 1773, he set out on a journey to inspect the royal saltworks, the most important of which – in Dieuze, Rosière, Château-Salins, and Salins – formed small villages with pumps, kilns, ironworks, bakeries, administrations, inspectors, prisons, and chapels, along with guards and moats to protect the royal goods. The result of this journey was Ledoux's proposal for the construction of a new saltworks in Chaux, with him contracted to draw up plans for an ideal neoclassical urban complex.[25] The connection between architects and state services was even more obvious with

TAŤÁNA PETRASOVÁ

polytechnic students. The foundation in Paris of the École Polytechnique, originally the École centrale des travaux publics, was stimulated by the need of the young state to train engineers for the army as quickly as possible at a time when France was threatened by enemies. The school admitted each year 300 to 400 pupils, aged 16 to 20, and was heavily involved in Napoleon's military expedition to Egypt in 1799, with a group of pupils and teachers from the school taking part in the campaign.[26]

For the German-speaking countries, some of the offices of public works have not been examined in detail in terms of their possible connections to local educational institutions. Nevertheless, there is evidence to support a general thesis about the creation of a state Neoclassicism. The organization of the polytechnic in Paris was mirrored in that of the Bauakademie in Berlin, where teaching began in 1799 with 120 pupils. This institution was the result of negotiations between the Akademie der Künste in Berlin and the Oberhofbauamt (Royal Office of Works), which in 1770 had refused, against the will of the king, to cooperate with architects trained in artistic architecture, as well as to reform the teaching of architecture in accordance with academic syllabi, because it did not trust their competence in construction tasks of a technical nature. The teachers at the Akademie der Künste, who claimed responsibility for *schöne Baukunst* (fine arts building work),[27] instigated the establishment of several schools in Berlin, such as the École de génie et d'architecture and the Collegium publicum, the latter attached to the Oberhofbauamt, but none of them lasted very long. After the Akademie der Künste failed to have its teaching programme for architects accepted, David Gilly (whom King Frederick William II had invited to Berlin) established a separate school there in 1793 – what would later become the Bauakademie – with the consent of the state institutions. State officials had confidence in Gilly as he was an official himself: In Pomerania, where he came from, he had been the director of building at the office of public works. His best pupils oversaw the implementation of their works while occupying high official posts: Karl Friedrich Schinkel was appointed Privy Building Officer in 1815 and oversaw all state and royal building commissions.[28] Leo von Klenze enjoyed similar success in Munich in 1824 as head of the building authorities for Bavaria, as did Carl Ludwig Engel in Helsinki,

where he was appointed director of the state building department in 1824 and supervised the spread of neoclassical architecture throughout Finland (then part of Russia).[29]

The state interest was tacitly present throughout officialdom, and the interests of individuals and minorities were subordinated to it; it called for changes in traditional rights and for the circumvention of moral rules that were binding for individuals.[30] This value orientation, together with the emphasis on economical and normative thinking, drawing, and design, led to the rejection of some of the expedients of this state-interested system of architecture in which the architect with an academic education degenerated into an official.[31]

Nevertheless, through its methods for enforcing progress, state interest did help cultivate the general discussion about the tasks of architecture, as it created instruments for presenting new projects and plans to the public. Exhibitions and publications contributed substantially to increasing the moral credit of architects, and to explaining and advocating new ideas. In England and France, exhibitions were held that were accessible to the public: in London by the Society of Artists in 1760 and by the Free Society and the Royal Academy from the 1760s, and in Paris by the Académie d'architecture from 1740.[32] Works made in Rome were exhibited for an international public, and even local exhibitions, such as that staged by Johann Wolfgang von Goethe in Weimar, were not lacking in ambition.[33] Themes connected with extensive programmes for urban beautification dominated the competitions held by the Académie Royale in Paris, and the second half of the eighteenth century was a golden age for urban design.[34]

Not yet realized building designs by living architects even became part of universal compendia, which further emphasized the importance of the architect's calling. For example, De Wailly's *View from the Vestibule of the New Théâtre Français*, a gouache exhibited in a salon in the Louvre in 1771, was published in 1777 in an illustrated supplement to Diderot's *Encyclopédie*, part of Charles-Joseph Panckoucke's supplement to monumental editorial achievement in the years 1776–1779.[35] The move away from religious ideology in the Catholic part of Europe and overseas brought with it relativism, experimentation, and an autonomous way of viewing things, a shift felt in politics, economics, and civic thought.[36] And architects and engineers were part of this social experiment.

The Architecture of the Austrian State: The System versus Individuals

The period during which the new philosophical and aesthetic approach later known as Neoclassicism began to spread through Europe also saw, from 1804 onwards, the rise of the Austrian centralized state, officially called the Austrian Empire. The Habsburg territories first came to be regarded as an entity after 1700, when cartographers began to use the designation "House of Austria," drawn from the name of the historical heartlands of Habsburg territory, Upper and Lower Austria. At that time, this entity extended over the territories of present-day Austria, the Czech Republic, the Slovak Republic, the Republic of Slovenia, and Hungary, and it encroached on parts of present-day Poland, Croatia, Ukraine, Italy, and Belgium, along with parts of southern Germany (*Vorlande* or *Vorderösterreich*). When Maria Theresa (1717–1780) came to power in 1740, it was hardly possible for her to back up her policies with a unified administration. The degrees of independence of the individual countries from the central Austrian administration likewise differed considerably.[37] But by the end of her reign, Central Europe was a state entity with a centralized administration well prepared for the Enlightenment policies of her son Joseph II (1741–1790). The results of the decade of independent rule by Emperor Joseph II – i.e. the reforms of religious life (1781/82) and of the offices of public works (1783), the decree banning burials within towns (1783), and the educational reforms (1783, 1789) – in many respects built on the reforms of Maria Theresa.[38] Joseph II's belief in a strong centralized state run by competent bureaucrats, a belief strengthened by the examples of Prussia and France, meant that architecture was among the arts mobilized as an instrument of state policy. The situation of Austria after its defeat in the Silesian Wars (1740–1745) and the lack of success of the Habsburgs in the Seven Years' War (1756–1763) influenced the building activities of the emperor. Among his most important building undertakings in terms of size and expenditure (26 million guilders) were the Bohemian fortresses of Josefov near Jaroměř (1780–1787), Hradec Králové (1780–1789), and Terezín (1780–1790) (Pl. I).[39]

The centralization of building administration unified the character of public buildings as well. In 1783, an Ober- und Hofbaudirektion (Imperial Office of Public Works) was es-tablished in Vienna with the task of overseeing economic investment in public buildings, which was to be monitored in a systematic way. The system was based on a network of Landesbaudirektionen (offices of public works in the individual provinces), which supervised the work of the regional engineers. The result was a "drastically unified" production of public buildings, as "the architects in the central office in Vienna designed all public buildings in the provinces" in Christian Benedik's words.[40]

In the catalogue of the exhibition *The Age of Neo-Classicism* (1972), the only example of the architecture of the Austrian Monarchy to be presented was the design for the extensive complex of the newly established archbishopric of Esztergom, executed by the architect Pál Kühnel (1765–1824) from the Hofbauamt (Imperial Office of Works) in Vienna. The archbishop Sándor Rudnay (1760–1831) commissioned Kühnel to design the complex in the years 1820/21 (Fig. 5). As a state official, Kühnel relinquished the realization of this project, entrusting it to his fellow countryman János Kereszt-tély (Johann) Packh (1796–1839), who had carried out other building works for the archbishopric in Esztergom. The design of the cathedral was a typical example of the approval of a public building, in which the Hofbauamt in Austrian Monarchy intervened. After some years of preparation by regional architects, the Esztergom complex project came to Pietro Nobile, who submitted a proposal for a reduced budget. The architect designed not only two neoclassical variants (1824) – alternatives to Packh's design – but also one of his first forms of sacral construction in early Historicism forms (1830s).[41] According to Hungarian researchers, the architect designed a "veritable Vatican of Hungary" on the castle hill; according to others, the model was comparable to the Spanish Escorial. The project displays all the features of neoclassical urban design: the monumental scale; the terraced arrangement of the urban site, lending it the character of a fortress; and the strictly symmetrical layout of the wings of the seminary, closing off one end of the complex in a horseshoe shape. The dominant feature is the central-plan dome of the cathedral, with two towers situated well apart, on either side of the entrance portico. Hungary was part of the Austrian state, but its position was a considerably independent one, as is evident from its taxation and administrative systems. What significance would such a

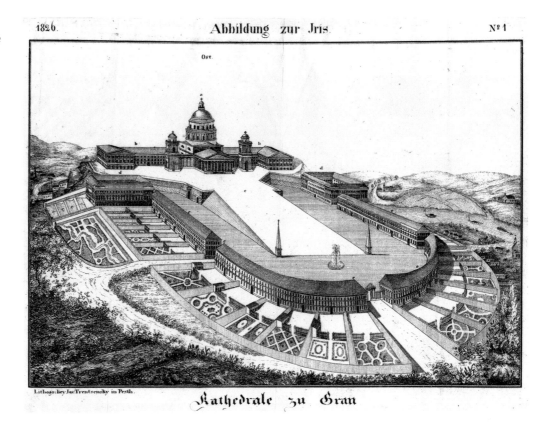

magnificent project have held? The archbishopric of Esztergom, together with that of Eger, were among the most senior in the Hungarian Catholic Church. At the same time, the position of the Catholic Church had been shaken by the policy of Josephinism, whose consequences continued to be felt during the reign of Emperor Francis I and up until the signing of a concordat between the Austrian state and the Vatican in 1855, during the reign of Francis Joseph I. The Primate of the Hungarian Catholic Church, Sándor Rudnay, convented a national synod in Bratislava in 1822 at the beginning of the construction of Esztergom cathedral. He wanted to get the Austrian emperor to ratify decrees that would end the period of Josephine secularization in Hungary, but this did not happen. A strategic importance had the architecture also for the archbishop of Eger, János Pyrker, who organized other great neoclassical building. "Art-political objectives" aimed to strengthen Hungarian art by commissioning work by Italian and Austrian artists and by creating suitable conditions for groups of local artists to work on these foreign projects, acquiring valuable experience in the process.[42] In 1783, the regalia were moved from Bratislava, which had been the capital of Hungary since 1536, to the new capital in Buda, and the central Hungarian offices were relocated there, too. The largest commissions for public buildings – the Hungarian National Museum or the Board of Trade (later known as the Lloyd Palace, 1827–1830) – were not supported financially by the Austrian state but by the Hungarian aristocracy, including the personal support of the Habsburg Joseph Anton, Palatine of Hungary from 1796. In the oversight of their appearance and design, buildings symbolizing public administration, such as the County Hall, retained considerable, if not complete, independence from the central office of public works, as can be seen from several well-known examples. In the case of a project for administrative buildings in Szekszárd, the capital of Tolna County, the plans – by a leading architect of Hungarian Neoclassicism, the Vienna-trained Mihály Pollack – were scrutinized by the Viceregal Council and then approved by the "Estates of the Realm" (feudal Diets). Securing funding for this building undertaking, the sub-prefect Dániel Csapó "initiated several campaigns to raise public donations, and managed to obtain financial support from the Viceregal Council."[43]

Even in Vienna, the influence of the Hofbauamt (Imperial Office of Architecture) was not so stultifying as to prevent during the reign of Joseph II the creation of original buildings whose budget no doubt exceeded the permitted expenditure laid down in the regulations. The patron of the Academy of Fine Arts at that time was Prince Wenzel Anton of Kaunitz-Rietberg, who served as chancellor to four Habsburg monarchs and developed an appreciation for French architecture's feel for comfort during his time as Austrian ambassador in Paris. However, he favoured the Italian, and in particular Roman, approach to training pupils at school.[44] The first neoclassical stimuli were brought to Vienna by architects with links both to France and to the scholars of the French Academy in Rome. Gottlieb Nigelli (1746–after 1812) completed the first part of his studies at the academy in Vienna, was a pupil of Jean-François Chalgrin in 1770–1775, and finally finished his formal education as a scholar in Rome in 1776–1780. At the beginning of his career, as an engineer for the Hofbauamt he designed the Protestant church in Vienna (1783/84), which reflected Emperor Joseph II's attempts at religious reform. Although it was a single-nave hall church, by using a series of two domes supported by broad arches Nigelli succeeded in creating the impression of a spacious basilica, in structure distantly reminiscent of Soufflot's sophisticated system for the Panthéon in Paris (1757–1790) or Chalgrin's basilica of Saint-Philippe-du-Roule (1774–1784).

It is not entirely clear to what extent the Hofpreis (Court Prize) of the academy influenced the construction of innovative neoclassical works. Pavel Zatloukal believes that as patron of the Academy of Fine Arts, Prince Kaunitz's own construction activity, namely the building of the church of the Resurrection (1786–1789) on his estate in Slavkov in Moravia, may have been connected with the academy prize. Indeed, in 1785 the institution announced a competition with the theme of a "rural church for 1000 believers combining the Doric order on the exterior and the Ionian one on the interior."[45] Zatloukal's hypothesis is further supported by the fact that the architect who designed the church in Slavkov, Johann Ferdinand Hetzendorf von Hohenberg (1733–1816), was the director of the School of Architecture at the Academy of Fine Arts Vienna from 1773 onwards. On the other hand, Renate Wagner-Rieger, commenting on the design for the reconstruction of the Belvedere in Vienna that Nigelli sent as the result of his Roman scholarship, expresses scepticism about the influence of academy designs.[46]

The buildings of Isidore Ganneval (Canevale; 1730–1786) – born in Vincennes, today part of Paris – occupy an exceptional position in the history of Neoclassicism in the Austrian lands. In 1753/54, he studied under Giovanni Niccolò Servandoni (1695–1766), whose work in Paris included the decorations for the celebrations and the operatic performances of the Académie Royale de Musique, full of Baroque imagination.[47] Ganneval, by contrast, managed to perfectly incorporate into his designs the requisites put forth by Joseph II, namely thrift, discipline of users, and functionality of buildings. The circular layout of the so-called Narrenturm (a psychiatric hospital, 1783) that he designed on the periphery of the extensive complex of Vienna General Hospital epitomizes a prison or fortress, with a well-functioning system of standardized hospital rooms that could be monitored from a connecting corridor with a staircase (Fig. 6). Ganneval's distinctive feel for the aesthetics of functionality is, in my view, best displayed in the library of the so-called Josephinum, the academy for army doctors named after its imperial founder. The complex, similar to a Baroque palace in type, with a *cour d'honneur*, is remarkable in particular for its interior layout.[48] As in the Narrenturm, here too a staircase functions as a central element of the building with the surgical amphitheatre, which could be entered in a representative way or quickly, by small spiral starcases, as the library at the ends of both pavilions. The all staircases lead to the convex wall of the two-storey surgical amphitheatre, with tall windows. The contrast with the Baroque-style classicist facade is even more striking in the layout of the library halls, supported by four columns. Their almost industrial appearance is due not only to the fact that their tall, slender pier shafts were later metal-plated but also to their high beams, supporting the roof in the fashion of the modular system of concrete constructions. The columns have wooden bases and stylized capitals, which speak the language of symbols – they may have referred to the origins of medical science in Egypt, with its knowledge of dissection – but at the same time perfectly met the requirements of Laugier and Durand for the construction of columns to be functional, and their questioning of the obligatory rules for the orders of columns.

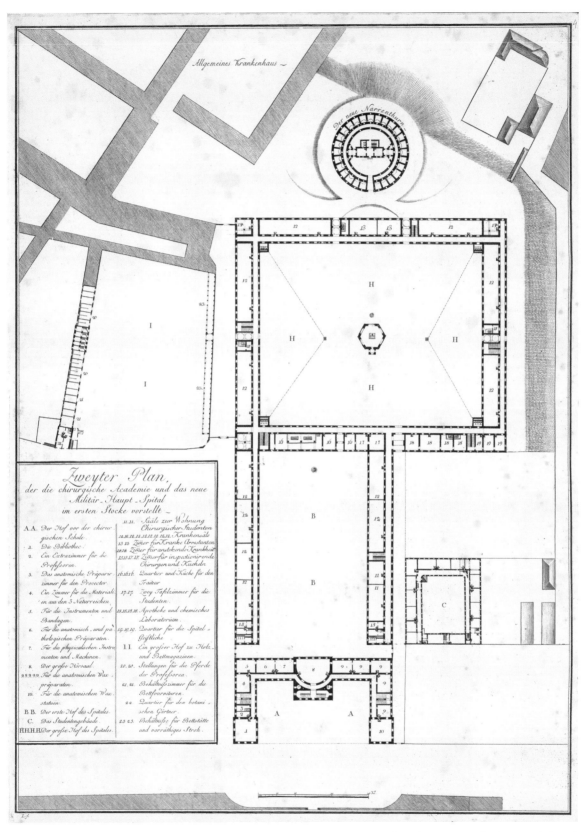

Fig. 6 Isidore Ganneval, Josephinum (bottom), the "new military hospital" (middle) and *Narrenturm* (top), ground plan of the *piano nobile*, print by Ferdinand Landerer, ca. 1785. Vienna, Austrian National Library, plan collection.

Fig. 7 Antonio Mollari, Stock Exchange, the main hall, Trieste, 1802, photo 1980s.

Among the private patrons of neoclassical architecture within the Habsburg Monarchy who could compete with French Neoclassicism was Prince Nikolaus Esterházy. He first engaged the French architect Thomas de Thomon and then his compatriot Charles Moreau, who studied architecture at the Academy of Arts in Paris with Louis-François Trouard. Trouard's office had also earlier employed Claude-Nicolas Ledoux.[49] The strong impact of Ledoux's thought is evident in Moreau's design for the expansion of Esterházy Palace in Eisenstadt, with its four roof pavilions and two cube pavilions at the end of colonnades (Pl. II).

There is undeniably a link between the late Enlightenment figures who surrounded Joseph II and the refined aesthetic sobriety of the Biedermeier period.[50] The most original architect during this phase was Joseph Kornhäusel, who had been a court architect for Liechtensteins but later worked in Vienna for rich clients from various social groups, including the imperial family, the Jewish community, monasteries, and owners of tenement houses (Pl. III).[51] Typical of his work was originality of spatial design in linking staircases

and corridors with representative halls (something that could be observed in the most radical cases of Ganneval's Neoclassicism), along with distinctive tectonic features, for example, in the vestibule and main staircase in the Albertina, adapted for Archduke Charles in 1822–1824.

In order to understand what unified and what differentiated the local variants of Neoclassicism in the Austrian state, it is also necessary to mention the neoclassical buildings and designs in northern Italy, in particular Milan and the Free Port of Trieste, which, after having been occupied several times by Napoleon's armies, once again fell to the Austrian Habsburgs in 1816. In Lombardy, the era of large neoclassical public buildings was ushered in by Villa Reale-Belgiojoso (1790–1793), designed by Leopoldo Pollack, who studied at the academy in Vienna under Vinzenz Fischer and became a pupil of Giuseppe Piermarini after arriving in Milan in 1775. Pollack had in common with the Viennese neoclassicists an orientation towards France, something that Carroll L.V. Meeks detects in the design of the entrance facade, which closes off the *cour d'honneur* within the gradually increasing masses of the arcaded screen among two wings and the *corps de logis* creating perfectly contrasts to the garden facade (Pl. IV).[52] This compositional design is well known from the Salm-Kyrburg Palace in Paris, which later also inspired Pietro Nobile. In Milan, the Austrian state had to deal with the large-scale urbanistic projects that had been initiated while the city was under the administration of Napoleon's nephew Eugène de Beauharnais. Giovanni Antonio Antolini's Foro Buonaparte (1801–1806) was realized only in the form of a circular boulevard around Sforza Castle, but the system of entry gates into the city was still being worked on in the 1830s. The work was supervised by a commission made up of the architects and designers Luigi Cagnola, Luigi Canonica, Paolo Landriani, Giocondo Albertolli, and Giuseppe Zanoia.[53] These large-scale urbanistic projects evidently inspired Francis I when he commissioned the Äußeres Burgtor (Outer Castle Gate) in Vienna and the landscaping of the surrounding area, which Cagnola began work on by 1820.

The Free City of Trieste was integrated into the Austrian administrative system of offices of public works, but as far as public commissions went it reflected the specific situation of an independent city administration and, at the same

Fig. 8 Office of Public Works (after Pietro Nobile), Design for the Casa Fontana with the city's fish market, facade, ground and first floor, pencil, ink with watercolour, ca. 1826/27, Trieste, SABAP FVG, Fondo Nobile.

time, of a strategic site that provided the Austrian Habsburgs with access to the sea. Neoclassicism came to the city through private buildings, such as the summer residence used in turn by two governors of Trieste, the imperial councillor for foreign trade Carlo Zinzendorf and, from 1782 Pompeo de Brigido di Bresowitz. Around the year 1800, the residence was acquired by Pietro Sartorio, a prominent merchant from San Remo, who had a prospect tower, the so-called Rotonda Sartorio, built in the garden (after 1800).[54] Another example was the Carciotti Palace (1798–1805) by Matteo Pertsch, an extensive block of buildings on the bank of the Trieste Grand Canal, which, in addition to the rooms of the merchant Demetrio Carciotti, also contained extensive warehouse premises. Neoclassical public buildings also started being built on the instigation of local merchants. The

Corporation of Merchants set up a fund, from which it bought land in the centre of the city for the construction of a new stock exchange. However, the plot of land was quite narrow, and a large part of it was located directly on the waters of the Trieste "Small Canal." The stock exchange (1802–1806) was designed by Antonio Mollari, a well-known Roman architect, and the commission for its construction requested an opinion from the Reale Accademia di Belle Arti di Parma. The main trading hall exemplifies the successful application of contemporary Palladian principles for a "Corinthian hall," and the entrance facade with its high portico also utilizes Palladian forms (Fig. 7). The building, which shows the joint efforts of city officials and local merchants for monumental neoclassical architecture, was the city's fish market with 34 Doric columns (1813 draft, 1827 realization), inspired by the temples of Paestum, with two residential floors for Trieste merchant Carlo d'Ottavio Fontana (Fig. 8). The only strictly state commission whose design and approval process corresponded to what we know of the system of the Ober- und Hofbaudirektion was the Trieste General Hospital. It was commissioned by the imperial administration in 1819, and the Trieste Landesbaudirektion entrusted the task of designing it to the architect Antonio Juirs. The high-quality, essentially Josephine facade – as well as the unusually protracted process of approving the plans, which were sent to Vienna in 1826 – bears all the hallmarks of the state construction system of that time. Even with Pietro Nobile pulling strings, the design was not approved until 1831.[55]

The connection between the reformed Josephine offices of public works (on all levels) and educational establishments (usually in the person of the director) was an essential part of the Austrian system of designing and building. The latter was sometimes an academy-trained architect, as in the examples of the directors of the School of Architecture at the Academy of Fine Arts Vienna; other times, the director of the office of public works was also the director of a polytechnic, as was the case at the polytechnic in Prague with Georg Fischer (1768–1828), trained by Andreas Fischer (1755–1819) at the Academy of Fine Arts Vienna. Regardless, this connection between offices of public works and educational establishments was based on and facilitated through architectural drawing, in which Pietro Nobile also found his unusual approach to aesthetics and technology.

NOTES

1. Damie Stillmann, *English Neo-classical Architecture*, vol. 1, (London: A. Zwemmer, 1988), 79.

2. Sigfried Giedion, *Construire en France. Construire en fer. Construir en beton*, trans. Guy Balangé, introduction Jean-Louis Cohen (Paris: Édition de la Villette, 2000), 3. Originally published *Bauen in Frankreich: Eisen, Eisenbeton* (Leipzig and Berlin: Klinkhardt and Biermann, 1928).

3. Marc-Antoine Laugier, *An Essay on Architecture; in which its true Principles are explained, and invariable rules proposed, for directing the Judgment and Forming the Taste of the Gentleman and the Architect [...]* (London: T. Osborne and Shipton, 1755), VII: "Vitruvius has only learnt us what was practiced in his time; and altho' some lights escape from him, that shews a genius capable of penetrating into the true secrets of his art, he does not confine himself to the tearing of the veil that covers them, and avoiding always the abysse's of theory, he leads us thro' the road of practice, which frequently make us wander from the end." The idea of what the "theory" is has changed. Jacques-François Blondel divided his lectures into three sections: decoration, disposition, and construction. The last two parts, dealing with spatial arrangement and construction, were considered the teaching of practice, while the section devoted to ornamentation, which included the basic principles of composition and in particular the rules for the orders of columns, consisted of theory, referred to as science. See *Étienne-Louis Boullée : L'architecte visionnaire et néoclasique*, ed. Jean-Marie Pérouse de Montclos, (Paris: Hermann, 1993), 45, note 6.

4. Laugier, *An Essays on Architecture*, 10–13.

5. Émile- Louis Boullée, "L'architecture. Essai sur l'art," in *É.-L. Boullée*, ed. Pérouse de Montclos, 45. On the reception of the Boullée's unpublished manuscript see Klaus Jan Philipp, Rendez-vous bei Boullée. Pariser Architektur im Urteil deutscher Architekten um 1800, in Reinhard Wegner (ed.), *Deutsche Baukunst um 1800* (Köln, Weimar and Vienna: Böhlau, 2000), 122.

6. Wend von Kalnein, *Architecture in France in the Eighteenth Century* (New Haven and London: Yale University Press, 1995), 139.

7. Kalnein, *Architecture*, 155.

8. Sigfried Giedion, *Space, Time, and Architecture: The Growth of a New Tradition* (Cambridge, Ma.: Harvard University Press, 1997).

9. Giedion, *Construire*, 6–7.

10. Giedion, *Space*, 168–170.

11. Ibidem, 190.

12. Ibidem, 192–193.

13. Werner Szambien, *J.-N.-L. Durand 1760–1834: De l'imitation à la norme* (Paris: Picard, 1984), 75, note 19: "Durand uses the term 'appearance of the construction' when referring to Gay Head Lighthouse in le Précis, II, p. 58. This is in no way a functionalist creed, since the lighthouse is the testimony of a speaking architecture. In using this term, Durand is referring to the appearance of stones (of a wall, of a vault)."

14. Ibidem, 74–80.

15. Ibidem, 93.

16. Antoine Picon, "From 'Poetry of Art' to Method: The Theory of Jean-Nicolas-Louis Durand," in *J.-N.-L. Durand. Précis of the Lectures on Architecture: With Graphic Portion of the Lectures on Architecture*, trans. David Britt (Los Angeles: The Getty Research Institute, 2000), 1–68.

17. Picon, "From 'Poetry of Art'," 36.

18. *J.-N.-L. Durand. Précis of the Lectures on Architecture: With Graphic Portion of the Lectures on Architecture*, trans. David Britt (Los Angeles: The Getty Research Institute, 2000), 131.

19. John Knowles, The Life and Writnigs of Henry Fuseli (London: Henry Colburn and Richard Bentley, 1831), 303.

20. Hugh Honour, "Neo-Classicism," in *The Age of Neo-Classicism* (London: The Arts Council of Great Britain, 1972), XXIV.

21. https://www.larousse.fr/encyclopedie/personnage/Jean-Baptiste_Colbert/114048 cf. Nicolaus Pevsner, *Academies of Art: Past and Present* (New York: Cambridge University Press, 1940, reprint 2014). The only authority of French Neoclassicism without the support of people in high official posts was Jacques-François Blondel (1705–1774). His relationship to the state academy was a strained one from the beginning, because from the year 1742 he was head of a private educational establishment, at which Boullée, Chambers, Ledoux, and de Wailly all studied. Gradually, however, he worked his way up to the position of professor in 1762.

22. Barbara Arciszewska, New Classicism and Modern Institutions of Georgian England, in Lynda Mulvin, ed., *The Fusion of Neo-Classical Principles* (Dublin: Wordwell, 2011), 16–19, 24 (note 75).

23. Kalnein, *Architecture*, 90.

24. James Stevens Curl, "Soufflot, Jacques-Germain," in *Dictionary of Architecture* (Oxford: Oxford University Press, 1999), 624.

25. Antony Vidler, *Ledoux*, trans. Serge Grunberg (Paris: Hazan, 1987), 41.

26. Picon, "From 'Poetry of Art'," 64. Thanks to this, Durand possessed some of the prints that illustrated Denon's *Déscription de l'Égypte*.

27. Reinhard Strecke, "Bauschüler in Berlin. Zwischen Wissenschaft und Baustelle," in *Neue Baukunst. Berlin um 1800*, ed. Elke Blauert and Katharina Wippermann (Berlin: Nicolai, 2007), 37.

28. Wend von Kalnein, "Architecture in the age of Neo-Classicism," in *The Age of Neo-Classicism* (London: Art Council 1972), LXIII.

29. KA, "Engel, Carl Ludwig (1778–1840)," in *The Age of Neo-Classicism*, 528.

30. Friedrich Meinecke, *Die Idee der Staatsräson in der neueren Geschichte* (Munich and Berlin: R. Oldenburg, 1929), 1; Miloš Havelka, "Úředník a občan, legitimita a loajalita," in Taťána Petrasová and Helena Lorenzová, eds., *Opomíjení a neoblíbení v české kultuře 19. století* (Praha: KLP – Konias Latin Press, 2007), 23.

31. Jan Klaus Philipp, "Architekturausbildung zwischen Baukunst und Polytechnik," in *Von vorzüglicher Monumentalität*, ed. Lavesstiftung, (Berlin: Lavesstiftung, 2014), 75–83.

32 Stillmann, *English Neo-classical Architecture*, 347.

33 Hugh Honour, *Neo-Classicism* (Harmondsworth: Penguin Books Ltd., 1968), 31; Frank Büttner, "Die Weimarischen Kunstfreunde und die Krise der Kunstakademien um 1800," in *Klassizismus in Aktion. Goethes 'Propyläen' und das Weimarer Kunstprogramm*, Daniel Ehrmann and Norbert Christian Wolf, eds., (Vienna, Cologne und Weimar: Böhlau, 2016), 295–328.

34 Daniel Rabreau, *Architectural Drawings of the Eighteenth Century / Les Dessins d'architecture au XVIIIe siècle / I Disegni di architettura nel settecento*, (Paris: Bibliothèque de l'Image, 2001), 95–96. In France, the symbols of urban beautification were the grand theatres – those designed by Victor Louis in Bordeaux (1771–1780), Ledoux in Besançon (1776–1784), or Lequeu in Lille (unrealized). Designs for new quarters and new towns or the reconstruction of old city centres could be found all across Europe: in Great Britain (Bath, Edinburgh), France (Chaux), Russia (St Petersburg, Moscow), Germany (Berlin, Kassel, Karlsruhe), and the Habsburg Monarchy (Vienna, Budapest, Prague, Trieste, Lviv).

35 Ibidem, 98.

36 Ibidem, 85.

37 Pieter M. Judson, *The Habsburg Empire. A New History* (Cambridge, Ma. and London: The Belknap Press of Harvard University Press, 2016), 23–24.

38 Anna Mader-Kratky, "Neustrukturierung des Hofbauwesens durch Joseph II.," in Hellmut Lorenz and Anna Mader-Kratky, eds., *Die Wiener Hofburg 1705–1835. Die kaiserliche Residenz vom Barock bis zum Klassizismus* (Vienna: Austrian Academy of Sciences, 2016), 258–259.

39 Taťána Petrasová, "Architektura státního klasicismu, palladiánského neoklasicismu a počátků romantického historismu," in Taťána Petrasová and Helena Lorenzová, eds., *Dějiny českého výtvarného umění 1780–1890*, vol. I (Prague, Academia, 2001), 29–32.

40 Christian Benedik, "Organisierung und Regulierung der k.k. Generalbaudirektion und deren Landesstellen," *Das Achtzehnte Jahrhundert und Österreich*. Jahrbuch der Österreichischen Gesellschaft zur Erforschung des achtzehnten Jahrhunderts 11 (1996): 20–21; Elisabeth Springer, "Die josephinische Musterkirche," ibidem: 67–79.

41 John Winton-Ely, "Pál Kuehnel," in *The Age of Neo-Classicism* (London: Art Council, 1972), 569–570; Pavan, *Lettere*, 350–351, Pietro Nobile's commentary in 1834 on the projects for Esztergom shows that he was aware of the sensitivity of his mission: "Là [in Esztergom] avrò un osso duro da rosicare, certamente il più duroche mi si sia presentato giammai, ma vedrò di disimpegnarmi dal incarico il meno male possibile."; Peter Plaßmeyer, "Peter von Nobile (1776–1854)," in Klaus Jan Philipp, Winfried Nerdinger and Hans-Peter

Schwarz, eds., *Revolutionsarchitektur: Ein Aspekt der europäischen Architektur um 1800* (exh. cat. Deutsches Architektur Museum, Frankfurt am Main) (Munich: Hirmer, 1990), 236–237.

42 József Sisa, ed., *Motherland and Progress. Hungarian Architecture and Design 1800–1900* (Basel: Birkhäuser, 2016), 156–165.

43 Ibidem, 121–122.

44 Renate Wagner-Rieger, *Wiens Architektur im 19. Jahrhundert* (Wien: Österreichischer Budesverlag für Unterricht, Wissenschaft und Kunst, 1970), 24.

45 Pavel Zatloukal, *Příběhy z dlouhého století. Architektura let 1750–1918 na Moravě a ve Slezsku* (Olomouc: Muzeum umění 2002), 36.

46 Only Wagner-Rieger's written commentary has been preserved; the whereabouts of the drawing itself are unknown. See Wagner-Rieger, *Wiens Architektur*, 23–24. – www.architektenlexicon.at. Cf. Brigitte Litschauer, Die großen Preise der Akademie: Architektur von den Anfängen bis 1820 (PhD diss.), Vienna 1964.

47 Kalnein, *Architecture*, 110, 112.

48 Wagner-Rieger, *Wiens Architektur*, 51; Hellmut Lorenz, "The Josephine Building Complex. Allgemeines Krankenhaus, Garnisonspital, Narrenturm and Josephinum," in Julia Rüdiger and Dieter Schweizer, eds., *Sites of Knowledge. The University of Vienna and its Buildings. A History 1365–2015* (Vienna and Cologne and Weimar: Böhlau, 2015), 99–108, especially: 106–108.

49 Sisa, ed., *Motherland*, 199.

50 Himmelheber, *Biedermeier*, 12–20; Kassal-Mikula, "Architecture," 139–159; Petrasová, "Aristokratický biedermeier," 149–159.

51 Hedwig Herzmansky, "Josef Kornhäusel" (PhD diss., University of Vienna 1965); Wilhelm Georg Rizzi, "Josef Kornhäusel," in *Bürgersinn und Aufbegehren. Biedermeier und Vormärz in Wien 1815–1848* (exh. catalogue Historisches Museum der Stadt Wien 1987/1988), (Vienna: self-publishing without date [1987]), 505–513.

52 Carroll L.V. Meeks, *Italian Architecture 1750–1914* (New Haven and London: Yale University Press, 1966), 88.

53 Ibidem, 101.

54 Franco Firmiani, *Arte neoclassica a Trieste* (Trieste: B & MM Fachin, 1989), 84–97.

55 Ibidem, 169–171; Marzia Vidulli Torlo, "Gli ospedali e le opere di beneficenza," in *Neoclassico. Arte, architettura e cultura a Trieste 1790–1840*, ed. Fulvio Caputo, 355–357. Venice: Marsilio, 1990. See UAABKW, VA ex 1828/29, Zl. 121: The list of topics of the School of Architecture, which Nobile prepared for the Hofpreis on 18 May 1829, also includes the elaboration of a hospital with the remark: "Ein solches Gebäude wird in Triest ausgeführt" (such a building is being executed in Trieste). Courtesy of Richard Kurdiovsky.

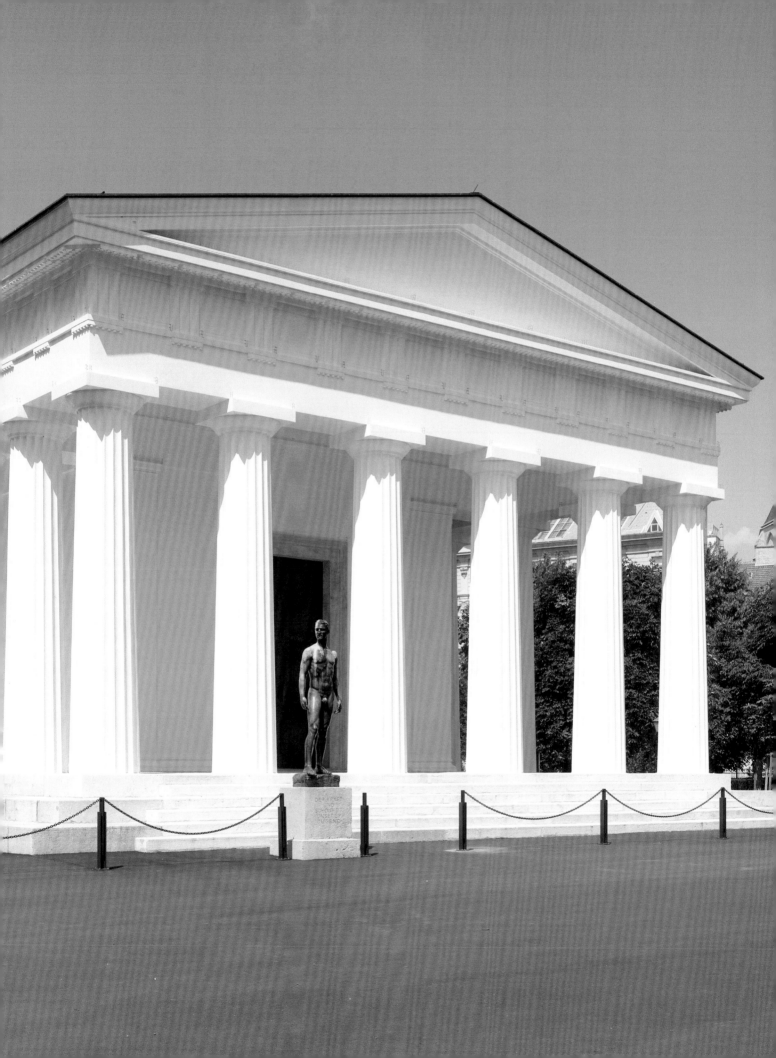

THE LIFE AND WORK OF PIETRO NOBILE

Richard Kurdiovsky, Taťána Petrasová, and Rossella Fabiani

1776[1]

October 10, born in Campestro (Capriasca), Tesserete parish (Ticino canton; Fig. 9).

1785

The family moves to Trieste to be with their father Stefano Nobile, who probably worked there as a master builder from 1766.

Attends the Accademia di Nautica (the institution that preceded the Accademia Reale o Scuola Reale di Commercio e di Navigazione, which was founded in 1807) under Michael Andreas Stadler von Breitwerg (diploma 1797).

After 1789, continues training and works with Ulderico Moro.

Employed on various building sites in Trieste.

Works: Drawing of a Corinthian temple (Pl. XVII), probably as part of his training with Moro.

1797

Towards the end of the year, Nobile departs for Rome.

Works: City *vedute* with scenes from the first French occupation of Trieste.[2]

1798

Studies in Rome at the Accademia di San Luca, with a scholarship from the city of Trieste (until September 1799).

Establishes friendships with Antonio Canova and Giuseppe Valadier, among others.

Works: Printed reproductions of a *veduta* of Piazza San Pietro (today Piazza dell'Unità d'Italia) in Trieste (Fig. 25).

1801

Sojourn in Vienna (on a temporary scholarship from the Academy of Fine Arts),[3] during which he probably presents his project for a *Campidoglio* (Pl. XVIII) to the future emperor Francis I and, as a result, is awarded the academy's scholarship to Rome.[4]

Autumn departure, and December arrival in Rome.[5]

1801

Studies in Rome until 1805. In 1802, is commissioned by the president of the Academy of Fine Arts, Baron Anton I of Doblhoff-Dier, to acquire models for the academy library.[6]

1803

In December 1803, Nobile applies for an extension of his stay for another year.[7]

Works: Designs for a funerary temple for the installation of Antonio Canova's tomb for Archduchess Maria Christina.[8]

1805

In February, cancels the Rome scholarship early because of an eye complaint and returns to Trieste to recover,[9] remaining there until at least March 1806.

1806

From December, internship at the Generalhofbaudirektion (Central Office of Public Works) in Vienna and, above all, with the 1st court architect Louis Montoyer (until November 1807).

Fig. 9 Pietro Nobile's birthplace in Campestro (Capriasca), Ticino canton, Switzerland, photo 2018.

1807

From the end of the year, employed as 3rd adjunct at the office of public works in Trieste.[10]

1808

In addition to his work in civil, road, and hydraulic engineering, Nobile repeatedly travels (until 1818) through Istria and Dalmatia (resulting in drawings of the Temple of Augustus and the arena in Pula, among others, Fig. 94).[11] Nobile makes archaeological studies, especially in Trieste (1814, discovery of the Roman theatre; studies of the campanile of the cathedral of San Giusto), in Pula (arena; Temple of Augustus; Arch of the Sergii), and in Aquileia (1815, supervises the excavations by Girolamo de Moschettini in cooperation with the court councillor in the Triestine district office, Count Karl Chotek).

Works: Takes part in the competition for the construction of the church of Sant'Antonio in Trieste.

1809

Drafts a reform of the state building administration in the *Notizie statistiche di Trieste*.

Works: Tomb of Johann Heinrich Dumreicher for the Chiesa del Rosario in Trieste (now in the Evangelical Lutheran Church in Trieste).

1810

Appointment as 1st-class engineer for road and bridge construction in the French province of Illyria.

First lecture to the Società di Minerva in Trieste, recently established by Domenico Rossetti.

1813

Appointed interim head of the Direzione delle Fabbriche or Baudirektion (Office of Public Works) in Trieste.

Appointed as a member of the Accademia italiana di Pisa.

Nobile prepares the document *Projet relatif aux Antiquitées architectonique d'Illyrie* for the French authorities, on the preservation of state monuments and the systematic registration of local archaeological artefacts. Nobile renewed it

Fig. 10 Pietro Nobile, Bas-relief found in the year 1814, engraving, 1814, Trieste, CMSA.

in 1814 for Count Franz Josef Saurau, the Habsburg court commissioner responsible for the former French province of Illyria (Fig. 10).

Trieste Stock Exchange, celebrating the visit of Francis I to the city.
Works: Prison at Gradisca d'Isonzo (attributed).[14]

1814

Publication of a description of Nobile's *Campidoglio* designs of 1800/01 in the book *Progetti di varj monumenti architettonici immaginati per celebrare il trionfo degli Augusti Alleati, la Pace, la Concordia dei popoli e la rimanente felicità d'Europa nell'anno 1814*[12] (Pls. XVIII, LVIII).

1815

Appointed a member of the Academy of Fine Arts Vienna.
Works: Construction of the Soča Bridge in Kanal ob Soči.

1816

Appointed permanent Landesoberbaudirektor (director of the office of public works) in Trieste.[13]
Cicerone for Emperor Francis I through Istria and Trieste.
Works: Design of the decorations for the facade of the

1817

In January, negotiations begin for his appointment to the Academy of Fine Arts Vienna (in Vienna in September; imperial permission granted in December).
Works: In May, Nobile completes his competition entry for the Äußeres Burgtor in Vienna with seven variants (Pl. XLIV and XLV; 1818 decision in favour of Luigi Cagnola [Pl. XLVI and Fig. 59 and 60]).
Realization of Casa Costanzi (first sketches made in 1816), the Accademia Reale o Scuola Reale di Commercio e di Navigazione in Trieste, and the Savudrija Lighthouse with the first gas lighting in Europe (Pl. XXXV).

1818

In January, the council elects Nobile as the new director of the School of Architecture at the Academy of Fine Arts Vienna (Fig. 11).

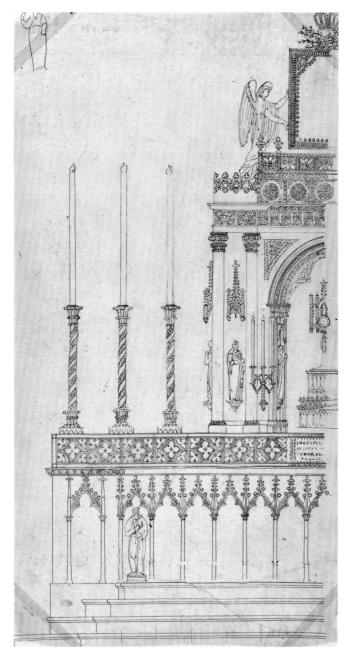

Fig. 12 Pietro Nobile, Design for the high altar of St. Stephen's Cathedral in Vienna, pencil and ink, between 1819 and 1827, Trieste, SABAP FVG, Fondo Nobile.

In February, appointed as a member of the council of this academy.

Arrival in Vienna in mid-July; commissioned as a consultant on reforming the teaching of architecture in Lviv, where Ignaz Chambrez has been a professor of civic architecture at the Kaiserlich-Königliches Lyceum since 1816 and at the university since 1817.

On 1 August, takes the oath of office as Hofbaurat (State Building Councillor) and becomes director of the School of Architecture.

At the beginning of the semester, produces sample drawings for the School of Architecture.

Works: New facade for St Peter's Church in Piran.

Planning of the villa for the state councillor Sir Josef Hudelist in Baden near Vienna (Fig. 50).

Consultancies: Participates in the commission for the design of the attic of the Polytechnisches Institut in Vienna[15] (compare Pl. XXXVIII).

1819

In January, Nobile presents the plan to reform the teaching of architecture at the Vienna academy.

In April, imperial approval for the purchase of plaster casts of antique architectural elements and decorations to form a specimen collection for the School of Architecture (the first deliveries arrive in Vienna in 1822).

Towards the end of the year, a dispute among the academy staff about expansions to the School of Architecture; academy curator Prince Clemens Wenzel Lothar Metternich commissions Nobile to draw up plans for the expansion of the school's premises into the neighbouring Mariazellerhof.[16]

Also towards the end of the year, a proposal to employ Ludwig Christian Förster as a new corrector at the School of Architecture (he holds this position until 1826).

Works: Drafts of a library and museum in Lviv (the Ossolineum; Pl. LXXII and LXXIII) for the prefect of the court library Count Joseph Maximilian Ossoliński of Tenczyn, in return for the donation of twenty-five copies of Francesco Milizia's *Principi di architettura civile* as textbooks for the School of Architecture.[17]

Projects for the reconstruction of Mirabell Palace in Salzburg (Fig. 66–68) and for the redesign of the facades of Schönbrunn Palace near Vienna (Fig. 69).

Designs for a new high altar in St Stephen's Cathedral in Vienna, including a "Gothic" variant (ongoing until 1827; Pl. V and Fig. 12).[18]

Fig. 13 Pietro Nobile (together with Antonio Canova), *Theseustempel* in *Volksgarten*, Vienna, 1820–1822, photo 2011.

Designs for the installation of Giacomo Raffaelli's mosaic after Leonardo's *Last Supper*, including a new chapel to be built near the Oberes Belvedere in Vienna or as a side altar in the Minoritenkirche (ongoing until 1837; Pl. VI).[19]

Consultancies: Participates in the commission for the erection of a monument to the field marshal Count Joseph Colloredo in the imperial armoury on Renngasse in Vienna (construction finished in 1828).[20]

1820

In spring, the first public exhibition of works by students of the School of Architecture in the rooms of the academy,[21] attracting great interest from the court and the public.[22]

In April, Nobile proposes to create at the academy a "Galleria sistematica di opere di Architettura" for teaching purposes and as an architecture museum open to the public.[23]

In June, Nobile's first visit to Kynžvart with Metternich.[24]

In November, imperial commission to revise the reform plan for teaching architecture at the academy in line with the teaching programme at the Polytechnisches Institut in Vienna.

Works: Approval of the design for the Theseustempel in the Volksgarten in Vienna (Pl. XLVII and XLVIII and Fig. 13) based on Canova's specifications (completed in 1822; in 1823 imperial decision to expand the cellar into a museum of Roman antiquities discovered in Austria, based on Nobile's idea).

Plans for the Second Corti Café in the Volksgarten (completed 1822; Pl. VII and Fig. 14).

Installation of the 1:1 models of the alternative designs for Cagnola's Burgtor.

Projects for the redesign of the Badeschloss (spa palace) in the town of Bad Gastein (probably completed in 1821).[25]

In summer, design of the Metternich family tomb in Milíkov near Mariánské Lázně.[26]

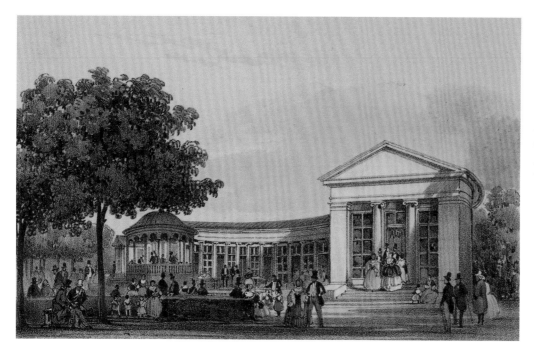

Fig. 14 Pietro Nobile, Zweites Cortisches Kaffeehaus (Second Corti Café) in Volksgarten, 1820–1822, lithography by Franz Xaver Sandmann after a drawing by Rudolf Alt from: Album der schönsten Ansichten etc., plate 18, ca. 1850, Vienna, Austrian Academy of Sciences, Woldan collection.

1821

In summer, Nobile presents the revised reform plan for the teaching of architecture at the academy.

Works: Takes over the construction site of the Äußeres Burgtor, which is now to be completed according to his own design (Fig. 15, 61 and 62).

1822

Appointed as honorary member of the Accademia di San Luca.

Consultancies: Participates in the commission evaluating the work of Joseph Klieber in the Invalidenhaus in Vienna.[27]

1823

Appointed as an honorary member of the Accademia di Belle Arti in Venice.

In December, plans to publish a printed textbook with drawing exercises and systematically arranged sample sheets.[28]

Works: Wins the new competition for the construction of the church of Sant'Antonio in Trieste (Pl. VIII a, b and Fig. 45–48), design accepted in October 1825,[29] completion in 1849.

1824

On the occasion of an exhibition of students' work in spring, plans to publish a sample book for architects and builders with the support of the academy president Count Johann Rudolf Czernin of Chudenitz and the curator Metternich.[30]

Proposal of Franz Xaver Lössl[31] for the Rome scholarship is the first by a graduate of the School of Architecture.

Under Nobile, the School of Architecture produces sample drawings for the architecture lessons of Chambrez in Lviv (ongoing until 1827).[32]

Works: Expansion plans for the premises of the School of Architecture into Mariazellerhof, developed until 1825 (Fig. 16), completed by 1827.[33]

Revision of the plans for the Estates Theatre in Graz (today's Schauspielhaus; completed in 1825; Fig. 64), including the layout of Franzens-Platz (today's Freiheitsplatz).

Completion and opening of the Äußeres Burgtor in Vienna.

1825

In October, work on the publication *Opera d'Architettura.*[34]

Works: Design of the pedestal for Johann Nepomuk Schaller's *Schwarze Madonna* on the glacis in front of the Äußeres

Fig. 15 Pietro Nobile, *Äußeres Burgtor* (Outer Hofburg gate), 1821–1824, photo 2011.

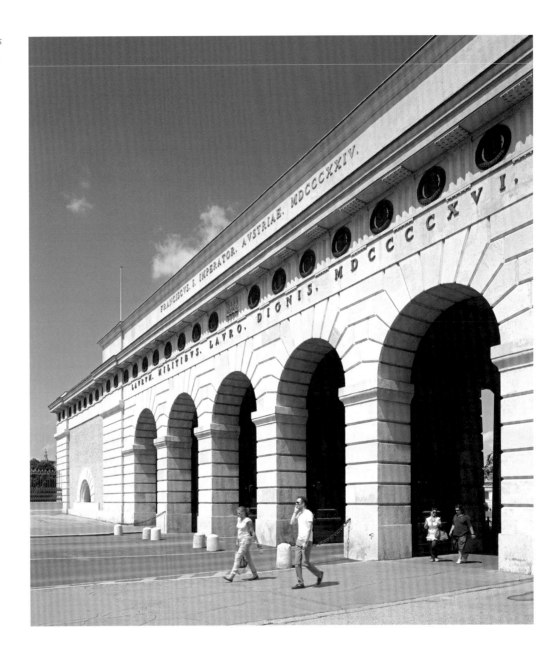

Burgtor in Vienna (Fig. 17), transferred to the Schotten-kloster in 1828.[35]

Consultancies: Participates in the commission that considered proposals for the sculptures for Cagnola's Arco della Pace or Arco del Sempione in Milan (ongoing until 1826).[36]

1826

In November, proposes to hire Carl Roesner[37] as corrector at the academy in Vienna.

Works: Draft for the design of the ceremonial hall of the polytechnic in Vienna (Pl. LI; execution 1836–1842).

Glasshouse with Gothic decorations for the banker Johann Mayer in Penzing near Schönbrunn (Fig. 77).

Draft for the redesign of the Metternich family crypt[38] (ongoing until 1829; Pl. IX) and residence in Plasy,[39] executed by Nobile's student Josef Kranner from Prague.[40]

Consultancies: Participates in the commission for the construction of two new side altars in the church of Maria am Gestade in Vienna; designs probably by Ludwig Ferdinand Schnorr von Carolsfeld, among others (ongoing until 1828).[41]

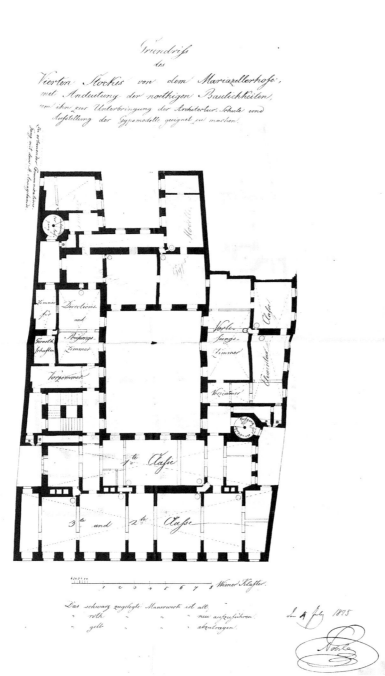

Fig. 16 Pietro Nobile, modification plan for the top floor of the Mariazellerhof in Annagasse, next to the building of the Academy of Fine Arts Vienna, to create new rooms for the School of Architecture, pencil and ink, 1825, Vienna, University Archives of the Vienna Academy of Fine Arts.

1827

Installation of the plasters ordered from Rome in the Maria-zellerhof premises of the School of Architecture.[42]

Nobile proposes Paul Sprenger as professor of mathematics at the academy.

Works: Realization of the Casa Fontana in Trieste (Fig. 8 and 18; first draft in 1813).

Project for the expansion of the Hofburg (Imperial Palace) in Vienna (Pl. LV).

Projects for the construction of the Hofburgtheater (Imperial Court Theatre) in Vienna (ongoing until 1828; Pls. LII, LIII, LIV and Fig. 70).

Designs for a *sestiga* with the figure of Emperor Francis I to crown the Äußeres Burgtor (further designs produced up until 1839–1842; Pl. LVII).

Designs for the Landesgerichtsgebäude (Regional Court) in Vienna, executed by Johann Fischer from 1831–1839 (Pl. X).[43]

RICHARD KURDIOVSKY, TAŤÁNA PETRASOVÁ, AND ROSSELLA FABIANI

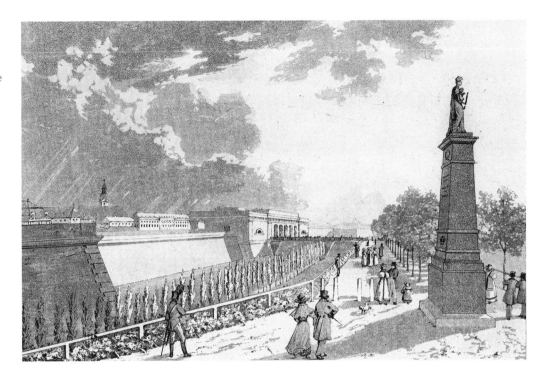

Fig. 17 Monument of the *Schwarze Madonna* by Johann Nepomuk Schaller with the pedestal by Pietro Nobile on the *Glacis* next to the new Burgtor, 1825, print after a drawing by Joseph Ignaz or Eduard Gurk published by Tranquillo Mollo, Vienna, Wien Museum.

In October, first commission from Metternich to draw up reconstruction plans for Kynžvart Castle (Fig. 20).[44]
Consultancies: Participates in the commission for the erection of a monument to Emperor Francis I in Graz (ongoing until 1837).[45]

Alternative design for a monument to Emperor Francis I on the city wall of Sibiu (Fig. 89).[51]
Consultancies: Participates in the commission for a monument to the field marshal and director of the military academy in Wiener Neustadt Count Francis Kinsky.[52]

1828

Works: Design of the new stamp for the directorate of tobacco and stamps.[46]
Glasshouse modelled on the Mayer glasshouse in Penzing for the garden of the Keglevich Castle in Topoľčianky (construction finished in 1829).[47]
Project for the reconstruction of Johannisberg Castle near Ingelheim on the Rhine for Metternich (ongoing until 1829).
Designs for the reconstruction of the Rosstor (Horse Gate) in Prague (Pl. XI) for Count Karl Chotek, Colonel Burgrave and Imperial-Royal District President of the Kingdom of Bohemia from 1826.[48]
Alternative designs for the renovation of the monument to the general field marshal Baron Karl Reinhard of Ellrichshausen on the Marienschanze in Prague (Pl. XII).[49]
Alternative designs for the tomb of Bishop Joseph Chrysostomus Pauer in St Pölten Cathedral (ongoing until 1830).[50]

1829

Architectural instruction for the duke of Reichstadt (Napoleon II), probably until 1832.
Supports Roesner's application for a Rome scholarship.
Project to create a fund for the promotion of visual artists in the Austrian Empire, with the support of the wholesale and banking house Stametz and Company (ongoing until 1832).[53]
Appointed member of the Accademia di Belle Arti of Milan.[54]
Works: Designs a new title page for the diplomas of nobility awarded by the emperor (ongoing until 1830).[55]
Project for the Redemptorist monastery near Maria am Gestade in Vienna (Fig. 19).[56]
Consultancies: Commissioned by Metternich to advise on Major Lukacsich's hospital project in Frankfurt am Main (ongoing until 1830), brokered through the lieutenant field marshal Prince Philipp von Hessen-Homburg.[57]

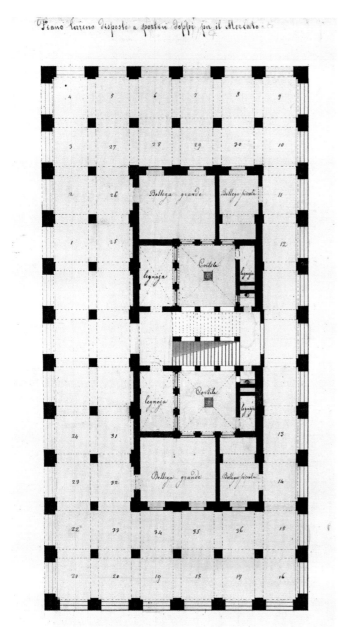

Fig. 18 Pietro Nobile, Design for the Casa Fontana with the city's fish market, ground floor, pen and ink, (1813) 1827, Trieste, SABAP FVG, Fondo Nobile.

1830

Proposes to employ Lössl as a substitute corrector for Roesner.

Consultancies: Commissioned by Metternich to advise on Frankfurt am Main's main cemetery, opened in 1828, in order to draw the attention of the court chancellery to this subject.[58]

1831

Appointed member of the Royal Danish Academy of Fine Arts in Copenhagen.

Supports the application of the architecture student Leopold Ernst[59] for an extraordinary scholarship to Italy.[60]

In September, sojourn in Bohemia (visits building sites in Plasy, Mariánské Lázně, and Kynžvart; also Cheb, Františkovy Lázně, and Karlovy Vary).[61]

1832

Works: In February, commissioned by Countess Sofia Potocka (née Branicka) to rebuild the Potocki Chapel in Kraków Cathedral in memory of her late husband Count Artur Potocki from Krzeszowice (completed in 1840; Pl. LXXIV).[62]

1833

Recommends the purchase of plaster casts from Venice, including some from the Middle Ages.[63]

Nobile supports the application of the architecture student Friedrich Stache[64] for a scholarship.[65]

Works: During a summer stay in Kynžvart, focuses particularly on the adaptation of the plans for the castle chapel (Pl. XIII, LXIX and Fig. 84) to accommodate the altar from San Paolo fuori le mura donated by Pope Gregory XVI.[66]

Alternative design for a monument to Joseph II in Rousínov.[67]

Project to reconstruct the access to the picture gallery of the academy donated by the late president Count Anton Franz de Paula Lamberg-Sprintzenstein (ongoing until 1834).[68]

1834

Presentation of a 250-plate print collection of models as teaching material for students of architecture.[69]

Works: Projects for the Esztergom Cathedral (Pl. XIV).[70]

Reconstruction and expansion project for the Prague Old Town Hall, design work until 1836,[71] execution 1839/40 (Fig. 88, compare Fig. 92).[72]

Fig. 19 Pietro Nobile, design for the Redemptorist monastery near *Maria am Gestade* in Vienna, pencil, ink with watercolour, 1829, Trieste, SABAP FVG, Fondo Nobile.

1835

Proposal to appoint Roesner as professor of architecture and Ferdinand Kilian as corrector.[73]

Gives a significantly higher amount than his academy colleagues towards a medal celebrating Metternich's twenty-fifth anniversary as curator of the academy.[74]

In October and November, trip via Kynžvart and Teplice to Dresden, Berlin, Leipzig, Nuremberg, Regensburg, and Munich; meetings during this trip with Karl Friedrich Schinkel, Leo von Klenze, Friedrich Gärtner, and Georg Friedrich Ziebland, among others.[75]

Works: Design of the sarcophagus for Francis I in the Capuchin Crypt in Vienna.

Construction of Villa Metternich on Rennweg in Vienna (completed 1837; Pls. LXIV–LXVI, compare Fig. 82).

Designs for a monument to Francis I, including a corresponding monument to Maria Theresa, on the Äußerer Burgplatz (Outer Hofburg Square) in Vienna (erection of a 1:1 model in spring 1838, further designs up to 1841/42; Pl. LVI and Figs. 73, 74).

From July to September, supervises work on the monument commemorating the victory of the Russian troops over Napoleon at Chlumec in Přestanov, including the figure of Victory modelled on the ancient bronze statue found in Brescia in 1826 (cast at the ironworks of Count Wrbna in Hořovice);

some parts of the monument displayed at the exhibition of Bohemian trades in Prague in 1836;[76] unveiling of the monument on 29 July 1837; Pl. LXXV and Fig. 90).

At the same time, supervision of the work on the monument to Francis I in the park of Kynžvart Chateau, along with a design for a temporary triumphal arch and a temporary Doric temple on the same site.[77]

Project for the construction of the residence for Duke William I of Nassau at Luisenplatz in Wiesbaden (Figs. 75, 76).[78]

Design for the Bratislava Gate in Komárno (attributed).[79]

1836

On Metternich's initiative and as part of his trip to Esztergom, visits the residence in Bajna of Metternich's son-in-law Count Moritz Sándor and publishes, probably at his own expense, *Reminiscenza di una rapida corsa a Bajna comitato di Gran in Ungheria nel mese di giugno del anno 1836* (Fig. 93).[80]

Publication of the first issue of Förster's *Allgemeine Bauzeitung* (including an article on Nobile's lighthouse at Savudrija, compare Pl. XXXV).[81]

Work: Design for the lighthouse on the island of Porer off the Premantura Peninsula in Istria.[82]

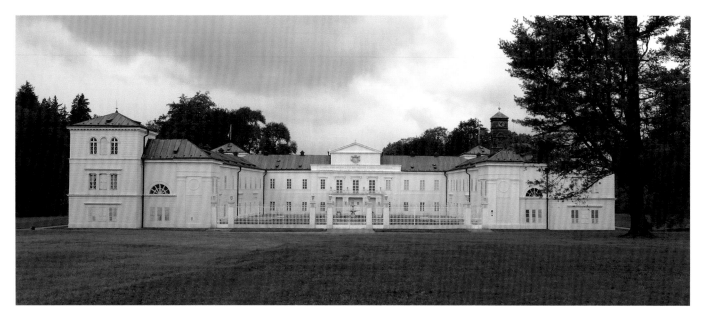

Fig. 20 Pietro Nobile, Kynžvart Château, 1827–1839, photo 2018.

1837

Travels to Milan and, among other things, prepares the ceremonies for Ferdinand I's coronation as king of Lombardo-Venetia (makes another trip there in 1838).[83]

Project reproducing 244 selected architectural drawings in print (one bound copy is dedicated to Metternich in his library in Kynžvart Castle).[84]

Works: Construction of a garden pavilion or "Gloriet" according to Nobile's design for Mayer in Penzing.[85]

1838

Made a member of the Institute of British Architects in London (later the Royal Institute of British Architects, i. e. RIBA).

In May, accompanies Klenze during his visit to Vienna.[86]

In September, receives the engineer William Tierney Clark from London in connection with the forthcoming construction of the Széchenyi Chain Bridge in Budapest.[87]

Giovanni Mandrian painted his first portrait of Pietro Nobile as a copy of a portrait of Natale Schiavoni from 1832/33.

Proposes the award of the Rome scholarship to the two winners of the Hofpreis, August Sicard von Sicardsburg[88] and Eduard van der Nüll,[89] and supports their wish to use the scholarship for studies in France, England, and the Netherlands.

1839

In April, Nobile's several visits to Förster's successful zinc factory with Metternich and Chotek, because of the latter's intention was to use prefabricated iron products for the reconstruction of Prague Old Town Hall.[90]

In July, travels from Vienna to Brno on the Kaiser Ferdinands-Nordbahn, which was opened for passenger traffic the year before.

In September, Metternich reports that Andreas Ettingshausen, on his way back from Paris, used the new technique of the daguerreotype to take a series of views of Johannisberg Chateau.[91]

Works: Restoration of the Schottentor (Scots' Gate) in Vienna (ongoing until 1840; compare Fig. 54).[92]

1840

In June, on Metternich's initiative, plans a trip to Frankfurt am Main, Cologne, Brussels, London, and Paris (departs in September and ultimately visits Bamberg, Würzburg, Frankfurt am Main, Wiesbaden, Johannisberg, Amsterdam, and Brussels).

Spa stay in Mariánské Lázně and Karlovy Vary; accommodation in Metternich's spa house, with frequent visits to the castle and park in Kynžvart.[93]

Works: Design for the government building in Lviv.[94]

Project to renovate the parish church of Inzersdorf near Vienna (early 1840s; Pls. XLIX, L).

Designs the triumphal arch celebrating the visit of Archduke Franz Karl to Kynžvart in September.

In September, drawings for the neo-Gothic Belvedere at "Richardsbühl" near Kynžvart.[95]

Giovanni Mandrian painted a second portrait of Pietro Nobile in Vienna and he finished the work at Christmas (Fig. 21).

1841

Works: Project for the completion of the forecourt at Kynžvart is his last work for Metternich's castle (documented in the oldest photographic record of the castle, probably by Anton Starck or Anton Martin).[96]

First drafts for the redesign of the facade of the Capuchin Church in Vienna (ongoing until 1842; compare Fig. 56).

1842

In February, disputes in the Hofbaurat (probably connected to the change of leadership from Sir Joseph Schemerl von Leytenbach to major general Karl Myrbach von Rheinfeld) about Nobile's position; he fears that his jurisdiction could be limited to the Italian provinces[97] and that perhaps Myrbach is spreading dissatisfaction with his "style Tedesco," i.e. German style.[98]

Receives official letter of thanks from the city of Teplice for his drawings of the monument to the king of Prussia.[99]

In March, Förster assigned to review Nobile's reconstruction plans for the Prague Old Town Hall.

Appointment of Förster to replace the departing Sprenger as professor of architecture (he holds this position until 1845).[100]

Works: Design of a stock exchange building on Minoritenplatz in Vienna (Fig. 65).

Participates in the competition for a palace in Lugano (cf. Fig. 22).[101]

Fig. 21 Giovanni Mandrian, Portrait of Pietro Nobile, oil on canvas, 1837–1839, Trieste, SABAP FVG.

1843

Approves Sicardsburg's appointment as professor in the School of Architecture and van der Nüll's as professor of ornamentation and perspective.

The Society of Patriotic Friends of the Arts, via Johann Gottfried Gutensohn, commissions comments and Nobile's own design for the reconstruction of Queen Anne's Summer Palace (the Belvedere) in Prague.[102]

1844

In February, Johann Gottlieb Gutensohn thanks Nobile for his comments on the church of the Assumption of the Virgin Mary (1844–1848) in Mariánské Lázně.[103]

In April, proposal by Förster to replace Nobile's facade for the Prague Old Town Hall with a new facade based on Sprenger's design (Fig. 88).[104]

In August, stays at the spa in Piešťany.

Fig. 22 Pietro Nobile, A public building (the Senate) in Ticino canton, pencil, 1840s, Trieste, SABAP FVG, Fondo Nobile.

Project to found a drawing school in Tesserete.

In September, Nobile takes over the management of the Hofbaurat on short notice (until January 1845)[105] and hands over his Viennese agenda to Sprenger.[106]

Works: Design for the customs house in Milan.[107]

1845

Appointed a knight of the Order of the Iron Crown, 3rd class.

Schinkel's pupil and co-worker Friedrich Ludwig Persius visits Vienna.

Nobile stops regular visits to the Metternich salon because the prince no longer undertakes building projects.[108]

Works: Design for a public building (probably the senate building) in Ticino canton (Fig. 22).

1847

Supports the application of the architecture student Ferdinand Kirschner for an extraordinary scholarship to Italy.[109]

In October and November, Nobile substitutes for Roesner during his visit to London.[110]

Works: Redesign of the facade of the Capuchin Church on the Neuer Markt in Vienna (Fig. 56).

Consultancies: In June, trip to Budapest as a member of the jury to examine the designs for the new building of the

RICHARD KURDIOVSKY, TAŤÁNA PETRASOVÁ, AND ROSSELLA FABIANI

Deutsches Theater in Pest (Roesner wins first prize, but his plans are never realized).[111]

1848

Donation of his library to the academy;[112] a medallion portrait of Nobile for the top of a specially made bookcase modelled in 1849.[113]
In December, applied for retirement as Hofbaurat.[114]

1849

Retires as director of the School of Architecture at the Academy of Fine Arts Vienna.[115]
In September, sends a proposal for the reorganization of the Academy of Fine Arts to the provisionally reappointed academy president Roesner.[116]
In October, a daguerreotype portrait of Nobile wearing a hat is produced (now lost).[117]
Idea to open an architecture school in Lugano.[118]
Works: draft for rebuilding the family home in Campestro (compare Fig. 9).[119]
Consultancies: Member of the jury (along with Paul Sprenger, Josef Stummer von Traunfels, Eduard van der Nüll, and Ferdinand Fellner the Elder) for the Emperor Francis Joseph-citygate in Vienna.[120]

Fig. 23 Tomb of Pietro Nobile on St Marx cemetry in Vienna-Erdberg, ca. 1854, photo 2020.

1850

In March, farewell ceremony at the Academy of Fine Arts Vienna; but continues to have contact with Metternich and professional colleagues as well as with public and Habsburg political figures.[121]

1854

7 November, dies in Vienna and buried on St Marx cemetery in Vienna-Erdberg (Fig. 23).[122]
Pietro Nobile's addresses and architectural works in Vienna (Pl. XV)

NOTES

1 Comprehensive general information on Nobile's life: Giuseppe Fra-schina, *Biografia di Pietro Nobile* (Bellinzona: Tipolitografia Colombi, 1872); www.architektenlexikon.at (entry on Pietro Nobile).

The present chronology refers to: Gino Pavan, *Pietro Nobile architetto (1776–1854)* (Trieste and Gorizia: Istituto Giuliano di Storia, Cultura e Documentazione, 1998), 17–78. As Pavan also records information strictly chronologically, the current timeline does not give detailed references to his pagination.

Concerning the date of Nobile's birth: 1774 was first erroneously given as the year of his birth by: Friedrich Müller et al., *Die Künstler aller Zeiten und Völker etc. 3 (M–Z)* (Stuttgart: Ebner & Seubert, 1864), 183–184. This date was repeated by: Constant von Wurzbach, *Biographisches Lexikon des Kaiserthums Oesterreich etc. 20* (Vienna: k.k. Hof- und Staatsdruckerei, 1869), 376–377; Franz Vallentin, "Nobile: Peter von N.," In *Allgemeine Deutsche Biographie* 52 (1906): 638–642 (with a lot of other false information); Johanna Béha-Castagnola, "Pietro Nobile," in *Schweizerisches Künstler-Lexikon*, ed. Carl Brun, 2 vols. H–R (Frauenfeld: Hubert & Co., 1908), 478 (false date and place of birth); Ulrich Thieme and Felix Becker, *Allgemeines Lexikon der Bildenden Künstler von der Antike bis zur Gegenwart* (Leipzig: Wilhelm Engelmann, 1931–1932), 493; Irmgard Köchert, "Peter Nobile. Sein Werdegang und seine Entwicklung mit besonderer Berücksichtigung seines Wiener Schaffens (PhD diss., University of Vienna, 1951), 3; R. Schachel, "Nobile Peter, Architekt," in *Österreichisches Biographisches Lexikon 1815–1950*, vol. 7 (Vienna: Austrian Academy of Sciences, 1976), 139–140; Peter Prange, "Nobile, Peter (Pietro)," in *Neue Deutsche Biographie* 19 (1998): 302–303. In his entry on Nobile in the online-encyclopedia on Viennese architects http://www.architektenlexikon.at/de/1196.htm Diego Caltana, "Pietro Nobile," in *Architektenlexikon Wien 1770–1945*, accessed 23 June 2020, was the first to point to this discrepancy between publications in Italian which convey the correct date of birth as 1776 (as it was engraved on Nobile's tombstone in the cemetery of St Marx in Vienna), and Austrian and German publications which regularly present the false date of 1774. The correct date corresponds to the information in the register of the parish archive of the church Santo Stefano in Tesserete, Liber baptizatorum 1725–1809, 298: "Mille sette cento settanta sei alli undeci Ottobre: Pietro Ant.o figlio Steffano Nobile e di Marianna pure Nobile iugali / di Campestro, nato jeri circa l'ore tredici, è stato battezzato questa / mattina da' me Lu.o inf.to. Padrini furono Carlo Fran.co figlio di / Andrea Ferrari di Cagiallo [?], e Maria Catt.na figlia di Giovan / Ant.o Nobile di Campestro, ambi di questa cura di Tesserrete. / Ed in fede S. Tomaso Ant.o Frapoli Cu. di Tesserete." We would like to thank Jana Zapletalová from the Palacký University in Olomouc for her support with the archive research in Switzerland.

2 Trieste, Collezione Fondazione Scaramangà.

3 UAABKW, VA ex 1801, fol. 615v and 675v: quarterly statement from 1 February to 30 April 1801 (a hundred florins paid to Nobile "als Aushilfe zu seinen Studien," as help for his studies).

4 UAABKW, SProt. ex 1801, fol. 50–63: 31 August 1801.

5 UAABKW, VA ex 1801, fol. 547° and c: Nobile (from Rome) to Dobl-hoff-Dier on 19 December 1801.

6 UAABKW, VA ex 1801, fol. 547b: concept for a letter from Doblhoff-Dier to Nobile on 15 March 1802; UAABKW, VA ex 1802, fol. 128: Nobile to Doblhoff-Dier on 23 April 1802.

7 UAABKW, VA ex 1803, fol. 335: Nobile (from Rome) to President Doblhoff-Dier or Curator Cobenzl on 14 December 1803.

8 Selma Krasa, "Antonio Canovas Denkmal der Erzherzogin Marie Christine," *Albertina-Studien* 5–6 (1967/68): 84–87.

9 UAABKW, VA ex 1805, fol. 163: Khevenhüller from Rome to Doblhoff-Dier on 8 June 1805; UAABKW, VA ex 1805, fol. 164: concept for a letter from Doblhoff-Dier to Khevenhüller on 30 June 1805; UAABKW, VA ex 1806, fol. 64–65: Abel from Rome to Doblhoff-Dier on 20 March 1806.

10 OeStA, HHStA, OMeA 136, Akten, Zl. 626: Generalhofbaudirektor Struppy to Obersthofmeister Starhemberg on 25 November 1807.

11 Marijan Bradanović, "Istra iz putnih mapa Pietra Nobilea / L'Istria dalle cartelle da viaggio di Pietro Nobile / Istra iz potnih map Pietra Nobila," in *Pietro Nobile. Viaggio artistico attraverso l'Istria* (Koper: Histria Editiones, 2016), 32–47.

12 Drawings for this project in Trieste, SABAP FVG, Fondo Nobile, vol. 1 and rotolo 4. Cf., Rossella Fabiani, ed., *Pagine architettoniche. I disegni di Pietro Nobile dopo il restauro* (Pasian di Prato: Campanotto, 1997), 28–32.

13 Gino Pavan, "Pietro Nobile, i francesi e un padiglione trionfale per Napoleone," *Archeografo Triestino* LXXI (2011): 79–93.

14 Rossella Fabiani, "Pietro Nobile (1776–1854)," in *Contro il barocco*, ed. Angelo Cipriani et al. (Rome: Campisano, 2007), 451.

15 UAABKW, VA ex 1818, fol. 468: Nobile to the Presidium of the Academy on 19 September 1819.

16 UAABKW, VA ex 1819, fol. 572–573: note by Nobile on the discussion with Metternich on 5 December 1819.

17 UAABKW, VA ex 1819, fol. 550, 562, 565–566 (various documents between May and November 1819).

18 UAABKW, VA ex 1819, fol. 323: concept for the note of the Academy to the Imperial Chancellery on 10 June 1819; UAABKW, VA ex 1822, fol. 235: concept for the note of the Academy to the Imperial Chancellery on 27 April 1822; UAABKW, SProt. ex 1826: 6 and 27 November 1826; UAABKW, VA ex 1826/27, Zl. 118: decree of the Presidium of the Academy to Nobile, dispatched on 20 January 1827.

19 UAABKW, MR ex 1818/19, Zl. 10: Francis I to Metternich on 1 February 1819; UAABKW, MR ex 1818/20–22, Zl. 33: Metternich to Obersthofmeister Trauttmannsdorff on 10 August 1820; UAABKW, SProt. ex 1837: 21 September and 30 November 1837.

20 UAABKW, VA ex 1819, fol. 515: Lamberg to Metternich on 25 September 1819; UAABKW, VA ex 1820, fol. 391–392: most humble submission

of Metternich on 23 August 1820 with the on high resolution from Schönbrunn on 27 August 1820; UAABKW, VA ex 1827/28, Zl. 102: Metternich to the Presidium of the Academy on 10 April 1828 (demand for simplifications); UAABKW, VA ex 1830/31, Zl. 125b: Vienna *Artillerie-Distriktskommando* to the Presidium of the Academy on 24 May 1831 (preparations for setting-up the bust completed).

21 UAABKW, VA ex 1820, fol. 228–229: Nobile to Lamberg on 5 May 1820.

22 Gino Pavan, *Lettere da Vienna di Pietro Nobile (dal 1816 al 1854)* (Trieste: Società di Minerva 2002), 73–75.

23 UAABKW, MR ex 1818/20-22, Zl. 21: description of the project by Nobile on 24 April 1820.

24 *Aus Metternichs nachgelassenen Papieren*, ed. Richard Metternich-Winneburg, vol. 3 (Wien: Wilhelm Braumüller, 1881), 334, 336.

25 UAABKW, VA ex 1821, fol. 117–118: Nobile to Lamberg on 31 March 1821; Köchert, "Nobile," 20–22.

26 *Aus Metternichs Papieren*, vol. III, 336; Taťána Petrasová, *Neoklasicismus mezi technikou a krásou: Pietro Nobile v Čechách* (Prague and Plzeň: Artefactum and Západočeská galerie v Plzni, 2019), 61.

27 OeStA, KA, ZSt HKR HR Protocolla 1347, D 1748, D/1045-2420: 1 May 1822.

28 UAABKW, VA ex 1823/24, Zl. 79: Nobile to the Presidium of the Academy on 15 December 1823.

29 Rosella Fabiani, "Pietro Nobile e la chiesa di Sant'Antonio Nuovo," *Archeografo Triestino* 89 (1980): 96.

30 UAABKW, MR ex 1823–24, Zl. 23: Nobile to Czernin on 29 April 1824.

31 Katharina Schoeller, *Pietro Nobile direttore dell'Accademia di architettura di Vienna (1818–1849)* (Trieste: Società di Minerva, 2008), 346–347.

32 UAABKW, VA ex 1823/24, Zl. 230: Goes (*Studienhofkommission*, Studies Court Commission) to Czernin on 13 March 1824; UAABKW, VA ex 1826/27, Zl. 313: Nobile to the Presidium of the Academy on 25 August 1827.

33 UAABKW, VA ex 1823/24, Zl. 269: Nobile to Czernin on 19 April 1824.

34 Alberto Tanzi, *Alcune lettere del dr. Domenico Rossetti* (Milan: Tipografia Fratelli Richiedei, 1879).

35 Selma Krasa-Florian, *Johann Nepomuk Schaller 1777–1842. Ein Wiener Bildhauer aus dem Freundeskreis der Nazarener* (Vienna: Anton Schroll & Co., 1977), 91–93, 119.

36 UAABKW, SProt. ex 1825: 22 August and 6 September 1825.

37 Schoeller, *Nobile*, 388–389.

38 Pavan, *Lettere*, 132–133.

39 Pavan, *Lettere*, 213, Nobile to his brother on 16 February 1829.

40 Schoeller, *Nobile*, 332.

41 UAABKW, SProt. ex 1826: 11 January 1826; UAABKW, SProt. ex 1828: 29 and 30 March 1828.

42 UAABKW, VA ex 1826/27, Zl. 134: Nobile to the Presidium of the Academy on 5 February 1827.

43 Cf. UAABKW, VA ex 1828/29, Zl. 121: register of topics for the Hof-preis at the School of Architecture for 1829 by Nobile on 18 May 1829: design for a tribunal building as a third proposal with the comment: "Ein solches Gebäude ist in Wien zur Herstellung in Vorschlag", such a building has been proposed for Vienna.

44 Pavan, *Lettere*, 159: Nobile to his brother on 7 October 1827.

45 UAABKW, SProt. ex 1827: 18 April 1827; UAABKW, SProt. ex 1837: 21 September 1837.

46 UAABKW, SProt. ex 1828: 16 January 1828.

47 Anonymous, "Klein-Tapolesán," in *Oesterreichische National-Encyklopädie, oder alphabetische Darlegung der wissenswürdigsten Eigenthümlichkeiten des österreichischen Kaiserthumes* etc., vol. 3 (Vienna: Michael Schmidt's Witwe und Ignaz Klang, 1835), 219.

48 Alois Kubíček, "Nová Koňská brána v Praze," *Umění* 8 (1960): 300–303.

49 UAABKW, SProt. ex 1828: 7 July 1828; UAABKW, VA ex 1829/30, Zl. 81: note by the Lower Austrian provincial government to the Academy on 16 January 1830.

50 UAABKW, SProt. ex 1828: 7 July 1828.

51 UAABKW, VA ex 1828/29, Zl. 82: most humble submission by Metternich on 22 July 1829 with the on high resolution on 4 September 1829.

52 UAABKW, SProt. ex 1828: 29 and 30 March 1828.

53 UAABKW, SProt. Ex 1829: 23 and 24 December 1829; UAABKW, VA ex 1832, Zl. 200: Metternich to the Presidium of the Academy on 26 June 1832.

54 Giovanna d'Amia, "Pietro Nobile e l'ambiente Milanese. Materiali per una storia della cultura artistica nel Lombardo-Veneto," *Archeografo Triestino* 59 (1999): 274.

55 UAABKW, VA ex 1829/30, Zl. 179: Academy to Nobile on 5 July 1830.

56 Trieste, SABAP FVG, Fondo Nobile, vol. 38 no. 162–170; Pavan, *Lettere*, 244.

57 UAABKW, MR ex 1828–31, Zl. 45: Metternich to the Academy on 28 November 1829; UAABKW, VA ex 1830/31, Zl. 67: Ellmaurer to Metternich, undated (after a reminder sent on 20 December 1830).

58 UAABKW, VA ex 1829/39, Zl. 203: Metternich to the Presidium of the Academy on 17 July 1830; UAABKW, SProt. ex 1830: 29 July 1830.

59 Schoeller, *Nobile*, 281–282.

60 UAABKW, VA ex 1830/31, Zl. 213: Nobile to the Presidium of the Academy on 6 September 1831.

61 Pavan, *Lettere*, 291–293.

62 Archiwum Państwowe w Krakowie (APKr), Archiwum Potockich z Kreszowic (AKPot), sign. 3091, 3093, 3095, cf. Andrzej Betlej, Nieznane projekty z Archiwum Potockich z Kreszowic, in *Architektura znaczeń. Studia ofiarowane prof. Zbigniewowi Bani w 65. rocznicę urodzin i w 40-lecie pracy dydaktycznej* (Warszawa: Instytut historii sztuki, Uniwersytet Kardynala Sztefana Wyszyńskiego, 2011), 132–139.

63 UAABKW, VA ex 1832/33, Zl. 257: Nobile to the Presidium of the Academy on 20 July 1833.

64 Schoeller, *Nobile*, 415.

65 UAABKW, VA ex 1833/34, Zl. 110: Nobile to the Presidium of the Academy on 23 December 1833.

66 Pavan, *Lettere*, 325–329.

67 UAABKW, VA ex 1832/33, Zl. 274, 290–291: from July till September 1833.

68 UAABKW, SProt. ex 1833: 14 October 1833; UAABKW, SProt. ex 1834: 8 July 1834.

69 UAABKW, MR ex 1835/II, Zl. 89: account by Nobile to the Presidium of the Academy on 6 November 1834.

70 József Sisa, ed., *Motherland and Progress. Hungarian Architecture and Design 1800–1900* (Basel: Birkhäuser 2016), 156–162; Pavan, *Lettere*, 350–351; Peter Plaßmeyer, "Peter von Nobile (1776–1854)," in *Revolutionsarchitektur: Ein Aspekt der europäischen Architektur um 1800*, ed. Winfried Nerdinger et al. (exh. cat. Deutsches Architektur Museum, Frankfurt am Main) (Munich: Hirmer, 1990), 236–237.

71 Pavan, *Lettere*, 401: Nobile to his brother on 28 September 1836.

72 Josef Teige and Jan Herain, *Staroměstský rynk v Praze* (Praha: Společnost přátel starožitností českých, 1908), 54–67; Taťána Petrasová, "Romantické přestavby pražské Staroměstské radnice (1836–1848) a jejich význam pro počátky pražské neogotiky," in Marie Mžyková, ed., *Kamenná kniha. Sborník k romantickému historismu* (Sychrov: zámek Sychrov, 1997), 137–147; Taťána Petrasová, "The History of the Town Hall in Prague in the 19th Century," in Jacek Purchla, ed., *Mayors and City Halls. Local Government and the Cultural Space in the Late Habsburg Monarchy* (Kraków: International Cultural Centre, 1998),183–188.

73 UAABKW, VA ex 1834/35, Zl. 302: Nobile to the Presidium of the Academy on 19 May 1835; UAABKW, MR ex 1835/II, Zl. 59: Remy to Metternich on 24 September 1835.

74 UAABKW, VA ex 1834/35, Zl. 134 ½: "Subscription zu dem Bildnisse und zur Medaille auf die Feyer der 25jährigen Curatel Sr. Durchlaucht des k.k. Herrn geh.[eimen] Haus-, Hof- und Staatskanzlers Fürsten von Metternich" (Subscription for the portrait and the medal on the occasion of the 25th anniversary of his highness the Imperial-Royal House-, Court- and State-Chancellor Prince Metternich's curatorship), undated, entries up until December 1835.

75 Pavan, *Lettere*, 593–596.

76 *Bericht der Beurtheilungs-Kommission über die im Jahre 1836 Statt gefundene vierte öffentliche Ausstellung der böhmischen Gewerbsprodukte* (Prag: Gottlob Haase Söhne, 1837), 40–41; Pavan, *Lettere*, 386–391, 587–593. Irena Laboutková, *Umělecká litina ve sbírkách Národního technického muzea* (Praha: Národní technické muzeum, 2017), 36.

77 *Aus Metternichs nachgelassenen Papieren*, vol. 6, 59.

78 Pavan, *Lettere*, 372: Nobile to his brother on 14 and 27 April 1835.

79 Fabiani, "Pietro Nobile (1776–1854)," 451.

80 NA, Prague, Metternich Family archive, RAM AC 142.

81 Anonymous (Ludwig Christian Förster?), "Die Leuchtthürme in dem Meerbusen von Triest. Der Leuchtthurm von Salvore," *Allgemeine Bauzeitung* 1 (1836): 17–18, pl. 9.

82 Pavan, *Lettere*, 399; Cf. Anonymous, "Die Leuchtthürme," 17–18.

83 d'Amia, "Pietro Nobile e l'ambiente Milanese." 268, 278.

84 Pavan, *Lettere*, 418–419; Petrasová, *Neoklasicismus*, 16–23.

85 Ibidem, 416–417.

86 Ibidem, 445–446.

87 Ibidem, 451.

88 Schoeller, *Nobile*, 410–411.

89 Ibidem, 364–365.

90 Pavan, *Lettere*, 465–466.

91 Ibidem, 474–477; Markus Walz and Petra Schwarze, "'Man kann sich nichts vollkommeners und geschmackvollers denken.' Fürst Metternich und die Daguerreotypie," in *Spurensuche: Frühe Fotografen am Mittelrhein*. Katalog zur Ausstellung 150 Jahre Fotografie – Stationen einer Entwicklung, ed. Ulrich Löber (Koblenz: Veröffentlichungen des Landesmuseums Koblenz, 1989), 19, 21.

92 Eva Hüttl-Ebert, "Nobile a Vienna," *Archeografo Triestino* 59 (1999), 146.

93 Pavan, *Lettere*, 491–492.

94 Markian Prokopovych, *Habsburg Lemberg. Architecture, Public Space, and Politics in the Galician Capital, 1772–1914* (West Lafayette: Purdue University Press, 2009), 137.

95 Petrasová, *Neoklasicismus*, 81–82. The exact location of this hill is currently not clearly identifiable.

96 NPÚ Prague, State château Kynžvart, inv. č. KY 08500, around 1840. We would like to thank Petra Trnková from the Institute of Art History at the Czech Academy of Sciences for providing us with the unpublished text on Metternich's cabinet of precious objects.

97 Pavan, *Lettere*, 529: Nobile to his brother on 16 February 1842.

98 Ibidem, 531: Nobile to his brother on 28 February 1842.

99 Ibidem, 529–530: Nobile to his brother on 16 February 1842.

100 Ibidem, 540–541.

101 Ibidem, 544. Possibly identical to the public buildings for Ticino canton from 1845.

102 NA, 1.CG II, 1858; ANG, SVPU, AA 1549/1; Věra Vostřelová, *Zkamenělá hudba. Tvorba architekta Bernharda Gruebera 1806–1882* (Praha: Vysoká škola uměleckoprůmyslová v Praze, 2018), 148.

103 Pavan, *Pietro Nobile*, 60.

104 F[ranz] M[ertens], "Prag und seine Baukunst," *Allgemeine Bauzeitung* 10 (1845): 15–38. Franz Mertens, a German art historian and architect, rightly compared this neo-Gothic facade by Nobile to one of the first reconstructions of its kind in Prague, the governor's Summer Palace (1804–1821) in Stromovka.

105 Pavan, *Lettere*, 565: Nobile to his brother on 4 January 1845.

106 Ibidem, 562: Nobile to his brother on 15 November 1844.

107 Ibidem, 555: Nobile to his brother on 7 July 1844.

108 Ibidem, 574: Nobile to his brother on 25 May 1845.

109 UAABKW, SProt. ex 1847: 22 April 1847.

110 Pavan, *Lettere*, 657, 661.

111 Pavan, *Pietro Nobile*, 63; Márta Nemes, "Die unbekannten Pläne von

Carl Roesner zum Wiederaufbau des Pester Deutschen Theaters im Jahre 1847/48," *Österreichische Zeitschrift für Kunst und Denkmalpflege* 39 (1985), 99–104.

112 UAABKW, SProt. ex 1848: 7 September 1848.

113 Pavan, *Lettere*, 692: Nobile to his brother on 19 July 1849.

114 Ibidem, 673–674.

115 UAABKW, VA ex 1849, Zl. 70: Temporary president of the Academy Roesner to curator Metternich on 23 January 1849.

116 Pavan, *Lettere*, 697; Cf. Wagner, *Akademie*, 121–137.

117 Pavan, *Lettere*, 703: Nobile to his brother on 27 October 1849. It was thirty years after Karl Jakob Theodor Leybold created Nobile's first portrait see Pavan, *Lettere*, 609–611.

118 Ibidem, 710: Nobile to his brother on 22 November 1849.

119 Trieste, SABAP FVG, Fondo Nobile, lett. 689.

120 Elisabeth Springer, *Geschichte und Kulturleben der Wiener Ringstraße: Die Wiener Ringstraße. Bild einer Epoche. Die Erweiterung der Inneren Stadt Wien unter Kaiser Franz Joseph*, ed. Renate Wagner-Rieger, (Wiesbaden: Franz Steiner, 1979), 38.

121 Pavan, *Pietro Nobile*, 73.

122 WStLA, 3.1.4.A1.N4, Estate, Wien 1855: original of the last will in Italian, translated into German, inventory of the legacy, etc.

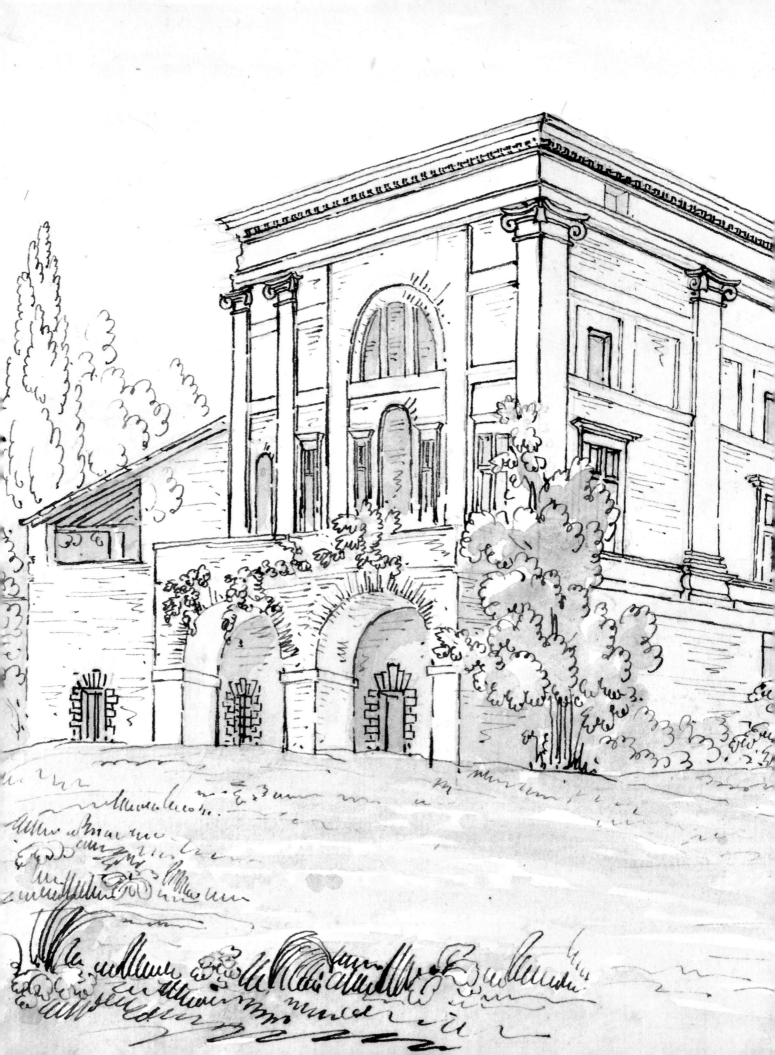

ARCHITECTURAL TRAINING

Rossella Fabiani

Trieste, a seaport in the northernmost part of the Adriatic, underwent a change in its economic fortunes when Emperor Charles VI proclaimed it a free port in 1719. "The Emperor introduced legislative incentives during the first three decades of the century. In 1717, he encouraged navigation and during the following year, he established trading relations with the Ottoman Empire."[1] The city grew from a small, enclosed town on the hill of San Giusto, trading in salt, fish, and wine, to the Austrian Empire's main outlet on the Mediterranean. Trieste was engaged in a perpetual struggle with the nearby Republic of Venice for domination over the northern Adriatic and for trade supremacy. In 1382, the former had placed itself under the protection of the Habsburgs through an act of dedication to Austria. This offered a protective shield for the city's maritime territory, located dangerously close to the Balkans. A rapid population increase, fed by peoples from many European and Near Eastern countries, led the town to expand beyond its hilltop confines towards the salt flats overlooking the sea and the surrounding areas. This prompted a building boom that gave Trieste the appearance of a brand-new city, characterized by a mix of all the architectural styles then popular in Western countries, from eighteenth-century archetypes to a more modern neoclassical style. The city's population swelled from 4,000 to some 40,000 and was mainly engaged in trading activities.[2] Credit for this era of great social and political transformation throughout Habsburg territory goes to the government of Maria Theresa, daughter of Charles VI, who had been allowed to take the throne as a result of the 1713 Pragmatic Sanction. The empress initiated a series of reforms to modernize the machinery of state.[3]

New horizons were opening up as Pietro Nobile took his first steps as an architect. In 1810, Nobile commented in his *Discorso sulle arti del dissegno*:[4] "Until the times of our living forefathers, a combination of geographical and political circumstances meant that Trieste was but a small enclosure inhabited by a few citizens. Trade prosperity has made it grow almost miraculously under all our eyes."[5] Nobile went on to mention the city's contemporary situation: "as soon as the spacious public streets had been marked out in the form of rectangular intersecting lines over those forsaken bogs, the enclosed areas were occupied by goods warehouses and the homes of well-received foreign merchants."[6] (Pl. XVI)

Trieste thus became the cornerstone of Nobile's working life and the starting point for a career that would propel him to Vienna to work within the uppermost circles of power. The city met its aspiration to become Austria's leading port and Eastern Europe's leading access point to the Mediterranean, in open competition with the ports of Northern Europe. It took on a crucial role in the life of the empire, becoming a melting pot of architectural and urban development.[7]

Pietro Nobile and Trieste: Initial Training

Pietro arrived in Trieste with his family, to re-join his father, in 1785. He was then about 10 years old and just beginning to visit building sites and acquire his first knowledge of the trade. Cultivating know-how through hands-on experience was the traditional *Comacina* way for all builders from the Como area. The archives do not encompass all the stages of Nobile's formative years:[8] There is barely any mention of him in his contemporaries' biographies. All we can infer is that his father Stefano came to Trieste from Milan, setting himself up as a builder in 1766.[9] Pietro does not mention his father except very briefly in institutional letters and correspondence, even though the former's copious correspondence with well-known contemporary figures and with family members often touched on personal matters. The historian

of Trieste Giuseppe Righetti spoke in general of "a fruitful high school education […], the prescient father having become aware of his son's gifts."[10]

The family seems to have believed that practical training must be backed by a solid theoretical grounding, and the youngster was accordingly sent to begin his academic studies in the belief that he had the intellectual qualities to succeed. In those days, the schools in Trieste had been reformed on the orders of Maria Theresa and offered good educational opportunities. The Accademia reale e di nautica headed by Michael Andreas Stadler, was the institute that most closely matched the cultural interests of the young Nobile. It was organized to offer a fairly good standard of education.[11] This institution was a benchmark for higher education within the city and its surrounding areas, allowing students to train in "three different classes: merchants, engineers, or inspectors and pilots."[12] Attending this institution allowed Nobile to acquire the basic scientific and technical knowledge that would pave the way for his civil service career as a manager of buildings and roads. Above all, it offered him access to a scholarship with which he would undertake the first part of his apprenticeship in Rome.

The subjects taught at the Accademia reale e di nautica dealt primarily with "the practical doctrines of geometry, architecture, and mechanics, as components of the mathematical sciences."[13] Lessons were geared towards the "study of mechanics, statics, hydrostatics, hydraulics, hydrography, pilotage, trigonometry, astronomy, and geography."[14] "Subjects such as the two architectures, civil and military, which come easily to those with a good grounding in arithmetic and geometry, will not be formally taught. Instead, I will suggest [Stadler] a good author to be read privately by those with a flair for such disciplines."[15]

By visiting building sites during his initial academic training, Nobile gained practical insight into the management of work on the road system of the new Borgo Teresiano and, in addition, met the engineers engaged in building homes and warehouses in the city at that time. A few years after the Lazzaretto di Santa Teresa was built (in 1769), work began on the hospital, which was converted to a barracks in 1785. Other building projects in those years included the slaughterhouse (built 1780), the customs house (opened 1791), and the trade route to Ljubljana (opened 1779).[16] Trieste was an open-air building site, populated by workers who had flocked from the Italian-speaking canton of Ticino, in Switzerland. Righetti referred to this phenomenon when he wrote: "Giuseppe Soldati, Francesco Aprile, and Giuseppe Zanini were also from the Italian part of Switzerland. They often joined forces for individual ventures […]. They were followed by more Swiss architects from Ticino, Botta, Ardia, Lepori, Meneghelli, and Trezzini, who also practiced this profession between 1796 and c. 1820 with intelligence, zeal, and discretion, building several homes."[17]

During that period, a demand for buildings to be used as warehouses, offices, and homes led to the growth of another neighbourhood adjacent to the Borgo Teresiano. This became known as Borgo Giuseppino – named after Maria Theresa's son, Emperor Joseph II. The south-facing neighbourhood was made up of residential buildings parallel to the seashore, overlooking piers and docks. Architects from many European countries worked on both the Borgo Teresiano and Borgo Giuseppino projects. They brought with them traditional eighteenth-century influences along with innovative neoclassical trends. For example, Giovanni Bubolini built Casa Czeike at the end of the eighteenth century with decorations harking back to a late Austrian Baroque heritage. The French architect Champion, on the other hand, produced Villa Necker and Villa Murat, both dating from 1790 and displaying a distinct French influence in their clean-cut geometries, albeit with obvious references "to the anti-Baroque culture of Louis XVI's French classicism, which wedded the Italian Renaissance tradition with the neoclassical and also late Roman Baroque, tracing its ancestry to the Renaissance."[18]

Eighteenth-century archetypes therefore rubbed shoulders in the city with more innovative styles introduced by people from different cultural backgrounds: "This was the moment when neoclassical culture finally made its presence felt in Trieste."[19] Champion left traces of French architecture in his building, while Piermarini – through his pupil Matteo Pertsch – followed the canons of the Accademia di Belle Arti di Brera in Milan, albeit with a nod to Luigi Vanvitelli. Although Giannantonio Selva had no hand in Trieste's building boom, he was responsible for introducing Carlo Lodoli's more theoretical and extreme form of Neoclassicism to the building world at large.[20]

Pietro Nobile and His First Teacher
of Architecture: Ulderico Moro

Pietro Nobile witnessed the completion of a building in the city centre that was to be influential in his training. Palazzo Plenario (now Palazzo Pitteri), owned by the merchant Domenico Plenario and located in what was then Piazza San Pietro (now Piazza dell'Unità d'Italia), was built in 1780 by Ulderico Moro and remains a shining example of late eighteenth-century architecture. While the facade is neoclassical, the vertical distribution of the building's elements contains references to the architectural culture of the late Austrian Baroque.[21] This "imposing yet erudite work brought a variety of associations and inferences to the neoclassical Triestine tradition."[22] Righetti noted this when he wrote: "working with a design by Ulderico Moro, the wealthy and distinguished merchant Plenario ordered the building of the finest house that had hitherto existed [...]. The exterior of this house still remains the most majestic building anywhere in the vicinity due to its unprecedented size, its architectural style, the ionic columns reminiscent of Sanmicheli, the extravagant sumptuousness of the decorative stonework, and its finely judged proportions."[23] Pietro knew and spent time with the creator of this building, and this period marked a change of pace in his discovery of new approaches to architectural knowledge. It instilled in him an openness to composition, theoretical knowledge, and the study of graphic representation, which were also fundamental to his architectural education.

The archives confirm that the pair knew one another, and their interaction is confirmed by the existence of drawings reflecting the short-lived yet profitable relationship between pupil and master. Moro, who came from the predominantly alpine region of Carnia, appears to have been active from 1761 in Udine as a carpenter and later as a public appraiser and land surveyor.[24] He also established an important contact in Francesco Riccati, which led him to adopt Palladian theories,[25] i.e. the harmoniously proportioned organization of a building's parts. His focus on principles of stability and compositional order was founded in a "knowledge of Vitruvian culture and classical architectural theories."[26] Alongside Moro's significant activity as a designer, he made views of Udine's most iconic locations.[27]

The spatial composition and choice of subjects in Moro's etchings reveal his ability to create views – real and imaginary – under the clear influence of Piranesi.

Moro arrived in Trieste in 1789 and began to work as both a designer and a private drawing teacher.[28] He himself boasted that Pietro Nobile had been his disciple, a revelation that Moro clearly believed would advance his career. In a 1797 application for the post of *proto* (foreman), Moro preferred to dwell on his merits as an instructor of young talents rather than enumerate his architectural achievements, with the exception of his theatre for Gorizia, which he stated to be perhaps the most harmonious in Italy.[29]

His instruction involved spatial composition on paper: Moro's 1783 *Capriccio architettonico* was the probable starting point for Nobile's training in spatial distribution and organization. Nobile found this illustration, crowded as it is with buildings and people in clear eighteenth-century style, to be extremely useful for purposes of practice, judging by surviving drawings showing similar decorative ideas.[30] Works in volume 7 of the Nobile Collection show clear similarities to those produced by Moro. The master claimed that the academic exercises he put to his disciples "could hold their own with honour at any university."[31] On this subject, Moro also mentioned the "penultimate lesson I put to my disciple Pietro Nobile, which was to represent an imaginary ancient temple in perspective."[32] An examination of the illustrations preserved in volume 7 of the Nobile Collection bearing the title "Perspective Studies" reveals a large painting on cardboard, executed in delicate watercolours (Fig. 24). This may well be the work Moro was referring to, though it lacks annotations, captions, or indications of any kind. It shows a classical temple standing on six steps, with a pediment and with eight Corinthian columns on the facade and fifteen along each of the long sides. It is inspired by the Maison Carrée in Nîmes and the Temple of Augustus in Vienne, characterized by their series of narrowly spaced fluted Corinthian columns (Pl. XVII). Nobile's drawing of the side and facade of the temple seems to accurately fulfil Moro's instructions, apparently intended to prepare him for the academic environment that awaited him in Rome.

The 1798 etching entitled *Prospectum Tergesti Forum*, which Pietro Nobile dedicated to Pompeo de Brigido di Bresowitz, the city governor from 1782, demonstrates what

Fig. 24 Pietro Nobile, Ideal view of the square, pen, ink, ca. 1797, Trieste, SABAP FVG, Fondo Nobile.

he had learned about compositional organization in art (Fig. 25).[33] The etching depicts the city's main square and exemplifies the transition between eighteenth-century Trieste and the classical revival. The archaeological artefacts shown at the foot of Charles VI's statue indicate a cultural turn towards modernity. Because Nobile had spent his formative years in the burgeoning city, it is unsurprising that his art bears witness to the opening up of a new world. The print can be considered his passport for the new era. The randomly arranged ancient remains signposted a new approach in local architecture. A contrast is evident between this and the buildings around the square, eighteenth century in their modest arrangements. The old Teatro di San Pietro, the church bearing the same name, the large inn, and the town hall are remarkable for their simplicity. Yet even the small scenes, reminiscent of genre painting, conjure up episodes

of daily life that played out alongside the ancient relics brought to light by recent excavations carried out in Trieste and the surrounding area. The dedication of the illustration to de Brigido was strategic.[34] The governor, who was also the president of the Accademia degli Arcadi Romano-Sonziaca, put Nobile's name forward for a scholarship to Rome for a period of study, deemed "necessary and useful to ensure that the buildings in this city, which are growing in number, are stable and fair to behold."[35]

After obtaining a diploma from the Accademia reale e di nautica, Nobile appealed to the magistrate for a study grant, describing himself as a "student of civil architecture [...] willing to move to Rome to learn about architecture [...], being a young man with particular and innate qualities."[36]

The spring of 1797, between April and May, was a crucial period marked by Napoleon's short-lived first occupation of

Trieste.[37] Nobile recorded the event in six watercolours, each showing a stage in the troops' occupation of the city's main squares. These images are intended to chronicle events, showing the people and soldiers against the backdrop of a city poised on the cusp of great mercantile success. They are also a valuable snapshot of the architecture of the city, depicting its central squares lined with buildings that bespeak Trieste's new, monumental appearance. Like a news editor recording live images, Nobile painted small watercolours describing the various stages of the occupation between 17 April 1797 (the date of a demonstration by the people before Bonaparte's arrival) and 30 April (when the French departed). He illustrated the episodes connected with this bellicose event meticulously. The attention to detail is remarkable: bustling scenes crowded with people, horses, wagons, and soldiers tell a story in the eighteenth-century tradition, with the figures sketched quickly in pencil and filled in with strokes of colour. This very simple but effective approach recurs in other illustrations in the Nobile Collection that depict series of small drapery-clad figures – some still, others in motion – almost reduced to ciphers. The first watercolour is entitled *Il popolo che marcia armato contro i francesi viene indotto a deporre le armi, il 17 aprile 1797* (The Armed People Marching against the French Are Forced to Lay Down Their Weapons, 17 April 1797). The second shows Napoleon Bonaparte's arrival in Trieste on 29 April 1797. Two more illustrations depict the Austrians returning along the Corso to Piazza San Pietro, and the last shows Napoleon's departure from Trieste on 30 May 1797.[38]

Nobile's departure from Trieste for Rome in October of that year, to finish his training as an architect, coincided with a political situation of great uncertainty that affected the city between February 1798 and September 1799, i.e. the period of the Roman Republic.[39]

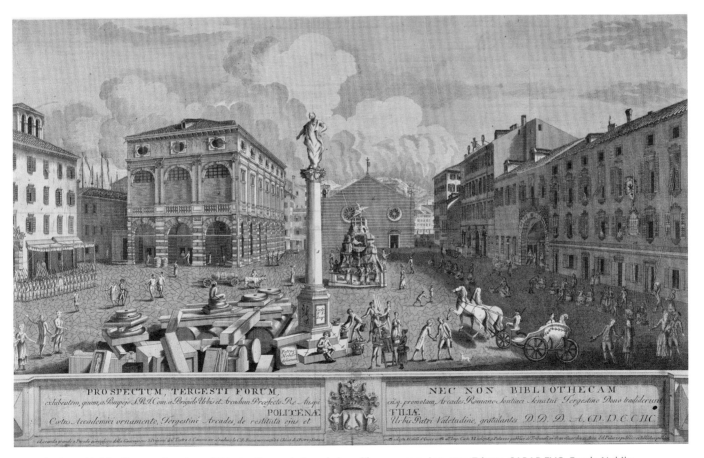

Fig. 25 Pietro Nobile, Perspective view of Trieste, the market, and also a library, engraving, 1797, Trieste, SABAP FVG, Fondo Nobile.

In Rome, 1798–1800

We turn again to Giuseppe Righetti for a summary of the event:

> Once Pietro's prescient father had become aware of his son's gifts, and his great love for study, he wished to support his inclinations by sending him to Rome, heart of the Italian talent for fine art and sciences. There he had enormous scope to exercise his obedient hand in the design of ornaments, figures, architecture, and perspective; and to come into contact with the most eminent men in every discipline. Architecture was about to abandon the aberrations and corruption of the seventeenth and eighteenth centuries to assume a beauty that found nobility in simplicity of form, majesty through grandness and severity and loveliness through harmony between parts and the whole – ascending to a new level of philosophical and rational expressionism. Our hero Nobile therefore lingered in Rome to contemplate the great artistry, study the secrets of beauty, measure the sublime and seek out stable relationships fit to challenge the inequities of the barbarians as well as the damage wrought by the centuries, evident in monuments that would outlive later, more ephemeral productions. As a philosopher, he was convinced that Greco-Roman style was the only way to create great works and the most sublime memories for posterity.[40]

As the education system in the Habsburg Monarchy continued to develop under Leopold II, more benefits became available for students, i.e. grants to attend further education courses at the Graz Lyceum (to be designated a university again starting in 1827) or the University of Vienna in various subjects relating to the humanities and sciences. Michael Andreas Stadler accordingly put forward Pietro Nobile's name, "being the first son of a father who has been established in this city for thirty years," for a grant "to go to Rome and study civil architecture."[41] Stadler also suggested the esteem in which Nobile was held due to his scholarly achievements, being gifted "with great talents and having given sufficient evidence of his diligence and ability."[42]

The table of public salaries for the 1797 academic year is a record of his first stay in Rome.[43] A grant awarded by the municipality of Trieste enabled him to extend this through 1799, while another document records that "he finished his studies at the Accademia reale e di nautica in order to go to Rome to study civil architecture."[44]

With the aid of his father, Nobile applied on 23 December 1800 for financial support to continue his studies in civil architecture.[45] He sought backing for his application in Vienna in 1801: "Accompanied by Minister Cobenzel [sic], he was received by Francis II [...]. He gave the sovereign his work entitled *Il Campidoglio in Trionfo*, on which he had laboured in Rome day and night."[46] Nobile was now able to put to good use the cultural stimuli he had encountered, injecting them with Triestine sensibilities. His drawing was ambitious in the complexity of its composition, and its arrangement of volumes closely reflected the current norm in academic spheres (Pl. XVIII). His intention was to show the ruler and his advisers that he had the ability to design a multifaceted work and that he was also fully *au fait* with contemporary trends (Fig. 26).[47]

Alongside elements that clearly refer to the ancient world, the large temple in the centre of the giant complex is reminiscent of the tempietto of San Pietro in Montorio in Rome. This reference must have been partly influenced by Moro's teaching in Trieste. The distribution of parts in the subject seems to refer to two cathedral plans designed by Combes (1781) and Forestier (1782) respectively, and such eighteenth-century references still appear in Nobile's later depiction of Boullée's project for the church of the Madeleine (1777–1785). The quintessential features of such monuments are evident: columns in the Trajan mould and the Roman-influenced triumphal arch, crowned by sculpture groups featuring a dense array of bas-reliefs and decorations. The drawing that Nobile presented in Vienna was a dazzling outpouring of erudition, intended to show off not only the knowledge he had gained in Roman academic environments but also his understanding of contemporary design trends: "In 1785, Boullée designed a large monument to Newton in the form of a globe that paved the way for the design of other gigantic works of imposing size. A few years later, in 1797, Gilly proposed a monument for Frederick of Prussia whose composition appears to have been a direct inspiration for Nobile: triumphal arches lead to a central space housing a temple of archaic form with obelisks."[48] Nobile's design

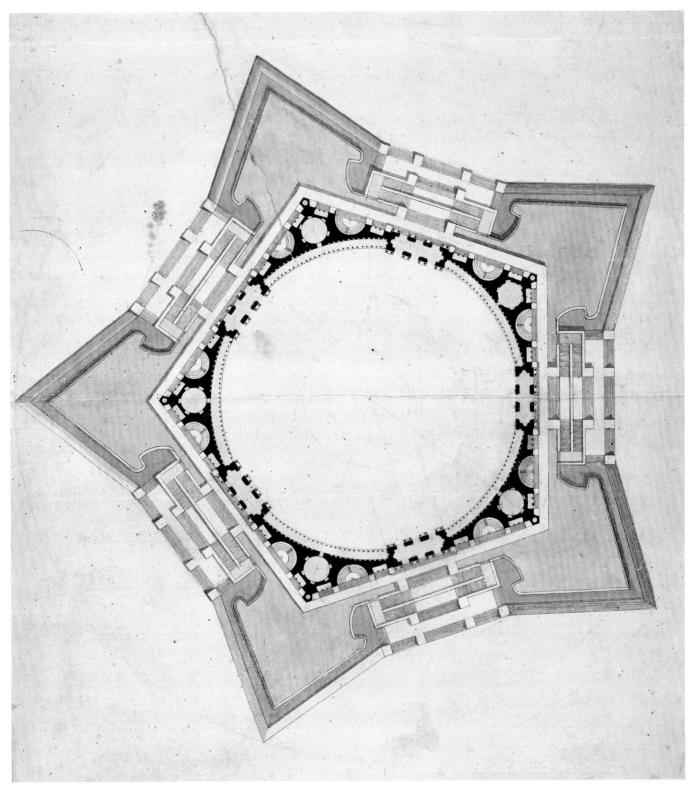

Fig. 26 Pietro Nobile, Design for the Peace and Concord Temple (*Tempio della Pace e della Concordia*), groundplan, ink, 1798 or 1814, Trieste, SABAP FVG, Fondo Nobile.

shares with Gilly's its solemnity and grandeur; but Nobile did not cloak his design in the metaphysical, as Gilly had, but remained anchored to an erudite evocation of antiquity.

The idea for the drawing also stems from the lively and dynamic environment that Nobile inhabited and in which he was working hard to complete his training. A new frontier had opened up in the arena of architecture around 1780, sparking a revolution in design and teaching. Francesco Milizia burst onto the Roman scene with his publications *Principi di architettura civile* (1781) and *Roma delle belle arti del disegno* (1785), introducing a new "anti-Baroque" architecture that "should obey simple principles borrowed from ancient architecture [...], leaving behind the debate over Greek and Roman forms [...] to recognize its own, autonomous principles" while not neglecting the influences of Palladian and French architecture.[49] Nobile also learned about this new system by frequenting the group of artists who revolved around the academic world and who had been involved in the Accademia della Pace.[50] This alternative to the Accademia di San Luca, active from 1792, offered a place where architects could freely express their ideas, until it closed in 1797. By spending time with young people who had lived through those experiences, Nobile learned of the innovative ideas that were to lead to simpler forms of reference to the ancient world that were less archaeological and more geometric (Pls. XIX and XX).[51] We can see evidence of this in Giuseppe Camporese's elevation of a monument for the Palatine Hill, meant "to preserve the eternal memory of Peace restored to Europe in 1801."[52] In comparison with the drawing that Nobile presented in Vienna, "the colonnaded facade closed at the sides by two entrances follows the same compositional layout, at least in the development of the front line, but Camporese ended the central part with a column, whereas Nobile ended it with a triumphal arch and a domed temple in the area behind."[53]

Nobile seems to have absorbed Camporese's architectural language, judging by the presence of buildings with a round floor plan and a Doric portico in the former's "Roman" designs (Pls. XXI and XXII). Nobile used them again in his design for temples of Peace and Concord, which he described in a small book published in 1814 to illustrate features taken from Greek and Roman building systems and to combine them with French geometric abstraction.[54]

Cultural exchange through Nobile's contact with the young architects he knew in the Eternal City, recorded in letters, consolidated his acquisition of the models and shapes that were to emerge in the drawings he executed in Rome. We need only look to Mario Asprucci and some illustrations related to his activities in the Accademia della Pace to discern analogies in ground plans, elevations, and compositions.[55] The fertile interactions between the two architects are particularly evident in Nobile's treatment of subjects incorporating all the ideas gleaned from his academic studies, such as a hunting lodge or a round mausoleum.[56] Nobile may have been in contact with Asprucci when the Accademia di San Luca resumed its activities in 1800.[57] On 7 September 1800, Mario's own father, Antonio Asprucci, together with Andrea Vici and Giuseppe Camporese and on behalf of the academic congregation, examined "some drawings by Nobile representing the Temple of Immortality destined for the five sovereigns united in the current war against the French."[58] Their opinion was positive, and they referred to "the good taste and talents of young Mr Nobili [sic], who already exhibits the qualities of a studious follower of architecture and will eventually make an able professor."[59]

During Nobile's first stay in Rome, he acquired an array of experiences that inspired him to continue his artistic development. Though, as Franco Fraschina pointed out, Nobile's life in the city was very tough – given that he had very few financial resources, and also given the context of the Napoleonic army's siege of the city in 1800[60] – the gratifying results of his Roman experience prompted him to go to Vienna to petition the academy for a scholarship to continue his studies.

Second Period in Rome, 1801–1805

Despite the serious political situation, the curator of the Academy of Fine Arts Vienna, Count Cobenzl, and its president, Anton von Doblhoff-Dier, considered it important to relaunch the institution's strategic training by restoring scholarships for study in Rome.[61] Study periods in the Eternal City were coveted by those who worked in artistic fields in Vienna and who wished to complete a course of further pro-

fessional development. The scholarships initially lasted for three years, but an extension could be requested for a further stay, not in Rome but in France, particularly Paris, where Pietro would have the opportunity to see modern building work, particularly in the form of palaces and houses.[62]

The painter Josef Abel and the sculptor Leopold Kiesling joined Nobile in Rome as beneficiaries of the emperor's financial largesse.[63] Their stay was governed by specific requirements and instructions. Indeed, being paid by the Austrian government was a privilege as well as a considerable commitment, as the academy intended the three artists they had singled out for the disciplines of painting, sculpture, and architecture to undertake significant monumental public commissions upon their return.[64] Abel, Kiesling, and Nobile arrived in Rome in December 1801.[65] Pietro took a different route than his classmates, undertaking a solo trip to visit the works of Palladio in Vicenza, Venice, Florence, and at the academy in Bologna, "just enough to form a clearer idea of the best monuments, most of which I recorded in my sketchbook."[66] The day after their arrival in Rome, the three students delivered a letter from the secretary of the Vienna academy, Baron Joseph von Sonnenfels, to Antonio Canova, offering help and assistance.[67]

Baron Doblhoff-Dier and Nobile corresponded continuously, partly because the Austrian institution monitored its grant holders closely.[68] On 15 March 1802, he asked Nobile to obtain for the academy drawings and prints of "plans and elevations" of palaces and theatres as well as of houses and homes, "if the opportunity arises to obtain drawings or prints that could serve as original material for our architecture students."[69] A month later, Nobile reassured Baron Doblhoff-Dier that he was doing his best to obtain teaching material, while also confirming that he was busy drawing and "examining the remains of the temples gracing the Roman Forum."[70] Yet Doblhoff insisted on the need to collect "well-executed drawings [...] that can serve as models for the study of architecture [...] to help students develop their ideas along grandiose lines."[71]

The exchange of correspondence revealed the grant holders' desire to make the best use of their period of learning and to obtain "an extension to enable them to meditate with greater insight on the wonderful monuments of Rome and other [...] cities in Italy."[72] As the destination for a kind of cultural pilgrimage into vestiges of the past, Rome had established itself as "the main European centre of international and cultural exchanges, a capital of European Enlightenment that would open itself up to the neoclassical movement."[73] The presence of an artist of Slovenian, Jewish, and Austrian origin, Francesco Caucig, who lived and completed his studies in Rome from 1780 to 1787, attests to this. He executed many drawings illustrating the Roman countryside and ancient remains, supported by a scholarship from Emperor Joseph II.[74]

The Austrian ruler Francis II invested in Pietro Nobile, believing that Nobile's experience in Italy would influence his professional development and help to bring about an era of stylistic revival in the field of architecture, which would spread through the Habsburg lands and inspire a new generation of designers. Austrian state architecture was still mired in the traditional eighteenth-century ideals of Johann Lucas von Hildebrandt and Johann Bernhard Fischer von Erlach. Though some private clients of Charles Moreau or Joseph Kornhäusel vividly supported innovations, the discipline still needed to be reformed and updated with the specific aim of giving Vienna a new face worthy of the capital of a great European empire.

The academy did not approve an extension of Nobile's stay nor its continuation in another city such as Paris, even though Antonio Canova had endeavoured to support the request, as evidenced by his letter dated 27 June 1805, which stated: "As soon as I arrived in Vienna, I made sure I spoke to the right people to ask for an extension to their studies, if possible."[75] However, Nobile had already completed the term of study concluding in 1805, and Emperor Francis II was against the idea of him going to France due to the political situation.[76]

Nobile also appealed to Count Johann Emanuel Joseph Khevenhüller-Metsch.[77] Leopold Kiesling stayed in Rome, as is clear from a letter written to Nobile on 1 August 1807 informing his friend of the cultural situation, which he claimed was stagnating: "Nothing is happening in the world of painting at the moment, apart from a few altarpieces or portraits. Architects restore and decorate little apartments. No new buildings are being erected here."[78]

Pietro Nobile's stays in Rome opened up new universes: He discovered the ancient world, studied Renaissance and

Baroque architecture, and attended the Accademia di San Luca.[79] He became familiar with the world of artists and met Northern Europeans who came on the Grand Tour to enjoy the Mediterranean landscape and engage in the joyous outpouring of art during the second half of the eighteenth century.[80] Rome was such a sought-after and desirable destination that when Goethe visited it for the first time, he exclaimed "I have finally arrived in this city, the capital of the world!"[81] Rome was the universal centre for the arts and for forays into the neoclassical culture that was then taking shape and gaining ground.[82]

Nobile was young – only 22 years old – but was aware that this was a significant opportunity to drive his career forward. Years later, in a letter dating from July 1840, his friend Luigi Basiletti remembered his passion for observing monuments and executing etchings from life: "I wish to see the principles that you studied in Rome with so much passion and keen intelligence put into practice in your buildings and works. I still remember you meticulously measuring ancient relics in a quest to find the real truth of your art. I was often present at your labours and we ended the day with a fine repast or in the company of other artists of the new wave."[83] Dining out must have been a frequent habit, judging by Antonio Canova's invitation on 14 March 1803 "to take a bowl of soup at the usual place on Monte Citorio next Sunday at around 2 pm."[84] Further invocations of this golden period come again from Basiletti: "our stay in Rome, all the time we spent together, and the mutual tests of sincere friendship are thoughts that often come to mind and take me back to my salad days."[85] Nobile agreed, "I think back to those good times in Rome, when we lived on art, joined by bonds of true friendship."[86]

People flocked from lands under Austrian, German, Flemish, and English influence to the city, and surrounding places such as Ostia and Tivoli, to share in the beauty of the scenery, hoping to capture and illustrate some aspects of the Roman countryside by putting pencil to paper. The artists who accompanied Johann Wolfgang von Goethe on his first trip to Italy in 1786 produced some outstanding work: This circle of painters and engravers depicted the landscape and the beautiful ruins coexisting with exuberant and unruly nature.[87] Johann Heinrich Wilhelm Tischbein, Angelika Kauffmann, Jakob Philipp Hackert, and others joined Goethe in

lending their own incisive visions to their depictions of the countryside.

Nobile spent his second period in Rome from the spring of 1801 to February 1805 in a climate made cultured and stimulating by the presence of these important individuals. His stay was backed by Emperor Francis. In his own words, "All this time, I have been measuring and examining ancient Roman remains […] funded by His Majesty with 800 florins per year to pursue my studies in Italy."[88]

Nobile seems to have gone back to Trieste in February 1805 due to an eye complaint and stayed there until 1806.[89] On 30 June 1805, Baron Doblhoff-Dier wrote to Nobile from Vienna to offer sympathy concerning his health problems and to wish him a speedy recovery, not neglecting to remind Nobile how much Canova thought of him.[90] Documents dating from that year and the following year refer to delays in grant payments of which Nobile complained to government bodies, but in January 1807 the government authorized the Trieste magistracy to pay him an initial instalment of 150 florins for his role as an architect in Vienna. This was followed by a second payment for "practicing architecture at the official Generalhofbaudirektion in Vienna."[91] Nobile's apprenticeship spanned December 1806 and November 1807.[92] The support of the Trieste magistracy enabled him to gain public building experience for his future work in the area.[93] The Viennese academic bodies and the offices of state and court clearly wished to test the technical and cultural mettle of the young man, to see whether he was capable of taking on the role of 3rd adjunct in the Landesbaudirektion in Trieste.[94] Pietro was hindered in the continuation of his apprenticeship by his poor knowledge of written and spoken German and by his poor eyesight. These factors stood in the way of him gaining a good reputation in the Generalhofbaudirektion.[95] He enjoyed a positive partnership with the 1st court architect Louis Montoyer, who was then busy finishing the ceremonial hall of the Hofburg in Vienna[96] and wrote a flattering recommendation for Nobile.[97] The 2nd court architect Johann Aman was not of the same opinion, observing that Nobile was unwilling to cooperate,[98] perhaps partly due to Aman's own difficult character.[99]

By the end of the apprenticeship, Nobile's professional qualities had won the administration's appreciation. Even though he had not been a pupil of the academy of Vienna

but had, however, received a scholarship from this very same institution, he won the confidence not only of the emperor but also the president Doblhoff-Dier and the curator Cobenzl as well as the sculptor Canova and the ambassador Khevenhüller-Metsch. The latter remembered Nobile as "un sujet rempli de bonnes qualités et dont l'habilité fonde l'espoir d'en retirer les services auxquels l'on a droit de s'attendre."[100]

Due to Nobile's knowledge of Trieste and also to the temporary problem with his eyes, Cobenzl proposed that he be sent to that city to manage the building works, being considered fit to play a public role.

Pietro Nobile and the Academy

The teaching at the Vienna academy led him to explore topics speculated upon by writers of treatises, namely technical views and themes of historical investigation. This is borne out by numerous drawings kept in the Nobile Collection in Trieste that were executed in Rome (Fig. 27). These reveal the careful way he worked on paper, reflecting his desire to identify, learn, and understand ancient building methods and to familiarize himself with the architectural theories then in vogue by assiduously attending the academy, which provided him with information on the latest trends in composition.[101]

Nobile was in Rome at a strategic juncture in the debate between architectural practitioners and teachers: "Artists and scholars continued to converge on the city from all over Europe in search of a hands-on relationship with Roman antiquities and the exhilarating experience of recording and excavating. Some prominent people who were active in Rome played a fundamental role in clarifying the issue of protecting ancient monuments and in reforming the French and Roman schools of architecture: David, Canova, and Quatremère de Quincy were all in Rome during the 1780s."[102] The weight of French culture informed teaching methods, particularly regarding the "special status of architecture compared to other arts"; though "the Accademia di San Luca continued to stress that drawing could still justifiably be considered a fine art, arguing that it played a fundamental role as an interdisciplinary field common to painting,

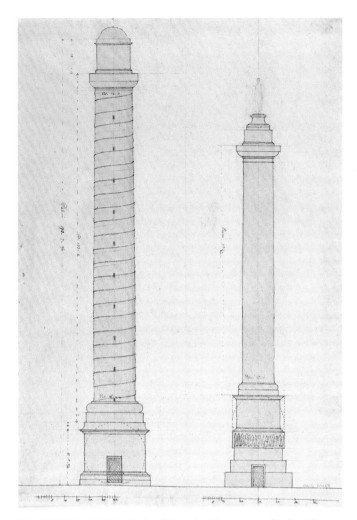

Fig. 27 Pietro Nobile, Study of Trajan's Column, pencil, ink with watercolour, 1801–1805, Trieste, SABAP FVG, Fondo Nobile.

sculpture, and architecture, France had for some time acknowledged architecture's special status compared to the other arts."[103]

It was in the midst of this that Nobile explored the architectural dictates of the French revolutionaries, particularly Boullée and Ledoux but also the theories of J.N.L. Durand, Friedrich Gilly, and many other Germans, including Friedrich Weinbrenner, who were trailblazers of the new neoclassical canons.[104] Among the models Nobile would consider was the inclusion of ancient styles in a new approach to residential building. The notions of stylistic and artistic movements that would equip Nobile to design the impressive buildings he conceived upon his return to Trieste took shape here.[105] He embraced the new methodological directions that advo-

cated delving into studies of relics in the vehement belief that Greek and Roman art reigned supreme, but he brought an Enlightenment-era scientific approach to the quest. The Accademia di San Luca offered an education based on "the direct study of classical heritage as a proving ground for young people."[106]

Nobile studied Greek architecture at the academy, as attested by some pages showing parallel views of two Ionic capitals in Athens and Rome, based on James Stuart and Nicholas Revett's *The Antiquities of Athens Measured and Delineated.*[107] This work was part of the contemporary movement but also featured hitherto-unknown Greek architectural monuments as sources for the study of new variants to be added to the five classical orders. Nobile's drawings also reveal that he was very interested in the structural aspects of Roman architecture. These simple sketches, probably executed from life, demonstrate his eagerness to learn about the ancient world, even in its most technical aspects. One typical page containing short notes shows a section of the Aurelian Walls, drawn with a careful analysis of the construction methods and the arrangement of ashlars on the arches. The parts are carefully distinguished, with the towers and the archways numbered. He also studied an aqueduct to understand the technical construction process, paying attention to the proportions of the building and its material characteristics. The drawing is executed in brief yet effective pen strokes.[108] In another similarly revealing drawing, Nobile "demonstrated the construction of the Pantheon (Pl. XXIII), or of its framework."[109] He was fascinated by the grandeur of Roman architecture. His reconstructions of the floor plans of the Roman baths are accurate, giving a detailed description of the purposes of different parts.[110]

Nobile said: "Architecture and all the other fine arts that imitate it came to a peak of perfection that has never again been achieved. Those outstanding craftsmen were driven by a grand purpose to produce memorable pieces of art."[111] These words bespeak his almost abnormal passion for the ancient world, as evidenced by the frenzied way he recorded and studied the compositional features of those monuments. During Nobile's period of learning, the academy appointed the Roman architect Andrea Vici as director of studies in 1802, in accordance with the tradition that the head of school be a painter or sculptor. Undoubtedly, this appointment was an advantage for Nobile because Vici's educational curriculum prioritized architecture. In the words of Missirini: "Our academy's charter is to promote the study of the fine arts and ensure their spread. I therefore call on the academy to fulfil this all-important objective, not with the aim of setting regulations but to ensure that we are at least engaged in doing something useful."[112]

At the beginning of the nineteenth century, academic taste turned against the tradition of Borromini and the Baroque in favour of a return to Palladian architecture and a classical approach inspired by the theories of Francesco Milizia. In this fertile environment, amidst a process of radical educational reform and renewal, the horizons of Nobile's concepts of style and character broadened. Tomaso Manfredi describes this reform as follows:

> Compared to the *Regola* of Vignola and other classical treatises [...], Milizia's *Principi* offered a broad reinterpretation of the Vitruvian triad of beauty, utility, and stability, considering them in the light of modern science and philosophy with the intention of training a revolutionary breed of architects [...]. Milizia's book is organized as a complete course of studies in three parts. The first is dedicated to the basic premises of the discipline centring on the four parameters of beauty, symmetry, eurythmy, and utility, concluded by two disquisitions on beauty and taste. The second covers the utility and the form and function of public buildings and cities. The third deals with all technical and scientific aspects inherent in the stability of buildings.[113]

Nobile grafted his understanding onto these foundations, becoming open to new theoretical and philosophical experiences. Milizia was to be a continual presence in Nobile's design and learning activities, judging by impressions gleaned by Carl Roesner, to whom Nobile wrote on 19 January 1832 with an update on his Roman sojourn. Nobile reported having bought Milizia's *Le vite degli architetti*, finding "much knowledge, philosophy, and judgement therein."[114] He would soon meet Camporese and the entire academic body.

Fig. 28 Pietro Nobile, Details of Roman monuments: Tempel of Honour and Virtue, Aurelian Walls, Arch of Claudius, pencil, ink with watercolour, 1801–1805, Trieste, SABAP FVG, Fondo Nobile.

Fig. 29 Pietro Nobile, View of the Villa Madama in Rome, pencil, ink with watercolour, 1801–1805, Trieste, SABAP FVG, Fondo Nobile.

Drawing at the Academy

Although many drawings in the Nobile Collection can be traced back to his period of learning under Moro, still during his period in Rome he used pen and paper as the main medium for his great expressive talent. He explored and studied that medium in every possible way through his academic studies, which required an extensive range of themes and subjects to be copied and recorded from life. The culture of the Accademia di San Luca "was founded on the unifying power of drawing in art, i.e. on the overriding importance of design at all levels of creativity: painting, sculpture, architecture, and poetry."[115] Its curriculum was organized into "faculties of theoretical architecture, practical architecture, and elementary or ornate architecture, two faculties for life drawing, two for sculpture, one for mythology, one for history, one for archaeology, one for anatomy, and one for geometry and perspective."[116] The overarching role of the architect thus dominated many artistic genres. This doctrine was reflected in the systematic way Nobile organized the illustrations he produced while studying at this educational establishment. The Accademia di San Luca believed that an architect's education should be broad-ranging, making students aware of the works of the most famous painters and sculptors by requiring them to study and imitate the compositional specificities of individual artists in the belief that the key to good design lay in knowledge of detail (Fig. 28).[117] For architects, drawing therefore served the technical purpose of reproducing elements but also that of representing the natural landscape surrounding a building. It was a vehicle for transposing the view and the imagination as parts of a complex whole. Nobile accordingly painted small watercolours in which buildings and decorative details take centre stage and the surrounding space is relegated to the background.[118]

Nobile also studied Italian Renaissance monuments, such as Villa Madama, which figures in many of his illustrations with its ample decorative details and its large arches alternating with Ionic pilasters (Fig. 29).[119] The pleasure of representational painting creeps into his works: Nobile exhibited a narrative ease, revealing that his objects of interest were the power of the masonry and of formal organization.

Mindful of his previous studies, he returned to the inventive and interpretive approach so dear to Piranesi. For exam-

ple, his illustrations of ruins are watercolours with unfinished figures barely sketched in pencil. These compositions detail architectural remains with columns, architraves, coffered vaults, sarcophagi, and entablatures as well as the romantic ruins of temples.

He allowed his creativity and imagination to run riot in other illustrations, in which the natural landscape intertwines with the artificial. Artefacts and ruins triumphantly share the space with columns, architraves, sarcophagi, and subjects inspired by the works of Charles-Louis Clérisseau and Charles-Joseph Natoire, whom he knew from his studies (Fig. 33).[120] The art that Nobile produced during his stay in Rome reveals his personal interpretation of Roman architecture. A process of experimentation with different types led him to produce series of drawings and designs exploring an extensive and almost infinite range of variables. Playing around with different combinations would prove to be the guiding method of all his design work for buildings and monuments. Nobile's drawings of the ancient world reveal his particular interest in the works of Piranesi as well as in those of the various artist-architects who were inspired by the Roman environment before Nobile's arrival. Clérisseau, for instance, scrutinized the Roman ruins much in the same way as Nobile: Accurate observation of materials and shapes is closely combined with an interest in settings with artefacts and decorative elements. The lessons in perspective that Nobile took from Clérisseau's drawings, coupled with his own talent for invention, led him to create new images of ancient relics using his imagination, with architecture always taking centre stage. The lessons learned from Piranesi through the filter of the *pensionnaires* of the French Academy in Rome stuck in Nobile's mind, making him see Roman monuments not merely as ruins but as an inspiration and starting point for new styles (Pl. XXIV). Nobile also drew on the effective example of Giacomo Quarenghi, who combined landscape painting and architecture into a happy balance between ancient artefacts and romantic settings.

Some of the drawings in the Nobile Collection reflect the lessons that the Accademia di San Luca taught its students. Painters, sculptors, and architects were united in the pursuit of one science: learning from life, i.e. from the ancient world. This was seen as the only true cradle of art because it still lived, existing in a close bond with the eighteenth-century world that believed Rome to be an inexhaustible fount of knowledge and a holy place from which to learn everything about beauty.[121]

Nobile's study of the ancient world became a reflection and also a bridge to the contemporary, which was absent from Rome at that time, as almost nothing was being built. Nobile learned about contemporary trends instead from the academy, from teachers, and from fellow students. He wanted to stay in Rome because he realized he was gaining useful insights that would allow him to develop ideas towards the purposes of the Vienna academy: design on a grand scale for a new and up-to-date image of the empire.

Nobile followed the school's guidelines and theoretical methods, which at that time required students to study all the visual arts without prioritizing one in particular. They were all considered of equal merit due to their common source. "It was therefore a form of teaching that abhorred specialism in a climate that tended to take the words of Bottari literally, but never to the extent of losing sight of the overriding importance of design as an opportunity to celebrate the unity of culture and its essentially humanistic roots."[122] An architect's curriculum thus had to delve into other areas. Evidence of this comes in the large number of illustrations of mythological figures, drawn on different grades of tissue paper. These depict nudes and anatomical studies seen in the context of mythology and ancient history. Students were intended to copy these subjects from life during visits to public or private collections or from prints accessible at the academy.[123] Students from other disciplines shared these subjects as well, judging by Nobile's notes on an illustration depicting "Mercury and Faun" copied "from the books of Dr Caucig, 1805."[124] Nobile practiced anatomical details such as faces wearing various expressions and mouths, noses, and hands based on a repertoire of motifs used by painters and sculptors. Architects also had to be familiar with these subjects, as Volpato and Morghen demonstrated in 1786 when they borrowed elements from famous ancient statues in their work *Principi del disegno*.[125] This series of drawings features a variety of subjects and expressions, testifying to Nobile's technical ability as an artist. In this sense, it is reminiscent of Lavater's first compendium of facial details, his *Essai sur la physiognomie, destiné à faire connoître l'homme et à le faire aimer (1781–*

1803), which contains a vast array of faces wearing the most diverse expressions.[126]

As a student of the academy, Nobile was lucky enough to have the opportunity to analyse what he saw around him in order to understand – with the eye of an architect but also as an observer of his surroundings – how different parts were put together. Alongside works depicting landscapes from the Roman countryside and showing nature and monuments in close association, in certain illustrations Nobile placed a single tree at the centre so that he could study its constitutive shapes, its structure, construction, and segmentation. His architectural attention focused on nature as a source of knowledge and research, allowing him to explore compositional arrangements in a sequence of works featuring parts of trees, executed with swift strokes in pencil and pen. Some illustrations depict a single central tree, with a smooth or knotty trunk. He places great emphasis on the tree's canopy, densely packed with branches and leaves that move in various directions, with the intention of understanding the tree's construction and its configuration in space. However, Nobile often emphasized the monumental nature of trees and allowed subjects that similarly impose themselves on the landscape to take centre stage. He dwelled on the bark, which he executed using chiaroscuro pen shading to mark its bulk and its natural folds and slopes. His work in this area resembles a general tendency connecting the landscape and architecture as two spatial forms, as shown by two watercolours from Albertina drawings collections. Jacob Wilhelm Mechau created on them a landscape romantic frame for Schiller and Klopstock's architectural monuments by Johann Gottfried Klinsky (1806), as if illustrates the latter theoretical essay *Versuch über die Harmonie der Gebäude zu den Landschaften* (1799). These depict two trees in the foreground, spanning the space in much the same way as commemorative architecture.[127]

Oaks, maritime pines, and cypresses were the trees that Nobile encountered on his Roman walks and in the city gardens. The same gardens had been visited by other *pensionnaires* some years prior, judging by the views that Jean-Honoré Fragonard and Hubert Robert, for example, drew in their sketchbooks during their stay in the Eternal City to convey the feelings they experienced when outdoors (Pl. XXV). The same dialogue between architecture and vegetation or art

and nature is a deep vein flowing through Nobile's illustrations. A few years earlier, Goethe expressed the same feelings in his work *Viale a villa Borghese*, where the majestic trees and thick foliage break up the space in a rhythmic sequence, forming a green tunnel.[128]

Volume 51 of the Nobile Collection contains fifteen illustrations and is entitled "Landscape sketches."[129] Some pages contain a drawing of a single tree, a specific study of the trunk and branches; others depict two different-looking trees side by side, with the rounded, lobed leaves becoming a cipher, as in other illustrations (Pl. XXVI).[130] The featured tree is represented in all its individuality and unity, midway between direct observation of nature and artistic interpretation. This work also refers closely to the steps traced by Goethe during his visit to Villa Aldobrandini in Frascati, where the writer found beauty in the tightly packed trees with tall trunks and leafy brunches.[131] Nobile's are bigger but otherwise seem to recall what Durand depicted in 1790 in a series of small drawings that Antoine Rondelet dubbed *Rudimenta operis magni et disciplinae*. These small sketches feature trees either at the centre or at the edge of the page in a spatial context; alternatively, they show trees on their own, showing off their distinctive traits. "Durand found inspiration in theories of character" and in the ideas of Boullée, in the artistic realm of architecture. His desire was to bring architecture closer to painting or sculpture, using nature as a "source of the senses, of the soul, and of imitation."[132] Though Nobile did not forget the tradition of Piranesi, which he had first been made aware of in Trieste by Ulderico Moro and had then gone on to cultivate with greater insight in Rome, at the academy he embraced the dictates of French architecture and opened himself up to new horizons.[133]

While Nobile saw landscape art as a chance to observe nature and to make space for contemplation, trees were a real-life element that had to be detailed in every part. His analysis focused on trees' architectural make-up, enhancing the spatial distribution of form and the balance between branches, almost as though he wished to overcome the diversity and individuality of each specimen, to locate an archtype.

Pietro Nobile and his Notebook

This notebook full of sketches of buildings and decorative details perfectly epitomizes Nobile's studies in Rome.[134] It is not merely a travel book but a pocket anthology of patterns and shapes embodying his training period. The survival of the original binding, along with a certain regularity and care in his drawing strokes, suggests that Nobile used the notebook to work from life from his desk, recording what he saw in the academy and in prints and books.[135]

From a formal viewpoint, the notebook contains free, spontaneous inventions alongside other work he must have meditated over in an attempt to put on paper what he had in mind. He would go on to develop some of these into finished, completed drawings. His technique ranged from accurate sketches, which he went over with pen, to rapid pencil sketches. He sometimes executed drawings with a light pencil stroke, showing a prevalence of chiaroscuro shading, and then worked in watercolour. In some, he used mainly swift strokes, always in pen or ink, to indicate the simple linear structure of a facade. In others, his stroke was more cursory barely present. These three types of drawing approaches alternate in the notebook without any precise distinction. They are grouped by subject. Nobile seems to have alternated and adapted the different forms of expression according to his needs. Incomplete drawings of some elevations suggest a predilection for tripartite building organization, with the central body either set back from or protruding. He was less interested in showing the arrangement of colonnades and pilasters, and these are barely hinted at. Nobile's use of Diocletian, or thermal, windows harks back to the ancient world, as do his frequent arched openings with tapered architrave portals. However, there are few references to archaeology or classic citations in the notebook.

The notebook reflects his Roman sojourn, recording his meetings and encounters with teachers and prominent personalities. One such figure was the architect Giuseppe Valadier, a distinguished person who was active in the field of design and restoration during that period. The building facades Nobile depicted were clearly no longer based on the decorative legacy of the Baroque and revealed great openness to new revolutionary trends, a desire to seek a compact and rational architectural language. Evidence of this comes

on pages 10 and 11 where a classic component stands alongside pure geometries, combining tradition with the new wave. Page 12 shows various elements joined to create spaces. This was probably a celebratory building arranged on different planes. It is reminiscent of the Valladier's arrangement of the Pincio with its interplay of arches, stepped ramps, and round-arched windows.

Nobile might have followed a route similar to Valadier's – starting with Vitruvius, Palladio, and Milizia and then embracing German and French theories – to become an independent designer (Figs. 30, 31). Nobile's artistic notes describe the building as an object, almost alien from its surrounding space, with lines and volumes pared down to grasp the very essence of the whole structure. He also addressed the motif of domed buildings, with a nod to Valadier. This is demonstrated by numerous sketches showing building elevations with domes (e.g. pages 15 and 21), exemplified in sketches for coffeehouses featuring similar patterns of composition and divisions of volume.

The Accademia della Pace, or rather the people whom Nobile is highly likely to have known personally, influenced his quest for a style of his own. For example, the extension of Genoa pier by Barabino and the Collegium Mercatorum Italica Borsa, drawn on pages 51 and 36 respectively, "strictly obey Milizia's 1781 *Principles*: the columns are all load-bearing, the other elements of the order (the entablature) are only present when a trilithic system is at work."[136] The semi-circular court motif on the facade of the building, as drawn by Nobile in illustrations 11 and 12, recalls Mario Asprucci and Ferdinando Bonsignore, who used it in their designs, again pointing to the influence of archetypes associated with the Accademia della Pace (Pl. LXXVII).

References to Palladian architecture in the notebook could be the result of visits Nobile made on his journey to Rome because the opening pages show buildings that are recognizably from the Vicenza area. In the middle of page 4, Nobile drew a perspective view of a single-storey villa with a central portal featuring a Serlian window and decorative, blind oculi in an attempt to understand the plastic modulation on a barely sketched facade that was clearly inspired by Villa Poiana. The focus is on the way space was divided within the buildings to create a unique architectural complex. The two watercolours on page 7 are inspired by Villa

Fig. 30 Pietro Nobile, Sketchbook, a page with villas, pencil, ink with watercolour, 1801–1805, Trieste, SABAP FVG, Fondo Nobile.

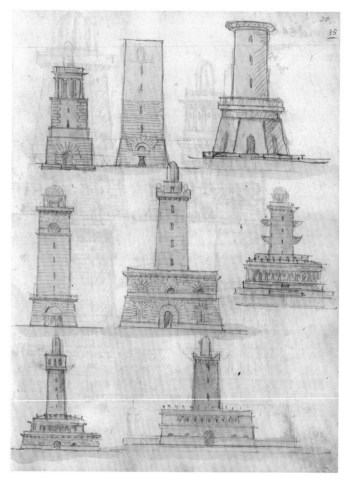

Fig. 31 Pietro Nobile, Sketchbook, a page with lighthouses, pencil, ink with watercolour, 1801–1805, Trieste, SABAP FVG, Fondo Nobile.

Caldogno and Villa Foscari (the latter also known as "Malcontenta"), and its subjects are shown mainly from a volumetric viewpoint.[137] Nobile explored the Serlian windows and characteristic roof covering of the basilica of Vicenza, seeking to understand a different compositional approach using Palladian language.

Traces of the architectural styles of Scamozzi and Sanmicheli emerge from the notebook, confirming that the study of sixteenth-century tradition was well established within the academy as a necessary entry point to the study of contemporary architecture. Other significant presences find their way into the notebook: Nobile learned about the French revolutionary architects Boullée and Ledoux through Valadier but also from direct examination of their printed works, as Emil Kaufmann reported when he recalled that

Nobile had numerous publications by Durand and Ledoux.[138] Irmgard Köchert emphasized that the so-called *Revolutionsarchitektur* predominated during Nobile's formative years, and confirmation of this can be found in the notebook, which is packed with French citations encapsulating the transformative properties of geometry and the effects achieved by joining solids in space. Nobile went on to develop these into larger illustrations. He strictly observed Vitruvian theories of symmetry, proportion, and utility, which were complemented during the Enlightenment by the additional principles of unity, method, and reason. Nobile was attracted to the way Ledoux and Boullée dealt with surfaces and with compositional balance. He particularly appreciated the fusion of classic forms with the rigorous severity of cubic shapes, as shown on pages 3, 4, and 14,

where this is evident in stripped-down volumes and rigorously sparse structures.[139]

The notebook reveals yet another path Nobile took in Rome to gain knowledge of architectural practice. He studied German architects, who had been receiving similar cultural training in Rome since the end of the eighteenth century and expressed themselves in distinctly geometric terms using severe shapes. Nobile was interested in Friedrich Weinbrenner, who lived in Rome between 1792 and 1797, judging by pages 18 and 36, which show subjects typified by rigour and clean lines. However, illustration 46 also demonstrates the out-and-out Dorism – the full, compact structures, the decisive, imposing volumes, and the distinctly ancient look – popularized by Friedrich Gilly.[140] Nobile's reading of the *Architektonisches Lehrbuch*, particularly on the

proportions of columns, is an important reference to which he devoted a lot of space in his drawings. He built up the notebook slowly, bit by bit, adding knowledge acquired during the course of his academic studies. This logical, step-by-step progression towards a definitive clarification of his ideas on composition ultimately enabled him to define his own expressive language.

We have a timeline of Nobile's movements through his exchange of letters. He returned to Trieste in 1808, after his long stay in Rome and a spell in Vienna, to find an Austrian government in power again in the Littoral. He was now in a position to undertake his new public tasks, backed by a wealth of theoretical and technical knowledge that he could use to make Trieste and its surrounding areas an important part of the Habsburg imperial organization.

NOTES

1 Fulvio Caputo and Roberto Masiero, "La città et l'architettura," in *Trieste: l'architettura neoclassica. Guida tematica*, ed. Fulvio Caputo and Roberto Masiero (Trieste: Edizioni B & M Fachin, 1988), 25.

2 *Descrizione storico statistica della città di Trieste e del suo territorio, 1782*, ed. and trans. Sergio degli Ivanissevich (Trieste: Italo Svevo, 1992), 20.

3 *Maria Teresa, Trieste e il porto: mostra storica*, ed. Laura Ruaro Loseri (Udine: Instituto per l'Encyclopedia del Friuli Venezia Giulia, 1980), 35.

4 Gino Pavan, "Pietro Nobile: discorso per l'inaugurazione del 'gabinetto di Minerva' Trieste, 1 gennaio 1810," *Archeografo triestino* 53 (1993): 17.

5 Pavan, "*Pietro Nobile: discorso*," 17.

6 Ibidem.

7 *Maria Teresa e Trieste*, 13.

8 Gino Pavan, "Pietro Nobile architetto. Vita ed opere," *Archeografo triestino* 49 (1989): 373–432.

9 Archivio generale Comune di Trieste, fascicle 20, 76. Stefano Nobile stated that he was Catholic, married and resident in house number 952 in the Borgo Teresiano together with other builders from Milan. Documents from the Trieste Chamber of Commerce shows that he was still active in 1804 (folder 5, fascicle 25, 1802–1804).

10 Giuseppe Righetti, *Cenni storici, biografici e critici degli artisti ed ingegneri di Trieste* (Trieste: L. Herrmanstorfer Tipografo-Editore, 1865), 56. Gianna Duda Marinelli, *I Nobile dal 1774 al 1918, Atti e memorie della Società Istriana di Archeologia e Storia Patria* 46 (1998): 281–355.

11 Marzari, "*L'Accademia di Commercio*," 404.

12 Diana De Rosa, "L'istruzione nella Trieste di fine Settecento e lo studente Pietro Nobile," *Archeografo triestino* 59 (1999), 33 = *L'architetto Pietro Nobile (1776–1854) e il suo tempo*. Atti del convegno internazionale di studio, Trieste: 1999, ed. Gino Pavan. On the same subject Diana De Rosa, *Piazza Lipsia No 1015. Gli studi nautici nell'Accademia reale e di nautica di Trieste* (Udine: Del Bianco Editore, 2008), 11–55.

13 De Rosa, "*L'istruzione nella Trieste*," 33.

14 Ibidem.

15 Ibidem.

16 Caputo and Masiero, "La città et l'architettura," 31.

17 Righetti, *Cenni storici*, 139, 146.

18 Caputo and Masiero, "La città et l'architettura," 47.

19 Ibidem, 50.

20 Ibidem.

21 Ibidem, 46.

22 Rossella Fabiani, "Palazzo Costanzi," in *Trieste: l'architettura neoclassica. Guida tematica*, ed. Fulvio Caputo and Roberto Masiero (Trieste: Edizioni B & M Fachin, 1990), 189.

23 Righetti, *Cenni storici*, 21.

24 Franco Firmiani, *Arte neoclassica a Trieste*. Con testi integrativi di Rossella Fabiani e Lucia D'Agnolo (Trieste: B&MM Fachin, 1989), 30.

25 Alessandro Giacomello and Paolo Moro, "Da falegname a architetto: Ulderico Moro da Priola a Trieste," *Archeografo triestino* 77 (1999): 251–271; Alessandro Giacomello and Paolo Moro, "Da falegname a architetto: Ulderico Moro da Priola a Trieste," in *Mistrùts*. (Udine: Museo Carnico delle Arti e Tradizioni popolari, Luigi e Michele Gortni, 2006), 207–219.

26 Gabriella Bucco, "La cultura 'riccatiana' in Friuli e l'edizione del Vitruvio udinese," *Arte in Friuli, Arte a Trieste* 2 (1976): 108. Anna L. Fan-

teschi, "Ulderico Moro: precisazioni sul periodo udinese," *Arte in Friuli Arte a Trieste* 15 (1995): 217–224.

27 "Ulderico Moro," in *Il Nuovo Liruti: Dizionario biografico dei friulani*, ed. Cesare Scalon, Claudio Griggio and Ugo Rozzo, vol. 2 *L'età veneta* (Udine: Forum, 2009), 1754–1757.

28 Franco Firmiani, "L'architetto Uldarico Moro (1737–1804). Documenti inediti, proposte, interrogativi," in *Neoclassico: La ragione, la memoria, una città: Trieste*, ed. Fulvio Caputo and Roberto Masiero (Venezia: Marsilio Editori, 1990), 182–189.

29 Firmiani, "L'architetto Uldarico Moro," 182.

30 Rossella Fabiani, ed., *Pagine architettoniche: i disegni di Pietro Nobile dopo il restauro* (Pasian di Prato: Campanotto, 1997), 26.

31 Firmiani, *L'architetto Uldarico Moro*, 188. Trieste, SABAP FVG, Fondo Nobile, vol. 7.

32 Ibidem.

33 Rossella Fabiani, "Pietro Nobile archeologo e conservatore," in *Artisti in viaggio 1750–1900. Presenze foreste in Friuli Venezia Giulia*, ed. Maria Paola Frattolin, (Udine: Università di Udine, 2006), 59–66; Barbara Tomizza, "Sigismondo Dimech, Ritratto di Pompeo Brigido," in *Neoclassico. Arte, architettura e cultura a Trieste 1790–1840*, ed. Fulvio Caputo (Venezia: Marsilio Editori, 1990), 171.

34 De Brigido had strenuously defended the city of Trieste at the time of the first French occupation.

35 Andreas Streibel, "Arte e restaurazione. Il neoclassico di Pietro Nobile," *Archeografo tirestino* 51 (1991): 363. Rome seemed to be the best place for Nobile to further his academic training.

36 The document has not been found and the quotation is from the reference log. Nicoletta Guidi, "Pietro Nobile: Regesto degli atti presenti nell'archivio storico," in *Atti e memorie della società istriana di archeologia e storia patria* 99 (1999): 215.

37 Fabiani, ed., *Pagine*, 23. Liliana Tassini, Il *governo francese a Trieste (1797–1813): Lineamenti storici, giuridici, economici* (Trieste: L. Smolars & Nipote, 1945), 435–487.

38 Rossella Fabiani, "'Sono pochi anni che Trieste vide un lampo della nobile architettura'," in *1797: Napoleone a Campoformido. Armi, diplomazia e società in una regione d'Europa*, ed. Giuseppe Bergamini (Milan: Electa, 1997), 156–162.

39 His nautical grant of a hundred lire was obtained through a state decree dated 11 January 1798.

40 Righetti, *Cenni storici*, 56, 57.

41 De Rosa, *L'istruzione*, 44.

42 Ibidem, 45.

43 Guidi, "Pietro Nobile: Regesto," 215.

44 Diana De Rosa, *Piazza Lipsia No 1015. Gli studi nautici nell'Accademia reale e di nautica di Trieste* (Udine: Del Bianco Editore, 2008), 44.

45 Many documents bear witnesses to the difficulties Pietro and his father encountered in renewing his grant. See: Guidi, "Pietro Nobile: Regesto," 216–217.

46 Pavan, "Pietro Nobile architetto," 379. Count Johann Philipp Cobenzl was then curator of the Academy and his position allowed him to suggest the names of people who should be awarded grants to go to Rome to the emperor (courtesy of Richard Kurdiovsky).

47 Fabiani, *Pagine*, 30–36. Trieste, SABAP FVG, Fondo Nobile, vol. 1. The design is drawn in pencil, pen and grey and blue watercolours on a scroll of paper, 60 × 1800 mm.

48 Ibidem, 31.

49 *Contro il barocco. Apprendistato a Roma e pratica dell'architettura civile in Italia 1780–1820*, ed. Angela Cipriani, Gian Paolo Consoli and Susanna Pasquali (Roma: Campisano Editore, 2007), 81–82.

50 *Alessandro Papafava e la sua raccolta. Un architetto al tempo di Canova*, ed. Susanna Pasquali and Alistair Rowan (Milan: Officina libraria, 2019), 135.

51 *Contro il barocco*, 100.

52 Fabiani, ed., *Pagine*, 31.

53 *Contro il barocco*, 506.

54 *Alessandro Papafava*, 172.

55 *Contro il barocco*, 512.

56 *Alessandro Papafava*, 141.

57 Ibidem, 142.

58 Archivio storico dell'Accademia nazionale di San Luca, vol. 55, minutes of the congregation of 7 September 1800, 86.

59 Archivio storico dell'Accademia nazionale di San Luca, vol. 55, minutes of the congregation of 7 September 1800, 87.

60 Fraschina referred to Nobile's difficulties in obtaining money as well as the Vienna academy's positive reception of his design for the Temple of Immortality see Franco Fraschina, "L'architetto Pietro Nobile, Commemorazione in occasione della 115.ma assemblea della Domopedeutica, held in Tesserete on 7 October 1962," *L'educatore della svizzera italiana* 104, (December 1962): 4–11.

61 Walter Wagner, "Die Rompensionäre der Wiener Akademie der bildenden Künste 1772–1848 nach den Quellen im Archiv der Akademie," *Römische Historische Mitteilungen* 14 (1972): 65–109; Katharina Scholler, *Pietro Nobile direttore dell'Accademia di architettura di Vienna (1818–1849)* (Trieste: Società di Minerva, 2008), 95.

62 Jörg Garms, "Introduction," in *Artisti austriaci a Roma dal barocco alla secessione* (Rome: Istituto Austriaco di Cultura in Roma, 1972), 2.

63 Joseph Abel (Aschach 1764–Vienna 1818). The reports Abel sent to the President of the Vienna academy, Doblhoff-Dier, record the people and monuments he visited and studied. He ended his career in Vienna, painting altarpieces and portraits according to the trends of the time see *Artisti austriaci*, Nos 1–10. For Leopold Kiesling, lastly Sabine Grabner, "Leopold Kiesling: ein Lebensbild," in *Der Mythos von Mars und Venus mit Amor*, ed. Stella Rollig and Sabine Grabner (Vienna: Belvedere, 2019).

64 Garms, "Introduction," 5.

65 Due to a stipend of 800 florins, as confirmed in the publication by Pietro Nobile, *Progetti di varj monumenti architettonici immaginati per*

celebrare il trionfo degli augusti alleati, la pace, la concordia de'popoli e la rinascente felicità d'Europa nell'anno 1814, inventati e disegnati da Pietro Nobile, Imperial – Regio ingegnere in Capo provvisorio delle Provincie di Trieste, d'Istria, Gorizia, Adelsberg e Fiume; architetto accademico, Membro dell'Accademia italiana e della Arcadia Romano-Sonziaca (Trieste: Imp. Reg. privilegiata Tipografia Governiale, 1814), 9.

66 UAABKW, VA ex 1801, fol. 547a and 547c: Nobile to Doblhoff-Dier from 19 December 1801.

67 UAABKW, VA ex 1802, fol. 118–119.

68 The grant holders were obliged to report back to the Academy regularly on the progress of their studies.

69 UAABKW, VA ex 1802, fol. 118–119.

70 UAABKW, VA ex 1802, fol. 128r–v: Nobile's report from Rome dated 23 April 1802.

71 Trieste, SABAP FVG, Fondo Nobile, 80 A–D, Vienna, 2 November 1804. Letter from Doblhoff-Dier to Nobile, Vienna 15 March 1802.

72 UAABKW, VA ex 1803, fol. 335r–v: Nobile to Doblhoff-Dier or Cobenzl from Rome, from 14 December 1803.

73 *Grand Tour. Il fascino dell'Italia nel XVIII secolo*, ed. Andrew Wilton and Ilaria Bignamini (Milan: Skira, 1997), 141.

74 *Artisti austriaci*, Nos 42–61; Maddalena Malni Pascoletti, "Caucig Francesco," in *La pittura in Italia. L'Ottocento* (Milan: Electa, 1991), 752–754; Ksenija Rozman, *Franc Kaučič Caucig and Bohemia* (Ljubljana: Narodna galerija v Ljubjani, 2005). Eadem, *Franc Kaučič Caucig. Paintings for Palais Auersperg in Vienna* (Ljubljana: Narodna galerija v Ljubjani, 2007), 45; Johannes Röll and Ksenija Rozman, ed., *Franz Caucig (1755–1828): Italienische Ansichten* (Petersberg: Michael Imhof Verlag 2018). An altarpiece he was destined to never complete, because he died in Vienna in November 1828. Adriano Drigo, "Francesco Caucig, un artista goriziano tra Roma e Vienna," in *Ottocento di frontiera* (Milan: Electa, 1995), 64–69. The watercolours that Nobile painted during his Roman period are typical of the output of the circle of artists present at that time, showing a keen eye for the spaces represented: his close, painterly focus on composition led him to depict vegetation, ruins and picturesque corners evoking bucolic moments. For example, his view of the villa of Domitian depicts a river, the Tiber (?) running along the same plane as the trees and caves in perfect and orderly harmony. His watercolour of the entrance portal to Parco Colonna in Marino also foregrounds the vegetation in a triumphant riot of leaves and branches. Pietro Nobile continued to visit him in Vienna after 1818 and held him in high enough esteem to recommend him for the execution of an altarpiece for the church of Sant'Antonio Taumaturgo in Trieste.

75 Livia Rusconi, "Pietro Nobile e il gruppo del Teseo di Antonio Canova a Vienna," *Archeografo triestino* 10 (1923): 363.

76 UAABKW, VA ex 1804, fol. 57–64.

77 Trieste, SABAP FVG, Fondo Nobile, Letter no. 121 E–K Rome, 7 September 1805. Khevenhüller and Doblhoff agreed that Nobile should remain in Trieste, where he had gone to treat an eye disorder.

78 Trieste, SABAP FVG, Fondo Nobile, E–K 115, passed on greetings from Papafava, Mazzoli, Desantis, Uggeri and Abel.

79 For a brief up-to-date bibliography Fabiana Salvador, "Pietro Nobile Architetto: bibliografia essenziale," in Rossella Fabiani, Fabiana Salvador and Giorgio Nicotera, ed., *Gli svizzeri a Trieste e dintorni. Pietro Nobile* (Trieste: Circolo svizzero di *Trieste* 2018, 59–81; Gino Pavan, *Pietro Nobile architetto (1776–1854): Studi e documenti* (Trieste and Gorizia: Istituto Giuliano di Storia, Cultura e Documentazione, 1998), 17–78.

80 Rossella Fabiani, "Pietro Nobile," in *Contro il barocco. Apprendistato a Roma e pratica dell'architettura civile in Italia 1780–1820*, ed. Angela Cipriani, Gian Paolo Consoli and Susanna Pasquali (Roma: Campisano Editore, 2007), 447–452. Before arriving in Rome, Nobile visited the works of Palladio in Vicenza and the Accademia di Belle Arti in Bologna.

81 *Paesaggi italiani dell'epoca di Goethe: Disegni e series di acqueforti della Casa di Goethe*, ed. Ursula Bongaerts (Rome: Arbeitskreis selbständiger Kultur-Inst., 2007); *…Finalmente in questa Capitale del mondo. Goethe a Roma*, eds. Konrad Scheurmann and Ursula Bongaerts-Schomer (Roma: Artemide, 2007).

82 *Grand Tour*, 17–25. Fabiani, ed., *Pagine*, 28.

83 *Luigi Basiletti 1780–1859: Carteggio artistico*, ed. Bernardo Falconi (Brescia: Scripta – Comunicazione Editoria, 2019), 382.

84 Rusconi, "Pietro Nobile e il gruppo," *Archeografo triestino* 10 (1923): 363.

85 *Luigi Basiletti 1780–1859*, 316: letter dated 17 February 1829.

86 Ibidem, 317: letter dated 1 April 1829.

87 Goethe arrived in Rome on 29 October 1786 and left on 23 April 1788.

88 Nobile, *Progetti*, 3.

89 Pavan, "*Nobile*," 381.

90 Trieste, SABAP FVG, Fondo Nobile, A–D 80 compare UAABKW, VA ex 1805, fol. 164: draft of a letter from Doblhoff-Dier to Khevenhüller-Metsch dated 30 June 1805.

91 Archivio generale Comune di Trieste, 6 January 1807, ref. 59, fasc. 15, folder F 96.

92 Finanzministerium, Zl. 25.623/152/50 ex 1849 (cited according to Köchert 1951, 201: Anhang No. 24).

93 OeStA HHStA, OMeA 133, Akten, Zl. 459: Obersthofmeisteramt a Generalhofbaudirektion of 10 August 1807.

94 OeStA HHStA, OMeA 136, Akten, Zl. 626: Struppy to Starhemberg dated 25 November 1807 and Obersthofmeisteramts to Generalhofbaudirektion dated 4 December 1807 (with notice of Nobile's departure from Vienna on 15 December 1807). Streibel, "Arte e restaurazione," 368.

95 OeStA HHStA, OMeA 133, Akten, Zl. 459: Obersthofmeisteramt to Generalhofbaudirektion on 10 August 1807.

96 Benedik, "Ludwig von Remy," 235–241.

97 OeStA HHStA, OMeA 133, Akten, Zl. 487: Obersthofmeisteramt to Generalhofbaudirektion dated 13 September 1807.

98 OeStA HHStA, OMeA 133, Akten, Zl. 487: Struppy to Starhemberg dated 8 September 1807.

99 Benedik, "Ludwig von Remy," 235. 2016, 235.

100 UAABKW, VA ex 1805, fol 163: Khevenhüller (from Rome) to Doblhoff-Dier dated 8 June 1805.

101 The Pietro Nobile Collection, including most of the graphic art produced by the architect is kept in the Friuli Venezia Giulia Archaeology, Fine Art and Landscape Department housed in *Palazzo Economo* in Trieste. See chapter 4. The collection was restored and an inventory was drawn up. The 8000 drawings, 500 letters and documents provide an insight into the architect's entire working life. In this part of the century, Nobile's timeline in Rome and Vienna can be traced through his correspondence with prominent personalities such as Count Cobenzl, curator of the Academy of Fine Arts, and the academy's president Baron Anton von Doblhoff-Dier as well as colleagues and friends who stayed with him in Rome.

102 Annarosa Cerutti Fusco, "Dibattito architettonico e insegnamento pubblico dell'architettura nell'Accademia di San Luca a Roma nella prima metà dell'Ottocento," in *L'architettura nelle accademie riformate. Insegnamento, dibattito culturale, interventi pubblici*, ed. Giuliana Ricci, (Milan: Guerini Studio, 1992), 45–46.

103 Ibidem, 47.

104 Rossella Fabiani, "Pietro Nobile a Roma," *Arte in Friuli Arte a Trieste* 10 (1988): 77–82. Eadem, "Modelli nei disegni di Pietro Nobile," *Arte in Friuli, Arte a Trieste* 11 (1989): 101–109. Eadem, "Pietro Nobile e l'architettura tedesca," *Arte in Friuli, Arte a Trieste* 15 (1995): 307–318. He was often in contact with *pensionnaires* of the French Academy, which was then based in what is now Via del Corso in Rome.

105 Such as the church of Sant'Antonio Nuovo or the Savudrija Lighthouse in Istria.

106 *Giuseppe Piermarini e il suo tempo*, (exh. catalogue Milan, Palazzo Trincini), (Milan, Electa, 1983), 134.

107 Fabiani, "Pietro Nobile a Roma," 78.

108 Trieste, SABAP FVG, Fondo Nobile, vol. 2, no. 44.

109 Trieste, SABAP FVG, Fondo Nobile, vol. 2, no. 45. This cross-section includes part of the vault and the wall, showing the system of drainage arches and the make-up of the masonry. In this case too, the drawing is quickly executed but essential: the column capitals and the windows are barely sketched, while the construction systems are emphasised, showing supporting arches and ribs. It also shows "the inner surface of the eye stripped of plaster with the bronze hook to which drapes are attached."

110 Trieste, SABAP FVG, Fondo Nobile, vol. 2, no. 18, 19, 20.

111 Trieste, SABAP FVG, Fondo Nobile, vol. 2, no. 44.

112 Melchior Missirini, *Memoria per servire alla storia della romana accademia di San Luca fino alla morte di Antonio Canova* (Rome: Stamperia de Romanis, 1823), 308.

113 Tomaso Manfredi, "Francesco Milizia e i principj di architettura civile: disegno e iconografia," *Trattato (Dal) al manuale: La circolazione dei modelli a stampa nell'architettura tra età moderna e contemporanea*, ed. Aurora Scotti Tosini (Palermo: Caracol, 2013), 61.

114 Trieste, SABAP FVG, Fondo Nobile, 14 RZ. Nobile also mentioned Milizia to his brother Antonio who went to Lecce, home of the theoretician, urging him to get information on his drawings from libraries or shops see Gino Pavan, *Lettere da Vienna di Pietro Nobile (dal 1816 al 1854)* (Trieste: Società di Minerva, 2002), 89: Nobile to his brother in January 1824.

115 Paolo Marconi, Angela Cipriani and Enrico Valeriani, *I disegni di architettura dell'Archivio storico dell'Accademia di San Luca* (Roma: De Luca, 1974), XIV.

116 Ibidem.

117 The volumes contain drawings of plans for monuments, religious and public buildings, elevations of ancient monuments, perspective studies, studies of colonnades and capitals and architectural elements; other works closely related to his academic activity include studies of the human body, mythological and biblical groups, heads of Roman emperors, classical figures, decorative details and preparatory illustrations for an unfinished treatise.

118 The drawings are views of Rome: Porta Portese and the San Michele building complex, the Farnese gardens on the Palatine Hill, *Fontana dell'Acqua Paola* on the Janiculum Hill or the *Acqua Vergine* spring in Villa Borghese.

119 Trieste, SABAP FVG, Fondo Nobile, vol. 56.

120 Fabiani, "Nobile a Roma," 80; Joselita Raspi Serra, "La Roma di Winckelmann e dei pensionnaires," *Eutopia* 2, no. 2 (1993): 79.

121 *Roma è l'antico. Realtà e visione nel '700*, ed. Carolina Brook and Valter Curzi (Milan: Skira, 2010).

122 Marconi, Cipriani, Valeriani, *I disegni*, XIV.

123 Observation of these illustrations reveals the extreme attention and accuracy with which Nobile depicted subjects taken from Roman art, for example the Rape of the Daughters of Leucippus by Castor and Pollux, Prometheus and other figures, a detail of the bust of Laocoon and many other subjects collected in volumes 21, 23, 25 and 27.

124 Trieste, SABAP FVG, Fondo Nobile, vol. 19, no. 154.

125 Volume 20 contains views of foreheads and eyes from figures that must have been copied during visits to the Vatican or taken from the collected works of Michelangelo and Raphael.

126 Johann Kaspar Lavater, *Frammenti di fisiognomica*, trans. M. De Pasquale, introd. Gorgio Celli (Rome: Mathilde de Pasquale, 1989). Originaly published as *Physiognomische Fragmente zur Beförderung der Menschenkenntnis und Menschenliebe* (1775–1778).

127 Christian Benedik, *Meisterwerke der Architektur. Zeichnungen aus der Albertina* (exh. catalogue Albertina), München, London and New York: Prestel, 2017, 136–139: Jacob Wilhelm Mechau und Johann Gottfried Klinsky, *Entwurf für ein Schiller-Denkmal*, 1806, Vienna, Albertina, GSA, 14.818. Iidem, *Entwurf für ein Klopstock-Denkmal*, 1806, Vienna, Albertina, GSA 14.817.

128 Johann Wolfgang von Goethe, *Viale a Villa Borghese*, 1787, pencil, pen, ink and watercolour, Weimar: Klassik Stiftung.

129 Luxuriant vegetation is a feature of Nobile's landscape sketches and drawings. The theme of trees is studied in terms of their specific configuration and in their relationship with the environment and function within the composition. Trieste, SABAP FVG, Fondo Nobile, vol. 51, no. 1, 2, 7, 10, 11 and 15.

130 The Antonio Fonda Savio bequest, kept in the Archive of Writers and Regional Culture at Trieste University, contains a drawing by Pietro Nobile depicting a *Study of vegetation* taken from an album of "pen and watercolour sketches of leaves, trees and landscape" on the same subject, pages 51, 8, 9 and 10.

131 Vincenzo Cazzato and Maria Gazzetti, "Goethe's gardens: seeking the 'archetypal tree' in Italy," in *Viaggio nei giardini d'Europa da le Nôtre a Henry James*, ed. Vincenzo Carrato and Paolo Cornalia (exh. catalogue, château Venaria Reale), (Turin: Edizioni La Venaria Reale, 2019), 234–246. Joseph Anton Koch, a young Austrian painter who was a student at the Accademia di San Luca and a contemporary of Nobile, delineated landscapes with the same features in his views of the Sabine Hills and the *Serpentara di Olevano*, adopting the same stylistic approach. See *Artisti austriaci*, no. 176.

132 Werner Szambien, *J.-N.-L. Durand: Il metodo e la norma nell'architettura* (Venice: Marsilio, 1986), 52–53.

133 Antoine Chrysostôme Quatremère de Quincy, *Dizionario storico di architettura:le voci teoriche*, ed. Valeria Farinati and Georges Teyssot (Venice: Polis / Marsilio editori, 1985), 106.

134 Trieste, SABAP FVG, Fondo Nobile, vol. 54.

135 The lack of any type of annotation, except on page 1, means that the subjects are not completely recognisable, but careful analysis allows us to identify familiar lines of thought.

136 *Alessandro Papafava*, 118.

137 The four books on architecture by Andrea Palladio were so widely read that we can assume that the young Nobile had read them even before he went to Rome: at the Accademia reale e di nautica in Trieste or maybe among the master builders, who certainly used Vignola as a construction manual at that time. Nobile certainly became familiar with them in Rome through his theoretical lessons in architecture at the Academy, which required knowledge of the treatise writers.

138 Emil Kaufmann, *Architecture in the age of reason: Barok and post-baroque in England, Italy and France* (Cambridge, Mass.: Harvard University Press, 1955), 117: "And it might be interesting to learn that Pietro Nobile, the author of the austere church of San Antonio at Trieste, who in his later years taught in Vienna, owned a copy of Ledoux's Architecture of 1804, which he donated to the library of the Vienna Academy of Fine Arts."

139 Rossella Fabiani, "Modelli nei disegni di Pietro Nobile," *Arte in Friuli, Arte a Trieste* 11 (1989): 104.

140 This theoretician and designer must have been important to Nobile, because in 1814 he proposed that a report on the *Lehrbuch* should be presented to the Società di Minerva in Trieste.

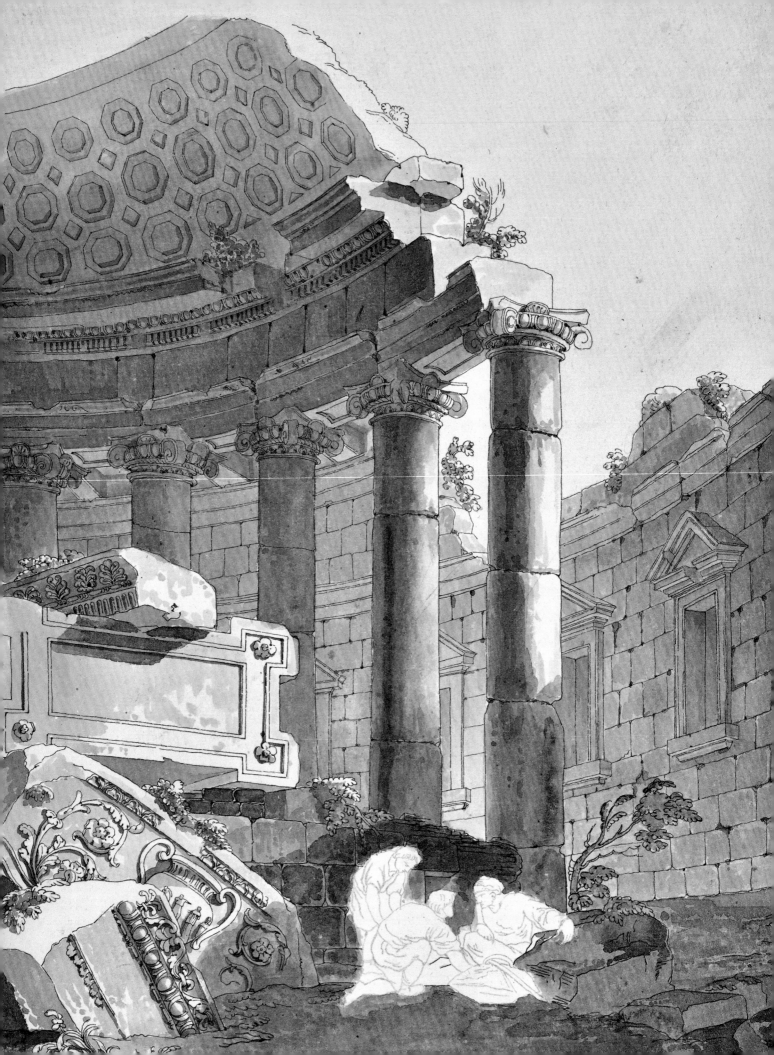

NOBILE'S DRAWINGS AND WAY OF THINKING

Rossella Fabiani

The Pietro Nobile Collection: Acquisition History

The Pietro Nobile Collection, which includes most of the visual art produced by the architect, is kept in the Friuli Venezia Giulia Soprintendenza Archeologia, belle arti e paesaggio (Heritage Office of Archaeology, Fine Art, and Landscape) housed in Palazzo Economo in Trieste.

In 1850, Pietro Nobile requested that his collected drawings be transferred to Trieste, the home of his younger brother Antonio (1793–1860). Upon Nobile's death on 7 November 1854, his grandson Carletto fulfilled his wishes by transporting the numerous crates containing the artworks from Vienna to Trieste. The documentation remained stored in the Borsa Vecchia in Trieste and was later moved to the home shared by Nobile's grandson Carletto and Carletto's son Rinaldo Nobile (1851–1931). At the end of the 1880s, Rinaldo moved to Lazzaretto (Bertocchi, now Bertoki), near Capodistria (now Koper in Slovenia), where his son Carlo (1880–1968) was born. The architect's impressive bequest remained here until the end of World War II. In July 1947, following the signing of the Paris Peace Treaties, the Nobile family had their home in Lazzaretto raided and were attacked by their fellow countrymen. The local Swiss consulate – represented by Consul Bonzanigo, who also mobilized the authorities of the government of Bern and the Belgrade legation to the Federal People's Republic of Yugoslavia – intervened to enable the Nobile family to transfer the movable items in their possession, including the drawing collection, to Trieste to prevent their possible seizure, as had happened with the goods of other Istrians.

The family, now exiled in Trieste, began negotiations with the Bellinzona State Archives over the transfer of the collection, and in February 1951 the Swiss consul Albertini approached the Trieste Soprintendenza to see if any difficulties might arise over obtaining an export permit. In his desire to keep this legacy of undoubted historical value in the city, the head of the Soprintendenza Fausto Franco replied that negotiations were already underway for the Italian state to acquire the drawings. Franco had been aware of the existence of the collection for some time: In the spring of 1950, Luigi Pavan, a Soprintendenza official and a close colleague of Franco's, wrote to Nobile asking if he could "consult the drawings again together with two architecture students" (18 May 1950). Later, he asked if about ten of the drawings could be photographed for a thesis (10 June 1950); that September, Franco asked for Irmgard Köchert, a student at the University of Vienna, to be granted permission to consult the drawings (19 September 1950). Having clarified his intentions with Nobile, who agreed to the proposal, Franco began to attempt to raise the purchase price of one million lire.

In 1951, a protection order was placed on the collection, under law no. 1089 of 1 June 1939 concerning "items of historical and artistic interest." Luigi Pavan formulated this on 15 May 1951 based on a previously drawn-up, detailed list of the contents of the collection. This established that, from then on, the collection could not be broken up or transferred to third parties without the consent of the Soprintendenza. The purchase proposal was submitted to the Ministry of Education (9 March 1951); to the education office of the Allied Military Government (hereafter GMA; 9 March 1951); to the mayor of Trieste Gianni Bartoli, looping in the director of the Civico Museo d'Antichità Silvio Rutteri (17 April 1951); and to the GMA finance department (20 April 1951).

Fausto Franco also turned to Luciano Sanzin, the head of the press and propaganda office of the insurance agency Riunione Adriatica di Sicurtà (hereafter RAS; 21 December 1951), who stated that he was unable to purchase the collection and that Franco would not be able to raise the sum from

one institution alone but should aim for "broad and piecemeal contributions from all the institutions and individuals who are interested in preserving an interesting collection of historical value." Franco insisted that the drawings, which had been executed at approximately the same time as the establishment of the RAS, could be a great attraction within an exhibition curated with "the incomparable taste" that he recognized in Sanzin. Franco believed that the collection could be used as a basis for an RAS promotional booklet to be circulated among engineers and architects, illustrating monuments (from Trieste to Vienna) designed by Nobile and insured by RAS – the latter's million lire soon to be recovered. Sanzin proposed to view the collection, but nothing came to fruition.

Franco, who had headed the Soprintendenza in Trieste since 1939, was also responsible for the provinces of Pola and Fiume (now Pula and Rijeka in Croatia). When war broke out, he was in charge of organizing the anti-aircraft protection of monuments and of consolidating works of art in locations considered less exposed to the perils of war. He was famed for personally manning his offices in the days of the Yugoslav occupation, between April and May 1945, and did not give up easily. He stubbornly continued to extol the importance of the collection to the education office of the GMA (16 February 1952). He emphasized that the city should be proud to have had an architect of Nobile's calibre as a past citizen and should boast a full collection of his works: It was only right and proper for the city of Trieste, which was "so poor in monuments but so tied to its history and its children".[1]

In June 1952, Franco was transferred to the Veneto's Soprintendenza, and Pavan followed him to Venice. On 11 July 1952, the sum of one million lire was allocated to buy the drawings under the new head of the Trieste Soprintendenza Benedetto Civiletti. On 20 December 1952, the Soprintendenza responsible for monuments, galleries, and antiquities bought the collection from Pietro's heir Carlo Nobile, a socialist agronomist from Koper.[2] The city and state thus secured a unique legacy, preventing it from being broken up and transferred abroad.

Trieste houses additional illustrations by the architect. These can be found in the Trieste State Archives, in the archives of the municipality technical office among documents relating to the office of public works of the Littoral, and in the Biblioteca Civica Attilio Hortis. The Fondazione Scaramangà, also in Trieste, houses some watercolours representing scenes from the siege of the city of Trieste by the French in 1797. The Fonda Savio collection holds some drawings that are collected into volumes and are similar in appearance to those in the Nobile Collection. These depict the "plan for the construction of the Church of Sant'Antonio Taumaturgo in Trieste" and sketches of foliage, trees, and landscapes."[3] Recently, coinciding with the publication of *Pietro Nobile. Viaggio artistico attraverso l'Istria*, this volume has been identified with drawings kept today in the archives in Rijeka, originating in the archives in Pula, and acquired by the historian Camillo De Franceschi in 1934.[4] In Vienna, some illustrations are kept in the Albertina, the Verwaltungsarchiv, and the Kriegsarchiv within the Austrian State Archive, the Fideikommissbibliotek of the Austrian National Library, the Haus-, Hof- und Staatsarchiv, and the University Archive of the Academy of Fine Arts. Some drawings and prints modelled on Nobile's drawing are in Czech and Polish archives.[5]

The Pietro Nobile Collection: First Exhibition in Trieste

The state's acquisition of the collection was announced to the public of Trieste on 3 August 1953 in an article in *Le Ultime Notizie* by Libero Mazzi, an official of the Soprintendenza. This was the first literary work to explain the contents of the collection and the importance of Nobile both to Trieste and to the history of architecture, comparing him to Palladio:

The acquisition includes the entire archive of drawings and letters by the architect Pietro Nobile. This consists of more than 7,000 illustrations (divided into 70 volumes), several files of observations and notes relating to the work carried out by Nobile, as well as more than 500 letters written by various luminaries of the time, which are very useful for drawing up a detailed outline of the biography of the distinguished builder, whose name was linked to some of the best-known and most interesting neoclassical buildings in

Fig. 32 Pietro Nobile, Sketch of building complex, pencil and sepia, ca. 1798–1800, Trieste, SABAP FVG, Fondo Nobile.

Trieste. […] The collection includes sketches, drawings, studies, plans, and elevations, anything that might interest an architect fascinated by the complex possibilities of his profession. It also includes plans for works in Trieste. Pen and pencil sketches of figures, ornate pottery, decorations for furniture, and views of places that Nobile had the opportunity to visit during the course of his duties are also executed with the same loving care. Everything in this admirable tide of art points to an active and sensitive individual who sprang up during an age buzzing with drive and artistic exploration.[6] (Fig. 32)

One year after the publication of the article, in the spring of 1954 (from 22 May to 5 June), Benedetto Civiletti and Libero Mazzi marked the centenary of Nobile's death and kept public interest alive by exhibiting some of his drawings at the town hall in Piazza dell'Unità d'Italia, Trieste. The event was considered to be of great cultural interest to the city, since it presented a huge and valuable resource of unpublished material that would otherwise have been lost. Among the goals of the exhibition was to focus public attention on the history of neoclassical art in Trieste. The works were intended to illustrate the movement's direct roots and to bring it to life with documents from the past, capturing its meticulous and indefatigable process of fervent exploration and its love for beautiful things.

The exhibition consisted of five vitrines with original drawings, which complemented thirty-eight photographic panels. These largely represented projects carried out for Trieste, along with views of some works in their urban set-

tings. Much space in the vitrines was reserved for the sketches, elevations, and notes that Nobile produced during his stay in Rome in the early nineteenth century. These depict many ancient monuments (baths, temples, and so on), sure signs of the strong influence of classic culture on the young Nobile. Accompanying these were drawings clearly revealing the fruits of his education. For instance, one elevation showed the Äußeres Burgtor in Vienna, i.e. the city gate and entrance to the imperial court and one of the best known and most accessible studies for the Hofburgtheater, also in Vienna.

Photographic documentation of Nobile's drawings of buildings in Trieste included an "effective internal review" of the dome of Sant'Antonio Nuovo, with comments on its design and two photographs of its spiral staircase. The authors also paid attention to the Costanzi and Fontana houses and the Biblioteca Civica building in Piazza Hortis, which was originally designed over two storeys as the main seat of the trade and nautical academy. The main intention of the exhibition was to inform the general public about the status of the collection within the city's artistic heritage and to inform academics about a wealth of completely new research material hitherto known only to a few.

The exhibition included a photographic enlargement showing a drawing of the Savudrija Lighthouse. This attracted the attention of the architect Ernesto Nathan Rogers, the author of the Torre Velasca in Milan (1958), who since 1954 had been editor of *Casabella*, an international architecture magazine based in Milan. He requested a copy to be published as a stand-alone illustration in the series

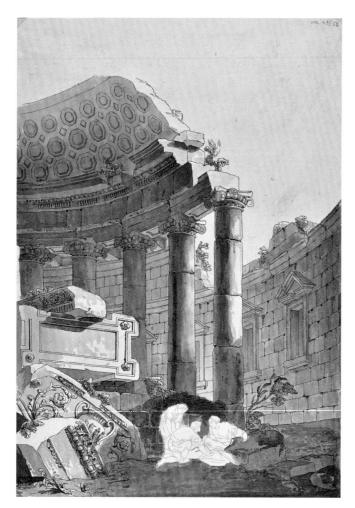

Fig. 33 Pietro Nobile (after C. J. Natoire and C. L. Clérisseau), View of ruins, pen and ink, ca. 1798–1800, Trieste, SABAP FVG, Fondo Nobile.

referred to the Nobile's arrangement of archeological findings in the bell tower of San Giusto (since 1808), with its characteristic arches; he made mention as well of various town-planning features of the city that are still recognizable even if they are no longer graced with buildings designed by Nobile. But Gioseffi dwelled mostly on the church of Sant'Antonio Nuovo, built between 1826 and 1849, which is perhaps Nobile's most significant work, although it is not without alterations and simplifications that had to be implemented in the course of construction for reasons of economy. In the original plans, the exterior was much more opulent and harmonious. It was therefore essential to obtain artwork documenting its construction history. Gioseffi believed that the interior fully revealed the designer's "class" – a Pietro Nobile who was "not just a cold plagiarist of the Greeks and Romans but capable of expressing the spatial scope of Bramante's architecture in severe neoclassical terms." His drawings revealed a "remarkable flair for building" and the "graphic qualities of an authentic designer, if not a painter."[7]

The Pietro Nobile Collection: Conservation and Development

After the 1954 exhibition, Nobile's drawings in the collection were rarely exhibited. It took thirty years for Luciano Semerani to take a selection of Nobile's drawings to Paris, from November 1985 to February 1986 as part of an event entitled "Trouver Trieste" (Fig. 33, Pl. XXVII). Few natives of Trieste had the privilege of admiring them at the Conciergerie, where they were on display alongside other works documenting the city. The exhibition *Portraits pour une ville, fortunes d'un port adriatique* was supposed to be transferred to Trieste, together with *Le bateau blanc*, another major exhibition staged at the same time at the Centre Pompidou, illustrating the fortunes of the Port of Trieste from the time of the Österreichischer Lloyd to that of Italia – Società di Navigazione.[8] Two drawings by Nobile examining the use of the Doric order were included in the exhibition *Le fortune di Paestum e la memoria moderna del dorico*, held in 1986 at the Certosa di San Lorenzo di Padula, in the province of Salerno (Fig. 34).[9] From 19 April to 19 May 2007, the Accademia di

"Disegno d'architetto" (10 May 1954). Decio Gioseffi – an assistant to Luigi Coletti and Roberto Salvini on the literature faculty at the Università di Trieste at that time, a militant critic in local newspapers since 1945, and a professor of medieval and modern art history from 1967 to 1989 – reviewed the exhibition on 3 June 1954, two days before its closure, in *Il giornale di Trieste*.

He described it as the first "presentation" of a truly immense body of visual artwork, specifying that "Pietro Nobile may not be a native of Trieste, but he is perhaps the only architect who has given his all to building in Trieste, and his name will remain indissolubly linked to the architectural face of the city." Among Nobile's works in the city, Gioseffi

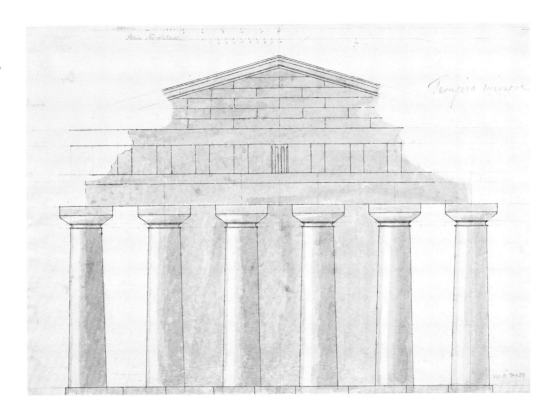

Fig. 34 Pietro Nobile, The façade of the temple in Paestum, ink with watercolour, ca. 1801–1805, Trieste, SABAP FVG, Fondo Nobile.

San Luca held the exhibition *Contro il barocco. Apprendistato a Roma e pratica dell'architettura civile in Italia 1780–1820.* Many of the drawings on display on this occasion highlighted Pietro Nobile's prominence among the generation of architects who trained in the Eternal City.[10] In 2019, the West Bohemia Gallery in Plzeň presented the exhibition *Architect Pietro Nobile (1776–1854): Neoclassicism between Technique and Beauty,*[11] featuring drawings relating to projects in Bohemia, mostly for the prince of Metternich.

At the time of its acquisition, the collection consisted of 7,106 architectural drawings, sketches, and elevations bound into 70 volumes, 11 project files, estimates, 11 scrolls containing plans and various drawings; Nobile's correspondence with Italian and foreign artists, including 544 letters; 5 publications on Nobile attached to the archive. After a major refiling operation, the numbers were revised to 8,236 documents containing drawings and prints. These relate to various aspects of the technical and artistic work that the architect Pietro Nobile carried out, firstly during his life as a civil servant and later as the head of the Trieste provincial office of public works, as a designer of monumental and residential buildings, as the head of the School of Architecture at the

Academy of Fine Arts Vienna, and finally as a Hofbaurat, state building counsellor at the Vienna (Fig. 35).

Only very few of the drawings are signed by Nobile. Many are the work of students of the academy, i.e. academic records collected to document their training, studies of classical and Renaissance models, vase shapes, pictorial, sculptural and architectural decorations, and furnishing elements (Pl. XXVIII). The collection includes architectural projects (rarely signed and dated) by other architects who submitted their work for Nobile's assessment due to his acknowledged expertise. There are also copies of projects for specific public tenders; residential projects for villas and palaces; ideas for monuments and technical engineering studies; studies showing operational proposals for ports and railway stations. There are entire monographic volumes on specific architectural subjects and autobiographical volumes with travel notes. The body of work is therefore a complete mixture, and this is also true of the supports, media, techniques, and styles.

The collection includes everything that was in the architect's possession at the time of his death. For an artist in those days, possessing a collection of artworks was a valua-

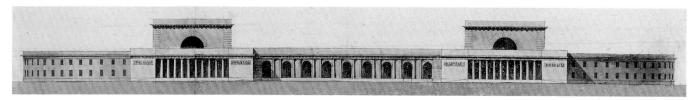

Fig. 35 Pietro Nobile, Complex of buildings, ink with watercolour, ca. 1801–1805, Trieste, SABAP FVG, Fondo Nobile.

ble professional asset. Knowledge of historical or even contemporary monuments had to be captured from real life in the form of printed texts, etchings, or oil paintings. The division of this significant legacy, so varied in nature, into volumes further complicated studies. This division was carried out by the architect's descendants after his death, as evidenced by the dating of the bindings. There are many inconsistencies in the organization of the material, which was done by subject and not always coherently, making it difficult to establish a timeline for the period of production. The person responsible for the reorganization presumably concentrated on the five volumes relating to the treatise on architecture that Nobile wished to publish and on which he worked for many years (Fig. 36, Pl. XXIX). These initial sorting efforts on the part of the heirs are reflected in the numerical indications pencilled and circled in the top-right corner of the title page of each volume. The tables of contents, pencilled on the title pages, as well as the progressive numbering of the individual pages, can be attributed to the same period. A second sorting of the volumes is evident in the pen-marked paper labels applied to the backs of the bindings, corresponding to the sequencing system used at the time of the state's acquisition of the collection in 1952.

To facilitate the study of this crucially important collection and a review of the architect as an individual, the Soprintendenza arranged a necessary reorganization, filing, and restoration of the collection with the aid of funds from the Ministry of Cultural and Environmental Heritage. These grants were allocated for the financial years 1989–1994, dedicated to the maintenance of state property. The individual volumes containing drawings or prints were all catalogued as part of this.[12] Those involved arrived at the number 8,236 by counting the obverse and reverse of every drawing and print. This number also includes drawings that appear on the

reverse of other works. Nobile clearly recycled these, and they relate closely to works stored in the same or in other volumes. In sum, the media include pencil, pen, watercolour, pen washed with watercolour, pencil washed with watercolour, various aquarelle shades, and India ink with watercolour. The supports include cardboard, paper, ivory cardboard, sepia or grey paper, light and dark tissue paper, and squared paper.

Nobile's intention was to systematically store all the material from his career. He often mentioned preserving and ordering the drawings in his possession in his correspondence with family and friends. Archival documentation also indicates that Nobile wished to publish an architectural treatise on his building method, accompanied by an extensive anthology of artwork based on well-known previous models. In addition, he wanted it to contain some technical and practical guidelines and teachings on traditional as well as new architectural trends. Most of the drawings in the collection are therefore part of this unfulfilled project (Fig. 37).

The Pietro Nobile Collection: Its Reasoning

The illustrations in the state collection, though not all executed by Nobile's hand, were all in the architect's possession at the time of his death. Some are simple sketches, almost like visual notes; others are more detailed works, such as elevations. Not all the pages share the same characteristics, penmanship, or overall approach. The drawings are on thick sheets, on light and dark tissue paper, or on squared paper. The varying formats and techniques of execution, as well as the varying stylistic features, suggest that some of the illustrations included in the collection were acquired by Nobile or given to him by colleagues and students.

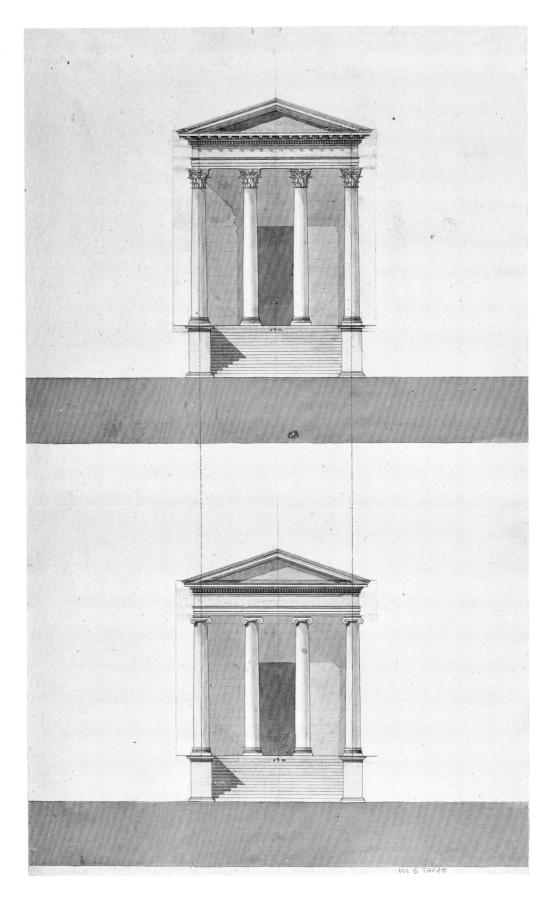

Fig. 36 Pietro Nobile, Scheme of Ionic and Corinthian temples, ink with watercolour, ca. 1801–1805, Trieste, SABAP FVG, Fondo Nobile.

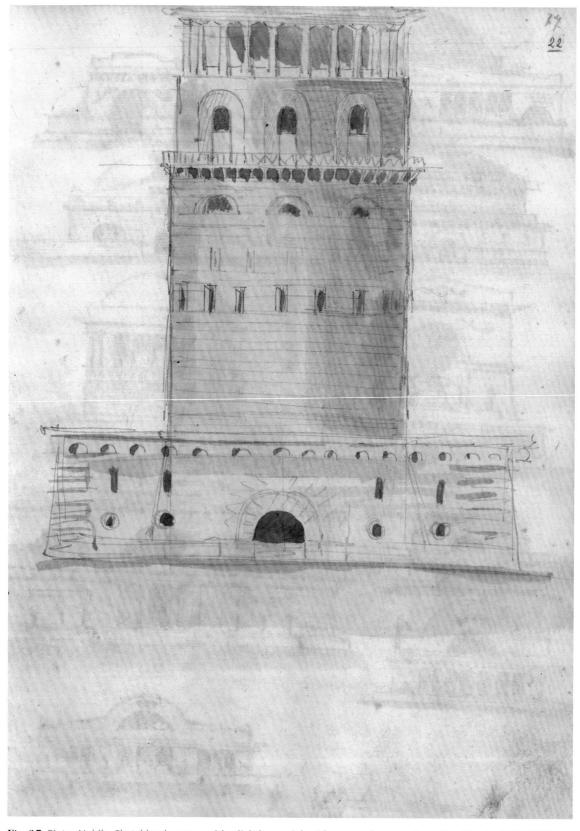

Fig. 37 Pietro Nobile, Sketchbook, a page with a lighthouse, ink with watercolour, ca. 1801–1805, Trieste, SABAP FVG, Fondo Nobile.

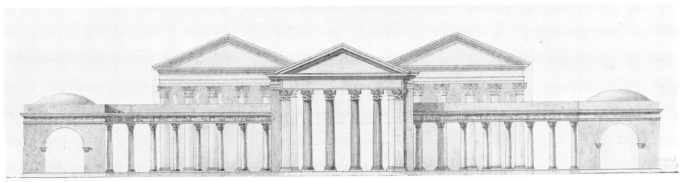

Fig. 38 Pietro Nobile, Reconstruction of Octavian Portico in Rome, pencil, ink with watercolour, 1798–1805, Trieste, SABAP FVG, Fondo Nobile.

Nobile's extensive output of artwork is not the result of any ordinary passion for drawing or any simple manual exercise. It should be seen partly as a collection of architectural reflections and partly as a series of useful teaching notes. Nobile presumably used these in the School of Architecture at the Academy of Fine Arts Vienna. During his first year, he held classes on the building elements used by the ancients, focussing on the parallels between orders used in various historical periods, including the Hellenistic, Roman, and Renaissance. It is also likely that Nobile intended to publish an architectural treatise on building method, based on famous examples that were well known to him (Pl. XXX).

In Nobile's time, "it was quite common for people to collect reflections in the form of drawings [...]. The end of the eighteenth century was a time when people liked to express their ideas by drawing, and there was a taste for reflections that were perceived as well as conceived."[13] The archive of Luigi Canonica is similar to that of Nobile in terms of its size and the types of documents it contained, reflecting a heterogenous array of compositional traits and design reflections.[14] The Alessandro Papafava collection is also relevant in that it came about in a unique way and portrays a moment in time: the artist's stay in Rome between 1803 and 1806, which coincided with Nobile's sojourn; the collection features works by some of Nobile's own Roman friends.[15] The drawings by Ottone Calderari, for example, resemble the contents of the Trieste collection in documenting the architect's intellectual journey, dwelling particularly on theories inspired by the output of Andrea Palladio.[16]

Among the many German artists represented in the collection, the work of Heinrich Christoph Jussow is particularly reflective of Nobile's own trajectory in that Jussow too explored and expounded on architecture through the medium of his studies on paper.[17] Like many of the architects who were contemporary to Nobile or active during the previous century, Jussow was a "theoretical architect who worked more on paper than on site."[18] This was typical of the spirit of the age and also consistent with the activities of the French, German, and Italian neoclassical artists, especially in terms of their operational and stylistic affinities. After his stay in Rome, Nobile – whose training had thus far been purely practical rather than academic – turned his attention to the study of architecture, partly setting aside his building activities to devote himself to the essential art of design and teaching in Vienna.

A deeper analysis teases out some of the main themes of the Trieste collection. Firstly, the contents reveal a great interest in studying the classics through a meticulous, almost pedantic observation of every constructive and decorative detail. These studies amount to a disquisition on Roman art, which Nobile considered a necessary precursor to learning, teaching, and making good architecture (Fig. 38). A second significant group of drawings including buildings of simple composition is useful for understanding Nobile's design process, as it includes all the individual areas he mapped out and studied. Converse to his analytic studies, these place great emphasis on purely constructive building factors, stripping away any ornamentation or embellishment to accentuate the importance of the wall structure and the compactness of volumes, which are always clearly defined. Here Nobile focused his interest on the essential parts of the building, not masking them with non-functional and superfluous decoration.

Nobile probably executed the illustrations over a long period of time, between his Roman and Viennese years and perhaps continuing until his death in 1854. Some are not his own work but rather that of his numerous students at the academy, showing buildings that were contemporary to him or designs and elevations submitted to him for approval. Nobile's stylistic approach to drawing bespeaks the confident hand of a draughtsman or copyist, in the Winckelmannian sense of the word. Sometimes he drew simply as an *aide mémoire* for study and reflection. Nobile treated drawings as simple tools that had to be accurate in order to provide details of architectural decoration, structural support, or whatever his mind was on at the time. Drawings were a working tool for Nobile the academic but also for Nobile the builder, and he observed the specific features of monuments very carefully. He worked toward a precise architectural framework, finding a perfect balance between his research on the ancient world and his explorations of design. Once the analysis was complete, the second step was interpretation, i.e. developing and processing the classical monuments and buildings he observed in order to transpose them to paper. All his actions were strictly aimed at establishing a close relationship between the object studied and the practical, everyday world around him. Even though the works in the collection are ordered by subject and follow no precise timeline, they nevertheless stress the importance and value that Nobile attached to a specific, unitary stylistic path.

The Pietro Nobile Collection: Drawings for the Architect

A letter written by Nobile to his grandson Carletto shows that the preservation and reorganization of his drawings was a recurring theme in his working life: "I've been very busy lately [...] sorting my drawings and studies into 60 volumes, most of them large, in folio format, there are more than 8,000 illustrations."[19] These words suggest that the author arranged his own artworks. But the binding of the volumes is not uniform in appearance, and the inconsistent division of the material indicates that Nobile was only able to partially complete his work and that it was finished, sometimes not to the best standard, by his descendants.

For an artist in those days, possessing a collection of such artworks was a valuable working asset. Knowledge of historical or even contemporary monuments had to be gathered from real life and set down in the form of texts, etchings, or oil paintings. It was not easy to get ahold of such material. The academies believed that having one's own architectural drawings was essential for training students. In this, Nobile probably met Doblhoff-Dier's requirements.[20] The former's correspondence with Roman friends is enlightening in this regard. For example, Angelo Uggeri wrote to Nobile about Basilio Mazzoli's drawings "concerning the ancient buildings of the age of decadence, i.e. the basilicas of Constantine. I cannot begin to describe the accuracy and grace with which he arranged the interiors of Santa Maria in Cosmedin, Santa Sabina, San Paolo, and Santa Maria Maggiore. One day you'll see them, and you'll be astounded [...]. I took the opportunity to buy you some drawings of the Foro Buonaparte and Teatro alla Scala."[21] Drawings of Roman sites, such as those described by Uggeri, can be found in volume 49 of the Nobile Collection.[22]

It was common to swap illustrations, as reported by Ignaz Chambrez, a professor of civil architecture in Lviv, who thanked Nobile for sending his drawings, namely of "your beautiful church in Trieste and the Porta di Vienna. The purity of the gate's architecture and the nobility of the church's are evidence of your talent and your mastery of your chosen art."[23] Such exchanges of illustrations were often opportunities for swapping ideas, as was the case with Girolamo Scaccia, who commented on one of Nobile's drawings that the "court door is simple and will create a good impression on those who enter."[24] He also said of the church of Sant'Antonio: "Everything is done with pure style and in beautiful proportion. It all seems to stem spontaneously from the main lines of the internal and external decoration."[25] Scaccia wrote from Rome in 1821 to let Nobile know that Basilio Mazzoli's widow was planning to sell off Mazzoli's designs and sketches. Three watercolours in the collection depicting an "elevation plan and cross-section of a monument to be erected on Monte Pincio in Rome" were in fact executed by Mazzoli.[26] Girolamo Scaccia's words further suggest that Nobile's resources were impressive: "Have you sent a drawing of yours to the Accademia di San Luca? Just shut your eyes, pick any one from your folder, and send it in."[27]

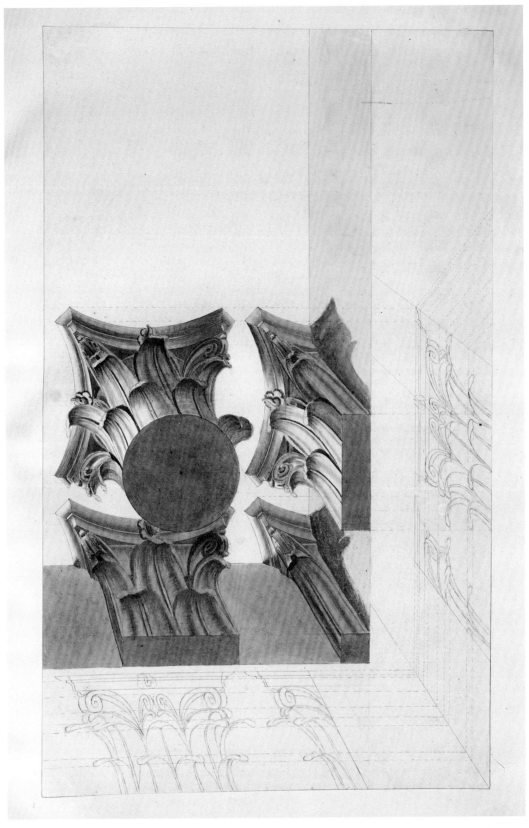

Fig. 39 Pietro Nobile (after Andrea Pozzo), Ideal plan of the composite capital of square or circular column from below, pencil and ink, 1820s, Trieste, SABAP FVG, Fondo Nobile.

The collection reflects Nobile's background and personality. It is a collection of architectural musings, an entirely visual manifesto of architecture by a man who fully believed that design and teaching should be based on lessons learned from Greek and Roman classics and from Renaissance culture. Volume 7, entitled "Perspective Studies," is particularly interesting because it includes drawings from Andrea Pozzo's first book on perspective (Fig. 39). Nobile did not simply copy the drawings but re-drew them with different measurements, sometimes changing the orientations of the subjects from Pozzo treatise, though copying faithfully Pozzo's comments on individual figures.[28] Nobile probably developed an interest in the Trentino artists during his training in Trieste, perhaps via his master Ulderico Moro.[29]

The Pietro Nobile Collection: The Unfinished Treatise

Nobile intended to systematically preserve all the material he collected, processed, and prepared during his career in order to write a treatise or another work of some sort containing his theory of architecture. Domenico Rossetti wrote to him on this subject in 1825:

> In answer to your question about the inscriptions to be put on your architectural illustrations. If these are intended to accompany a dissertation or some other text, you must use the same language for the inscriptions. But if this is not the case, I believe you must make use of both languages, German and Italian: the former in the interests of the academy and German scholars and the latter to make yourself understood by all amateurs [...] thank the Lord, I feel as though you are at last doing something to let others see something from your immense body of studies and show them all that architecture is not merely about throwing up four walls and a roof. So please could you give me an idea of how you plan to publish the work, i.e. if you will let people see only the engravings or if you will add any text.[30]

Nobile pursued the idea of producing a treatise throughout his life. He did not give up the idea until death intervened.

His collection of drawings is a visual diary of architectural forms. He set everything to paper. It is difficult to work out Nobile's theoretical thrust from his artwork. There were no notes or text, but many of his contemporaries were aware of his intentions. As his friend Parravicini said in 1841: "I think his book is a novel and comprehensive work due to his description of all the architectural figures. Every intelligent person [...] agrees with my opinion that he should publish the work soon for the benefit of scholars."[31] Pietro Paleocapa from Venice was aware of the problem, when he wrote: "I would love to know how he is getting on with his great architectural work. I hope that all his many activities do not distract him from completing his long-awaited work."[32] Sanfermo also wrote from Padua in 1837: "I also add my very genuine longing to that of his many admirers, in the hope that his work – conceived and developed on the basis of his refined criteria and deep knowledge – is at a very advanced stage and will soon be made public, since it will be of great benefit to young scholars and others."[33]

Volume 70 of the collection appears to be the target of these comments from colleagues and friends, given its comprehensive contents and the fact that its illustrations and concepts are arranged like a prototype for a treatise.[34] It could also be considered a proposed manual for students. In this case, Nobile would have devised the layout mainly for teaching purposes at the academy.[35] In his "initial ideas for reforming the School of Architecture" Nobile professed that

> architectural drawing exercises will make use of a series of sample drawings to be coordinated using a system that is effectively applied in sciences and arts but has not yet been practiced in the study of architecture, i.e. grouping things of the same kind in order to be able to recognize the variety of forms and proportions at a glance.[36]

This volume is preceded in the collection by five volumes (numbered 65 to 69) containing illustrations of building components of the key Roman monuments. Nobile considered these to be research paradigms; the illustrations show comparisons between the Tuscan, Doric, Ionic, Corinthian, and Roman orders and details of frames and capitals (Fig. 40, 41). Nobile advised the academy as follows: "The various exercises will include drawing all figures useful for teaching

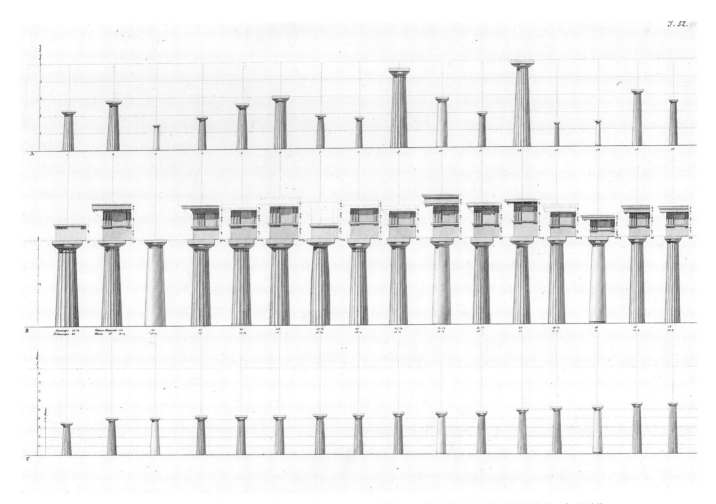

Fig. 40 Pietro Nobile, Three proportional patterns of Doric column, pen and ink, ca. 1808, Trieste, SABAP FVG, Fondo Nobile.

the rules of perspective and shading, architectural ornamentation [...] the various decorative systems and characteristics applied by modern architects to the various building parts, outside, and inside."[37] Volume 70 is subdivided into six parts that contain etchings on descriptive and perspective geometry, followed by various subjects, such as the circle; many spiral and volute forms; the components of capitals, frames, and edges; and etchings showing the ornamentation of capitals, coffering, leaf corbels, festoons of fruit, and flowers, together allowing students to practice "the design of ornamentation, figures, landscapes, perspectives, interior decoration, and furniture design and the application of ornamentation to architecture, the combination of various architectural parts in the facades of all kinds of buildings, in courtyard vestibules, and in halls."[38] It is laid out like a manual for exploring figures – all the individual orders, the spaces be-

tween columns, the compositions of windows and doors, and the proportions of arches and porticos – in accordance with the comparison method used in Vignola's treatises. His models were Renaissance theoreticians and, before them, Vitruvius. Parallels between "plain architectural members, ornate members, column bases, capital profiles [...]" replace Vignola's system of orders, forming the core of a new collection of samples for the academy to provide its students.[39]

The opening to volume 70 fully reflects Nobile's advice to take "the canons of architectural beauty from the renowned books of Cavalier Milizia, Vitruvius, and Palladio and other Italian, French, German, and English masters." The fourth section echoes what Nobile had to say about the importance of identifying the value of architecture in ancient culture. The "parallel" rule, which Nobile adopted in accordance with Durand's teaching, inspired many etchings that

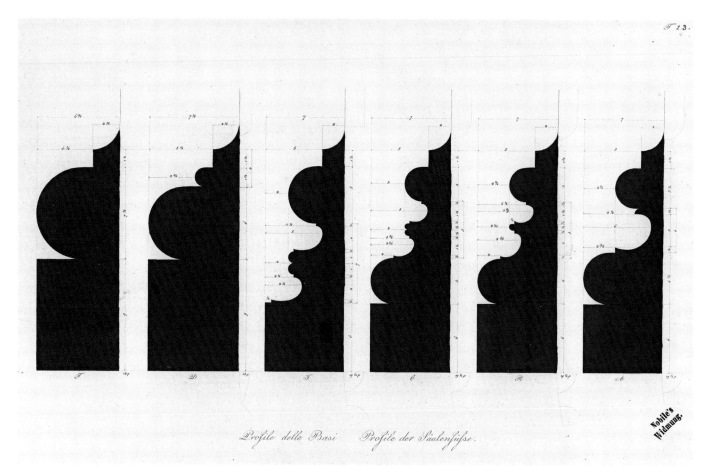

Fig. 41 Pietro Nobile, Profiles of the column bases, pen and ink, 1820s, Trieste, SABAP FVG, Fondo Nobile.

reflect his method in ancient and modern buildings. Nobile's most telling discussion of the proportions of building elements comes in the fifth section of volume 70 on the "construction of component parts of architectural buildings [...] following Rondelette's *art de batir* system, regarding the nature of materials.⁴⁰ Nobile emphasized that "the two methods can be used to show various architectural parts in parallel. In one you can show a series of objects to be compared using the same scale, and this allows you to assess the different sizes of parts of the various monuments by eye: this how the renowned French architect Durand examined ancient and modern buildings in parallel."⁴¹ The 1833 edition of Durand's volume can be found in Nobile's library, showing that he was directly aware of the work.

The catalogue of the library that Nobile left in Vienna makes clear his theoretical leanings, which are evident also from the draft treatise, as well as his cultural and stylistic

leanings, which are also identifiable in the contents of his drawing collection. The *Architektur* section contains the pillars of his theory of building: they can be divided up into the old school of architecture including Leon Battista Alberti (architecture, painting), Vignola (the rules of practical perspective), and various editions of Vitruvius; modern authors include those representing for Nobile a bridge between old and new. He owned a course on architecture and building construction by Blondel (1777). This treatise is part of a tradition in which academic training was seen as an opportunity to convey a system of absolute rules based on rational principles. He owned a German version of Marc-Antoine Laugier's *Essai sur l'architecture* (1768). Laugier's provocative views had great resonance and opened a path towards Blondel's new classical theory, despite Goethe's fierce criticism in Germany. Nobile was very aware of contemporary trends, as is clear from many illustrations in the collection. He

ROSSELLA FABIANI

owned a copy of Ledoux's *Architecture*, from which he borrowed models that were monumental but also extremely clear and sharp.

Indeed, the French were a constant source of inspiration for Nobile: We need only think of the stability, vigour, and monumentality of spaces he learned about from the etchings in Marie-Joseph Peyre's 1765 *Oeuvres d'architecture*. Among manuals and treatises by German cultural exponents, Nobile unsurprisingly looked to the person who most closely followed the works of Durand, namely Friedrich Weinbrenner, who drew up a teaching manual that was "systematic yet rational, in full adherence to Durand's principles."[42]

The Pietro Nobile Collection: More than just Architecture

When Nobile attended the Accademia di San Luca, it was going through a particularly lively and creative period under the influence of Antonio Canova, who left his indelible stamp on Roman culture of the day.[43] Nobile's collection bears witness to the flourishing activity at the school. Because it was packed with aspiring painters, sculptors, and architects, it offered pupils the opportunity to draw on a wide spectrum of teaching resources, reflecting a range of artistic procedures and practices.[44] The curriculum gave plenty of space to these interdisciplinary methods, which were shared by the École des élèves protégés in Paris and then adopted by the French Academy in Rome. In Nobile's collection, the large number of illustrations of mythological figures, on tissue papers of varying weight, were created in the course on myth and history that was part of the curriculum for all students at the Accademia di San Luca. Giuseppe Antonio Guattani introduced this course to the school.[45] Life studies on excavations or prints in the classroom allowed students to practice their observation of detail. The level of study was adjusted according to the drawing abilities of the student architects, painters, and sculptors.[46] Prints were mainly used within the faculty of elementary and ornate architecture.[47]

Nobile's illustrations reflect the Roman method of teaching designed to give artists an all-round education. The collection therefore contains many drawings showing details from the Sistine Chapel – prophets, sibyls, and the Last Judgement – but also studies of ancient and contemporary sculpture, including Canova's groups Theseus defeating the Centaur, Hercules and Lichas, and the Creugas and Damoxenos (Fig. 42, Pl. XXXI). Johann Georg Sulzer stated in *Allgemeine Theorie der bildenden Künste* (1792) that, "The academy must be well equipped with the tools it needs to teach the art of drawing," such as parts of the human body but also copies from famous works of painting and sculpture, great masters serving students of all artistic disciplines" and thus also aspiring architects.[48]

Fig. 42 Pietro Nobile, Study of the group of Theseus and the centaur by Antonio Canova, pen and ink with watercolour, around 1800, Trieste, SABAP FVG, Fondo Nobile.

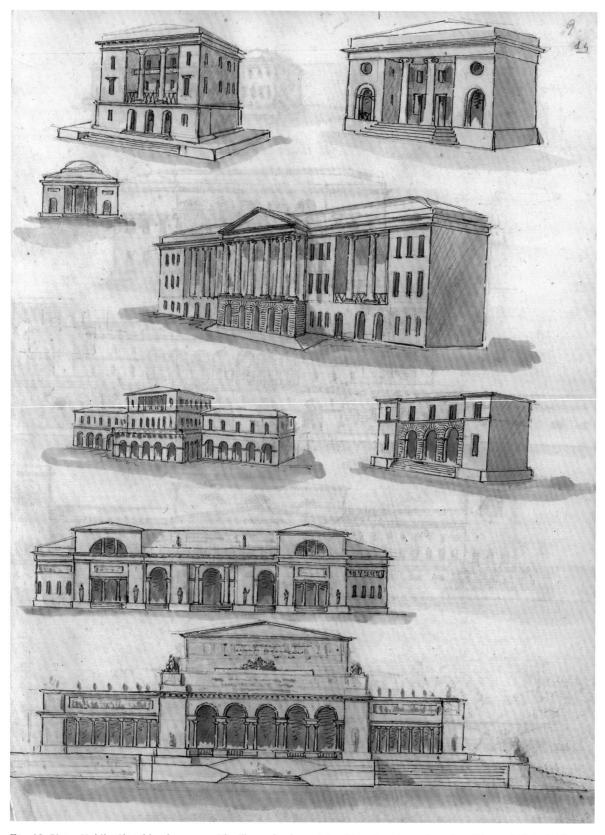

Fig. 43 Pietro Nobile, Sketchbook, a page with villas and palaces, ink with watercolour, 1801–1805, Trieste, SABAP FVG, Fondo Nobile.

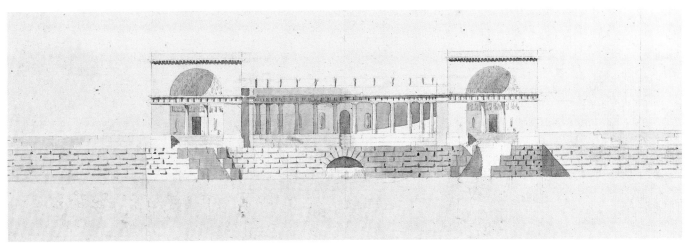

Fig. 44 Pietro Nobile, Design for a monumental building with one fountain, ink with watercolour, ca. 1801–1805, Trieste, SABAP FVG, Fondo Nobile.

Studies of Rome in its various guises make up a large part of the Nobile Collection. Nobile was clearly interested in depicting nature, but he also executed many watercolours and drawings while walking around the city.[49] Almost instantaneous views of the Fontana dell'Acqua Paola on the Janiculum Hill, of the entrance to the Villa Borghese gardens, or of the San Michele building complex on the Tiber illustrate the sensitive approach to landscape that the academy instilled in all its students (Pl. XXXII).[50]

The Pietro Nobile Collection: Five Orders

"Architecture students [...] begin [...] by drawing the five orders."[51] Nobile never deviated from this dictum, which was probably taught to him at the Accademia di San Luca in the early 1800s, judging by the many drawings confirming the young student's fierce devotion to the subject. This principle was at that time of particular importance in the debate over the use of orders and their sizes, with comparisons drawing upon Vitruvius, Serlio, Vignola, Palladio, and Scamozzi (Pl. XXXIII). These names crop up again and again in the collected illustrations: Nobile conformed to new teaching methods at the academies, meticulously embracing the study of orders, starting with ancient Greece.[52] In one comparative illustration showing temples with Doric columns, Nobile looked at the famous monuments of antiquity side by side in order to note differences in column dis-

tribution, column spacing, and building proportions.[53] Twenty-six cross-sections and facades of temples are depicted, with capitals barely discernible and with a dashed semi-circular line on the building facade to indicate the proportions.[54]

Nobile was also interested in the topic of orders more generally. He compared the Tuscan columns of Vitruvius, Palladio, Scamozzi, and Vignola to establish their respective proportions and construction differences. Elevations of buildings with several columns, trabeated columns, pillar bases, and details of capitals – taken from the main monuments of antiquity – appear in a progression that reflects Nobile's accuracy of analysis and exploration in the academic field.[55]

The Pietro Nobile Collection: Designs

The illustrations in the collection reveal the paradigms that Nobile observed on his architectural trajectory. He first drew these in a notebook, then magnified them to a greater size. The Palladian formal model emerges triumphant in Nobile's approach to composition, concatenation, and mechanisms of blending individual building parts borrowed from sixteenth-century Italian tradition and from Neoclassicism (Fig. 43).

Closer to Nobile's own time, Giuseppe Valadier played an important role in training with a view to protection, res-

toration, and design. Valadier's work demonstrates great openness to a compact and rational language in its simplified lines and volumes. Nobile's work is closely interwoven with his knowledge of the French revolutionary architects Boullée and Ledoux, whom Valadier encouraged him to read (Fig. 44). Nobile was interested in the transforming properties of geometry and the effects achieved by combining solids in space in strict compliance with Vitruvian theories of symmetry, proportion, and utility, which Enlightenment architects expanded to include unity, method, and reason. This architectural approach to building stripped-down, bare forms was a new way of thinking that Nobile studied and seemed to agree with.

This simplification of form inevitably led to the serial compositions subsequently developed by Durand. Nobile was interested in Durand's experiments with composition and new academic approach to architectural studies. Durand's standardization of processes for arranging elements was one aspect that attracted Nobile, and particularly the former's use of squared paper to combine and join parts on a grid imposing a strict distribution of forms. This graphic learning technique is linked to Gaspard Monge's descriptive geometry, revealing a propensity for abstract concepts and synthesis. Nobile added to this grid all the decorative motifs that were destined to become the trappings of Neoclassical Revival architecture. His illustrations reveal his focus on the interplay of combinations, the mechanisms of distributing spaces and volumes. Forms and wholes come together with a view to economy of design and execution.

German culture in Rome seems to have also been important to Nobile. After initially flirting with the ancients, Friedrich Weinbrenner, for example, established new construction models for civil residential buildings with essential lines and well-defined volumes.[56] Weinbrenner's designs reveal a blend of Greek and Roman elements and the influence of the French revolutionary architects, despite his severe stereometric blocks and lack of decorations.

In strictly educational terms, Nobile transitioned from the academic-theoretical tradition, initially studying the French revolutionary architects before going on to embrace Durand's most extreme theories in the course of his Italian and German encounters (Pl. XXXIV). He ended up adopting a Neoclassical Revival style of architecture: All this is contained in Nobile's artistic legacy.

NOTES

1 Fabiana Salvador, "Storia della collezione," in Rossella Fabiani, Fabiana Salvador, and Giorgio Nicotera, *Gli svizzeri a Trieste e dintorni: Pietro Nobile* (Trieste: Circolo svizzero di Trieste, 2018), 19.

2 Carlo Nobile, *L'ultima bugia. Autobiografia di un socialista istriano* (Trieste: ExtraMinerva, 2012).

3 Laura Paris, *Guida al lascito Antonio Fonda Savio,* introd. Nicoletta Zanni (Trieste: Edizioni Università di Trieste, 2015).

4 *Pietro Nobile. Viaggio artistico attraverso l'Istria: motivi istriani di inizio Ottocento,* ed. Dean Krmac (Koper: Historia Editiones, 2016).

5 Prague NA, Collection of maps and plans; NA, Metternich family archive (RAM); Prague, National Heritage Institute, State château Kynžvart; Kraków, Archiwum Narodowe w Krakowie, AKPot.

6 Libero Mazzi, "Acquistate due preziose collezioni," *Le ultime notizie*, 3 August, 1953.

7 Decio Gioseffi, "I disegni dell'architetto Nobile," *Il giornale di Trieste*, 3 June, 1954.

8 Gino Pavan, "Les dessins et la correspondance de Pietro Nobile à Trieste," in *Trouver Trieste. Portraits pour une ville. Fortunes d'un port adriatique* (exh. catalogue Paris, Conciergerie), ed. Luciano Semerani (Milan: Electa, 1985), 68–121.

9 Joselita Raspi Serra, "Il neo-dorico in Italia," in *La fortuna di Paestum e la memoria del dorico: 1750–1830*, ed. eadem (Firenze: Centro Di, 1986), 181–183.

10 Rossella Fabiani, "Pietro Nobile (1776–1854)," in *Contro il barocco. Apprendistato a Roma e pratica dell'architettura civile in Italia 1780–1820*, ed. Angela Cipriani, Gian Paolo Consoli and Susanna Pasquali (Rome: Campisano Editore, 2007), 447–452.

11 Taťána Petrasová, *Neoklasicismus mezi technikou a krásou: Pietro Nobile v Čechách* (exh. catalogue West Bohemian Gallery, Plzeň) (Plzeň and Praha: Západočeská galerie v Plzni and Artefactum, 2019).

12 The volumes are currently inventoried using a numbering system based on the order in which they were received, from 1 to 70. Volumes 11 and 14 are missing, as is mentioned in the inventory published in 1989 by Pavan; volume 46 in the inventory is also missing. This is described as "Sketches of figures, Roman and mythological characters and illustrious ancients" and contained 227 sketches. The collection includes volume 61bis, which was also present in the 1950s, while volume 58bis came to light during the inventory process. This contains "Pen drawings with views of ancient ruins,"

which the inventory shows must originally have been part of volume 58. Pavan, again in 1989, mistakenly reported that volume 62 was missing. During restoration, 2651 illustrations were detached from the volumes containing them and placed in individual folders to ensure better conservation and allow easier consultation see Rossella Fabiani, ed., *Pagine architettoniche. I disegni di Pietro Nobile dopo il restauro* (Pasian di Prato: Campanotto, 1997).

13 Elisa Debenedetti, *Valadier diario architettonico* (Rome: Bulzoni, 1979), 5.

14 *Luigi Canonica. Architetto di utilità pubblica e privata*, ed. Letizia Tedeschi and Francesco Repishti (Mendrisio: Silvana Editoriale, 2011).

15 *Alessandro Papafava e la sua raccolta: Un architetto al tempo di Canova*, ed. Susanna Pasquali and Alistair Rowan (exh. catalogue Vicenza, Palladio Museum). (Milan: Officina Libraria, 2019).

16 *I disegni di Ottone Calderari al Museo di Civico di Vicenza*, ed. Guido Beltramini (Venice: Marsilio, 1999).

17 *Heinrich Christoph Jussow 1754–1825. Ein hessischer Architekt des Klassizismus*, ed. Wanda Löwe (exh. catalogue Kassel, Museum Fridericianum), (Kassel: Wernersche Verlagsgesellschaft Worms, 1999).

18 Debenedetti, *Valadier*, 5

19 Fraschina, "Pietro Nobile," 50: Nobile to his nephew on 2 November, 1845.

20 Trieste, SABAP FVG, Fondo Nobile, letter 80 A-D.

21 *Milano nei disegni di architettura. Catalogo dei disegni conservati in archivi non milanesi*, ed. Luciano Patetta (Milan: Guerini e Associati, 1995), 18.

22 Trieste, SABAP FVG, Fondo Nobile, letter 64 R-Z: letter dated 10 May 1811.

23 Trieste, SABAP FVG, Fondo Nobile, letter 7 A-D.

24 Trieste, SABAP FVG, Fondo Nobile, letter 42 R-Z.

25 Trieste, SABAP FVG, Fondo Nobile, letter 47 R-Z.

26 Trieste, SABAP FVG, Fondo Nobile, letter 41 R-Z.

27 Trieste, SABAP FVG, Fondo Nobile, letter 34 R-Z.

28 Maria Walcher-Casotti, "Andrea Pozzo e le ripercussioni del suo trattato nel Friuli e nella Venezia Giulia," *Arte in Friuli, Arte a Trieste* 15 (1995): 103–131.

29 Pavan, "Les dessins et la correspondance," 68–77.

30 Alberto Tanzi, *Alcune lettere del dottor Domenico de Rossetti* (Milan: Tipografia Fratelli Rechiedei, 1879), 67.

31 Trieste, SABAP FVG, Fondo Nobile, letter 113 L–P.

32 Trieste, SABAP FVG, Fondo Nobile, letter 136 L–P.

33 Trieste, SABAP FVG, Fondo Nobile, letter 32 R–Z.

34 The volume measures 327 × 475 × 63 mm. It contains 259 copper engravings. No. 207 represents the part used for building, No. 24 shows the main works by Nobile. There are other copies of this volume. One is kept in the Fondazione Scaramangà in Trieste, proving that Nobile was willing to go ahead and print several copies.

35 Rossella Fabiani, "Pietro Nobile fra manuale e trattato di architettura," *Arte in Friuli, Arte a Trieste* 34 (2015): 139–144.

36 Gino Pavan, "Pietro Nobile e l'insegnamento dell'architettura nella Accademia di Vienna (1818–1849)," *Archeografo triestino* 52 (1992): 146.

37 Pavan, "Pietro Nobile e l'insegnamento," 160.

38 Ibidem, 158.

39 Ibidem, 150.

40 Jean-Baptist Rondelet, *Theoretisch-praktische Anleitung zur Kunst zu bauen*, vol. 1–5, trans. J. Hess (Leipzig and Darmstadt: Verlag von Karl Wilhelm Leske, 1833–1836).

41 Pavan, "Pietro Nobile e l'insegnamento," 146.

42 Fabiani, "Pietro Nobile fra manuale e trattato di architettura," 142; Eadem, "Pietro Nobile e l'architettura tedesca," *Arte in Friuli, Arte a Trieste* 15 (1995): 307–317.

43 *Canova: Eterna bellezza*, ed. Giuseppe Pavanello (exh. catalogue Roma, Palazzo Brasci), (Milan: Silvana Editoriale, 2019).

44 *Le scuole mute e le scuole parlanti: Studi e documenti sull'Accademia di San Luca nell'Ottocento*, ed. Paola Picardi and Pier Paolo Raciotti (Rome: De Luca Editori d'Arte, 2002).

45 Pier Paolo Raciotti, "'Per bene inventare e schermirsi dalle altrui censure:' Giuseppe Antonio Guattani," in ibidem, 88; Letizia Tedeschi, "Le séjour romain," in *Charles Percier (1764–1838): Architecture et design*, ed. Jean-Philippe Garric (exh. catalogue Château de Fontainebleu, Bard Graduate Center Gallery, New York), (Paris : Édition de la Réunion des musées nationaux – Grand Palais, 2016).

46 Fabiani, ed., *Pagine*, 46; Joselita Raspi Serra and Alessandra Themelly, "Disegni di antichità nelle collezioni della Bibliothèque municipale e del musée des Beaux-Arts et d'Archéologie di Besançon," *Eutopia* 2 (1993) : 133.

47 Loredana Lorizzo, "L'Accademia di San Luca e la questione dell'istituzione della Cattedra di Incisione in rame nei primi decenni dell'Ottocento," in *Le scuole mute*, 71.

48 Nicolaus Pevsner, *Le accademie d'arte* (Turin: Einaudi, 1982), 186.

49 See the chapter 3 on Nobile's training.

50 Nobile devoted a volume to Villa Madama in Rome, a great Renaissance gem designed by Raphael in approximately 1517. Various designs and watercolours with decorative details.

51 Fabiani, ed., *Pagine*, 66.

52 Trieste, SABAP FVG, Fondo Nobile, letter, 62 R-Z and 63 R-Z. Between 1809 and 1810, Uggeri wrote to Nobile from Rome to tell him about his publication on the Ionic and Corinthian orders, accompanied by many illustrations.

53 Trieste, SABAP FVG, Fondo Nobile, vol. 5, no. 5.

54 This was probably taken from the third book of Vitruvius's work, dedicated to the composition of antis, amphiprostyle, prostyle and peripteral temples. The classification system is intended to be used for combined study.

55 Fabiani, ed., *Pagine*, 67.

56 *Friedrich Weinbrenner: Architektonisches Lehrbuch*, ed. Ulrich Maximilian Schumann (Bad Salgau: Triglyph Verlag, 2015).

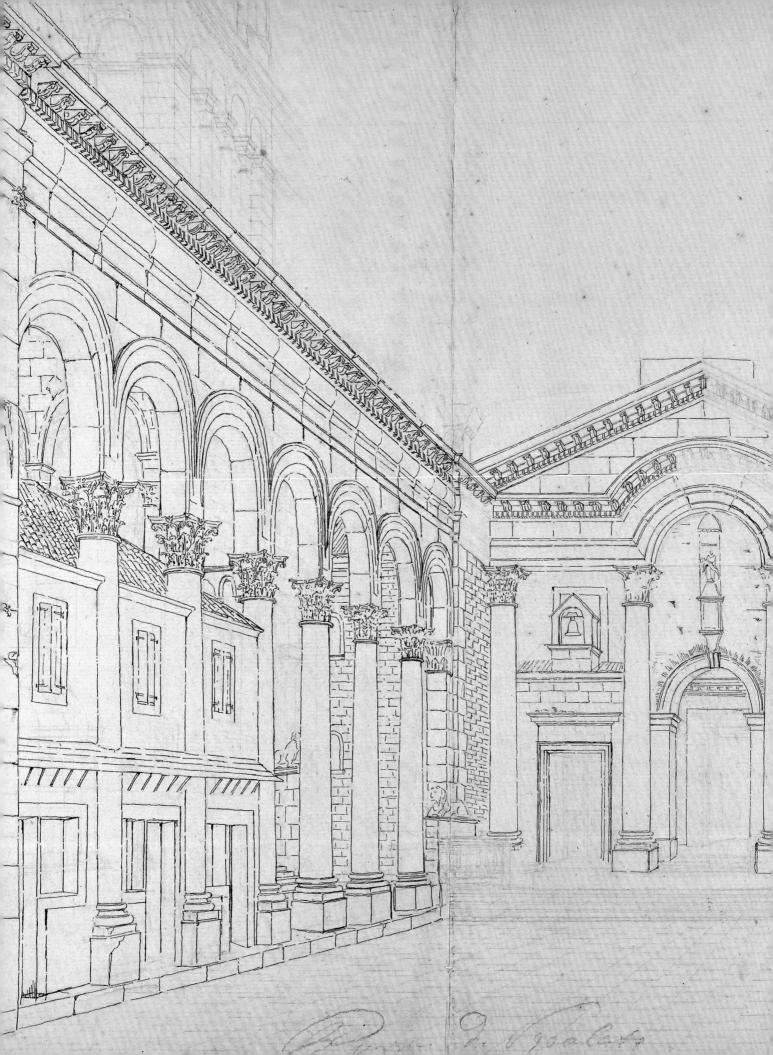

PUBLIC AGENCY AND THE PRESERVATION
OF HISTORIC MONUMENTS

Rossella Fabiani

After his training period in Rome and Vienna, Nobile arrived in Trieste in 1807 to take up an important role in the Austrian civil service as 3rd assistant in the Landesbaudirektion (Provincial Office of public works) responsible for the Trieste area.[1] Carlo Alessandro Steinberg was the Landesoberbaudirektor (Provincial Building Director) until 1808.[2] Set up during the time of Maria Theresa, this state institution was tasked with supervising building and land development operations. It was responsible for buildings owned by the municipality and those granted under concession to private individuals, and its geographical jurisdiction extended from Trieste to the Princely County of Gorizia and Gradisca. Members of the public were obliged to submit plans for new buildings as well as for renovation and refurbishment projects. During the third French occupation of Trieste (1809–1813), the department's control extended from the left bank of the River Soča (Isonzo) to the region of Karlovac, including the entire Istrian Peninsula and the Rijeka coast.[3] Nobile supervised all residential building work and the maintenance of communication routes, roads, and bridges.

In 1807, all civic inspection duties were transferred to the Landesoberbaudirektion, which employed one director, three assistants, and two draughtsmen.[4] The third French occupation in 1809 changed the organization of the building administration because the French government only employed engineers and architects, who were responsible for works such as bridges and roads and for control of the waterways. One continuous strand running through this period was the presence of Pietro Nobile, who was already attached to the Landesoberbaudirektion, working as a divisional engineer from 1809 to 1813 and then as chief engineer respon-

sible for Istria and Civil Croatia, i.e. two of the six French Illyrian provinces.

In 1809, the Treaty of Schönbrunn led to Austria relinquishing land along the Austrian and Dalmatian coast, which subsequently became the Illyrian Provinces. France was well aware of Nobile's professional and cultural standing and kept him in the role through a tacit agreement approved by the president of the Vienna academy, Baron Doblhoff-Dier, who called on Nobile to remember Vienna's contribution to his professional career if and when the Habsburgs returned.[5] When Austria did return to power, Nobile became provisional Baudirektor from 1813 to 1816 and then Landesoberbaudirektor until 1818.[6] Nobile enjoyed the trust of both governments due to his cultural background, which was admired by the French authorities, and to his friendly ties with Antonio Canova, who held Nobile in high regard and could intercede for him with the Austrian court. He therefore continued his organizational and technical work as office director and also embarked on the archaeological explorations, which would leave an important mark in Trieste, Aquileia, and Istria.

Nobile was strongly committed to building new roads between Trieste and Opicina and towards Rijeka and Pula. These various routes became of national importance: The coastal roads were state owned and connected Trieste, Rijeka, and the administrative centres of Gorizia, Pazin, and Rovinj, though the network to Istria's interior was still poorly developed. As early as the end of the eighteenth century, the Pazin-Volosko road towards Veli Učka, ordered built by Joseph II, was part of a strategic plan to connect the Venetian territories with northern and eastern territories for trade and military purposes. The region of Istria attracted the attention of Emperor Francis I, who wanted to promote

the territory's importance within the empire to ensure political and economic balance.

One of Nobile's tasks, which he was able to carry out in person due to his technical and historical skills, was to take care of the condition of treasury buildings and other state-owned property within his jurisdiction. The office took charge of the design, construction, and maintenance of state buildings, hospitals, prisons, and police barracks as well as the headquarters of administrative and judicial bodies. The Landesoberbaudirektion was also responsible for closely monitoring the building activity of private individuals, particularly any projects with a significant impact on town planning, such as those requiring adjustments to the city street or road networks.

Civic buildings also fell within his remit. One such example was the Teatro di San Pietro, formerly a civic building and then destined for demolition. Nobile's focus on the architectural layout of the centre of Trieste was crucial. During his tenure at the Landesoberbaudirektion, he sought to improve the city with the most of Trieste's three iconic monuments: Palazzo della Borsa, the old stock exchange building (1800, interiors 1805–1820) by Antonio Mollari, the city's symbol of finance; the Teatro Grande (1798–1799) by Gianantonio Selva and Matteo Pertsch, the city's symbol of culture; and Palazzo Carciotti (1798–1804), also by Pertsch, the symbol of trade around which the new city coalesced. With a view to ensuring fitting, well-ordered building development, rigorous official supervision under Nobile's leadership was a big factor in ensuring that Triestine architecture developed in a fairly uniform manner during the early years of the nineteenth century.

This telling episode showed that "the scrupulous and competent official in charge of protecting public buildings and responsible for restoring the ceiling of the cathedral of San Giusto, damaged by the French retreat during the final months of 1813 [...] will not allow such a valuable monument to be defaced and debased by replacing the original curved coffered ceiling with a flat ceiling for financial reasons."[7] Nobile devoted much attention to employee training and took personal charge of assessing people's technical skills in order to encourage individual operators to specialize. He believed in the importance of proper vocational training for his employees and, by focussing on this important aspect,

sought to nurture a generation of skilled technicians who were much more than mere foremen. The presence in Trieste of an institutionalized intelligentsia trained to a high technical and scientific standard was a significant plus for the city's cultural scene. The Landesoberbaudirektion employed the first generations of imperial and royal engineers, graduating them from special courses within the military academies and at the University of Vienna. There was a clear cultural divide between these cosmopolitan, technical employees and the heirs to age-old local traditions of inspectors and foremen, who, often through family apprenticeships, had grown up learning their trade on building sites, where they were able to perform simple building operations. The Landesoberbaudirektion's requirement that it approve applications before employees could practice their trade helped shape a new breed of state officials. These engineers were of local origin but benefitted from up-to-date training as part of a specialized career track that Nobile pursued with determination as part of his ten-year programme in Trieste.

Nobile threw himself energetically into activities connected with watercourses throughout his jurisdiction, including reclamation, bridge construction, and the shoring up of embankments. In Trieste, in particular, he supervised initial work to bury the Portizza Canal in order to help eliminate water fumes that were unhealthy for the inhabitants. He also reinforced other bank walls structure to defend against sea storms and improved the layout of water pipelines with a view to strengthening the aqueducts. After initial work to divert and bridge waterways running from the city's immediate hinterland, making it possible to bury the salt pans and build the new city, Nobile turned his attention to managing the streams. It became necessary to create embankments and quays and to build bridges over the city's road network.

Nobile was responsible for building bridges, including one at Kanal ob Soči. This was built in 1815 and featured one masonry arch. He also handled a project to build a bridge over the Reka-Timavo river system, first for the French government and then for the Austrians. His drawings show how he resolved many technical and logistical problems. During the same years, he carried out reclamation work on the Aquileia marshes. Nobile described this in a practical technical report addressing the construction of embankments,

locks, ditches, and bridges. This report was the subject of a lecture he delivered to the Società di Minerva on 29 December 1815.[8]

Nobile had his work cut out for him in managing an office that was often affected by funding and staff shortages and sometimes by difficult relations with Vienna. As Trieste stood at a historical crossroads due to the alternating governments and as this political uncertainty made local situations more precarious, Nobile seized the opportunity to offer his professional skills to the French. In particular, during the Napoleonic occupation, he succeeded in starting the archaeological work that was to yield such remarkable results.

Pietro Nobile and Domenico Rossetti

The Landesoberbaudirektion allowed Nobile to lead projects for new, monumental works that would end up having a great impact on Trieste's urban landscape. This aspect of Nobile's role within the office is the one that most interested him and for which he felt best qualified. The purely administrative and organizational aspects of his work weighed him down, and he took every opportunity to express his frustration to his superiors, as can be seen from many surviving documents.[9] Having left for Vienna, Nobile was unable to see the completion of certain construction work, but he monitored its progress from the Austrian capital through his close links with the civic procurator and benefactor Domenico Rossetti (1774–1842), who acted as a bridge between the Austrian capital and the Adriatic port.

Rossetti played a leading role in Trieste during the first half of the nineteenth century. As a lawyer, public attorney, and patrician member of Triestine society, he shined a special light on the city that he saw as his homeland; this was true both during his own lifetime and after his death, through a legacy allowing for the expansion of the Biblioteca Civica, which was built on the initiative of the Accademia degli Arcadi Romano-Sonziaca. Rossetti occupied a key position in the local neoclassical world. His contribution to culture and art helped shape the urban and civic setting of the new imperial Trieste.

After his studies – high school at the Cicognini National Boarding School in Prato, philosophy in Graz, and law in Vienna – in 1810, Rossetti set up the Società di Minerva in Trieste. This was a place of meeting and information-exchange for the city's industrious bourgeois inhabitants, one that aimed to keep up with the latest movements in history, science, and culture. In 1829, Rossetti launched the society's own scholarly publication following the model of the German-speaking historiographical journals. The *Archeografo Triestino* was one of the first such publishing initiatives in Europe.

He was interested in the past and in studying the origins of his city. These in turn inspired strong patriotic feelings in him and a desire to make Trieste a better place. Rossetti thus established himself as a point person in the political campaign to consolidate relations between Trieste and Vienna, with the intention of making his city's voice heard. He stood up for Trieste's rights against the abuses of the Austrian government and campaigned to defend local interest in art, particularly from 1817 when he became a public attorney. The acquaintance between Rossetti, as a connoisseur of archaeology and literature, and Pietro Nobile took on central importance. He became aware of Nobile's worth when he appointed the architect to deliver the Società di Minerva's opening speech in 1810. This charted the cultural course of this society and was crucial for the city's development in terms of aesthetic style and impact on public life and services.[10]

Rossetti found Nobile to be an expert and connoisseur with whom he could discuss artistic and aesthetic matters in the certainty that he would be properly understood and advised in his attempts to improve the appearance of the city. Nobile was also a valuable and intelligent adviser and lobbyist in Triestine practices, caught as they were between the intrigues of ministerial chancelleries and the slowness of the Habsburg bureaucracy.

When Rossetti announced Nobile's promotion to director of the School of Architecture at the Academy of Fine Arts Vienna at the general congress of the Società di Minerva in December 1817, he expressed that he was torn between regret over Nobile's departure and the conviction that Nobile would always take an interest in the situation in Trieste, albeit from afar.[11] Nobile in turn valued Rossetti as someone who was able to appreciate his ideas and initiatives. In his 1810 address to members of the Società di Minerva, Rossetti outlined a full programme of events and announced a plan

to establish a museum in the cloister of the Minorite monastery in what is now Piazza Hortis. In Rossetti's closing report for 1814, he listed the activities undertaken by Nobile, who had been appointed a member of the Accademia Romana di Archeologia that very year: Nobile donated six prints on the topic entitled "the Temple of Peace and Concorde," and some architectural exercises for young people designed to encourage the study of fine arts.[12] He advocated the restoration and conservation of Roman monuments to promote an interest in archaeology in Trieste, following the lead of other major European cities. Rossetti waited for Nobile to become established in Vienna before calling on him to advertise Trieste's historical and archaeological treasures – to make sure ministers remembered what the city had and to persuade them that these treasures would be worth even more were in Trieste, the empire's capital of trade and shipping.

The pair corresponded copiously and were able to address very topical subjects due to the promptness of their responses, particularly on the part of Rossetti, who was unfailingly enthusiastic and ready to do anything for the good of the city while also being aware of cultural developments at home and abroad. One key topic for Rossetti was his desire to honour the memory of Winckelmann: Almost as though he wanted to relieve the city of its burden of involuntary guilt, he proposed erecting a monument in memory of the German historian, who was murdered by a common criminal in Trieste in June 1768. Courts, universities, and academies throughout Europe expressed their outrage at the treacherous deed. In a letter written to Nobile in 1818, Rossetti called on him to seek financial backing in Vienna. Rossetti also asked Nobile for his opinion on the drawings of Antonio Bosa for the cenotaph and the site where it was to be erected. The construction of the hospital and the church of Sant'Antonio Nuovo were also frequently mentioned in their correspondence, as they discussed ideas for these building complexes. Rossetti took on a large part of the organizational work for these buildings, and Nobile's intervention was important for achieving the final result.

Rossetti's position was often diametrically opposed to that of the Austrian government, and for the most pressing public needs he saw Pietro as a useful direct link with the authorities.

Both were united by common ideals of good governance and public good, but the thing that really made their relationship fresh and contemporary was their meeting of minds on a cultural level. Nobile did a lot for the Società di Minerva, contributing archaeological fragments from his excavations, including a bas-relief he found in 1814 under the bell tower of the cathedral of San Giusto in Trieste (Fig. 10). Drawing on experiences and problem-solving skills he gained while managing the Landesoberbaudirektion, Nobile drew up reports that he then read to members of the Società di Minerva, such as his "report on the draining of the Aquileia marshes" in which he outlined the history of the Roman city and then went on to describe the reclamation work carried out in the marshes. He demonstrated the same versatility and skill in his work on the salt pans of Trieste and Istria.[13]

The Church of Sant'Antonio Taumaturgo and Its Architecture

Trieste's economic and population boom, which began at the beginning of the eighteenth century, continued apace, with the city becoming a focus of strategic interest for the Habsburg Empire. As the population grew, the Borgo Teresiano neighbourhood developed a need for a new Catholic church, which eventually became the neighbourhood's main place of worship.[14] It had to have all the dignity of a Christian hub and place of worship in Trieste's new neighbourhood, standing as a symbol of the burgeoning city. The choice of its show-stopping setting at the end of the Grand Canal reflected locations chosen for churches in other major European cities, such as the church of Gran Madre di Dio by Ferdinando Bonsignore on Piazza Vittorio in Turin or the church of San Francesco di Paola by Pietro Bianchi in Naples.

Government decrees issued on 11 October 1808 imposed strict conditions on the architects Matteo Pertsch, Pietro De Grandi, and Pietro Nobile, who submitted plans for the church of Sant'Antonio Taumaturgo.[15] On 28 December of the same year, Nobile submitted a report in which he examined the plans and justified his proposal, which was approved by the Landesoberbaudirektion: "Firstly, the church shall be large enough to comfortably accommodate all the religious ceremonies and to contain the required number of

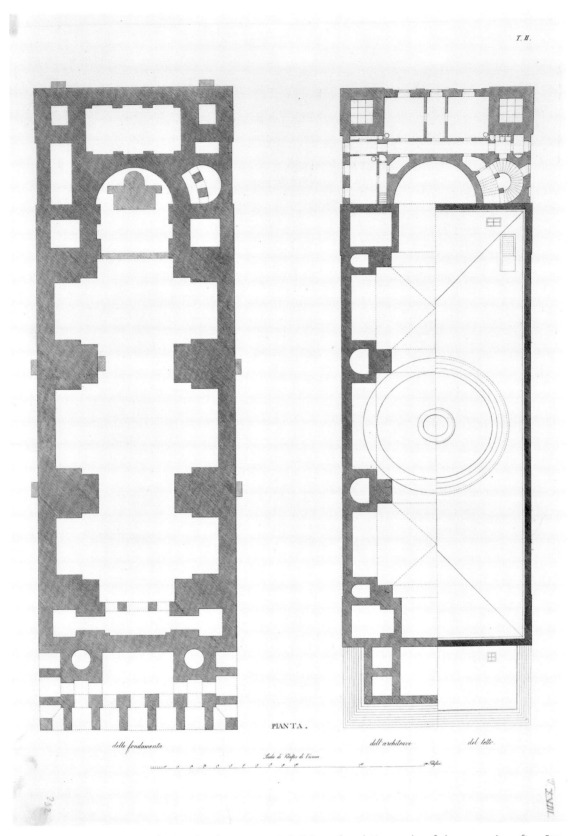

T. II.

PIANTA.

delle fondamenta *dell'architrave* *del tetto*

Scala di Klafter di Vienna

Fig. 45 Pietro Nobile, Design for the church Sant'Antonio in Trieste, foundations and roof plan, engraving, after 1822, Trieste, SABAP FVG, Fondo Nobile.

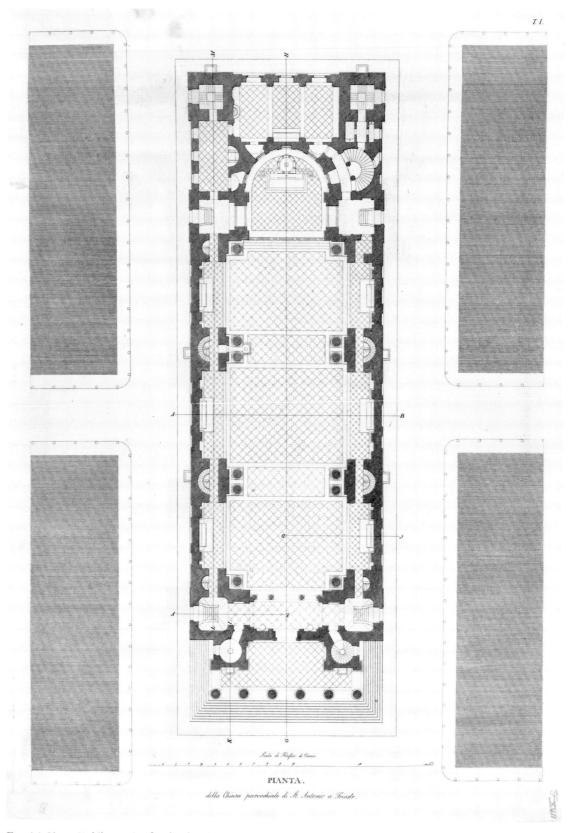

PIANTA.

della Chiesa parrocchiale di S. Antonio a Trieste

Fig. 46 Pietro Nobile, Design for the church Sant'Antonio in Trieste, planimetry, engraving, after 1822, Trieste, SABAP FVG, Fondo Nobile.

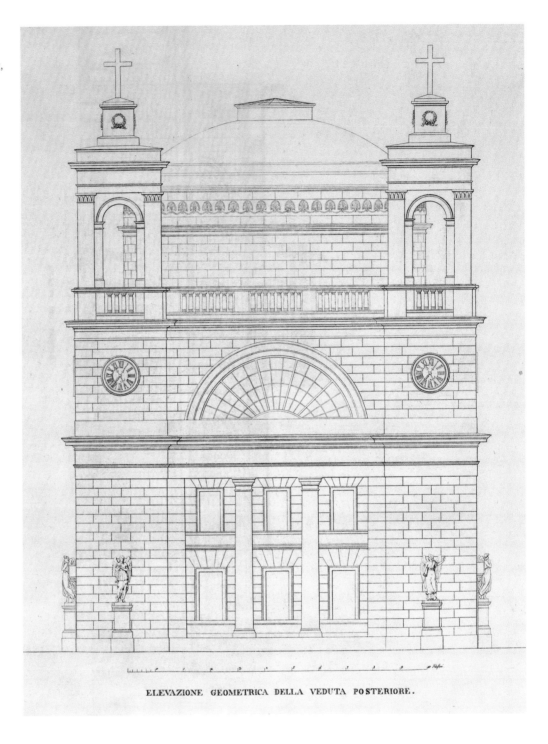

Fig. 47 Pietro Nobile, Design for the church Sant'Antonio in Trieste, the rear view, engraving, after 1822, Trieste, SABAP FVG, Fondo Nobile.

ELEVAZIONE GEOMETRICA DELLA VEDUTA POSTERIORE.

people; secondly, it shall be shaped to allow services to be seen by all, wherever they are celebrated in the church, without any problems being caused by the building's nature; thirdly, it shall be beautiful in that its size and shape will combine so nicely that its beholders gain a firm idea of its sublime intentions."[16]

All building work was suspended due to the third French occupation, which began in 1809. The pressing demand for a religious building designed to meet the needs of the local population and to meet the status of the city was not addressed until October 1822, at a meeting at the city hall presided over by the illustrious magistrate Ignazio de Capuano,

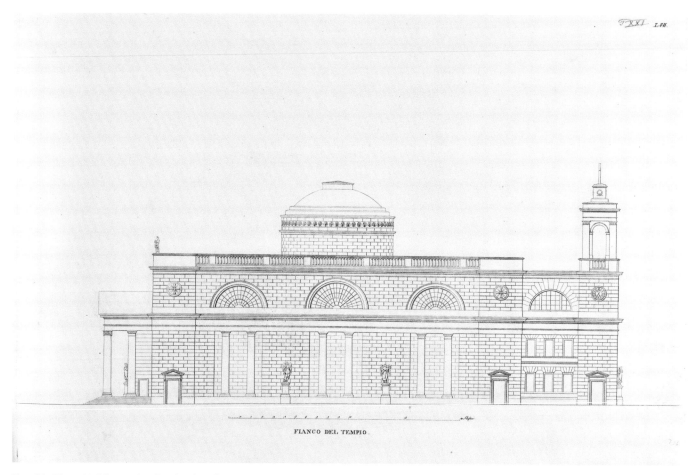

FIANCO DEL TEMPIO.

Fig. 48 Pietro Nobile, Design for the church Sant'Antonio in Trieste, side view, engraving, after 1822, Trieste, SABAP FVG, Fondo Nobile.

Count Alfonso Gabriele de Porcia, and the Oberbaudirector of the provincial office of public works Count Joseph Carl Huyn. The central government entrusted the project to Pietro Nobile, who resubmitted his 1808 design, with some changes (Fig. 45, 46). Seventeen years had passed since the first project was put forward, and the church would not be completed for another fourteen years.

The plan submitted by Nobile solved many logistical and formal problems that were overlooked by others. The building, enclosed in a parallelogram, was able to accommodate three thousand worshippers, who had a good view of the interior due to removal of the aisles that would have broken up the sweep of the central nave, given the limited amount of available space. It is not one compartment but rather an area with two narrow side passages, which do not detract in the least from the view of the presbytery, instead creating a spacious effect through an interplay of light and shade.[17] The

strong influence of Nobile's lessons in Rome is evident in his drawings proposing a colonnaded main facade with two to six columns of Doric, Ionic, and Corinthian order surmounted by a tympanum; the bell towers, almost always two in number, are placed alternately on the facade and next to the apse. Following the French and German model, Nobile decided not to add bell towers but rather side extensions to the main facade, which he then positioned within the rear elevation (Fig. 47). The prevailing features of these designs consist of Diocletian, or thermal, windows, a dome modelled on the Pantheon, oculus motifs, bas-reliefs, and statues in exterior niches (Fig. 48). The plan may have been inspired by Roman baths and basilicas as well as by French plans drawn up by Soufflot for the church of St Geneviève and Contant d'Ivry's initial idea for the church of the Madeleine, both in Paris. The strong influence of Bramante and of the frescoes painted by Raphael in the Vatican Rooms is evident in the spacious interiors.

Large twin columns skilfully break up the interior space leading towards the apse. This shows some neoclassical influence but mainly evokes the grandeur of the Roman baths. A dome and coffered arches grace the three spans up to the main altar, which is located in front of a semi-circular wall of the frescoed apse. The main altar is decorated with an open *tempietto* supported on Corinthian columns and a small, classically inspired dome. This motif is widespread in the Lombard sacred tradition and reflects Nobile's *Comacine* origins, as a native of the Lake Como area. Nobile brings in Greek references by reinterpreting the portico of the Temple of Minerva Polias in Athens as well as details from the portico of the Erechtheum. The columns of the balustrade above the roof lack bases and have Doric capitals and a partly fluted, partly smooth trunk, a clear reference to the Temple of Apollo in Delos. Nobile's studies of column orders are again in evidence in his use of a capital that clearly harks back to Paestum. This is present in the columns of the sacristy staircase, which was not included in the 1808 project. The staircase, with a semi-circular floor plan, ascends through three floors and revolves around a pivot formed by two smooth Doric columns. Here Nobile managed to exploit the available space and confer particular dignity on what is essentially a service staircase by adopting an idea completely new to Trieste.

The architect Durand included the church of Sant'Antonio in his collection of ancient and modern buildings, published in 1833. He criticized some parts of it but considered the work "colossal," while observing that it did not incorporate everything in the drawings published by Nobile.[18]

In 1808, the government commissioned Nobile to design the seat of the Accademia reale e di nautica in Piazza Lipsia. The name of the square was then changed to Piazza Luetzen in memory of Napoleon I's victory over the Prussian troops.[19] The French intended to go ahead with the plan and confirmed the idea of a large building featuring a series of porticos on the facade and decorations depicting mythological subjects. When the Austrians returned to power, they did not move ahead with building work on the complex, and Palazzo Biserini in the same square became the seat of the academy. This building was refurbished by Nobile, who left his signature by including in the internal staircase slender columns with Parthenon-style capitals.

One of Nobile's most interesting duties within the Landesoberbaudirektion was the restoration or recovery of local buildings of historical importance. A shining example was the church of St Peter in Piran. The church did not crop up in many accounts.[20] Count Girolamo Agapito referred to it in his book *Città e Portofranco di Trieste*, specifying that "an elegant chapel in modern taste known as St Peter's was built through the piety of the faithful on the main square in 1818 following a design by *Consigliere* Nobile."[21] The church dates back to the mid-thirteenth century, according to known historical records, and overlooks the lagoon, located just inland from the seashore.

At the beginning of the nineteenth century, the church must have been in a precarious state of repair for Pietro Nobile to have raised the subject of restoring the monument immediately following his arrival at the Landesoberbaudirektion in 1807.[22] Nobile had returned to Trieste only a few months earlier from Rome, where he had learned about architecture and monument restoration while studying at the Accademia di San Luca, surrounded by ancient sights. He took on the role of assistant at the Landesoberbaudirektion, which inspected and arranged for the construction of public roads and buildings for the local area. He was sent to work within Istria in this capacity, particularly after the third French occupation and Austria's final return to power in 1813. Renovating buildings of historical interest, which involved maintaining public buildings and places of worship, came under the remit of the Landesoberbaudirektion. These works also reflected the Habsburgs growing interest in Istria as a politically strategic area, an interest that reached its zenith when Francis I visited Koper and its surrounding region in 1816 and when the Savudrija Lighthouse was opened in 1818. The emperor was very much in favour of the lighthouse, seeing it as a mark of government presence and of the state's ability to influence the lives of its subjects.

The Nobile Collection includes illustrations by Pietro Nobile himself that refer to the church of St Peter in Piran,[23] namely a series of watercolours all in the same size, showing ten versions of the facade. Their numerical ordering does not appear to be random. For the church in Piran, Nobile found himself working in the dual role of restorer and civil servant as well as of designer. The building only had a small interior and space was restricted. He accordingly saved all

his creative energies for the facade, where he was able to work freely in an urban setting well defined by a skyline that was already mapped out in 1815, as Nobile himself reflected in his *View of the lagoon-side area of Piran*. When approached from the sea, the church had to be monumental and noticeable enough to stand out amidst the buildings crowning the lagoon's shore.

Following his normal composition method, Pietro Nobile drew many versions of the facade to find different ways of incorporating the building into the urban landscape. These contain explicit references to his academic studies in Rome, such as Diocletian windows and Doric and Corinthian columns, pilasters, and pediments. The church's facade features a pediment, a Diocletian window, and an entrance door flanked by fluted pilasters or columns with Doric capitals. The facade elevation follows a chapel-like model, with very linear decoration formed by columns or pilasters and Doric capitals in accordance with theoretical requirements for the architectural composition of small churches. This harks back to Roman architecture: columns or pilasters with Corinthian capitals on the facade, supporting a notched pediment with a door and a simple lintel. The illustrations clearly refer in particular to the Temple of Augustus in Pula, which Nobile knew very well because he had taken part in its excavation and maintenance.[24] He opted to refer to models in the classic tradition both because of the archaeological remains in the area and because of Pula's own Roman history. The French political regime had allowed Nobile to begin to explore, excavate, and study these archaeological relics in order to carry out recovery or restoration work in homage to Istria's history. The composition of these projects for the Piran church encapsulated everything Nobile had studied, including his explorations of contemporary methods and shapes. The variants captured in the drawings are reminiscent of Claude-Nicolas Ledoux's plan for Hôtel d'Hallwyll in Paris, with a Diocletian window over the lintel and entrance. This motif is taken up again in the facade of Villa Salve Hospes in Brunswick in Germany (1805–1808), and it is expressed in other ways in Lombardy through projects by Carlo Amati, an exponent of a form of Neoclassicism that would become established in the Lombardo-Venetian Kingdom, particularly in the churches of Sant'Eustorgio in Arcore (1802) and San Giovanni in Fusignano (1816). These layouts

had been used some years previously by Giacomo Quarenghi in the church of Our Lady of Smolensk in Pulkovo (1780). However, Giuseppe Valadier, one of Nobile's masters in Rome, to whom he owed his knowledge of forms, plan composition, and geometric bodies and proportions, suggested designing the facade with simple, uncluttered side faces: the church of San Pantaleo in Rome, dating from 1806, appears to be a direct influence on the Piran building, and the various designs for the facade and construction provide full evidence of this. The Piran church's neoclassical architecture was in keeping with what was being built at that time in Trieste as well as throughout Austria and all of Europe.

The Lighthouses

One project that had a forceful impact on its local area and was typical of Pietro Nobile's activity in Istria is the Savudrija Lighthouse, which was built to meet the needs of the local people and to speak to the Habsburg government's commitment to the Adriatic Sea. In 1816, Emperor Francis I made a trip to Istria. As Landesoberbaudirektor, Pietro Nobile accompanied him during the visit and showed him the local monuments, particularly the Roman archaeological finds present in Pula. Nobile drew the sovereign's attention to the need to build a lighthouse at Punta delle Mosche in Savudrija to ensure the safety of shipping and receiving. Francis I ordered the lighthouse built, and work began in March 1817 under the administration of Governor Karl Chotek, on a design by Nobile (Pl. XXXV).

In April 1818, the building was opened. This was the first time that a European lighthouse had used a gas lighting system, powered by coal from the mines of Istria and based on a project by Giovanni Aldini. The lighthouse was built out of large stone blocks. Its base was a quadrangular pedestal housing the lighthouse keeper's lodgings along with spaces for the gas to circulate. An inscription over the entrance door, commemorating for posterity the emperor's generosity, reads: "Cursibus / navigantium nocturnis dirigendis / Franciscus I / E.I. / 1818." Glass panes surround a copper candlestick that contains forty-two gas outlets, forming a six-foot-high cone that measures one klafter (1,896 cm) at its top.

Two other lighthouses were planned on the coast to ensure the safety of shipping and receiving: one in Trieste, subsequently built by Matteo Pertsch in 1834, and one at the tip of Premantura in Istria, which was never built. The many lighthouse designs in the Nobile Collection reflect the architect's interest in this type of construction. The subject was often the focus of competitions and exercises at the academies, and Nobile often weighed in to suggest constructional and decorative variations using different forms and solutions.[25]

Archaeologist in Theory and Practice

The years between 1809 and 1813 – coinciding with the third and longest French occupation of the newly formed Illyrian Provinces – were to prove crucial. During this time, Nobile played a leading role in managing a larger area. The skills he brought to bear were mainly technical but nevertheless allowed him to express the great interest in classical architecture he had gained during his studies in Rome, keenly aware of its hidden potential.[26]

Nobile succeeded in maintaining a continuous presence: Antonio Canova put in a good word on his behalf with Marshal Auguste Viesse de Marmont, which led to the French authorities leaving Nobile in charge of the building works even after the change of regime. The decision was farsighted because it meant that the office could pursue consistent policies, despite the change in circumstances.

Another sign of Nobile's desire to ensure the continuity of this important service in the area surrounding the city of Trieste comes from a report that he drew up in the summer of 1809 under the title *Notizie statistiche di Trieste volute nel 1809 dal Governo francese*, addressed to the intendant Louis Joubert.[27] This concerned a radical reorganization of the office in terms of staff distribution as well as workflow. Nobile singled out Carlo Alessandro Steinberg, who had been Landesoberbaudirektor from 1783 to 1808 under the Austrian regime, for particular censure, criticizing him for not properly observing standards. The chief engineer's area of responsibility was by then much wider, extending from the Soča River through Trieste, Istria and Dalmatia to Karlovac. Nobile suggested new ways of entrusting work and assignments to staff. Nobile's speech on the arts of design in the city of Trieste upon the opening of the literary casino of the Gabinetto di Minerva on 1 January 1810 made explicit Nobile's confidence in the new political direction "established by Napoleon, which placed national happiness at the centre of our new order" and his certainty that studying the ancient world was an important sign of civilization. He called on those present to look "around them in the Illyrian Provinces, scattered with the noblest monuments of those happy times, when the fine arts were entrusted with the exalted political task of passing down the celebrity and power of nations for posterity."[28]

Nobile therefore laid a groundwork for using the values of the ancient world as a tool for spreading culture from the other side of the Alps to Italy, adopting a pragmatism typical of the French method. His approach harked back to a glorious past that was lived on the fringes of the empire but still present in archaeological remains. Intoxicated by his passion for the ancient world but keenly aware of the lessons he had learned in the Eternal City, Nobile peeled away the layers left by different civilizations to rediscover local origins. Nobile's new sensibility fuelled his contribution to archaeological research, which he pursued in areas where there was hardly any awareness of the need to protect ancient ruins. Such ventures were determined by many political and organizational factors. First and foremost, Nobile's educational background led him to value the ancient world and prompted him to pursue this as a way of rediscovering the origins of Trieste. In addition to being a newly established city and a Habsburg bulwark on the Mediterranean—the latter a cradle of history and civilization in its own right—Trieste needed to show that it had glorious origins. Nobile was therefore central to ensuring continuity in this borderland where various civilizations had succeeded one another. His job was to secure the city's image as a thrusting power whose new architecture evidenced models from the past. Nobile made the inaugural speech, setting the society's agenda. Another outcome, in 1829, was the publication of the journal *Archeografo triestino*. This aimed to provide information about the inhabitants and history of Trieste and Istria by circulating information on inscriptions, artistic monuments, and numismatics backed by criteria of historical accuracy and scientific interpretation.

Nobile and his office came up with innovative projects in response to this new frontier of protecting monuments and discovering new evidence based on criteria of order and rationality. Nobile immediately submitted a request, dated 1809, to the Napoleonic governor to undertake excavations – in Trieste, Aquileia, Pula, Istria, and Dalmatia – as well as to work on monuments that had already been brought to light and to raise public awareness of the subject. Another reason for the urgency was that in those days it was common to reuse archaeological spoils to build houses and to reuse Roman artefacts in foundations or perimeter walls.[29]

In his travels across Istria, Croatia, and Dalmatia, he made numerous drawings and recorded the state of preservation of monuments and the work that needed to be done. The first result Nobile achieved was an ordinance issued by the Trieste city hall on 29 November 1809, stating that anyone who found ancient remains on their land should report them to the Landesoberbaudirektion in order to help preserve evidence of the ancient people who inhabited those areas. "The attached public notice called on all owners of houses and land who had ancient relics or fragments of architecture, sculpture, and stone inscriptions in their possession, to inform him [Nobile] of the existence of any interesting objects and help him in his research."[30] Nobile's petition to the magistrate painted a clear and earnest picture of the situation. Among other things, Nobile stated: "At no other time in Europe have we put so much energy into exploring and appreciating all that is ancient. During this and the last century, European writers and artists have worked exclusively under the protection of monarchs, magistrates, and patrons to unearth, measure, and illustrate architectural monuments from the most far-flung areas of the world, dating from the age of decadence as well as from the golden age of art, in order to join all the links in the chain of this wonderful and useful science and art and to use their achievements for improvement."[31] Fleshing out the implications of his request, Nobile noted that

> Trieste possesses architectural relics that record its past as a Roman colony, statues, bas-reliefs, and inscriptions that have not yet been discovered, or only partially and sketchily [...]. I propose to fill this gap by measuring and

drawing with all possible diligence objects of antiquity that deserve the attention of learned colleagues and amateur art lovers in this city [...]. In order to carry out such an undertaking, I need your gracious permission and assistance as a magistrate to enable me to measure fragments of public architectural monuments and excavate around them when needed to ensure their accuracy and identification, using labourers from the office of public works or calling on the aid of individuals from the office directorate. To help me in my research, I would ask you as an illustrious magistrate to call on anyone who possesses any such ancient objects on their land or in their homes to inform me, so that I can carry out the necessary examinations and research for the above purpose.[32]

He concluded by stating: "I am guided in this work by my patriotism and love of the arts." Members of the public were informed of this in a notice published in the daily newspaper *Osservatore Triestino* on 4 December 1809. Although this did not amount to a specific programme of archaeological research and interpretation, Nobile showed that he was aware of the significant results that could come out of studying history by acknowledging the authenticity and reliability of sources. Such work can be made scientific by executing accurate measurements, precise drawings, and detailed descriptions in order to allow documents to be directly compared with one another and with results found by other academics. Researching and surveying ancient monuments was not part of the duties of an engineer in the Landesoberbaudirektion, but Nobile was held in such high regard that he was able to suggest projects that allowed him to express his artistic training and passion for antiquity; Nobile dedicated a good part of his time to these occupations, in the conviction that Trieste could offer opportunities similar to those he had experienced during his stays in Rome.

However, it was the experience he gained in Istria and Dalmatia that led him to broaden his horizons towards themes of conservation and protection. In particular, a familiarity with the Napoleonic bureaucratic machinery, along with his academic and technical background, led Nobile to develop a working programme for the conservation of antiquities in Istria. Nobile entitled this *Projet relatif aux antiquitées* and submitted it to Count Henri-Gatien Bertrand,

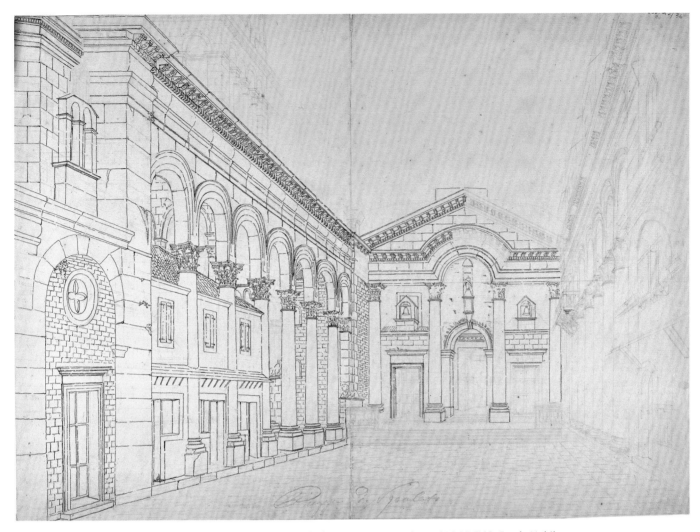

Fig. 49 Pietro Nobile, View of the "Square in Split", pencil and ink, ca. 1809–1818, Trieste, SABAP FVG, Fondo Nobile.

Governor of Illyria, on 27 February 1813.[33] It was partly prompted by observing French architects and historians, Italian or otherwise, attempting in vain to describe the monuments of Pula, which had been abandoned for so long that they had almost disappeared without trace. The document was significant because it stressed the need to catalogue local archaeological heritage and proposed setting up a museum in which relics found in the area could be kept. Everything that private individuals made available could be included in the catalogue and the museum, with no distinction between public and private property. The seventeen points of the project included proposals to entrust monument conservation and restoration to engineers from the office, to draw up cost estimates for monument maintenance, to reassemble architectural elements damaged by time, and to demolish buildings that prevented public enjoyment of the monuments. Nobile's reflections probably paved the way for the protective legislation launched in Austria by resolutions published by Emperor Francis I in 1818 (and also later, in 1850, after the emperor's death), which were specifically intended to protect works of art located throughout the empire.[34] In the appendix, Nobile listed a set of works that needed to be carried out immediately: excavations at the Pula Arena and isolation of the Arch of Riccardo in Trieste. Nobile was mainly interested in recovering monuments bearing witness to the Roman period that, partly due to French policies, were seen as enlightened examples, symbols of a much-admired age.[35]

Austria's return to power did not stop Nobile from continuing the programme he had already embarked on with the French. In a report delivered to Count Franz Joseph Saurau in 1814, the Trieste-based Illyrian court commissioner of the restored Austrian government, Nobile proposed establishing an archaeological society in the towns of Aquileia, Trieste, Istria, Dalmatia, Dubrovnik, and Kotor, with the aim of illustrating the architectural and sculptural antiquities extant in this area and tracing those not yet known (Fig. 49). One category of members was to be in charge of identifying, measuring, and drawing monuments and making proposals regarding their restoration; another category was to reconstruct the history of the monuments and sites. The overall intention was to set up museums in Trieste and other centres that would be packed with archaeological finds from Istria. This ambitious project nevertheless clashed with a more provincial faction, which had no time for Nobile's broad cultural and scientific scope.

Count Saurau, the Statthalter (governor) of Vienna in 1810–1813, was commissioned in 1814 to reorganize the administration of the former Illyria, had not taken the time to examine the proposal. This may have been because Nobile wrote to him only in December 1814, and Count Saurau became in the following months a commissioner of the Austrian general Frederick Bianchi. So, he could not think of Nobile's explanation of "those surviving monuments to Roman grandeur," and their "useful influence of further potential discoveries on national education and prestige."[36] Nobile's memories of the finds in Trieste and Pula are significant: "Neglected and not sufficiently known, those in Dalmatia damaged by time and man, and mostly still underground" and "relics of the once-great Aquileia reduced to a few architectural and statuary fragments contained within a rickety enclosure." Nobile went on to remind his excellency of the renown acquired by the antiquities of Split through the work of the Englishman Robert Adam, of Pula through the illustrations of Paolo Alessandro Maffei, and of Trieste through the writings of Ireneo della Croce, a Carmelite preacher and chronicler. Nobile argued that "similar results could be achieved by working on Roman antiquities between Aquileia and Kotor."[37] Aquileia, a fixed point in the campaign to develop archaeological heritage, therefore became central to the project of establishing the archaeological society mentioned above. The idea was to create a close connection between the various centres in Istria and Dalmatia where a considerable number of relics had been found. In particular, Nobile considered that

> in Aquileia you can see the remains of columns and frames belonging to great buildings that have not yet been brought to light: here and there you can find fragments of sculptures, coins and medals, and inscriptions. This is a sure sign that much remains hidden underground. The first job that needs to be done is to carry out some routine excavations in different parts of the ancient city. This has never been done before. The museum that has already been started must be reviewed and transported without delay to ensure that we do not lose the fragments we have collected so far.[38]

The document also addressed the issue of raising funds to finance new museums, fresh excavations, and the execution of drawings. Nobile believed that archaeological research as a tool for rediscovering the origins of antiquity was a topical theme for local action. He targeted works that were already known to scholars and that had been ruined by the ravages of time – as was the case with Pula – as well as new discoveries of remains that might have been recorded by historians but of which there was no direct evidence – as was the case with the Roman theatre in Trieste. His was mainly committed to these investigations from 1813 onwards. Nobile's archaeological zeal led to him having to defend himself before Baron Lederer, Governor General of Illyria and Intendant of Istria, when a complaint was lodged regarding his carrying out "insignificant excavations [...] (by myself) at the foot of the San Giusto Bell Tower." These investigations led him to identify "a bas-relief and to discover the remains of a fine temple." This situation indicates that the Austrian rulers had not yet grasped the importance of uncovering the history of such sites. In the hope of raising the authorities' awareness, Nobile carried out an excavation that brought to light the "remains of a magnificent Roman temple dating back to the golden age of the arts," which is today believed to be a propylaeum built to grace a religious area.

In the early part of 1814, Nobile ordered a few surveys in the area where an amphitheatre was alleged to be located:

the architect's interest was piqued by the fact that the houses were arranged in a specific curved pattern. The local residents clearly had a collective memory of such monuments, reflected by place names that referred to structures that were still *in situ*. After the initial works and the report delivered to Magistrate Ignazio de Capuano in July 1814, Nobile identified the exact dimensions of a theatre "not an amphitheatre following a Greek model, that has been in existence for at least 18 centuries." He came up against the *Intendenza*, which accepted the proposal to carry out an excavation but declared that it would not authorize the city hall to go ahead until it had been established that the returns would cover the outlay. Nobile's thorough reports once again demonstrate the architect's familiarity with archaeological matters: every find identified was treated with respect and was measured, finds were not allowed to be moved, and proper plans were drawn up to record the outcome of excavations.

In Trieste, Nobile continued with his research and succeeded in tracing the route of the Roman aqueduct in the Rosandra Valley and also in excavating around the Arch of Riccardo (Pls. XXXVI, XXXVII).[39] While the main thrust of this new quest for Roman antiquities was in Trieste – virgin territory for archaeologists – Nobile also focussed his attention on Aquileia and Pula, which were already known for their monuments. He wished to carry out new excavation campaigns and also recover items that had been marked by the ravages of time or plundered or vandalized by those who believed that the ancient relics were open to all.

Nobile summed up his reflections on Aquileia in a few words: "You can see the remains of columns and frames belonging to as yet undiscovered great buildings: here and there you can find fragments of sculptures, coins and medals, and inscriptions. This is a sure sign that much still remains hidden."[40] He also hoped to carry out new excavations at different sites and to set up a museum immediately. His wishes were granted when significant work on excavating the amphitheatre began in 1816 under Nobile's own guidance. Pula in Istria had also been at the top of Nobile's list since 1809, but restoration and research work did not begin until 1816, following a visit by Emperor Francis I, who was given a tour by the architect to be made aware of the need to preserve and develop the main monuments such as the amphitheatre, the Temple of Augustus, a double arched entrance to the city called the *Porta gemina*, (the Twin Gates), and the Arch of the Sergii.

During the ten years in which he lived in the Littoral, Nobile raised public awareness of the need to conserve artistic and historical heritage: his writings remain a model for how to raise consciousness of ancient ruins as public assets and part of collective memory. Nobile saw archaeological research not merely as rediscovering the past but also as a quest to preserve archetypes that could serve as models for the future.

On 14 July 1818, Pietro Nobile bid farewell to the magistrate of Trieste and handed over his trappings of office to the new assistant Count Huyn. He expressed his reluctance to leave his job and his hope that work would continue on "preserving what exists including [...] the relics of architectural antiquity that are so admired by learned travellers and are the surest sign of the ancient standing and importance of this land."

NOTES

1 Nicoletta Guidi, "Nuovi documenti sulla carriera di Pietro Nobile presso la direzione delle pubbliche fabbriche di Trieste," *Archeografo triestino* 59 (1999): 67. Eadem, "L'archivio Storico del Comune di Trieste miniera di documenti dell'architetto Pietro Nobile," *Neoclassico* 13 (1998): 77–81. Eadem, "Pietro Nobile: Regesto degli atti presenti nell'archivio storico del Comune di Trieste," *Atti e memorie della Società istriana di archeologia e storia patria* 99 (1999): 208–336.

2 Gino Pavan, "Note su Carlo Alessandro Steinberg direttore delle fabbriche a Trieste," *Archeografo triestino* 68 (2008): 53.

3 Fiorenza De Vecchi, "Pietro Nobile direttore delle fabbriche a Trieste," in *Neoclassico: Arte, architettura e cultura a Trieste 1790–1840*, ed. Fulvio Caputo (Venezia: Marsilio Editori, 1990), 121; Pierpaolo Dorsi, "L'imperial Regia Direzione delle fabbriche," in *Neoclassico: Arte, architettura e cultura a Trieste 1790–1840*, ed. Fulvio Caputo (Venezia: Marsilio Editori, 1990), 435; Fiorenza De Vecchi, "La normativa edilizia (1801–1854)," in *Neoclassico: Arte, architettura e cultura a Trieste 1790–1840* (Venezia: Marsilio Editori, 1990), 440–442; Rossella Fabiani, "Pietro Nobile: architetto ingegnere," in *Neoclassico: Arte, architettura e cultura a Trieste 1790–1840*, ed. Fulvio Caputo (Venezia: Marsilio Editori 1990), 448–451.

4 Fiorenza De Vecchi and Lorenza Resciniti, "Esami di abilitazione per le maestranze edilizie," in *Neoclassico: Arte, architettura e cultura a Trieste 1790–1840*, ed. Fulvio Caputo (Venezia: Marsilio Editori, 1990), 443–447.

5 UAABKW, VA ex 1810, fol. 252-253: Nobile from Trieste to Doblhoff-Dier, 6 October 1810.

6 Gino Pavan, "Pietro Nobile, i francesi e un padiglione trionfale per Napoleone," *Archeografo triestino* 71 (2011): 79.

7 Fiorenza De Vecchi, "Pietro Nobile funzionario presso la direzione delle fabbriche," *Atti e memorie della società di archelogia e storia patria* 91 (1991): 68. Nobile suggested themes for pictorial and decorative work on the main hall of Palazzo della Borsa see Enrico Lucchese, "Un disegno di Pietro Nobile per il volto della gran sala nel palazzo della Borsa di Trieste," *Atti e memorie della Società istriana di archeologia e storia patria* 105 (2005): 475.

8 De Vecchi, "Pietro Nobile funzionario," 62.

9 Archivio di Stato di Trieste, *Imperial Regio Governo del Litorale*, folder 1231.

10 Gino Pavan, "Pietro Nobile: discorso per l'inaugurazione del Gabinetto di Minerva Trieste, 1 January 1810," *Archeografo triestino* 53 (1993): 9–21.

11 Alberto Tanzi, *Alcune lettere del dottore Domenico de Rossetti* (Milan: Tipografia Fratelli Rechiedei, 1879).

12 Pietro Nobile, *Progetti di vari monumenti architettonici immaginati per celebrare il trionfo degli augusti alleati, la pace, la Concordia de'popoli e la rinascente felicità di Europa nell'anno 1814* (Trieste: Imp. Reg. privilegiata Tipografia Governiale, 1814).

13 Elvio Guagnini, "Minerva nel regno di Mercurio," in *Neoclassico: Arte, architettura e cultura a Trieste 1790–1840*, ed. Fulvio Caputo (Venezia: Marsilio Editori, 1990), 43–47; Fabio Cossutta, "Classicismo e 'Neoclassicismo' in Domenico Rossetti," in *Neoclassico: Arte, architettura e cultura a Trieste 1790–1840*, ed. Fulvio Caputo (Venezia: Marsilio Editori, 1990), 105–113; Fulvio Salimbeni, "La prima serie dell' 'Archeografo Triestino' (1829–1837): Una rivista di eruditi impegno civile," in *Neoclassico: Arte, architettura e cultura a Trieste 1790–1840*, ed. Fulvio Caputo (Venezia: Marsilio Editori, 1990), 115–119; Paola Bonifacio, "La Società di Minerva e Domenico Rossetti," *Neoclassico* 6 (1994): 61–75; Rossella Fabiani, "Dopo Winckelmann: la Società di Minerva," in *Trieste 1768: Winckelmann privato*, ed. Maria Carolina Foi e Paola Panizzo (Trieste: Edizioni Università di Trieste, 2019), 113–116.

14 Rossella Fabiani, "Pietro Nobile e la chiesa di S. Antonio Nuovo," *Archeografo triestino* 40 (1980): 101–109. Eadem, "L'architetto Pietro Nobile," *Arte in Friuli, Arte a Trieste* 4 (1980), no. 10, 77–89. Eadem, "La chiesa di S. Antonio Nuovo," in Franco Firmiani, *Arte neoclassica a Trieste*, con testi integrativi di Rossella Fabiani e Lucia D'Agnolo (Trieste: B & MM Fachin, 1989), 121. Eadem, "Sant'Antonio Nuovo: il concorso e i progetti," in *Neoclassico: Arte, architettura e cultura a Trieste 1790–1840*, ed. Fulvio Caputo (Venezia: Marsilio Editori, 1990), 461.

15 Known as Sant'Antonio Nuovo. The church was completed and opened for worship in 1849.

16 Fabiani, "La chiesa," 123.

17 Many illustrations that can be ascribed to the church are preserved in the Nobile Collection, while the preparatory drawings are kept in the Archivio degli scrittori e della cultura regionale della Università degli Studi di Trieste. Gino Pavan, "Pietro Nobile: gli studi preparatori per il tempio di S. Antonio a Trieste nella collezione Fonda Savio," *Archeografo triestino* 54 (1994): 37; Laura Paris, *Guida al lascito Antonio Fonda Savio*, introd. Nicoletta Zanni (Trieste: Edizioni Universita di Trieste, 2015).

18 The church project with plan and elevation views is included in volume 70 of the Pietro Nobile Collection. "Many parts are to be commended but many are lamentable. As for the former, the apse of the Tribune is beautiful, the order is not to be sneered at and the altars are well placed; but the decision to use a dome was bad," Jean-Louis-Nicolas Durand, *Recueil et parallèle des edifices de tout genre, anciens et modernes: remarcables par leur grandeur ou par leur singularité par J.L.N. Durand augmenté de plus de 300 autres bâtimens et de l'Histoire Générale de l'architecture de I. G. Legrand* (Venezia: Giuseppa Antonelli, 1833), 76 see Fabiani, "La chiesa," 132.

19 AST, Prot. 3215/1007, Fasc. 24, folder F 101 (1809); Giuseppe Caprin, *I nostri nonni: Pagine della vita tirestina dal 1800 al 1830* (Trieste: Sab. art Tip. G. Caprin Editore, 1926), 114. Fiorenza De Vecchi, *Il luogo e la storia. La toponomastica storica di Trieste: alla scoperta del sito quale bene culturale. Vol. 2: Il Borgo Giuseppino* (Trieste: Biblioteca civica Attilio Hortis, 1992), 49; Pietro Nobile, "Descrizione del Prospetto da costruirsi nella Piazza Lützen in Trieste," *Osservatore triestino*, 25

June, 1813, 268–269; Attilio Gentile, "Di un precedente dei premi municipali e di un progetto di Pietro Nobile," *Archeografo triestino*, 8–9 (1945): 417.

20 Maria Walcher, "Chiesa di San Pietro," in *Istria: Città Maggiori: Capodistria, Parenzo, Pirano, Pola: opere d'arte dal Medioevo all'Ottocento*, ed. Giuseppe Pavanello and Maria Walcher (Mariano del Friuli: Edizioni della Laguna, 2001), 247; Sonja Ana Hoyer, *Casa Tartini di Pirano: Evoluzione storica e apparato decorativo* (Koper: Lipa, 1993), 35.

21 Girolamo Agapito, *Descrizione storico-pittorica della fedelissima città e porto franco di Trieste* (Trieste: Italo Svevo, 1972), 189.

22 De Vecchi, "Pietro Nobile direttore," 121–128; Dorsi, "L'Imperial regia" 435–439; Gino Pavan, "Pietro Nobile conservator di monumenti antichi," in *Neoclassico: arte, architettura e cultura a Trieste 1790-1840*, ed. Fulvio Caputo (Venezia: Marsilio Editori, 1990), 194–201; De Vecchi, "Pietro Nobile funzionario," 53–78; Sandra Dellantonio, "Pietro Nobile archeologo," *Archeografo Triestino* 59 (1999): 339–370; Michela Maguolo, "La tutela dei monumenti: Pietro Nobile a Trieste," *Neoclassico* 4 (1993): 47–59; Rossella Fabiani, "La scoperta dell'antico a Trieste ed in Istria all'inizio dell'Ottocento: Pietro Nobile archeologo," in *L'architecture de l'Empire entre France et Italie*, ed. Letizia Tedeschi and Daniel Rabreau (Mendrisio: Silvana Editoriale, 2013), 383–394.

23 Rossella Fabiani, ed., *Pagine architettoniche: I disegni di Pietro Nobile dopo il restauro* (Pasian di Prato: Campanotto, 1997). Eadem, Fabiana Salvador and Giorgio Nicotera, *Gli svizzeri a Trieste e dintorni: Pietro Nobile* (Trieste: Circolo svizzero di Trieste, 2018). The illustrations can be found in volume 37 entitled *Chiese/Studj. piante, facciate, spaccati* (churches/studies: plans, facades, cutaway views), which contains plans for religious buildings. They show a facade featuring a pediment over a Diocletian window and an entrance door flanked by fluted pilasters or columns with Doric capitals. The facade elevation follows a chapel-like model, with very linear decoration formed by columns or pilasters and Doric capitals in accordance with theoretical requirements for the architectural composition of small churches.

24 Gino Pavan, *Il tempio d'Augusto di Pola* (Trieste: Istituto giuliano di storia cultura e documentazione, 2000).

25 *Trouver Trieste. Portraits pour une ville: fortunes d'un port adriatique* (exh. catalogue Trouver Trieste, Paris, Conciergerie 1985–1986), ed. Luciano Semerani (s.l.: Electa, 1985), 90–97.

26 Dellantonio, "Pietro Nobile archeologo," 339; Rossella Fabiani, "Pietro Nobile archeologo e conservatore," in *Artisti in viaggio 1750–1900* (Venezia: Ragione autonoma Friuli Venezia Giulia, 2006), 59.

27 ADT, 1/1-A-17 see Almerigo Apollonio, "Trieste tra guerra e pace (1797–1824)," *Archeografo triestino* 55 (1995): 330. Idem. "La Venezia Giulia francese: un'anomala 'province de l'Istrie' nell'ambito delle Province Illiriche," in *Napoleone e Campoformido 1797: Armi, diplomazia e società in una regione d'Europa* (exh. catalogue Villa Manin, Passariano of Codroipo) (Milano: Electa, 1997), 85. Idem. "Le province illiriche. Economia e società nell'età napoleonica," *Ricerche di storia sociale e religiosa* 25 (1996): 107–125.

28 Pavan, "Pietro Nobile: discorso," 16.

29 Rossella Fabiani, "Il teatro romano di Trieste e Pietro Nobile," in *Il teatro romano di Trieste*, ed. Monika Verzar Bass (Rome: Casa Ed. Quasar u.a., 1991), 236.

30 ADT, Antichità tergestine, Sticotti collection.

31 Ibidem.

32 Anonymus, "[…]," *Osservatore Triestino*, 4 December 1809, no. 96.

33 ADT, Antichità tergestine, Sticotti collection, No. 2666.

34 Lastly, on the protective actions of the Habsburg Empire see *Conservazione e tutela dei beni culturali in una terra di frontiera. Il Friuli Venezia Giulio fra Regno d'Italia e Impero Asburgico (1850–1918)*, ed. Giuseppina Perusini and Rossella Fabiani (Conference proceedings, 30 November 2006), (Vicenza: Terra Ferma Edizioni, 2008).

35 Livia Rusconi, "Pietro Nobile e i monumenti romani di Pola," *Archeografo triestino* 13 (1926): 343–358.

36 AST, *I.R.Governo del Litorale, Atti generali*, b. 18, 15 December 1814.

37 Ibidem.

38 Ibidem.

39 Fiorello de Farolfi, "L'arco romano detto di Riccardo a Trieste," *Archeografo triestino* 21 (1936): 135–147.

40 Rossella Fabiani, "'Si trovano grandiose vestigia di fabbriche': Pietro Nobile ed Aquileia," *Antichità Altoadriatiche* 64 (2007): 219–231.

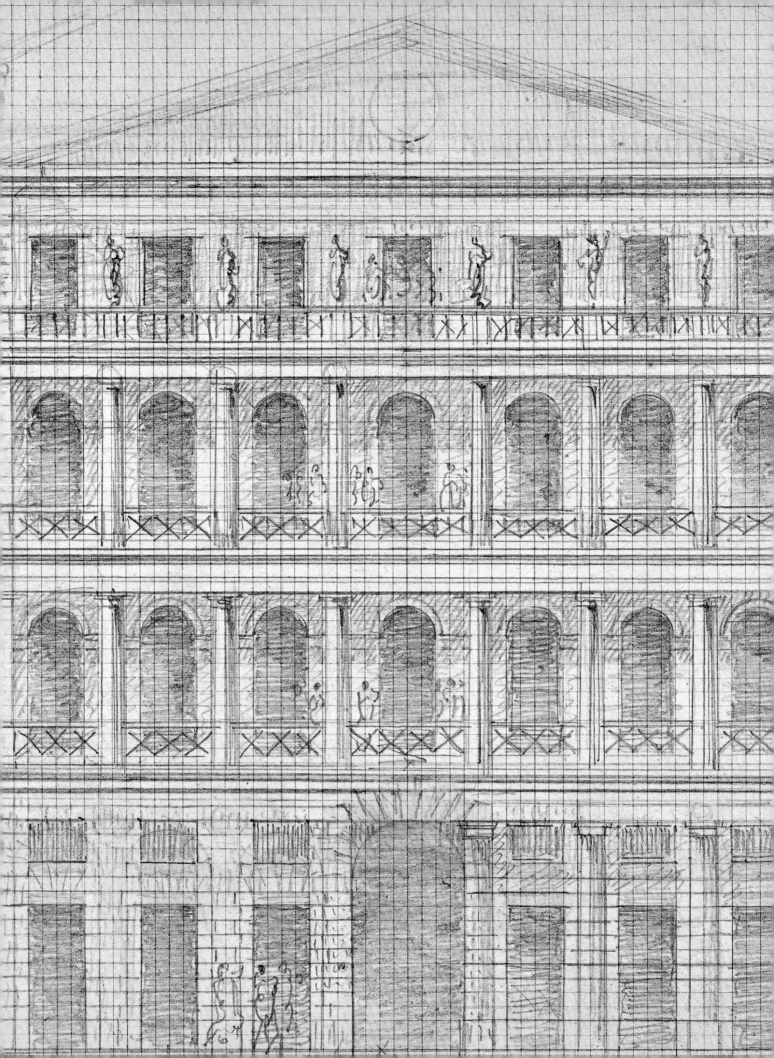

TEACHER AT THE ACADEMY OF FINE ARTS VIENNA

Richard Kurdiovsky

Appointment to the Academy of Fine Arts Vienna

Nobile's time in Trieste and the province of the Littoral was divided between his work as an architect, a senior building official, and an archaeological researcher. These occupations meant that in 1816, when Francis I visited the newly created Lombardo-Venetian Kingdom while on his trip of homage to Tyrol and Salzburg, Nobile was able to act as the emperor's personal cicerone on visits to the ancient sites of Istria[1] and, above all, of Pula (Fig. 94), which Nobile had spent time researching.[2] This personal relationship between the emperor and the architect probably contributed significantly to Nobile finding himself in Vienna some two years later as the head of architecture at the central art authority of the Austrian Empire.[3] The architect Johann Ferdinand Hetzendorf von Hohenberg died in Vienna on 14 December 1816, barely six months after the emperor's visit to Istria. Among those who applied to succeed him as director of the School of Architecture were Andreas Fischer,[4] a professor of architecture who was already teaching at the academy; Joseph Kornhäusel,[5] the building director for Prince Liechtenstein; Johann Aman,[6] the court architect at the Generalhofbaudirektion; and probably also Anton Ortner, who had been architect of the court theatre directorate since 1803.[7] Charles Moreau, who mainly worked as an architect for the noble families of Esterházy and Pálffy, may also have applied. He had been a member of the academy since 1812 and on its academic council since 1813,[8] and he had the support of Metternich[9] after sending him a proposal for reforming the teaching of architecture.[10]

Pietro Nobile's selection was ultimately made by the highest authority. At the beginning of 1817, Francis I commissioned his state chancellor Metternich, in his capacity as curator of the academy, to begin negotiations with Nobile.[11]

Metternich considered Nobile to be the only suitable candidate in the entire empire, and the emperor himself wanted to appoint Nobile to the academy in Vienna. The only obstacles were Nobile's inability to speak German[12] and the fact that the income of the director of the academy in Vienna was less than a third of what he had earned in Trieste as the head of the Landesoberbaudirektion. For this reason, Francis I also wanted to appoint Nobile as Hofbaurat[13] in order to match his existing salary, which meant that in the end he must have earned much more than his colleagues at the academy.[14] By the beginning of December 1817,[15] Nobile was responsible for not only the Academy of Fine Arts Vienna but for all of the building authorities in the empire, as it was believed that his knowledge of the language and the local area would prove to be of great service to his majesty in construction issues in the Italian provinces. As Nobile wrote: "I was granted the department of public works for the whole empire, which is the strongest department of all."[16]

While the emperor himself only appointed Nobile as Hofbaurat, he had no doubt that, at its January 1818 meeting,[17] the academy's council would freely decide to fulfil his wish to make Nobile the academy's new director of architecture.[18] As obsequiously thankful as the approval of the board of directors was, it was clear that Nobile's appointment was not the result of the academy's initiative but had come down from the highest echelons of the state. Indeed, the chairmanship of the council, which was vacant at the time, was held on an interim basis by Sir Josef Hudelist, a state councillor in Metternich's state chancellery, where he had arrived in 1803/04 after a career in the Habsburg embassies in Berlin and Russia. Hudelist was appointed an honorary member of the academy in 1811, at the same time as Metternich, and was accepted into the council of the academy the following year.[19] Whether Hudelist, who as a close colleague of Metternich shared his official views,[20]

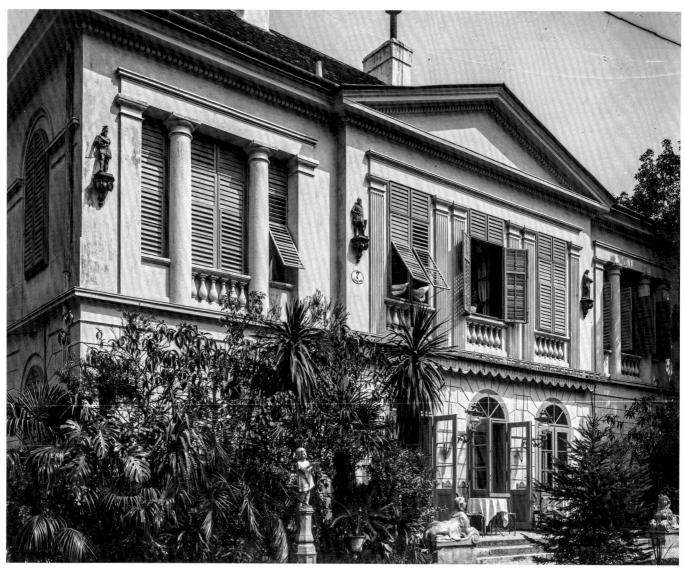

Fig. 50 Pietro Nobile, Villa Hudelist in Baden near Vienna, ca. 1818, anonymous photo, ca. 1900, Vienna, Austrian National Library, picture archive.

was to guide the academy's activities on behalf of the state chancellery or because he was particularly fond of art, we cannot say. In any case, it is striking that Hudelist had Nobile design a villa for him in Baden near Vienna (Fig. 50) at exactly the same time that he was made head of the School of Architecture.[21] Either Hudelist wanted to take the first available opportunity to secure a design from the new director, or Nobile was to be given an immediate opportunity to publicly demonstrate his skills at what was one of the most prominent places in the empire at the time, where the imperial court regularly spent its summer.[22]

The Reform of the School of Architecture

In the first days of January 1819, Nobile had already completed his most important task, presenting his proposal for reforming the teaching of architecture at the Academy of Fine Arts Vienna.[23] At first, everything proceeded quickly, and on 13 January 1819 Metternich explained the concept of the reform to the emperor.[24] But after this, things slowed down because the teaching at the academy had to be coordinated with the architecture courses at the Polytechnisches Institut so as to avoid repetition. What happened over

the following two and a half years only succeeded in putting things off further. [25] In addition to the first public exhibition of works by students from the School of Architecture in the spring of 1820, the acquisition of plaster casts of antique architectural elements, to be used as models, had been approved from on high at the end of 1819.[26] Furthermore, Nobile was commissioned to design various imperial palaces and was also entrusted with the completion of the *Äußeres Burgtor* (a commission that had been taken away from Luigi Cagnola) as well as the Theseustempel and the Second Corti Café. At the same time, Nobile was beginning to come into conflict with other staff members at the academy – in particular the secretary Joseph Ellmaurer, but also the president Count Anton Franz de Paula Lamberg-Sprintzenstein, who felt incensed by Nobile's manners. No doubt, the long-lasting uncertainty about the future of the School of Architecture also contributed to these conflicts, as did, perhaps, Nobile's unceasing activity. Nobile, for example, constantly promoted the achievements of his students, which some academic colleagues may have seen as competitive. In November 1820, about midway through this phase, Francis I officially commissioned Nobile to revise his reform proposal, which was already almost two years old, and to adapt it to the architectural curriculum of the polytechnic. By the summer of 1821, Nobile had fulfilled this task, and in September 1821 Metternich was able to present the new reform plan to the emperor.

Nobile's Reform Proposal for the Teaching of Architecture at the Academy

Nobile's description of his proposed reforms[27] sounds like a quotation from a personal audience with Emperor Francis I: "Give me good architects as soon as possible; this was the revered commandment given by your majesty to the subscriber."[28] Nobile's reform aimed to improve the teaching of architects by eliminating shortcomings in the content,[29] organization, and financing of their training and by creating synergies with the programme at the polytechnic. Nobile proposed "to enable the School of Architecture to educate architects, artists, and architectural decorators, and to produce for the next 10 years architecture students modelled

on the great Italian and Roman works."[30] The reforms concerned the training of three types of building professionals: the actual architects, the craftsmen, and the decorators. What would guarantee the quality of the architecture was the study of the ancient monuments of Rome, the monuments of the fifteenth century,[31] and the works of classical architects such as Palladio. Nobile formulated his criticism of certain historical styles even more clearly in his revised reform proposal of 1821, arguing that the "cattivissimi modelli," that is, the worst models of Bernini and the mannerist artists of the sixteenth century, ruined the good taste that had been successfully introduced.[32] Seen as a whole, Nobile's curriculum reads like a summary of his own professional life, from his research of ancient monuments during his scholarship in Rome to the knowledge of technical architecture he acquired when he was responsible for road and bridge construction in Trieste.[33] As can be seen from Nobile's 1834 report, his reform plan was probably implemented in 1819, essentially as he had formulated it.[34]

Nobile's Reform Plan and Competition with the Polytechnisches Institut

In order to understand Nobile's reform proposal and its innovative potential, we need to take into account the educational context in Vienna at the time, which was certainly no tabula rasa. The Polytechnisches Institut had recently been established[35] and presented significant competition to the traditional architectural education at the academy. In addition, there were military institutions such as the Ingenieursakademie (Engineering Academy),[36] which had emerged in 1717/18 from the Chaos Foundation at the suggestion of Prince Eugene of Savoy. This engineering academy taught mathematics, geometry, mechanics, physics, statics, and hydraulics as part of a military builders' training, along with hydraulic and road engineering as well as civil engineering. At this time, there was a shift in personnel from the Ingenieursakademie to the Polytechnisches Institut. Johann Kudriaffsky, for example, a graduate of the engineering academy and a teacher there from 1813, moved to the polytechnic in 1818/19 as a professor of land and hydraulic engineering to train building officials, civil engineers, and architects.[37]

The Polytechnisches Institut in Vienna was founded on the ideas of the engineer and natural scientist Johann Joseph Prechtl, who had written the organizational plan for the Accademia Reale o Scuola Reale di Commercio e di Navigazione in Trieste in 1807[38] and was commissioned to develop one for the polytechnic in Vienna in 1810. The polytechnic in Prague, founded already in 1806, was also at least partially involved in the development process, as its co-founder and first director, Sir Franz Joseph Gerstner, received an imperial order in 1812 to examine Prechtl's organizational plan for the Vienna polytechnic.[39] Even though Prechtl's plan did not receive official imperial approval until 1817, instruction at the new polytechnic was able to begin as early as November 1815, at least two years before Nobile was considered for the directorship of the academy's School of Architecture.

With the polytechnic, Prechtl wanted to combine technical-scientific instruction with the practical promotion of trade, in a modern form of applied research that followed the example of the École Polytechnique in Paris, founded in 1795.[40] Prechtl was aware of the competition with the academy and specifically emphasized that the polytechnic was a technical educational institution.[41] The academy was to improve the *fine* arts, and the polytechnic the *useful* arts.[42] That Prechtl's programme at the polytechnic would complement the architectural education at the academy was already clear in his opening speech of 1815, in which he listed the contents of the agricultural and hydraulic engineering course (building materials, construction techniques, statics, and the calculation of costs, as well as hydraulics)[43] – just as Nobile's subsequent reform proposal had it. Prechtl's programme was controversial because it inevitably led to the question of whether architecture should be taught entirely at the polytechnic or whether it should remain at the academy. In the course of the academy's internal discussions under the then-president Baron Joseph von Sonnenfels, who felt that the responsibilities of his institution were being unduly limited,[44] the head of the Hofbaurat Joseph Schemerl von Leytenbach explicitly stated that the training of architects at the academy needed to be urgently reformed.[45]

In Nobile's reform programme, presented two years after Prechtl's, it is clear just how similar Nobile's and Prechtl's demands are. From the 1830s onwards, a close relationship existed between Nobile's architecture classes at the academy and those at the polytechnic, partly because the emperor demanded that all students study at the polytechnic before studying architecture at the academy. After Kudriaffsky and his successor Joseph Heinrich Purkyně, a district engineer trained at the Prague polytechnic who taught at the Vienna polytechnic from 1824 to 1827, the professors of architecture at the latter institution all came from the Nobile school: Josef Stummer studied with Nobile from 1827 to 1831[46] (as did his assistant August Sicard von Sicardsburg from 1833 to 1835, after his studies at the polytechnic);[47] Moritz Wappler from 1838 to 1841 (also after the polytechnic);[48] Emanuel Ringhofer from 1842 to 1846 (after attending the Prague polytechnic);[49] and Adolf Gabriely from 1847 to 1850 (after attending the Vienna polytechnic).[50]

Nobile's Reform Plan: Architecture as an All-Encompassing Art

The starting point for Nobile's presentation was the eminent importance of his own discipline: architecture as the "Arte principale di tutte le altre,"[51] the principal art of all the others. The means allowing architecture to achieve its goals are nature ("natura"), the mind ("ingegno"), the physical and mathematical sciences ("scienze fisico-matematiche"), true beauty ("bello reale"), and taste ("gusto"). In terms of existing architectural theory, this list does not contain any thematic or conceptual innovations, and it focuses on very topical issues. At the end of the eighteenth century, for example, the increasing lack of taste was much discussed, and internationally art authorities were commissioned by the state to monitor good taste.[52]

Particularly in relation to the teaching programmes at the polytechnic and at the engineering academy, Nobile's claim that architecture – as the "Arte principale" contributing to civilization and the economic prosperity of a society[53] – should encompass civil, military, and hydraulic engineering is quite remarkable, in that it claimed for the Academy of Fine Arts the entire field of construction, including its technical aspects. His ideal was therefore the training of the "architect-engineer,"[54] in a context in which, in practice, there was a separation between academically

trained architects and engineers who were trained in the natural sciences.[55] Nobile wanted to bridge this gap, which had already become manifest in a person like Kudriaffsky at the Vienna polytechnic, who made a name for himself as a bridge builder and not as a builder of architecture, the latter being understood as art. Nobile believed that a perfect architecture must be at once viable in construction, beautiful in form, and efficient in function. His colleagues at the academy shared his understanding of architecture as a comprehensive art and, in a council meeting shortly before Nobile's arrival in Vienna, had sharply criticized the fact that the polytechnic claimed to create accomplished architects despite giving completely inadequate artistic training in drawing.[56]

According to Nobile, an architect had to keep up to date with the natural sciences in order to be able to translate their constantly growing knowledge into practice.[57] He was fully aware that scientific methods of calculation in statics and precise design methods had become increasingly important to building construction since the end of the eighteenth century. As for the importance of the natural sciences to the architect, Nobile must have had his eye on the developments at the polytechnic, where Prechtl had based the technical department (to which architecture belonged) on mathematics and the natural sciences.[58]

Nobile's reform plan also referred to labour market policy, arguing that the state should provide work for fully trained architects, by giving them equal status with the district engineers, for example[59] – a suggestion that Prechtl had already made in 1817.[60] Nobile also linked his arguments about the training of architects to the state's responsibility for its economic resources. In public construction, approximately 100 million florins were spent on buildings, 98 million on roads, and 37 million on hydraulic engineering. In view of these enormous budgets, Nobile suggested, it would be irresponsible for state projects to be designed by artistically uneducated engineers. As a result, architects should be complete masters of their profession and therefore be able to exercise total responsibility for a construction project. An engineer, on the other hand, must only be technically competent and should not try to create architecture. Surprisingly, perhaps, it was precisely at this moment, in March 1820, that Nobile successfully lobbied to have the military

engineer Baron Karl Öttel,[61] a colonel of the Ingenieur-Corps, accepted as a member of the academy, although Nobile did note in proposing him that he had excellent architectural knowledge.[62]

Nobile's argumentation sought to guarantee that architecture, as taught at the Academy of Fine Arts Vienna, was seen on the same level as the technical sciences. The latter, with the recent construction of the Polytechnisches Institut between 1816 and 1818 (Pl. XXXVIII), had a magnificent and spacious monumental building, complete with every subsidy and educational apparatus.[63] It was even equipped with the latest technology, namely gas lighting and Meissner central heating.[64] The same recognition and esteem, Nobile suggested, should be afforded to the academic training of architects.

Nobile's Teaching Aid: The *Parallèles*

For Nobile, the central teaching aid for every class at the School of Architecture was the *parallèle* or *paralello*, which he adapted from the publications of Jean-Nicolas-Louis Durand.[65] The *parallèles* not only contained exemplary illustrative material but also provided a method of systematic comparison through observing, thinking, and understanding. Nobile was familiar with Durand, but rather than on technology Nobile focused on the natural sciences, such as mineralogy and botany, which organized their objects typologically and presented them synoptically. Using these methods from the natural sciences, students were able to recognize at a glance the range of architectural forms and proportions. For example, in contrast to Vignola's account, according to Nobile there are more than fifty differently proportioned variants of the Doric order in the preserved remains of ancient architecture.[66] One had to be aware of this diversity rather than of a supposedly canonical scheme of proportions.

The *parallèles* contained two fundamentally different possibilities. The first was the representation of various buildings on the same scale to illustrate their different proportions, a comparative method used by Durand for antique and modern buildings in his *Recueil et parallèle des édifices de tout genre, anciens et modernes*, the first edition of which was

published in 1800. The second was the representation of architectural elements of the same size in order to illustrate the effects of changing the proportions of columns, arcades, etc.[67] Nobile found this second type of representation particularly important, as it allowed the architect to choose the correct proportions for the desired character of a building (Pl. XXXIX).

As there was a general lack of model drawings, Nobile wanted them to be made from scratch and to be printed as teaching aids.[68] These were to be used for the general training of the eye and, more immediately, as a collection of templates for architectural solutions. There were similar methods of systematization being used at the polytechnic, where the Fabriksprodukten-Kabinett, the cabinet of factory-produced objects, in addition to its immediate practical function as a collection of exemplary models, was intended to illustrate the historical development of forms.[69] For Nobile as well as for Prechtl, the basic model was again the École Polytechnique, where the staff was responsible for the production of model drawings and models.[70]

The Impact of Nobile's First Reform Proposal

Nobile's reform proposal of January 1819 did not offer any innovative criticism of architectural education in the German-speaking world.[71] In Vienna, however, Nobile's proposal was the first to suggest a strict and systematic teaching structure, with teaching units that built on each other over the course of study, right up to the final units of free design under the direct supervision of Director Nobile. This approach proved very durable, and a similar sequence of study was still employed by Otto Wagner, concluding with the student's chosen topic for a utopian project in their final year.

Nobile was assertive in his efforts to gain for architectural education at the academy the same level of support that the polytechnic had recently received. He demanded that his teaching staff be paid salaries equivalent to those at the polytechnic,[72] that they be given more classroom space, and that they be allowed to develop an exhibition programme to showcase students' work. His introduction of the *parallèles* as teaching material was completely new; it

was compiled according to a systematic method that ensured the greatest possible clarity at a glance, and it was easily applied by selecting the variant most suitable for the task. More problematic, however, was its use of stencils for assembling architecture from model units – something for which the subsequent generation of architects would come to criticize the Beamtenarchitektur (civil servants' architecture) of the pre-March era, considering it uninspired.[73]

As pertains to distinguishing the curriculum of the School of Architecture from that of the polytechnic, this was less a question of competition between Nobile and Prechtl, who may have known each other from their time together in Trieste, and more about directing their efforts towards the same goal. In this sense, and despite all the duplication and competition between the two institutions, a large number of Nobile's graduates, including the most important among them, such as Paul Sprenger and August Sicard von Sicardsburg, either received their training at both institutions or later worked at both of them.

The Reform of the Reform Plans

It took more than a year and a half before a clear response to his reform proposal arrived, during which time Nobile continued with his provisional teaching. On 6 November 1820, Francis I demanded that the teaching of civil, land, road, and hydraulic engineering be carried out at the polytechnic in accordance with Prechtl's organizational plan and that the sublime aesthetics of architecture be taught at the academy.[74] In the future, by imperial order, architects were to begin studying at the polytechnic and then transfer to the academy to complete their study.[75] This was a clear demand for, on the one hand, a separation of competences and, on the other, for the two competing institutions to be combined, under the artistic authority of the academy.

Metternich presented Nobile's revised reform plan to the emperor on 18 September 1821.[76] In it, Nobile basically repeated his ideas of January 1819, clarified them in some areas, and found clearer criticisms of the limiting of architectural education to the polytechnic. If after graduating from the polytechnic students were immediately employed as district engineers with the state building authorities, No-

Fig. 51 Pietro Nobile or students of the Academy, Model drawing of a Parallèle for balusters of varying proportions, pencil and ink, after 1819, Trieste, SABAP FVG, Fondo Nobile.

bile feared that they would not continue their studies at the academy. In fact, in 1827, for example, only a small number of graduates from the polytechnic in turn attended the academy, while a much larger group studied exclusively at the academy before working as nothing more than theatre and perspective painters or as draughtsmen for architects.[77] As a result, Nobile argued, attendance at the academy after the polytechnic had to be made compulsory to raise the quality of architecture in the empire.[78] This never happened, however, and what finally emerged in the 1820s actually contradicted Nobile's concept of the comprehensive training of an architect, seeming instead like a rather vague and hasty compromise. In 1829, the council of the academy stated that education at the polytechnic should ultimately differ from that at the academy in terms of building typology: all building types were to be taught at the polytechnic except splendid buildings, such as magnificent churches, palaces, theatres, etc., which would be reserved for the high art of fine architecture.[79]

Furthermore, Nobile argued in his revised reform that study should be oriented around contemporary building problems, the climatic and regional conditions in the Habsburg Empire, and its regional customs and traditions.[80] In addition, Nobile even specified individual lectures, which contained a conspicuous amount of historical material, in particular the "storia ed archeologia delle fabbriche" (the history and archaeology of built works). Students, especially those studying theatre painting, had to be taught all historical architectural styles. In this way, Nobile expanded the limits of pure Neoclassicism, at least theoretically, as early as 1820/21.

At the beginning of his first semester at the academy, Nobile, with Metternich's permission,[81] commissioned a number of students along with his teaching staff to produce model drawings[82] – very much like at the polytechnic, where the institution's own craftsmen produced three-dimensional models in specially equipped workshops, under the supervision of the professor of mechanical engineering, to serve as teaching and illustrative materials.[83] At the academy, Georg Pein was to make a systematic representation of the Ionic order in various proportions, following the example of Durand's *Parallèle*, corrector Wilhelm Ostertag produced the Doric drawings, and graduate Andreas Zambelli[84] the Corinthian.[85] When Nobile presented his reform proposal for the

School of Architecture, he could already proudly point to a large number of plates, primarily in watercolour and representing twenty-four categories, which not only included the classical orders but also architectural elements such as bases, architraves, balustrades, doors, and windows (Fig. 51).[86]

It is likely that, in the course of this work, Nobile met and came to appreciate people who would in turn help shape architecture classes in the years to come. When Nobile found particularly outstanding draughtsmen,[87] like Ferdinand Kilian and Ludwig Christian Förster,[88] he apparently paid them out of his own pocket. The former was a graduate of the Academy of Fine Arts Munich who had worked for Nobile before he was appointed corrector at the School of Architecture in 1835,[89] and the latter,[90] who had just completed his training, also with Carl Fischer in Munich, may have been involved in other Nobile building contracts.

While there were obviously talented draughtsmen among Nobile's first students, their architectural qualifications were not yet sufficient in his eyes,[91] and he explicitly forbade their participation in the competition for the Hofpreis of 1819 and for the Rome scholarship.[92] Only Franz Xaver Lössl was to meet Nobile's expectations in this respect.

Personnel Politics at the School of Architecture: The Existing Staff

In his reform proposal of January 1819, Nobile did not describe in glowing terms the qualifications of his teaching staff – the professors Andreas Fischer for architecture, Johann Georg Pein for ornament and perspective, and Johann Conrad Abbé Blank for mathematics, as well as the corrector Wilhelm Ostertag – although he did emphasize Pein's and Ostertag's achievements in the production of the model drawings.[93] Apart from copying stencils, which was Hohenberg's method of teaching, they lacked first-hand experience of the "Capi di opera dell'Arte," those ancient monuments that could only be discovered on expensive trips to Rome.[94] Since 1805, that is, since Nobile's own travel grant, the Rome scholarship of the School of Architecture had not been awarded.[95] Although the professors had dutifully presented Milizia's teachings in their lessons, Nobile claimed that they

had not explained his ideas, let alone illustrated them on the blackboard.[96] He touched on how difficult it was in the Habsburg Empire to find teachers who were well versed in the subject and suitable for academic teaching, pointing out that no one had yet been found to give architecture lessons at the polytechnic, despite the salaries there being considerably higher than at the academy.[97] It is unclear whether this statement concealed a disparaging assessment of Kudriaffsky, who took up the professorship for land and hydraulic engineering at the polytechnic at this time.

Rivals: Ludwig Christian Förster as Corrector at the School of Architecture

In October 1819, Andreas Fischer, the professor of architecture at the academy, died, and Nobile wanted to replace him with corrector Ostertag.[98] Ostertag had practical experience through his own construction work, along with pedagogical experience, having frequently replaced Fischer when he was ill or when he was employed by the provincial office of public works of Lower Austria.[99] The most remarkable personnel decision, however, concerned the choice of Ludwig Christian Förster as the new corrector; Nobile had privately employed Förster to prepare model drawings and must therefore have felt that he was particularly competent. But so long as Nobile's reform plan as a whole was not sanctioned by the emperor, Förster's appointment could only be provisional.[100] Nobile characterized the young candidate Förster as a good draughtsman (Pl. XL) who could prepare cost estimates and write art essays – an assessment confirmed a little more than a decade later when Förster began to publish the *Allgemeine Bauzeitung*.[101]

The next few years must have been to everyone's satisfaction. Probably in order to promote his claims to the vacant professor position, Förster was allowed from January 1823 to lead his own course in architectural drawing and preparation for higher architecture. Nobile was apparently very satisfied and praised Förster's proven skill as well as his hard work, the latter having achieved more than he was strictly obliged to. Consequently, in the summer of 1823, Förster was appointed to the regular staff of the School of Architecture.[102]

When Förster wanted to resign from his position as corrector in April 1826, however, a professional and possibly also a personal break seems to have occurred. Förster asked for a three-week leave of absence in order to be able to carry out private commissions in Hungary, which would supplement his small corrector's salary. Because there were many opportunities to work independently in the art field, he asked for his contract as corrector to be terminated but offered to continue giving evening classes free of charge to prove his loyalty to the academy.[103] One can sense some disappointment in Nobile's reaction,[104] but Förster's requests also reaffirmed Nobile's demand for higher salaries at the academy. Förster had recently not only been allowed to reduce his working hours, but the School of Architecture had also offered him additional income to make model drawings for Vienna and Lviv. Now Förster was tempted by other, more beneficial occupations. His offer of free courses was laudable, but such courses would have to be in harmony with the reformed architecture classes. In the end, the possibility that Förster's private activities might force him to interrupt or cancel his teaching led Nobile and Pein to reject his offer.[105] Similar criticisms were voiced when Förster was ultimately appointed a professor in 1842.

In the intervening years, Förster had only occasional contact with the academy. In April 1828, he asked for a testimonial on his work as corrector in order to be able to take over the lithographic institute Mansfeld and Company[106] and to run it further under his own name.[107] In February 1836, when the council of the academy discussed the first admission of art members since 1824,[108] it seems Förster asked to be admitted on the grounds of his establishing the *Allgemeine Bauzeitung*, and he was told that he had to apply like all the other candidates.[109] In fact, Förster was never accepted as an art member of the academy. Rather, when the architects Carlo Amati, Leo von Klenze, Georg Moller, Karl Friedrich Schinkel, and John Soane, along with Friedrich Gärtner and Angelo Uggeri at Nobile's explicit suggestion,[110] were appointed honorary members,[111] only art members were selected who adhered entirely to the neoclassicist canon: Franz Xaver Lössl as well as the Hungarian architects József Hild and Mihály Pollack.[112] It was not until 1842 that Förster was to return to the academy, this time as a professor and with the support of Nobile, even though he was not entirely

sure of Förster's loyalty: "My business in Prague now lies in the hands of Förster, and I cannot tell you how honourable his demeanour will be in my regard, for in my experience my pupils can be my most overt enemies." [113]

Pupils: Carl Roesner and Franz Xaver Lössl

In November 1826, Nobile proposed Carl Roesner to fill Förster's post as corrector (active 1826–1835).[114] Roesner had studied under Nobile (Fig. 52) and, on his advice, had attended the polytechnic.[115] In contrast to Förster, however, Roesner probably never worked directly for Nobile, which is why Metternich only appointed him provisionally in February 1827, to give Nobile a chance to assess his new employee's abilities. As Roesner apparently performed his supplementary tasks, such as supervising the placement of the plasterwork at the School of Architecture,[116] to Nobile's complete satisfaction, he was definitively appointed, along with Paul Sprenger,[117] in October 1828.

In those same years, Nobile proposed for the Rome scholarship one of his most talented students, Franz Xaver Lössl, so that he could educate himself to become an excellent architect useful to the state.[118] Lössl had studied at both the polytechnic and the academy, and had won several academy prizes, among them the Hofpreis of 1823 for his design of a national theatre[119] "in the Greco-Roman style" [120] (Pl. XLI). In the spring and summer of 1824, under Nobile's direction, Lössl had not only produced model drawings for the architecture classes given by Ignaz Chambrez in Lviv[121] but was responsible for this work.[122] As a result, Lössl was the first student Nobile could most highly recommend for study in Rome, a fact Metternich emphasized in his submission to Francis I.[123]

When a potential extension of Lössl's stay in Italy came up, Nobile made clear that he wanted to bind him to the academy.[124] If drawing classes for building professionals were to be established per Nobile's proposal, then Lössl would be the most suitable candidate to teach them. Later, in the course of 1830, when Lössl won a contract to construct the building for the Musikverein on the street Unter den Tuchlauben in Vienna,[125] Nobile suggested him to replace Roesner as corrector,[126] who on his part was approved for the Rome scholarship at the turn of 1831.[127]

Nobile had suggested that Roesner apply for a Rome scholarship in May 1829,[128] as this would give him the excellent training required for any architectural construction and for successfully fulfilling the teaching entrusted to him.[129] In contrast to Lössl, Roesner had never won the Hofpreis, and in Nobile's eyes he still needed to acquire essential skills necessary for an architect. Unlike the previous Rome scholarship holders, Roesner travelled to Sicily (1833),[130] following the example of architects like Karl Friedrich Schinkel (1804), Charles Robert Cockerell (1812), Friedrich Gärtner (1816), Jacques Ignace Hittorff (1820 and 1823), and Leo von Klenze (1823/24). The first graduate of the academy in Vienna to visit the island, Roesner was there coincidently at almost the same time as Gottfried Semper, who travelled in southern Italy and Greece between 1830 and 1833. After this, only Sicardsburg and van der Nüll were to set foot on Sicilian soil as scholarship holders from the Vienna academy.

When Roesner resumed his regular work as corrector in the winter semester of 1833/34,[131] he received support from the highest authorities, and, through Metternich's mediation, Francis I even gave him in an audience.[132] When he presented his drawings from Italy at the academy in March 1834, Roesner was met with a very positive response and was described as an effective member of the teaching staff.[133] That Roesner would be the successor to Georg Pein, who had recently died, seemed obvious; this was also Nobile's choice, and he proposed him for the position in May 1835.[134]

For Lössl, the graduate whom Nobile had previously favoured, things did not turn out so well. Possibly to avoid getting in Roesner's way, Lössl did not apply for Pein's position at the School of Architecture. Instead, he applied for the position of professor of ornamental drawing at the School of Engraving and Metal Cutting, which is why he had, as he wrote, specialized in this subject in Rome.[135] Nobile had wanted to employ Lössl as early as 1829, but this wish remained unfulfilled as Lössl's application was rejected. His appointment as an art member in 1836 was perhaps an effort by the council to offer him some consolation. His application for a professorship at the School of Architecture in 1842[136] was also unsuccessful. By this time, the requirements for personnel had changed noticeably and, as far as questions of style were concerned, also artistically.

Opponents: Paul Sprenger, Professor of Mathematics and Perspective

Paul Sprenger, if we follow the requests to speak in the academy council meetings, was the professor who most clearly opposed Nobile.[137] Sprenger had studied under Nobile at the academy, as well as at the polytechnic, without attracting much attention, only winning the Gundel Prize for decorative drawing in 1818. After an internship at the hydraulic engineering directorate of Lower Austria, from March 1824 he worked in the department of land and hydraulic engineering at the polytechnic as Purkyně's assistant, whom he had to replace several times on account of illness.[138] On 13 February 1827, following the murder of Abbé Johann Conrad Blank, the mathematics professor at the academy,[139] Nobile suggested Sprenger (on an initially provisional basis) as the most suitable replacement, given that he was already experienced as a teacher. Just under a year later, he was appointed to the position at the academy (active 1827–1842), at the same time that Roesner was permanently made corrector.[140]

Sprenger's career as an architect ran parallel to his teaching activities at the academy. In November 1834, Francis I commissioned him to build the central office of the Austrian Mint in Vienna, one of the most prominent public constructions by the state administration after the polytechnic.[141] In May 1836, he was commissioned to build the new central customs office at the meeting point between the Wien River and the Danube Canal.[142] Finally, in July 1836 Sprenger was appointed as a member of the commission that was to manage the construction of the Emperor Ferdinand Aqueduct.[143] With these commissions, Sprenger rose to become the leading state architect in the empire:[144] "Sprenger enjoys the highest protection of those on high who see him as a superior genius, he has become the man in vogue."[145] His career at the academy, however, was rather modest, with him taking over the professorship of perspective and the theory of shadow after Pein's death in 1835, while Roesner taught architecture.[146] At the turn of the school year of 1836/37, Sprenger accepted an offer of membership from the recently founded Institute of British Architects in London, which was soon to rise to the rank of a royal institute[147] – an international recognition that Nobile would not receive until 1838.[148] Sprenger's activities outside the academy,

above all in the Lower Austrian Gewerbeverein (Trade Association),[149] founded in 1840, were so numerous that he left teaching in 1842 when he was appointed as Hofbaurat. He thus not only sat on the same committee as Nobile for almost a quarter of a century but was also his equal in official rank. And when it came to the question of the forthcoming replacements at the academy, he understood how to exert his influence effectively.

Changes at the School of Architecture between 1842 and 1845

The council's deliberations between November 1842 and November 1843 concerning replacements for Wilhelm Ostertag's and Paul Sprenger's professorships, which in Nobile's own words was a "fastidio"[150] (annoyance), reveal for the first time clear differences of opinion between Nobile, as the director of the School of Architecture, and his colleagues.[151] While this initially concerned organizational matters, the dispute also touched on questions of the correct architectural style, and this came out in the preference for or rejection of various candidates. Clearly, the door to Early Historicism was now open.

All agreed on one thing: Nobile, Roesner, and Sprenger supported the candidacy of Förster, who was then working with Karl Etzel on the new swimming hall for the Diana Bath, the first large iron hall construction in Vienna. Förster was predestined for the position because of his various activities as an architect, industrialist, and publisher, and in particular his *Allgemeine Bauzeitung*, which was praised throughout Europe, giving him valuable international contacts, and for which both Roesner and Sprenger worked, as deputy editor and author respectively.[152] Nobile, on the other hand, agreed to Förster "per il bene accademico più che il mio"[153] (for the academic good, more than my own).

However, the members of the School of Architecture disagreed on the candidates for Sprenger's professorship, an issue that was connected to their demand for reforms in the teaching of architecture. Before a decision was made on staffing, Sprenger wanted clarity on the relationship between the courses offered by the academy and those by the polytechnic, in order to resolve whether the technical part

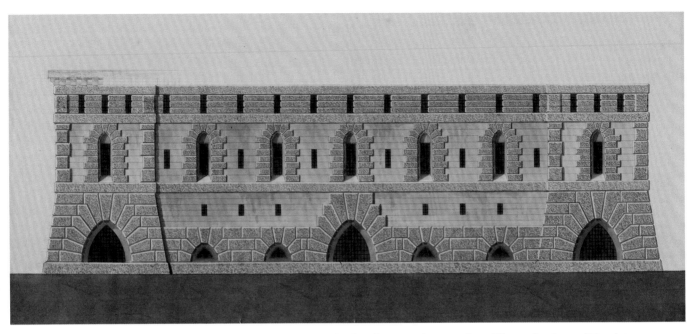

Fig. 52 Carl Roesner (attributed), Design for prison, elevation, pencil, ink with watercolour, ca. 1820s, Vienna, Academy of Fine Arts, Kupferstichkabinet.

of the training should be more firmly anchored at the polytechnic and whether a separate professorship for ornament should be established at the academy. In January 1843, Förster was commissioned to draw up a reform plan addressing this issue, but he left the teaching staff in 1845 without having submitted it. As a result, the matter became less about reform and more about the relationships among the men who were expected to produce innovative architectural work.

Sprenger's demand must have been very offensive to Nobile, given that he had been brought to Vienna more than twenty years earlier precisely to reform the relationship between the academy and the polytechnic. Sprenger seemed to be suggesting that Nobile's reforms now needed to be reformed. If we consider as an example the reforms that the Lower Austrian Gewerbeverein was attempting to make, it is striking that these did not so much concern methodology and objective as the question of what the ideal style should be. Everyone wanted to combine art, industry, and science by creating collections of models and model drawings, but the Gewerbeverein criticized the academy for having become alienated from practical life, and in an era of growing nationalism demanded that German art of the Middle Ages also be used as a model.[154]

As on previous occasions, Nobile championed his most successful students, those who had received the Hofpreis and the Rome scholarship. This time, he nominated as his first choice Joseph Haslinger, who had established himself as an architect in the Styrian provincial office of public works and whom Nobile held in high esteem,[155] then Franz Xaver Lössl, who had already been sponsored several times, and finally August Sicard von Sicardsburg as his third choice.

Haslinger was a graduate of the academy and the polytechnic,[156] had, like many other of Nobile's students, worked as a trainee with the Hofbaurat in the early 1830s, had won the Hofpreis in 1829, and after undertaking the academy's Rome scholarship was employed at the provincial office of public works in Lviv before moving to the one in Graz. There, he was very active in the construction of both religious and civil buildings all over the crown land of Styria, including in what is today Slovenia. In contrast to previous Rome scholarship holders, Haslinger visited Munich on his return journey to study the latest architectural work being undertaken there, including the buildings by Klenze on Königsplatz and especially those by Gärtner on Ludwigstraße, which were largely completed, as well as the latter's Feldherrnhalle, which was at the planning stage. Haslinger's turn away from neoclassicist ideas can be seen, as it can in Roesner's work,

Fig. 53 Carl Roesner, Johann Nepomuk church on Jägerzeile (today Praterstraße) in Vienna, elevation of the main façade, 1841–46, *Zeitschrift für praktische Baukunst* (ed. J. Andreas Romberg) 8 (1848), plate 28.

in the small-scale, fine decoration on his clearly stereometric cubes, whose motifs, such as rounded-arch friezes, are borrowed from medieval architecture (Fig. 58).

As with his previous applications, Lössl's chances were poor. Nobile's second choice had recently planned a series of large apartment buildings in prominent locations in downtown Vienna and the parish church of Altmannsdorf, a village south of Vienna, but his work did not cohere stylistically with the younger generation of teachers at the School of Architecture. Indeed, Roesner, who was working on his church of St John of Nepomuk in today's Praterstraße (Fig. 53) and the parish church of Meidling, criticized Lössl's style, saying that since his stay in Rome public taste had changed, no longer simply demanding Greek or Roman styles but an all-round education without any specific orientation.[157] As ambiguous as Roesner's statement is, it also reveals how his generation longed for something new and did not want to be limited in its choice of historical models.

The candidate that everyone finally agreed on was another Nobile pupil, Sicardsburg. He too had studied at both the academy and the polytechnic, working at the latter institution from 1835 to 1839 as an assistant to Purkyně, as Sprenger had done before him. He won the Hofpreis of 1838 with his design of a stock exchange building, sharing it with van der Nüll – the first time the Hofpreis and the Rome scholarship were awarded to two architecture students at the same time. Nobile justified this remarkable decision by stating that both students were equally suited to civil service and that he supported their wish to spend half of the time studying in France, England, and the Netherlands, where, according to Nobile, great progress had recently been made in the field of building science and especially in building construction.[158] Although the council agreed to this only after lengthy discussion, it was obvious that exemplary solutions were now to be found in Western Europe for the new demands on architecture. While Nobile saw these as primarily technical achievements, for Sicardsburg and van der Nüll they also involved new historical models, as the use of French Renaissance forms in their later work clearly indicates. Sicardsburg and van der Nüll were not the only students applying for a study trip to Western Europe. At almost the same time, Johann Marschick, who was on a leave of absence from his internship at the Bohemian provincial of-

fice of public works to pursue academic studies, also applied for financial support for a trip to Italy, France, the Netherlands, and northern Germany.[159] In supporting his application, Nobile pointed out the growing construction industry in Bohemia and the future responsibilities of the state building authorities.[160]

Nobile must have respected Sicardsburg because he commissioned him to produce construction drawings of his monument in Chlumec[161] and recommended him in May 1839 as the foreman for an unspecified reconstruction of a treasure chamber, possibly in the Vienna Capuchin Monastery.[162]

After Sprenger and Roesner demanded clarity about the reform plan for the School of Architecture and the nature of the professorship to be awarded, the council made a majority decision against Nobile in only provisionally awarding the professorship.[163] This clearly blocked the candidates preferred by Nobile because the most promising of them, Haslinger, who could probably not be rejected on stylistic grounds, was not interested in giving up his post in the Styrian provincial office of public works for a provisional position at the academy. In November 1843, Nobile finally voted in favour of Sicardsburg's provisional appointment. He expressly hoped that, in view of what he considered a crisis in architecture in Germany,[164] Sicardsburg would strive to embellish and maintain classical architecture.[165]

At the same time, van der Nüll was unanimously chosen as professor of ornamentation and perspective because of his skill in ornamentation. And when Förster departed from the teaching profession in July 1845, Director Nobile and his professors Roesner and Sicardsburg unanimously voted van der Nüll his successor.[166]

From the "Neoclassicist" Nobile to the Beginning of Historicism

In the history of Viennese architecture, Nobile is depicted as an exemplary neoclassicist who referred exclusively to antiquity and the classical architects of the Renaissance.[167] As he held important positions in the state administration (being director at the academy and member of the Hofbaurat) Nobile – along with his colleague Paul Sprenger, who has been even more fiercely criticized because of his domi-

nating position in the public administration – has been held responsible for turning Neoclassicism into a doctrinaire state style that unimaginatively removed art from pre-March architecture and, above all, passed on this Beamten-architektur through teaching at the academy. Allegedly, it was only the revolutionary uprisings of 1848 and the rebellion by the hitherto-suppressed forces of reform that brought liberation and the long-awaited upswing in Austrian architecture. Unsurprisingly then, Nobile applied for retirement in January 1849.[168]

This bleak narrative about architecture in the pre-March era was, however, essentially constructed by the art critic and first art historian of the University of Vienna, Rudolf Eitelberger (1817–1885),[169] who used it to support his criticism of the architecture of the state and municipal building authorities of his own time.[170] According to Eitelberger, all the building needs of a given time could not be solved using the principles of any single architectural style. Especially for church building, one should not use ancient styles, as one should be a pupil of but not a slave to Greek art – especially in the face of architects "who perhaps know Vitruvius by heart and with fearful conscientiousness adhere to the measurements they have taken from archaeological books or monuments of classical antiquity, like most architects of Italy,"[171] an argument that sounds like it refers directly to Nobile. This narrative was continued by subsequent generations until it became an accepted fact, such that Ludwig Hevesi, for example, later described Nobile as the "Baukom-mandanten von Wien" (commander of building in Vienna") and as a "strenger Autokrat des Klassizismus [...] unduldsam gegen alle Andersgläubigen" (strict autocrat of Neoclassicism [...] intolerant of all those of different faiths)."[172]

More recently, research building on that of Renate Wagner-Rieger has reassessed this one-sided judgement.[173] Nobile's actual attitude towards other historical styles was considerably more complex than Eitelberger's simple opposition of "conservative" neoclassicists and "innovative" reformists suggests. Certainly, Nobile emphasized the exemplary nature of antique Roman and Greek architecture in his teaching and, as in the case of the polytechnic's ceremonial hall, was able to insist on it against the majority of his academy colleagues because he had the backing of Ferdinand I and Metternich. But as early as 1819, he was also

Fig. 54 Pietro Nobile, Design for the facades of the houses next to the Schottentor in Vienna, pencil, late 1830s, Trieste, SABAP FVG, Fondo Nobile.

aware that the library of the School of Architecture did not have any books on German architecture from past times,[174] obviously referring to medieval architecture. While in the 1820s, the plaster casts of antique architectural elements found in the School of Architecture were all Roman, in 1833 Nobile recommended the purchase of plaster casts from buildings such as SS. Giovanni e Paolo or the Frari in Venice, which would comprise sculptural work from the best modern patterns as well as from the Middle Ages.[175] He also stipulated that *all* historical styles should be taught to theatre painters, whose stage sets could include all manner of historical settings.[176] Many of Nobile's students also emphasized the breadth of their historical knowledge. Florian

Fig. 55 Pietro Nobile, Design for a public building in the canton of Ticino in Switzerland, pencil, late 1830s, Trieste, SABAP FVG, Fondo Nobile.

Schaden, for example, in his application to succeed Ostertag as professor at the academy in 1842, not only stressed his classical training but also the historical and geographical breadth of his knowledge of architecture, including Greek, Egyptian, and Indian architecture and all architectural styles up to the present.[177] Students such as Franz Beer, Leopold Ernst, and Georg Wingelmüller later distinguished themselves as designers of neo-Gothic or romanticizing neo-medieval buildings.[178] Limiting Nobile to Neoclassicism therefore seems something of an injustice.

During his work at the academy, Nobile was also regularly involved with the restoration of historical buildings that do not really fit into the canon of neoclassicist aesthetics but that Nobile was remarkably open-minded about as historical monuments. In the early 1830s, when Peter Krafft

restored Andrea Pozzo's ceiling paintings in the University Church in Vienna, the question arose as to whether the High Baroque wall decorations beneath the frescoes, which originated in "the century of lesser taste," should be removed.[179] In their expert opinion, however, Nobile, Sprenger, and Pein stated that the wall decorations were a continuation of the ceiling paintings and should remain in the same style, recommending the walls be restored "without omission or mutilation." [180] Even though the work of art was High Baroque, and therefore *tasteless*, Nobile considered it remarkable and worth preserving in its entirety. His argumentation was similar for medieval architecture, as in the case of the pilgrimage church of Maria Laach am Jauerling.[181] Here too, Nobile recommended a restoration that would return the venerable Gothic building to its original state and for which

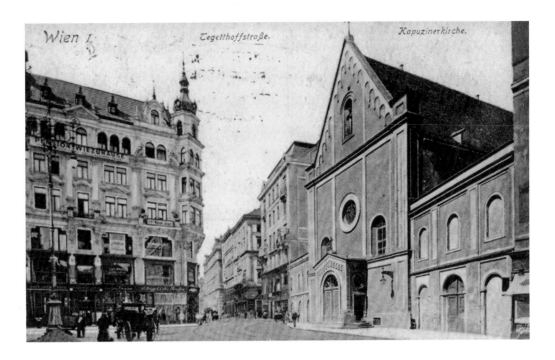

Wien I. Tegetthoffstraße. Kapuzinerkirche.

Roesner, as the most well-qualified teacher at the academy, was to make ideal sketches.

In the training of architects, however, Nobile absolutely preferred classical architecture, both as the universal foundation on which architecture should be based and as the clearest architectural expression of state authority in public buildings, for which Nobile trained his students. In 1843, for example, he agreed to the election of Sicardsburg, hoping that he would guarantee the continuation of classical architecture.[182] Two years later, Nobile reiterated that the purpose of his school was not to be a copy shop, producing elegant drawings in various styles, but to educate students according to clear principles in the superior style of the fifteenth and sixteenth centuries, the art of the Greeks and Romans, and in new construction methods.[183] As for other styles, students should only generally be pointed to the historical development of works of art, "to avoid any aberration in concept and taste" in their own projects.[184]

There was indeed a stylistic change in Nobile's work that parallels certain general developments in Early Historicism. While his Graz theatre facade of the 1820s (Fig. 64) is still block-like and voluminous, with the smooth surfaces of the large units contrasting with the fine decorative relief, the facades of his houses at the Schottentor (Fig. 54)[185] from the late 1830s appear as serially structured surfaces covered

in a fine network of lines. Similarly, on a public building in Ticino (Fig. 55),[186] the facade has a grid-like appearance due to the dense use of pilasters and entablatures. This tendency towards early historicist notions is even more obvious in Nobile's use of medieval forms. The use of Gothic elements on the classical cube structure of Mayer's glasshouse from around 1826 (Fig. 77) is very reminiscent of the way in which Gothic influences were adopted in Italian villa construction from the same time. Similarly, in the 1847 redesign of the facade of the Vienna Capuchin Church (Fig. 56),[187] the arched friezes rising along the gable's edges obviously incorporate medieval forms. In fact, this facade stands as a remarkable contradiction to the rather resigned statement Nobile made during discussions about reforming the academy's teaching programme in 1848: "No one wants to know about Italian architecture by good classical authors, instead everyone is restoring Gothic, Byzantine, and Romantic architecture, as in Germany and France."[188] This statement becomes especially remarkable in view of an article published by Ludwig Christian Förster only a year later in the *Allgemeine Bauzeitung* about the newly built evangelical church in Vienna-Gumpendorf, which Förster designed with the assistance of the young Theophil Hansen, in which the choice of Byzantine forms as a model is justified as responding best to the building task presented by a Protes-

Façade des Kirchen- und Klosterbaues der würdigen Frauen vom Orden des
heiligsten Erlösers in Wien.

Fig. 57 Carl Roesner, Redemptorist convent on Rennweg in Vienna,
elevation of the main façade, 1834–1836, Vienna, Austrian National
Library, *Allgemeine Bauzeitung* 1 (1836), 91.

tant church.[189] From this, it is hard to believe that Nobile
used "Roman-Italian" or even "Roman-Byzantine" forms, as
the Hofbaurat suggested for the Capuchin Church, out of
stylistic conviction.[190]

But then, who imparted these early historicist tenden-
cies at the School of Architecture? After all, Nobile was not
the only teacher who taught architecture. Roesner's oeuvre
in particular follows these contemporary developments. His
facade for the Redemptorist convent on Rennweg in Vienna
(Fig. 57), for example, still derived its proportions from clas-
sical buildings such as St Pietro in Montorio, but, already in
this project from the mid-1830s, a fine network of rustication
covers the whole surface within a framework of narrow
stripes. The church of St John of Nepomuk in today's Prater-
straße (Fig. 53), built in the 1840s,[191] features a fine graphic
lineament reminiscent of the marble-encrusted facades of
the Venetian quattrocento. Roesner's church of Maria vom
Siege in the Vienna Arsenal, from the 1850s, uses Gothic

forms in the ribbed vaults and tracery windows. Finally, in
the 1860s, Roesner designed an interior decoration for the
former winter palace of Prince Eugene, which was being
used as the Ministry of Finance at that time. This design
quoted motifs from the Austrian High Baroque, specifically
from the Oberes Belvedere, the imperial rooms of Kloster-
neuburg Abbey, and from Schloßhof castle.[192] The step to-
wards so-called *Strenger Historismus*[193] (Strict Historicism)
had been taken. If we compare buildings designed by No-
bile's students, such as Joseph Haslinger's parish church in
Eggersdorf near Graz (Fig. 58) or the church of the Holy
Cross at Rogaška Slatina dating from the middle of the cen-
tury, with Roesner's designs, we can see that in both the
cubic volumes are already becoming softened by the bev-
elled edges of the tower, for example. The same is true of the
varied forms of the doors and windows and their distribu-
tion and of the repertoire of forms, such as the arched
friezes, commonly used by Nobile's students' generation.
The friezes are similar to those Nobile used in his late works,
including for the Capuchin facade, although he never uses
them as extensively. In addition, we must not forget that
Paul Sprenger, another teacher at the School of Architec-
ture, had spoken out against idealizing antiquity and in fa-
vour of clear contemporary references as early as 1837 in the
ceremonial hall of the Vienna polytechnic (Pl. LI). Sprenger
was one of those architects who, from the 1840s at the lat-
est, drew on the broad repertoire of architectural styles and
forms that was then available in publications. The com-
pletely non-antique ornaments that Sprenger used around
the portal of the building for the Finanzlandesdirektion
(Financial Provincial Directorate), built between 1840 and
1847,[194] seem to have been taken from Jules Goury's and
Owen Jones's publications on the Alhambra, the first volume
of which appeared in 1842. While Sprenger is still very re-
strained in his use of Baroque elements such as the Atlantes
herms in the inner courtyard of the building for the Statt-
halterei (the Lower Austrian governor's office) from 1846/47,
he enlarged them significantly in his 1851 design for the
stock exchange (Pl. XLII).[195] Sprenger's segmented circular
window canopies on the Statthalterei building may also
have been historical quotations of the Waldstein Palace in
Prague.[196] Albeit with some reservations, Nobile promoted
Sicardsburg and van der Null, among the most important

Fig. 58 Joseph Haslinger, Parish church of Eggersdorf near Graz, around 1850 (first plans from before 1842), photo 2018.

representatives of so-called *Romantischer Historismus* (romantic, early Historicism),[197] as part of his teaching staff at the academy, and he supported them in decisions on style – for example, in the jury competition for the construction of the Francis Joseph Gate in 1849 against the representatives of the building authorities and the polytechnic.[198] This suggests that Nobile, despite appearances, may have been open to the new developments of the time. The historian Baron Joseph Hormayr surprisingly noted this characteristic as early as 1822, claiming that Nobile was "a link between the classics and the romantics [...] and a transition [...], which leaves something for everyone."[199]

NOTES

1 Eleonore Hartmann, "Die Hofreisen Kaiser Franz I.," (PhD diss., University of Vienna, 1968), 103, 252; Henrike Mraz, "Das Königreich Lombardo-Venetien im Vormärz," in *Kaisertum Österreich 1804–1848* (exh. catalogue Schallaburg 1996) (Bad Vöslau: Niederösterreichisches Landesmuseum, 1996), 72–74.

2 Gino Pavan, *Pietro Nobile architetto (1776–1854), studi e documenti* (Trieste and Gorizia: Istituto Giuliano di Storia, Cultura e Documentazione, 1998), 32.

3 Cf. Katharina Schoeller, *Pietro Nobile. Direttore dell'Accademia di architettura di Vienna (1818–1849)* (Archeografo Triestino extra serie 5) (Trieste: Società di Minerva, 2008), 19–21. See also Christina Salge, *Baukunst und Wissenschaft. Architektenausbiludng an der Berliner Bauakademie um 1800* (Berlin: Gebrüder Mann 2021).

4 UAABKW, MR ex 1816/17, Zl. 3: application by Andreas Fischer dated 5 January 1817.

5 Eduard Josch, "Peter Nobiles Ernennung zum Direktor der Architekturschule der Akademie der bildenden Künste in Wien und Joseph Kornhäusels Bewerbung um diese Stelle," *Mitteilungen der Gesellschaft für vergleichende Kunstforschung in Wien* 3 (1950): 69–71.

6 UAABKW (quoted in: Renate Wagner-Rieger, "Vom Klassizismus bis zur Secession," in *Geschichte der bildenden Kunst in Wien. Geschichte der Architektur in Wien. Geschichte der Stadt Wien*, ed. Verein für Geschichte der Stadt Wien, Neue Reihe 7/3 (Vienna: Verein für Geschichte der Stadt Wien, 1973), 108, footnote 148.

7 Walter Wagner, *Die Geschichte der Akademie der bildenden Künste in Wien* (Vienna: Brüder Rosenbaum, 1967), 82; UAABKW, VA ex 1803, fol. 206–201r.

8 Wagner, *Akademie*, 420, 424.

9 Biblioteca civica Bertoliana di Vicenza, Carte Bongiovanni, C. vol. 1, Memorie: Biografia di Pietro Nobile, fol. 55r.

10 UAABKW, MR ex 1816/17, Zl. 21: 10 August 1816; Cf. Wagner-Rieger, "Klassizismus Secession," 108. On Moreau: Stefan Kalamar, "Die baulichen Aktivitäten von Nikolaus II. Fürst Esterházy im ersten Jahrzehnt seiner Regierung," in *28. Schlaininger Gespräche: Die Familie Esterházy im 17. und 18. Jahrhundert* (Wissenschaftliche Arbeiten aus dem Burgenland 128) (Eisenstadt: Amt der Burgenländischen Landesregierung and Landesmuseum, 2009), 312–314, 316.

11 UAABKW, MR ex 1816–1817, Zl. 8: most humble submission by Metternich of 24 January 1817 with the on high decision of 14 February 1817.

12 Cf. Eva Hüttl-Ebert, "Nobile a Vienna," in *L'architetto Pietro Nobile (1776–1854) e il suo tempo* (Atti del convegno internazionale di studio, Trieste 1999), ed. Gino Pavan (Trieste: Società di Minerva, 1999), 133, footnote 5.

13 UAABKW, MR ex 1816/17, Zl. 39: Francis I on 4 November 1817.

14 UAABKW, MR ex 1816/17, Zl. 49: most humble submission by Metternich on 17 November 1817.

15 See also: UAABKW, VA ex 1817, fol. 205–208: most humble submission by Metternich on 17 November 1817 with the on high decision on 12 December 1817.

16 Gino Pavan, *Lettere da Vienna di Pietro Nobile (dal 1816 al 1854)* (Trieste: Società di Minerva, 2002), 48: Nobile to his brother-in-law on 1 August 1818. "Mi è stato accordato il Dipartimento delle fabbriche di tutta la Monarchia che è il Dipartimento più forte degli altri."

17 UAABKW, MR ex 1816/17, Zl. 63: 27 December 1817.

18 See also: UAABKW, SProt. ex 1818, fol. 1–18: 2 January 1818, here: fol. 1v.

19 Wagner, *Akademie*, 420, 433.

20 Heinrich Ritter von Srbik, *Metternich. Der Staatsmann und der Mensch 3* (Graz: Akademische Druck- und Verlagsanstalt, 1954), 63–64, 106–107.

21 Giuseppe Fraschina, *Biografia di Pietro Nobile* (Bellinzona: Colombi, 1872), 27–28: Nobile to his mother on 18 August 1818; Cf. Irmgard Köchert, "Peter Nobile. Sein Werdegang und seine Entwicklung mit besonderer Berücksichtigung seines Wiener Schaffens" (PhD diss., University of Vienna, 1951), 74.

22 For example, in October 1818 Nobile stayed several times in Baden "presso un gran Personaggio" (with a great personage), by which he possibly meant Hudelist see Pavan, *Lettere*, 50: Nobile to his sister on 15 October 1818.

23 UAABKW, VA ex 1819, fol. 12–37: Rapporto del entroscritto [Nobile] contenente il Progetto del nuova sistema di Studj introdotto da confermarsi per la Scuola di Architettura della Imp.[eriale] Re.[ale] Accademie on 5 January 1819; transcribed with minor deviations see Pavan, *Nobile*, 173–191.

24 UAABKW, MR ex 1819, Zl. 3: most humble submission by Metternich on 13 January 1819.

25 Wagner, *Akademie*, 87–88.

26 UAABKW, VA ex 1819, fol. 189: Metternich to Francis I on 20 April 1819 with the on high resolution from Rome on 24 April 1819.

27 Wagner, *Akademie*, 83–87; Pavan, *Nobile*, 133–210; Schoeller, *Nobile*, 37–46.

28 UAABKW, MR ex 1818/20–22, Zl. 21: draft of a petition from Nobile on 26 April 1820 (Cf. Pavan, *Nobile*, 39, footnote 132): "*Datemi al più presto possibile dei buoni Architetti; fu il venerato comandamento abbassato dalla Maestà Vostra al Sottoscritto.*"

29 UAABKW, VA ex 1819, fol. 12r: reform proposal of 5 January 1819.

30 UAABKW, VA ex 1819, fol. 34v–35r: reform proposal of 5 January 1819: "[…] per mettere la Scuola di Architettura in stato di ben educare gli Architetti, gli Artieri e decoratori architettonici, e per offrire alla Capitale da qui a 10 anni alquanti Allievi Architetti modellati sul gusto delle grandi opere italiane e romane."

31 UAABKW, VA ex 1819, fol. 41r: reform proposal of 5 January 1819.

32 Pavan, *Nobile*, 209 (Nobile's revised reform proposal of 1821).

33 Cf. Köchert, "Nobile," 16.

34 UAABKW, MR ex 1835/II, Zl. 89: Nobile's accountability report of 6 November 1834.

35 Richard H. Kastner, "Die Technische Hochschule in Wien. Ihre Gründung, Entwicklung und ihr bauliches Werden," in *150 Jahre Technische Hochschule in Wien 1815–1965. Bauten und Institute, Lehrer und Studenten*, ed. H. Sequenz (Vienna: Technische Hochschule Wien, 1965), 7–109.

36 Friedrich Gatti, *Geschichte der k. k. Ingenieur- und k. k. Genie-Akademie 1717–1869* (Geschichte der k. und k. technischen Militär-Akademie 1) (Vienna: Wilhelm Braumüller, 1901), 1.

37 According to the university calendar (quoted in: Jaro K. Merinsky, "Institut für Hochbau für Bauingenieure," in *150 Jahre Technische Hochschule in Wien 1815–1965. Bauten und Institute, Lehrer und Studenten*, ed. H. Sequenz (Vienna: Technische Hochschule Wien, 1965), 266).

38 Mario Marzari, "L'Accademia di Commercio e Nautica," in *Neoclassico: Arte, architettura e cultura a Trieste 1790 1840*, ed. Fulvio Caputo (Venice: Marsilio, 1990), 404.

39 Wagner, *Akademie*, 73.

40 Ulrich Pfammatter, *Die Erfindung des modernen Architekten. Ursprung und Entwicklung seiner wissenschaftlich-industriellen Ausbildung* (Basel, Boston and Berlin: Birkhäuser, 1997).

41 Johann Joseph Prechtl, *Rede bei der ersten Eröffnung der Vorlesungen am k. k. polytechnischen Institute in Wien den 6. November 1815,* (Vienna: Carl Gerold, 1815) (reprint: Vienna, Cologne and Weimar: Böhlau, 1992), 25.

42 Prechtl, *Rede*, 23.

43 Prechtl, *Rede*, 30–31.

44 UAABKW, MR ex 1811–1815, Zl. 6: expert opinion of Sonnenfels in October 1813; Cf. Wagner, *Akademie*, 72–73.

45 Wagner, *Akademie*, 74.

46 Schoeller, *Nobile*, 422.

47 Ibidem, 410–411.

48 Ibidem, 432.

49 Ibidem, 386.

50 Ibidem, 293.

51 UAABKW, VA ex 1819, fol. 13r: reform proposal of 5 January 1819.

52 Klaus Jan Philipp, *Um 1800. Architekturtheorie und Architekturkritik in Deutschland zwischen 1790 und 1810* (Stuttgart and London: Menges, 1997), 17–21.

53 UAABKW, VA ex 1819, fol. 13r: reform proposal of 5 January 1819.

54 Pavan, *Nobile*, 145: Nobile's expert opinion for the architectural education at the University of Lviv.

55 UAABKW, VA ex 1819, fol. 13v: reform proposal of 5 January 1819.

56 UAABKW, SProt. ex 1818, fol. 70–81: 30 June 1818 (Committee meeting), here: fol. 79v–80r; compare Salge, *Baukunst*, 267.

57 UAABKW, VA ex 1819, fol. 15r: reform proposal of 5 January 1819.

58 Prechtl, *Rede*, 26–27.

59 UAABKW, VA ex 1819, fol. 35v: reform proposal of 5 January 1819.

60 Wagner, *Akademie*, 77.

61 Gatti, *Ingenieur- und Genie-Akademie*, 313. The lack of detailed biographical information about Öttel, who was honoured for his participation in the siege of Milan in 1799 and had been in charge of the archives of the Geniedirektion since 1813, leaves it unclear how Nobile was acquainted with him. Possibly, it was because of Nobile's involvement with the design for the Äußeres Burgtor at the time.

62 UAABKW, SProt. ex 1820, fol. 6r: minutes of the academic council meeting of 22 March 1820.

63 UAABKW, VA ex 1819, fol. 36: reform proposal of 5 January 1819.

64 Kastner, "Technische Hochschule," 39–40. The gas lighting was developed by the mechanics professor Johann Arzberger together with Prechtl, and the heating was developed by chemistry professor Paul Treugott Meissner.

65 UAABKW, VA ex 1819, fol. 26v: reform proposal of 5 January 1819.

66 Durand also did not demand strict adherence to canonical proportions, but allowed for any proportions, see Hanno-Walter Krufft, *Geschichte der Architekturtheorie* (Munich: Beck, 52004), 311.

67 UAABKW, VA ex 1819, fol. 27r: reform proposal of 5 January 1819; Cf. Pavan, *Nobile*, 158–164.

68 UAABKW, VA ex 1819, fol. 27v: reform proposal of 5 January 1819. See Salge, *Baukunst*, 259.

69 Prechtl, *Rede*, 34.

70 Pfammatter, *Erfindung*, 28.

71 Philipp, *Architekturtheorie*, 19–21.

72 UAABKW, VA ex 1819, fol. 33r–33v: reform proposal of 5 January 1819.

73 Susanne Kronbichler-Skacha, "Die Wiener ‚Beamtenarchitektur' und das Werk des Architekten Hermann Bergmann (1816–1886)," *Wiener Jahrbuch für Kunstgeschichte* 39 (1986), 163–203.

74 UAABKW, VA ex 1820, fol. 574a: transcript from 24 November 1820 of the on high resolution from Troppau of 6 November 1820.

75 Wagner, *Akademie*, 87–88.

76 UAABKW, VA ex 1821, fol. 228: draft of the letter from Lamberg to Metternich of 21 June 1821; UAABKW, MR ex 1818/20–22, Zl. 8: Metternich's most humble submission of 18 September 1821 (Cf. Wagner, *Akademie*, 88).

77 Wagner, *Akademie*, 97; Cf. the situation in Nobile's statement of accounts of 6 November 1834 (UAABKW, MR ex 1835/II, Zl. 89).

78 Pavan, *Nobile*, 204–205 (Nobile's reworked reform proposal of 1821).

79 UAABKW, SProt. ex 1829: 29 August and 11 and 14 September 1829.

80 Pavan, *Nobile*, 207 (Nobile's reworked reform proposal of 1821).

81 UAABKW, VA ex 1819, fol. 116–117: Lamberg to Metternich on 16 February 1819.

82 UAABKW, MR ex 1818/19, Zl. 17: Letter to Metternich on 17 February 1819.

83 Prechtl, *Rede*, 35–36.

84 Schoeller, *Nobile*, 441–442.

85 UAABKW, VA ex 1819, fol. 30r–30v: reform proposal of 5 January 1819.

86 UAABKW, VA ex 1819, fol. 32r: reform proposal of 5 January 1819.

87 UAABKW, VA ex 1819, fol. 33r: reform proposal of 5 January 1819.

88 UAABKW, VA ex 1819, fol. 224–225: Nobile to Lamberg on 5 May 1819.

89 Wagner, *Akademie*, 110.

90 Katharina Schoeller, "Ludwig Förster, Architekt und Geschäftsmann. Neues zu seiner Biografie," in *Theophil Hansen – ein Resümee: Symposionsband anlässlich des 200. Geburtstages, Symposion der Universitätsbibliothek der Akademie der bildenden Künste Wien, Juni 2013*, ed. Beatrix Bastl (Weitra: Verlag der Provinz, 2014).

91 UAABKW, VA ex 1819, fol. 30v–31r: reform proposal of 5 January 1819.

92 UAABKW, SProt. ex 1819, fol. 18r; VA ex 1819, fol. 551a–b.

93 UAABKW, VA ex 1819, fol. 33v: reform proposal of 5 January 1819.

94 UAABKW, VA ex 1819, fol. 18v–19r, 20r: reform proposal of 5 January 1819.

95 UAABKW, VA ex 1819, fol. 21r: reform proposal of 5 January 1819.

96 UAABKW, VA ex 1819, fol. 19v: reform proposal of 5 January 1819.

97 UAABKW, VA ex 1819, fol. 19r: reform proposal of 5 January 1819.

98 UAABKW, SProt. ex 1819, fol. 29r–30r.

99 UAABKW, VA ex 1819, fol. 573d–e: Ostertag to the Presidium of the Academy on 14 December 1819.

100 UAABKW, SProt. ex 1819, fol. 29r–30r, 33r: approved by Metternich on 18 February 1820.

101 UAABKW, VA ex 1819, fol. 573g–h: Nobile to the Presidium of the Academy of 15 December 1819.

102 UAABKW, SProt. ex 1823, Zl. 310: 3 June 1823.

103 UAABKW, VA ex 1825/26, Zl. 205 (Annex): Förster to the Academy on 13 April 1826.

104 UAABKW, VA ex 1825/26, Zl. 205: Nobile to the Presidium of the Academy on 2 June 1826.

105 UAABKW, SProt. ex 1826: 20 June 1826.

106 Peter R. Frank and Johannes Frimmel, *Buchwesen in Wien 1750–1850. Kommentiertes Verzeichnis der Buchdrucker, Buchhändler und Verleger* (Wiesbaden: Harrassowitz, 2008), 124.

107 UAABKW, VA ex 1827/28, Zl. 104: Förster to the Presidium on 18 April 1828.

108 UAABKW, SProt. ex 1836: 8 February 1836.

109 UAABKW, VA ex 1835/36, Zl. 97: Förster to the Academy on 15 February 1836.

110 UAABKW, SProt. ex 1836: 26 March 1836.

111 Wagner, *Akademie*, 437–439.

112 Ibidem, 425.

113 Pavan, *Lettere*, 531: Nobile to his brother on 23 March 1842: "Il mio affare di Praga sta adesso nelle mani di Förster, e non so dirti quanto sarà lodevole il suo contegno a mio riguardo, giaché o fatto l'esperienza che i miei allievi sono i miei più dichiarati nemici per quanto lo possono essere."

114 UAABKW, SProt. ex 1826: 22 November 1826.

115 UAABKW, VA ex 1821, fol. 193–195: Nobile to Lamberg on 21 May 1821. On the subject of Roesner Cf. Schoeller, *Nobile*, 388–389.

116 UAABKW, VA ex 1826/27, Zl. 134: Nobile to the Presidium on 5 February 1827.

117 UAABKW, SProt. ex 1828: 13 October 1828.

118 UAABKW, VA ex 1823/24, Zl. 337: Nobile to the Presidium on 30 May 1824.

119 Schoeller, *Nobile*, 346–347, ill. 37–41, which may have been Lössl's submission for the Hofpreis of 1823.

120 UAABKW, SProt. ex 1823, Zl. 198, Supplement F: Nobile's suggested theme for the Hofpreis of 1823 on 13 March 1823: "im griechischrömischen Style."

121 UAABKW, VA ex 1823/24, Zl. 465: Goes (*Studienhofkommission*) to the Academy on 29 August 1824.

122 UAABKW, VA ex 1823/24, Zl. 418: Nobile to the Presidium on 17 August 1824, with a list of drawings by Lössl as an annex.

123 UAABKW, VA ex 1823/24, Zl. 475: most humble submission by Metternich on 20 September 1824 with on high approval on 16 November 1824.

124 UAABKW, SProt. ex 1829: 29 August and 11 and 14 September 1829.

125 Richard Bösel, "Bauen für die Tonkunst. Wiener Konzertstätten des 19. Jahrhunderts im Lichte der europäischen Entwicklung," in *Das Wiener Konzerthaus 1913–2013 im typologischen, stilistischen, ikonographischen und performativen Kontext Mitteleuropas*, ed. Richard Kurdiovsky and Stefan Schmidl, (Vienna: Austrian Academy of Sciences, 2020), 63–68.

126 UAABKW, VA ex 1829/30, Zl. 146: various letters between March and May 1830.

127 UAABKW, VA ex 1829/30, Zl. 53: Metternich's most humble submission of 30 December 1829 with the on high approval on 18 March 1830.

128 UAABKW, VA ex 1829/30, Zl. 55: Roesner to Nobile on 9 May 1829.

129 UAABKW, VA ex 1829/30, Zl. 53: most humble submission from Metternich on 30 December 1829 with the on high approval on 18 March 1830.

130 UAABKW, VA ex 1833/34, Zl. 41: Lützow to Metternich on 5 June 1833.

131 UAABKW, VA ex 1833/34, Zl. 18: draft for the Presidium's submission to Metternich on 9 November 1833.

132 UAABKW, VA ex 1833/34, Zl. 106: Roesner to the Presidium of the Academy on 21 December 1833.

133 UAABKW, SProt. ex 1834: 6 March 1834.

134 See also: UAABKW, VA ex 1834/35, Zl. 302: Nobile to the Presidium of the Academy on 19 May 1835.

135 See also: UAABKW, VA ex 1834/35, Zl. 418: Lössl to the Presidium of the Academy on 4 April 1835.

136 UAABKW, SProt. ex 1842: 10 November 1842 (including Lössl's application on 30/31 May 1842).

137 Wagner, *Akademie*, 110.

138 UAABKW, VA ex 1826/27, Zl. 155: Sprenger to the Presidium of the Akademie on 22 February 1827.

139 UAABKW, VA ex 1826/27, Zl. 156: Czernin to Metternich on 16 February 1827.

140 UAABKW, SProt. ex 1828: 13 October 1828; VA ex 1827/28, Zl. 213, 214: Ellmaurer to Metternich on 21 October 1828.

141 UAABKW, VA ex 1834/35, Zl. 112: decree of Metternich on 15 or 16 January 1835 (with the copy of the on high resolution of 7 November 1834 to the above-mentioned submission of the *Hofkammer* (General Court Chamber) of 31 March 1833, Zl. 3344/545).

142 UAABKW, VA ex 1835/36, Zl. 223: Metternich to the director of the School of Architecture with the note of the *Hofkammer-Präsidium* (Court Chamber Presidium) dated 17 May 1836.

143 UAABKW, VA ex 1835/36, Zl. 293: Note of the Presidium of the Lower Austrian government on 11–12 July 1836.

144 Elisabeth Springer, *Geschichte und Kulturleben der Wiener Ringstraße* (*Die Wiener Ringstraße. Bild einer Epoche* 2, ed. Renate Wagner-Rieger) (Wiesbaden: Franz Steiner Verlag GmbH, 1979), 18–23; Elisabeth Schmalhofer, "Paul Sprenger 1798–1854. Architekt im Dienst des Staates," (PhD diss., University of Vienna, 2000).

145 Pavan, *Lettere*, 540: Nobile to his brother on 1 November 1842: "*Sprengher* [sic] *gode la più alta protezione dei Grandi che vedono in Lui un Genio superiore, ed è divenuto l'Uomo di moda.*"

146 UAABKW, VA ex 1834/35, Zl. 302: Nobile to the Presidium of the Academy on 19 May 1835.

147 UAABKW, MR ex 1836/II, Zl. 155: Correspondence with Sprenger on 31 December 1836 and 4 and 23 January 1837.

148 UAABKW, VA ex 1838, Zl. 70: Nobile to the Presidium of the Academy on 12 January 1838.

149 Springer, *Geschichte*, 18–20.

150 Pavan, *Lettere*, 533: Nobile to his brother Antonio on 22 May 1842.

151 UAABKW, SProt. ex 1842: 10 November 1842; UAABKW, SProt. ex 1843: 28 January 1843; UAABKW, SProt. ex 1843: 23 November 1843; Cf. Wagner, *Akademie*, 110–112.

152 Springer, *Geschichte*, 246.

153 Pavan, *Lettere*, 542: Nobile to his brother on 12 December 1842.

154 Springer, *Geschichte*, 19–20.

155 Nobile wished that one of his nieces might find a husband like Haslinger (Pavan, *Lettere*, 383: Nobile to his brother on 23 June and 7 July 1835).

156 Schoeller, *Nobile*, 306–307.

157 Wagner, *Akademie*, 112.

158 UAABKW, SProt. ex 1839: 9 July 1839.

159 Schoeller, *Nobile*, 351.

160 UAABKW, SProt. ex 1839: 9 July 1839; UAABKW, SProt. ex 1840: 3 and 8 January 1840.

161 UAABKW, VA ex 1835–1836, Zl. 238: Sir Peter Josef Eichhoff, *Hofkammerpräsident* (President of the Court Chamber), to Metternich on 26 June 1836; UAABKW, MR ex 1836/I, Zl. 82: Nobile to Metternich on 6 June 1836. cf. Pavan, *Lettere*, 592: Secondo viaggio […] a Kulm.

162 OeStA, HHStA, StK Wissenschaft, Kunst und Literatur 9: Nobile to Metternich on 20 May 1839.

163 UAABKW, SProt. ex 1843: 28 January 1843.

164 To which crisis Nobile exactly referred to is unclear since Heinrich Hübsch's famous publication on the question of choice of style had already been published years earlier in 1828 (Heinrich Hübsch, *In welchem Style sollen wir bauen?* (Karlsruhe: Christian Friedrich Müller, 1828).

165 UAABKW, SProt. ex 1843: 23 November 1843.

166 UAABKW, SProt. ex 1845: 9 July 1845.

167 See also: Carl von Lützow, *Geschichte der kais. kön. Akademie der bildenden Künste. Festschrift zur Eröffnung des neuen Akademie-Gebäudes* (Vienna: Carl Gerold's Sohn, 1877), 97, 100; Josef Bayer, "Die Entwicklung der Architektur Wiens in den letzten fünfzig Jahren," in *Wien am Anfang des 20. Jahrhunderts. Ein Führer in technischer und künstlerischer Richtung*, red. Paul Kortz (Vienna: Gerlach & Wiedling, 1906), 3.

168 UAABKW, VA ex 1849, Zl. 70: provisional President Roesner to provisional Curator Lebzeltern-Collenbach on 23 January 1849.

169 Eva Kernbauer et al., ed., *Rudolf Eitelberger von Edelberg. Netzwerker der Kunstwelt* (Vienna-Cologne-Weimar: Böhlau, 2019).

170 Springer, *Geschichte*, 27–32.

171 Rudolf Eitelberger, "Die kirchliche Architektur in Oesterreich II," *Wiener Zeitung* of 10 January 1853 (Österreichische Blätter für Literatur und Kunst. Beilage zur Österreichisch-Kaiserlichen Wiener Zeitung), 11: "die den Vitruv vielleicht auswendig wissen und sich mit ängstlicher Gewissenhaftigkeit an die Maße halten, die sie archäologischen Büchern oder Denkmäler des klassischen Alterthums entnommen haben, wie die meisten Architekten Italiens".

172 Ludwig Hevesi, *Oesterreichische Kunst im Neunzehnten Jahrhundert* (Leipzig: Seeman, 1903), 42.

173 See for instance: Walter Krause, "Wende oder Übergang? 1848 und die Anfänge der franzisko-josephinischen Architektur: Mythos und Motive," in *Acta historiae artium Academiae Scientiarum Hungaricae: revue de l'Académie des Sciences de Hongrie* 36 (1993): 133–148.

174 UAABKW, VA ex 1819, fol. 17r: reform proposal of 5 January 1819. Cf. Pavan, *Nobile*, 156, 223–227 (document no. 7).

175 UAABKW, SProt. ex 1833: 14 and 19 November 1833.

176 Pavan, *Nobile*, 207 (Nobile's revised reform proposal of 1821).

177 UAABKW, SProt. ex 1842: 10 November 1842.

178 Wagner-Rieger, "Klassizismus Secession," 122.

179 UAABKW, VA ex 1832/33, Zl. 189: *Stadthauptmann* Bartenstein to the Presidium of the Academy on 10 June 1833: "Jahrhundert eines minder guten Geschmacks".

180 UAABKW, VA ex 1832/33, Zl. 190: Nobile to the Presidium of the Academy on 6 July 1833: "ohne Hinweglassung oder Verstümmelung".

181 UAABKW, SProt. ex 1842: 4 March 1842.

182 UAABKW, SProt. ex 1843: 23 November 1843.

183 Wagner, *Akademie*, 111–112.

184 Ibidem, 112: "zur Vermeidung der Verirrung im Concept und im Geschmack".

185 Trieste, SABAP FVG, Fondo Nobile vol. 16, no. 90.

186 Trieste, SABAP FVG, Fondo Nobile, vol. 3, no. 51–52, especially 52A.

187 Günther Buchinger et al., *Bau-, Ausstattungs- und Restauriergeschichte der Kapuzinerkirche in Wien I., Neuer Markt* (typoscript-report) (Vienna: self-publishing of Denkmalforscher, 2015), 36–42.

188 Pavan, *Lettere*, 667: Nobile to his brother on 2 September 1848: "Nulla si vuole sapere delle Architetture italiane dei buoni Autori classici, tutto tende a ripristinare l'Architettura gotica bizantina e romantica, come succede in Germania ed anche in Francia."

189 Ludwig Förster, "Das Bethaus der evangelischen Gemeinde A. C. in der Vorstadt Gumpendorf in Wien," *Allgemeine Bauzeitung* 14 (1849), 1–4.

190 Buchinger et al., *Kapuzinerkirche*, 36.

191 Dagmar Redl, "Karl Rösner (1804–69). Ein Wiener Architekt von europäischem Format," *Österreichische Zeitschrift für Kunst und Denkmalpflege* 52 (1998), 555–560.

192 Richard Kurdiovsky, "'its name is known all over Europe and is reckoned among the loveliest of buildings.' The Winter Palace: The History of its Construction, Decoration and its Use," in *Prince Eugene's Winter Palace*, ed. Agnes Husslein-Arco (Vienna: Österreichische Galerie Belvedere, 2013), 22.

193 Wagner-Rieger, *Architektur*, 147–223.

194 Wagner-Rieger, "Klassizismus Secession," 132.

195 Ibidem, 168–169.

196 Ibidem, 168.

197 Wagner-Rieger, *Architektur*, 95–145.

198 Springer, *Geschichte*, 37–39.

199 Joseph Hormayr, "Die außerordentliche Kunstausstellung des Jahres 1822 zu Wien," *Archiv für Geographie, Historie, Staats- und Kriegskunst* 95 (1822): 508: "*zwischen den Classikern und Romantikern* […] *ein Mittelglied* […] *und einen Übergang* […], *welcher Jedem das Seinige läßt.*"

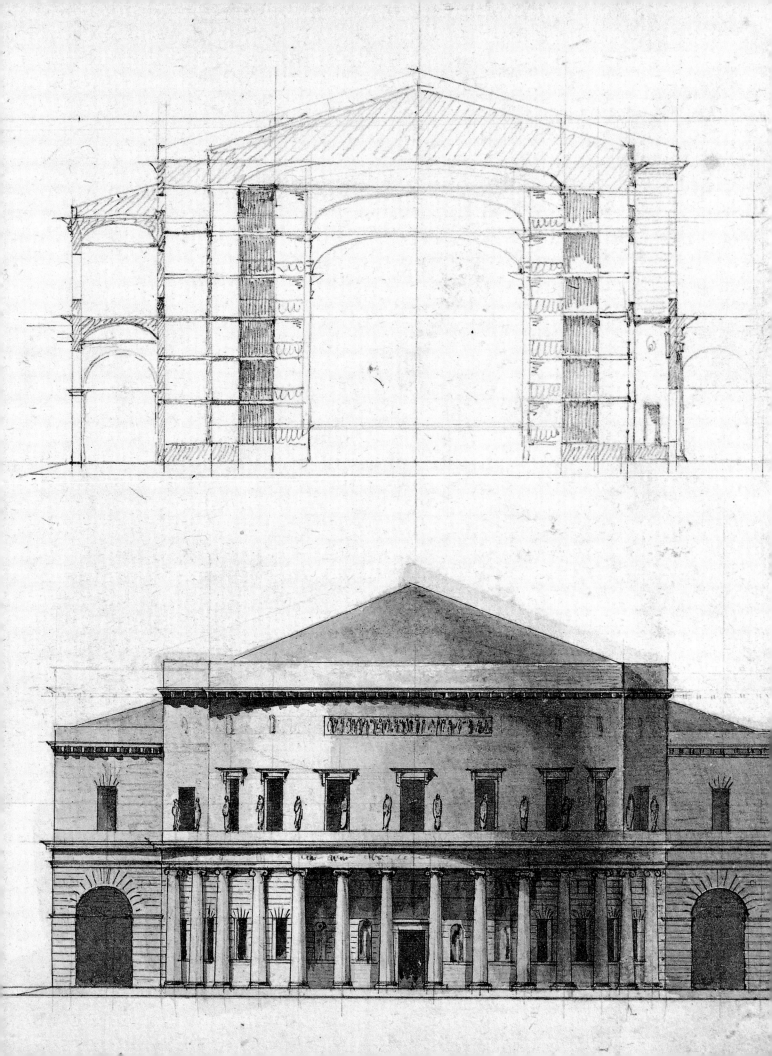

ARCHITECT FOR THE AUSTRIAN EMPIRE

Richard Kurdiovsky

Äußeres Burgtor: Planning History

The history of the Äußeres Burgtor[1] begins with a great destruction. When, as a result of the Peace of Schönbrunn, the victorious French troops withdrew from Vienna in October 1809 after occupying the city for six months, they blew up the Baroque fortifications next to the Hofburg,[2] as a symbolic humiliation of their defeated Habsburg enemy. The work necessary to secure the ruins was carried out in 1810/11 by the Geniedirektion (the military construction division responsible for Vienna's city walls as military buildings).[3] At the same time, the Generalhofbaudirektion, the highest civil building authority which worked directly for the imperial court and was actually not responsible for military buildings, was considering redesigning the area. Ludwig Remy, the technical director of this authority, planned to create space within the new fortifications for a large square, including new gardens (Pl. XLIII).[4] The Generalhofbaudirektion was anxious to gain control over the planning and design of the surroundings of the imperial palace because this was closely connected with expansion plans for the Hofburg itself. Thus was born the idea of a square accompanied by gardens in front of the Hofburg, in which the court gardener Franz Antoine the Elder might also have been involved.[5]

In 1815, Remy defined his ideas about the Burgtor,[6] which he planned with three axes and lateral pedestrian gates, bringing the total number of gate openings to five. The building was to present itself to the outside as a closed, massive structure evoking a city wall, while the facades were to open onto the inside of the city through arcades. Remy gave the entire complex the form of a hornwork, for the first time in its history.[7] The project, however, did not begin until the end of 1817, when the complex, including the location of the new Burgtor, and its estimated costs were finalized.[8] The work was to be completed by the Miners and Sappers Corps under the direction of the Fortifications-Districts-Direktion, which was subordinate to the Geniedirektion. No decision had, however, been made about the appearance of the gate itself. Although in 1814 Johann Aman, the court architect in the Generalhofbaudirektion, had already conceived of a gate project with three openings,[9] the idea of a three-port system must have seemed too novel – and even still when Remy argued that the middle of the three gates could be reserved exclusively for the emperor's use.[10] Thus, in January 1817, Remy was officially commissioned to develop a two-port project,[11] as had been customary in Vienna since the construction of the Rotenturmtor (Red Tower Gate) and the two Kärntnertore (Carinthian Gates),[12] used as points for high traffic since 1802. Most probably around 1817, employees of the Geniedirektion also worked out their own gate designs,[13] which, while quite solid, were artistically less ambitious, being modelled on the city gates of Michele Sanmicheli in Verona, Zadar, and Venice. The question remained open as to whose responsibility it was to design the area around the city walls, in front of the Hofburg. Consequently, additional plans were solicited, from no less than Luigi Cagnola in Milan[14] and Pietro Nobile in Trieste.[15] Both architects had not only gained renown through their respective building projects but were also personally acquainted with Emperor Francis I. For example, on the occasion of the emperor's trip to Italy in 1816, Cagnola had shown him the city of Milan, including his own buildings: the Arco del Sempione, to be completed a short time later as the Arco della Pace, and the Porta Marengo (today the Porta Ticinese), which demonstrated the architect's competence in city gate systems and representative square designs. Nobile, on the other hand, as the Landesoberbaudirektor (Provincial Building Director) of Trieste and the Austrian Littoral, had acted as the emperor's guide to the buildings and archaeological sites in Trieste and Istria. Nobile presented seven proposals

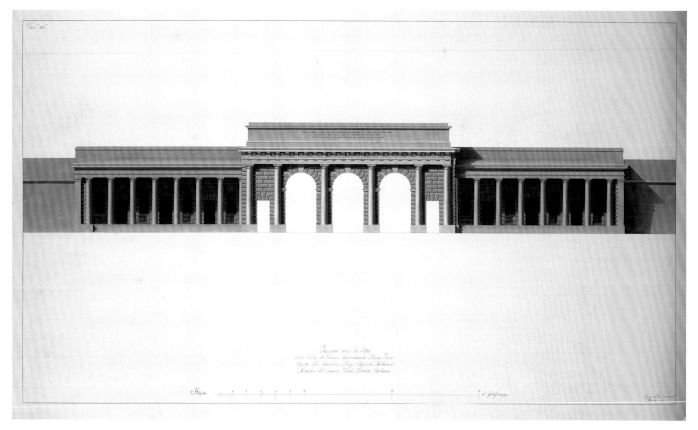

Fig. 59 Luigi Cagnola, Design for a new *Burgtor*, elevation of the inner façade, pencil, ink with watercolour, 1817, Vienna, Albertina.

for the Burgtor, with an astonishing wealth of variations in the structure and decoration of the building,[16] however showing only the facades of the gate building (Pls. XLIV, XLV). In contrast, Cagnola created only one proposal (Fig. 59 and 60, Pl. XLVI),[17] presenting an ambitious idea for merging, as an architectural unit, the suburban front of the expanded Hofburg with the square and the new Burgtor. In 1818, a decision was made in favour of Cagnola's gate design.[18] The laying of the foundations began, and the three- or even five-port variant tacitly won the day.

The Theseustempel and Cagnola's "Dismantling"

In the following year (1819), during his stay in Rome, Francis I made the significant purchase of Antonio Canova's unfinished Theseus statue,[19] which was to be housed in a dedicated building in Vienna, the Theseustempel in the Volks-

garten. Nobile, the head of the School of Architecture at the Academy of Fine Arts since the autumn of 1818, drew up the design in close collaboration with his friend and mentor Canova.[20] This commission was certainly beneficial to his new position on the teaching staff of the academy. After 1820, when Nobile's plans for the temple were approved and the military building authorities under the direction of Major General Schall von Falkenhorst began work on it, Cagnola's Burgtor was no longer the only building on the new square.[21] Indeed, the Theseustempel presented serious architectural competition to Cagnola's Burgtor, putting forth a very different conception of Neoclassicism, compared to Cagnola's severe version, who reshaped the Roman antique models according to modern ideas. Nobile's Dorism was based on archaeologically accurate studies of architectural elements[22] (namely the baseless Greek Dorica) and of entire buildings (namely the peripteros), and he also took as a model the architecture of Greek antiquity, in particular the Temple of Hephaistos in Athens.

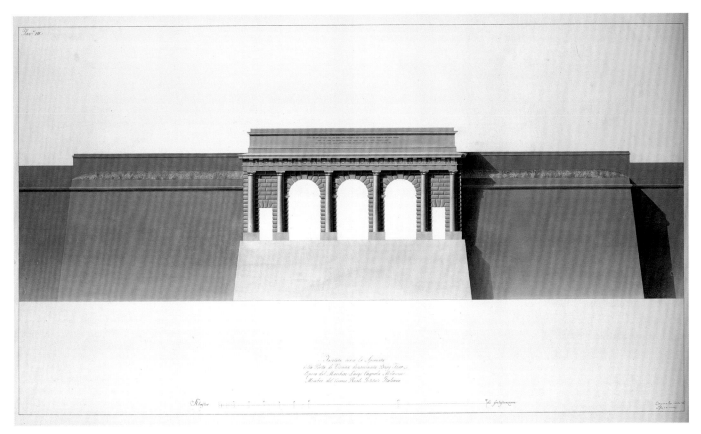

Fig. 60 Luigi Cagnola, Design for a new *Burgtor*, elevation of the outer façade, pencil, ink with watercolour, 1817, Vienna, Albertina.

The criticism that from the winter of 1819/20 successively dismantled Cagnola's design made use of another, thoroughly dubious argument: that Cagnola's building would turn out to be too high. The conflict came to a head when Pietro Nobile,[23] Ludwig Remy,[24] Luigi Pichl,[25] and Johann Aman[26] were asked to work out alternative plans that could be erected over Cagnola's foundations. In the summer of 1820, full-sized canvas stencils of the designs by Nobile, Cagnola, and Remy were set up for examination.[27] This would have been expensive for the competing architects, since Nobile alone had to use 2,500 yards of cloth for the stencils.[28] In the face of this imperial brief, the competitive pressure must have been enormous. Nobile, who was perhaps a little biased, later said that the Viennese architects had found Cagnola's structure to be faulty and that the Viennese public had made fun of the bucrania on his frieze, remarking that they appeared to announce the entrance to a meat market ("ingresso ad un macello").[29] Whether with this anecdote Nobile intended to criticize Cagnola's design or the Viennese public's lack of architectural knowledge remains an open question.

Targeted polemics against Cagnola obviously supported another, very cynical argument, which Nobile even presented to Emperor Francis I. This was that Cagnola wanted his Burgtor design to be made of granite. Nobile argued that this would have meant that only porphyry could then possibly be used as the building material for the expansion of the Hofburg[30] – an argument that was of course illusory. In fact, in March 1818 Francis I had already commissioned the Academy of Fine Arts for an expert opinion on the best construction material for the castle gate.[31] This commission had first of all discussed granite, obviously Cagnola's preferred material, which he had also used at the Porta Marengo.[32] In Vienna, this material had been used for such important monuments as the equestrian statue of Joseph II, and was later repeatedly proposed by Nobile for other projects, but could only be obtained in limited quantities from the Mauthausen quarry in Upper Austria. In terms of beauty and

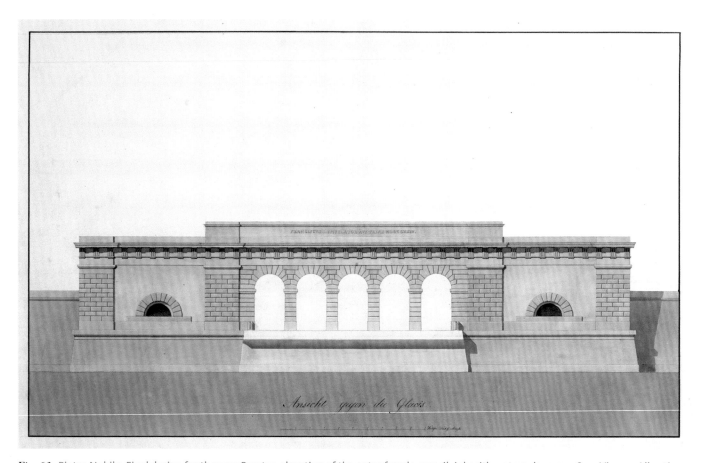

Fig. 61 Pietro Nobile, Final design for the new *Burgtor*, elevation of the outer façade, pencil, ink with watercolour, ca. 1824, Vienna, Albertina.

durability, granite was particularly suitable for the Burgtor, but its processing would be far too expensive, which is why the academy commission recommended other types of stone from the area around Vienna. According to Nobile, Cagnola had angrily left Vienna because his design would not be made of granite.[33]

Nobile also seems to have used his work at the academy in a targeted and timely manner in the competition for the completion of the Burgtor. In the spring and early summer of 1820, i.e. at the critical phase of the decisions on the Burgtor, he was able to present an exhibition of his students' work to Metternich, the curator of the academy, as well as to the emperor and various archdukes, which showcased his plans to reform the architecture programme.[34] These student works dealt precisely with the subject of the Burgtor.[35]

Nobile adapted and, above all, monumentalized his 1817 Burgtor designs. He retained the block-like form but concentrated the facade design on fewer, yet all the more significant, motifs (Fig. 61 and 62): the uninterrupted and completely regular Doric entablature running around the entire building and, especially, the consistently sized Greek Doric columns, which he had used in the nearby Theseustempel and now introduced as the only column decoration for the entire Burgtor. In addition, Nobile succeeded in making this order of columns into an element inseparable from the building. This was unlike Karl Friedrich Schinkel's Neue Wache (New Guardhouse) in Berlin, built shortly before (1816–1818), on which the Doric portico appears as an element independent of the basic cube of the building, with its four corner towers, as can be seen from the individual cornices of each building component.[36] By assigning one and the same entablature to each section of the building, Nobile reinforced the unified, block-like character of his gate. The uniformity of his overall plan, which resulted from the formal harmonization of its style and could now be applied to the other new buildings around the Äußerer Burgplatz,[37]

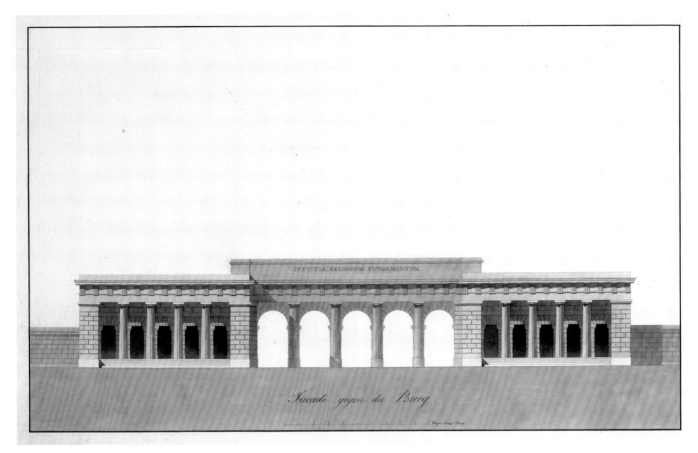

Fig. 62 Pietro Nobile, Final design for the new *Burgtor*, elevation of the inner façade, pencil, ink with watercolour, ca. 1824, Vienna, Albertina.

must have also contributed to the convincing nature of Nobile's design.

In addition, Nobile was able to legitimize his idea historically by referring to a gate building that had served as one of the classic models of architectural history since the publication of Julien-David Le Roy's *Les Ruines des plus beaux monuments de la Grece* (1758) and James Stuart and Nicholas Revett's *Antiquities of Athens* (vol. 2, 1787/88), as well as for buildings such as the Brandenburg Gate in Berlin: namely the Propylaea of the Acropolis of Athens.

Nobile himself systematically compiled the series of precedents for his Burgtor design on a single page. Under the title "Propyleen,"[38] he flanked his design for the Äußeres Burgtor with the Athens Propylaea and the Brandenburg Gate (Fig. 63). The fact that his design was "specialmente conforme"[39] (particularly consistent) with the Athenian building resulted, according to Nobile, from the process by which he dealt with ancient Greek architecture.[40] It was the

Theseustempel, he said, that "mi ha risvegliato l'idea di Propilei"[41] (woke me up to the idea of the Propylaea). In contrast to the Theseustempel, however, Nobile's Burgtor design was not a copy of an ancient building; apart from its Doric columns, it merely took inspiration from the Propylaea, in flanking the receding, middle part of a gate building with frontal colonnades on both sides. By opening the Athenian facade completely towards the Hofburg and the city rather than orienting it towards the outside as in the ancient model, Nobile created colonnaded halls facing the city square that recalled Roman forums and Greek agoras. Carl Gotthard Langhans' Brandenburg Gate from 1788–1791 must have also been decisive for this. A few years after its completion, this gate, too, had been published in juxtaposition with the Athenian Propylaea[42] and had been identified with the ancient building in contemporary poetry, for example.[43] Langhans took various aspects of this ancient example as a model:[44] the use of the Doric order (although the Branden-

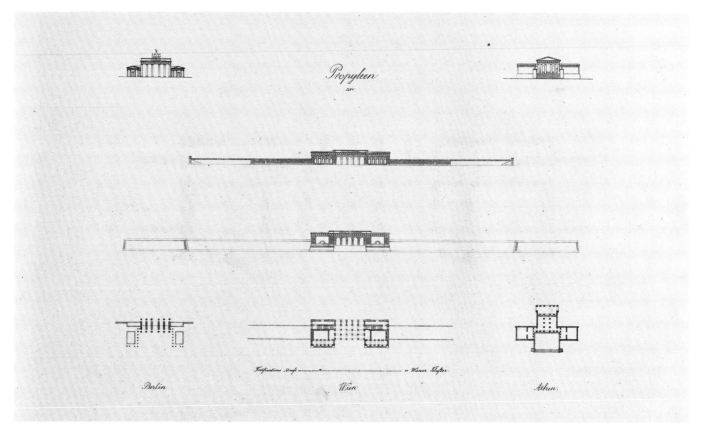

Fig. 63 Comparison between the Propylaea in Berlin (Brandenburg gate), in Vienna (*Burgtor*) and in Athens (Propylaea of the Acropolis), etching, ca. 1824, Trieste, SABAP FVG, Fondo Nobile.

burg Gate was intended to be Roman in the design of its base and proportions), the emphasis on the central section, and the spatial arrangement, which, like the Vienna Burgtor, was oriented towards the city centre and towards a square.

The Äußeres Burgtor Designed by Pietro Nobile

The decision as to whose design the Burgtor should be completed was only made in 1821, in Nobile's favour. In the summer of 1821, Major General Schall von Falkenhorst was commissioned to come to an agreement with Nobile regarding the continuation of the construction of the Burgtor according to Nobile's designs.[45] In 1822, Canova's *Theseus* sculpture group was set up in the Theseustempel,[46] and Nobile completed the neighbouring Zweites Cortisches Kaffeehaus[47] (Fig. 14) – a building whose Ionic order was an exception to

the uniform Doric style of the Äußerer Burgplatz and was therefore interpreted as exemplary of the leisure function of the building.[48] On 16 October 1824, the Burgtor was inaugurated in commemoration of the eleventh anniversary of the Battle of Leipzig. And the very same day, Francis I ordered his chancellor Metternich to present Nobile with a snuffbox in recognition of his work, which the emperor called "a monument of prior happy events for the descendants."[49]

The Vienna Burgtor and the neighbouring Theseustempel expressed a patriotic enthusiasm that was strongly focused on the House of Habsburg but was, however, more clearly communicated by textual representations than by the physical form of the building itself. The two poles, the "gate [...] as a memory of the defeated past" and the "temple dedicated to art,"[50] were architectural symbols of the army and art, respectively. As the influential garden theorist Christian Cay Lorenz Hirschfeld demanded in his *Theorie der*

Gartenkunst of 1785, the temple and the gate had an educational role in the "Volksgarten." For a people's garden, he wrote, "seems to be the place where it is easy to teach the people a valuable lesson along the paths of their amusement and to stimulate their attention through important memories."[51] There, the people should be told the history of the nation and should remember deceased benefactors and important events "that remind the people of their national strengths, of the generosity of their patriots, and of the happiness of their nation's circumstances."

That the Burgtor would be a consciously staged site of remembrance was the result of a demand made by Remy in 1810,[52] namely that the destruction caused by Napoleon's troops not be concealed by a simple reconstruction but that a representative counterpoint to them be built from scratch.[53] Accordingly, the paper *Wiener Zeitung* wrote of the opening of the Burgtor that the new layout of the Äußerer Burgplatz served to glorify the "sites of earlier destruction."[54] The date of the opening established this concrete historical reference: Francis I set the opening "on the eleventh anniversary of the Battle of Leipzig, so decisive for the whole of Europe, and especially for Germany." The Burgtor thus became a monument to the self-sacrificing and victorious Habsburg army, without explicit reference being made to this in the building itself.[55] A logical connection was established with military virtues, as the ancient Romans had demonstrated in an exemplary manner. While no mention was made of the fact that, as part of the Vienna city wall, the Burgtor automatically fell under the jurisdiction of the military authorities, the historian Baron Joseph Hormayr, for example, was able nevertheless to declare the Burgtor a monument to the honour of the virtuous Austrian army: The "miners" of the Habsburg army had broken the stones out of the rock and the "military transport" ("Militärfuhrwesen") had brought these stones to the building site, where "military stone masons" had worked the stones, such that "the entire work was completed in the military, Roman style"[56] – even though the columns of the Burgtor were decidedly Greek!

Despite all the military interpretations of the Burgtor, the inscriptions actually turned the gate into a monument for Francis I. The inscription of the emperor's name on the outer side and of his motto "IVSTITIA. REGNORVM. FVN-DAMENTVM" (law and justice are the basis of rule) on the inner side sought to legitimize the Habsburg exercise of power, signalled towards the city centre. Both inscriptions clearly show that the only legible signs on the Burgtor referred exclusively to the Habsburg emperor and not, or not explicitly, to his army. Knowledge about the implicit meaning of the building must be drawn from contemporary descriptions, from daily newspapers, and from oral narratives and traditions.[57] Apart from the building's typological message that the Burgtor was part of a fortress, which remained visible, there were no iconographic references to the military character of the monument (no trophies, cannons, etc.) that made it visually recognizable as a military sign.

In opposition to the Burgtor, which could be read as military, the Theseustempel was a work of "admiration" ("Bewunderung")[58] for "every friend of art and classical antiquity" because it housed the work of one of the most famous sculptors of his time – Canova's *Theseus*. It was precisely the *Theseus* sculpture group, and the reorientation of its original meaning, that turned the temple into a triumphant sign of victory par excellence. Here, the re-established order embodied in Theseus triumphed over the brutal violence of the French "barbarians," embodied in the centaur lying on the ground.[59] In contemporary descriptions, Theseus appeared as a hero of virtue and the model of a wise prince, in whom we can imagine the reigning emperor, who not only performed incredible heroic deeds but also rendered outstanding services to the improvement of the state."[60] While the Burgtor remained comparatively vague or at least flexible in its symbolic meaning, visitors to the Theseustempel witnessed the victory over Napoleon in a very concrete manner. The temple of art was thus actually a temple of victory, illustrated by the means of art (Pl. XLVII, XLVIII).

State Tasks: Hofbaurat

In 1818, Nobile was appointed Hofbaurat so that he would not suffer any financial loss upon leaving his position as head of the provincial office of public works in Trieste. In addition, his language skills and local knowledge of the construction issues in the Italian provinces were considered useful to his majesty[61] and in particular to the office of the

State Building Council (Hofbaurat). This institution, which probably commenced operations in 1809,[62] was the successor to the Generalhofbaudirektion, which had been introduced during the reforms of the state building industry under Joseph II to design and supervise, from the capital of Vienna, both court and public building projects within the empire.[63] During the pre-March era, the Hofbaurat fulfilled the ambitions of Joseph II's reforms and centrally managed the entire building industry of the Habsburg Empire. The council examined the designs and finances of projects, prepared expert opinions, and, if necessary, drew up alternative designs. This entity literally examined and worked on everything, not only large monumental buildings such as the Vienna polytechnic, built 1816–1818 with a great deal of creative effort and at high cost (Pl. XXXVIII), but also official buildings representing the empire in cities and towns of various sizes, as well as a large number of small to very small buildings in remote corners of the provinces, such as customs houses, rectories, and even inns. In the process, the examinations carried out by the Hofbaurat became intertwined with those carried out by the academy as the central authority concerning artistic matters. A prominent example were was Josef Klieber's designs for the decoration of the pediment of the Viennese Institute of Animal Medicine from around 1823, concerning which first the Hofbaurat prepared an expert opinion, followed by the academy.[64] We cannot exclude the possibility that Nobile was involved in both. In any case, the Hofbaurat was exclusively responsible for the construction work of the state rather than of the imperial court, which remained the responsibility of the Hofbaudirektion under Prince Johann Nepomuk Clary-Aldringen, along with the head of the technical office Ludwig Remy and the two court architects Louis Montoyer and Johann Aman.[65] Nobile was therefore never an imperial court architect, neither as Hofbaurat nor as director of the academy's School of Architecture.

The specializations of the directors of the Hofbaurat shed significant light on its field of action, objectives, and organizational forms. Until 1841, the council was headed by Joseph Schemerl von Leytenbach, who was mainly concerned with hydraulic engineering, such as the construction of the *Wiener Neustädter* Canal, and who, according to Nobile, had little interest in architecture.[66] In 1842, Major General Karl Myrbach von Rheinfeld took over[67] after specializing in land surveying, having advanced to head of cadastral surveying in 1833. Following his death in 1844, Major General Franz Weiß von Schleusenburg became the interim director in 1845. Weiß von Schleusenburg had at least taught civil and military construction at the Ingenieursakademie, for which he had written the *Lehrbuch der Baukunst* in 1830. In 1847, there was no director of the Hofbaurat, and in 1848, the last year of its existence, Baron Friedrich Froon von Kirchrath presided. As a result, the architectural and artistic expertise of the council ultimately lay in two of its members: Nobile and his former pupil Paul Sprenger. Sprenger worked in the Hofbaurat either from 1842, when he had to be replaced as academy professor due to his nomination to this council, or from 1844, when he was first mentioned as a member of the council in the state administrative directory.

From an administrative point of view, until 1844 the Hofbaurat was an accountancy agency for the Habsburg states and was subordinate to the Generalrechnungsdirektorium (Central Accounting Office), presumably because the primary task of the council was to audit building costs. It was not until 1845 that the council moved to the Vereinigte Hofkanzlei (United Court Chancellery), which acted at this time like a Ministry of the Interior. In accordance with its administrative function, and according to the state directory, the Hofbaurat's salaried workers were mainly accountants. The architectural staff apparently consisted entirely of unpaid trainees who were becoming familiar with the public building service in preparation for future careers in the Landesbaudirektionen. This was the case with various students of Nobile's including Joseph Haslinger, who later worked in the Styrian provincial office of public works. These trainees were not mentioned by name in the state handbooks. As can be seen in its staff ratio, the Hofbaurat did not focus on artistic architecture but on administration, seeking to ensure the greatest possible economy for the Habsburg Empire.[68] The frugal use of a client's budget was already an essential element in Nobile's plan of January 1819 to reform architectural education. Precisely because of this emphasis on accounting and administration, Nobile's dual function as a Hofbaurat and a member of the academy gave him a special role, as he was not only responsible for the technical and financial inspection of state buildings but also for their ar-

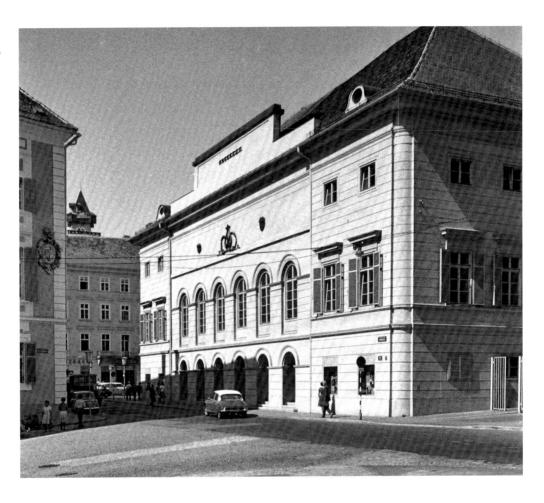

Fig. 64 Pietro Nobile,
Estates Theatre in Graz, 1824/25,
Bildarchiv Foto Marburg,
anonymous photo 1976.

tistic quality. As head of the School of Architecture, he was able to offer internships to his students, and this significantly influenced the appearance of state buildings according to his personal aesthetic. Of his students, Andreas Zambelli around 1820,[69] Joseph Haslinger in the early 1830s,[70] and Carl Rziwnatz in the early 1840s[71] worked in the Hofbaurat and produced alternative designs for projects, another example being Gottfried Haweleg's 1832 design for the Estates House of Lower Austria.[72] It is difficult to determine, however, whether these designs were independent works by the students or simply echoed the ideas of their teacher. In any case, they are stylistically very close to the work of Nobile, who had trained these architects and as Hofbaurat was effectively their boss. Criticism of the Hofbaurat's work as "civil servant architecture," as the following generation would put it, was not only aimed at institutionalized architectural production in general, which followed a quasi-state-approved Neoclassicism, but must also have been directed at Nobile himself – even if, especially in contrast to the widely disliked Paul Sprenger, he does not seem to have been such a clear target, at least not in print.

On the other hand, Nobile was only one of several members of the Hofbaurat, which was entirely capable of making decisions contrary to Nobile's ideas. In the mid-1830s, for example, Nobile demanded that all engineers working in the civil service must have completed training at the academy in addition to the polytechnic in order to guarantee adequate artistic standards in public buildings,[73] which was the main purpose of his architecture lessons. The Hofbaurat, however, came to the conclusion that this requirement could not be fulfilled and should, at most, be limited to the senior personnel in building departments. Nobile's influence as Hofbaurat was therefore not unlimited. He must have feared being deprived of responsibility for the buildings in Vienna and the provinces and being reassigned to the Italian provinces instead, as happened in February 1842.[74]

The Architectural Activity of the Hofbaurat

The Hofbaurat was able to directly commission design work, as it did in 1819 for the rebuilding of the Mirabell Palace in Salzburg.[75] On this occasion, and by imperial order, the Hofbaurat suggested that Nobile prepare sketches, despite the fact that the council was not technically responsible for court buildings. A good example of the Hofbaurat's influence was the Estates Theatre in Graz (today's Schauspielhaus; Fig. 64), in which case, after the building suffered a fire in 1823, the local building authorities sent their restoration plans to the council in Vienna for approval.[76] In March 1824, Nobile went to Graz in person,[77] and by the summer he had improved the plans both aesthetically (in particular the design of the facade and the interior decoration) and in terms of its urban setting. At Nobile's suggestion, a new square called Franzens-Platz was laid out so that the theatre was now free-standing on two sides. The theatre reopened already in October 1825. Similarly, Nobile could be commissioned to examine plans as an "impartial member" of the Hofbaurat, as was the case with the Esztergom Cathedral in 1834,[78] a commission that also resulted in a number of alternative designs (Pl. XIV).

The Hofbaurat could recommend that one of the several submitted designs be constructed, usually arguing for the least expensive version or even cutting costs on that, as was the case with the parish church of Vienna-Erdberg in 1827, in which the Doric order and the sculptural decoration on the facade were removed, along with the slate roof and all stone elements.[79] In the course of the building work, the Hofbaurat could also intervene creatively, such as by altering cornice profiles, as happened at Erdberg around 1831.[80] The council could also, however, subsequently approve additional costs that were deemed unavoidable.[81]

In most cases, the review of a project was probably directly linked to the production of alternative designs, as was the case in 1826 when the facade of the Accademia in Venice was redesigned and plans from the Hofbaurat were discussed alongside the originals.[82] Another example was Paul Sprenger's building for the central office of the Austrian Mint in Vienna, in which, in 1834, Francis I ordered that the council's proposed alterations to the main staircase be carried out and that the council should produce an alternative design before making a final decision on the facade.[83] For the Vienna Stock Exchange project of 1842,[84] Nobile assessed the suitability of the building site and the price of the land before providing a rough sketch of ideas for the building (Fig. 65), which could be worked out in more detail if required.

The parish church of Inzersdorf in the south of Vienna offers an example in which Nobile's neoclassical proposals were not implemented, with romanticized forms being used instead. Built between 1816 and 1821 as a rotunda, it was rebuilt or extended in the early 1840s and consecrated in 1846.[85] At an unknown time, Nobile may have made designs for the addition of a tetrastyle or hexastyle portico entrance (Pl. XLIX), for a modification of the dome on the model of the Pantheon, and for a new internal wall division and an expansion of the gallery (Pl. L),[86] which together would have created a cubical and clearly defined neoclassical architecture modelled on antiquity. Indeed, other forces must have given rise to alternative solutions, and these were ultimately realized, borrowing motifs from various times and places to give the church an early historicist look. The church has ogival hood moulds, a classical pronaos with a triangular pediment, and a bell tower whose wall structure and roof are reminiscent of buildings like the church of St Mary and St Nicholas by Thomas Henry Wyatt and David Brandon at Wilton (1841–1844), a building that explicitly took as models Tuscan and northern Italian campaniles.[87]

Sometimes, however, the Hofbaurat's reviews remained purely financial and did not interfere in creative matters. In the case of the restoration of the Habsburg mausoleum in the abbey church of Seckau, for example, the council accepted both the cost estimate and the suggestion that a certain Jankovsky should take over the commission.[88]

The Battle between the Classical and the Contemporary

Nobile was able to realize his classical ideal – as the style appropriate for the state's public buildings – in the ceremonial hall of the Vienna polytechnic,[89] albeit with clear opposition from his colleagues at the academy. In 1826, when he executed the first sketches comparing painted to stucco

Ansicht der Börse gegen den Minoriten-Platz

Fig. 65 Pietro Nobile, Design for a stock exchange building on Minoritenplatz in Vienna, elevation of the main front on the narrow side, pencil and ink, 1842. Vienna, Austrian State Archives, Archives of Finances and of the Court Chamber, plan collection.

decoration,[90] the academy council was still unreservedly in favour of the "Greco-Roman style."[91] Indeed, the council praised Nobile's choice of the Ionic columns of the Erechtheion as the model for the pilasters because they imparted "the character of uplifting seriousness" that such a hall required (Pl. LI).[92]

When work resumed in 1836, some ten years later, and the academy council discussed the design of the emperor's statue that would be placed in this hall,[93] the stylistic tastes of the majority of the academy's teachers had clearly changed.[94] The decision, in which Nobile wisely refrained from taking part because of a simultaneous audience with the emperor, was made in favour of the design by Johann Nepomuk Schaller depicting the emperor in contemporary imperial regalia. As Nobile may have perceived, however, and as individual members of the council expressly stated,[95] a stylistic shift had occurred between Nobile's antique decoration of the hall and the costume of the imperial statue, between his ideal view of the past on the one hand and their more contemporary view on the other. This shift threatened to destroy the stylistic uniformity of the hall and was reinforced by Joseph Klieber's frieze, in which the figures representing the scientific and technical disciplines taught at the polytechnic wore antique costumes, while the emperor

wore his current imperial regalia. This "mistake" was corrected through the intervention of the highest authority: When Emperor Ferdinand I gave his permission for the project, he ordered all the figures in Klieber's frieze to be dressed in antique costumes.[96] Nobile's ideal was thus approved by the emperor himself, whose opinion also affected the council's approval of Schaller's statue, as only a figure dressed in antique costume was now feasible. As an alternative there was Klieber's competing design, which the council had rejected but which Metternich in turn particularly liked because of its beautiful drapery.[97]

Nobile, supported by his colleague Bartolomeo Bongiovanni, whom he had just recently helped to gain the post of professor of ornamental drawing at the academy, argued vehemently for "the unchanging Roman-Greek costume, which is always used in classical monuments and not subject to changing fashions."[98] To demonstrate how inappropriate contemporary costume was, he referred to two triumphal arches, the Paris Arc du Carrousel, with its attic statues dressed in contemporary uniforms, and the figures on the Milanese Arco della Pace, dressed in antique costumes: "What frivolous variations of fashion in the former, what dignity and significance in the latter!"[99] Sprenger's criticism, which Remy agreed with, was that figures in antique costumes could not represent modern science and technology, which were not known in antiquity. The final decision of the council, however, was that stylistic uniformity had to take precedence over everything else and, since the frieze had already been approved by the emperor, an antique-clad statue of the emperor should also be erected; but, the council reasoned, if the whole matter were reopened and a new competition announced, then contemporary costume should definitely be worn.[100] This option was certainly not in Nobile's interest, threatening to destroy his concept and at the same time demonstrating that his taste in art had clearly become outdated.[101] Support for Nobile once more came from the very top, and in December 1837 the imperial decision was made that the statue by Klieber should be executed in antique costume, the frieze should be altered accordingly, and Nobile should ensure that stylistic uniformity was maintained.[102]

Since arriving in Vienna, Nobile had repeatedly received commissions from or for the imperial house, not least the design of the sarcophagus of Francis I for the Capuchin Crypt,[103] a fact that reveals the high esteem in which members of the House of Habsburg held his work. The style of Nobile, who had taught architecture to the duke of Reichstadt,[104] obviously met the approval of several generations of the imperial family.[105] On the other hand, this meant that Nobile impinged on the territory of his colleagues who were responsible for court building projects, resulting in his own designs either remaining largely unrealized or taking the form of corrections or expert opinions that presented alternative solutions and new ways of thinking. In the early 1820s in particular, Nobile's imperial commissions were perhaps intended to soothe an architect who had arrived in Vienna with a great deal of energy and determination but whose main task, the reform of architectural teaching at the academy, had remained in limbo for years.

Mirabell and Schönbrunn

In the summer of 1819, Nobile was occupied with two very prominent imperial buildings: the reconstruction of the Mirabell Palace in Salzburg, which had been destroyed by fire in April 1818, and the remodelling of Schönbrunn Palace.

For the Mirabell Palace,[106] Francis I ordered that an individual known to be outstanding in civil architecture be sent to Salzburg, whereupon the Hofbaurat unanimously proposed Nobile.[107] Nobile developed an extensive reconstruction project that would have modernized the High Baroque building by Johann Lucas von Hildebrandt into a neoclassicist palace, a "buona architettura di gusto oggi dominante" (a beautiful architecture to today's dominant taste),[108] including a neoclassical transformation of the High Baroque interiors.[109] We may assume that the official design proposal is that contained in the archive of the Chamber of Finance,[110] while a number of preliminary studies and alternatives are kept in the Nobile bequest in Trieste.[111] Although Nobile's project finally proved too expensive and a simpler variant was realized in 1827 by Johann Wolfgang Hagenauer, the district engineer in Salzburg at the time and later the director of the Upper Austrian provincial office of public works,[112] the ceiling decoration of the great hall is still attributed to Nobile on stylistic grounds.[113]

Fig. 66 Pietro Nobile, Remodelling design for Mirabell Palace in Salzburg, elevation of the main front towards Mirabellplatz, pencil, ink with watercolour, 1819, Vienna, Austrian State Archives, Archives of Finances and of the Court Chamber, plan collection.

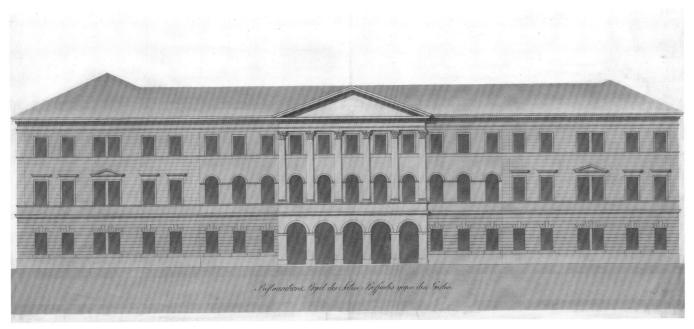

Fig. 67 Pietro Nobile, Remodelling design for Mirabell Palace in Salzburg, elevation of the front towards the great garden parterre, pencil, ink with watercolour, 1819, Vienna, Austrian State Archives, Archives of Finances and of the Court Chamber, plan collection.

In his proposal, Nobile unifies Hildebrandt's various designs with a great deal of effort, transforming the eaves of varying heights into a compact structure of uniform storeys, bound together by a continuous cornice. Nobile significantly changes the value of Hildebrandt's wings, giving an individual character to each of the exterior facades. As in Hildebrandt's building, the front entrance[114] faces Mirabellplatz and features a colossal pilaster colonnade, while a triumphant arch motif frames the portal (Fig. 66). Nobile significantly enhances the facade facing the large garden parterre[115]

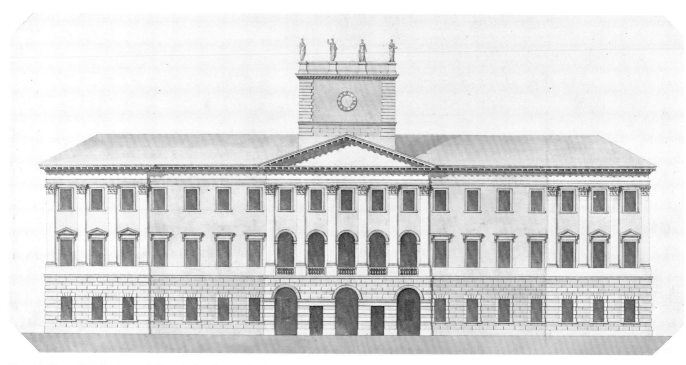

Fig. 68 Pietro Nobile, Remodelling design for Mirabell Palace in Salzburg, preliminary design for the front towards Mirabellplatz with the remains of the central tower, pencil, ink with watercolour, 1819, Trieste, SABAP FVG, Fondo Nobile.

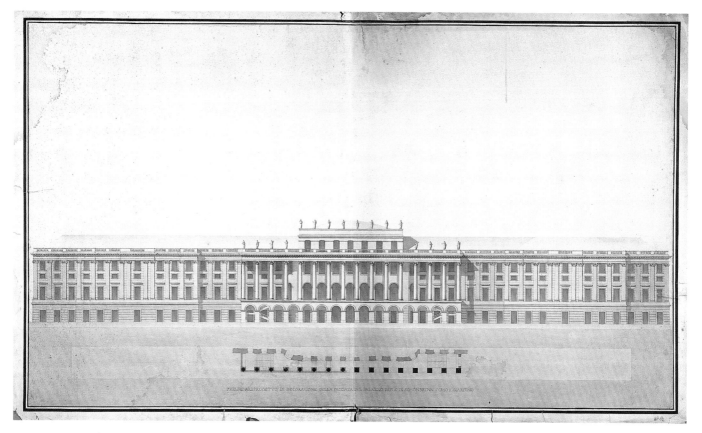

Fig. 69 Pietro Nobile, Remodelling design for Schönbrunn Palace, elevation of the garden façade, pencil, ink with watercolour, 1819, Schönbrunn Kultur- und Betriebsgesellschaft.

by making it symmetrical and introducing a central *avant-corps* distinguished by a temple front with pilasters (Fig. 67). Access to the garden from the palace is via an arcade that mediates between a *sala terrena* and an entrance hall. Nobile completely devalues the third facade, Hildebrandt's main garden facade,[116] by not decorating it with any order and leaving only a small door as an exit, thus adapting it to the modest spaces of this part of the garden. The variations found in the Nobile Collection do not change this basic concept. They emphasize the generous open space in front of the facade facing the garden parterre,[117] where they even suggest a voluminous portico with full columns that allows for flat pilaster divisions even on the minor side, towards the river Salzach.[118] That these drawings are at least partly preliminary studies can be seen in the two alternatives for the facade facing the square, which adopt large parts of the original design. In one, the biaxial, layered lateral *avant-corps* are left as they were,[119] while in the other Hildebrandt's central facade tower is at least partially retained (Fig. 68).[120] In any case, the overall aim of Nobile's design was to create a compact cube modelled on Italian palaces.

Probably at about the same time as his work for Salzburg, Nobile was commissioned to design new facades for Schönbrunn Palace by the highest court official, the *Obersthofmeister* (lord chamberlain) Count Ferdinand Trauttmannsdorff,[121] and so effectively by Francis I. Although Nobile was allowed to present his design to the emperor in person,[122] this project was not realized, probably because of its cost.[123] As early as October 1819, the plans were handed over to Johann Höhenrieder, an engineer from the Generalhofbaudirektion, to be archived.[124]

Here, too, Nobile wanted to turn the overall volume into a block through the continuous and uniform position of the entablature and by drastically reducing the projections and recesses on both the courtyard and garden facades. He did this by placing straight colonnades of free columns in the middle of the facades in order to reduce the deep recesses on the courtyard side and to conceal the rounded corners of the central *avant-corps* on the garden side (Fig. 69). In this way, the perron would also have disappeared behind this veil of columns. The new facades were ultimately built according to less radical plans, by Aman who as court architect was responsible for the imperial palaces. Nevertheless, he allowed the entablature above the pilaster capitals to run uninterrupted and at a uniform height, as Nobile had planned.

New Building Projects for the Hofburgtheater

In the late 1820s, Nobile developed plans for the rebuilding of the Hofburgtheater.[125] These were among the first to develop new forms in theatre construction, a movement culminating in Gottfried Semper's famous Königliches Hoftheater in Dresden (1838–1841), which was considered exemplary at the time.[126] Nobile's theatre designs responded to an idea that had regularly appeared from the end of the eighteenth century,[127] namely to rebuild the old Hofburgtheater and finally complete the front of the Hofburg facing Michaelerplatz according to Fischer von Erlach's plans. The building project had been left as a shell after the death of Charles VI, and his successor Maria Theresa had built the Burgtheater there during the first years of her reign,[128] denying the Hofburg a representative and uniform side facing the city.

After initial projects by the court theatre architect Anton Ortner (in 1810), the 2nd court architect Johann Aman (in 1814/15), and the head of the Generalhofbaudirektion Ludwig Remy (in 1821),[129] Ortner was again commissioned in 1827 under the Burgtheater director Count Johann Rudolf Czernin to plan a new building for the Burgtheater.[130] This was wisely done in Czernin's last year as president of the Academy of Fine Arts Vienna, and it is no surprise that at the end of 1827 Nobile was called in, alongside Remy and Aman, to assess the design that was to form the basis of a competition (Pl. LII).[131] In January 1828, Nobile began work on plans for seven variants, which he discussed with Francis I in a private audience.[132] Based on this, a site plan was drawn up[133] and lithographed as a competition document,[134] but it was archived as early as March 1829.[135]

Nobile's theatre designs are remarkable because they contain ideas that were not developed by any of the architects who had previously worked on the Burgtheater. These thoughts point to the ultra-modern training Nobile received in Rome around 1800, where the newest ideas from France were reworked and processed to the very latest standards. Following Milizia's ideas,[136] Nobile developed a "facciata

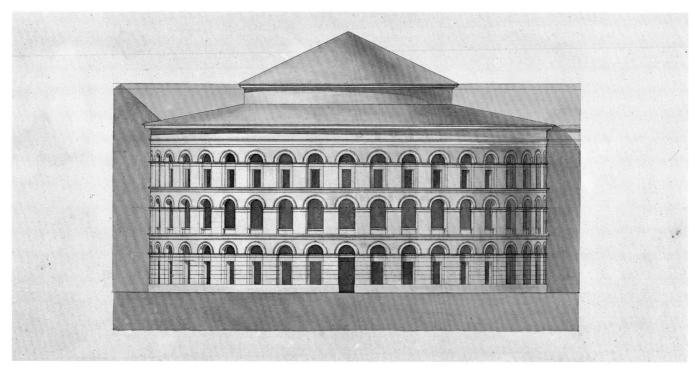

Fig. 70 Pietro Nobile, Design for rebuilding the *Hofburgtheater*, elevation of the façade towards the summer riding school, pencil, ink with watercolour, 1827/28, Trieste, SABAP FVG, Fondo Nobile.

semicircolare a foggia degli anfiteatri antichi" (semi-circular facade in the shape of ancient amphitheatres),[137] whose outer appearance reflected the inner space of the theatre. Starting from the circular auditorium, which he extended in a horseshoe-shape towards the stage gantry, Nobile placed access corridors, staircases, and foyers in several rings parallel to the inner core, so that the outer facade of the theatre was just as circular as the inner wall of the auditorium (Pl. LII). Nobile's extension of the facade well beyond the circumference of a semi-circle intensified the effect of a perfectly regular rounded facade, so that the outside strongly suggested the volume of a perfect cylinder.

The elevations of this facade (Fig. 70) followed the model of ancient Roman theatres, without Nobile using the typical motif of combining the arcade and colonnade. Allowing this uniform structure to run unbroken around the entire building was also decisive. At the same time, these elevations somewhat mediated this "revolutionary" building because while the strict clarity of the facade was a novel form of architecture, it looked out over an inner courtyard of the Hofburg, the summer riding school, and so was not visible from the publicly accessible urban space. As a result, this part of the building was hidden behind the familiar facades of the old imperial residence, as if one could not show such radicalism to the public in Vienna in the pre-March era.

Nobile's forerunners had assumed quite different conditions, especially with regard to the location of the theatre. Durand's ideal design, which he published in 1805 in his *Précis des leçons*,[138] was conceived as a free-standing building visible from all sides. Pietro Sangiorgi's theatre project, published in 1821,[139] was to take up an entire block and, significantly, directed the flat side containing the stage towards the comparatively narrow street of the Corso, while the mighty, curved facade of the auditorium faced onto the much larger open space of a new square (Fig. 71). Similarly, the free-standing theatre in Mainz by Georg Moller, built 1829–1833 on the basis of Durand's theatre designs, directed the effect of its rounded facade towards the open space of Gutenbergplatz.

Nobile tried out various shapes for the theatre, all of which, apart from a reference to Ennemond Alexandre Petitot's famous *Chinea* decoration of 1749, can ultimately be

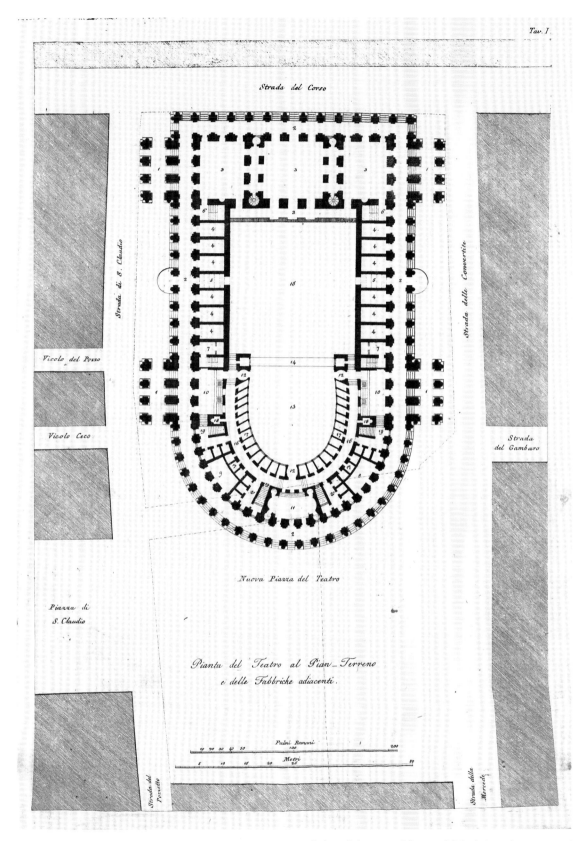

Fig. 71 Pietro Sangiorgi, Design for a theatre on the Corso in Rome, ground plan of the ground floor, published 1821, Vienna, Austrian National Library, Pietro Sangiorgi, *Idea di un teatro adattato al locale detto delle convertite nella strada del Corso di Roma* (Rome: Mordacchini, 1821), plate 1.

Fig. 72 Pietro Nobile, Design for a theatre with both facades in a semi-circular shape, ground plan, cross section and elevation – detail, pencil, ink with watercolour, around 1827, Trieste, SABAP FVG, Fondo Nobile.

traced back to the projects of Jacques-Denis Antoine or to Charles De Wailly and Marie-Joseph Peyre's for the Paris Comédie-Française,[140] proving Nobile's wide knowledge of current theatre construction in France. His theatre designs carry the circular shape of the auditorium outwards towards the front of the building (Pl. LIII),[141] but they also reflect this circular form at the rear of the theatre and thus become a building viewable from all sides, although this second circular form is not used as a second theatre space (Fig. 72).[142] For Nobile, the memory of the antique theatre is clearly more important than the formal correspondence between the inside and the outside of the building.

The final version of the Hofburgtheater[143] reversed the orientation of the theatre by 180 degrees (Pl. LIV), thus rendering the correspondence between the exterior and interior a kind of reductio ad absurdum. The theatre's interior functional operation obviously took precedence over the search for formal agreements, with the audience now being afforded access to the theatre directly from Michaelerplatz. The consistent spatial logic of earlier design phases was therefore lost, as the circular form looking onto the summer riding school now absorbed the rectangular stage house, which was surrounded by a ring of irregular adjoining rooms. But at least Nobile was able to argue to the emperor that such a rounded facade in an inner courtyard minimized the shade on the adjacent wings of the court.[144]

The Expansion of the Vienna Hofburg

Variant proposals for the rebuilding of the Burgtheater can also be found in the drawings for a large-scale expansion project for the Hofburg (Pl. LV),[145] first presented by Richard Bösel and dated sometime between 1824 and 1828. In fact, in the summer of 1827, just a few months before the commission for the Hofburgtheater project, Nobile received a more generally formulated commission from the director of the Generalhofbaudirektion Baron Andreas Pley von Schneefeld and from Baron Johann Kutschera, Lieutenant Field Marshal and Adjutant General. Nobile was to draw up a "compilazione del Progetto del Palazzo di Corte" (compilation of the Court Palace project) following a programme that the emperor would issue as soon as possible.[146]

Bösel attributed the drawing in question to Nobile by comparing it to the facade of the Burgtor, which is mirrored and rhythmically multiplied on the planned Hofburg facade,[147] and to designs of Nobile's from Trieste[148] that show a "four-part grouping rhythmically arranged in intervals of varying length,"[149] similar to his new Hofburg front.

Nobile's expansion project mainly involves two things: the completion of the Hofburg facing Michaelerplatz with the new Hofburgtheater building and the expansion of the palace onto the Äußerer Burgplatz. On both sites, Nobile was concerned with a neoclassical transformation of Ba-

roque designs and a systematic regulation of uneven historical conditions. He reduced the Baroque dynamics of the concave facade facing Michaelerplatz to varying degrees, with the most radical solution being to reinterpret the half-finished rotunda as a half-conchos.

The aim of the expansion towards the Äußerer Burgplatz was to unify the irregular facade of the Hofburg and, above all, to conceal behind a new wing Montoyer's ceremonial hall, ridiculed as a "nose." Hohenberg had already tried this in 1809,[150] as had Remy in several projects between 1815 and 1831,[151] Aman in 1817[152] and again as part of his *Historischer Atlas* of the Hofburg[153] completed in 1824, and Cagnola in connection with his Burgtor project of 1817.[154] While the forms and programmes of all these projects had corresponded to the traditional construction of a residential palace, Nobile emphasized the character of his new Hofburg wing as a monument – rather than its function as a residential and administrative building and seat of government. Nobile's new main facade for the Hofburg, facing the suburbs, would have displayed four domed halls with porticos, which could be entered at ground level from the Äußerer Burgplatz but would not have a clear place in the traditional ceremony of the Habsburg court and would not fulfil any functional requirement. Unfortunately, we have no information about how Nobile imagined these domed rooms to be used and decorated. He may have had in mind something similar to the Hofgartenarkaden in Munich, where a cycle of wall paintings, open to the public, was created in 1826–1829 based on Peter Cornelius's designs showing significant events from the history of the Wittelsbachs.[155] A similar idea was proposed for the Vienna Hofburg decades later in the Geschichts-Hallen of Anton Barvitius's expansion project[156] as well as in Moritz Löhr's plans. The expansion of the Hofburg was ultimately realized by Gottfried Semper and Carl Hasenauer in the form of the "Imperial Forum."

The Monument to Emperor Francis I and the *Sestiga* Project for the Äußeres Burgtor

The planning of a monument to the late emperor Francis I, commissioned by his son Ferdinand I and strongly supported by the empress dowager Caroline Augusta, took place against the backdrop of the construction of other monuments in comparable urban settings and it revealed various interrelationships between members of the family. King Ludwig I of Bavaria, for example, a brother of Caroline Augusta, had a monument to his father Maximilian I Joseph erected by Christian Daniel Rauch in Munich, unveiled in October 1835. At the same time in Dresden, where two other sisters of Caroline Augusta were married to later kings of Saxony (Maria Anna, wife of Frederick Augustus II, who reigned from 1836; and Amalie Auguste, wife of John I, who reigned from 1854), the erection of a monument to Frederick Augustus I by Ernst Rietschel as part of Gottfried Semper's planned development of the Zwinger-Forum was discussed.

The choice of site for the monument in Munich was part of a redesign of the city centre that reinterpreted the dynamic between the Residenz and the urban space surrounding it. The new monument was to be in the centre of the square, framed by Carl Fischer's Nationaltheater (from the 1810s), the Königsbau (a recently completed extension to the Residenz), and the post office building that was in its planning stage. In Dresden, the monument was not placed in the middle of the crossed axes of Pöppelmann's Zwinger complex but rather against the wall pavilion, so that the line of sight from the Kronentor (Crown Gate) to the Elbe remained unobstructed.[157] Similar concerns about the placement of the monument also determined the discussions in Vienna.

A few days after the monarch's death in March 1835, Metternich commissioned the council of the Academy of Fine Arts Vienna to discuss a monument to the emperor, taking into account a design by the Milanese bronze caster Luigi Manfredini that Francis I had approved.[158] The designs for the pedestal[159] (Fig. 73, see also Fig. 74) may have been by Nobile,[160] who had recently introduced Manfredini to Metternich.[161] With regard to the location of the monument, the majority of the council favoured the Äußerer Burgplatz. The monument was to be placed in its centre, where the traffic axis leading from Michaelerplatz to the castle gate met the transverse axis of the entrances to the side gardens. This, however, was not what Nobile and Remy had imagined, as such a monument would obstruct traffic and the line of sight. Both developed a plan to move the monument towards the side, similar to Dresden, and to erect a counter-piece answering it, to maintain symmetry. Remy sug-

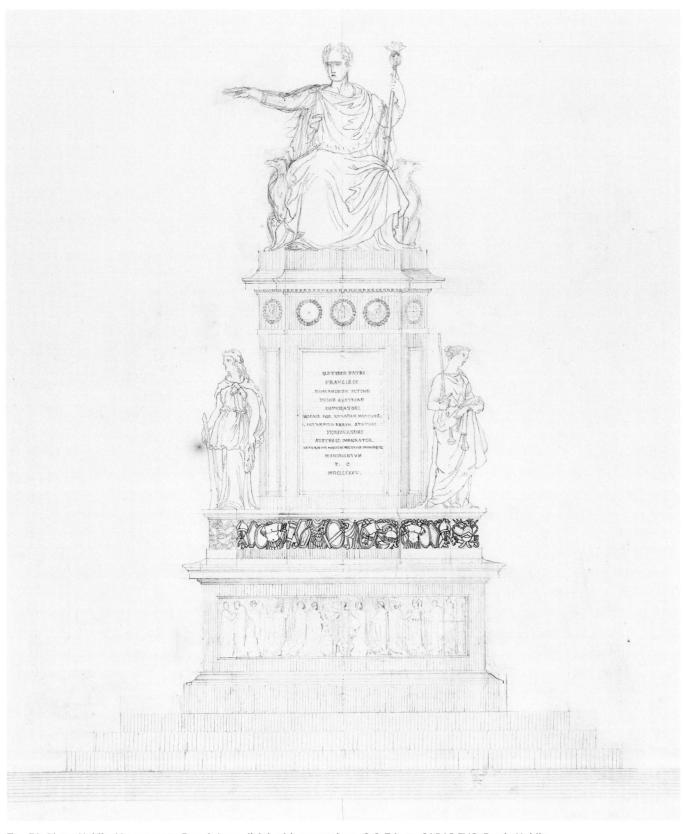

Fig. 73 Pietro Nobile, Monument to Francis I, pencil, ink with watercolour, 1838, Trieste, SABAP FVG, Fondo Nobile.

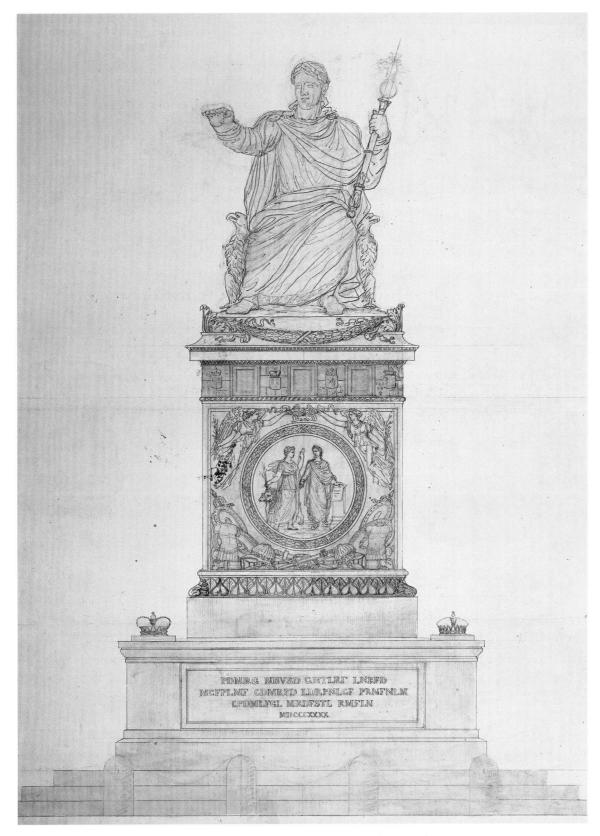

Fig. 74 Pietro Nobile, Monument to Francis I, second version, pencil, ink with watercolour, 1838, Trieste, SABAP FVG, Fondo Nobile.

gested a fountain, while Nobile wanted a monument to Maria Theresa, who had a special importance to him, as a Triestian, due to her construction of the Borgo Teresiano. Years later, Nobile praised himself for being the first to uphold the duty to remember this monarch.[162] In July 1835, he submitted a draft of this monument[163] but only to the curator Metternich rather than to the council of the academy. Throughout these negotiations, Nobile bypassed his fellow academics, preferring direct contact with the very highest court, and this led to disagreements between him and the council. In May 1835, in the middle of the council's ongoing deliberations, Nobile and Metternich visited the monarchs Ferdinand I and Maria Anna Carolina Pia to discuss "cose di arte" (art matters),[164] perhaps including the issue of the monument. Two years later, with still no decision, Caroline Augusta summoned Nobile in an effort to finally get the monument to Francis I completed, after which Metternich orally commissioned Nobile to prepare drafts and cost estimates.[165] Even though Nobile was simply carrying out orders from on high,[166] this caused resentment among his academy colleagues, who had decided in August 1835 to hold a public competition.[167] Already by the summer of 1835, more than twenty designs had been submitted,[168] although the council's competition programme was not approved by Ferdinand I until the turn of the year 1837/38. At the same time, the emperor ordered that a model of Nobile's and Manfredini's design be erected on the Äußerer Burgplatz,[169] but at the location that Nobile had originally rejected and without the counterpart of the Maria Theresa monument; the model was erected by spring 1838 (Pl. LVI).[170] In autumn 1838, prizes were given to the winners of the competition, Raffaele Monti, Michael Nußpaumer, and Ludwig Schaller. At the same time, however, Pompeo Marchesi, who had already received the commission for the imperial monument in Graz in 1837, was ordered from on high to execute the monument in Vienna. In February 1839, Nobile's model, which had neither the approval of the Viennese public nor of his colleagues at the academy, was demolished.[171] Subsequently, Nobile resubmitted his plan for the two complementary monuments, but in October 1841 a contract was signed with Marchesi, who was now to realize the monument on the inner Burgplatz of the Hofburg.[172]

We can perhaps better understand the conflict caused by Nobile's actions in the matter of the Francis monument if we consider the other projects for monuments on the Äußeres Burgtor that he had already developed and launched in the 1820s. For example, his bequest in Trieste contains drawings for monumental groups of sculptures on the Burgtor[173] in which the figure of a genius either hands the peace palm to the victorious Austria[174] or crowns the emperor in the *sestiga* with the victor's wreath (Pl. LVII).[175] Nobile even had the version with the *sestiga* reproduced in print[176] in order to publicize his design. This sculptural decoration would have enabled the public to perceive the Burgtor, which apart from its inscriptions had no clearly legible signs,[177] as a victory monument.[178]

As early as 1826, Nobile was being considered to design the altar structure on top of the Äußeres Burgtor for the open-air Mass to be held for the convalescence of Francis I.[179] During a personal conversation with the imperial couple in June 1827, Nobile proposed the construction of a *sestiga* on the Burgtor, which still lacked a "principale ornamento."[180] As Caroline Augusta apparently disagreed with the emperor's opinion that this sculpture would be too massive, Nobile asked to be allowed to make a model and received an imperial order from *Obersthofmeister* Trauttmannsdorff to draw up an estimate as well.

Nobile wrote that he let the matter rest for the time being, but he brought the casting of the "cavalli p[er] la Porta di Corte"[181] (probably the *sestiga* group for the Burgtor) back to Metternich in February 1835, while Francis I was still alive. When Nobile discussed the idea of the "Sessiga [sic] sulla Porta"[182] with Metternich again a few days after the death of Francis I, however, it seems that Ferdinand I did not concur with Nobile's idea to crest the Burgtor with a monument to Francis I. In Nobile's view, the topic could only be discussed again at a later date. The last versions of the project appear after 1839, when Nobile worked on a series of drawings of the two corresponding monuments to Francis I and Maria Theresa together with the *sestiga* for the Burgtor.[183] He must have worked on this up until 1842,[184] by which point Pompeo Marchesi's commission had long been sealed.

NOTES

1 Basic: Irmgard Köchert, "Peter Nobile. Sein Werdegang und seine Entwicklung mit besonderer Berücksichtigung seines Wiener Schaffens" (PhD diss., University of Vienna, 1951), 84–99, 211–215; Renate Wagner-Rieger, *Wiens Architektur im 19. Jahrhundert* (Vienna: Österreichischer Bundesverlag für Unterricht, Wissenschaft und Kunst, 1970), 83–85; Renate Wagner-Rieger, "Vom Klassizismus bis zur Secession," in *Geschichte der bildenden Kunst in Wien. Geschichte der Architektur in Wien. Geschichte der Stadt Wien*, ed. Verein für Geschichte der Stadt Wien, Neue Reihe 7/3 (Vienna: self-publishing of the Verein für Geschichte der Stadt Wien, 1973), 116–119; Maria Kaufmann, "Das Burgtor in Wien: Planung und Bau" (Dipl. phil., University of Vienna, 2010; Christian Benedik, "Die Genese des Äußeren Burgplatzes," in *Die Wiener Hofburg 1705–1835. Die kaiserliche Residenz vom Barock bis zum Klassizismus*, ed. Hellmut Lorenz and Anna Mader-Kratky (*Veröffentlichungen zur Bau- und Funktionsgeschichte der Wiener Hofburg 3*, ed. Artur Rosenauer) (Vienna: Austrian Academy of Sciences, 2016), 214–222; Christian Benedik, "Planung und Errichtung des Äußeren Burgtores," in *Die Wiener Hofburg 1705–1835. Die kaiserliche Residenz vom Barock bis zum Klassizismus*, ed. Hellmut Lorenz and Anna Mader-Kratky (*Veröffentlichungen zur Bau- und Funktionsgeschichte der Wiener Hofburg 3*, ed. Artur Rosenauer) (Vienna: Austrian Academy of Sciences, 2016), 222–230; Richard Kurdiovsky, "Das Äußere Burgtor. Planungs-, Bau- und Nutzungsgeschichte 1817–1916," in *Gedächtnisort der Republik*, ed. Heidemarie Uhl, Richard Hufschmied and Dieter A. Binder (Vienna, Cologne and Weimar: Böhlau, 2021), 15–71; on the iconographic interpretation of the architecture see Peter Stachel, *Mythos Heldenplatz* (Vienna: Pichler, 2002), 45–62.

2 Anna Mader-Kratky, "Wien ist keine Festung mehr. Zur Geschichte der Burgbefestigung im 18. Jahrhundert und ihrer Sprengung 1809," *Österreichische Zeitschrift für Kunst und Denkmalpflege* 64 (2010): 141–144.

3 Baron Joseph Hormayr, ed., *Wien, seine Geschicke und seine Denkwürdigkeiten* 2, issue 2–3, Vienna: Franz Härter'sche Buchhandlung, 1825, 33.

4 ÖStA, HHStA, HBA, K. 253 ex 1810, Nr. 506; see Benedik, "Burgplatz," 215–216.

5 Jochen Martz, "'Waren hier die alten Wälle?'. Zur Genese und Entwicklung der gärtnerischen Nutzung auf dem Gelände der fortifikatorischen Anlagen im Bereich der Wiener Hofburg," *Österreichische Zeitschrift für Kunst und Denkmalpflege* 64 (2010): 125–126.

6 Albertina Vienna, Az. 8202–8204.

7 ÖNB, Kartensammlung (map collection), Roll. 103, Kar. 2.

8 Plans by the Geniedirektion, ÖNB, Bildarchiv (picture archive), Pk 312 from 10 December 1817.

9 Albertina Vienna, Az. 8831 and probably also 6239.

10 ÖNB, Bildarchiv, Pk 314: explanatory note; see Kaufmann, "Burgtor," 38.

11 ÖNB, Bildarchiv, Pk 314: explanatory note; see Kaufmann, "Burgtor," 37.

12 Benedik, "Burgtor," 223, note 904.

13 ÖNB, Bildarchiv, Pk 317; see Angelina Pötschner, "Das Burgtor auf dem Heldenplatz. Einst repräsentatives Stadttor und Denkmal der Völkerschlacht bei Leipzig, heute Heldendenkmal in Wien," *Arx* 21 (1999), no. 1: 10; Benedik, "Burgtor," 224.

14 ASVS, series IV: Franz Joseph Saurau to Luigi Cagnola, 16 April 1817 (quoted in Gianluca Kannés, "Commissioni ed incarichi per Vienna del marchese Luigi Cagnola," in *L'architetto Pietro Nobile (1776–1854) e il suo tempo* (Atti del convegno internazionale di studio, Trieste 1999), ed. Gino Pavan (Trieste: Società di Minerva, 1999), 175–176).

15 Gino Pavan, *Lettere da Vienna di Pietro Nobile (dal 1816 al 1854)* (Trieste: Società di Minerva, 2002), 76: Nobile to his brother on 19 May 1820.

16 ÖNB, Bildarchiv, Pk 315, 1–6: "Progetto primo" to "Progetto settimo"; Benedik, "Burgtor," 226.

17 Albertina Vienna, Az. 6262–6272; see the more extensive plans in: Milan, Castello Sforzesco, Civica Raccolta delle Stampe Achille Bertarelli (Kannés, "Cagnola," note 34).

18 On the influence of Metternich and Giacomo Mellerios, the President of the Provisional Government of Lombardo-Venetia after 1815, on the choice of Cagnola: Kannés, "Cagnola," 164–165 and Kaufmann, "Burgtor," 49.

19 Selma Krasa, "Kat.-Nr. 119–121. Theseus besiegt den Kentauren," in *Monumente. Wiener Denkmäler vom Klassizismus zur Secession*, ed. Richard Bösel and Selma Krasa (Vienna: Adolf Holzhausens Nachfolger KG, 1994), 170–176; Johannes Myssok, "Canovas Theseus – ein kolossales Missverständnis," *Jahrbuch des Kunsthistorischen Museums Wien* 11 (2009) (Sabine Haag and Gabriele Helke, ed., *Mythos der Antike. Beiträge des am 1. und 2. März 2009 vom Kunsthistorischen Museums in Wien veranstalteten internationalen Symposiums*): 169–185.

20 Richard Bösel, "Kat.-Nr. 15. Entwurf zur Ausgestaltung des Äußeren Burgplatzes mit Denkmälern für Franz I. und Maria Theresia," in *Monumente. Wiener Denkmäler vom Klassizismus zur Secession*, ed. Richard Bösel and Selma Krasa (Vienna: Adolf Holzhausens Nachfolger KG, 1994), 43; Richard Bösel, "Kat.-Nr. 115–117. Der Theseustempel," in *Monumente. Wiener Denkmäler vom Klassizismus zur Secession*, ed. Richard Bösel and Selma Krasa (Vienna: Adolf Holzhausens Nachfolger KG, 1994), 165.

21 Bassano del Grappa, Museo Civico, manoscritti canoviani 1195 (Bösel, "Theseustempel," 166).

22 Wagner-Rieger, "Klassizismus Secession," 117–119.

23 Albertina Vienna, Az. 6231–6236 and Trieste, SABAP FVG, Fondo Nobile, vol. 16/4.

24 Albertina Vienna, Az. 6224–6230 and 8205–8212: "Mit Rücksicht auf die bestehenden Fundamente im Monat Aprill [sic] 820 entworfen."

(Designed with respect to the existing foundations in the month April 1820).

25 ÖNB, Bildarchiv, Pk 313, 1–10.

26 Aman's participation in this "competition" is documented in: ASVS, Series VI, Busta 164: Paolo d'Adda Salvaterra to Luigi Cagnola, 7 August 1820 (see Kannés, "Cagnola," 185).

27 Hormayr, *Wien*, 40; Paolo d'Adda Salvaterra to Luigi Cagnola, 7 August 1820 (see Kannés, "Cagnola," 185); see Kaufmann, "Burgtor," 72.

28 Pavan, *Lettere*, 78–79: Nobile to his brother on June 1820.

29 Pavan, *Lettere*, 78: Nobile to his brother on 19 May 1820.

30 Pavan, *Lettere*, 76: Nobile to his brother on 19 May 1820.

31 UAABKW, MR, Fasc. 1/3 ex 1818/19, Zl. 38: Francis I to Metternich, 31 March 1818.

32 Anonymous, "Nekrolog (Mit einer Abbildung.) Marchese Luigi Cagnola," *Allgemeine Bauzeitung* 3 (1838): 24.

33 Pavan, *Lettere*, 77: Nobile to his brother, 19 May 1820.

34 Pavan, *Lettere*, 72–75: Nobile to his brother on April 1820; Nobile to Metternich on 24 May 1820 cf. Gino Pavan, *Pietro Nobile architetto (1776–1854), studi e documenti* (Trieste-Gorizia: Istituto Giuliano di Storia, Cultura e Documentazione, 1998), 39 and 237; Kaufmann, "Burgtor," 67.

35 Gino Pavan, "Les dessins et la correspondance de Pietro Nobile à Trieste," in *Portraits pour une ville. Trouver Trieste* (exh. catalogue Paris Conciergerie 1985/86) (Trieste: Electa, 1985), 71; Trieste, SABAP FVG, Fondo Nobile, vol. 16, no. 4 and 57: "Pianta del Progetto I della Scuola di Architettura"; see Rossella Fabiani, ed., *Pagine architettoniche. I disegni di Pietro Nobile dopo il restauro* (Passian di Prato: Campanotto, 1997), fig. 216.

36 Andreas Haus, *Karl Friedrich Schinkel als Künstler. Annäherung und Kommentar* (Munich: Deutscher Kunstverlag, 2001), 157.

37 Fabiani, *Pagine*, 131.

38 Trieste, SABAP FVG, Nobile Collection, vol. 70, no.6 and 244; see Fabiani, *Pagine*, 130–131; Kaufmann, "Burgtor," 86.

39 Trieste, SABAP FVG, Nobile Collection, vol. 16, no. 4 and 54b: Legenda esplicativa (see Fabiani, *Pagine*, 134).

40 On Nobile's study of Dorian architecture: Fabiani, *Pagine*, 66–73; Kaufmann, "Burgtor," 86.

41 Livia Rusconi, "Pietro Nobile e il gruppo del Teseo di Antonio Canova a Vienna," *Archeografo Triestino* 10 (1923), 352 (quoted in Fabiani, *Pagine*, 131 and note 180).

42 View of the Propylaea in Athens and the Brandenburg Gate after a drawing by Johann Carl Richter, in: Anonymous, "Die Propyläen des Perikles in Athen, und das Brandenburger Thor in Berlin," *Der Torso. Eine Zeitschrift der alten und neuen Kunst* 1 (1796): plate after 77.

43 Ludwig Gleim, *An Berlin*, 1795: "Das Thor Athens hast Du Berlin!" (Berlin you have the gate of Athens!; quoted in Jürgen Reiche, "Symbolgehalt und Bedeutungswandel eines politischen Monuments," in *Das Brandenburger Tor 1791–1991. Eine Monographie*, ed. Willmuth Arenhövel and Rolf Bothe (Berlin: Arenhövel, 1991), 274.

44 Pro Memoria by Carl Gotthard Langhans (quoted in Laurenz Demps, "Zur Baugeschichte des Tores," in *Das Brandenburger Tor 1791–1991. Eine Monographie*, ed. Willmuth Arenhövel and Rolf Bothe (Berlin: Arenhövel, 1991), 40–42, or the appendix in: Arenhövel and Bothe, *Brandenburger Tor*, 319).

45 OeStA, KA, *Hofkriegsrat* (Court War Office), Protocolla 1821/L Nr. 2823 (quoted in Kaufmann, "Burgtor," 82 and note 227); Alphons Lhotsky, *Festschrift des Kunsthistorischen Museums zur Feier des fünfzigjährigen Bestandes. Erster Teil: Die Baugeschichte der Museen und der Neuen Burg*, (Vienna-Horn: Ferdinand Berger, 1941), 22.

46 Christian Benedik, "Der Theseustempel," in *Die Wiener Hofburg 1705–1835. Die kaiserliche Residenz vom Barock bis zum Klassizismus*, ed. Hellmut Lorenz and Anna Mader-Kratky (*Veröffentlichungen zur Bau- und Funktionsgeschichte der Wiener Hofburg 3*, ed. Artur Rosenauer) (Vienna: Austrian Academy of Sciences, 2016), 550.

47 Anonymous, "Peter von Nobile. Zweites Corti'sches Kaffeehaus, 1820–1822," in *Klassizismus in Wien. Architektur und Plastik* (exh. catalogue Historisches Museum der Stadt Wien 1978) (Vienna: self-publishing, 1978), 122–123.

48 Franz Carl Weidmann, "Verschönerungen Wiens I: Der Volksgarten, und Canova's Theseus," *Archiv für Geschichte, Statistik, Literatur und Kunst* 51–52 (1823): 270–271.

49 UAABKW, MR ex 1823/24, Zl. 41: Francis I to Metternich, 16 October 1824: "ein Denkmal früherer glücklicher Ereignisse an die Nachkommen."

50 *Wiener Zeitung*, 16 October 1824, 1: "Thor [...] als Erinnerung an die besiegte Vergangenheit"[...] "Tempel [...] der Kunst gewidmet."

51 Also for the following: Christian Cay Lorenz Hirschfeld, *Theorie der Gartenkunst 5* (Leipzig: Weidmann, 1785), 70. "[...] scheint der Ort zu seyn, wo man leicht dem Volk mitten auf den Weg seiner Vergnügungen eine gute Lehre hinstreuen und seine Aufmerksamkeit durch wichtige Erinnerungen wachhalten kann."

52 ÖStA, HHStA, HBA, K. 253 ex 1810, Nr. 506.

53 Kaufmann, "Burgtor," 5.

54 Also for the following: *Wiener Zeitung*, 16 October 1824, 1: "Stätten früherer Zerstörung."

55 Stachel, *Heldenplatz*, 56–60.

56 Hormayr, *Wien*, 40: "überhaupt das ganze Werk durch das Militär, nach Römerweise vollendet".

57 Christian Benedik, "Ludwig von Remy – Erweiterungsprojekt der Wiener Hofburg, 1815/1831," in *Die Wiener Hofburg 1705–1835. Die kaiserliche Residenz vom Barock bis zum Klassizismus*, ed. Hellmut Lorenz and Anna Mader-Kratky (*Veröffentlichungen zur Bau- und Funktionsgeschichte der Wiener Hofburg 3*, ed. Artur Rosenauer) (Vienna: Austrian Academy of Sciences, 2016), 241.

58 Hormayr, *Wien*, 50.

59 Stachel, *Heldenplatz*, 52–55; finally: Myssok, "Theseus."

60 Anonymous, *Beschreibung des kais.[erlich] königl.[ichen] Volksgartens, des Theseus-Tempels, der in demselben befindlichen Statue des Theseus,*

des Garten-Salons und des neuen Burgthores in Wien, (Vienna: Tendler and von Manstein, 1824), 13–14: "Verbesserung des Staatswesens."

61 UAABKW, VA ex 1817, fol. 205–208: The humble submission of Metternich on 17 November, 1817 with the on high authorization on 12 December, 1817.

62 Elisabeth Springer, "Die Baubehörden der österreichischen Zentralverwaltung in der Mitte des 19. Jahrhunderts," (research paper ["Hausarbeit"] at the Institut für österreichische Geschichtsforschung, typoscript, University of Vienna, 1971).

63 Anna Mader-Kratky, "Neustrukturierung des Hofbauwesens durch Joseph II.," in *Die Wiener Hofburg 1705–1835. Die kaiserliche Residenz vom Barock bis zum Klassizismus*, ed. Hellmut Lorenz and Anna Mader-Kratky (Veröffentlichungen zur Bau- und Funktionsgeschichte der Wiener Hofburg 3, ed. Artur Rosenauer) (Vienna: Austrian Academy of Sciences, 2016), 258–259.

64 UAABKW, VA ex 1822/23, Zl. 368: Lower Austrian Governor's Office to President Czernin on 11 July 1823.

65 Christian Benedik, "Strukturreformen im Hofbauwesen unter Franz II. (I.)," in *Die Wiener Hofburg 1705–1835. Die kaiserliche Residenz vom Barock bis zum Klassizismus*, ed. Hellmut Lorenz and Anna Mader-Kratky (Veröffentlichungen zur Bau- und Funktionsgeschichte der Wiener Hofburg 3, ed. Artur Rosenauer) (Vienna: Austrian Academy of Sciences, 2016), 260–262.

66 Pavan, *Lettere*, 527: Nobile to his brother on 5 January 1842.

67 Anonymous, "Nr. 227 Karl Myrbach v. Rheinfeld," *Neuer Nekrolog der Deutschen* 22 (1844), 2nd part (Weimar 1846): 718–723.

68 For comparison see Susanne Kronbichler-Skacha, "Die Wiener ‚Beamtenarchitektur' und das Werk des Architekten Hermann Bergmann (1816–1886)," *Wiener Jahrbuch für Kunstgeschichte* 39 (1986): 173.

69 UAABKW, VA ex 1819, fol. 30r–30v: Reform proposal, 5 January 1819.

70 UAABKW, VA ex 1833/34, Zl. 282: Joseph Haslinger to the director of the School of Architecture on 22 April 1834.

71 UAABKW, SProt. ex 1843: 23 November 1843.

72 Robert H. Beutler, "Das Niederösterreichische Landhaus in Wien – der klassizistische Umbau durch Alois Pichl," (Phil. dipl., University of Vienna, 2003); Wilhelm Georg Rizzi, "Die Architektur des Niederösterreichischen Landhauses," in *Altes Landhaus*, ed. Anton Eggendorfer et al. (Vienna: Brandstätter, 2006), 99–104.

73 Elisabeth Springer, *Geschichte und Kulturleben der Wiener Ringstraße* (*Die Wiener Ringstraße. Bild einer Epoche* 2, ed. Renate Wagner-Rieger) (Wiesbaden: Franz Steiner Verlag GmbH, 1979), 21.

74 Pavan, *Lettere*, 529: Nobile to his brother on 16 February 1842.

75 UAABKW, VA ex 1819, fol. 302: President of the Court Chamber Count Ignaz Chorinsky to President Lamberg-Sprinzenstein on 31 May 1819.

76 Also see: Fritz Tumlirz, "Das Grazer Schauspielhaus. Seine Baugeschichte," (PhD diss., Karl Franzens-University Graz, 1956), 41–73; U. Ocherbauer, "Die Instandsetzung und Modernisierung des Grazer Schauspielhauses," *Österreichische Zeitschrift für Kunst und Denk-*

malpflege 14 (1960), 150–156; *Die Kunstdenkmäler der Stadt Graz. Die Profanbauten des I. Bezirkes. Altstadt* (Österreichische Kunsttopographie 53), ed. Bundesdenkmalamt (Vienna-Horn: Berger, 1997), LXXIII and 268–273.

77 It is possible that Ignaz Kollmann was also involved, after having worked as a civil servant in Trieste, and being an editor of the *Grazer Zeitung* and confidant of Archduke Johann; see: Otfried Hafner, "Zur Grazer Kunstgeschichte des Klassizismus," *Mitteilungen der Gesellschaft für vergleichende Kunstforschung in Wien* 29 (1977), 1–7.

78 UAABKW, VA ex 1833/34, Zl. 381: Metternich to the Academy on 5 July 1834.

79 OeStA, AVA, Kultus AK Katholisch 307, Vienna suburban parishes: B-M: Expert opinion of the *Hofbaurat* of 12 July 1827.

80 OeStA, AVA, Kultus AK Katholisch 307, Vienna suburban parishes: B-M: Expert opinion of the *Hofbaurat* of 6 December 1831.

81 OeStA, AVA, Kultus AK Katholisch 307, Vienna suburban parishes: B-M: *Hofbaurat* to Court Chancellery on 25 February 1835.

82 UAABKW, VA ex 1825/26, Zl. 314: Note from the Academy to the *Studienhofkommission*, dispatched on 30 September 1826.

83 UAABKW, VA ex 1834/35, no. 112: Copy of the on high resolution of 7 November 1834 (in response to the submission of the General Court Chamber of 31 March 1833, no. 3344/545).

84 ÖStA, FHKA, Collection of plans, Rb 712/1–6.

85 Johann Weißensteiner, "Regesten zur Geschichte der Pfarre Inzersdorf-St. Nikolaus (Wien 23) 1571–1932 nach den Pfarrakten im Diözesanarchiv Wien," *Wiener Katholische Akademie Miscellanea, Neue Reihe* 129 (1983): 17–19, 24–25.

86 Trieste, SABAP FVG, Fondo Nobile, vol. 4, no. 40–43.

87 Anonymous (initial "G."), "Neue Kirche zu Wilton bei Salisbury," *Allgemeine Bauzeitung* 14 (1849): 90–93 and Taf. 244–246.

88 UAABKW, SProt. ex 1828: 7 July 1828.

89 Mario Schwarz, "Die Baugeschichte des Festsaales der Technischen Hochschule in Wien," *Österreichische Zeitschrift für Kunst und Denkmalpflege* 27 (1973): 35–40.

90 UAABKW, VA ex 1825/26, Zl. ad 321: Nobile to Czernin on 24 June 1826.

91 See also: UAABKW, VA ex 1826/27, Zl. 53: most humble submission from President Czernin on 8 December 1826.

92 UAABKW, VA ex 1826/27, Zl. 126: Decree of the Presidium of the Academy sent to Nobile on 3 February 1827 (supplement): "jenen auf das Gebäude sich beziehenden Charakter von gefälligem Ernst."

93 UAABKW, SProt. ex 1836: 19 and 22 December 1836.

94 Selma Krasa-Florian, *Johann Nepomuk Schaller (1777–1842): ein Wiener Bildhauer aus dem Freundeskreis der Nazarener* (Vienna: Anton Schroll, 1977), 82–84.

95 UAABKW, SProt. ex 1837: 8 June and 20 July, 1837.

96 UAABKW, MR ex 1837/I, Zl. 152: 20 April 1837.

97 UAABKW, MR ex 1836/II, Zl. 152: 18 August 1837.

98 See also: UAABKW, VA ex 1837, Zl. 193: 14 June 1837: "das römisch-griechische, sich immer gleichbleibende, in klassischen Monu-

menten angewendete, dem Wechsel der Moden nicht unterworfene Ideal-Costüm."

99 Ibidem: "Welche frivole Mode-Varietäten in dem ersten, welche Würde und Bedeutung in dem zweiten!"

100 UAABKW, SProt. ex 1837: 8 June and 20 July 1837. "Welche frivole Mode-Varietäten in dem ersten, welche Würde und Bedeutung in dem zweiten!"

101 Krasa-Florian, *Schaller*, 83.

102 UAABKW, MR ex 1837/I, Zl. 152: 16 December 1837.

103 Karl Ginhart, *Die Kaisergruft bei den pp. Kapuzinern in Wien* (Vienna: Logos, 1925), 19–20, 46; Köchert, "Nobile," 157–158, 235; Magdalena Hawlik-van de Water, *Die Kapuzinergruft. Begräbnisstätte der Habsburger in Wien* (Vienna-Freiburg-Basel: Herder, 1987), 182; Pavan, *Nobile*, 53; Eva Hüttl-Ebert, "Nobile a Vienna," in *L'architetto Pietro Nobile (1776–1854) e il suo tempo* (Atti del convegno internazionale di studio, Trieste 1999), ed. Gino Pavan (Trieste: Società di Minerva, 1999), 148; Brigitta Lauro, *Die Grabstätten der Habsburger. Kunstdenkmäler einer europäischen Dynastie* (Vienna: Brandstätter, 2007), 201, 210.

104 Pavan, *Nobile*, 48–50; Pavan, *Lettere*, 228: Nobile to his brother on 20 July 1829; 234: Nobile to his brother on 16 August 1829.

105 Hüttl-Ebert, "Nobile," 132–133.

106 Essential to the pre-March planning and construction measures: Wilfried Schaber, "Pietro Nobile e la ricostruzione del castello Mirabell a Salisburgo," in *L'architetto Pietro Nobile (1776–1854) e il suo tempo* (Atti del Convegno internazionale di studio Trieste, 7–8 Maggio 1999), ed. Gino Pavan (Trieste: Società di Minerva, 1999), 208–214.

107 UAABKW, VA ex 1819, fol. 302: President of the Court Chamber Count Ignaz Chorinsky to President Lamberg on 31 May 1819.

108 Rapporto [...] di ricostruzione dell'incendiato palazzo di Mirabello a Salisburgo by Nobile on 4 August, 1819, quoted in: Schaber, "Mirabell," 202, note 14.

109 OeStA, FHKA, plan collection Ra 28/16: Section with neoclassical reconstruction of the great hall.

110 OeStA, FHKA, plan collection Ra 28/1–30: Plans for the renovation of Mirabell Palace.

111 Trieste, SABAP FVG, Fondo Nobile, vol. 18 no. 58–67 (Studies on four-winged palace buildings, possibly made in relation to the plans for Mirabell) and 68–74 (Alternatives for the facades of Mirabell).

112 *Schematismus* (administrative directory) of the Archduchy of Austria ob der Enns (Upper Austria), Linz 1820, 272.

113 Schaber, "Mirabell," 208–214.

114 OeStA, FHKA, plan collection, Ra 28/13.

115 OeStA, FHKA, plan collection Ra 28/15.

116 OeStA, FHKA, plan collection Ra 28/14.

117 Trieste, SABAP FVG, Fondo Nobile, vol. 18 no. 70.

118 Trieste, SABAP FVG, Fondo Nobile, vol. 18 no. 72.

119 Triest, SABAP FVG, Fondo Nobile, vol. 18 no. 68.

120 Triest, SABAP FVG, Fondo Nobile, vol. 18 no. 69.

121 OeStA, HHStA, HBA, K. 379, Zl. 1125 ex 1819.

122 Pavan, *Nobile*, 38.

123 Elfriede Iby and Alexander Koller, *Schönbrunn* (Vienna: Brandstätter, 2000), 251.

124 OeStA, HHStA, HBA, K. 379, Zl. 1125 ex 1819.

125 Köchert, "Nobile," 221–222; Pavan, *Nobile*, 47.

126 Heidrun Laudel, "Sempers Theaterbauten – Stätten monumentaler Festlichkeit," in *Gottfried Semper 1803–1879. Architektur und Wissenschaft*, ed. Winfried Nerdinger and Werner Oechslin (Munich, Berlin, London, New York and Zurich: gta and Prestel, 2003), 134.

127 Christian Benedik and Andrea Sommer-Mathis, "Neubauprojekte für die Hoftheater," in *Die Wiener Hofburg 1705–1835. Die kaiserliche Residenz vom Barock bis zum Klassizismus*, eds. Hellmut Lorenz and Anna Mader-Kratky (*Veröffentlichungen zur Bau- und Funktionsgeschichte der Wiener Hofburg 3*, ed. Artur Rosenauer) (Vienna: Austrian Academy of Sciences, 2016), 199–200.

128 Andrea Sommer-Mathis and Manuel Weinberger, "Das alte Burgtheater, 1741–1792," in *Die Wiener Hofburg 1705–1835. Die kaiserliche Residenz vom Barock bis zum Klassizismus*, eds. Hellmut Lorenz and Anna Mader-Kratky (Veröffentlichungen zur Bau- und Funktionsgeschichte der Wiener Hofburg 3, ed. Artur Rosenauer) (Vienna: Academy of Sciences, 2016), 134–140.

129 Benedik and Sommer-Mathis, "Neubauprojekte Hoftheater," 201–202, 204.

130 Christian Benedik, "Kat.-Nr. 65.–66. Vorprojekt für einen Gesamtumbau des Burgtheaters, Anton Ortner, 1828," in *Der Michaelerplatz in Wien. Seine städtebauliche und architektonische Entwicklung* (exh. catalogue Looshaus and Albertina Vienna, 1991–1992), ed. Richard Bösel and Christian Benedik (Vienna: Kulturkreis Looshaus, without date [1991]), 104–106.

131 Pavan, *Lettere*, 161: Nobile to his brother on 1 December 1827.

132 Pavan, *Lettere*, 162: Nobile to his brother on 14 January 1828.

133 Trieste, SABAP FVG, Fondo Nobile, vol. 18 no. 9.

134 Trieste, SABAP FVG, Fondo Nobile, vol. 18 no. 4.

135 Benedik and Sommer-Mathis, "Neubauprojekte Hoftheater," 205.

136 Francesco Milizia, *Principi di architettura civile* (Bassano-Venezia: Remondini, 1785), vol. 2, 377.

137 Pavan, *Lettere*, 164: Nobile to his brother on 14 January 1828.

138 Jean-Nicolas-Louis Durand, *Précis des leçons d'architecture données à l'école Polytechnique*, 2nd vol. (Paris: Chez l'Auteur et Bernard, 1805), plate 16.

139 Pietro Sangiorgi, *Idea di un teatro adattato al locale detto delle convertite nella strada del Corso di Roma* (Rome: Mordacchini, 1821).

140 Daniel Rabreau, *Le Théâtre de l'Odéon. Du Monument de la Nation au Théâtre de l'Europe* (Paris: Belin, 2007); Daniel Rabreau, *Apollon dans la ville. Essai sur le théâtre et l'urbanisme à l'époque des Lumières* (Paris: Éditions du patrimoine, 2008).

141 Trieste, SABAP FVG, vol. 43 no. 2.

142 Trieste, SABAP FVG, vol. 43 no. 3, 5 and 14.

143 Trieste, SABAP FVG, vol. 18 no. 9.

144 Pavan, *Lettere*, 162: Nobile to his brother on 14 January 1828.

145 Wien Museum, Inv.-Nr. 107.056; see: Richard Bösel, "Kat.-Nr. 69. Zustandsplan der Hofburg mit Ausbauprojekt für die Vorstadtfront, das Burgtheater und den Michaelertrakt, Pietro Nobile (?), um 1827," in *Der Michaelerplatz in Wien. Seine städtebauliche und architektonische Entwicklung* (exh. catalogue Looshaus and Albertina Vienna, 1991–1992), eds. Richard Bösel and Christian Benedik (Vienna: Kulturkreis Looshaus, without date [1991]), 108–112.

146 Pavan, *Lettere*, 151: Nobile to his brother on 20 June 1827.

147 Bösel, "Hofburg," 111.

148 Triest, SABAP FVG, Fondo Nobile, vol. 3, no. 94.

149 Bösel, "Hofburg," 111.

150 Anna Mader-Kratky, "Ausbaupläne für die Wiener Hofburg von Johann Ferdinand Hetzendorf von Hohenberg," in *Die Wiener Hofburg 1705–1835. Die kaiserliche Residenz vom Barock bis zum Klassizismus*, eds. Hellmut Lorenz and Anna Mader-Kratky (Veröffentlichungen zur Bau- und Funktionsgeschichte der Wiener Hofburg 3, ed. Artur Rosenauer) (Vienna: Austrian Academy of Sciences, 2016), 212–213.

151 Benedik, "Remy – Erweiterungsprojekt," 237–241.

152 Benedik, "Burgplatz," 220.

153 Christian Benedik and Hellmut Lorenz, "Der *Historische Atlas* der Wiener Hofburg von Johann Aman," in *Die Wiener Hofburg 1705–1835. Die kaiserliche Residenz vom Barock bis zum Klassizismus*, eds. Hellmut Lorenz and Anna Mader-Kratky (*Veröffentlichungen zur Bau- und Funktionsgeschichte der Wiener Hofburg 3*, ed. Artur Rosenauer) (Vienna: Austrian Academy of Sciences, 2016), 233–234.

154 Civica Raccolta delle Stampe Achille Bertarelli, Castello Sforzesco, Mailand (See: Kannés, "Cagnola," n. 34).

155 Adrian von Buttlar, *Leo von Klenze. Leben – Werk – Vision* (Munich: Beck, 1999), 200–206; Sonja Hildebrand, "Werkverzeichnis," in *Leo von Klenze. Architekt zwischen Kunst und Hof 1784–1864* (exh. catalogue Münchner Stadtmuseum and Altes Museum Berlin 2000–2001), ed. Winfried Nerdinger (Munich, London and New York: Prestel, 2000), 306.

156 Richard Bösel, "Kat.-Nr. 78. Projekt für den Ausbau der Hofburg und die Regulierung ihres städtebaulichen Umfeldes, Massenplan Anton Barvitius, 1856," in *Der Michaelerplatz in Wien. Seine städtebauliche und architektonische Entwicklung* (exh. catalogue Looshaus and Albertina Vienna, 1991–1992), eds. Richard Bösel and Christian Benedik (Vienna: Kulturkreis Looshaus, without date [1991]), 122–124.

157 Martin Fröhlich, *Gottfried Semper. Zeichnerischer Nachlass an der ETH Zürich* (Basel-Stuttgart: Birkhäuser, 1974), 40.

158 See also Selma Krasa, "Kat.-Nr. 14: Entwurf zu einem Denkmal für Kaiser Franz I. auf dem Äußeren Burgplatz," in *Monumente. Wiener Denkmäler vom Klassizismus zur Secession* (exh. catalogue Looshaus and Graphische Sammlung Albertina Vienna 1994), eds. Richard Bösel and Selma Krasa (Vienna: Adolf Holzhausens Nachfolger KG, without date [1994]), 38–41.

159 Trieste, SABAP FVG, Fondo Nobile, vol. 1, no. 43 and 45.

160 Krasa, "Denkmal," 39–40.

161 Pavan, *Lettere*, 366: Nobile to his brother on 23 January 1835.

162 Pavan, *Lettere*, 421: Nobile to his brother on 11 May 1837.

163 Bösel, "Burgplatz,," 43; see Werner Telesko, *Kulturraum Österreich. Die Identität der Regionen in der bildenden Kunst des 19. Jahrhunderts* (Vienna-Cologne-Weimar: Böhlau, 2008), 116.

164 Pavan, *Lettere*, 378: Nobile to his brother on 19 May 1835.

165 Pavan, *Lettere*, 421–422: Nobile to his brother on 25 May 1837.

166 Pavan, *Lettere*, 423: Nobile to his brother on 11 June 1837.

167 UAABKW, SProt ex 1835: 5 August 1835.

168 UAABKW, VA ex 1834/35, Zl. 421: Directory of projects.

169 Pavan, *Lettere*, 440–441: Nobile to his brother on 3 April 1838; 445–446: Nobile to his brother on 29 May 1838.

170 See also: Krasa, "Denkmal," 40–41.

171 Krasa, "Denkmal," 41.

172 Werner Telesko, "Das Denkmal für Kaiser Franz II. (I.) im Inneren Burghof," in *Die Wiener Hofburg 1835–1918. Der Ausbau der Residenz vom Vormärz bis zum Ende des "Kaiserforums,"* ed. Werner Telesko (Veröffentlichungen zur Bau- und Funktionsgeschichte der Wiener Hofburg 4, ed. Artur Rosenauer) (Vienna: Academy of Sciences, 2012), 423.

173 Bösel, "Burgplatz," 43.

174 Trieste, SABAP FVG, Fondo Nobile, vol. 16, no. 71. We may have to understand the 1840 drawings ascribed to Marchesi (Lhotsky, *Festschrift*, 194) of groups of sculptures for the Äußeres Burgtor as alternatives to these designs by Nobile.

175 Trieste, SABAP FVG, Fondo Nobile, vol. 16, no. 82.

176 Copies of these prints: Trieste, SABAP FVG, Fondo Nobile, vol. 16 no. 85–86; Albertina Wien, Supplement in portfolio 67, Envelope 15; State château Kynžvart, Library, publication dedicated to Metternich.

177 Christian Benedik, "Die Wiener Hofburg unter Kaiser Franz II. (I.) im Kontext politischer Ereignisse," in *Die Wiener Hofburg 1705–1835. Die kaiserliche Residenz vom Barock bis zum Klassizismus*, eds. Hellmut Lorenz and Anna Mader-Kratky (*Veröffentlichungen zur Bau- und Funktionsgeschichte der Wiener Hofburg 3*, ed. Artur Rosenauer) (Vienna: Austrian Academy of Sciences, 2016), 241.

178 Cf. the text on the Burgtor in this publication.

179 Pavan, *Lettere*, 108: Nobile to his brother on 31 March 1826.

180 See also: Pavan, *Lettere*, 149–150: Nobile to his brother on 6 June 1827.

181 Pavan, *Lettere*, 367: Nobile to his brother on 11 February 1835.

182 Pavan, *Lettere*, 369: Nobile to his brother on 8 March 1835.

183 Albertina Wien, AZ 9794–9799.

184 Bösel, "Burgplatz," 43.

INDIVIDUAL ARCHITECT FOR
INDIVIDUAL CUSTOMERS

Taťána Petrasová and Richard Kurdiovsky

In the eighteenth and nineteenth centuries, working in the service of the state was the pinnacle of an architect's career. Within the organization of the offices of public works at the time, a state commission often meant the approval of the monarch himself, in addition to a regular income, an official post, and the general prestige attached to tasks commissioned by the offices of the court. However, it also brought with it certain limitations so far as freedom to work was concerned, as it was practically impossible for architects working in the state services to accept commissions from private clients. This was even the case when architects were made to wait in the role of "reserves" until the more prestigious commissions had been divided up by their competitors, as can be seen from the short period that Johann Gottfried Gutensohn, the architect of the Bavarian king Ludwig I, spent during his medical leave as a teacher at the School of Architecture at the Academy of Fine Arts in Prague, or from the difficulties that Pietro Nobile experienced in getting time off from his official post when he was supervising the construction of the buildings in Kynžvart.[1] Nobile's positions as director of the School of Architecture at the Academy of Fine Arts Vienna and as Hofbaurat of the homonymous institution not only brought with them the favour of the Austrian chancellor and the curator of the academy, Clemens Wenzel Lothar Metternich, but also enabled him to acquire private commissions, which in terms of prestige were almost equal to official state and imperial commissions. With respect to the fees paid for private commissions, however, they frequently ended in disappointment.[2] Nevertheless, Metternich's patronage and interest in technical innovations provided Nobile with ample opportunity for architectural experiments, resulting during the years 1826–1833 in his attempts to introduce prefabricated iron elements into the ornamentation and structure of monumental architecture.

The first clients to commission designs from Nobile, either for private buildings or for public commissions based on shared contacts in communal politics, were the businesspeople and officials of Trieste. The first such project connecting the private and public spheres seems to have been the plans for an open hall, perhaps from the year 1813, originally intended for the new design of what is today Piazza Hortis (the former Piazza Lipsia or Leipzig Square). This project, prepared during the French administration of Trieste, was never implemented, but the design is believed to have been used for the later municipal marketplace and residence of the businessman Carlo d'Ottavio Fontana. It is thought that the city council commissioned this project when it decided to build the marketplace on a plot of land belonging to the city and used for storing salt.[3] The history of the construction is not entirely clear, but modified plans (from the year 1827) of the original open, five-aisled hall intended for the sale of fish state that the Hofbaurat Nobile was responsible for the design (Fig. 8 and 18). Thirty-four stone Doric columns supported the raised ground floor, topped by the domes of the various bays. On the upper floor, the architect inserted an open terrace into one of the inner sections of the building, thus improving the lighting of the inner residential parts of the house. The house is exceptional, not only for the monumental character of its Doric columns, which have no bases, but also for the dressing of the facade, whose bossage is covered with the delicate "hatching" of the ashlars, carried out by stonemasons. In 1817, shortly before his appointment as Landesoberbaudirektor in Trieste with jurisdiction over the coastal area, Nobile was given a commission by *cancelliere di sanità* Giobatto Costanzi.[4] This city pal-

ace, Casa Costanzi, stood on a long, elongated plot of land, where only the narrow front of the house allowed for a design appropriate for a city palace. The monumental, stone-clad facade is divided up by three axes, with alternating rectangular, oval, and semi-circular endings above the entrances and doors. The openings seem to be "carved" into the facade, with a play of light reminiscent of the shading technique of neoclassical drawing.[5] Nobile's third commission for a private client in Trieste was the design for the reconstruction of the palace of the high-ranking French official Angelo Calafati, but the extent to which this was carried out is uncertain. Like the first phase of the marketplace project, this design can be classified with the 1813–1817 alterations to what is today Palazzo della Biblioteca Civica in Piazza Hortis.[6] With a few exceptions, these early commissions in Trieste left no traces on the architect's later work, in spite of the fact that his first biographer, his nephew Giuseppe Fraschina, had a very high opinion of Nobile's early period during and immediately after the French occupation of Trieste.[7] The exceptional quality of these youthful works lies in their monumental character, the use of the Greek Doric order, and the quality of the dressing of the stonework on the façade – the latter a result of Nobile's collaborations with the local stonemason and master builder Valentino Valle, who carried out later building work on the church of Sant'Antonio Taumaturgo and also extended some of Nobile's buildings in the 1840s.[8]

Nobile's correspondence mentions a number of designs for private clients, both realized buildings and unrealized proposals. These include commissions for Count Johann Rudolf Czernin of Chudenitz from the year 1826,[9] the palace of the duke of Nassau, and plans drawn up for Count Franz Anton Kolowrat-Liebsteinsky for a garden building on Grünberg next to the imperial summer residence in Schönbrunn.[10]

Project for the Construction of Duke William I of Nassau's Residence

In April 1835, Nobile wrote to his brother Antonio that Duke William I of Nassau had spent many hours over several days with him studying princely palaces because he wanted Nobile to design a building for half a million guilders.[11] Indeed, the Nobile archive in Trieste contains a group of untitled drawings[12] that present floor and elevation plans for a rectangular palatial building, whose main facade faces "Luisen Strasse."[13] The inscriptions on the floor plans indicate the use of the individual apartments. On the main floor, only a very general distinction is made between the duke's and duchess's apartments,[14] but on the second-floor plan several rooms are marked as separate apartments and labelled with the titles and first names of members of the duke's family.[15] Evidently, Nobile made himself familiar with other buildings in Wiesbaden at the time, as a building survey of an unspecified house whose main facade faces "Friedrichs-Strasse"[16] – drawn by a certain Janatte and measured in Rhenish feet – is also kept in the Trieste archive and can be identified as the house of Carl Friedrich Schenk, designed by Christian Zais and built between 1813 and 1816.

Nobile's palace design must belong to a series of design proposals submitted to William I for a new residence in the spa town of Wiesbaden.[17] This palace was initially planned for Luisenplatz, on the site of the burnt Catholic Hofkirche, and in April 1836 a decision was made in favour of Georg Moller's design. Only a few months later, however, another central site at the Marktplatz was considered, and it was here that Moller finally built the duke's house, with its characteristic corner solution referencing Karl Friedrich Weinbrenner, between 1837 and 1841. That Nobile designed a palace for the duke of Nassau was probably facilitated by Metternich, a native of the Rhineland whom Emperor Francis I had given Johannisberg Palace, to the west of Wiesbaden, after the Congress of Vienna. This property was famous for its vineyards and also held political significance, being an important symbol of the conflict between Napoleonic France and the now-dissolved Holy Roman Empire and of its consequences. Although Nobile drew up plans for the renovation of Johannisberg Palace, from 1826, Metternich also commissioned modernization plans from the architect Georg Moller in Darmstadt, in the Grand Duchy of Hesse, which were ultimately realized.[18] Moller's favour in the Rhine region, both by the local ruler and the chancellor from the Habsburg Monarchy, can be attributed to both pragmatic and patriotic reasons. In any case, Moller received the same honours in Vienna as did other great architects of the time, and he was appointed art-member to the Academy of Fine

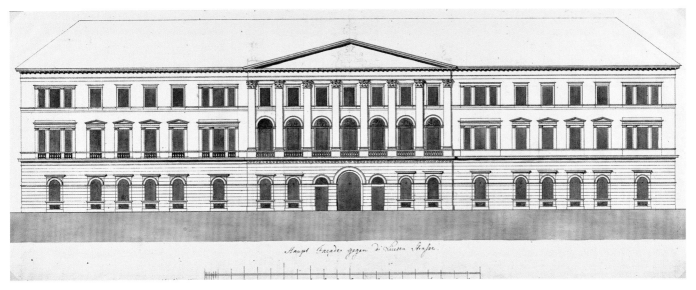

Fig. 75 Pietro Nobile, William I of Nassau's residence in Wiesbaden, first version of the facade, pencil, ink with watercolour, ca. 1835, Trieste, SABAP FVG, Fondo Nobile.

Arts Vienna in 1836, at the same time as Karl Friedrich Schinkel, Leo von Klenze, and John Soane.[19]

For his design of the ducal palace at Luisenplatz, Moller relied on Durand's floor plans,[20] and he probably had Klenze's Königsbau in Munich in mind when designing the elevation of the building, where he added an additional floor across the width of the central section of the block-like main building, which ultimately followed the example of the Pitti Palace in Florence. Nobile, on the other hand, retained the closed cube as in his designs for the Mirabell Palace, without breaking it up with any additional *avant-corps*; in his first version of the façade, he achieved a livelier rhythm by forming the outermost axes into wide groups of Serlian windows, with a straight entablature following the model of the monument of Thrasyllos (Figs. 75, 81). The design of the windows in the Mirabell Palace from around 1820 was less voluminous in its plastic elements than the aedicule windows in Wiesbaden in the 1830s, the latter recalling the way Klenze had used them years earlier at the Leuchtenberg Palace. Similarly, in the revised version of the facade Nobile used voluminous volutes in place of the classical architectural motif of balusters that appear in the first version.

Nobile's interior solutions were strikingly schematic (Fig. 76). He completely isolated the ducal apartments – laying them out without any consideration of gender – from the group of rooms around the ballroom at the back of the palace, which in turn schematically mirrored the ducal apartments. His spatial integration of the festival staircase, which led exclusively to the main floor, into the overall structure of the palace is particularly striking. Nobile assigned it no spatial or hierarchical preference, keeping it strictly equivalent to the entirely functional staircase that provided access to all floors. He even set the two staircases into dynamic with each other spatially and visually through large openings. Here, Nobile seems to have been less concerned with the theatrical staging of royal claims to power than with a completely rational and correspondingly systematic solution for a building that had a specific functional requirement – the residence of a reigning prince.

The Mayer Glasshouse in Penzing: Nobile's Practical Approach to the Middle Ages in the Late 1820s

With the exception of the dramatically rebuilt Prague Old Town Hall and some designs for chancellor Metternich, the glasshouse built for Johann Mayer, head of the wholesaler and bank Stametz and Company, is Nobile's best-known neo-Gothic work because, unlike his other designs incorporating medieval architecture,[21] it was published in the *Allgemeine Bauzeitung* (Fig. 77).[22] The choice of style was made at

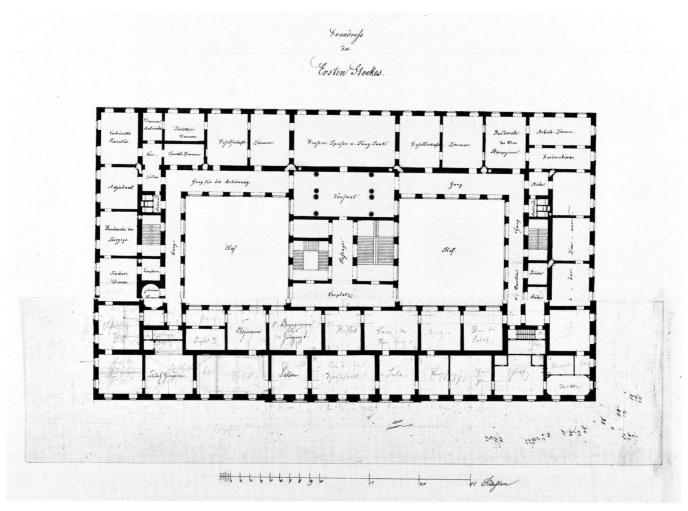

Fig. 76 Pietro Nobile, William I of Nassau's residence, ground plan of the piano nobile, pencil, ink with watercolour, ca. 1835, Trieste, SABAP FVG, Fondo Nobile.

the explicit request of the client, who prescribed a well-designed imitation of the Tudor style, and corresponds to romanticizing notions of the garden building typology. Nobile used medieval forms in a very classical manner, a solution appearing elsewhere at this time, such as in the royal glasshouse of the Margherie in the park of Racconigi Castle, by Pelagio Palagi and Carlo Sada.[23] There, Carlo Alberto of Savoy wanted to evoke a medieval chivalric atmosphere in Piedmont, as had been achieved in the Rittergau of the imperial castle park of Laxenburg.[24] He also wanted the historical origins of the family pointed out, as at the abbey church of Hautecombe.[25] The glasshouse in Penzing, however, was probably not built for such historical references but rather followed current trends in garden design.

Nobile was in active contact with Johann Mayer by 1823 at the latest, and by 1824 he had created expansion plans, including a new interior design, for Mayer's house (on the premises of the present embassy of the Czech Republic in Vienna) in Penzing,[26] a wealthy suburb of Vienna on the northern side of the Wien River opposite the imperial summer palace of Schönbrunn. In 1829, they discussed the possibility of Mayer financing a patriotic-artistic fund that Nobile wanted to set up to support visual artists.[27] The numerous invitations to Mayer's house are further evidence of their ongoing friendly contact.[28]

Mayer's property in Penzing was famous for its garden and for a botanical collection cultivated in at least two large glasshouses.[29] The older of the two structures was the work

TAŤÁNA PETRASOVÁ AND RICHARD KURDIOVSKY

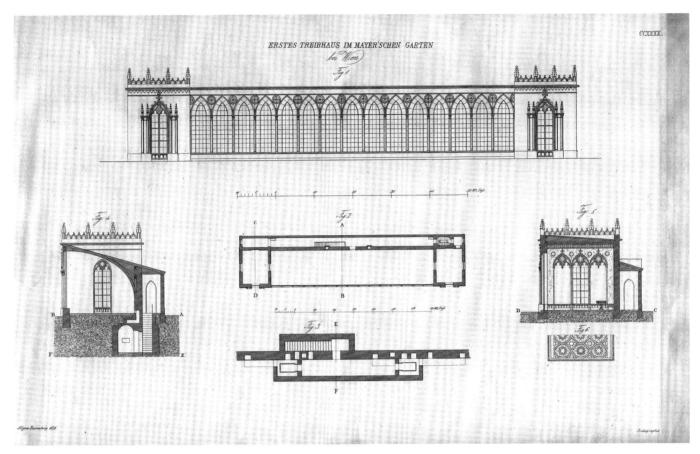

Fig. 77 Pietro Nobile, The Mayer glasshouse in Penzing, etching, ca. 1826, *Allgemeine Bauzeitung* 3 (1838): plate 240.

of Nobile, while the newer was designed by a certain Schedel, an otherwise unknown architect. The newer glasshouse had cast-iron ornaments whose manufacture had been supervised by none other than Ludwig Christian Förster at the Salm-Reifferscheidt ironworks in Blansko (Fig. 78).[30] Nobile's glasshouse seems to have been under construction in 1826,[31] with Friedrich Gentz reporting that, when he visited the Mayer garden in September 1831,[32] he could already see Nobile's work completed.[33]

Nobile's glasshouse consists of two block-like pavilions, between which the front span dissolves into a glass-iron construction without protrusions or recesses. The uniform entablature runs along the entire building. This is quite in contrast to the newer glasshouse, whose vigour comes from its differentiation of building elements and its dramatic staggering of heights towards the centre. Nobile's concept for the building is similar to that of Remy's in the Kaisergarten of the Hofburg in Vienna,[34] whose decoration is albeit neoclassical. Nobile's glasshouse evokes the Gothic by using motifs such as the ogival arch (repeated in a way similar to the arches in the glasshouse in Racconigi) rather than classical forms of decoration. This gives a medieval impression to the glass-iron frontage, without the building as a whole losing any of its classical cubic appearance. Nobile places Gothic decorative forms – such as slender bundles of pillars, tracery, and pinnacles – on an entirely neoclassical base. The entrance doors of his side pavilions, for example, are based on the Serlian window and are merely clad with Gothic forms and applied to the empty surface of the cube. With this building, then, Nobile remains a long way from a historical approach to artforms of the past, an approach Nobile's students and staff at the academy were to take. Nobile's imbued his glasshouse with a medieval character only by affixing Gothic motifs to its surface, something he likely did only because this was a special type of building. Given this approach, we should not expect to find Gothic interiors like

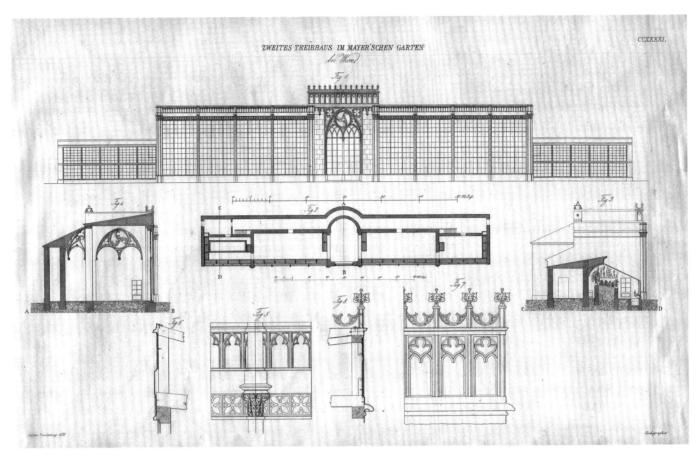

Fig. 78 Schedel (first name unknown), The second Mayer glasshouse in Penzing, etching, ca. early 1830s, *Allgemeine Bauzeitung* 3 (1838): plate 241.

those in the side pavilions of his glasshouse on the interior of Villa Mayer.

An immediate reaction to the Mayer glasshouse can be seen in the glasshouse in the garden of the château in Topoľčianky, commissioned from Nobile by Count János Keglevich, who was a passionate botanist whose political orientation facilitated contact with the court in Vienna. The glasshouse (1828/29) was evidently created as a replica of the prototype in Penzing and was the only work by Nobile in the château complex, designed by the Italian-Austrian Luigi Pichl in the years 1818–1825.[35]

Works Built for Chancellor Metternich

His cooperation with the chancellor Clemens Wenzel Lothar Metternich was of exceptional social and personal importance for Nobile. Their first meeting took place in 1816 dur-

ing the emperor's visit to his back acquired Italian territories, on the journey from Trieste to Rijeka.[36] When Nobile was successful in the competition for the directorship of the School of Architecture at the Academy of Fine Arts Vienna in 1818, his audiences with Metternich acquired a collegial character. Two years later in the summer of 1820, when Metternich was in Kynžvart, he noted in his diary that he had decided to have adaptations made to his residence and had brought with him "his Viennese architect."[37] Nobile gradually became a regular guest at lunches and at evening salons at the state chancellery and at family celebrations at the villa on Rennweg, which he had designed for the prince according to his instructions in the 1830s. His summer journeys to Kynžvart at the prince's invitation can be regarded as work visits, in view of the tasks that awaited Nobile on the estate during the summer. But the prince continued to treat warmly "his" architect even after he stopped making intensive use of him for his building projects. Evidence of

TAŤÁNA PETRASOVÁ AND RICHARD KURDIOVSKY

this can be seen in Nobile's visit to Mariánské Lázně in August 1840, during which at the prince's invitation he stayed in his spa house. The close personal ties between these two prominent figures in the courtly cultural scene gradually weakened in the early 1840s, and in 1845 Nobile stated: "I have not visited the prince's salon for quite some time now because he no longer undertakes building projects. And since I do not have a position as architect there, I have no reason to go there on account of protocol, because the prince does not care much about that."[38] However, Nobile was pleased when, in the summer of 1849, Metternich replied from exile in Brussels to a letter of his and spoke highly of Nobile's service to the academy at the time when he had to leave it. He writes:

> I have learned from the official announcement that you are no longer director of the School of Architecture at the Academy of Fine Arts but remain a councillor of the academy. The first fact caused me pain, the second was a source of joy, and I understand your position at the academy. [...] You are fully entitled to share my conviction that you have provided tremendous service to this branch of architecture in our empire.[39]

The last meeting between the two men seems to have taken place in February 1853, a year before Nobile's death, when they were both invited as guests to an audience with a commercial delegation from Trieste. From personal comments recorded by the architect and his patron, it becomes clear why the relationship between the two managed to last more than thirty years even within the "unhealthy atmosphere" of the Viennese court.[40] Nobile had a high regard for the inventiveness of the prince, in spite of the fact that it caused him difficulties, as "the prince wants things with a certain mystifying variability, analysing them, and commissions projects that satisfy his wishes at any price."[41] Metternich, for his part, characterized the architect's abilities as "everything with which Providence might equip a human being," and the architect's imagination – which on the occasion of the emperor's visit to Kynžvart transformed some fir trees into the columns of a colonnade (never realized), which Nobile proposed to the prince to close off the *cour d'honneur* – continually engaged Metternich.[42]

The motif of a colonnade closing off a *cour d'honneur*, with a triumphal arch forming the main entrance, became (in various forms) one of the main themes of Nobile's oeuvre. The author of the first modern monograph on this architect, Imgard Köchert, identified the source of this motif in a series of French buildings, such as the Salm-Kyrburg Palace in Paris, designed by Pierre Rousseau in 1786.[43] According to more recent research, however, it was also connected to Nobile's training as an architect in Rome and the notion of "grande Architettura." We can get some idea of this grand architecture from Nobile's description of the Temple of Peace and Concord, which he published in Trieste in 1814 on the occasion of the formal unveiling of the bust of Emperor Francis I to mark the renewal of Austrian rule over Trieste, Istria, Dalmatia, and northern Italy. The text was published without illustrations, but Rossella Fabiani has made a convincing case for linking the text with of the Nobile's alleged school works with variations on the triumphant Capitoline Hill (Pl. XVIII and LVIII).[44] The architect applied the concept of grand architecture in connection with the emperor's request for "a city gate on canvas, which I was supposed to deliver to Prague via Metternich, so that he could have it erected on the main square on the occasion of the emperor's arrival in Prague or Vienna."[45] He continued to use the motif of a triumphal arch as part of a grand colonnade in further designs for Metternich's summer residences in Johannisberg and Kynžvart.

The reconstruction of Johannisberg was Nobile's first commission for the chancellor.[46] It dates from 1826 and in effect was never implemented, although further research is needed to provide a more accurate picture. The major Darmstadt architect Georg Moller is today considered the architect of the rebuilding. His work on the reconstruction of the Baroque château is documented from 9 February 1827 to 6 September 1836.[47] Surviving designs by Nobile for the reconstruction of the château and part of the monastery document the three areas he was involved with: the south facade with a staircase facing the Rhine, the entrance vestibule, and the main hall. We know that Nobile was familiar with Moller's variant because his workbook features the north facade turned towards the courtyard, with a loggia under an elevated roof and a portal reminiscent of an Italian palace, just as Moller mentioned in his professional report.[48]

But, different from Moller, Nobile wanted to use the high pedestal of the original building, given the inclination of the terrain, for the staircases of two or more branches. He worked out a novel variant, with two iron spiral staircases leading from the balcony to the garden. He later put a stone spire version into practice at Kynžvart, apparently because it turned out how exaggerated his expectations were for Metternich's interest in the use of iron and the possibilities of the foundry in Plasy. By demolishing the cavetto at Johannisberg and using the upper row of Baroque windows, he turned a relatively intimate salon into a representative hall (Pl. LIX). In addition to a south facade with a viewing terrace facing the Rhine, Nobile's designs incorporated a closed *cour d'honneur*, which should be bounded by a wall with arcades and a triumphal arch. It shifted the entrance further from the palace to the original Baroque receptions and enlarged the courd'honneur. Finally, Nobile's recommendation for the connection between the private apartments and the formal areas of the building is his only idea accepted by Metternich for Johannisberg.[49]

The Kynžvart domain had belonged to the Metternich family since the seventeenth century. When, in autumn 1794, the parents of the future chancellor, Count Franz Georg Metternich-Winneburg and his wife Beatrix, née Kageneck, fled to Vienna from the Rhineland, they left not only all their property in Koblenz but also a substantial part of their social capital. In this situation, the domain of Kynžvart, until then somewhat neglected, suddenly became the source of the family's security and the basis for negotiating the wedding of Chancellor Prince Wenzel Kaunitz-Rietberg's granddaughter Eleonore. In November of the same year, the young Clemens visited Kynžvart so that he could, on the authorization of his father, draw up the balance of the family property.[50] Twenty years later, Metternich noted: "I have no ties to Kynžvart, no memory, and it seems an entirely out-of-the-ordinary thought, other than that one day my dust will be laid to rest there alongside the dust of my father."[51]

Every reference in the correspondence between Metternich and Nobile between 1820 and 1827 confirms that the efforts of both the client and his architect were focused on construction works anywhere other than Kynžvart: first the family tomb project in Milíkov, and then in Plasy.[52] It was not until autumn 1827 that Nobile named Kynžvart among his projects in Bohemia. Plans of the Baroque state of the château were made in 1832, when a builder from the Kynžvart château administration, Adam Fischer, carried out an up-to-date survey for the purposes of a planned reconstruction. However, Metternich expressed in June 1820: "I am ready with my plans for reconstruction. My château is composed of a central building with two wings, one of which is only half completed. Once the whole of it is ready, I will comfortably be able to accommodate thirty persons."[53] Nobile first looked for a way of achieving symmetry for the new building (Pls. LX, LXI). He made use of a composition consisting of a set of circles, from which he created a *cour d'honneur* closed by a colonnade centred around a triumphal arch that straddled the inside and outside of the courtyard (Fig. 79). He then raised the central pavilion in the *corps de logis* above the line of the roof so that the mass of the colonnade did not completely eclipse the main wing (Pl. LXII).

The château acquired immense popularity with its chapel and museum in the north-wing extension of the residence. From an architectural point of view, the chapel was a plain cube lit by two rows of windows, and it was accessible from both the outside and inside of the château. The walls of its interior were originally projected to be smooth in order to create a background for a costly metal candelabra. Once the design was ready, the altar arrived, gifted to Metternich by the pope. Nobile expressed his excitement: "It is magnificent and full of ancient marble and gilt bronzes."[54] The marble and porphyry slabs came from the Roman basilica of San Paolo fuori le mura, which had burned down in 1823. The gift from Pope Gregory XVI was in thanks for the papal conclave that lasted from December 1830 to February 1831, during which Cardinal Bartolomeo Cappellari, as the future pope was known at that time, was with Austrian support elected the head of the Roman Catholic Church.[55] The gift strikingly transformed the appearance of the altar both in colour and shape. The lower part could be opened, in order to insert a porphyry reliquary, while the legs of the table were decorated with bronze reliefs (Pl. LXIX).

To properly understand Nobile's concept for the château, we must look at it in relation to the dominant features of the park, including the other buildings. Nobile oriented the château, the granaries and the farmyard buildings, and the inn

TAŤÁNA PETRASOVÁ AND RICHARD KURDIOVSKY

Fig. 79 Pietro Nobile, Design for closing the court d'honneur of the Kynžvart château with a colonnade, pencil, ink with watercolour, ca. 1827–1833, Archivio di Stato del Cantone Ticino, Bellinzona, Fondo Pietro Nobile.

(which was ultimately never built) hierarchically around an imaginary centre point, as can be seen from a situational sketch of the château and surrounding area, evidently from the year 1827. Also outlined on the drawing is a brewery complex, which adjoins Baroque farm buildings and a cellar, and a glasshouse. Other remnants of Baroque history in the vicinity of the château, such as a masonry Baroque chapel and place of pilgrimage, were adapted by Nobile into their definitive form in 1835 on the occasion of the visit of Emperor Ferdinand I to Kynžvart. Already in 1829, Metternich described the basic layout of the park in enthusiastic terms:

> The park will have a circular walk with more than two structures built on it, as there is not one point here where art – with some small financial help – could not come to the assistance of nature, which is some of the harshest and wildest in the world. Everything – the masses of the gigantic rocks, the abundance of water, a lawn like in England, vegetation that I cannot compare to anything other than that in the Alpine valleys – all of this is in the hands of Mr Riedl and his outstanding gardener [Martin Bieba].[56]

The buildings for the park demonstrate Nobile's resourcefulness and a certain variety of style, although his neoclassicist convictions remained firm. This resourcefulness is most evident in the farmyard buildings with the granary, whose front facing the park he divided up with a high row of Ionic pilasters like in residential palace buildings, whereas the facade looking onto the courtyard is, with its aloofness and massive bossage, more reminiscent of fortress architecture. In terms of views, the architect displayed great inventiveness with his roadside inn and spa coffeehouse (a building that was unfortunately never constructed), with views along three approach axes. When approached from Kynžvart spa, the courtyard of the roadside inn appeared as part of a refined composition, linking the stables and coach house to the restaurant building, while the front part of the facade, with the entrance to the coffeehouse, corresponded to the early Historicism of the spa pavilions (Pl. LXIII).[57] He used a style similar to that of the spa building for the tearoom, which was adapted from a Baroque chapel on a rock and featured a glass front wall and columned entrance. Nobile had no inhibitions about using pointed arches and windows of the Roman thermal type within the same building, as can be seen from his design for the reconstruction of the brewery, later carried out in a simplified form (Fig. 80). It is because of the hybrid style of the neo-Gothic capitals of the forest chapel of the Holy Cross, which resemble the simplified Corinthian capitals on the corners of the château at Kynžvart, that we might perhaps attribute this chapel to Nobile as well, although at present we have no historical evidence for this. Other features of the park include temporary buildings, such as a temple modelled on that in Paestum in Greece, which was praised by Metternich, and a triumphal arch, erected on the occasion of the emperor's visit to Kynžvart.

Nobile's design for Villa Metternich on Rennweg (1835–1837) is typologically remarkable.[58] The origins of this estate lie in the Baroque garden palace of Esterházy, which belonged to Metternich's first wife Countess Eleonore Kaunitz-Rietberg. During the Congress of Vienna, on 18 October 1814, Metternich held an opulent celebration there, marking the anniversary of the Battle of Leipzig.[59] He commissioned Charles Moreau to design temporary buildings for the party as extensions to the existing garden palace, in particular a

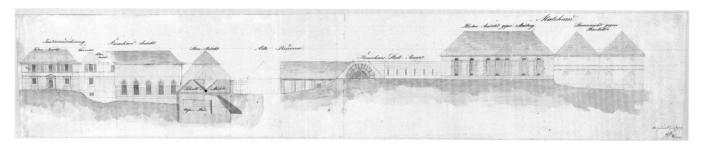

Fig. 80 Pietro Nobile, Panoramic facade of the brewery yard of the Kynžvart residence with the administrative buildings, the crushing mill, the malt house and the cellars, pencil, ink with watercolour, before 1835, Trieste, SABAP FVG, Fondo Nobile.

wooden ballroom and an entrance pavilion with a tent-covered staircase. A little later, on neighbouring land he had bought in 1815, a new building appeared featuring a cruciform ground plan with long, narrow wings and a conspicuously shallow depth compared to the Baroque garden palace.[60] This building seems to have been more of a gallery or a festive building than a habitable summer residence. As Moreau had been working on this property for Metternich a

short time before, we can assume that he was also responsible for this first "villa."

Decades later, there was to be a large-scale expansion of this building. In February 1835, Nobile submitted the cost estimates to Metternich,[61] and in the spring of 1835 the building plans.[62] In June the official laying of the foundation stone took place, by which time, as was customary, the roof had already been erected.[63] In July 1836, Nobile asked his brother Antonio for fabric samples for the terrace awnings,[64] and in spring 1837 the building was probably nearing completion.[65] At the same time, Metternich acquired the property to the west, and the villa underwent a final expansion, with the addition of a winter garden, an orangery, etc.[66] As there was now sufficient space to replace the Baroque palace, it may have been demolished at this time to enlarge the garden area; by the 1840s, it no longer appears on city maps.

The first planning phase is probably represented by the plan submitted in March 1835, in which the building is composed of three wings arranged in a U-shape.[67] The south wing of the new villa incorporated the remains of the first cruciform building and probably also of its facade, the latter consisting of large window and door openings reproducing the motif of the choragic monument of Thrasyllos (Fig. 81), whereas Nobile used rounded arches or simple rectangular openings on the remaining facades. A first structural expansion can be seen in the undated floor plans preserved in Trieste, in which an additional wing for a large hall is added to the south (Pl. LXV).[68] Finally, the plan submitted in 1837 shows the villa connected to the buildings on the neighbouring property,[69] which are in turn structurally extended by a long gallery and additional service rooms. Nobile's sketches of alternatives to this constellation have survived in the No-

Fig. 81 Choragic monument of Thrasyllos in Athens, from: James Stuart and Nicholas Revett, *The Antiquities of Athens*, vol. 2, London 1787, chapt. IV, plate III.

TAŤÁNA PETRASOVÁ AND RICHARD KURDIOVSKY

Fig. 82 Pietro Nobile, Extension to the Villa Metternich with polygonal rooms, pencil and ink, ca. 1835, Trieste, SABAP FVG, Fondo Nobile.

the time, but utilized a combination of wings radiating from a U-shaped structure in order to properly enmesh the villa within the surrounding garden. This idea may have been taken from the previous building, whose cruciform floor plan automatically ensured a close interlocking of its interior with the garden. For Nobile, it seems to have been important, however, to emphasize the centre of the villa with a tower, the only multi-storey structure in the entire complex.

Nobile's architecture was strictly symmetrical, but this symmetry was only applied to individual sections of the complex and was therefore only apparent when the building was viewed parallel to the facade. Thus, the three sides of the enclosed inner courtyard were laid out on a strictly symmetrical, axial cross, the dominant feature of which was the tower-like central *corps de logis* with two pedimented *avant-corps* on the side wings. A central portico emphasized the strict symmetry of the northern facade. However, this portico was actually positioned against the axis of the corresponding *avant-corps* in the inner courtyard, such that it did not include an entrance to the building but rather was closed off by a massive wall. The entrance to the villa on this northern face was shifted to the side, but in relation to the inner courtyard it was logically placed on the axis of the corresponding *avant-corps*. When seen from the garden, the villa dissolved into a multiplicity of picturesque views, as is revealed in the series of drawings by Eduard Gurk in which the building is viewed exclusively from its corners. The individual cubes that made up the building were constantly regrouped within these changing perspectives, a process that the elevated *corps de logis* in the middle of the complex accentuates, its cubic volume overhanging the building in ever-changing ways. Metternich's villa was certainly a reaction to the trend during the 1820s and 1830s of picturesquely embedding architecture in a garden landscape, such as at Charlottenhof in Potsdam (Fig. 83). At the latter site, however, Schinkel did not abandon the block-like form for the individual buildings, the painterly effect being created primarily by the picturesque placement of and combination among the structures. Conversely, Nobile created an architecture of connected wings that, for all its painterly effect, was still strictly symmetrical.

In contrast to the closed cubic block of Villa Hudelist (Fig. 50), Nobile's design for Villa Metternich of around fif-

bile Collection in Trieste and include glasshouses with remarkable polygonal, obliquely inserted rooms (apparently intended to accommodate plant troughs) as well as plans for another hall (Fig. 82).[70] As Nobile's sketches reveal how connectivity could be achieved between the villa, whose plan had already been submitted to the authorities, and the newly acquired holdings, we can assume that he was responsible for the overall design of the complex. The appearance of the buildings, which were demolished in 1873, can be seen in a small series of views published by Johann Höfelich around 1840 (Pls. LXIV, LXVI and LXVIII).

Villa Metternich was a single-storey building with many doors, terraces, and porticos linking the house and garden. Nobile's villa was remarkable in that it was not centred on a cube-shaped block, as was customary in villa construction of

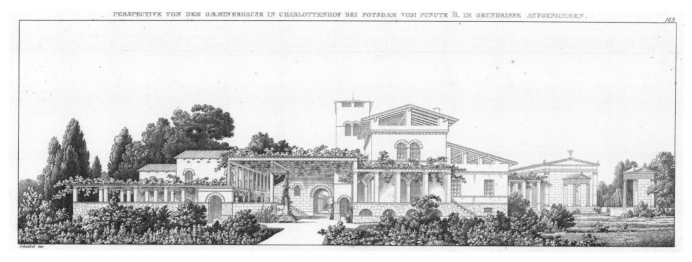

PERSPECTIVE VON DEM GÆRTNERHAUSE IN CHARLOTTENHOF BEI POTSDAM VOM PUNCTE B. IM GRUNDRISSE AUFGENOMMEN.

169

Fig. 83 Wischneski (engraver) and Karl Friedrich Schinkel (drawing), Perspective view of the Roman Baths of Charlottenhof palace in Potsdam – detail, etching, 1834, Carl Friedrich Schinkel, *Sammlung architektonischer Entwürfe* etc. (Berlin: Ernst & Korn, 1858), plate 169.

teen years later bears similarities to his designs for the expansion of the Ossolineum in Lviv (Pl. LXXII and LXXIII). There, Nobile formed an ensemble that appeared symmetrical from the front but offered an ever-changing appearance from the side. He achieved this by combining building units that were basically symmetrical in themselves but featured quite diverse architectural motifs, such as the centrally planned, domed building, the long gallery with colonnades, etc.

The layout of the interiors of Villa Metternich, whose wings, with the exception of the central wing with its tower, were conceived as an *appartement simple*, allows us to speculate on their intended use. The largest part of the villa probably served as an art gallery[71] and as garden halls (Pl. LXVIII), which could be arranged, one behind the other, without complex spatial development. Areas suitable for private living (i.e., rooms of various dimensions, rooms for servants, and corridor systems for adequate access) were limited to a small area, in which a large bathroom,[72] although still modelled after the plans published by Jacques-François Blondel in 1737/38, provided modern comfort.[73] In line with the Viennese Baroque tradition of temporary stays at garden palaces in the suburbs and thus close to the city, the villa seems to have been intended for short stays and, above all, for social events rather than as a permanent summer residence.

Technology and Beauty

In Metternich's guidelines for the final adaptations to the rooms at Kynžvart, presented in a list of eleven points, number seven reads: "The entry to the salon remains as it is, with the improvement of the damaged pilasters and an iron cover for the plinth."[74] So, Nobile inserted iron mouldings under the stucco in some places of the residence, not only as a plinth but also cornices in the chapel, which should protect the wall from abrasion (Pl. XIII and Fig. 84). By 1860, however, when an inventory of the estate was being drawn up after Metternich's death, the cast-iron and zinc elements were not for the most part visible on the buildings, since the regional building engineer Franz Filous, considering them unimportant, did not record these elements as he did, for example, the zinc consoles on the facade of the *corps de logis*.[75] This is one of the earliest examples of the use of prefabricated metal components in Central European architecture. This case is all the more interesting because, shortly before, Metternich had commissioned Nobile to draw up plans for a small foundry complex with a blast furnace, a house for administrative staff, and quarters for the workers. Nobile's use of cast iron and zinc in the transformation of the Baroque château complex in Kynžvart into a modern, neoclassicist summer residence encompassed traditional assignments such as inscriptions, vases, lattices, balustrades, and a large fountain in the

TAŤÁNA PETRASOVÁ AND RICHARD KURDIOVSKY

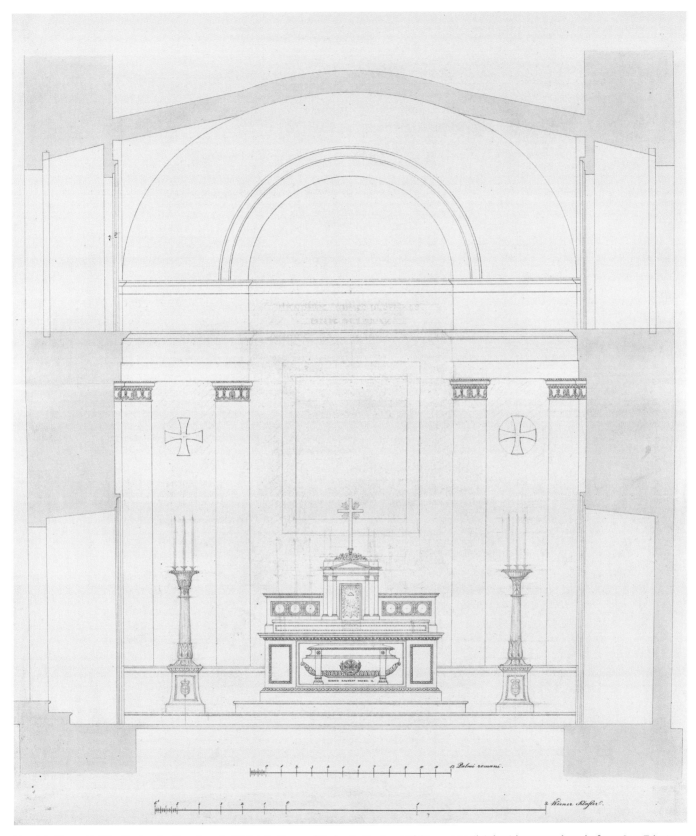

Fig. 84 Pietro Nobile, Design for the chapel of Saint Anthony of Padua in Kynžvart Château, pencil, ink with watercolour, before 1834, Trieste, SABAP FVG, Fondo Nobile.

Fig. 85a, b Pietro Nobile (attributed), Kynžvart Château, Ionic cast iron capital from the facade of the granary and Corinthian cast iron capital from the facade of the *corps de logis*, ca. 1832/33, photo 2019.

ized Doric and Corinthian capitals on the window pilasters of the corner towers (Fig. 85b).[76]

In England around the year 1800, Charles Sylvester and Charles Hobson discovered that metal reaches an optimal degree of malleability at a temperature of 115 degrees. They therefore abandoned the technology of tempering in air in favour of heating the metal. Apart from England, the more advanced European countries included France and Prussia, where they experimented with zinc bricks and zinc roof tiles. The first Prussian attempts at casting this material were in 1818 following Christian Fürchtegott Hollunder's handbook. The most recent research casts doubt on the information passed down by the sculptor Johann Gottfried Schadow, namely that the first example of the use of zinc components in a public building were his 1818 sculptures of Victoria for Schinkel's Neue Wache. According to information from August Vogel in 1858, it was not until 1833 that large elements were supplied by the royal foundries in Berlin.[77] It is equally difficult to trace the origin of the zinc and cast-iron elements used experimentally by Nobile in the construction of the Kynžvart residence. Dating them is made easier by the cast-iron inscription on the granary in the farmyard complex, which Fraschina published in 1889. According to him, Metternich sent this draft text to Nobile in September 1833: "Schüttkasten und Wirthschafts Gebäude gegenüber des Schlosses zu Königswart S.W.L.P.A. METTERNICH EXST. A.D. MDCCCXXXII" (Granary and farm buildings opposite Kynžvart Château 1832).[78] Though it is not clear whether this is a transcription by the editor or by the author of the letter, in any case it must logically belong to the phase of the reconstruction of the residence, which the prince first showed his young wife Melanie in the summer of 1833. Although the entry in her diary only refers to the staircase and the comfortable state of the rooms, the vestibule, with its Doric cast-iron columns, must evidently also have been completed by then (Pl. LXX).[79] In view of the fact that at that time Metternich owned the ironworks in Plasy, we can proceed on the hypothesis that the cast-iron elements in Kynžvart come from Plasy, the place where Nobile first began working on Metternich's estates in the Czech lands.

The Plasy estate, whose Baroque Cistercian monastery had been reconstructed in stages by the outstanding architects Jean Baptiste Mathey, Johann Blasius Santini-Aichel,

middle of the *cour d'honneur*. But he also used a relatively large number of prefabricated cast-iron and zinc elements as a substitute for traditional stone or stucco ones. In addition to eight Ionic capitals on the facade of the granary in the farmyard complex looking onto the park (Fig. 85a), he included forty other consoles supporting window cornices, six acroteria on the gables of the main wing, and sixty-four styl-

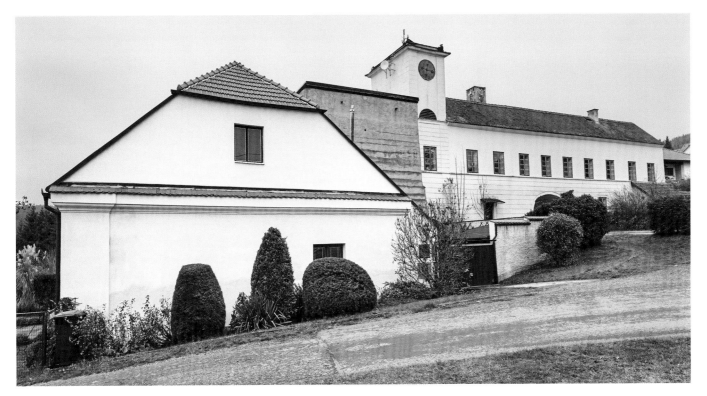

Fig. 86 Foundry in Plasy today, photo 2020.

and Kilian Ignaz Dientzenhofer, was bought by Metternich at an auction in 1826 from the state *Religionsfonds* that administered the property of the monasteries dissolved by the 1782 decree of Joseph II. The chancellor entrusted Nobile with the task not only of adapting the prelature building for residential purposes but, in particular, with designing the buildings related to the foundry he was establishing, which is to say, drawing up plans for operational, administrative, and residential buildings for the administrative staff and the workers. The architect did not visit the site until 1831, as evidenced in a letter dated 21 September 1831: "I lunched in Plzeň, and by the evening I was on the prince's estate in Plasy, where the next day I inspected the large buildings and devoted an entire day to the monastery and prelature building of the brothers. Magnificent buildings, which in Italy would not be used for these purposes."[80]

The seigneurial office had already, in 1827, prepared a situational map for the architect, with descriptions of the various buildings earmarked for conversion.[81] The adaptation of the residential portion was very demanding, consisting primarily in providing independent access to the various rooms intended for the prince, his retinue, and guests who might be staying in the prelature building. It is of far greater interest to observe how this academy-trained architect dealt with the other tasks. According to an extant illustration produced shortly after it began operations in August 1829, the ironworks complex comprised a series of masonry and wooden buildings centred around a low foundry with a blast furnace of the Belgian type, two blast engines at the bottom, and a taphole for letting out the pig iron. Dosage of iron ore were conveyed along a covered wooden bridge and charged by workers into the top of the blast furnace. The blast engines for the furnace and the iron mills were driven by water wheels, for which the ironworks used a millrace more than a kilometre in length, fed by water from the nearby river (Pl. LXXI).[82] A later illustration, probably from the 1840s, documents plans for expanding operations. In addition to the foundry and blast furnace with the old iron mill, a one-storey hall had been created by extending the old preparation plant. The new hall housed two puddling works with flat hammers, a boiler house with steam hammers, a welding shop, a tooling workshop, and a storeroom. All the former

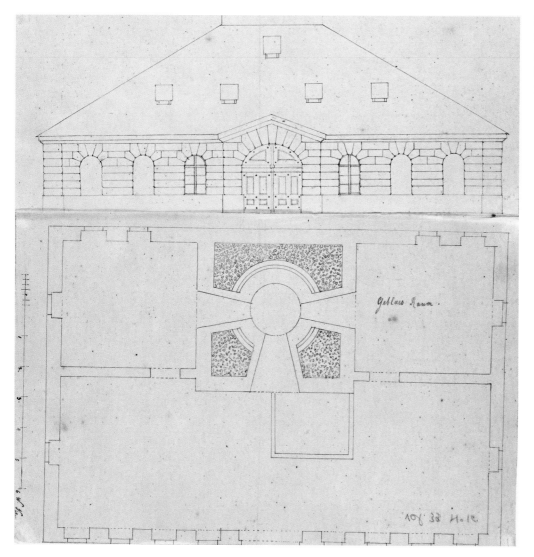

Fig. 87 Pietro Nobile, Design of the foundry in Plasy, elevation and floor plan, pen and ink, before 1828, Trieste, SABAP FVG, Fondo Nobile.

wooden buildings had disappeared and been replaced with masonry ones, including the bridge leading to the charging tower (still preserved today in an adapted form, Fig. 86). In his design for the foundry from 1827, Nobile drew up plans for a single-storey building with a high-hipped roof lit by six or more windows flanking a broad entrance (Fig. 87). In the ground plan, he sketched in outline in the rear part of the building a furnace with blast engines and a taphole. Further plans for an administrative building and a residential building for the workers also survive.[83] However, the range of products of this small foundry plant could not compete with that of Count Hugo Salm-Reifferscheidt's ironworks in Moravia or that of Count Wrbna's in Hořovice in Western Bohemia. The only items from Metternich's foundry to be found in the catalogues of industrial exhibitions in Prague and Vienna are nails for fixing shingles to roofs.[84] An extant sketch of the window display for his shop in Prague, located from 1836 at 388 Na Příkopě Street, indicates that Metternich used the display to publicize the high quality of his various iron parts in terms of their patterns and casting.[85]

The most likely thesis about the origins of Nobile's work with cast iron was published by Jitka Sedlářová in the context of her long-term research into the life and work of Count Salm-Reifferscheidt and his foundry in Rájec. The count's correspondence provides evidence of continual contact with Nobile in connection with cast iron, from 1823 on. "Now I use all my interactions with the building chancellor Nobile so that we can acquire all the work in cast iron in the

course of embellishing Vienna."[86] Salm-Reifferscheidt had in mind a statue of Our Lady[87] (Fig. 17) and the Angel of Victory, which he allegedly wanted to situate near the Burgtor.[88] At that time, he was also thinking of using cast iron for construction purposes, namely for the manufacture of "iron houses": "In England two- and three-storey houses are being built from cast iron. I cannot see any problem in casting hollow inter-storey supports. On the ground floor and the first floor, they could be one inch thick, then higher up they could be thinner. The window frames and vault trusses could be made of iron, the roof trusses would be of firm wrought iron, and they would be covered with sheet zinc."[89] But in fact, he had decorative architectural details cast rather than iron structural elements, as he mentioned in a letter dated 4 May 1825: "[...] the Governor of Styria, Count Hartig, who is well disposed towards me, found some work for me in the new theatre. Nobile will discuss the details with me. The result will be some beautiful work, heavy pieces, and mostly architectural decoration."[90]

No mention of working with Salm-Reifferscheidt has been preserved in Nobile's correspondence. Count Franz Hartig, Governor of Styria and from 1836 Governor of Milan, figures there relatively often but never in connection with work in cast iron. And yet there are explicit contemporary references to Hartig's cooperation with Salm-Reifferscheidt as an "economist experimenting on a grand scale."[91] The director of Salm-Reifferscheidt's ironworks, Karl Reichenbach, mentions that he acquired from Nobile for his pattern makers a plaster cast of a lion from the Barberini Palace, "because it was laying in the academy doing nothing, I had it brought to Blansko."[92] We can perhaps attribute the lack of information about contact between Nobile and Salm-Reifferscheidt to the loss of certain letters. Another architect who experimented with cast iron, Nobile's colleague at the Academy of Fine Arts Ludwig Christian Förster, does not appear in the extant sources to have advised Nobile in the use of prefabricated cast-iron elements, either. Yet, within Nobile's circle, it was Förster who was most knowledgeable about the possibilities of this new technology, since he worked as director of the foundry in Sankt Stefan ob Leoben in Styria from 1829 to 1832.[93] In June 1829, Salm-Reifferscheidt even considered taking on Förster as a pattern maker at his ironworks in Jedovnice: "Today the architect

Förster visited me. He is an extremely talented architect, has more knowledge and skills than Koch did, and would like to cast architectural decorations for house facades, especially cornices and iron roof pipes."[94] From 1824, Förster's visits to his foundry plant were directly aimed at acquiring technical information and cast-iron prototypes. After reaching an agreement with the plant's director Reichenbach, Förster carried out all the casting of architectural elements for houses that he designed. In September 1829, he brought to Blansko three wooden patterns for Ionic cornices. It was then that a disadvantage of cast iron became evident: its considerable weight. The workshops in Blansko manufactured the iron patterns and then cut them up into smaller pieces. Using these, the individual parts were cast at the Marian Ironworks and then joined together into the final form of the cornice. Because of the lack of a satisfactory technical solution for handling these cast-iron elements, Förster's cooperation with Salm-Reifferscheidt ended. But it had been the ideal preparation for him to open his own foundry in Vienna in 1839.

Between the Private and the Public

In a letter of 24 April 1839, Nobile wrote to his brother Antonio:

> The foundry for zinc goods established by Förster with a Berliner who was recommended to me by the famous Schinkel, general manager of construction in Berlin, is causing an upheaval here. I was the first to propose to Prince Metternich the realization of columns with capitals, window consoles, vases, cups, sculptures, relief according to the best model. I twice went with His Highness to visit that building, which today is visited by leading nobility and intelligentsia. I was there yesterday with His Excellency Count Chotek, who fell in love with it and exploits it to build a communal house and palace in Prague.[95]

Count Karl Chotek ranks alongside Metternich as one of Nobile's most important clients, though this work can be described as a private commission only in the sense of the longstanding personal relationship between the two men,

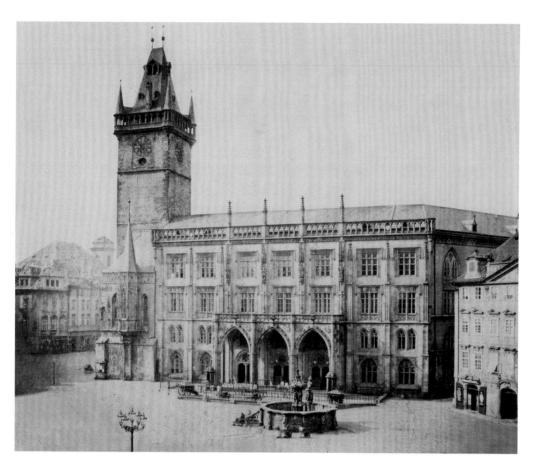

both of whose careers had begun in Trieste. After he had successfully held official posts in Brno and Přerov, Chotek was entrusted with the organization of the regional office in Trieste by Count Saurau in 1813.[96] Two years later, he was called on to take part in the war that followed General Murat's proclamation, on 30 March 1815 upon hearing of Napoleon's escape from Elba, of the independence of Italy, from the Alps to Sicily. After Chotek had marched on Naples with General Bianchi, he became governor there for a short time, until the arrival of King Ferdinand of Bourbon. He commented on the situation laconically: "[...] It is extremely easy for the king to become ruler at the expense of Austria and of Austrian blood – but such is life."[97] In 1816, he returned to Trieste and, among other things, oversaw the construction of the lighthouse in Savudrija (Pl. XXXV).[98] It is therefore clear that, by this year at the latest, Chotek must have met Pietro Nobile, who was responsible for the architectural design of the lighthouse and arranged the technical execution with Prechtl.[99] Chotek and Nobile had in common not only

their loyalty to the Austrian state, strengthened by personal memories of Trieste, but also a love of archaeology and new technologies. During the time of the Italian campaign, Chotek "frequently visited the archbishop of Naples, who had a valuable collection of coins and archaeological finds of various kinds coming from Herculaneum and Pompeii."[100] The first joint building project between Chotek and Nobile was the Rosstor in Prague. Unlike the Äußeres Burgtor in Vienna, ceremonially unveiled in 1824, the concept for the Rosstor had no features celebrating the victory of the allies near Leipzig (Pl. XI). In spite of this, Count Franz Anton Kolowrat-Liebsteinsky arranged for a monumental sculptural decoration for the gate in the form of a cast-iron equestrian statue of Emperor Francis I, manufactured in the Fürstenberg ironworks.[101] Chotek, a lifelong rival of Kolowrat, became enthusiastic about cast iron. He did not want to use it only for decorative purposes but also considered the economic effect of prefabricated cast-iron elements in the reconstruction of the Prague Old Town Hall, as is indicated in

Nobile's above-mentioned letter. The collaboration between Nobile and Chotek on the reconstruction of the Old Town Hall began in 1836. Unfortunately, due to the loss of a large portion of the archival materials relating to this project, we can only go on the documents that were published – a loss that such published contemporary comments fail to compensate for. When, in 1836, Nobile was asked for an expert opinion on plans that had been drawn up by the municipal architect Jan Schöbl and the engineer from the provincial office of public works in Prague Josef Esch, he wrote that the facades should not have as many windows as in previous designs so that the building would give an impression of "magnificence" and dignity, as befitted the town hall of such an important city.[102] This change in the facade, for which Nobile planned Gothic ornaments of cast iron and burnt clay, altered its previous articulation in storeys by introducing high windows that passed through several storeys.[103] After a joint protest by the Society of Patriotic Friends of the Arts and the Society of the Patriotic Museum in Bohemia, representing the voice of a specialist public in support of the protection of medieval monuments, it was clear that the decision taken by the city council in 1826 had not been a judicious one. But this did not diminish the responsibility of the architects who designed the new wing in place of the medieval monument. Contemporary protests (some of them preserved in verse form) show that the resistance of the people of Prague was directed at the final entity to have made the decision on building the new wing, namely the Hofbaurat Nobile in Vienna. It was not only the grandiose design for the facade, containing a neoclassical layout beneath the neo-Gothic form and structure, including a *piano nobile*, that damaged Nobile's reputation. The realization of the neo-Gothic facade came up against technical discrepancies in connecting the ground plan with the facade. In 1844, on the decision of the architect Förster as the authority representing the Academy of Fine Arts Vienna, the Prague City Council had the facade torn down and replaced it with another neo-Gothic facade, this one designed by Paul Sprenger, a former pupil and a current colleague of Nobile, who had become responsible "for architecture in the provinces of Upper Austria, Lower Austria, and Bohemia, and for waterworks in the first two provinces [...]" at the Hofbaurat.[104] Nobile found the situation hard to deal with. As he wrote in a letter dated 3 April 1844,

after two years of fighting for the facade for the Old Town Hall, he was faced with a painful decision (Fig. 88).[105] Nobile attributed the demolition of the facade solely to his pupils and rivals, seemingly unaware that he had entered the delicate territory of the protection of medieval buildings, something altogether different from the practice with the archaeological findings in Trieste, Istria, and Aquileia. With the failure of the reconstruction of the Old Town Hall, commissions from Count Chotek came to an end. The Colonel Burgrave and Imperial-Royal District President of the Kingdom of Bohemia himself came into conflict with the Bohemian estates in April 1842 when negotiating funding for a grandiose project, namely the first embankment in Prague to feature an architectural design, including a monument to the late emperor Francis I and "buildings for an arts academy, a polytechnic, an academy of sculpture, a fencing and equestrian school, a musical society, and a museum."[106]

The Culture of Memory: Chlumec, Kraków, Lviv, Sibiu

In the first half of the nineteenth century, the Austrian Empire cultivated a specific culture of remembering. This manifested itself primarily in memorials "in indirect speech," in other words, projects that did not develop as an expression of the political convictions of civil society.[107] Such memorials were commissioned by the monarch and the provincial estates as well as by landowners on their estates, and they included not only sculptures but also architectural commissions, important for preserving personal, familial, or national values. Among sculptural monuments, representative life-size busts acquired great popularity, of which it was easy to produce cast-iron miniatures. For example, in 1814 the court ladies in Prague ordered miniature busts of the Russian general Count Alexander Osterman-Tolstoy, a hero of the 1813 Battle of Chlumec. The Dietrichstein foundry in Ransko supplied this pocket "monument" in a size of 11.5 cm.[108]

Nobile's first experience with monuments came while he was still in Trieste. On the occasion of the unveiling of a bust of Emperor Francis I in 1814, he prepared a text attached to a proposal to construct a monumental architectural complex.[109] In the first decade after his arrival in Vienna, in 1826,

Fig. 89 Pietro Nobile, Design for a monument to Emperor Francis I, probably for Sibiu, pencil, ink with watercolour, ca. 1828, Trieste, SABAP FVG, Fondo Nobile.

he drew up an architectural design for situating a bust of the emperor in the park of the Habsburg residence in Laxenburg, south of Vienna. His idea to set the bust in a circular building of the tempietto type drew upon models widespread at the time,[110] and so it is not surprising that he used it again, in a modified form, two years later for a bust of the emperor in Sibiu, to commemorate the visit of Emperor Francis I to the city in 1817.

In December 1828, the president of the Siebenbürgische Hofkanzlei (Transylvanian Court Chancellery) asked the council of the Academy of Fine Arts for an expert opinion on the design.[111] The documents provided to the academy, however, were so meagre that the council was unable to form a real picture of the situation on the ground. Consequently, President Remy demanded floor and site plans, as he suspected that the monument was to be erected "at the city wall next to a gate and in a low-lying place," or in other

words, in the moat, and such a location would not be appropriate "for the dignity of the sublime object." Half a year later, the required plans were available.[112] Though there was no longer any concern that the monument would be erected in the moat, the design was nevertheless rejected, and Nobile was commissioned to produce an alternative. In the summer of 1829, Metternich presented Nobile's design, already approved by the council, to the emperor, who ordered the monument built according to Nobile's plans (Fig. 89).[113] The monument preserved today on the promenade along the city's southern wall is a bust on a high pedestal set into an architectural niche; it is very similar in proportion to a design by Nobile or his school kept in Trieste and was possibly realized by local artists.[114]

Nobile's most important commissions in connection with the preservation of familial or national-collective memory came from three individuals: Joseph Maximilian Ossoliński commissioned the project of the Ossolineum Library; Countess Potocka the construction of a family chapel in Kraków Cathedral; and Metternich the Habsburg monument in Kynžvart and the memorial to the 1813 Russian victory near Chlumec (today Přestanov).

The design for the "national" library of Polish literature, established in what is today the city of Lviv in Ukraine and was then the capital of the Austrian province of Galicia, was the first private commission that Nobile received for a monumental public building. He accepted it at the invitation of Count Joseph Maximilian Ossoliński of Tenczyn in 1819.[115] This was a typical example of a private initiative in the interest of the state. Ossoliński, whose family estates passed to the Habsburg Empire during the first division of Poland in 1772, lived in Vienna from 1790. He gathered around himself a circle of scholars (from the inscription "MUSIS SLAVICIS" above the portal of his palace in Baden near Vienna, it is clear that it did not include just Polish patriots), and together with the linguist Samuel Linde he began to prepare, in the years 1795–1803, the publication of a Polish dictionary.[116] This endeavour, which Ossoliński additionally made use of to acquire books from the some sixty monasteries dissolved by Joseph II, continued after Linde left for Warsaw and became the basis for an extensive private library.[117] In 1809, Emperor Francis I supported Ossoliński's intention of "establishing a national library of Galicia, as you decided,"

but when he assumed official patronage of the library in 1817, he described his reasoning for "establishing a library in the capital of our Kingdom of Galicia and Lodomeria" as "to expand and support scholarly and public education."[118] State interests in Galicia are also evidenced in Nobile's assignment to assess the statutes of the architecture school in Lviv, which became part of the university in 1817.[119]

Nobile was offered the Ossolineum Library commission shortly after he settled in Vienna, and while he was preparing the concept for it he was also working on the reconstruction of the imperial residence of Mirabell in Salzburg (May 1819) and of the residence in Schönbrunn (January 1820).[120] We can thus compare among these Nobile's approaches and aims. One key difference was that Nobile had not spent time in Lviv and had only a general idea of the specifications for the project, whereas he knew both Salzburg and Schönbrunn from his own experience. He knew that the burnt Carmelite monastery in Lviv had two wings, one of which was in ruins when he received the commission, while the other one had been adapted by the city authorities for residential purposes. When he drew up his plans, however, he completely failed to take into account the preservation of the church building in the western wing. Together with the lack of surveying, this meant that the seven sheets of plans that the architect sent with a cover letter on 2 May 1819 remained simply evidence of his never-realized intentions. Ossoliński did include the plans, as property of the foundation, as an appendix to the founding charter of the Ossolineum in 1817, but for financial and technical reasons the building remained unfinished at the death of the founder on 17 March 1826, and its present-day appearance is the work of the engineer Józef Bem.[121] As can be seen from the surviving plans, Nobile's layout for the reconstruction was grand in scale. The building was to have several wings of differing lengths and widths.[122] He designed the main entrance as an *avant-corps* protruding prominently into the *cour d'honneur* between the two main wings. As Rossella Fabiani has pointed out, he drew his inspiration from a city palace in Paris, the Hôtel d'Hallwyll designed by Claude-Nicolas Ledoux. He imitated Ledoux's designs in attempting to incorporate into one of the variant versions for the entrance a large conch in the style of the entrance to the Hôtel Guimard.[123] The other variants evidently appeared too austere, and so the Austrian medallist Josef Nicolaus Lang

used several of Nobile's motifs for his memorial medal dedicated to the founder of the Ossolineum, combining Ionic columns, a dome, and an entrance whose *sopraporta* took the form of a thermal window. Lang gave his medal design a sacred feel by also incorporating the dome of the former church from a different part of the monastery, thus creating a sort of pantheon of great national figures.

Unlike the Ossolineum project, which was never realized and remained unpaid, Countess Sofia Potocka's commissioning of a funeral chapel for the Krzeszowice branch of her extended aristocratic family ended with the completion of the project and a personal gift from the countess. Most Polish researchers date the creation of Nobile's design to before 1 June 1832, and this is more or less confirmed by Nobile's correspondence.[124] The first written reports of the medieval chapel in Kraków Cathedral that Potocka commissioned Nobile to convert into a family tomb come from the fourteenth century. Before Nobile's reconstruction, it underwent alterations in the late sixteenth century in connection with the construction of a late Renaissance tomb for the Kraków bishop, canon, and patron of the arts Filip Padniewski. Also buried in the chapel in the early nineteenth century was Julia Potocka of the Lubomirski family, the mother of Artur Potocki.[125] This nobleman inherited from his Lubomirska grandmother the Krzeszowice family seat, and Kraków became the place dearest to his heart. For this reason, Artur's widow wrote in her request to Bishop Karol Skórkowski that "reasons of the heart and memories" had led her to ask for permission to build a memorial to her husband in Kraków Cathedral.[126] Thanks to surviving archival reports, we know that work on the chapel was initially overseen by the principal architect of the reconstruction of Wawel Castle, Franciszek Maria Lanzi, and then from 1833 until its consecration in 1840 by the architect Wilhelm Hofbauer from Berlin. Three unsigned designs by Nobile have been preserved: a colour sketch of the front wall with the altar, alterations to the tomb of Filip Padniewski, and a design for the front wall with the altar, beneath which Artur Potocki was buried (Pl. LXXIV).[127] The chapel has a square ground plan, and from contemporary descriptions it is clear that Nobile thought about how, by bricking in old windows, he could achieve unbroken surfaces whose windows would stand out against a background of coloured artificial marble. The sophisticated use of light, fall-

ing on the altar from above, thus became a powerful feature of the reconstruction, together with the large number of prefabricated gilt-bronze elements: the rosettes of the coffered dome, the capitals of the pilasters, the wreathwork, and other similar ornaments. According to a letter that the architect wrote to his brother in April 1834, it was Countess Potocka who chose this material. This choice was no doubt connected to the fact that bronze fittings became fashionable in the early nineteenth century, leading to the search for cheaper zinc and prefabricated cast-iron elements. Although on the occasion of the coronation of Ferdinand I in Milan in 1838 the Viennese court ordered from Paris a set of gilt-bronze features with which to decorate the ceremonial plaque, among artists working with this technology in the Habsburg lands, the company of Johann Georg Danninger became established at industrial exhibitions from 1835 onwards.[128] The great prestige of this company is attested by the fact that the altar that Countess Potocka commissioned from Danninger for the chapel in Kraków was viewed in the chapel of St Joseph in Vienna by the empress dowager, the archdukes Ludwig and Franz Karl, and the chancellor Metternich, before it was transported to Kraków.[129]

The commission was carried out virtually without any of the usual difficulties, and both sides were satisfied. The arrival of the sculptural decoration in February 1837 filled Nobile with joy at the quality of the works by Bertel Thorvaldsen, intended for the decoration of the chapel: "Yesterday at the customs house [in Vienna], Countess Potocka and I viewed the Saviour by Thorvaldsen, the relief [the three children of the Potockis on the front wall by the altar, above Artur's tomb], and two busts by the same artist intended for the chapel in Kraków, and I found everything to be very beautiful. We then saw work on the altar by Danningher [sic] and the gilt-bronze mensa. The lady was extremely pleased with everything and so was I."[130] The only disagreement arose when paying for the marble, which had not yet arrived on site, and Nobile also regretted that the excessive modesty of his patron did not allow him to publish the plans for the chapel.[131] Although the present-day layout, with Thorvaldsen's statue *The Saviour* at the front of the chapel and Nobile's altar to the side, represents a change from the architect's original concept, and although during the course of the project the high candelabras planned for the side of the

altar had to give way to Thorvaldsen's busts of Artur Potocki and his mother, the chapel remains one of the few authentic sacred projects carried out as Nobile planned it. In order to express his gratitude to his patron, the architect sent her a drawing of another one of his works, to which he attached a personal dedication.[132] It depicts Nobile's best-known cast-iron monument, the memorial to the 1813 victory of the Russian troops near Chlumec.

If it can be said that Metternich's activities during the time he held the position of state chancellor varied between public and private commissions, this applies still more so to the monuments for which he commissioned Nobile.[133] The political background to the construction of the memorial near Chlumec is to be found in Metternich's negotiations among Austria, Russia, and Prussia, the aim of which was to prevent an alliance between France and Russia, which he feared might be formed after the revolution in July 1830. Negotiations held in Mnichovo Hradiště in Bohemia in 1833, attended by the Russian czar Nicholas I and the Prussian crown prince, led to a treaty between the three great powers, which was intended to reactivate the anti-French system of 1815. During these negotiations, the Russian czar also promised his support to Ferdinand, the successor to the Austrian throne.[134] After the death of Emperor Francis I in March 1835, Metternich decided to embark on a monument policy combining his interests with those of Austria: using the monument near Chlumec to strengthen the foreign coalition and demonstrating his loyalty to the House of Habsburg. In the first case, the Chlumec monument recalled Russian losses on a battlefield where the Royal Prussian Army (in 1817) and the Austrian Imperial Army (in 1825) had already commemorated their fallen soldiers. In the second case, the presence of the Austrian emperor and other distinguished guests provided a social lustre at the laying of the foundation stone for a separate monument, an obelisk, in the park in Kynžvart. Both events of the laying of the foundation stone took place in September 1835. Nobile worked intensively on the Chlumec and Kynžvart commissions from May 1835, when he alludes to two secret projects that greatly interested Metternich.[135] As the architect mentions an audience with Emperor Ferdinand I and approval for the extent of and the financing for a project that was small but historically and politically important, it can be assumed that this

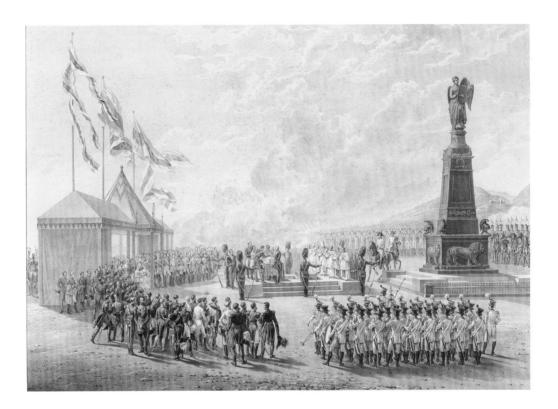

Fig. 90 The ceremony of laying the foundation stone in Chlumec, 1835, National Heritage Institute, Regional office in Prague, State château Kynžvart.

refers to the cast-iron memorial for the battle near Chlumec and the obelisk in the park in Kynžvart dedicated to the late emperor Francis I. In July 1835, he sent both designs to his patron.[136] Nobile described his creative ideas for the Russian monument as follows:

> Three steps form the base for a quadrilateral socle, on whose sides can be seen four prowling lions executed in relief, and on the four raised corners are the four helms of the proud defenders. Out of the socle rises up an obelisk bearing the winged figure of Victory, who is standing on the helm of a defeated enemy and writing of the glorious day on a shield. The upper part of each side of the prism is decorated by a laurel wreath, and the lower part by an oak sprig. Between these two ornaments is the place for the inscription. The letters of the inscription should be about two inches high, and the inscriptions will be in four languages, namely in Latin, German, Russian, Czech, etc.[137]

The choice of material was based in part on the popularity of miniature cast-iron copies for the home, but it also sought to make use of the exceptionally well-preserved ancient cast of the goddess *Vittoria* that had been discovered in 1826 during the exploration of a temple site in Brescia. This archaeological site had already been known earlier, and Metternich had a publication about it in his library.[138] The discovery of this large sculpture was surprising because in antiquity most artefacts made of this material had been liable to reuse. The statue of Victory had been saved from this fate by a long-dead inhabitant of the town, who had hidden it. Either Metternich himself or the court in Vienna commissioned a model from the Italian sculptor Antonio Marchesi for use for the Russian monument. As Nobile relayed to his brother, "Victoria will be from Brescia; I am waiting for a model made by Marchesi in Brescia itself, which will be nine feet high. The cast will be manufactured in Bohemia. By mid-September the socle will be ready; it will contain the foundation stone and the documents relating to it. The prince has entrusted me with the task of creating all this in a life-size model on the site, so that it will be ready for the great military celebration."[139]

The foundry of Count Wrbna in Komárov near Hořovice manufactured the cast and displayed some parts of it at the

Fig. 91 Unknown (maybe Johann Stark or Anton Martin), Cour d'honneur of the Kynžvart Château, daguerreotype, after 1841, National Heritage Institute, Regional office in Prague, State château Kynžvart.

fourth decorative arts exhibition in Prague in 1836.[140] A ceremony of the laying of the foundation stone in Chlumec took place on 29 September 1835, with the model of the monument but with the original cast of the statue of Victory (Fig. 90). Nobile's supervision of the erection of the monument also entailed making a design for alterations to the site, including a house for the watchman, a kiosk with refreshments, and a water channel. As early as 20 August 1835, the architect commissioned "publicity" for the monument in the form of a painting by the leading German landscape artist Carl Robert Croll, who captured it along with a striking view of the surrounding countryside (Pl. LXXV).[141] The ceremonial unveiling of the monument in Chlumec was held two years later, on 29 August 1837, as part of a grand military celebration.[142]

The monument in Kynžvart was likewise dominated by the symbolism of lions. Metternich first dedicated it to his friend Emperor Francis I but later realized that it would be more diplomatic to remember his successor, Emperor Ferdinand I, as well.[143] The stone socle on which the obelisk stands was therefore decorated with two cast-iron lions: the sleeping deceased monarch and the watchful young one. The lo-

cation of the obelisk corresponded to Metternich's idea that there would be two main structures built in the park. He may have intended even earlier to situate a memorial of the obelisk type there, as indicated in the documentation of the old Baroque facade of Kynžvart Château, which features a lightly sketched obelisk to the side of the facade facing towards what would later be the park.[144] According to contemporary prints, the obelisk was a connecting point between a distant hill and the residence along one of the main viewing axes of the park. Its importance was also realized by the photographer responsible for a series of four daguerreotypes with views of the château and Franzensberg Hill, dating from sometime around 1840, only one of which has survived.[145] This image illuminates something of the construction history of the complex as well as how Metternich and Nobile worked together on the concept for the château park because it shows a connection between the buildings of the Kynžvart residence and the Habsburg monument.[146] Contemporary prints emphasized the axis from the opposite viewpoint: Franzensberg, the château, the farm-building complex. However, we do not see in these prints the conclusion of Nobile's original idea for closing off the cour d'hon-

neur. The daguerreotype, by contrast, shows that it was not until the summer of 1840 – after the intense social commotion caused by the construction and unveiling of the two monuments had died down – that the owner of the château had the *cour d'honneur* closed off with simple high iron railings with masonry pillars (Fig. 91).

Already in 1835, Metternich had taken a sceptical view of closing off the *cour d'honneur* in opulent fashion with a triumphal arch in preparation for the visit of the new Austrian emperor to Kynžvart. However, thanks to Nobile, he was able to adapt the unfinished state of the residence for the purposes of the emperor's ceremonial arrival by arranging greenery, while the triumphal arch was one of the temporary buildings erected on the occasion of the imperial visit, at the entrance to the park. "Nobile […] is so obsessed with triumphal arches that he neither sleeps nor eats. […] He assumes that closing off the château courtyard with trees will give the impression of a bronze lattice. I assume that the emperor and his entire entourage will see nothing but fir trees and more fir trees. He even asks young girls to stand along the vistas and places them in postures to make them look like statues. I let him do it, because it makes him quite happy; I have never seen him more enthusiastic."[147]

The failure to implement the original design linking the two wings using a colonnade centred around a triumphal arch, together with the fact that a cast-iron fountain designed by Nobile came to be positioned in the middle of the *cour d'honneur*, definitively put an end to Nobile's ideas for a triumphal entrance into Kynžvart.[148] In spite of this, in August 1840 the architect evaluated his cooperation with his most important private patron without the disappointment that he had felt earlier:

I stepped out of the carriage, climbed onto the post-chaise, and set out for Kynžvart. The prince and princess looked pleased to see me and expressed their utmost satisfaction with the excellent result of the work on the palace, which does look like a palace today, whereas it formerly only looked like a large country house (*un gran casolare*).[149]

NOTES

1 Věra Laštovičková and Jindřich Vybíral, "Die Architektur zwischen München und Prag," in Taťána Petrasová and Roman Prahl, eds., *Mnichov – Praha. Výtvarné umění mez tradicí a modernou / München – Prag. Kunst zwischen Tradition und Moderne* (Praha: Academia) 2012, 259–260; Gino Pavan, *Lettere da Vienna di Pietro Nobile (dal 1816 al 1854)* (Trieste: Società di Minerva 2002), 186, 291–292, 294: Nobile to his brother on 10 September 1831. The architect was granted 14 days off during a cholera epidemic as the maximum possible concession. Nor did the emperor want his officials to leave their posts. "Il P(rincipe) Metternich mi à intercesso il permesso dal Presside Baldacci, il quale dice di non potermi accordare più di due settimane di congedo, perché S. M. vuole che gl'impiegati restino al loro posto." In 1828 Nobile commented on a planned journey to Trieste: "The Prince of Saurau could not give me permission for such a journey, being able to refer to decisions by Metternich and President Baldacci, who are my superiors." On 29 September 1831, it once again proved impossible to leave his post and travel to Trieste. The President of the *Hofbaurat*, Joseph Schemerl von Leytenbach, did not allow Nobile to make a six-week journey to Trieste to oversee progress on the construction of the church of Sant'Antonio Taumaturgo.

2 Pavan, *Lettere*, 318–319: Nobile to his brother on 20 January, 1833. "Da te viene il P(rinci)pe Metternich da me viene il P(rinci)pe Meterniente a te si porta l'argenteria nel anticamera nel mentre che dormi a me si rubbano dal corridore perfino gli originali di majolica."

3 Rossella Fabiani, "Casa Fontana," in: Fulvio Caputo and Roberto Masiero, *Trieste: l'architettura neoclassica. Guida tematica* (Trieste: Edizioni B & M Fachin), 1990, 193; Umberto Wetzl, "Casa Fontana a Trieste," *Neoclassico* 18 (2000), 34–81. The fact that it was the work of Nobile is indirectly indicated by the note "from the State Building Councillor" (*vom k.k. Hofbaurathe*).

4 Rossella Fabiani, "Palazzo Costanzi," in: Fulvio Caputo and Roberto Masiero, *Trieste: l'architettura neoclassica. Guida tematica* (Trieste: Edizioni B & M Fachin), 1990, 189–190.

5 Ibidem.

6 Rossella Fabiani, "Palazzo della Bibliotheca civica," in: Fulvio Caputo and Roberto Masiero, *Trieste: l'architettura neoclassica. Guida tematica* (Trieste: Edizioni B & M Fachin), 200.

7 Giuseppe Frascina, *Biografia di Pietro Nobile* (Bellinzona: Colombi, 1872), 19–25.

8 Fabiani, "Palazzo Costanzi," 189–190; Fabiani, "Casa Fontana," 193; Pavan, *Lettere*, 1186.

9 Pavan, *Lettere*, 132: Nobile to his brother on 5 October 1826.

10 Pavan, *Lettere*, 380: Nobile to his brother on 7 June 1835.

11 Pavan, *Lettere*, 372: Nobile to his brother on 14 and 27 April 1835.

12 Trieste, SABAP FVG, Fondo Nobile, vol. 18, no. 42–51.

13 Trieste, SABAP FVG, Fondo Nobile, vol. 18, no. 46.

14 Trieste, SABAP FVG, Fondo Nobile, vol. 18, no. 43.

15 Trieste, SABAP FVG, Fondo Nobile, vol. 18, no. 44. We can identify the apartments of the following children of Duke William I of Nassau: the two daughters and two sons from his first marriage to Luise of Saxony-Hildburghausen, the then 20-year-old Therese Wilhelmine, the 10-year-old Marie Wilhelmine, the 18-year-old Adolph Wilhelm and the 15-year-old Moritz Wilhelm, and Helene Wilhelmine the 4-year-old daughter from his second marriage to Pauline of Württemberg.

16 Trieste, SABAP FVG, Fondo Nobile, vol. 18, no. 52.

17 See also: Rolf Bidlingmaier, *Das Stadtschloss in Wiesbaden* (Regensburg: Schnell and Steiner, 2012), 12–15.

18 Eva Huber, "Schloss Johannisberg – Umbauten," in *Darmstadt in der Zeit des Klassizismus und der Romantik* (exh. catalogue Darmstadt, Mathildenhöhe 1978–1978), ed. Bernd Krimmel (Darmstadt: self published, without year (1978), 156–158.

19 UAABKW, SProt. ex 1836: 26 March.

20 For example the palace design for St Petersburg (Durand, *Précis*, plate 24).

21 Among the infrequent designs by Nobile that use medieval and Gothic forms are gate designs (Trieste, SABAP FVG, Fondo Nobile, vol. 44 no. 28 with a medieval city tower or vol. 61 no. 3 with an ogival lattice), Old Town Hall (Albertina Wien, AZ 7334; M 87/14/13; NA Prague, 324 Collections of maps and plans, sign. F VI 10) and possibly the high altar for St Stephen's Cathedral (Trieste, SABAP FVG, Fondo Nobile, vol. 4 no. 88), which may have been his design.

22 See also: Anonymous, "Die Treibhäuser im Mayer'schen Garten in Penzing," *Allgemeine Bauzeitung* 3 (1838): 395–396.

23 Johann Kräftner, *Klassizismus und Biedermeier in Mitteleuropa. Architektur und Innenraumgestaltung in Österreich und seinen Kronländern 1780–1850* (Vienna: Brandstätter, 2016), 770–771.

24 Géza Hajós, ed., *Der malerische Landschaftspark in Laxenburg bei Wien* (Vienna, Cologne, and Weimar: Böhlau, 2006), 81–90 and 131–133.

25 Luciano Re, "Torino e il Piemonte," in *Storia dell'architettura italiana: L'ottocento*, ed. Amerigo Restucci (Milan: Electa, 2005), 30; Elena Dellapiana, "Il mito del medioevo," in *Storia dell'architettura italiana: L'ottocento*, ed. Amerigo Restucci (Milan: Electa, 2005), 404–405.

26 Johann Gabriel Seidl, "Bilder aus der Nähe 8: Schönbrunn, Hietzing, Penzing," *Archiv für Geschichte, Statistik, Literatur und Kunst* 15 (1824): 751; Pavan, *Lettere*, 86, Nobile to his brother on 13 December 1823.

27 UAABKW, SProt. ex 1829: 23 and 24 December 1829.

28 For example: Pavan, *Lettere*, 536–537: Nobile to his brother on 10 July and 15 August 1842.

29 C. Zwgr., "Dreissigste Ausstellung der k. k. österr. Gartenbaugesellschaft in Wien," *Oesterreichisches Botanisches Wochenblatt* 5 (1855): 158.

30 Anonymous, "Treibhäuser," 396.

31 Pavan, *Lettere*, 108, Nobile to his brother on 31 March 1826.

32 August Fournier and Arnold Winkler, ed., *Tagebücher von Friedrich Gentz (1829–1831)* (Zurich, Leipzig and Vienna: Amalthea, 1920), 319.

33 Nobile's work for Mayer seems to have continued in the years that followed, and in 1837 he mentions a "Gloriat [sic] [...] dietro un mio pensiero" (after my ideas) which Mayer is currently having executed (Pavan, *Lettere*, 417: Nobile to his brother on 27 March 1837). This glasshouse was also published by Nobile in the last chapter of his learning patternbook "Systematische Studien über das Schöne und Charakteristische in der Civil-Architektur," State château Kynžvart, KY 34 A 15. See also Taťána Petrasová, "Pietro Nobile's and Clemens Wenzel Lothar Metternich's Idea of the Summer Residence Königswart (1827–1840). Modern Villa and an Experiment," *Umění / Art* 67 (2019): 434–435.

34 Jochen Martz, "Das Glashaus von Ludwig von Remy," in *Die Wiener Hofburg 1705–1835. Die kaiserliche Residenz vom Barock bis zum Klassizismus*, eds. Hellmut Lorenz and Anna Mader-Kratky (Veröffentlichungen zur Bau- und Funktionsgeschichte der Wiener Hofburg 3, ed. Artur Rosenauer) (Vienna: Austrian Academy of Sciences, 2016), 542–545.

35 József Sisa, "Alois Pichl in Ungarn. Die Tätigkeit eines Wiener Architekten in Ungarn während der ersten Hälfte des 19. Jahrhunderts," in *Acta Historiae Artium* (1982), 78–79; József Sisa (ed.), *Motherland and Progress. Hungarian Architecture and Design 1800–1900* (Basel: Birkhäuser 2016), 214–217.

36 Taťána Petrasová, "Metternich–Nobile–Metternich: Patronát jako vztah s proměnlivou konstantou," in Petr Jindra and Radim Vondráček, ed., *Tvůrce jako předmět dějin umění: pozice autora po "jeho smrti"* (Praha: Artefactum, 2020), 157.

37 *Aus Metternichs nachgelassenen Papieren*, ed. Richard Metternich-Winneburg, Vol. 3. (= Zweiter Theil Friedens-Aera 1816–1848. Erster Band) (Vienna: Wilhelm Braumüller) 1881, 334.

38 Pavan, *Lettere*, 574: Nobile to his brother on 25 May 1845: "E un gran pezzo che non frequento il Salone del P(rinci)pe, giaché egli no fabbrica più, e se io non vi tengo posto come Architetto, non ò titolo trovarmivi per pura cerimonia alla quale il P[rinci]pe non mette alcun pregio."

39 Fraschina, *Biografia*, 53–54.

40 Pavan, *Lettere*, 319: Nobile to his brother on 20 January 1833: "Pure mi trovo si contento in queste pittocherie che non vorrei cambiar stato con chichesia tanto meno con quelli che devono (ingiottire?) l'aria di corte. O corte corte e qual vapori maligni, L'aer che spira in te corrompe e infetta [...]."

41 Pavan, *Lettere*, 327, Nobile to his brother on 28 July 1833.

42 *Aus Metternichs nachgelassenen Papieren*, ed. Richard Metternich-Winneburg, Vol. 6. (= Zweiter Theil Friedens-Aera 1816–1848. Zweiter Theil, vierter Band) (Vienna: Wilhelm Braumüller) 1883, 59.

43 Köchert, "Nobile," 147–148.

44 Fabiani, ed., *Pagine*, 28–30.

45 Pavan, *Lettere*, 78–79, undated letter from June 1820. Cf. Taťána Petrasová, *Neoklasicismus mezi technikou a krásou: Pietro Nobile v Čechách* (Plzeň and Praha: Západočeská galerie and Artefactum 2019), 24.

46 Petrasová, "Nobile's and Metternich's Idea," 47–48.

47 Marie Fröhlich and Hans-Günther Sperlich, *Georg Moller: Baumeister der Romantik* (Darmstadt: Eduard Roether Verlag 1959), 278–282, 403–404.

48 Frölich and Sperlich, *Moller*, 280.

49 Giuseppe Fraschina, "Lettere del principe di Metternich all'architetto Nobile," *Bolletino storico della Svizzera italiana* 11 (1889): 26–29, 74–76, 112–117, quoted from 114.

50 Wolfram Siemann, *Metternich: Stratege und Visionär. Eine Biografie* (Munich: Verlag C. H. Beck 2016), 174.

51 *Aus Metternich's Papieren*, vol. 3, 292.

52 Petrasová, *Neoklasicismus*, 61–65.

53 *Aus Metternich's Papieren*, vol. 3, 336.

54 Pavan, *Lettere*, 320, letter dated 14 March 1833.

55 Drahomír Suchánek, "Kancléř Metternich a rakouské intervence do papežských voleb," in Ivo Budil and Miroslav Šedivý, eds., *Metternich a jeho doba*. Proceedings from a conference held in Plzeň on 23–24 April 2009 (Plzeň: Fakulta filozofická Západočeské university, 2009), 21–24.

56 Aus Metternich's Papieren, vol. 4 (Zweiter Theil Friedens-Aera 1816–1848. Zweiter Band), (Vienna: Wilhelm Braumüller, 1881), 554, Plasy, 26 August 1829.

57 Petrasová, *Neoklasicismus*, 78–79.

58 Ricarda Oettinger, "Archivalische Vorarbeiten zur Österreichischen Kunsttopographie: Wien, III. Bezirk. Beschreibung der nicht mehr bestehenden Profanbauten," (typescript, ed. Institut für Österreichische Kunstforschung des Bundesdenkmalamtes, Wien I, Hofburg), 64–69; see also: Serenita Papaldo, *L'Ambasciata d'Italia a Vienna* (Rome: De Luca, 1987), 12–18; Raffaele Berlenghi, *Il Palazzo d'Inverno di Villa Metternich a Vienna. Uno scrigno crisoelefantino* (Rome: De Luca editori d'arte, 2007) lacks reliable sources, but is the first presentation of a series of building plans, which together with redrawn garden plans vividly reconstruct the stages of building.

59 See also: Gernot Mayer, "Der ephemere Kongress: Fest- und Erinnerungskultur nach dem Ende Napoleons zwischen Siegestaumel und Harmoniesucht," in *Der Wiener Kongress 1814/1815. Band 2: Politische Kultur* (Denkschriften der philosophisch-historischen Klasse 517), ed. Werner Telesko, Elisabeth Hilscher, and Eva Maria Werner (Vienna: Austrian Academy of Sciences, 2019).

60 Manlio Gabrieli, ed., *Il Giornale di Vienna di Giuseppe Acerbi (settembre – dicembre 1814)* (Milan: L'Ariete, 1972),103.

61 Pavan, *Lettere*, 366–367, Nobile to his brother on 11 February 1835.

62 Berlenghi, *Palazzo*, fig. 50: submission of the plan on 27 March 1835, with the approval of the Lower Austrian provincial government on 9 or 16 April 1835.

63 Pavan, *Lettere*, 382, Nobile to his brother on 14 June 1835.

64 Pavan, *Lettere*, 396, Nobile to his brother on 5 July 1836.

65 Pavan, *Lettere*, 417, Nobile to his brother on 27 March 1837; 420: Nobile to his brother on 11 April 1837.

66 Pavan, *Lettere*, 420, Nobile to his brother on 11 May 1837.

67 Berlenghi, *Palazzo*, fig. 50.

68 Triest, SABAP FVG, Fondo Nobile vol. 17, no. 125–126.

69 Berlenghi, *Palazzo*, fig. 51.

70 Triest, SABAP FVG, Fondo Nobile vol. 17, no. 141.

71 Johann Pezzl, *Beschreibung von Wien* (Vienna: Sammer, 1841), 325.

72 Trieste, SABAP FVG, Fondo Nobile, vol. 17, no. 143.

73 Ulrika Kiby, *Bäder und Badekultur in Orient und Okzident. Antike bis Spätbarock* (Cologne: DuMont, 1995), 235–239.

74 Fraschina, "Lettere," 27.

75 State regional archive in Plzeň, Nepomuk Monastery Site, fond velkostatek lázně Kynžvart 1564: 1947, I. Knihy A. Dominikální agenda inv. no. 17., unpaginated [3]: "die Säulen, Lesenen, Säulengebälke und Balkongeländer, Deckenpfeiler sind von massiver Steinmetzarbeit, die Fensterlesenen Kapitäler bei der Schloßrisaliten vom Gußeisen angefertigt, die Gesimse bei der letzteren durch massive Steinconsolen dekorativ gestützt."

76 Some of Nobile's pupils as well as many contemporary architects used zinc as a substitute material for balusters or the bases and capitals of columns e.g. for the Coburg palace in Vienna, designed by Karl Schleps and executed by Franz Ritter Neumann the Elder, both students of Nobile at the Academy see Richard Kurdiovsky, "Zink – Das technische 19. Jahrhundert und seine neuen Erfindungen," in Klaus-Peter Högel and Richard Kurdiovsky, ed., *Das Palais Coburg. Kunst- und Kulturgeschichte eines Wiener Adelspalastes zwischen Renaissance-Befestigung und Ringstraßenära* (Vienna: Christian Brandstätter, 2003), 192–193.

77 Sabine Hierath, *Berliner Zinkguß. Architektur und Bildkunst im 19. Jahrhundert* (Köln: Letter Stiftung, 2004), 17.

78 Fraschina, "Lettere," 28.

79 Petrasová, "Nobile's and Metternich's Idea," 53.

80 Pavan, *Lettere*, 292–293: Nobile to his brother on 21 September 1831.

81 Trieste, SABAP FVG, Fondo Nobile, vol. 39, no. 16.

82 Petr Hubka, "Plasy a Metternichové," in Ivo Budil and Miroslav Šedivý, ed., *Metternich a jeho doba*. Sborník příspěvků z konference uskutečněné v Plzni ve dnech 23. a 24. dubna 2009 (Plzeň: Západočeská univerzita v Plzni, 2009), 74-75; Jan Hučka, "K historii Metternichovy železárny v Plasích," in Ivo Budil and Miroslav Šedivý, eds., *Metternich a jeho doba*. Sborník příspěvků z konference uskutečněné v Plzni ve dnech 23. a 24. dubna 2009 (Plzeň: Západočeská univerzita v Plzni, 2009), 86–88.

83 Trieste, SABAP FVG, Fondo Nobile, vol. 39, nos. 17, 18. cf. Petrasová, *Neoklasicismus*, 7–9.

84 *Protokoll* 1833; *Bericht* 1835, 209. This testifies to Metternich's commercial instinct, because, at a time when Russia dominated the Eu-

ropean manufacturing scene, even Count Salm-Reifferscheidt himself regarded this product as commercially interesting.

85 Petrasová, *Neoklasicismus*, 10–11.

86 Jitka Sedlářová, *Hugo Franz Salm: Průkopník průmyslové revoluce, železářský magnát, mecenáš, sběratel, lidumil* (Kroměříž: Národní památkový ústav, územní památková správa v Kroměříži, 2016), 67, letter dated 30 April 1823.

87 Probably the *Schwarze Madonna* by the sculptor Johann Nepomuk Schaller for which Nobile designed the pedestal, both of cast iron (Krasa-Florian, *Schaller*, 150–152, 218–219), which was initially erected next to the city moat and north of the Äußeres Burgtor (cf. chaptre 2).

88 Jitka Sedlářová, "Blanenská litina a její průkopník starohrabě Hugo Franz Salm 1776–1836)," in Taťána Petrasová and Helena Lorenzová, eds., *Opomíjení a neoblíbení v české kultuře 19. století* (Praha: Academia 2007), 205.

89 Sedlářová, *Salm*, 69.

90 MZA, G 150, inv. č. 420, k. 92. cf. Jitka Sedlářová, "Salmův anglický sen a Försterův experiment se železnými domy," in Taťána Petrasová and Pavla Machalíková, eds., *Člověk a stroj v české kultuře 19. století* (Praha: Academia 2013), 233.

91 Constant von Wurzbach, "Hartig, Franz," in *Biographisches Lexikon des Kaiserthums Oesterreich*, vol. 7 (Vienna: Hof- und Staatsdruckerei, 1861), 399–401, quote 400; Pavan, *Lettere*, 421, Nobile to his brother on 11 May 1837: "Oggi vedrò Hartig per combinare se sarà possibile altro abbellimento di Milano."

92 Sedlářová, *Salm*, 99.

93 Katharina Schoeller, "Ludwig Förster (1797–1863): Der Architekt als Pädogoge und Universalunternehmer. Aspekte seines frühen Lebens und Schaffens" (PhD diss., University of Vienna, 2016), 188–189.

94 Sedlářová, *Salm*, 109. Förster was responsible for the cast-iron decorations of one of the glasshouses in Johann Mayer's garden in Penzing (see above).

95 Pavan, *Lettere*, 465–466: Nobile to his brother on 24 April 1839. "Jeri vi fui con S.E. il Sig. Conte Coteck che ne restò inamorato e ne tirerà profitto per la fabbrica della Casa comunale o Palazzo a Praga." cf. Petrasová, *Neoklasicismus*, 9.

96 Constant von Wurzbach, "Chotek von Chotkowa und Wognin, Karl," in *Biographisches Lexikon des Kaisertums Österreich*, Vol. 2 (Vienna: Verlag des Hof- und Staatsdruckerei, 1857), 360–361; cf. https://de.wikipedia.org/wiki/Karl_Chotek_von_Chotkow, accessed 26 May 2020.

97 Archive of the National Museum, fond Karel Chotek, inv. č. 47, k. 1. Quoted in Eva Lisá, *Karel hrabě Chotek, nejvyšší purkrabí Království českého*, ed. Milada Sekyrková (Praha: Národní technické muzeum, 2008), 38–39.

98 Wurzbach, "Chotek," 360.

99 *Fanale di Salvore nell Istria illuminato a gaz / Leuchtturm bey Salvore in Istrien mit Gas beleuchtet* (Vienna: Ghelen'sche Erben, 1821).

100 Lisá, *Chotek*, 38; Pavan, *Lettere*, 216, Nobile to his brother on 25 March 1829: "Jeri pranzai dal Conte Saurau a gran tavola con il Conte

Cotek [...] e con tanti altri Signori del Consiglio di Stato, della Camera e della Cancelleria, ove si parlò molto di Trieste [...]." or 327, Nobile to his brother on 28 July 1833: "[...] il Conte Cotek che ripartì il mattino seg(uen)te di buon ora. Parlammo molto di Trieste che non sà dimenticare, e restammo d'accordo che avessimo continuato la conversazione al proposito a Carlsbad dove mi attende [...]."

101 NA, Prague, Collections of maps and plans, sign. 60, inv. č. A III/20; Alois Kubíček, "Nová Koňská brána v Praze," *Umění* 8 (1960): 300–303; Adam Hnojil, "Neprovedená varianta Koňské brány v Praze," *Zprávy památkové péče* 68 (2004): 446–447.

102 Josef Teige and Jan Herain, *Staroměstský rynk v Praze*, (Praha: Společnost přátel starožitností českých, 1908), 63.

103 Taťána Petrasová, "Romantické přestavby pražské Staroměstké radnice (1836–1848) a jejich význam pro počátky pražské neogotiky," in Marie Mžyková, ed., *Kamenná kniha: Sborník k romantickému historismu – neogotice*, (Sychrov: zámek Sychrov 1997), 141.

104 Pavan, *Lettere*, 541; cf. Petrasová, "Romantické přestavby," 142–143; Taťána Petrasová, "The History of the Town Hall in Prague in the 19th Century," in Jacek Purchła, ed., *Mayors and City Halls*, (Kraków: International Cultural Centre 1998), 183–188.

105 Pavan, *Lettere*, 549: Nobile to his brother on 3 April 1844.

106 Lisá, *Chotek*, 78–85.

107 Jiří Pokorný, "Pomníky a politika," in Kateřina Kuthanová and Hana Svatošová, eds., *Metamorfózy politiky: Pražské pomníky v 19. století* (Praha: Archiv hl. m. Prahy, 2013), 14.

108 Dana Stehlíková, Miniatury pomníků, in Kateřina Kuthanová and Hana Svatošová, eds., *Metamorfózy politiky: Pražské pomníky v 19. století* (Praha: Archiv hl. m. Prahy, 2013), 127, 135.

109 Pietro Nobile, *Progetti di vari monumenti architettonici immaginati per celebrare il trionfo degli augusti alleati, la pace, la Concordia de'popoli e la rinascente felicità di Europa* (Trieste: Imp. Reg. privilegiata Tipografia Governiale, 1814); Cf. chapter 3 in this book.

110 Pavan, *Lettere*, 126–127.

111 See also: UAABKW, SProt. ex 1828: 20 December 1828.

112 See also: UAABKW, SProt. ex 1829: 23 and 25 May 1829.

113 See also: UAABKW, VA ex 1828/29, Zl. 82: most humble submission by Metternich of 22 July 1829 with the on high decision of 4 September 1829. Trieste, vol. 1, no. 36.

114 Trieste, SABAP FVG, Fondo Nobile, vol. 1 no. 36.

115 Constant von Wurzbach, "Ossoliński Graf von Tenczyn, Joseph," *Biographisches Lexikon*, vol. 21 (Vienna: Hof- und Staatsdruckerei, 1870), 114–118.

116 Eva Hüttl-Hubert, "Vision 'Nationalbibliothek'," *Biblos* 58 (2009): 56, 69; Samuel Linde, *Słownik języka polskiego*, a six-volume monolingual dictionary, was published in Warsaw in 1807–1814.

117 Hüttl-Hubert, "Vision," 57.

118 Hüttl-Hubert, "Vision," 61.

119 Gino Pavan, "La Scuola di Architettura di Leopoli (Lemberg) nel giudizio di Pietro Nobile, direttore della Scuola di Architettura di

Vienna," *La scuola viennese di storia dell'arte*, ed. Marco Pozzetto (Gorizia: Istituto per gli Incontri Culturali Mitteleuropei, 1996), 17–22.

120 Cf. Chapter 7 in this book.

121 Eva Hüttl-Hubert, "Nowy materiał archiwalny dotyczący budowy Ossolineum. Ossoliński i Nobile," *Czasopismo Zakładu Narodowego im. Ossolińskich* (zeszyt 5, 1994): 115–124.

122 Fabiani, *Pagine*, 147–149. Trieste, SABAP FVG, Fondo Nobile, vol. 3, nos. 34, 41, 43, 48.

123 Fabiani, *Pagine*, 149.

124 Andrzej Witko bases himself on archive research: "Nowe spojrzenie na fundację kaplicy Potockich w katedrze na Wawelu," *Studia Waweliana* 3 (1994): 77–78; Pavan, *Lettere*, 338, Nobile to his brother on 27 or 28 December 1833: "Ti scrivo per significarti che o ricevuto un regalo magnifico dalla Contessa Potocka p(er) il disegno di una Capella che fecci sono già due anni quando andai a Cracovia e p(er) il quale allora non volli recevere il (palpè) contenente delle Banco Note offertomi dal suo Maggiordomo a nome di essa."

125 Witko, "Nowe spojrzenie," 77.

126 Wojciech Bałus, Eva Mikołajska, Jacek Urban and Joanna Wolańska, *Sztuka sakralna Krakówa w wieku XIX* (Kraków: Universitas, 2004), 97.

127 APK, AKPot 3093 Pietro Nobile, Colour sketch of the front wall of the chapel, probably from 1837. Andrzej Betlej, "Nieznane projekty z Archiwum Potockich Krzeszowic," in [s.a.], *Architektura znaczeń. Studia ofiarowane prof. Zbigniewowi Bani w 65. rocznicę urodzin i w 40-lecie pracy dydaktycznej*, (Warszawa: Instytut historii sztuki, Uniwersytet Kardynała Sztefana Wyszyńskiego, 2011), 132–139.

128 Ulrike Scholda, "Tafelaufsatz," in Gerbert Frodl, ed., *Geschichte der Bildenden Kunst in Österreich: 19. Jahrhundert*, (Munich, Berlin, London and New York: Prestel 2002), 564–595.

129 Witko, "Nowe spojrzenie," 79. We can probably identify the chapel of St Joseph with the chapel of that name in the Leopoldine wing of the Hofburg.

130 Pavan, *Lettere*, 413, Nobile to his brother on 23 February 1827.

131 Pavan, *Lettere*, 486, Nobile to his brother on 8 April 1840; 528, Nobile to his brother on 19 January 1842.

132 APK, AKPot sign. 3089: "Alla ilustris. Sg. Artur Potocka omaggio dell Autore."

133 Due to the loss of various source materials, we will evidently be unable to say with certainty which of Nobile's projects for Chancellor Metternich were carried out in the state service and which ones were private commissions. Nobile was decorated for his faultless organization of the ceremony of laying the foundation stone for the memorial. Apart from a letter documenting that Metternich paid Nobile's expenses connected with having a print made of the memorial to the Russian army, so far no materials have been found docu-

menting commissioning of and payment for these projects of Nobile's. Cf. Fraschina, "Lettere," 75–76, a letter written by Metternich's secretary Gerway to Nobile in Innsbruck on 11 August 1838, confirming that he had received from Burgrave Chotek the bill for Croll's work on the print.

134 Siemann, *Metternich: Stratäge*, 424–426, 783–785.

135 Pavan, *Lettere*, 379, Nobilet to his brother on 22 May 1835.

136 Pavan, *Lettere*, 384, undated letter from 1835.

137 Pavan, *Lettere*, 593: Secondo viaggio […] a Kulm. In referring to the four defenders, in addition to Austria, Russia, and Prussia, Nobile also had in mind England. Monuments to four defenders had already been mentioned in 1826.

138 Giovanni Labus, *Intorno vari antichi monumenti scoperti in Brescia. Relazione del Prof. Rodolfo Vantini ed alcuni cenni sugli scavi del Signor Luigi Basileti*, (Brescia: Atheneo Bresciano, 1823).

139 Pavan, *Lettere*, 386–387, Nobile to his brother on 18 July 1835.

140 *Bericht der Beurtheilungs-Kommission über die im Jahre 1836 stattgefundene vierte öffentliche Ausstellung der böhmischen Gewerbsprodukte*, (Prag: Beurtheilungs-Commission über die öffentliche Ausstellung der Industrieerzeugnisse Böhmens and Verein zur Ermunterung des Gewerbsgeistes in Böhmen, 1837), 41.

141 Petrasová, *Neoklasicismus*, 12–14.

142 Pavan, *Lettere*, 425, letter dated 29 July 1837.

143 Fraschina, "Lettere," 74–75.

144 Trieste, SABAP FVG, Fondo Nobile, vol. 17, no. 10.

145 Petra Trnková, "Pretiosen kabinet knížete Metternicha," quoted from pp. 9–10. The photographer is thought to have been either Johann Stark, a daguerreotypist from Mariánské Lázně, or Anton Martin, a close associate of Andreas Ettingshausen, the pioneer of Austrian daguerreotypy. Many thanks to the author for providing me with a very inspiring, unpublished text. National Heritage Institute regional office in Prague, State château Kynžvart, inv. č. KY 08500, c. 1840, daguerreotype, see Paul Rath, "Kurzgefasster Übersichts-Alphabet sämmtlicher Museumsobjecte mit genauer Hinweisung auf ihre im Universal-Kataloge niedergelegten Detailbeschreibungen," 1850–1867, library of the château Kynžvart, sign. 27-C-08/b/I–VII. vol. 4, fol. 138, 140, nos. 774, 776, 777.

146 Taťána Petrasová, "Metternich – Nobile – Metternich: Patronát jako vztah s proměnlivou konstantou," in Petr Jindra and Radim Vondráček, ed., *Tvůrce jako předmět dějin umění: Pozice autora po jeho "smrti,"* (Praha: Artefactum 2020), 155–162.

147 *Aus Metternich's Papieren*, vol. 6, 58, Metternich to his wife on 6 September 1835. Trieste, SABAP FVG, Fondo Nobile, vol. 17, no. 24.

148 Petrasová, *Neoklasicismus*, 10, 12.

149 Pavan, *Lettere*, 494, Nobile to his brother on 11 August 1840.

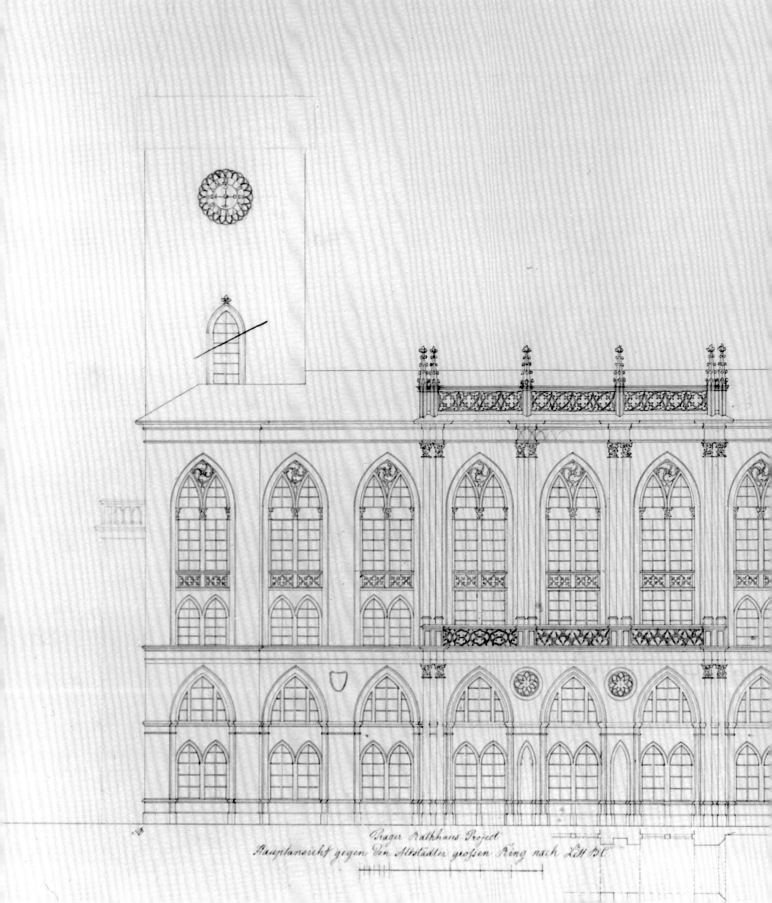

Prager Rathhaus Project
Hauptansicht gegen den Altstädter großen Ring nach Litt: BC.

CONCLUSION

Taťána Petrasová

It is no easy task to reconstruct the full range of Nobile's activities in the 1840s and in the last decade of his life. From his correspondence with his brother, which enables us to follow the peripeteia of Nobile's life virtually in diary form up until his death in 1854, we can see that a major turning point occurred in 1842. His previous clients were looking towards younger architects, the dispute about demolishing Nobile's facade for the Prague Old Town Hall was coming to a head, and his pupils were now becoming his colleagues (Fig. 88, 92); for example, in November 1842 Paul Sprenger was appointed a councillor and joined Nobile in the Hofbaurat. In 1844, Nobile went to the spa town of Piešťany to take a cure there. In some of his letters, we can still sense his ironic attitude to the ups and downs of life:

> The medical commissioner of the spa has been absent for several days now, and foreigners have been trying to take a cure without him: and that is what I do, too. I have drunk the water, I have been in the mud in the baths [...], and the day after tomorrow I will immerse myself in the mud once again.[1]

At the same time, he did not cease to inform his brother from the spa about the development of his idea to set up in Tesserete a school of architecture for local craftsmen, which would be accessible to his fellow countrymen from the Capriasca valley. He carried out an analysis of the number of people who might be interested (a surprising 187 pupils) and explained to his brother how funding for this school could be secured. Until the end of Nobile's life, a bank in Lugano would pay out a sum of a hundred guilders per year to the person entrusted with the directorship of this institution. Nobile also arranged for the school to be equipped with books and drawings, some of which he had already sent to his sister Teresina in Campestro, and he laid down conditions for admitting pupils and guidelines for teaching. 1. Only those who mastered the *trivium* would be admitted. 2. Pupils would learn to draw geometric bodies both with compasses and freehand. 3. Only decorative and figural artists would be taught to draw ornaments and figures. 4. Architecture would be understood to mean not only the theory of the five orders of columns but also technical buildings, especially the method of bricklaying currently practiced by the inhabitants of this region. 5. Poor pupils from Campestro would be exempted from fees "depending on their circumstances and talent." 6. Nobile would be informed each year of the results that the school submitted to the school commission.

The events of 1848 spurred Nobile to revise his decision and to donate the collection of books and drawings to the academy in Vienna, with only a small number being sent to Tesserete, "because in Trieste or Lugano there are no teachers who would appreciate them or pupils who would benefit from them [...]."[2] The school ceased to function after Nobile's death.

"Grande Architettura" and Academic Drawing

Let us return to the idea of "grande architettura," which Pietro Nobile laid down as the aim of and yardstick for his oeuvre and which he realized with his project of the Äußeres Burgtor in Vienna as a triumphal arch in the early 1820s.[3] It is a concept that historians of architecture also resort to when explaining the position of neoclassical architecture between art and science, between – to use today's terms – an academically trained artist and a civil engineer oriented towards technology. "The *Bauakademie* was oriented not so much towards 'great' architecture as towards the practical

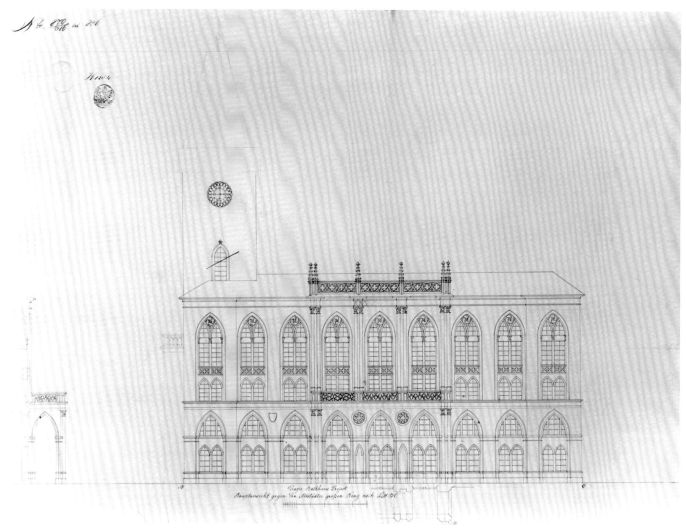

Fig. 92 Office of Public Works or students (after Pietro Nobile), Old Town Hall in Prague, view towards of the Old Town Square, pen and ink, 1836, Vienna, Albertina.

and technical problems associated with training engineers and architects for government service."[4] What did Nobile's "grand" architecture mean in the context of the contemporary aspiration to combine fine art and science in the work of an architect?

As a student at the Accademia di San Luca in Rome in 1798/99, this native of Ticino was able to witness first hand the re-establishment of the French Academy in Rome in the Villa Medici in the Viale della Trinità dei Monti. The school was rehoused there after having been based in Palazzo Mancini in the Via del Corso from 1725 to 1793, when it had to suspend activities as a result of the unrest caused by the French Revolution. Nobile began studying at the Accademia

di San Luca in 1798, when it received neither an annual subsidy for its running costs nor a contribution towards its annual prizes.[5] In spite of this, Nobile was able to focus on the essentials: He learned to draw large-format architectural drawings with such bravura that, because of this and his swiftly acquired contacts, he was awarded a scholarship by the Austrian government that allowed talented students of the Academy of Fine Arts Vienna to stay in Rome for three to five years. The second period that Nobile spent in Rome, from 1801 to 1805, reflected the revolutionary ideals of the time (Pls. LXXVI, LXXVII). According to Melchior Missirini, under the direction of the Roman architect Andrea Vici the Accademia di San Luca was involved in a major discussion

TAŤÁNA PETRASOVÁ

about the calling of architects in society and was building up a relationship of public trust between the academy and the government. At the same time, Vici formulated the conditions necessary for creating a relationship between the public (*popolo*) and art. In his view, this was a question of the public's degree of experience: Art is not like science, which is carried out in sanctuaries and is not accessible to the uninitiated. Art is intended for the public. The people judge the products of art without any preformed opinions and are not beholden to a given set of values. Their decisions are based on feelings and nature, since they do not understand rules, styles, or fine details. But, Vici noted, the judgements of cultivated, educated people are sometimes just like those of the Roman people: They are false. Correct judgements can only be reached through exposure to exhibitions, in other words through repeated experience. And this is why it is the task of public exhibitions to educate citizens.[6]

The Accademia di San Luca emphasized drawing, which was seen as the tool common to painting, sculpture, and architecture. Lessons for architecture students therefore included some of the same exercises used in the academic training of painters: character studies of faces or landscape drawings. Through drawing, architects in Rome absorbed something of the experience of the first scholars at the French Academy in Rome, such as Clérisseau, and the surveys of ancient Greek architecture by Stuart and Revett. Nobile's drawings testify to the importance of understanding the constructional details of Roman buildings, not only the obligatory Pantheon but also the details of a particular gateway in the Aurelian Wall, for example. Also important was Nobile's opportunity to confront the official attitude of the Accademia di San Luca (though admittedly an open one under Vici) with approaches exemplified in the architectural drawings made at the private Accademia della Pace. Nobile's architecture teacher Giuseppe Valadier broadened his student's experience by exposing him to designs made by the *pensionnaires* in Rome and to the so-called "revolutionary" architecture, in the form of his own magnificent urban designs realized during the period of the Napoleonic administration. Also of significance for Nobile must have been the compositional flexibility of his teacher, as evident in the coffeehouse on the Pincian Hill, today known as Casina Valadier (1807).

Influential theoretical treatises aided Nobile in understanding the deeper meaning of drawing for an architect's thinking. Giovanni Gaetano Bottari, in his text *Dialoghi sopra le tre Arti del Disegno* (1754), reminded Nobile of the unity between the arts of painting, sculpture, and architecture, which he would come to know in practice at the Accademia di San Luca. Francesco Milizia, through his writings *Principi di architettura civile* (1781) and *Roma delle belle arti del disegno* (1785), equipped the young architect with the ability to distinguish between the everyday practice of drawing, as a tool for recording a work that had been created or observed, and its philosophical and theoretical interpretation. Nobile cultivated the classical Vitruvian values of *firmitas, utilitas,* and *venustas* in their modern form in the relationship between symmetry, economy, and utility, and he learned to carry them through into reflections on beauty and taste. This experience, in turn, enabled him to formulate his own theoretical theses and approaches. Nobile's first published text was a diplomatically formulated New Year's speech delivered in occupied Trieste on 1 January 1810, "in happy times, when the fine arts were entrusted with the supreme political task of passing on the glory and bygone power of the nations to their descendants today."[7] From an architectural point of view, he took this triumphal rhetoric a step further in a text published in 1814 to celebrate the return of the Austrian emperor and his allies from the Battle of Leipzig; thanks to this text, descriptions of his unpublished designs for a triumphal monument on the Capitoline Hill have been preserved. He employed his ability to describe and generalize from architectural works on his journey to what is today Bajna in Hungary, where he had been sent by Metternich to give his opinion on the new summer residence built by Count Sándor, the husband of Metternich's daughter. Once again, we see how strong an influence Milizia's theory of drawing had on Nobile. For a text published in Vienna, evidently at his own expense, he chose a quotation from a book by his fellow countryman: "Beauty is simply what gives us lively pleasure. If we do not pursue it, this is because we do not know it, and we are satisfied with a small beauty for we do not know of a greater one. In order to come to know beauty and to be able to judge it, it is necessary to cultivate good taste."[8] Nobile took full advantage of the opportunity afforded by this visit to the residence in Bajna, with its columned portico, its gal-

lery used as a glasshouse, and a major attraction on the interior in the form of Alessandro Sanquirico's Pompeian decoration in the library and the salon. In the conclusion to his text, he gave free rein to his capacity for theory in a reflection on beauty and method:

> Directives and rules never produced genius or imagination, and with their help alone no poem, building, decoration, or painting producing the greatest pleasure and admiration ever came into being or matured to harmony; on the contrary, such works arise out of genius and a fertile imagination; they represent the fruits of the sparks uniting and mingling these two qualities of a harmonious soul; they are that harmony of the proportions and relationships which have defined the intensification of beauty which is welcomed and recognized by all, and which those

seeking for the factors making up the qualities of that beauty have discovered and pointed out, terming them the rules and directives of beauty. However, their purpose is rather to reproduce beauty with its qualities under the same circumstances, but not a further intensification, for in each style each intensification of beauty is governed by different factors. Directives and rules have been shown by those who establish them to be like a number of pillars of Hercules demarcating certain borders; crossing them without the compass of genius and clear-headed imagination, consisting in a harmonious soul capable of combining new appropriate factors according to need, usually means exposing oneself to the risk of serious errors and tasteless dissonances.[9]

Durand's Lesson

At the École Polytechnique in Paris, Jean-Nicolas-Louis Durand taught his pupils to conceptualize and compose their designs with a "clear-headed imagination" toward the "harmony of proportions and relationships," moving beyond the mere reproduction of beauty. Evidence of Nobile's efforts to connect artistic drawing with the modular system of architectural drawing, as Durand described it in his *Recueil et parallèle des édifices de tout genre, anciens et modernes* (1800), can be found in his reform of teaching at the Academy of Fine Arts Vienna, formulated in a text presented in January 1819. Nobile aspired not so much to the creation of space with the aid of a modular system as to the creation of a typological order enabling what in his *Reminiscenza di una rapida corsa a Bajna* he called the intensification of beauty (Fig. 93). According to sources documenting the organization of the first semester of architectural teaching after his reform, Nobile established a workshop, led by the professors at the School of Architecture, to make materials and subject matters available to pupils in the form of models. Each of the three teachers (Georg Pein, Wilhelm Ostertag, and the graduate Andreas Zambelli) was given the task of teaching the Doric, Ionic, and Corinthian orders on the basis of Durand's *Parallèle*. Paradoxically, art historians would later come to regard this method as a source of the artistic sterility of Beamten-

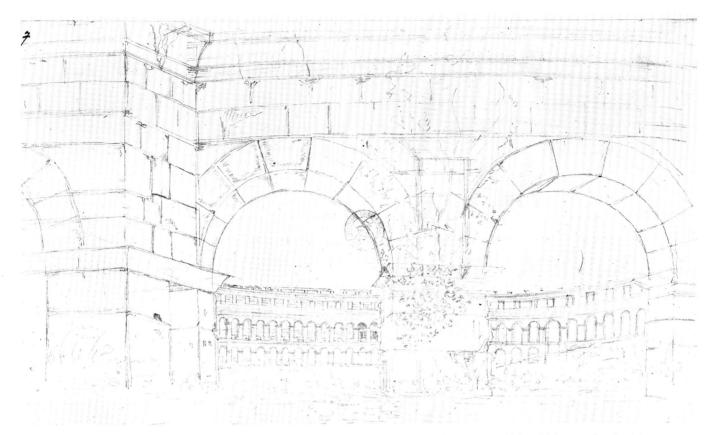

Fig. 94 Pietro Nobile, View inside the amphitheater in Pula, pencil, after 1807, Državni arhiv u Rijeci, Zbirka arhiskog gradiva Gradskog muzeja u Puli.

architektur. Durand appraised Nobile's work, specifically the church of Sant'Antonio Taumaturgo in Trieste, in a new edition of his *Parallèle* published in 1833. He praised the apse with its galleries, all proportionally well laid out, and only considered the use of a dome to be a misstep. Nobile's design for the marketplace in Trieste, which with its rhythm of Doric columns is reminiscent both of its Renaissance predecessors and of Durand's modules (Fig. 8, 18), certainly warrants closer analysis. Be that as it may, many extant drawings by Nobile's pupils, published and commented on by Katharina Schoeller, demonstrate that the modular method remained in use in Vienna roughly as long as it did in Paris, that is, up until a further reform in the syllabus took place in the early 1840s, when Nobile's pupils had taken over leading roles in the Vienna academy. Nobile's interest in the use of prefabricated metal elements in architecture is based especially on the combination of a modular system and the classical theory of the five orders. However, Metternich's pragmatic management of the foundries in Plasy did not allow the experiment

to be developed. The extent of the cooperation with Count Salm-Reifferscheidt in Vienna and Moravia or Count Hartig in Graz regarding the use of structural and decorative cast iron has not yet been reconstructed.

Methods of Monument Conservation: Antiquity versus the Middle Ages

Nobile's experience in Rome searching for monuments from antiquity that could help elucidate certain neoclassicist tenets (i.e. the manner of repeating architectural elements, work with light and shade, and perspective), together with his study of Clérisseau's drawings (Fig. 33), influenced his attitude to monument conservation, which he started to apply after taking up his post at the provincial office of public works in Trieste. Thanks to his position as a civil engineer at this office during the third occupation of the city (1809–1813), Nobile was able to approach General

Henri-Gatien Bertrand, Governor of Illyria, with a request for support for archaeological excavations in Pula. In December 1814, he addressed a similar request to the high-ranking Austrian official Count Franz Josef Saurau with respect to excavations in Trieste, Aquileia, Pula, and on the territory that is today Istria and Dalmatia. At the same time, he submitted a request to the city council that any artefacts from antiquity that were discovered by citizens be collected by the provincial office of public works in order to create a centralized catalogue of these works. Through his activities, Nobile preserved in Pula basic documentation of the amphitheatre (Fig. 94), the Temple of Augustus, and the triumphal arch of the Roman tribune Lucius Sergius Lepidus; in and around Trieste, he preserved monuments such as the Arch of Riccardo (Pl. XXXVI), the Roman theatre, and the aqueduct in the Rosandra Valley (Pl. XXXXVII). Nobile returned to this idea of a catalogue in a certain fashion during his later journeys to Istria, as can be seen from his travel sketches.[10] Acquiring a thorough knowledge of monuments in this way became the basis for his method of protecting the cultural monuments of antiquity and of incorporating this cultural heritage into the modern building practice of Neoclassicism. However, this did not protect Nobile from bitter experiences in the context of the conservation of medieval monuments, such as he had with the reconstruction of the Prague Old Town Hall. It was not just the gap in time that led to this change in his approach to the study of medieval details, which were quite different in terms of construction. Nobile's situation was also made more difficult by the changing specification for the commission: The original intention of expanding the offices and prison, which had been under the purview of the municipal rights of the city council since medieval times, was later extended to include a historical reminiscence of the no longer extant medieval hall. And the situation was further complicated by Nobile's close friendship with Count Chotek: "Count Chotek was always here as my friend, and I also did something for him."[11] The attitude of these two loyal officials of the Austrian state to the reconstruction of the dilapidated medieval building was a modernizing one. In Nobile's sketchbooks, unlike those of Gilly or Schinkel, we do not find any studies of Gothic capitals or other Gothic details. His training, based on the principles of the five orders of columns, led him to the idea that, just as with the cast-iron capitals of the neo-Gothic glasshouses, it would be sufficient to design proportionally correct features for which prefabricated cast-iron, zinc, and ceramic building elements could be used. He already had experience with this experimental approach thanks to his design for the city theatre in Graz (1826) in contact with Count Salm-Reifferscheidt, and he returned to this when using cast-iron and zinc ornamental and utility elements in his buildings for Metternich in Kynžvart (1832/33). In 1839, he took Count Chotek several times to visit the architect Ludwig Christian Förster's newly opened foundry in Vienna and filled him with enthusiasm for an approach that was difficult to defend in Central Europe in the 1830s. It proved fatal for Nobile that he lacked contacts within the circle of Count Thun-Hohenstein and the Society of Patriotic Friends of the Arts in Prague, which, together with the scholars in the Society of the Patriotic Museum in Bohemia, made a strong protest against the architect's method. This eventually led to a decision by the Academy of Fine Arts Vienna whereby Nobile's facade, with its high proportion of glass and almost skeletal structure, was proclaimed an aesthetic travesty and was replaced with a facade that was more correct in terms of the early neo-Gothic style, designed by Nobile's pupil Paul Sprenger, himself a very capable civil engineer.

Social Capital

"Yesterday evening at Prince Metternich's, I found Count Hartig, who on other occasions had been well disposed towards me, to be considerably changed, for he is now the patron of someone else, whom he wants to advance."[12] Nobile owed his success to what Pierre Bourdieu called symbolic capital. In his text *Sur la théorie de l'action*, Bourdieu states that "[...] with the formation of the state there emerges a certain type of common historical transcendent that is special to all its 'subjects.' In creating a certain framework for practical activities, the state at the same time establishes and inculcates common forms and categories, perceptions and ways of thinking, social frameworks for receiving and understanding or remembering, social structures, and state forms of classification."[13] Nobile knew intuitively how to

work with these state forms of classification. The first step occurred exactly as Bourdieu describes it in his lecture on social space and symbolic space, with reference to the choice of the right school. As the recipient of a scholarship from the Trieste City Council to study in Rome, Nobile got to know Count Cobenzl, who accompanied the young student to see the Austrian monarch Francis I in order to help him obtain an Austrian scholarship to study in Rome for the year 1801. Thanks to the latter scholarship, Nobile was not only able to complete his studies but also to form a friendly relationship with the sculptor Antonio Canova. Baron Doblhoff-Dier also appreciated Nobile's ability to develop for the benefit of Austria what had previously been used by the French administration, supporting him in his application for the scholarship in 1801 and again during the difficult moment of the third occupation of Trieste by the French in 1810. Nobile's relationship with Metternich offers a classic example of the deployment of social capital by both the architect and his patron. In 1816, when the two men first became personally acquainted, Nobile's symbolic capital was on the rise: He was accompanying the Austrian emperor Francis I through his newly regained provinces and, together with Chotek, was working on the lighthouse in Savudrija, a building that symbolized the return of this part of Europe to Austria. As time went on, however, the value of Metternich's capital became more important, and with various fluctuations he became the architect's most reliable patron right up to the revolutionary year of 1848. When, in an 1849 letter written from exile in Brussels, Metternich asked about Nobile's social nexus, he did so with an awareness that the former professor at the Academy of Fine Arts had been pensioned off but also with a hope that post-revolutionary circumstances would renew the usefulness of former contacts. But Nobile's capital had lost its value – and not only because of political changes. Paradoxically, his position was weakened by the academy, whose reputation had for many years assured Nobile a place in the sun.

If today we return to Nobile's architectural and theoretical oeuvre, we do so knowing well that, in spite of the fragmentary nature of his surviving work, he was one of the most experimental practitioners in a field that most historians of architecture would consider to have been completely exhausted by the nineteenth century: that of the orders of columns and the theory of proportions. For the history of architecture, it is not important that ultimately it was impossible to take this experiment beyond certain boundaries. What is more imperative is to observe what took place on the threshold between tradition and innovation.

August 2020

NOTES

1 Gino Pavan, *Lettere da Vienna di Pietro Nobile (dal 1816 al 1854)* (Trieste: Società di Minerva 2002), 556: Nobile to his brother on 20 August 1844.

2 Pavan, *Lettere*, 668: Nobile to his brother on 23 September 1848.

3 Other Nobile's projects of the "grande architettura" presented the ephemeral architecture or remained unrealised see Trieste, SABAP FVG, Fondo Nobile, vol. 17, no. 24, vol. 39, no. 23; Bellinzona, Archivio di Stato del Cantone Ticino, Repertorio delle fonti modern e contemporanee, Fondo Nobile, inv. č. 317.

4 Fritz Neumeyer, introduction to *Friedrich Gilly: Essays on Architecture 1796–1799*, trans. David Britt (Santa Monica, CA: The Getty Center for the History of Arts and Humanities 1994), 57.

5 Melchior Missirini, *Memoria per servire alla storia della romana accademia di San Luca fino alla morte di Antonio Canova*, Rome: Stamperia de Romanis 1823, 301.

6 Missirini, *Memoria*, 339.

7 Gino Pavan, "Pietro Nobile: discorso per l'inaugurazione del 'Gabinetto di Minerva' Trieste, 1 gennaio 1810," *Archeografo triestino* 53 (1993): 16.

8 Francesco Milizia, *Principj di architettura civile* (Bassano: Giuseppe Remondini e figli, 1813).

9 Pietro Nobile, *Reminiscenza di una rapida corsa a Bajna comitato di Gran in Ungheria nel mese di Giugno dell'Anno MDCCCXXXVI* (Vienna: s.e., 1836).

10 *Pietro Nobile. Viaggio artistico attraverso l'Istria*, ed. Dean Krmac (Koper: Histria Editiones, 2016).

11 Pavan, *Lettere*, 349: Nobile to his brother on 8 June 1834.

12 Pavan, *Lettere*, 529: Nobile to his brother on 16 February 1842.

13 Pierre Bourdieu, *Raisons pratiques: Sur la théorie de l'action* (Paris: Edition du Seuil, 1994), 88.

ACKNOWLEDGEMENTS

Many friends and colleagues have devoted their time to providing feedback and offering us encouragement at various stages.

Carlo Agliati, Mauro Carmine, Nora Fischer, Petra Jadlovská, Jan Kahuda, Irena Laboutková, Giorgio Nicotera, Filip Paulus, Roberta Ramella, Katharina Schoeller, Jiří Špaček, Soňa Topičová and Jana Zapletalová shared with us their knowledge and previously unconsulted material, some of it presented on the exhibition "Neoclassicism between Technique and Beauty: Pietro Nobile in the Czech Lands" in Pilsen (2019).

This book is based on archival sources from many archives across Europe. We are very grateful to all the archivists and librarians who patiently answered our queries especially at: Archivio di Stato Bellinzona; Archiwum narodowe w Krakowie; Institut of Art History, Czech Academy of Sciences; National Archives of the Czech Republic; National Heritage Institute in the Czech Republic; Austrian National Library; Austrian State Archives, Vienna; Società di Minerva; State château Kynžvart; Státní oblastní archiv v Plzni, pracoviště Klášter; University Archives of the Academy of Fine Arts, Vienna; Municipal and provincial Archives of Vienna. Special thanks to all libraries that helped us to read books during the pandemic years 2020 and 2021.

The Ministero della cultura, Soprintendenza Archeologia, belle arti e paesaggio del Friuli Venezia Giulia, Trieste, the owner of the Pietro Nobile collection, has given generous support to the project, which would not have been possible without their consent to the publication of many images. Thanks to cooperation with the Institute for Habsburg and Balkan Studies of the Austrian Academy of Sciences we were able to put together results of the research that was done on the topic of urban and architectural development of the Viennese Hofburg in the long 19th century.

We are grateful to our translators Peter Stephens, Stephen Zepke, for their patient work with the text.

The main financial support was received by the project in 2017–2019 from the Czech Science Foundation, which provides financial support for the project "Neoclassicism between Technique and Beauty. Pietro Nobile (1776–1854)", 17–19952S, carried out in the Institute of Art History of the Czech Academy of Sciences.

Our thanks, finally, go to the De Gruyter publisher house for helping us to finish our task and – after the demanding process of reading, editing and proofreading – to recall part of our common European history.

ABBREVIATIONS

ADT — Archivio diplomatico del Comune di Trieste

APK AKPot

Archiwum Narodowe (Państwowe) w Krakowie

ANG — Archív Národní galerie, Praha

AST — Archivio di Stato, Trieste

ASVS — Archivio di Stato di Vercelli, archivio privato della famiglia d'Adda Salvaterra (State Archives of Vercelli, private archive of the d'Adda-Salvaterra family), Vercelli

Az. — Architekturzeichnung (architectural drawing)

CMSA — Civici Musei di Storia ed Arte (Civic Museum of Art, Trieste)

GMA — Allied Military Government

Hz. — Handzeichnung (hand drawing)

IAH CAS — Institute of Art History, Czech Academy of Sciences, Prague

Inv.-Nr. — Inventarnummer (registration number)

K. — Karton (box)

Kat. — Katalog (catalogue)

MiC SABAP FVG

Su concessione del Ministero della cultura, Archivio Fotografico SABAP del Friuli Venezia Giulia

NA — Národní archiv (National Archives of the Czech Republic), Prague

NPÚ — Národní památkový ústav (National Heritage Institute)

Nr. — Nummer (no.)

OeStA, AVA, Kultus AK

Österreichisches Staatsarchiv (Austrian State Archives), Allgemeines Verwaltungsarchiv (Archives for general administration), Kultus i.e. Ministerium für Kultus und Unterricht (Ministry for religious affairs and education) Alter Kultus (old religious affairs), Vienna

OeStA, FHKA

Österreichisches Staatsarchiv (Austrian State Archives), Finanz- und Hofkammerarchiv (Archives of Finances and of the Court Chamber), Vienna

OeStA, HHStA, HBA

Österreichisches Staatsarchiv (Austrian State Archives), Haus-, Hof- und Staatsarchiv (House, Court, and State Archives), Hofbauamt (court construction office), Vienna

OeStA, HHStA, PAB

Österreichisches Staatsarchiv (Austrian State Archives), Haus-, Hof- und Staatsarchiv (House, Court, and State Archive), Planarchiv Burghauptmannschaft (Archives of plans for the Building Administration of the Hofburg), Vienna

OeSta, HHStA, StK

Österreichisches Staatsarchiv (Austrian State Archives), Haus-, Hof- und Staatsarchiv (House, Court, and State Archives), Staatskanzlei (State Chancellery), Vienna

OeStA, KA

Österreichisches Staatsarchiv (Austrian State Archives), Kriegsarchiv (War Archives), Vienna

ÖNB, KS — Österreichische Nationalbibliothek, Kartensammlung (Austrian National Library, Map Collection), Vienna

RAS — Riunione Adriatica di Sicurtà

Roll. — Rolle (roll)

SABAP FVG

Soprintendenza Archeologia, belle arti e paesaggio del Friuli Venezia Giulia, Fondo Nobile, Trieste

SLUB — Sächsische Landesbibliothek – Staats- und Universitätsbibliothek Dresden (Saxon State and University Library), Dresden

UAABKW, MR

Universitätsarchiv der Akademie der bildenden Künste Wien (University Archives of the Vienna Academy of Fine Arts), Metternich-Registratur (Metternich registry), Vienna

UAABKW, SProt

Universitätsarchiv der Akademie der bildenden Künste Wien (University Archives of the Vienna Academy of Fine Arts), Sitzungsprotokolle (minutes), Vienna

UAABKW, VA

Universitätsarchiv der Akademie der bildenden Künste Wien (University Archives of the Vienna Academy of Fine Arts), Verwaltungsakten (administrativ files), Vienna

WStLA — Wiener Stadt- und Landesarchiv, Vienna

Zl. — Zahl (no.)

BIBLIOGRAPHY

Agapito, Girolamo. *Descrizione storico-pittorica della fedelissima città e porto franco di Trieste*. Trieste: Italo Svevo, 1972.

Alessandro Papafava e la sua raccolta: Un architetto al tempo di Canova, edited by Susanna Pasquali and Alistair Rowan (exbihition catalogue Vicenza, Palladio Museum). Milan: Officina libraria, 2019.

Anonymous. "Die Propyläen des Perikles in Athen, und das Brandenburger Thor in Berlin." *Der Torso. Eine Zeitschrift der alten und neuen Kunst* 1 (1796): 76–78.

Anonymous. "[...],"*Osservatore Triestino*, December 4, 1809, no. 96.

Anonymous. *Beschreibung des kais.[erlich] königl.[ichen] Volksgartens, des Theseus-Tempels, der in demselben befindlichen Statue des Theseus, des Garten-Salons und des neuen Burgthores in Wien*. Vienna: Tendler and von Manstein, 1824.

Anonymous. "Klein-Tapolesán," in *Oesterreichische National-Encyklopädie, oder alphabetische Darlegung der wissenswürdigsten Eigenthümlichkeiten des österreichischen Kaiserthumes* etc., vol. 3, 219. Vienna: Michael Schmidt's Witwe und Ignaz Klang, 1835.

Anonymous, "Die Leuchtthürme in dem Meerbusen von Triest. Der Leuchtthurm von Salvore," *Allgemeine Bauzeitung* 1 (1836): 17–18, pl. 9.

Anonymous. "Nekrolog (Mit einer Abbildung.) Marchese Luigi Cagnola." *Allgemeine Bauzeitung* 3 (1838): 22–24.

Anonymous. "Nr. 227 Karl Myrbach v. Rheinfeld." *Neuer Nekrolog der Deutschen* 22 (1844), 2nd part (Weimar 1846): 718–723.

Anonymous (initial "G."). "Neue Kirche zu Wilton bei Salisbury." *Allgemeine Bauzeitung* 14 (1849): 90–93.

Anonymous. "Peter von Nobile. Zweites Corti'sches Kaffeehaus, 1820–1822." In *Klassizismus in Wien. Architektur und Plastik* (exhibition catalogue Historisches Museum der Stadt Wien 1978), 122–123. Vienna: self-publishing, 1978.

Anonymous. "Die Treibhäuser im Mayer'schen Garten in Penzing." *Allgemeine Bauzeitung* 3 (1838): 395–396.

Apollonio, Almerigo. "Trieste tra guerra e pace (1797–1824)." *Archeografo triestino* 55 (1995): 295–342.

Apollonio, Almerigo. "Le province illiriche: Economia e società nell'età napoleonica." *Ricerche di storia sociale e religiosa* 25 (1996): 107–125.

Apollonio, Almerigo. "La Venezia Giulia francese: un'anomala 'province de l'Istrie' nell'ambito delle Province Illiriche." In *Napoleone e Campoformido 1797: Armi, diplomazia e società in una regione d'Europa* (exhibition catalogue Villa Manin di Passariano Codroipo), edited by Giuseppe Bergamini, 85–89. Milano: Electa, 1997.

Arciszewska, Barbara. "New Classicism and Modern Institutions of Georgian England." In *The Fusion of Neo-classical Principles*, edited by Lynda Mulvin, 11–24. Dublin: Wordwell, 2011.

Artisti austriaci a Roma dal barocco alla secessione (exhibition catalogue Museo di Roma – palazzo Braschi), 213–215. Rome: Istituto Austriaco di Cultura in Roma,1972.

L'Architetto Pietro Nobile (1776–1854) e il suo tempo (Atti del convegno internazionale di studio, Trieste 1999), ed. Gino Pavan (Trieste: Società di Minerva, 1999).

Aus Metternichs nachgelassenen Papieren, edited by Richard Metternich-Winneburg, selected by Alfons von Klinkowström, vol. 3 (Zweiter Theil Friedens Aera 1816–1848. Erster Band). Wien: Wilhelm Braumüller, 1881.

Aus Metternichs nachgelassenen Papieren, edited by Richard Metternich-Winneburg, selected by Alfons von Klinkowström, vol. 4 (Zweiter Theil Friedens-Aera 1816–1848. Zweiter Band). Wien: Wilhelm Braumüller, 1881.

Aus Metternichs nachgelassenen Papieren, edited by Richard Metternich-Winneburg, selected by Alfons von Klinkowström, vol. 5 (Zweiter Theil Friedens-Aera 1816–1848. Dritter Band). Wien: Wilhelm Braumüller, 1882.

Aus Metternichs nachgelassenen Papieren, edited by Richard Metternich-Winneburg, selected by Alfons von Klinkowström, vol. 6. (Zweiter Theil Friedens-Aera 1816–1848. Vierter Band). Wien: Wilhelm Braumüller, 1883.

Bałus, Wojciech, Eva Mikołajska, Jacek Urban and Joanna Wolańska, *Sztuka sakralna Krakówa w wieku XIX* (Kraków: Universitas, 2004)

Bayer, Josef. "Die Entwicklung der Architektur Wiens in den letzten fünfzig Jahren." In *Wien am Anfang des 20. Jahrhunderts. Ein Führer in technischer und künstlerischer Richtung*, edited by Paul Kortz, 3–24. Vienna: Gerlach & Wiedling, 1906.

Béha-Castagnola, Johanna. "Pietro Nobile." In *Schweizerisches Künstler-Lexikon*, edited by Carl Brun, vol. 2, H–R, 478. Frauenfeld: Hubert & Co., 1908.

Benedik, Christian. "Kat.-Nr. 65.–66. Vorprojekt für einen Gesamtumbau des Burgtheaters, Anton Ortner, 1828." In *Der Michaelerplatz in Wien. Seine städtebauliche und architektonische Entwicklung* (exhibition catalogue Looshaus and Albertina Vienna), edited by Richard Bösel and Christian Benedik, 104–106. Vienna: Kulturkreis Looshaus, without date (1991).

Benedik, Christian. "Die Genese des Äußeren Burgplatzes." In *Die Wiener Hofburg 1705–1835. Die kaiserliche Residenz vom Barock bis zum Klassizismus*, edited by Hellmut Lorenz, and Anna Mader-Kratky (*Veröffentlichungen zur Bau- und Funktionsgeschichte der Wiener Hofburg 3*, edited by Artur Rosenauer), 214–222. Vienna: Austrian Academy of Sciences, 2016.

Benedik, Christian. "Organisierung und Regulierung der k.k. Generalbaudirektion und deren Landesstellen." *Das Achzehnte Jahrhundert und Österreich. Jahrbuch der Österreichischen Gesellschaft zur Erforschung des achtzehnten Jahrhunderts* 11 (1996): 13–28.

Benedik, Christian. "Planung und Errichtung des Äußeren Burgtores." In *Die Wiener Hofburg 1705–1835. Die kaiserliche Residenz vom Barock bis zum Klassizismus*, edited by Hellmut Lorenz, and Anna Mader-Kratky (*Veröffentlichungen zur Bau- und Funktionsgeschichte der Wiener Hofburg 3*, edited by Artur Rosenauer), 222–230. Vienna: Austrian Academy of Sciences, 2016.

Benedik, Christian. "Ludwig von Remy – Erweiterungsprojekt der Wiener Hofburg, 1815–1831." In *Die Wiener Hofburg 1705–1835. Die kaiserliche Residenz vom Barock bis zum Klassizismus*, edited by Hellmut Lorenz, and Anna Mader-Kratky (*Veröffentlichungen zur Bau- und Funktionsgeschichte der Wiener Hofburg 3*, edited by Artur Rosenauer), 235–241. Vienna: Austrian Academy of Sciences, 2016.

Benedik, Christian. "Die Wiener Hofburg unter Kaiser Franz II. (I.) im Kontext politischer Ereignisse." In *Die Wiener Hofburg 1705–1835. Die kaiserliche Residenz vom Barock bis zum Klassizismus*, edited by Hellmut Lorenz, and Anna Mader-Kratky (*Veröffentlichungen zur Bau- und Funktionsgeschichte der Wiener Hofburg 3*, edited by Artur Rosenauer), 241–246. Vienna: Austrian Academy of Sciences, 2016.

Benedik, Christian. "Strukturreformen im Hofbauwesen unter Franz II. (I.)." In *Die Wiener Hofburg 1705–1835. Die kaiserliche Residenz vom Barock bis zum Klassizismus*, edited by Hellmut Lorenz and Anna Mader-Kratky (*Veröffentlichungen zur Bau- und Funktionsgeschichte der Wiener Hofburg 3*, edited by Artur Rosenauer), 260–262. Vienna: Austrian Academy of Sciences, 2016.

Benedik, Christian. "Der Theseustempel." In *Die Wiener Hofburg 1705–1835. Die kaiserliche Residenz vom Barock bis zum Klassizismus*, edited by Hellmut Lorenz and Anna Mader-Kratky (*Veröffentlichungen zur Bau- und Funktionsgeschichte der Wiener Hofburg 3*, edited by Artur Rosenauer), 548–551. Vienna: Austrian Academy of Sciences, 2016.

Benedik, Christian, and Hellmut Lorenz. "Der *Historische Atlas* der Wiener Hofburg von Johann Aman." In *Die Wiener Hofburg 1705–1835. Die kaiserliche Residenz vom Barock bis zum Klassizismus*, edited by Hellmut Lorenz and Anna Mader-Kratky (*Veröffentlichungen zur Bau- und Funktionsgeschichte der Wiener Hofburg 3*, edited by Artur Rosenauer), 230–235. Vienna: Austrian Academy of Sciences, 2016.

Benedik, Christian and Andrea Sommer-Mathis. "Neubauprojekte für die Hoftheater." In *Die Wiener Hofburg 1705–1835. Die kaiserliche Residenz vom Barock bis zum Klassizismus*, edited by Hellmut Lorenz and Anna Mader-Kratky (*Veröffentlichungen zur Bau- und Funktionsgeschichte der Wiener Hofburg 3*, edited by Artur Rosenauer), 199–205. Vienna: Austrian Academy of Sciences, 2016.

Benedik, Christian. *Meisterwerke der Architektur Zeichnungen aus der Albertina* (exhibition catalogue Albertina), München, London and New York: Prestel, 2017.

Bericht der Beurtheilungs-Kommission über die Ausstellung der Industrie-Erzeugnisse Böhmens vom Jahre 1831. An attachement: *Protokoll über die im Jahre 1831 zur Ausstellung böhmischer Gewersprodukt eingelangten Gegenstände*, Prag: Beurtheilungs-Commission über die öffentliche Ausstelung der Industrieerzeugnisse Böhmens, 1833.

Bericht der Beurtheilungs-Kommission über die im Jahre 1836 stattgefundene vierte öffentliche Ausstellung der böhmischen Gewerbsprodukte. Prag: Gottlob Haase Söhne, 1837.

Bericht über die erste allgemeine oesterreichische Gewerbsprodukten im Jahre 1835. Wien: Gedruckt bei Carl Gerold, 1835.

Berlenghi, Raffaele. *Il Palazzo d'Inverno di Villa Metternich a Vienna. Uno scrigno crisoelefantino*. Rome: De Luca editori d'arte, 2007.

Betlej, Andrzej. "Nieznane projekty z Archiwum Potockich Krzeszowic." In *Architektura znaczeń*. Studia ofiarowane prof. Zbigniewowi Bani w 65. rocznice urodzin i w 40-lecie pracy dydaktycznej, 132–139. Warszawa: Instytut historii sztuki, Uniwersytet Kardynala Sztefana Wyszyńskiego, 2011.

Beutler, Robert H. "Das Niederösterreichische Landhaus in Wien – der klassizistische Umbau durch Alois Pichl" (Phil. dipl., University of Vienna, 2003).

Bidlingmaier, Rolf. *Das Stadtschloss in Wiesbaden*. Regensburg: Schnell and Steiner 2012.

Bonifacio, Paola. "La Società di Minerva e Domenico Rossetti," *Neoclassico* 6 (1994), 61–75.

Bösel, Richard. "Kat.-Nr. 69. Zustandsplan der Hofburg mit Ausbauprojekt für die Vorstadtfront, das Burgtheater und den Michaelertrakt, Pietro Nobile (?), um 1827." In *Der Michaelerplatz in Wien. Seine städtebauliche und architektonische Entwicklung* (exhibition catalogue Looshaus and Albertina Vienna), edited by Richard Bösel and Christian Benedik, 108–112. Vienna: Kulturkreis Looshaus, without date (1991).

Bösel, Richard. "Kat.-Nr. 78. Projekt für den Ausbau der Hofburg und die Regulierung ihres städtebaulichen Umfeldes, Massenplan Anton Barvitius, 1856." In *Der Michaelerplatz in Wien. Seine städtebauliche und architektonische Entwicklung* (exhibition catalogue Looshaus and Albertina Vienna), edited by Richard Bösel and Christian Benedik, 122–124. Vienna: Kulturkreis Looshaus, without date (1991).

Bösel, Richard. "Kat.-Nr. 15. Entwurf zur Ausgestaltung des Äußeren Burgplatzes mit Denkmälern für Franz I. und Maria Theresia." In *Monumente. Wiener Denkmäler vom Klassizismus zur Secession* (exhibition catalogue Looshaus and Graphische Sammlung Albertina Vienna), edited by Richard Bösel and Selma Krasa, 42–44. Vienna: Adolf Holzhausens Nachfolger KG, without date (1994).

Bösel, Richard. "Kat.-Nr. 115–117. Der Theseustempel." In *Monumente. Wiener Denkmäler vom Klassizismus zur Secession* (exhibition catalogue Looshaus and Graphische Sammlung Albertina Vienna), edited by Richard Bösel and Selma Krasa, 164–169. Vienna: Adolf Holzhausens Nachfolger KG, without date (1994).

Bösel, Richard. "Bauen für die Tonkunst. Wiener Konzertstätten des 19. Jahrhunderts im Lichte der europäischen Entwicklung." In *Das Wiener Konzerthaus 1913–2013 im typologischen, stilistischen, ikonographischen und performativen Kontext Mitteleuropas*, edited by Richard Kurdiovsky and Stefan Schmidl, 37–86. Vienna: Austrian Academy of Sciences, 2020.

Bourdieu, Pierre. *Raisons pratiques: Sur la théorie de l'action*. Paris: Edition du Seuil, 1994.

Bradanović, Marijan. "Istra iz putnih mapa Pietra Nobilea / L'Istria dalle cartelle da viaggio di Pietro Nobile / Istra iz potnih map Pietra Nobila." In *Pietro Nobile. Viaggio artistico attraverso l'Istria*. Koper: Histria Editiones, 2016), 32–47.

Bucco, Gabriella. "La cultura 'riccatiana' in Friuli e l'edizione del Vitruvio udinese," *Arte in Friuli, Arte a Trieste* 2 (1976): 91–116.

Buchinger, Günther, Franz Peter Wanek, and Andreas Winkel. *Bau-, Ausstattungs- und Restauriergeschichte der Kapuzinerkirche in Wien I., Neuer Markt* (typoscript-report). Vienna: self-publishing of Denkmalforscher, 2015.

Buttlar, Adrian von. *Leo von Klenze. Leben – Werk – Vision*. Munich: Beck, 1999.

Büttner, Frank. "Die Weimarischen Kunstfreunde und die Krise der Kunstakademien um 1800." In *Klassizismus in Aktion. Goethes 'Propyläen' und das Weimarer Kunstprogramm*, edited by Daniel Ehrmann and Norbert Christian Wolf, 295–328. Vienna, Cologne und Weimar: Böhlau, 2016.

Caltana, Diego. "Pietro Nobile." last modified November 18, 2013, accessed June 23, 2020, www.architektenlexikon.at.

Canova. Eterna bellezza (exhibition catalogue Palazzo Brasci, Roma), edited by Giuseppe Pavanello. Milan: Silvana Editoriale, 2019.

Canova, Hayez, Cicognara. L'ultima gloria di Venezia (exhibition catalogue Gallerie dell'Accademia, Venezia), edited by Fernando Mazzocca, Paola Marini, and Roberto De Feo. Venezia: Marsilio Editori, 2017.

Caprin, Giuseppe. *I nostri nonni: Pagine della vita triestina dal 1800 al 1830*. Trieste: Sab. art Tip. G. Caprin Editore, 1926.

Caputo, Fulvio, and Roberto Masiero. "La città et l'architettura." In *Trieste: l'architettura neoclassica. Guida tematica*, edited by Fulvio Caputo and Roberto Masiero, 23–66. Trieste: Edizioni B & M Fachin, 1990.

Cazzato, Vincenzo and Maria Gazzetti. "Goethe's gardens: seeking the 'archetypal tree' in Italy." In *Viaggio nei giardini d'Europa da le Nôtre a Henry James* (exhibition catalogue château Venaria Reale), edited by Vincenzo Carrato and Paolo Cornalia, 234–246. Turin: Edizioni La Venaria Reale, 2019.

Cerutti Fusco, Annarosa. "Dibattito architettonico e insegnamento pubblico dell'architettura nell'Accademia di San Luca a Roma nella prima metà dell'Ottocento." In *L'architettura nelle accademie riformate. Insegnamento, dibattito culturale, interventi pubblici*, edited by Giuliana Ricci, 45–46. Milan: Guerini Studio, 1992.

"Chotek von Chotkow, Karl", accessed May 26, 2020, http://www.biographien.ac.at/oebl/oebl_C/Chotek_Karl_1783_1868.xml

Conservazione e tutela dei beni culturali in una terra di frontiera: Il Friuli Venezia Giulia fra Regno d'Italia e Impero Asburgico (1850–1918), edited by Giuseppina Perusini and Rossella Fabiani (Conference proceedings, 30 November 2006). Vicenza: Terra Ferma Edizioni, 2008.

Contro il barocco. Apprendistato a Roma e pratica dell'architettura civile in Italia 1780–1820, edited by Angela Cipriani, Gian Paolo Consoli, and Susanna Pasquali. Roma: Campisano Editore, 2007.

Cossutta, Fabio. "*Classicismo e 'Neoclassicismo' in Domenico Rossetti*." In *Neoclassico: Arte, architettura e cultura a Trieste 1790–1840*, edited by Fulvio Caputo, 105–113. Venezia: Marsilio Editori, 1990.

Curl, James Stevens. "Soufflot, Jacques-Germain." In *Dictionary of Architecture*, 626. Oxford: Oxford University Press, 1999.

D'Amia, Giovanna. "Pietro Nobile e l'ambiente Milanese. Materiali per una storia della cultura artistica nel Lombardo-Veneto," *Archeografo Triestino* 59 (1999): 274.

Debenedetti, Elisa. *Valadier diario architettonico*. Rome: Bulzoni, 1979.

De Farolfi, Fiorello. "L'arco romano detto 'di Riccardo' a Trieste." *Archeografo triestino* 21 (1936): 135–147.

Dellantonio, Sandra. "Pietro Nobile archeologo." *Archeografo triestino* 59 (1999), 339–370.

Dellapiana, Elena. "Il mito del medioevo." In *Storia dell'architettura italiana: L'ottocento*, edited by Amerigo Restucci, 404–405. Milan: Electa, 2005.

Demps, Laurenz. "Zur Baugeschichte des Tores." In *Das Brandenburger Tor 1791–1991. Eine Monographie*, edited by Willmuth Arenhövel and Rolf Bothe, 40–69. Berlin: Arenhövel, 1991.

De Rosa, Diana. "L'istruzione nella Trieste di fine Settecento e lo studente Pietro Nobile." 29–47. In *L'architetto Pietro Nobile (1776–1854) e il suo tempo.* (Atti del convegno internazionale di studio, Trieste), edited by Gino Pavan. Trieste: Società di Minerva, 1999.

De Rosa, Diana. *Piazza Lipsia No 1015: Gli studi nautici nell'Accademia reale e di nautica di Trieste*, 11–55. Udine: Del Bianco Editore, 2008.

Descrizione storico statistica della città di Trieste e del suo territorio, 1782, edited and translated by Sergio degli Ivanissevich. Trieste: Italo Svevo, 1992.

De Vecchi, Fiorenza. "Pietro Nobile direttore delle fabbriche a Trieste." In *Neoclassico: Arte, architettura e cultura a Trieste 1790–1840*, edited by Fulvio Caputo, 121–128. Venezia: Marsilio Editori, 1990.

De Vecchi, Fiorenze. "La normativa edilizia (1801–1854)." In *Neoclassico: Arte, architettura e cultura a Trieste 1790–1854*, edited by Fulvio Caputo, 440–442. Venezia: Marsilio Editori, 1990.

De Vecchi Fiorenza, and Lorenza Resciniti. "Esami di abilitazione per le maestranze edilizie." In *Neoclassico: Arte, architettura e cultura a*

Trieste 1790–1840, edited by Fulvio Caputo, 443–447. Venezia: Marsilio Editori, 1990.

De Vecchi, Fiorenza. "Pietro Nobile funzionario presso la direzione delle fabbriche." *Atti e memorie della società di archelogia e storia patria* 91 (1991), 53–78.

De Vecchi, Fiorenza. *Il luogo e la storia. La toponomastica storica di Trieste. Alla scoperta del sito quale bene culturale.* Vol. 2: *Il Borgo Giuseppino*, 30–35. Trieste: Biblioteca civica hortis, 1992.

I disegni di Ottone Calderari al Museo di Civico di Vicenza, edited by Guido Beltramini. Venice: Marsilio Editori, 1999.

Dorsi, Pierpaolo. "L'imperial Regia Direzione delle fabbriche." In *Neoclassico: Arte, architettura e cultura a Trieste 1790–1840*, edited by Fulvio Caputo, 435–439. Venezia: Marsilio Editori, 1990.

Drigo, Adriano. "Francesco Caucig, un artista goriziano tra Roma e Vienna." In *Ottocento di frontiera*, 64–95. Milan: Electa, 1995.

Duda Marinelli, Gianna. "I Nobile dal 1774 al 1918," *Atti e memorie della Società Istriana di Archeologia e Storia Patria* 46 (1998): 281–355.

Durand, Jean-Nicolas-Louis. *Précis des leçons d'architecture données à l'école Polytechnique*, vol. 2. Paris: Chez l'Auteur et Bernard, 1805.

Durand, Jean-Nicolas-Louis. *Précis of the Lectures on Architecture: With Graphic Portion of the Lectures on Architecture.* Translated by David Britt. Los Angeles: The Getty Research Institute, 2000.

Durand, Jean-Louis-Nicolas. *Recueil et parallèle des edifices de tout genre anciens et modernes remarcables par leur grandeur ou par leur singularité par J. L. N. Durand augmenté de plus de 300 autres bâtimens et de l'Histoire Générale de l'architecture de I. G. Legrand.* Venezia, Giuseppe Antonelli, 1833.

Étienne-Louis Boullée: L'architecte visionnaire et néoclasique, edited by Jean-Marie Pérouse de Montclos. Paris: Hermann, 1993.

Fabiani, Rossella. "L'architetto Pietro Nobile." *Arte in Friuli, Arte a Trieste* 4 (1980), no. 10, 77–89.

Fabiani, Rossella. "Pietro Nobile e la chiesa di S. Antonio Nuovo." *Archeografo triestino* 49 (1980), 101–109.

Fabiani, Rossella. "Pietro Nobile a Roma." *Arte in Friuli, Arte a Trieste* 10 (1988): 77–82.

Fabiani, Rossella. "Modelli nei disegni di Pietro Nobile." *Arte in Friuli, Arte a Trieste* 11 (1989): 101–109.

Fabiani, Rossella. "La chiesa di S. Antonio Nuovo." In Franco Firmiani, *Arte neoclassica a Trieste.* Con testi integrativi di Rossella Fabiani e Lucia D'Agnolo. Trieste: B & MM Fachin 1989, 121–135.

Fabiani, Rossella. "Casa Fontana", "Palazzo Costanzi", "Palazzo della Bibliotheca civica." In *Trieste: l'architettura neoclassica. Guida tematica*, edited by Fulvio Caputo and Roberto Masiero, 193, 189–190, 200. Trieste: Edizioni B & M Fachin, 1990.

Fabiani, Rossella. "Pietro Nobile. Architetto ingegnere," in *Neoclassico: Arte, architettura e cultura a Trieste 1790–1840*, ed. Fulvio Caputo, 443–447. Venezia: Marsilio Editori 1990.

Fabiani, Rossella. "Sant'Antonio Nuovo: il concorso e i progetti." In *Neoclassico: Arte, architettura e cultura a Trieste 1790–1840*, edited by Fulvio Caputo, 461–468. Venezia: Marsilio Editori, 1990.

Fabiani, Rossella. "Il teatro romano di Trieste e Pietro Nobile." In *Il teatro romano di Trieste: monumento, storia, funzione*, edited by Monika Verzar-Bass, 235–240. Rome: Casa Ed. Quasar u.a., 1991.

Fabiani, Rossella. "Pietro Nobile e l'architettura tedesca." *Arte in Friuli, Arte a Trieste* 15 (1995): 307–318.

Fabiani, Rossella, ed. *Pagine architettoniche: i disegni di Pietro Nobile dopo il restauro.* Pasian di Prato: Campanotto, 1997.

Fabiani, Rossella. "'Sono pochi anni che Trieste vide un lampo della nobile architettura'." In *1797: Napoleone a Campoformido. Armi, diplomazia e società in una regione d'Europa*, edited by Giuseppe Bergamini, 156–162. Milan: Electa, 1997.

Fabiani, Rossella. "Pietro Nobile archeologo e conservatore." In *Artisti in viaggio 1750–1900*, edited by Maria Paola Frattolin, 59–66. Venezia: Ragione autonoma Friuli Venezia Giulia, 2006.

Fabiani, Rossella. "Pietro Nobile (1776–1854)." In *Contro il barocco. Apprendistato a Roma e pratica dell'architettura civile in Italia 1780–1820*, edited by Angela Cipriani, Gian Paolo Consoli, and Susanna Pasquali, 447–452. Roma: Campisano Editore, 2007.

Fabiani Rossella. "'Si trovano grandiose vestigia di fabbriche.' Pietro Nobile ed Aquileia." *Antichità Altoadriatiche* 64 (2007): 219–231.

Fabiani, Rossella. "La scoperta dell'antico a Trieste ed in Istria all'inizio dell'Ottocento: Pietro Nobile archeologo." In *L'architecture de l'Empire entre France et Italie*, edited by Letizia Tedeschi and Daniel Rabreau, 383–394. Mendrisio: Silvana Editoriale, 2013.

Fabiani, Rossella. "Pietro Nobile fra manuale e trattato di architettura." *Arte in Friuli, Arte a Trieste* 34 (2015), 139–144.

Fabiani, Rossella, Fabiana Salvador, and Giorgio Nicotera, eds. *Gli svizzeri a Trieste e dintorni. Pietro Nobile.* Trieste: Circolo svizzero di *Trieste*, 2018.

Fabiani, Rossella. "Dopo Winckelmann: la Società di Minerva." In *Trieste 1768: Winckelmann privato*, edited by Maria Carolina Foi and Paola Panizzo, 113–116. Trieste: EUT, 2019.

Fanale di Salvore nell Istria illuminato a gaz / Leuchtturm bey Salvore in Istrien mit Gas beleuchtet. Wien: Gedruckt by den Edlen v. Ghelen'schen Erben, 1821.

Fanteschi, Anna L. "Ulderico Moro: precisazioni sul periodo udinese." *Arte in Friuli, Arte a Trieste* 15 (1995), 217–224.

...Finalmente in questa Capitale del mondo. Goethe a Roma, edited by Konrad Scheurmann and Ursula Bongaerts-Schomer. Roma: Artemide, 2007.

Firmiani, Franco. *Arte neoclassica a Trieste.* Con testi integrativi di Rossella Fabiani e Lucia D'Agnolo. Trieste: B & MM Fachin 1989.

Firmiani, Franco. "L'architetto Uldarico Moro (1737–1804). Documenti inediti, proposte, interrogativi," in *Neoclassico: La ragione, la memoria, una città: Trieste*, edited by Fulvio Caputo and Roberto Masiero, 182–189. Venezia: Marsilio Editori, 1990.

Förster, Ludwig. "Das Bethaus der evangelischen Gemeinde A. C. in der Vorstand Gumpendorf in Wien," *Allgemeine Bauzeitung* 14 (1849): 1–4.

La fortuna di Paestum e la memoria del dorico: 1750–1830, edited by Roselita Raspi Sera. Firenze: Centro Di, 1986.

Fournier, August, and Arnold Winkler, eds. *Tagebücher von Friedrich Gentz (1829–1831)*. Zurich, Leipzig and Vienna: Amalthea, 1920.

Frank, Peter R. and Johannes Frimmel. *Buchwesen in Wien 1750–1850. Kommentiertes Verzeichnis der Buchdrucker, Buchhändler und Verleger.* Wiesbaden: Harrassowitz, 2008.

Fraschina, Franco. "L'architetto Pietro Nobile, Commemorazione in occasione della 115.ma assemblea della Domopedeutica." *L'educatore della svizzera italiana* 104, December (1962): 4–11.

Fraschina, Giuseppe. *Biografia di Pietro Nobile*. Bellinzona: Colombi, 1872.

Fraschina, Giuseppe. "Lettere del principe di Metternich all'architetto Nobile," *Bolletino storico della Svizzera italiana* 11 (1889): 26–29, 74–76, 112–117.

Friedrich Weinbrenner: Architektonisches Lehrbuch, edited by Ulrich Maximilian Schumann. Bad Salgau: Triglyph Verlag, 2015.

Fröhlich, Marie, and Hans-Günther Sperlich. *Georg Moller: Baumeister der Romantik*. Darmstadt: Eduard Roether Verlag, 1959.

Fröhlich, Martin. *Gottfried Semper. Zeichnerischer Nachlass an der ETH Zürich*. Basel and Stuttgart: Birkhäuser, 1974.

The Fusion of Neo-Classical Principles, edited by Lynda Mulvin, 11–24. Dublin: Wordwell, 2011.

Gabrieli, Manlio, ed. *Il Giornale di Vienna di Giuseppe Acerbi (settembre–dicembre 1814)*. Milan: L'Ariete, 1972.

Garms, Jörg. "Introduction," in *Artisti austriaci a Roma dal barocco alla secessione* (exhibition catalogue Museo di Roma – palazzo Braschi), 1–27. Rome: Istituto Austriaco di Cultura in Roma,1972.

Gatti, Friedrich. *Geschichte der k. k. Ingenieur- und k. k. Genie-Akademie 1717–1869 (Geschichte der k. und k. technischen Militär-Akademie 1)*. Vienna: Wilhelm Braumüller, 1901.

Gentile, Attilio. "Di un precedente dei premi municipali e di un progetto di Pietro Nobile." *Archeografo triestino* 8–9 (1945): 415–433.

Giacomello, Alessandro, and Paolo Moro. "Da falegname a architetto: Ulderico Moro da Priola a Trieste." *Archeografo triestino* 77, (1999): 251–271.

Giacomello, Alessandro, and Paolo Moro. "Da falegname a architetto: Ulderico Moro da Priola a Trieste." In *Mistrùts: Piccoli maestri del Settecento carnico*, edited by Giorgio Ferigo, 207–219. Udine: Museo Carnico delle Arti e Tradizioni popolari Luigi e Michele Gortni, 2006.

Giedion, Sigfried. *Construire en France. Construire en fer. Construir en beton*. Translated by Guy Balangé, introduction by Jean-Louis Cohen. Paris: Édition de la Villette, 2000. (Originally published in Sigfried Giedeon, *Bauen in Frankreich: Eisen, Eisenbeton*. Leipzig and Berlin: Klinkhardt and Biermann, 1928.)

Giedion, Sigfried. *Space, Time, and Architecture: The Growth of a New Tradition*. Cambridge, Ma.: Harvard University Press, 1997.

Ginhart, Karl. *Die Kaisergruft bei den pp. Kapuzinern in Wien*. Vienna: Logos, 1925.

Gioseffi, Decio. "I disegni dell'architetto Nobile," *Il giornale di Trieste*, 3 June, 1954.

Giuseppe Piermarini e il suo tempo (exhibition catalogue Palazzo Trincini). Milan: Electa, 1983.

Grabner, Sabine. "Leopold Kiesling: ein Lebensbild." In Stella Rollig and Sabine Grabner, eds., *Leopold Kiesling: Der Mythos von Mars und Venus mit Amor*, 9–26. Vienna: Belvedere, 2019.

Grand Tour. Il fascino dell'Italia nel XVIII secolo, edited by Andrew Wilton and Ilaria Bignamini. Milan: Skira, 1997.

Guagnini, Elvio. "Minerva nel regno di Mercurio," in *Neoclassico: Arte, architettura e cultura a Trieste 1790–1840*, edited by Fulvio Caputo, 43–47. Venezia: Marsilio Editori, 1990.

Guidi, Nicoletta. "L'archivio Storico del Comune di Trieste miniera di documenti dell'architetto Pietro Nobile." *Neoclassico* 13 (1998): 77–81.

Guidi, Nicoletta. "Nuovi documenti sulla carriera di Pietro Nobile presso la direzione delle pubbliche fabbriche di Trieste." *Archeografo triestino* 59 (1999): 67–81.

Guidi, Nicoletta. "Pietro Nobile: Regesto degli atti presenti nell'archivio storico." *Atti e memorie della società istriana di archeologia e storia patria* 99 (1999): 208–336.

Hajós, Géza, ed. *Der malerische Landschaftspark in Laxenburg bei Wien*. Vienna, Cologne and Weimar: Böhlau, 2006.

Hafner, Otfried. "Zur Grazer Kunstgeschichte des Klassizismus." *Mitteilungen der Gesellschaft für vergleichende Kunstforschung in Wien* 29 (1977): 1–7.

Hartmann, Eleonore. "Die Hofreisen Kaiser Franz I." PhD diss., University of Vienna, 1968.

Haus, Andreas. *Karl Friedrich Schinkel als Künstler: Annäherung und Kommentar*. Munich: Deutscher Kunstverlag, 2001.

Havelka, Miloš. "Úředník a občan, legitimita a loajalita." In Taťána Petrasová and Helena Lorenzová, eds., *Opomíjení a neoblíbení v české kultuře 19. století*, 19–29. Prague: KLP–Konias Latin Press, 2007.

Hawlik-van de Water, Magdalena. *Die Kapuzinergruft: Begräbnisstätte der Habsburger in Wien*. Vienna, Freiburg and Basel: Herder, 1987.

Heinrich Christoph Jussow 1754–1825. Ein hessischer Architekt des Klassizismus, edited by Wanda Löwe (exhibition catalogue Museum Fridericianum, Kassel). Kassel: Wernersche Verlagsgesellschaft Worms, 1999.

Herzmansky, Hedwig. "Josef Kornhäusel" (PhD diss., Universität Wien, 1965).

Hevesi, Ludwig. *Oesterreichische Kunst im Neunzehnten Jahrhundert*. Leipzig: Seeman, 1903.

Hierath, Sabine. *Berliner Zinkguß: Architektur und Bildkunst im 19. Jahrhundert*. Köln: Letter Stiftung, 2004.

Hildebrand, Sonja. "Werkverzeichnis." In *Leo von Klenze. Architekt zwischen Kunst und Hof 1784–1864* (exhibition catalogue Münchner

Stadtmuseum and Altes Museum Berlin), edited by Winfried Nerdinger, 196–499. Munich, London and New York: Prestel, 2000.

Himmelheber, Georg. *Biedermeier 1815–1835: Architecture, Painting, Sculpture, Decorative Arts, Fashion*. München: Prestel, 1989.

Hirschfeld, Christian Cay Lorenz. *Theorie der Gartenkunst*, vol. 5. Leipzig: Weidmann, 1785.

Hnojil, Adam. "Neprovedená varianta Koňské brány v Praze." *Zprávy památkové péče* 68 (2004): 446–447.

Honour, Hugh. *Neo-Classicism*. Harmondsworth: Penguin Books Ltd., 1968.

Honour, Hugh. "Neo-Classicism." In *The Age of Neo-Classicism* (exhibition catalogue The Royal Academy and the Victoria & Albert Museum, 1972), XXI–XXIX. London: Art Council, 1972.

Hormayr, Joseph. "Die außerordentliche Kunstausstellung des Jahres 1822 zu Wien." *Archiv für Geographie, Historie, Staats- und Kriegskunst* 11 (1822): 505–508.

Hormayr, Joseph (Freiherr), ed. *Wien, seine Geschicke und seine Denkwürdigkeiten* 2, no. 2–3. Vienna: Franz Härter'sche Buchhandlung, 1825.

Hoyer, Sonja Ana et al. *Casa Tartini di Pirano: Evoluzione storica e apparato decorativo*. Nel trecentesimo anniversario della nascita di Giuseppe Tartini 1692–1992. Koper: Lipa, 1993.

Hubert, Eva. "Schloss Johannisberg – Umbauten." In *Darmstadt in der Zeit des Klassizismus und der Romantik* (exhibition catalogue Darmstadt, Mathildenhöhe 1978), edited by Bernd Krimmel, 156–158. Darmstadt: self published, 1978.

Hubka, Petr. "Plasy a Metternichové." In *Metternich a jeho doba*, edited by Ivo Budil and Miroslav Šedivý. (Sborník příspěvků z konference uskutečněné v Plzni ve dnech 23. a 24. dubna 2009), 74–75. Plzeň: Fakulta filozofická Západočeské university, 2009.

Hübsch, Heinrich. *In welchem Style sollen wir bauen?* Karlsruhe: Christian Friedrich Müller, 1828.

Hučka, Jan. "K historii Metternichovy železárny v Plasích." In *Metternich a jeho doba*, edited by Ivo Budil and Miroslav Šedivý. (Sborník příspěvků z konference uskutečněné v Plzni ve dnech 23. a 24. dubna 2009), 86–88. Plzeň: Fakulta filozofická Západočeské university, 2009.

Hüttl-Hubert, Eva. "Nobile a Vienna." In *L'architetto Pietro Nobile (1776–1854) e il suo tempo* (Atti del convegno internazionale di studio, Trieste 1999), edited by Gino Pavan, 131–156. Trieste: Società di Minerva, 1999.

Hüttl-Hubert, Eva. "Nowy materiał archiwalny dotyczący budowy Ossolineum: Ossoliński i Nobile." *Czasopismo Zakładu Narodowego im. Ossolińskich* (1994): 115–124.

Hüttl-Hubert, Eva. "Vision 'Nationalbibliothek'." *Biblos* 58 (2009): 53–71.

Iby, Elfriede, and Alexander Koller. *Schönbrunn*. Vienna: Brandstätter, 2000.

Josch, Eduard. "Peter Nobiles Ernennung zum Direktor der Architekturschule der Akademie der bildenden Künste in Wien und Joseph Kornhäusels Bewerbung um diese Stelle." *Mitteilungen der Gesellschaft für vergleichende Kunstforschung in Wien* 3 (1950): 69–71.

Judson, Pieter M. *The Habsburg Empire. A New History*. Cambridge, Ma. and London: The Belknap Press of Harvard University Press, 2016.

KA. "Engel, Carl Ludwig (1778–1840)." In *The Age of Neo-Classicism* (exhibition catalogue The Royal Academy and the Victoria & Albert Museum), 528–530. London: Art Council, 1972.

Kalamar, Stefan. "Die baulichen Aktivitäten von Nikolaus II. Fürst Esterházy im ersten Jahrzehnt seiner Regierung." In 28. *Schlaininger Gespräche: Die Familie Esterházy im 17. und 18. Jahrhundert* (Wissenschaftliche Arbeiten aus dem Burgenland 128), 289–316. Eisenstadt: Amt der Burgenländischen Landesregierung, Abt. 7 and Landesmuseum, 2009.

Kalnein, Wend von. *Architecture in France in the Eighteenth Century*. New Haven and London: Yale University Press, 1995.

Kalnein, Wend von. "Architecture in the age of Neo-Classicism." In *The Age of Neo-Classicism* (exhibition catalogue The Royal Academy and the Victoria &Albert Museum, 1972), LIII–LXVI. London: Art Council, 1972.

Kannés, Gianluca. "Commissioni ed incarichi per Vienna del marchese Luigi Cagnola." In *L'architetto Pietro Nobile (1776–1854) e il suo tempo* (Atti del convegno internazionale di studio, Trieste 1999), edited by Gino Pavan, 157–194. Trieste: Società di Minerva, 1999.

Kassal-Mikula, Renata. "Architecture." *Vienna in the Biedermeier Era 1815–1848*, edited by Robert Waissenberger, 139–159. London: Alpine Fine Arts Collection (U.K.) Ltd. 1986.

Kastner, Richard H. "Die Technische Hochschule in Wien: Ihre Gründung, Entwicklung und ihr bauliches Werden." In *150 Jahre Technische Hochschule in Wien 1815–1965. Bauten und Institute, Lehrer und Studenten*, edited by H. Sequenz, 7–109. Vienna: self-publishing Technische Hochschule Wien, 1965.

Kaufmann, Emil. *Architecture in the age of reason: Barok and postbaroque in England, Italy and France*. New York: Dover Publications, 1955.

Kaufmann, Maria. "Das Burgtor in Wien: Planung und Bau." Dipl. phil., University of Vienna, 2010.

Kernbauer, Eva at al., eds. *Rudolf Eitelberger von Edelberg: Netzwerker der Kunstwelt*. Vienna, Cologne and Weimar: Böhlau, 2019.

Kiby, Ulrika. *Bäder und Badekultur in Orient und Okzident: Antike bis Spätbarock*. Cologne: DuMont, 1995.

Knowles, John. *The Life and Writnigs of Henry Fuseli*. London: Henry Colburn and Richard Bentley, 1831.

Köchert, Irmgard. "Peter Nobile. Sein Werdegang und seine Entwicklung mit besonderer Berücksichtigung seines Wiener Schaffens." PhD diss., University of Vienna, 1951.

Krasa, Selma. "Antonio Canovas Denkmal für Erzherzogin Marie Christine." *Albertina-Studien* 5–6 (1967–68): 67–134.

Krasa, Selma. "Kat.-Nr. 119–121. Theseus besiegt den Kentauren." In *Monumente. Wiener Denkmäler vom Klassizismus zur Secession* (exhibition

catalogue Kulturkreis Looshaus and Graphic Collection Albertina, Vienna 1994), edited by Richard Bösel and Selma Krasa, 170–176. Vienna: Adolf Holzhausens Nachfolger KG, without date (1994).

Krasa-Florian, Selma. *Johann Nepomuk Schaller 1777–1842. Ein Wiener Bildhauer aus dem Freundeskreis der Nazarener*. Vienna: Anton Schroll & Co., 1977.

Kräftner, Johann. *Klassizismus und Biedermeier in Mitteleuropa. Architektur und Innenraumgestaltung in Österreich und seinen Kronländern 1780–1850*. Vienna: Brandstätter, 2016.

Krause, Walter. "Wende oder Übergang? 1848 und die Anfänge der franzisko-josephinischen Architektur: Mythos und Motive." In *Acta historiae artium Academiae Scientiarum Hungaricae: revue de l'Académie des Sciences de Hongrie* 36 (1993): 133–148.

Kronbichler-Skacha, Susanne. "Die Wiener 'Beamtenarchitektur' und das Werk des Architekten Hermann Bergmann (1816–1886)." *Wiener Jahrbuch für Kunstgeschichte* 39 (1986): 163–203.

Krufft, Hanno-Walter. *Geschichte der Architekturtheorie*. Munich: Beck, 2004⁵.

Kubíček, Alois. "Nová Koňská brána v Praze." *Umění* 8 (1960): 300–303.

Die Kunstdenkmäler der Stadt Graz. Die Profanbauten des I. Bezirkes. Altstadt (Österreichische Kunsttopographie 53), edited by Bundesdenkmalamt. Vienna and Horn: Berger, 1997.

Kurdiovsky, Richard. "Zink – Das technische 19. Jahrhundert und seine neuen Erfindungen." In *Das Palais Coburg. Kunst- und Kulturgeschichte eines Wiener Adelspalastes zwischen Renaissance-Befestigung und Ringstraßenära*, edited by Klaus-Peter Högel and Richard Kurdiovsky, 192–193. Vienna: Christian Brandstätter, 2003.

Kurdiovsky, Richard. "'its name is known all over Europe and is reckoned among the loveliest of buildings.' The Winter Palace: The History of its Construction, Decoration and its Use." In *Prince Eugene's Winter Palace*, edited by Agnes Husslein-Arco, 9–23. Vienna: Österreichische Galerie Belvedere, 2013.

Kurdiovsky, Richard. "Das Äußere Burgtor. Planungs-, Bau- und Nutzungsgeschichte 1817–1916." In *Gedächtnisort der Republik. Das Österreichische Heldendenkmal im Äußeren Burgtor der Wiener Hofburg. Geschichte – Kontroversen – Perspektiven*, edited by Heidemarie Uhl, Richard Hufschmied and Dieter A. Binder, 15–71. Vienna, Cologne and Weimar: Böhlau, 2021.

Laboutková, Irena. *Umělecká litina ve sbírkách Národního technického muzea*. Praha: Národní technické muzeum, 2017.

Labus, Giovanni. *Intorno vari antichi monumenti scoperti in Brescia*. Relazione del Prof. Rodolfo Vantini ed alcuni cenni sugli scavi del Signor Luigi Basiletti. Brescia: Atheneo Bresciano, 1823.

Laštovičková, Věra, and Jindřich Vybíral. "Die Architektur zwischen München und Prag." In *Mnichov – Praha. Výtvarné umění mezi tradicí a modernou / München – Prag. Kunst zwischen Tradition und Moderne*, edited by Taťána Petrasová and Roman Prahl, 257–291. Prague: Academia, 2012.

Laudel, Heidrun. "Sempers Theaterbauten – Stätten monumentaler Festlichkeit." In *Gottfried Semper 1803–1879. Architektur und Wissenschaft*, edited by Winfried Nerdinger and Werner Oechslin, 133–137. Munich, Berlin, London, New York and Zurich: gta and Prestel, 2003.

Laugier, Marc-Antoine. *An Essay on Architecture; in which its true Principles are explained, and invariable rules proposed, for directing the Judgment and Forming the Taste of the Gentleman and the Architect [...]*. London: T. Osborne and Shipton, 1755. (Originally published in Marc-Antoine Laugier, *Essai sur l'architecture*. Paris: Duchesne 1753.)

Lauro, Brigitta. *Die Grabstätten der Habsburger. Kunstdenkmäler einer europäischen Dynastie*. Vienna: Brandstätter, 2007.

Lavater, Johann Kaspar. *Frammenti di fisiognomica*. Translated by Matilde De Pasquale, introduction Giorgio Celli, Rome: Matilde de Pasquale, 1989.

Lhotsky, Alphons. *Festschrift des Kunsthistorischen Museums zur Feier des fünfzigjährigen Bestandes. Erster Teil: Die Baugeschichte der Museen und der Neuen Burg*. Vienna and Horn: Ferdinand Berger, 1941.

Lisá, Eva. *Karel hrabě Chotek, nejvyšší purkrabí Království českého*, edited by Milada Sekyrková. Prague: Národní technické muzeum, 2008.

Litschauer, Brigitte. "Die großen Preise der Akademie: Architektur von den Anfängen bis 1820." PhD diss., Wien Universität 1964.

Lorenz, Hellmut. "The Josephine Building Complex. Allgemeines Krankenhaus, Garnisonspital, Narrenturm and Josephinum." In *Sites of Knowledge. The University of Vienna and its Buildings. A History 1365–2015*, edited by Julia Rüdiger and Dieter Schweizer, 99–108. Vienna, Cologne and Weimar: Böhlau 2015.

Lorizzo, Loredana. "L'Accademia di San Luca e la questione dell'istituzione della Cattedra di Incisione in rame nei primi decenni dell' Ottocento." In *Le scuole mute e le scuole parlanti. Studi e documenti sull'Accademia di San Luca nell'Ottocento*, edited by Paola Picardi and Pier Paolo Raciotti, 59–77. Roma: De Luca Editori d'Arte, 2002.

Lucchese, Enrico. "Un disegno di Pietro Nobile per il volto della gran sala nel palazzo della Borsa di Trieste." *Atti e memorie della Società istriana di archeologia e storia patria* 105 (2005), vol. 2, 475–481.

Luigi Basiletti 1780–1859: Carteggio artistico, edited by Bernardo Falconi. Brescia: Scripta – Comunicazione Editoria, 2019.

Luigi Canonica. Architetto di utilità pubblica e privata, edited by Letizia Tedeschi and Francesco Repishti. Mendrisio: Silvana Editoriale, 2011.

Lützow, Carl von. *Geschichte der kais. kön. Akademie der bildenden Künste. Festschrift zur Eröffnung des neuen Akademie-Gebäudes*. Vienna: Carl Gerold's Sohn, 1877.

Mader-Kratky, Anna. "Wien ist keine Festung mehr: Zur Geschichte der Burgbefestigung im 18. Jahrhundert und ihrer Sprengung 1809." *Österreichische Zeitschrift für Kunst und Denkmalpflege* 64 (2010): 134–144.

Mader-Kratky, Anna. "Ausbaupläne für die Wiener Hofburg von Johann Ferdinand Hetzendorf von Hohenberg." In *Die Wiener Hofburg 1705–1835. Die kaiserliche Residenz vom Barock bis zum Klassizismus*, edited by Hellmut Lorenz and Anna Mader-Kratky (Veröffentlichungen zur

Bau- und Funktionsgeschichte der Wiener Hofburg 3, edited by Artur Rosenauer), 209–213. Vienna: Austrian Academy of Sciences, 2016.

Mader-Kratky, Anna. "Neustrukturierung des Hofbauwesens durch Joseph II." In *Die Wiener Hofburg 1705–1835. Die kaiserliche Residenz vom Barock bis zum Klassizismus*, edited by Hellmut Lorenz and Anna Mader-Kratky (Veröffentlichungen zur Bau- und Funktionsgeschichte der Wiener Hofburg 3, edited by Artur Rosenauer), 258–259. Vienna: Austrian Academy of Sciences, 2016.

Maguolo, Michela. "La tutela dei monumenti: Pietro Nobile a Trieste." *Neoclassico* 4 (1993): 46–59.

Malni Pascoletti, Maddalena. "Caucig Francesco." In *La pittura in Italia. L'Ottocento*, 752–754. Milan: Electa, 1991.

Manfredi, Tommaso. "Francesco Milizia e i principj di architettura civile: disegno e iconografia." In *Trattato (Dal) al manuale: La circolazione dei modelli a stampa nell'architettura tra età moderna e contemporanea*, edited by Aurora Scotti Tosini, 41–55. Palermo: Caracol, 2013.

Marconi, Paolo, Angela Cipriani, and Enrico Valeriani. *I disegni di architettura dell'Archivio storico dell'Accademia di San Luca*. Roma: De Luca, 1974.

Maria Teresa, Trieste e il porto: mostra storica, edited by Laura Ruaro Loseri. Udine: Instituto per l'Encyclopedia del Friuli Venezia Giulia, 1980.

Martz, Jochen. "Das Glashaus von Ludwig von Remy." In *Die Wiener Hofburg 1705–1835. Die kaiserliche Residenz vom Barock bis zum Klassizismus*, edited by Hellmut Lorenz and Anna Mader-Kratky (Veröffentlichungen zur Bau- und Funktionsgeschichte der Wiener Hofburg 3, edited by Artur Rosenauer), 542–545. Vienna: Austrian Academy of Sciences, 2016.

Martz, Jochen. "'Waren hier die alten Wälle?': Zur Genese und Entwicklung der gärtnerischen Nutzung auf dem Gelände der fortifikatorischen Anlagen im Bereich der Wiener Hofburg." *Österreichische Zeitschrift für Kunst und Denkmalpflege* 64 (2010): 116–127.

Marzari, Mario. "L'Accademia di Commercio e Nautica." In *Neoclassico: Arte, architettura e cultura a Trieste 1790–1840*, edited by Fulvio Caputo, 404–408. Venice: Marsilio Editori, 1990.

Mayer, Gernot. "Der ephemere Kongress: Fest- und Erinnerungskultur nach dem Ende Napoleons zwischen Siegestaumel und Harmoniesucht." In *Der Wiener Kongress 1814/1815*. vol. 2: *Politische Kultur*, edited by Werner Telesko, Elisabeth Hilscher, and Eva Maria Werner (Denkschriften der philosophisch-historischen Klasse 517), 221–231. Vienna: Austrian Academy of Sciences, 2019.

Mazzi, Libero. "Acquistate due preziose collezioni" *Le ultime notizie*, August 3, 1953.

Meeks, Carroll Louis Vanderslice. *Italian Architecture 1750–1914*. New Haven and London: Yale University Press, 1966.

Meinecke, Friedrich. *Die Idee der Staatsräson in der neueren Geschichte*. München and Berlin: R. Oldenburg, 1929.

Merinsky, Jaro K. "Institut für Hochbau für Bauingenieure." In *150 Jahre Technische Hochschule in Wien 1815–1965. Bauten und Institute, Lehrer und Studenten*, edited by Heinrich Sequenz, 266–270. Vienna: self-publishing of the Technische Hochschule Wien, 1965.

M[ertens], F[ranz]. "Prag und seine Baukunst," *Allgemeine Bauzeitung* 10 (1845): 15–38.

Milano nei disegni di architettura. Catalogo dei disegni conservati in archivi non milanesi, ed. Luciano Patetta. Milan: Guerini e associati 1995.

Milizia, Francesco. *Principj di architettura civile*. Bassano: Giuseppe Remondini e figli, 1785, 1813.

Missirini, Melchior. *Memoria per servire alla storia della romana accademia di San Luca fino alla morte di Antonio Canova*. Rome: Stamperia de Romanis, 1823.

Mraz, Henrike. "Das Königreich Lombardo-Venetien im Vormärz." In *Kaisertum Österreich 1804–1848* (exhibition catalogue Schallaburg 1996), 67–79. Bad Vöslau: self-publishing of the Niederösterreichisches Landesmuseum, 1996.

Müller, Friedrich et al. "Nobile, Peter." In *Die Künstler aller Zeiten und Völker etc.* vol. 3 M–Z, 183–184. Stuttgart: Ebner & Seubert, 1864.

Myssok, Johannes. "Canovas Theseus – ein kolossales Missverständnis." *Jahrbuch des Kunsthistorischen Museums Wien* 11 (2009) (= *Mythos der Antike. Beiträge des am 1. und 2. März 2009 vom Kunsthistorischen Museum in Wien veranstalteten internationalen Symposiums*, edited by Sabine Haag and Gabriele Helke): 169–185.

Nemes, Márta. "Die unbekannten Pläne von Carl Roesner zum Wiederaufbau des Pester Deutschen Theaters im Jahre 1847/48," *Österreichische Zeitschrift für Kunst und Denkmalpflege* 39 (1985), 99–104.

Neoclassico: Arte, architettura e cultura a Trieste 1790–1840, edited by Fulvio Caputo. Venezia: Marsilio Editori, 1990.

Neoclassico, la ragione, la memoria, una città: Trieste, edited by Fulvio Caputo and Roberto Masiero (Le relazioni presentate dai partecipanti al convegno Neoclassico a Trieste, 1989). Venezia: Marsilio Editori, 1990.

Neumeyer, Fritz. "Introduction." In *Friedrich Gilly: Essays on Architecture 1796–1799*. Translated by David Britt, 1–101. Santa Monica, CA: The Getty Center for the History of Arts and Humanities, 1994.

Nobile, Carlo. *L'ultima bugia. Autobiografia di un socialista istriano*. Trieste: ExtraMinerva, 2012.

Nobile, Pietro. "Descrizione del Prospetto da costruirsi nella Piazza Lützen in Trieste," *L'Osservatore triestino*, 1813, n. 31, 268–269.

Nobile, Pietro. "Notizia archeologica," *L'Osservatore triestino*, gennaio 1814, no. 31–32.

Nobile, Pietro. *Progetti di vari monumenti architettonici immaginati per celebrare il trionfo degli augusti alleati, la pace, la Concordia de'popoli e la rinascente felicità di Europa nell'anno 1814, inventati e disegnati da Pietro Nobile, Imperial-Regio ingegnere in Capo provvisorio delle Provincie di Trieste, d'Istria, Gorizia, Adelsberg e Fiume; architetto accademico, Membro dell'Accademia italiana e della Arcadia Romano-Sonziaca*. Trieste: Imp. Reg. privilegiata Tipografia Governiale, 1814.

Nobile, Pietro. *Reminiscenza di una rapida corsa a Bajna comitato di Gran in Ungheria nel messe di giugno del anno MDCCCXXXVI.* Vienna: Tipografia della vedova di Ant. Strauss, 1836.

Pietro Nobile. Viaggio artistico attraverso l'Istria, ed. Dean Krmac (Koper: Histria Editiones, 2016).

Il Nuovo Liruti: Dizionario biografico dei friulani, edited by Cesare Scalon, Claudio Griggio, and Ugo Rozzo, vol. 2 *L'età veneta*, 1754–1757. Udine: Forum, 2009.

Ocherbauer, Ulrich. "Die Instandsetzung und Modernisierung des Grazer Schauspielhauses." *Österreichische Zeitschrift für Kunst und Denkmalpflege* 14 (1960): 150–156.

Oettinger, Ricarda. "Archivalische Vorarbeiten zur Österreichischen Kunsttopographie: Wien, III. Bezirk. Beschreibung der nicht mehr bestehenden Profanbauten," 64–69. (Typoscript, edited by Institut für Österreichische Kunstforschung des Bundesdenkmalamtes, Wien I, Hofburg), s.d.

Paesaggi italiani dell'epoca di Goethe: Disegni e series di acqueforti della Casa di Goethe, edited by Ursula Bongaerts. Rome: Arbeitskreis selbständiger Kultur-Institut, 2007.

Papaldo, Serenita. *L'Ambasciata d'Italia a Vienna.* Rome: De Luca, 1987.

Paris, Laura. *Guida al lascito Antonio Fonda Savio.* Introduction by Nicoletta Zanni. Trieste: Edizioni Universita di Trieste, 2015.

Pavan, Gino. "Les dessins et la correspondance de Pietro Nobile à Trieste." In *Portraits pour une ville: Fortunes d'un port adriatique* (exhibition catalogue *Trouver Trieste*, Paris Conciergerie 1985–1986), edited by Luciano Semerani, 68–121. S.l.: Electa, 1985.

Pavan, Gino. "Pietro Nobile architetto. Vita ed opere." *Archeografo triestino* 49 (1989): 373–432.

Pavan, Gino. "Pietro Nobile coservator di monumenti antichi," 194–201. In *Neoclassico: arte, architettura e cultura a Trieste 1790–1840*, ed. Fulvio Caputo (Venezia: Marsilio Editori, 1990).

Pavan Gino. "Pietro Nobile e l'insegnamento dell'architettura nella Accademia di Vienna (1818–1849)." *Archeografo triestino* 52 (1992): 95–193.

Pavan, Gino. "Pietro Nobile: discorso per l'inaugurazione del 'gabinetto di Minerva' Trieste, 1 gennaio 1810." *Archeografo triestino* 53 (1993): 9–21.

Pavan, Gino. "Pietro Nobile: gli studi preparatori per il tempio di S. Antonio a Trieste nella collezione Fonda Savio." *Archeografo triestino* 54 (1994): 37–90.

Pavan, Gino. "La Scuola di Architettura di Leopoli (Lemberg) nel giudizio di Pietro Nobile, direttore della Scuola di Architettura di Vienna", *La scuola viennese di storia dell'arte*, edited by Marco Pozzetto, 17–22. Gorizia: Istituto per gli Incontri Culturali Mitteleuropei, 1996.

Pavan, Gino. *Pietro Nobile architetto (1776–1854): Studi e documenti.* Introduction by Marco Pozzetto. Trieste and Gorizia: Istituto Giuliano di Storia, Cultura e Documentazione, 1998.

Pavan, Gino. *Il tempio d'Augusto di Pola.* Trieste: Istituto giuliano di storia cultura e documentazione, 2000.

Pavan, Gino. *Lettere da Vienna di Pietro Nobile (dal 1816 al 1854).* Trieste: Società di Minerva 2002.

Pavan, Gino. "Note su Carlo Alessandro Steinberg direttore delle fabbriche a Trieste," *Archeografo triestino* 68 (2008): 53–73.

Pavan, Gino. "Pietro Nobile, i francesi e un padiglione trionfale per Napoleone." *Archeografo triestino*, 71 (2011): 79–93.

Petrasová, Taťána. "Romantické přestavby pražské Staroměstké radnice (1836–1848) a jejich význam pro počátky pražské neogotiky." In *Kamenná kniha: Sborník k romantickému historismu – neogotice*, edited by Marie Mžyková, 137–147. Sychrov: zámek Sychrov, 1997.

Petrasová, Taťána. "The History of the Town Hall in Prague in the 19th Century." In *Mayors and City Halls*, edited by Jacek Purchła, 183–188. Cracow: International Cultural Centre, 1998.

Petrasová, Taťána. "Architektura státního klasicismu, palladiánského neoklasicismu a počátků romantického historismu." In *Dějiny českého výtvarného umění 1780–1890*, edited by Taťána Petrasová and Helena Lorenzová, vol. 1, 28–60. Prague, Academia, 2001.

Petrasová, Taťána. "Aristokratický biedermeier." In *Biedermeier v českých zemích*, edited by Taťána Petrasová and Helena Lorenzová, 149–159. Prague, Konias Latin Press, 2004.

Petrasová, Taťána. *Neoklasicismus mezi technikou a krásou: Pietro Nobile v Čechách.* Prague and Plzeň: Artefactum and Westbohemian Gallery, 2019.

Petrasová, Taťána. "Pietro Nobile's and Clemens Wenzel Lothar Metternich's Idea of the Summer Residence Königswart (1827–1840). Modern Villa and an Experiment," *Umění / Art* 67 (2019): 417–439.

Petrasová, Taťána. "Metternich–Nobile–Metternich: Patronát jako vztah s proměnlivou konstantou." In *Tvůrce jako předmět dějin umění: pozice autora po "jeho smrti"*, edited by Petr Jindra and Radim Vondráček, 155–164. Prague: Artefactum, 2020.

Pevsner, Nicolaus. *Academies of Art: Past and Present.* New York: Cambridge University Press, 1940 (reprint 2014).

Pevsner, Nicolaus. *Le accademie d'arte.* Turin: Einaudi, 1982.

Pezzl, Johann. *Beschreibung von Wien.* Vienna: Sammer, 1841.

Pfammatter, Ulrich. *Die Erfindung des modernen Architekten. Ursprung und Entwicklung seiner wissenschaftlich-industriellen Ausbildung.* Basel, Boston and Berlin: Birkhäuser, 1997.

Philipp, Klaus Jan. *Um 1800. Architekturtheorie und Architekturkritik in Deutschland zwischen 1790 und 1810.* Stuttgart and London: Menges, 1997.

Philipp, Jan Klaus. "Rendez-vous bei Boullée. Pariser Architektur im Urteil deutscher Architekten." In Reinhard Wegner, ed., *Deutsche Baukunst um 1800*, 109–128. Köln, Weimar and Vienna: Böhlau, 2000.

Philipp, Jan Klaus. "Architekturausbildung zwischen Baukunst und Polytechnik." In *Von vorzüglicher Monumentalität*, edited by Lavesstiftung, 75–83. Berlin: Lavesstiftung, 2014.

Picon, Antoine. "From 'Poetry of Art' to Method: The Theory of Jean-Nicolas-Louis Durand." In *J.-N.-L. Durand. Précis of the Lectures on Architecture: With Graphic Portion of the Lectures on Architecture.*

Translated by David Britt, 1–68. Los Angeles: The Getty Research Institute, 2000.

Plaßmeyer Peter. "Peter von Nobile (1776–1854)." In *Revolutionsarchitektur: Ein Aspekt der europäischen Architektur um 1800*, eds. Winfried Nerdinger, Klaus Jan Philipp and Hans-Peter Schwarz, 236–237. (exhibition catalogue Deutsches Architektur Museum, Frankfurt am Main) München: Hirmer, 1990.

Pokorný, Jiří. "Pomníky a politika." In *Metamorfózy politiky: Pražské pomníky v 19. století*, edited by Kateřina Kuthanová and Hana Svatošová, 14–28. Prague: Archiv hl. m. Prahy, 2013.

Pötschner, Angelina. "Das Burgtor auf dem Heldenplatz. Einst repräsentatives Stadttor und Denkmal der Völkerschlacht bei Leipzig, heute Heldendenkmal in Wien." *Arx* 21 (1999), no. 1: 9–14.

Prange, Peter. "Nobile, Peter (Pietro)." In *Neue Deutsche Biographie*, vol. 19, 302–303. München: Bayerische Akademie der Wissenschaften, 1999. Online version; https://www.deutsche-biographie.de/pnd121066215.html#ndbcontent.

Prechtl, Johann Joseph. *Rede bei der ersten Eröffnung der Vorlesungen am k. k. polytechnischen Institute in Wien den 6. November 1815*. Vienna: Carl Gerold, 1815 (reprint: Vienna, Cologne and Weimar: Böhlau, 1992).

Prokopovych, Markian. *Habsburg Lemberg. Architecture, Public Space and Politics in the Galician Capital, 1772–1914*. West Lafayette: Purdue University Press, 2009.

Quatremère de Quincy, Antoine-Chrysostôme. *Dizionario storico di architettura: le voci teoriche*, edited by Valeria Farinati and Georges Teyssot. Venice: Polis / Marsilio Editori, 1985.

Rabreau Daniel. *Architectural Drawings of the Eighteenth Century / Les Dessins d'architecture au XVIIIe siècle / I Disegni di architettura nel settecento*. Paris: Bibliothèque de l'Image, 2001.

Rabreau, Daniel. *Le Théâtre de l'Odéon. Du Monument de la Nation au Théâtre de l'Europe*. Paris: Belin, 2007.

Rabreau, Daniel. *Apollon dans la ville. Essai sur le théâtre et l'urbanisme à l'époque des Lumières*. Paris: Éditions du patrimoine, 2008.

Raciotti, Pier Paolo. "'Per bene inventare e schermirsi dalle altrui censure:' Giuseppe Antonio Guattani." In *Le scuole mute e le scuole parlanti. Studi e documenti sull'Accademia di San Luca nell'Ottocento*, edited by Paola Picardi and Pier Paolo Raciotti, 79–98. Roma: De Luca Editori d'Arte, 2002.

Raspi Serra, Joselita. "Il neo-dorico in Italia." In *La fortuna di Paestum e la memoria del dorico 750–1830*, edited by eadem, 181–183. Firenze, Centro Di, 1986.

Raspi Serra, Joselita. "La Roma di Winckelmann e dei pensionnaires." *Eutopia* 2 (1993): 79–132.

Raspi Serra, Joselita, and Alessandra Themelly. "Disegni di antichità nelle collezioni della Bibliothèque municipale e del musée des Beaux-Arts et d'Archéologie di Besançon." *Eutopia* 2 (1993): 133–151.

Re, Luciano. "Torino e il Piemonte." In *Storia dell'architettura italiana: L'ottocento*, edited by Amerigo Restucci, 20–44. Milan: Electa, 2005.

Redl, Dagmar. "Karl Rösner (1804–69). Ein Wiener Architekt von europäischem Format." *Österreichische Zeitschrift für Kunst und Denkmalpflege* 52 (1998): 550–574.

Reiche, Jürgen. "Symbolgehalt und Bedeutungswandel eines politischen Monuments." In *Das Brandenburger Tor 1791–1991. Eine Monographie*, edited by Willmuth Arenhövel and Rolf Bothe, 270–316. Berlin: Arenhövel, 1991.

Revolutionsarchitektur: Ein Aspekt der europäischen Architektur um 1800, eds. Winfried Nerdinger, Klaus Jan Philipp and Hans-Peter Schwarz, (exhibition catalogue Deutsches Architektur Museum, Frankfurt am Main), München: Hirmer, 1990.

Righetti, Giuseppe. *Cenni storici, biografici e critici degli artisti ed ingegneri di Trieste*. Trieste: L. Herrmanstorfer Tipografo-Editore, 1865.

Rizzi, Wilhelm Georg. "Josef Kornhäusel." In *Bürgersinn und Aufbegehren. Biedermeier und Vormärz in Wien 1815–1848* (exhibition catalogue Historisches Museum der Stadt Wien), 505–513. Vienna: self-publishing, without date (1987).

Rizzi, Wilhelm Georg. "Die Architektur des Niederösterreichischen Landhauses." In *Altes Landhaus*, edited by Anton Eggendorfer, Wolfgang Krug, and Gottfried Stadler, 86–119. Vienna: Brandstätter, 2006.

Röll, Johannes, and Ksenija Rozman, *Franz Caucig (1755–1828): Italienische Ansichten*. Petersberg and Ruhpolding: Michael Imhof Verlag and Verlag Franz Philipp Rutzen, 2018.

Roma è l'antico. Realtà e visione nel '700, (exhibition catalogue), edited by Carolina Brook and Valter Curzi, Milan: Skira, 2010.

Rondelet, Jean-Baptist. *Theoretisch-praktische Anleitung zur Kunst zu bauen*, vol. 1–5. Translated by J. Hess. Leipzig and Darmstadt: Verlag von Karl Wilhelm Leske, 1833–1836.

Rozman, Ksenija. *Franc Kaučič Caucig and Bohemia*. Ljubljana: Narodna galerija v Ljubjani, 2005.

Rozman, Ksenija. *Franc Kaučič Caucig. Paintings for Palais Auersperg in Vienna*. Ljubljana: Narodna galerija v Ljubjani, 2007.

Rusconi, Livia. "Pietro Nobile e il gruppo del Teseo di Antonio Canova a Vienna." *Archeografo triestino* 10 (1923): 350–371.

Rusconi, Livia. "Pietro Nobile e i monumenti romani di Pola." *Archeografo triestino* 13 (1926): 343–358.

Salge, Christina. *Baukunst und Wissenschaft. Architektenausbiludng an der Berliner Bauakademie um 1800*, Berlin: Gebrüder Mann 2021.

Salimbeni, Fulvio. "La prima serie dell' 'Archeografo Triestino' (1829–1837): Una rivista di erudito impegno civile," *Neoclassico: Arte, architettura e cultura a Trieste 1790–1840*, edited by Fulvio Caputo. Venezia: Marsilio Editori, 1990, 115–119.

Salvador, Fabiana. "Pietro Nobile Architetto: bibliografia essenziale." In Rossella Fabiani, Fabiana Salvador, and Giorgio Nicotera, *Gli svizzeri a Trieste e dintorni. Pietro Nobile*, 59–81. Trieste: Circolo svizzero di Trieste, 2018.

Salvador, Fabiana. "Storia della collezione, in Fabiani," In Rossella Fabiani, Fabiana Salvador, and Giorgio Nicotera, *Gli svizzeri a Trieste e dintorni. Pietro Nobile*, 15–35. Trieste: Circolo svizzero di Trieste, 2018.

Sangiorgi, Pietro. *Idea di un teatro adattato al locale detto delle convertite nella strada del Corso di Roma*. Rome: Mordacchini, 1821.

Schaber, Wilfried. "Pietro Nobile e la ricostruzione del castello Mirabell a Salisburgo," in *L'architetto Pietro Nobile (1776–1854) e il suo tempo*. Atti del Convegno internazionale di studio Trieste, 7–8 Maggio 1999, edited by Gino Pavan. Trieste: Società di Minerva, 1999.

Schachel, R. "Nobile Peter, Architekt." In *Österreichisches Biographisches Lexikon 1815–1950*, vol. 7, 139–140. Vienna: Austrian Academy of Sciences, 1976.

Schmalhofer, Elisabeth. "Paul Sprenger 1798–1854. Architekt im Dienst des Staates." PhD diss., University of Vienna, 2000.

Schoeller, Katharina. *Pietro Nobile. Direttore dell'Accademia di architettura di Vienna (1818–1849)* (Archeografo Triestino extra serie 5). Trieste: Società di Minerva, 2008.

Schoeller, Katharina. "Ludwig Förster, Architekt und Geschäftsmann. Neues zu seiner Biografie." In *Theophil Hansen – ein Resümee: Symposionsband anlässlich des 200. Geburtstages, Symposion der Universitätsbibliothek der Akademie der bildenden Künste Wien, Juni 2013*, edited by Beatrix Bastl, 255–272. Weitra: Verlag der Provinz, 2014.

Schoeller, Katharina. "Ludwig Förster (1797–1863): Der Architekt als Pädagoge und Universalunternehmer. Aspekte seines frühen Lebens und Schaffens." PhD diss., Universität Wien, 2016.

Scholda, Ulrike. "Tafelaufsatz." In *Geschichte der Bildenden Kunst in Österreich: 19. Jahrhundert*, edited by Gerbert Frodl, 564–595. München, Berlin, London and New York: Prestel, 2002.

Schwarz, Mario. "Die Baugeschichte des Festsaales der Technischen Hochschule in Wien." *Österreichische Zeitschrift für Kunst und Denkmalpflege* 27 (1973): 29–40.

Le scuole mute e le scuole parlanti. Studi e documenti sull'Accademia di San Luca nell'Ottocento, edited by Paola Picardi and Pier Paolo Raciotti. Rome: De Luca Editori d'Arte, 2002.

Sedlářová, Jitka. "Blanenská litina a její průkopník starohrabě Hugo Franz Salm (1776–1836)." In *Opomíjení a neoblíbení v české kultuře 19. století*, edited by Taťána Petrasová and Helena Lorenzová, 195–211. Prague: Academia, 2007.

Sedlářová, Jitka. "Salmův anglický sen a Försterův experiment se železnými domy." In *Člověk a stroj v české kultuře 19. století*, edited by Taťána Petrasová and Pavla Machalíková, 230–241. Prague: Academia, 2013.

Sedlářová, Jitka. *Hugo Franz Salm: Průkopník průmyslové revoluce, železářský magnát, mecenáš, sběratel, lidumil*. Kroměříž: Národní památkový ústav, územní památková správa v Kroměříži, 2016.

Seidl, Johann Gabriel. "Bilder aus der Nähe 8: Schönbrunn, Hietzing, Penzing." *Archiv für Geschichte, Statistik, Literatur und Kunst* 15 (1824): 749–753.

Siemann, Wolfram. *Metternich: Stratege und Visionär: Eine Biografie*. München: Verlag C. H. Beck oHG, 2016.

Sisa, József. "Alois Pichl in Ungarn. Die Tätigkeit eines Wiener Architekten in Ungarn während der ersten Hälfte des 19. Jahrhunderts," *Acta Historiae Artium* (1982), 67–116.

Sisa, József, ed. *Motherland and Progress: Hungarian Architecture and Design 1800–1900*. Basel: Birkhäuser, 2016.

Sommer-Mathis, Andrea, and Manuel Weinberger. "Das alte Burgtheater, 1741–1792." In *Die Wiener Hofburg 1705–1835. Die kaiserliche Residenz vom Barock bis zum Klassizismus*, edited by Hellmut Lorenz and Anna Mader-Kratky (Veröffentlichungen zur Bau- und Funktionsgeschichte der Wiener Hofburg 3, edited by Artur Rosenauer), 134–140. Vienna: Academy of Sciences, 2016.

Springer, Elisabeth. "Die Baubehörden der österreichischen Zentralverwaltung in der Mitte des 19. Jahrhunderts." Typoscript, research paper ("Hausarbeit") at the Institut für österreichische Geschichtsforschung, University of Vienna, 1971.

Springer, Elisabeth. *Geschichte und Kulturleben der Wiener Ringstraße: Die Wiener Ringstraße. Bild einer Epoche* 2, edited by Renate Wagner-Rieger (Wiesbaden: Franz Steiner Verlag GmbH, 1979).

Springer, Elisabeth. "Die josephinische Musterkirche." *Das achtzehnte Jahrhundert in Österreich. Jahrbuch der Österreichischen Gesellschaft zur Erforschung des Achtzehnten Jahrhunderts* 11 (1996): 67–79.

Srbik, Heinrich Ritter von. *Metternich. Der Staatsmann und der Mensch*, vol. 3. Graz: Akademische Druck- und Verlagsanstalt, 1954.

Stachel, Peter. *Mythos Heldenplatz*. Vienna: Pichler, 2002.

Stehlíková, Dana. "Miniatury pomníků." In *Metamorfózy politiky: Pražské pomníky v 19. století*, edited by Kateřina Kuthanová and Hana Svatošová, 127–135. Prague: Archiv hl. m. Prahy, 2013.

Stillmann, Damie. *English Neo-classical Architecture*, vol. 1, 2. London: A. Zwemmer, 1988.

Strecke, Reinhard. "Bauschüler in Berlin. Zwischen Wissenschaft und Baustelle." In *Neue Baukunst Berlin um 1800*, edited by Elke Blauert and Katharina Wippermann, 37–47. Berlin: Nicolai, 2007.

Streibel, Andreas. "Arte e restaurazione. Il neoclassico di Pietro Nobile." *Archeografo triestino* 51 (1991): 363–369.

Suchánek, Drahomír. "Kancléř Metternich a rakouské intervence do papežských voleb." In *Metternich a jeho doba*, edited by Ivo Budil and Miroslav Šedivý (Sborník příspěvků z konference uskutečněné v Plzni ve dnech 23. a 24. dubna 2009), 21–24. Plzeň: Fakulta filozofická Západočeské university, 2009.

Szambien, Werner. *J.-N.-L. Durand 1760–1834: De l'imitation à la norme*. Paris: Picard, 1984.

Szambien, Werner. *J.-N.-L. Durand: Il metodo e la norma nell'architettura*, Venice: Marsilio Editori, 1986.

Tanzi, Alberto. *Alcune lettere del dottor Domenico de Rossetti*. Milan: Tipografia Fratelli Rechiedei, 1879.

Tanzi, Alberto. *Scritti inedita*. Udine: Idea publishers, 1944.

Tassini, Liliana. *Il governo francese a Trieste (1797–1813): Lineamenti storici, giuridici, economici*. Trieste: L. Smolars & Nipote, 1945.

Tedeschi, Letizia. "Le séjour romain." In *Charles Percier (1764–1838): Architecture et design* (exhibition catalogue Bard graduate center gallery, New York, Château de Fontainebleu), edited by Jean-Philippe Garric, 383–394. Paris: Édition de la Réunion des musées nationaux – Grand Palais, 2016.

Teige, Josef and Jan Herain. *Staroměstský rynk v Praze*. Prague: Společnost přátel starožitností českých, 1908.

Telesko, Werner. *Kulturraum Österreich. Die Identität der Regionen in der bildenden Kunst des 19. Jahrhunderts*. Vienna, Cologne and Weimar: Böhlau, 2008.

Telesko, Werner. "Das Denkmal für Kaiser Franz II. (I.) im Inneren Burghof." In *Die Wiener Hofburg 1835–1918. Der Ausbau der Residenz vom Vormärz bis zum Ende des "Kaiserforums"*, edited by Werner Telesko (Veröffentlichungen zur Bau- und Funktionsgeschichte der Wiener Hofburg 4, edited by Artur Rosenauer), 421–426. Vienna: Academy of Sciences, 2012.

Thieme, Ulrich and Felix Becker. "Nobile, Peter." In *Allgemeines Lexikon der bildenden Künstler von der Antike bis zur Gegenwart*, 493. Leipzig: Wilhelm Engelmann, 1931–1932.

Tomizza, Barbara. "Sigismondo Dimech, Ritratto di Pompeo Brigido." In *Neoclassico: Arte, architettura e cultura a Trieste 1790–1840*, edited by Fulvio Caputo, 170–171. Venezia: Marsilio Editori 1990.

Trouver Trieste. Portraits pour une ville: Fortunes d'un port adriatique (exhibition catalogue Paris Conciergerie 1985–1986), edited by Luciano Semerani. Milan: Electa, 1985.

Tumlirz, Fritz. "Das Grazer Schauspielhaus. Seine Baugeschichte." PhD diss., Karl Franzens-University Graz, 1956.

Vallentin, Franz. "Nobile: Peter von N." In *Allgemeine Deutsche Biographie*, vol. 52, 638–642. Leipzig: E.A Seemann,1906.

Vidler, Antony. *Ledoux*. Translated by Serge Grunberg. Paris: Hazan, 1987.

Vidulli Torlo, Marzia. "Gli ospedali e le opere di beneficenza," in *Neoclassico. Arte, architettura e cultura a Trieste 1790–1840*, edited by Fulvio Caputo, 355–357. Venice: Marsilio, 1990.

Vostřelová, Věra. *Zkamenělá hudba. Tvorba architekta Bernharda Gruebera 1806–1882*. Praha : Vysoká škola uměleckoprůmyslová v Praze, 2018.

Wagner, Walter. *Die Geschichte der Akademie der bildenden Künste in Wien*. Vienna: Brüder Rosenbaum, 1967.

Wagner, Walter. "Die Rompensionäre der Wiener Akademie der bildenden Künste 1772–1848 nach den Quellen im Archiv der Akademie." *Römische Historische Mitteilungen* 14 (1972): 65–109.

Wagner-Rieger, Renate. *Wiens Architektur im 19. Jahrhundert*. Wien: Österreichischer Budesverlag für Unterricht, Wissenschaft und Kunst 1970.

Wagner-Rieger, Renate. "Vom Klassizismus bis zur Secession." In *Geschichte der bildenden Kunst in Wien. Geschichte der Architektur in Wien. Geschichte der Stadt Wien*, edited by Verein für Geschichte der Stadt Wien, Neue Reihe 7/3, 81–244. Vienna: self-publishing of the Verein für Geschichte der Stadt Wien, 1973.

Walcher-Casotti, Maria. "Andrea Pozzo e le ripercussioni del suo trattato nel Friuli e nella Venezia Giulia." *Arte in Friuli, Arte a Trieste* 15 (1995), 103–131.

Walcher, Maria. "Chiesa di San Pietro," in *Istria: Città Maggiori: Capodistria, Parenzo, Pirano, Pola: opere d'arte dal Medioevo all'Ottocento*, edited by Giuseppe Pavanello and Maria Walcher, 247–249. Mariano del Friuli: Edizioni della Laguna, 2001.

Walz, Markus and Petra Schwarze. "'Man kann sich nichts vollkommeners und geschmackvollers denken.' Fürst Metternich und die Daguerreotypie." In *Spurensuche: Frühe Fotografen am Mittelrhein*. Katalog zur Ausstellung 150 Jahre Fotografie – Stationen einer Entwicklung, edited by Ulrich Löber, 17–23. Koblenz: Veröffentlichungen des Landesmuseums Koblenz, 1989.

Weidmann, Franz Carl. "Verschönerungen Wiens I: Der Volksgarten, und Canova's Theseus." *Archiv für Geschichte, Statistik, Literatur und Kunst* 51–52 (1823): 270–271.

Weißensteiner, Johann. "Regesten zur Geschichte der Pfarre Inzersdorf-St. Nikolaus (Wien 23) 1571–1932 nach den Pfarrakten im Diözesanarchiv Wien." *Wiener Katholische Akademie Miscellanea, Neue Reihe* 129 (1983): 17–19, 24–25.

Wetzl, Umberto. "Casa Fontana a Trieste." *Neoclassico* 18 (2000): 34–81.

Winton-Ely, John. "Kuehnel, Pál (d. 1824)." In *The Age of Neo-Classicism* (exhibition catalogue of the Council of Europe), 569–570. London: Art Council, 1972.

Witko, Andrzej. "Nowe spojrzenie na fundację kaplicy Potockich w katedrze na Wawelu." *Studia Waweliana* 3 (1994): 75–89.

Wurzbach, Constant von. "Chotek von Chotkow und Wognin, Karl." In *Biographisches Lexikon des Kaisertums Österreich*, vol. 2, 360–361. Vienna: Verlag des Hof- und Staatsdruckerei, 1857.

Wurzbach, Constant von. "Hartig, Franz." In *Biographisches Lexikon des Kaiserthums Oesterreich*, vol. 7, 399–401. Vienna: Hof- und Staatsdruckerei, 1861.

Wurzbach, Constant von. "Nobile, Peter." In *Biographisches Lexikon des Kaiserthums Oesterreich*, vol. 20, 376–377. Vienna: k. k. Hof- und Staatsdruckerei, 1869.

Wurzbach, Constant von. "Ossolinski Graf von Tenczyn, Joseph." In *Biographisches Lexikon des Kaiserthums Oesterreich*, vol. 21, 114–118. Wien: Hof- und Staatsdruckerei, 1870.

Zatloukal, Pavel. *Příběhy z dlouhého století. Architektura let 1750–1918 na Moravě a ve Slezsku*. Olomouc: Muzeum umění, 2002.

Zwgr., C. "Dreissigste Ausstellung der k. k. österr. Gartenbaugesellschaft in Wien." *Oesterreichisches Botanisches Wochenblatt* 5 (1855): 158.

SOURCES

Archivio diplomatico del Comune di Trieste

Archivio di Stato, Trieste

Archivio di Stato di Verceli, archivio privato della famiglia d'Adda Salvaterra

Archivio di Stato del Cantone Ticino, Repertorio delle fonti modern e contemporanee, Fondo Nobile, Bellinzona

Archivio generale Comune di Trieste

Archivio storico dell'Accademia nazionale di San Luca, Roma

Archiwum narodowe w Krakowie, Archiwum Potockich z Krzeszowic

Civici Musei di Storia ed Arte, Trieste

Institute of Art History, Czech Academy of Sciences, Prague, Collection of historical photographs

Ministero della cultura, Soprintendenza Archeologia, belle arti e paesaggio del Friuli Venezia Giulia, Fondo Nobile, Trieste

Národní archiv, Praha, Rodinný archiv Metternichů; Sbírka map a plánů

Národní památkový ústav, územní odborné pracoviště České Budějovice; Národní památkový ústav, územní odborné pracoviště Plzeň; Národní památkový ústav, územní odborné pracoviště Praha

Österreichisches Staatsarchiv, Wien, Allgemeines Verwaltungsarchiv; Ministerium für Kultus und Unterricht, Alter Kultus; Finanz und Hofkammerarchiv; Haus- Hof- und Staatsarchiv; Kriegsarchiv

Österreichische Nationalbibliothek, Kartensammlung, Wien

Státní oblastní archiv v Plzni, pracoviště Klášter

Universitätsarchiv der Akademie der bildenden Künste, Wien

Wiener Stadt- und Landesarchiv, Wien

PLATES

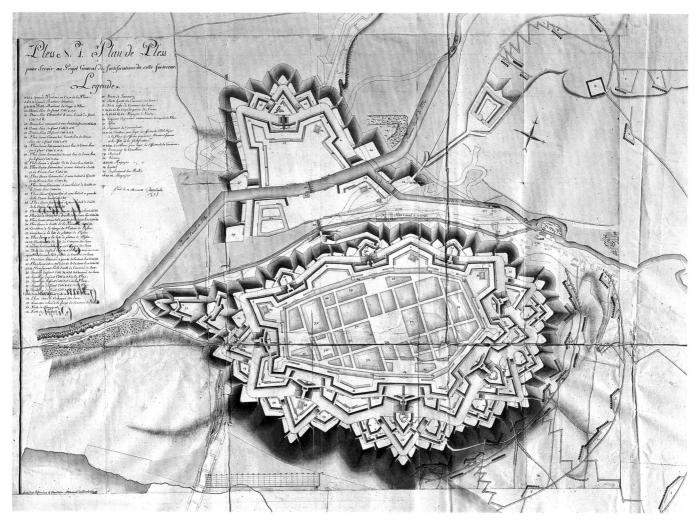

Pl. I Claude-Benoit Duhamel de Querlonde, Plan of the fortress Josefov, ink with watercolor, 1781, Vienna, Austrian State Archive.

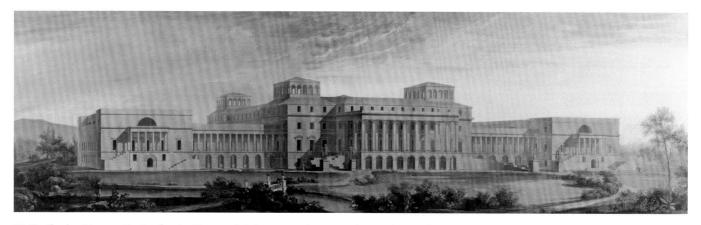

Pl. II Charles Moreau, Design for the Eisenstadt Palace, gouache, 1803, Eisenstadt, Esterházy Privatstiftung, Eisenstadt Palace – Collection of paintings.

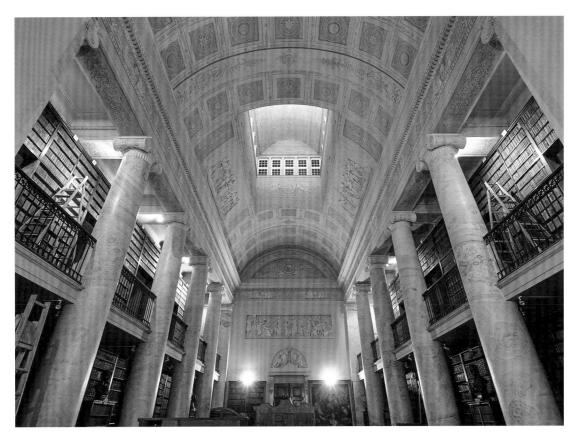

Pl. III Joseph Kornhäusel, Library of the Scottish Abbey, interior, Vienna, 1826, photo 2018.

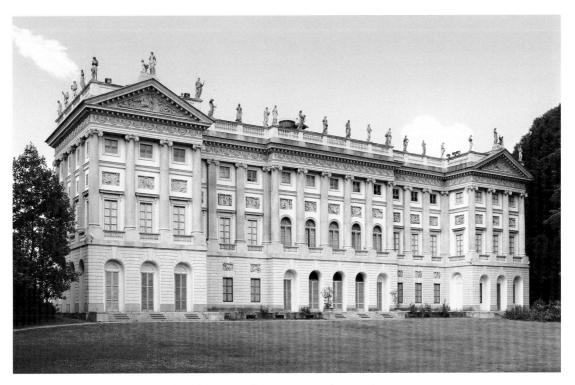

Pl. IV Leopoldo Pollack, Villa Reale-Belgiojoso, Milan, 1790–1793, photo 2018.

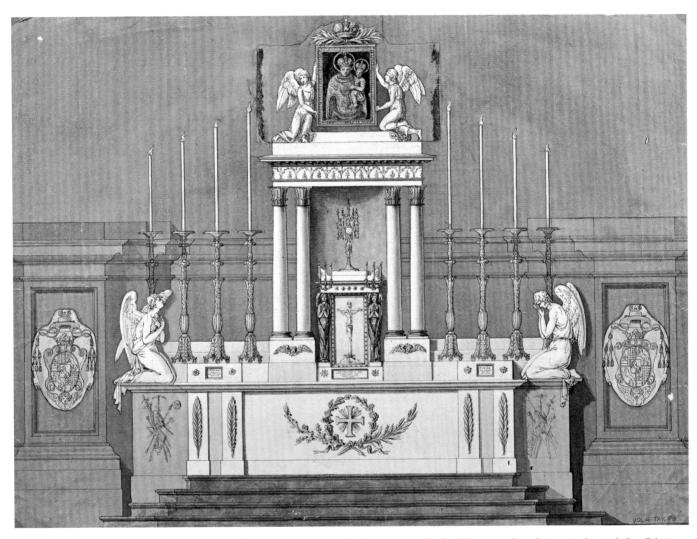

Pl. V Pietro Nobile, Design for the high altar of St. Stephen's Cathedral in Vienna, pencil, ink with watercolour, between 1819 and 1827, Trieste, SABAP FVG, Fondo Nobile.

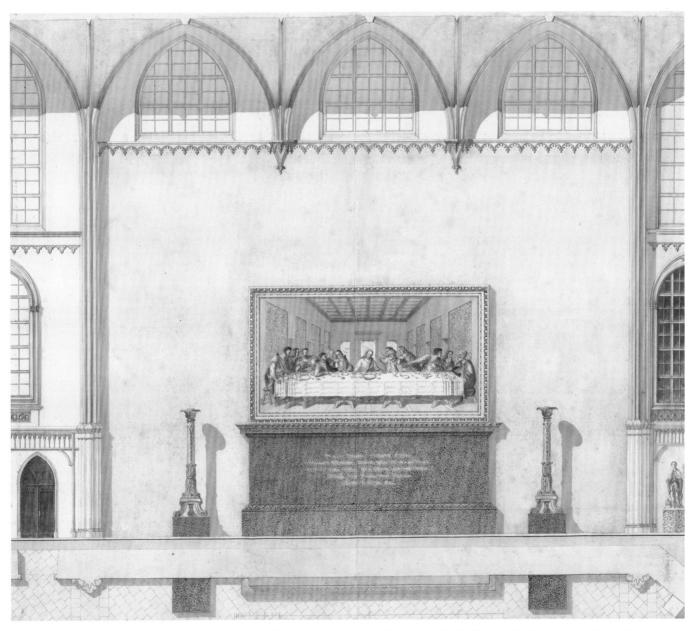

Pl. VI Pietro Nobile (attributed), Design for a side altar in Minoriten church in Vienna with Raffaelli's mosaic after Leonardo's Last Supper, pencil, ink with watercolour, between 1819 and 1837, Albertina Vienna.

Pl. VII Pietro Nobile, Preparatory design for the Second Corti Café, pencil, ink with watercolour, probably before 1820, Trieste, SABAP FVG, Fondo Nobile.

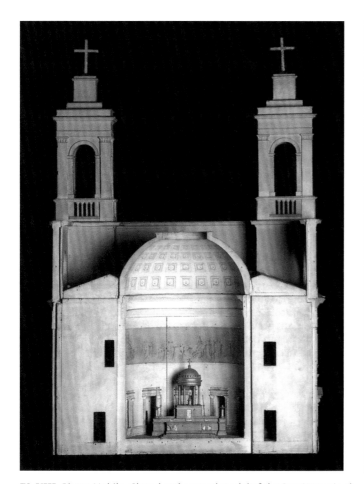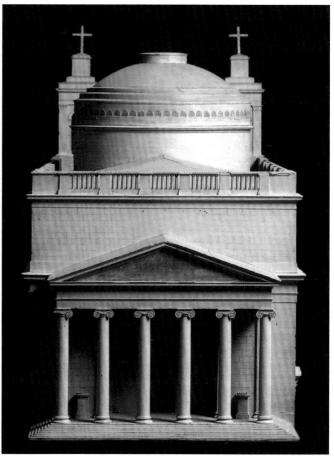

Pl. VIII Pietro Nobile, Closed and opened model of the Sant'Antonio church in Trieste, wood, colours, ca. 1825, Trieste, CMSA.

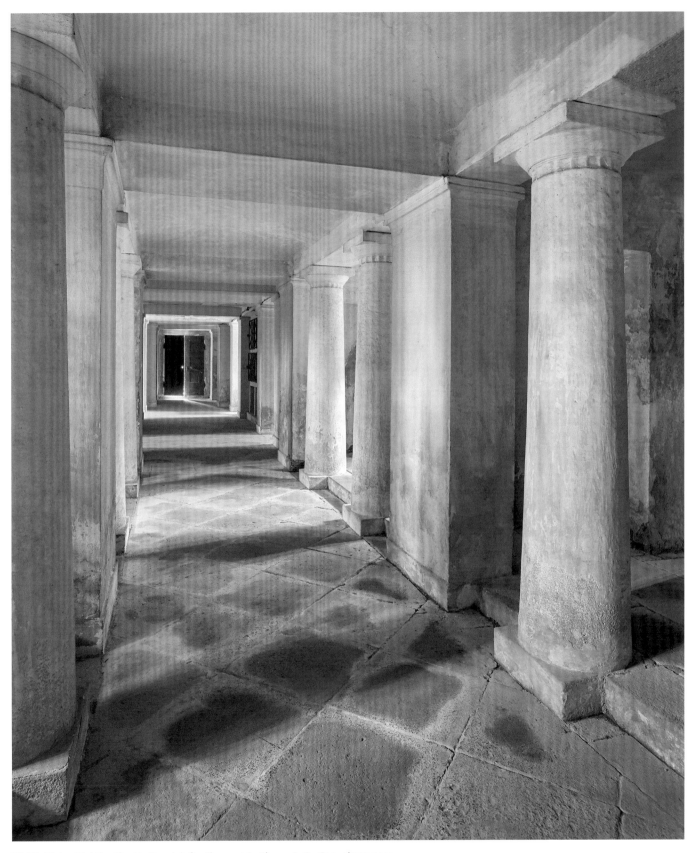

Pl. IX Pietro Nobile, The Metternich family crypt in Plasy, 1826–1829, photo 2019.

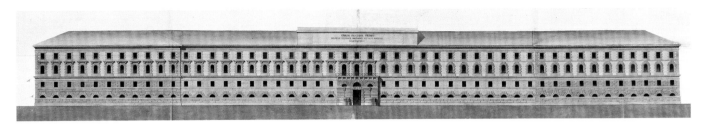

Pl. X Pietro Nobile or his pupils, design for the main façade of the Regional Court building (*Landesgerichtsgebäude*) in Vienna, pencil, ink with watercolour, ca. 1827–1829, Trieste, SABAP FVG, Fondo Nobile.

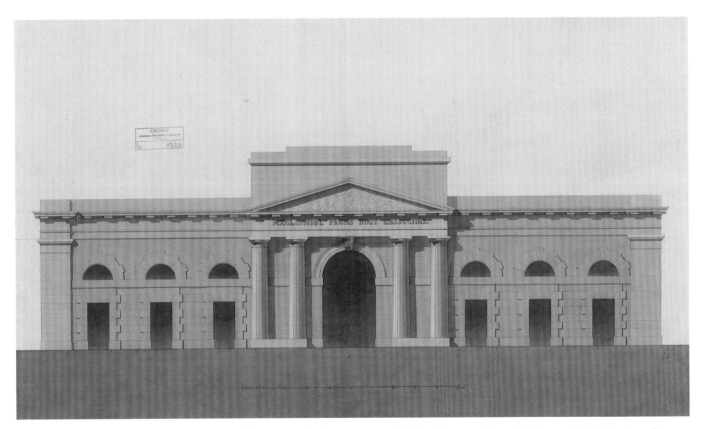

Pl. XI Pietro Nobile, Design for the renovation of the Horse Gate in Prague, pencil, ink with watercolour, 1828, Prague, NA, Collection of maps and plans.

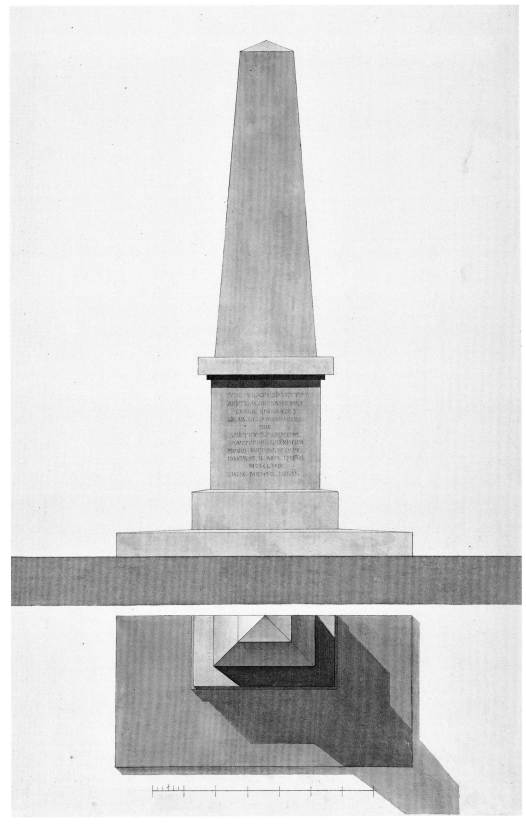

Pl. XII Pietro Nobile, design for the renovation of the monument to General Field Marshal Karl Reinhard Baron Ellrichshausen in Prague, pencil, ink with watercolour, 1828, Trieste, SABAP FVG, Fondo Nobile.

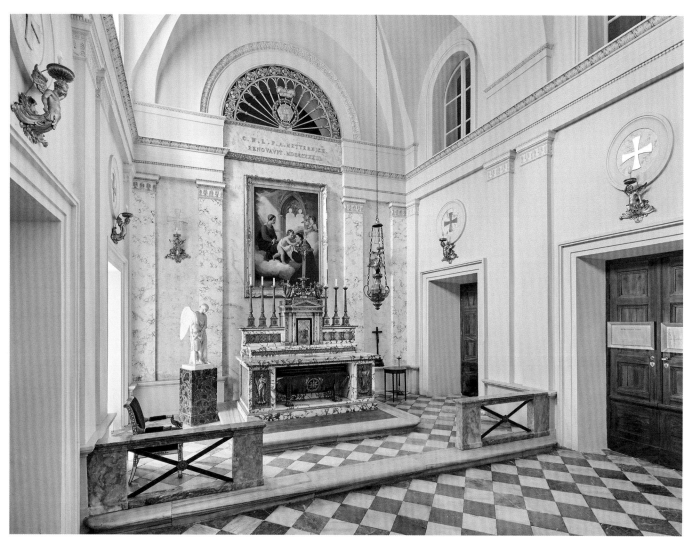

Pl. XIII Pietro Nobile, The Château chapel of St Anthony, Kynžvart, 1833, photo 2018.

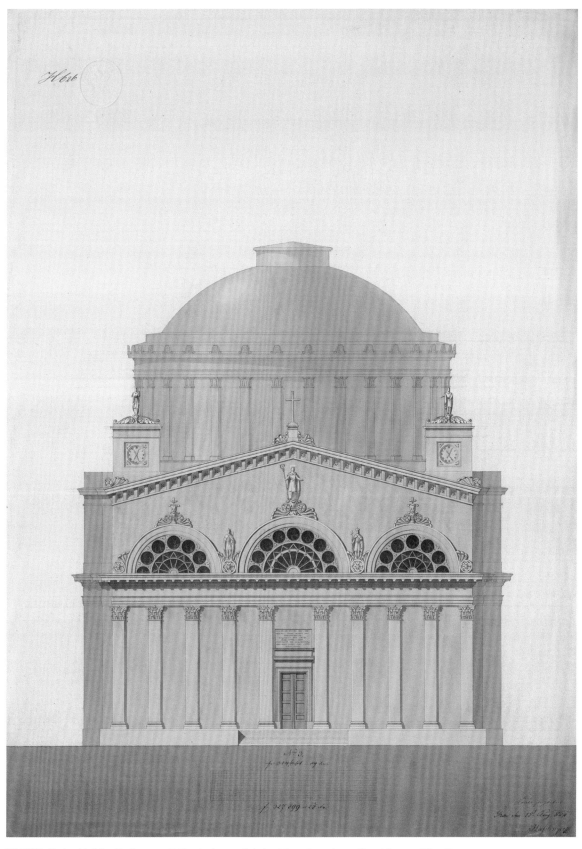

Pl. XIV Pietro Nobile, Esztergom Cathedral, pencil, ink with watercolour, 1834, Vienna, Albertina.

Pl. XV Map of Vienna by Carl Count Vasquez, published around 1835, with Pietro Nobile's addresses and architectural works in Vienna.

Pietro Nobile's Addresses in Vienna

Nobile's private addresses

1 1818: Bürgerspital (demolished in the 1870–80s; Nobile's apartment was in the triangular court no. 1 on the area of today's Helmut Zilk-Platz)
2 1819–25: Seilerstätte (conscription no. 1014 and 957 respectively; demolished in the late 19th century; today part of Seilerstätte 16)
3 1826–32: Riemerstraße (conscription no. 975) and Jakoberhof respectively (identical conscription no.; demolished; today Riemergasse 5)
4 1833–48/54: Franziskanerplatz (conscription no. 911; today Franziskanerplatz 1)

Buildings of the Academy of Fine Arts

5 St. Anna building of the Academy of Fine Arts (former novices' residence of the Jesuits; the gallery of Lamberg-Sprintzenstein around the smaller courtyard towards Annagasse; until 1827, the school of architecture in the wing towards Johannesgasse on the 3rd floor; partially demolished; today Annagasse 3–3A/3B and Johannesgasse 4–4A)
6 Kleinmariazellerhof (from 1827 onwards, the School of Architecture on the 4th and last floor towards Annagasse; today Annagasse 5 and Johannesgasse 6)

Offices of the *Hofbaurat*

7 until 1820: Fleischmarkt (conscription no. 752; former Dominican nunnery, from 1783 used as an office building for different departments of the public administration; today Fleischmarkt 19)
8 1821–29: Freyung (conscription no. 63, building of the *k. k. Generalkommando* [military command centre for Vienna, Lower and Upper Austria]; demolished; today Freyung 5 / Teinfaltstraße 1)
9 1830–1848: Petersplatz (conscription no. 564, building of the *k. k. Polizeidirektion* [police directorate]; today Petersplatz 7)

Realised buildings

10 *Theseustempel*
11 *Äußeres Burgtor*
12 Second *Cortisches Kaffeehaus*
13 *Schwarze Madonna* (pedestal; today in a courtyard of the *Schottenkloster* [Scots' cloister])
14 *Festsaal* of the Polytechnic
15 Church and crypt of the Capuchines
16 *Äußerer Burgplatz*
17 *Schottentor* (demolished in the 1850s)

Projected buildings

18 High altar of St. Stephen's cathedral
19 Side altar with Giacomo Raffaelli's mosaic in the Minorites' church
20 *Hofburgtheater*
21 Regional court building
22 Redemptorists' monastery
23 Exchange building

Expert opinion on

24 Colloredo monument in the imperial armory on Renngasse (demolished in the 1850s)
25 Müller gallery building as a possible site for the planned architectural gallery and the School of Architecture (demolished in the 1850s)
26 Joseph Klieber's decoration in the Invalids' building (demolished before 1900)
27 Side altars by Ludwig Ferdinand Schnorr von Carolsfeld in *Maria am Gestade* church
28 Emperor Francis Joseph-city gate (demolished in the early 20th century)

Pl. XVI Karl Friedrich Schinkel, View of Trieste, 1803, gouache, watercolor, pen, ink, paper, Kupferstichkabinet, Staatliche Museen zu Berlin.

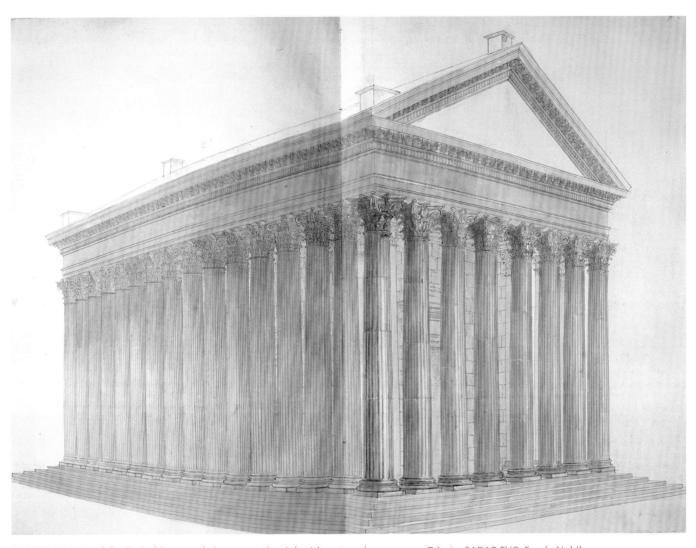

Pl. XVII Pietro Nobile, Corinthian temple in perspective, ink with watercolour, ca. 1797, Trieste, SABAP FVG, Fondo Nobile.

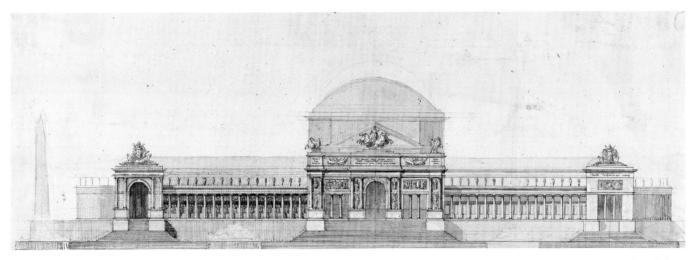

Pl. XVIII Pietro Nobile, Initial concept for the Capitol (Campidoglio), ink with watercolour, ca. 1798–1800, Trieste, SABAP FVG, Fondo Nobile.

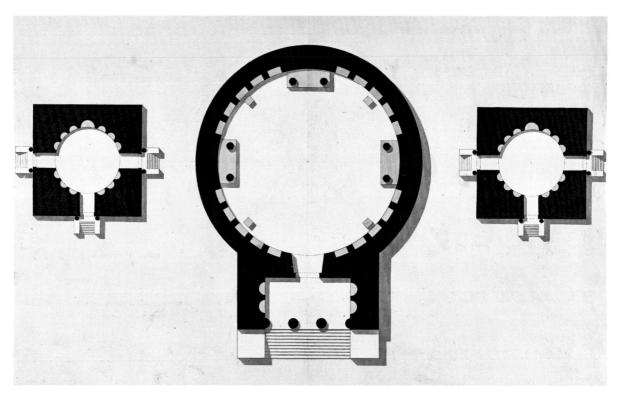

Pl. XIX Pietro Nobile, Design for a sepulchral monument in the form of a sphere between two pyramids, ground plan, ink with watercolour, 1798–1800, Trieste, SABAP FVG, Fondo Nobile.

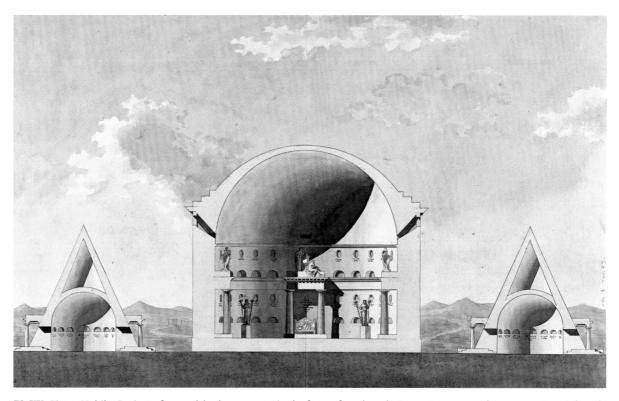

Pl. XX Pietro Nobile, Project of a sepulchral monument in the form of a sphere between two pyramids, cross section, ink with watercolour, 1798–1800, Trieste, SABAP FVG, Fondo Nobile.

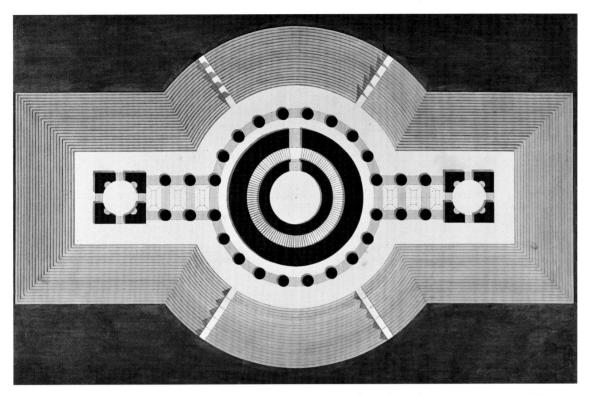

Pl. XXI Pietro Nobile, Design for a sepulchral monument with a circular floor plan and a Doric portico, ground floor, ink with watercolour, 1798–1800, Trieste, SABAP FVG, Fondo Nobile.

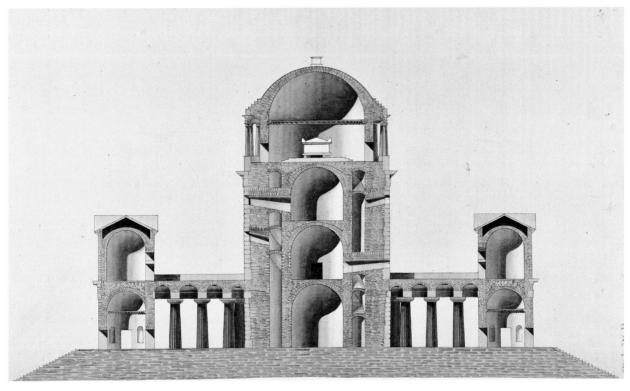

Pl. SABA XXII Pietro Nobile, Design for a sepulchral monument with a circular floor plan and a Doric portico, cross section, ink with watercolour, 1798–1800, Trieste, SABAP FVG, Fondo Nobile.

vol 2 n° 45

Pl. XXIII Pietro Nobile, The Pantheon, cross section, ink with watercolour, 1801–1805, Trieste, SABAP FVG, Fondo Nobile.

Pl. XXIV Pietro Nobile, View with ruins, ink with sepia, 1801–1805, Trieste, SABAP FVG, Fondo Nobile.

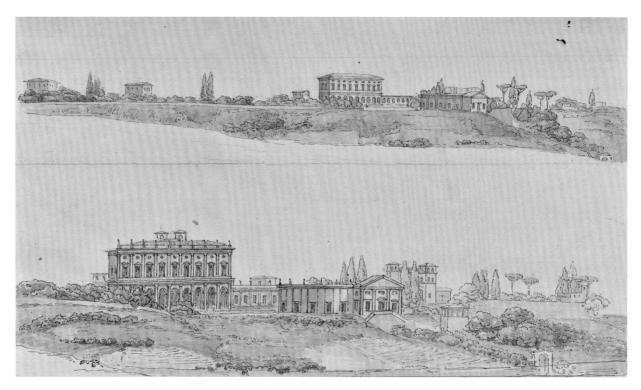

Pl. XXV Pietro Nobile, Surroundings of Rome, ink with watercolour, 1801–1805, Trieste, SABAP FVG, Fondo Nobile.

Pl. XXVI Pietro Nobile, Study of trees, ink with sepia, 1801–1805, Trieste, SABAP FVG, Fondo Nobile.

Pl. XXVII Pietro Nobile, Study of expressions, pencil, ink with watercolour, ca. 1798–1800, Trieste, SABAP FVG, Fondo Nobile.

Pl. XXVIII Pietro Nobile, Canopy bed after Charles Percier and Pierre Fontaine's *Recueil de décorations intérieures* (Paris 1801–1812), ink and watercolour, 1810s, Trieste, SABAP FVG, Fondo Nobile

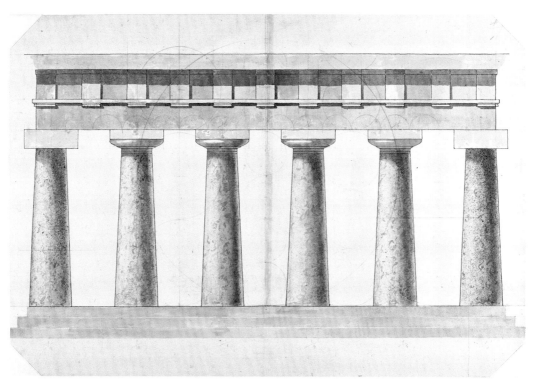

Pl. XXIX Pietro Nobile, Intercolumnial study, pencil, ink with watercolour, ca. 1801–1805, Trieste, SABAP FVG, Fondo Nobile.

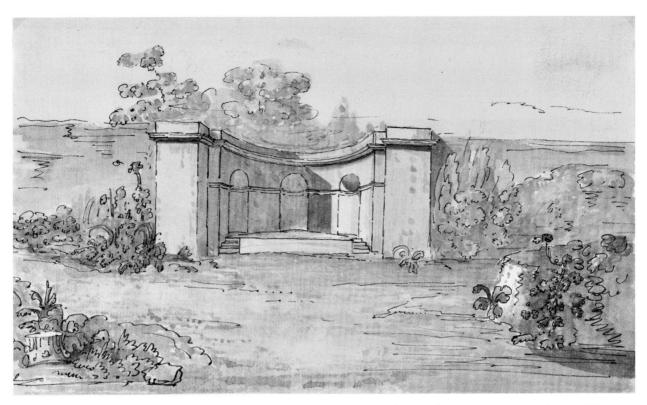

Pl. XXX Pietro Nobile, View of the fountain of the aqueduct *Acqua Vergine*, ink and watercolour, 1798–1805, Trieste, SABAP FVG, Fondo Nobile.

Pl. XXXI Pietro Nobile, Details of Michelangelo's Last Judgement in the Sistine Chapel, ink and watercolour, Trieste, SABAP FVG, Fondo Nobile.

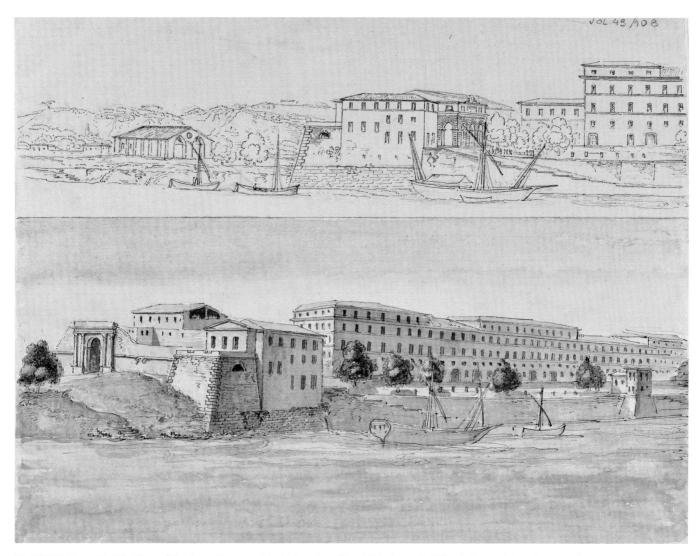

Pl. XXXII Pietro Nobile, View of the Porta Portese with the hospice of San Michele on the Tiber in Rome, ink and watercolour, 1798–1805, Trieste, SABAP FVG, Fondo Nobile.

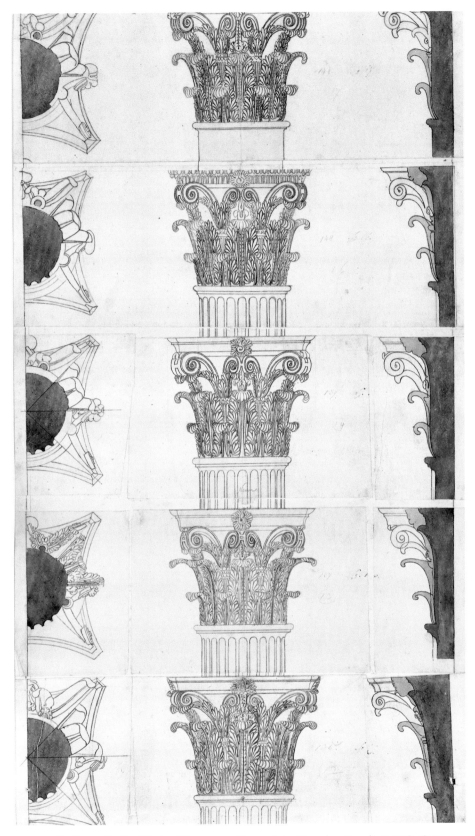

Pl. XXXIII Pietro Nobile, Study of five composite capitals, ink and watercolour, 1798–1805, Trieste, SABAP FVG, Fondo Nobile.

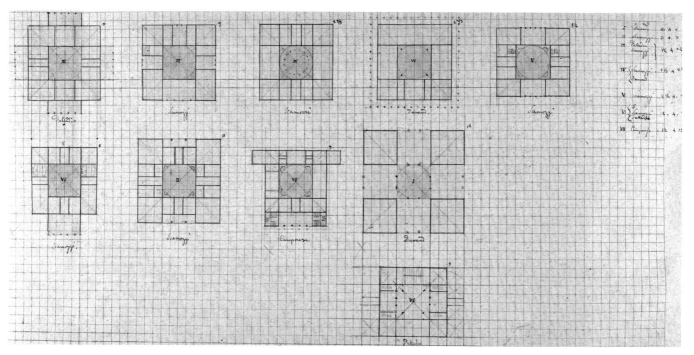

Pl. XXXIV Pietro Nobile, Comparative study of a floor plan (after Palladio, Scamozzi, Durand and Camporese), pen and ink, Trieste, SABAP FVG, Fondo Nobile.

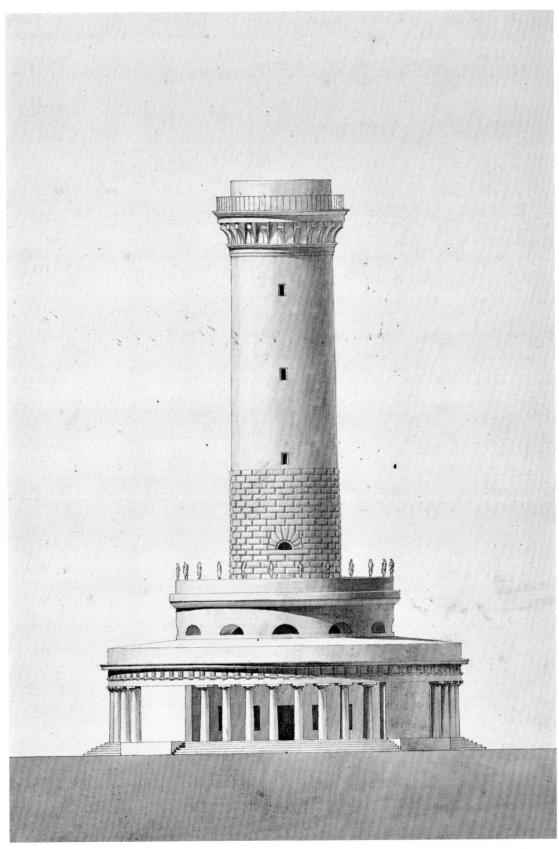

Pl. XXXV Pietro Nobile, Design for Savudrija lighthouse, ink and sepia, 1817, Trieste, SABAP FVG, Fondo Nobile.

Pl. XXXVI Trieste, Arco di Ricardo, 1st century BC.

Pl. XXXVII Roman aqueduct in Rosandra Valley, 1st century BC.

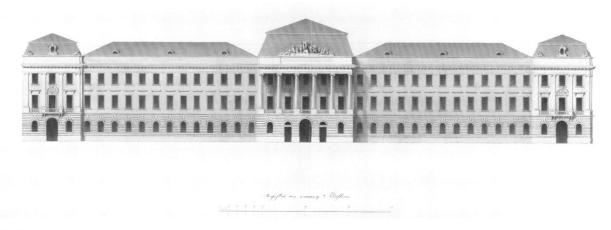

Pl. XXXVIII Anonymous, Elevation of the main facade of the Vienna Polytechnic, second version of the design submitted by the Hofbaurat, pencil, ink with watercolour, ca. 1815/16, Vienna, Albertina.

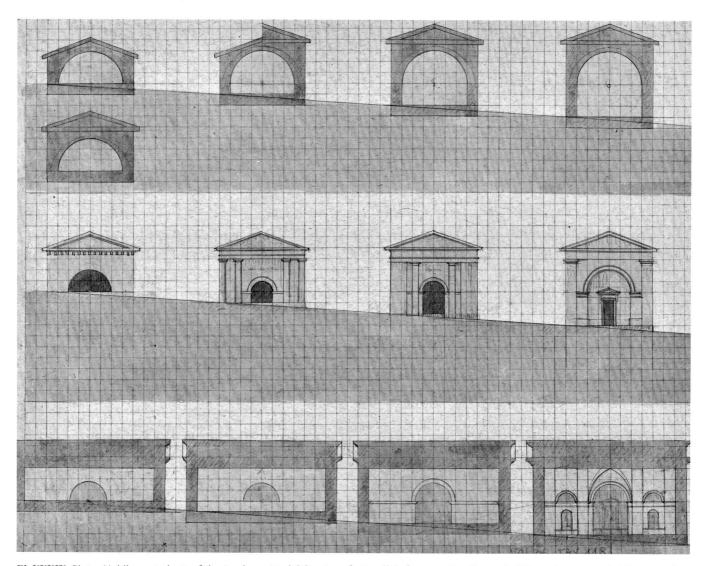

Pl. XXXIX Pietro Nobile or students of the Academy, Model drawing of a Parallèle for a small pediment building with varying heights, pencil, ink with watercolour, after 1819, Trieste, SABAP FVG, Fondo Nobile.

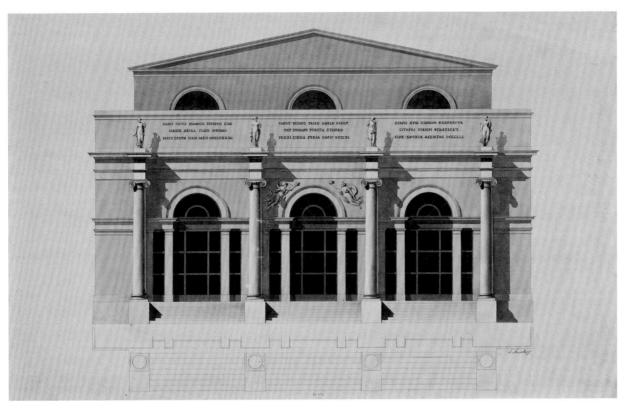

Pl. XL Ludwig Christian Förster, Odeion, elevation, pencil, ink with watercolour, ca. 1820s, Vienna, Academy of Fine Arts, Kupferstichkabinett.

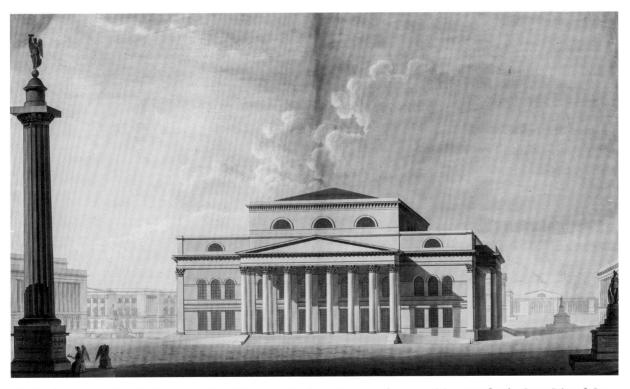

Pl. XLI Franz Xaver Lössl, Design for a national theatre in the Greco-Roman style, competition entry for the Court Prize of 1823, pencil, ink with watercolour, Vienna, Academy of Fine Arts, Vienna, Kupferstichkabinett.

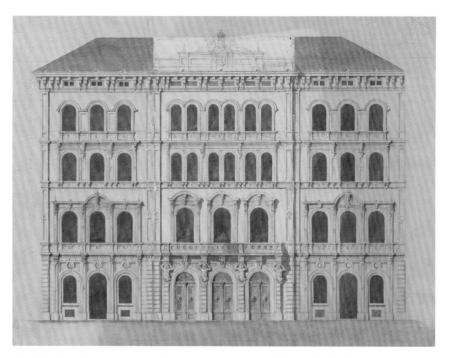

Pl. XLII Paul Sprenger, Design for a stock exchange building in Wollzeile street in Vienna, pencil, ink with watercolour, 1851, Vienna, Wiener Stadt- und Landesarchiv.

Pl. XLIII Ludwig Remy, Design for renovation of the destroyed fortification in front of the Hofburg, pencil, ink with watercolour, 1810, Vienna, Austrian State Archives, House, Court, and State Archives.

Pl. XLIV Pietro Nobile, Second design for a new Burgtor, pencil, ink with watercolour, 6 May 1817, Vienna, Austrian National Library, pictures archives.

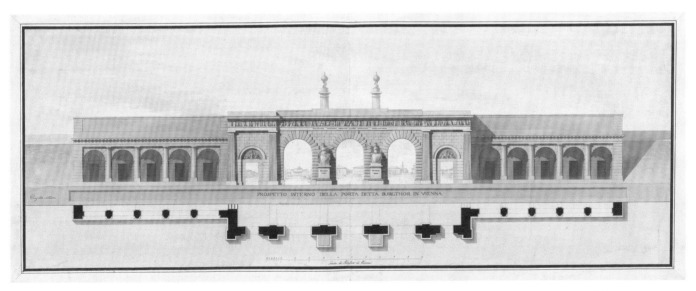

Pl. XLV Pietro Nobile, Seventh design for a new Burgtor, pencil, ink with watercolour, 6 May 1817, Vienna, Austrian National Library, pictures archives.

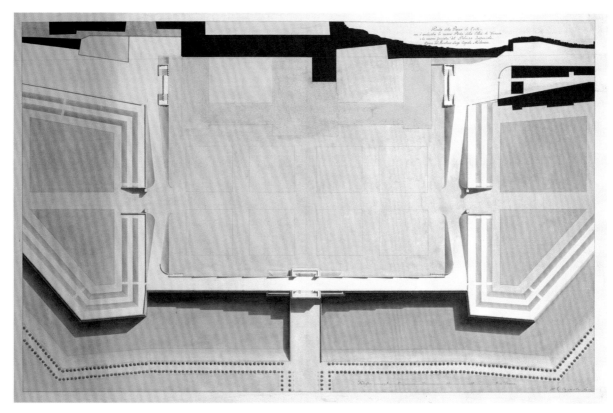

Pl. XLVI Luigi Cagnola, Design for a new Burgtor with the plan for an extension of the Hofburg, pencil, ink with watercolour, 1817, Vienna, Albertina.

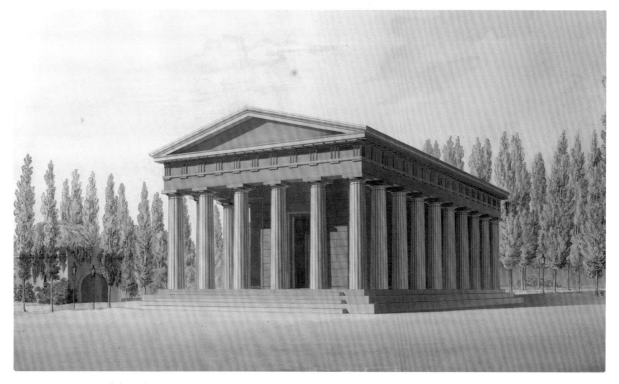

Pl. XLVII Pietro Nobile and Antonio Canova (drawing by Carl Schmidt, ca. 1825), Theseustempel, pencil, ink with watercolour, 1819–22, Vienna, Albertina.

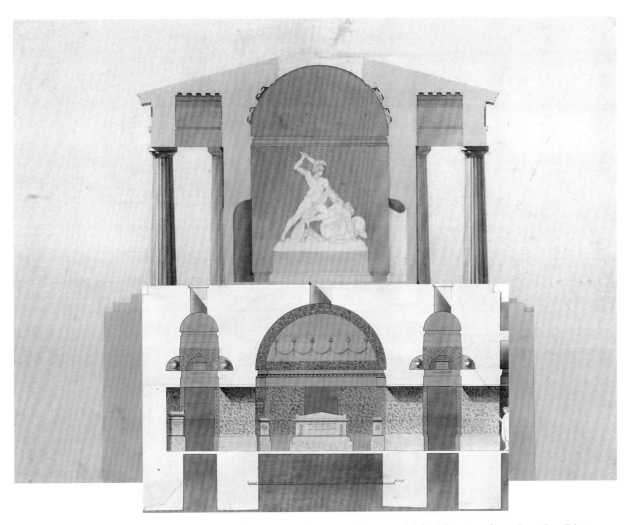

Pl. XLVIII Pietro Nobile and Antonio Canova, Theseustempel, cross section, pencil, ink with watercolour, 1819–1822, Trieste, SABAP FVG, Fondo Nobile.

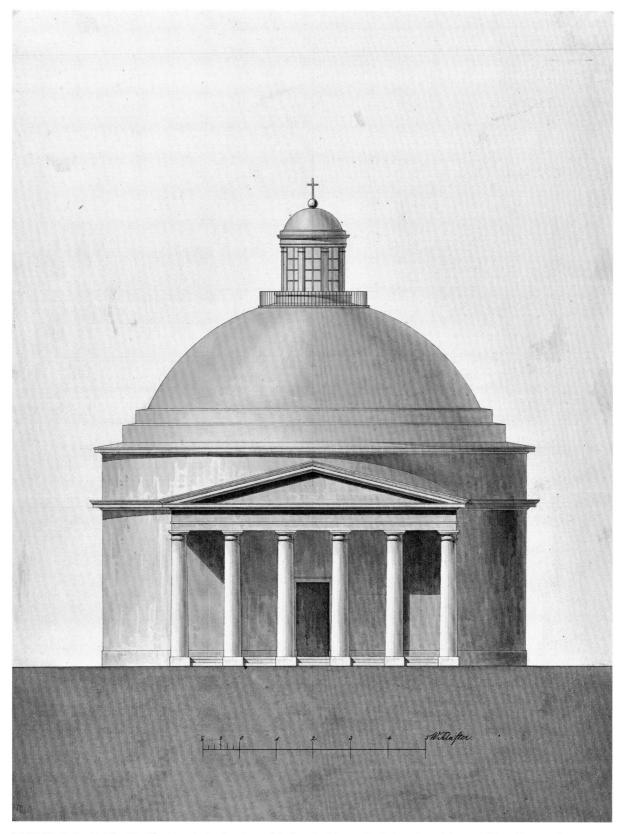

Pl. XLIX Pietro Nobile, Modification design for the parish church of Inzersdorf, elevation with an additional hexastyle portico, pencil, ink with watercolour, early 1840s, Trieste, SABAP FVG, Fondo Nobile.

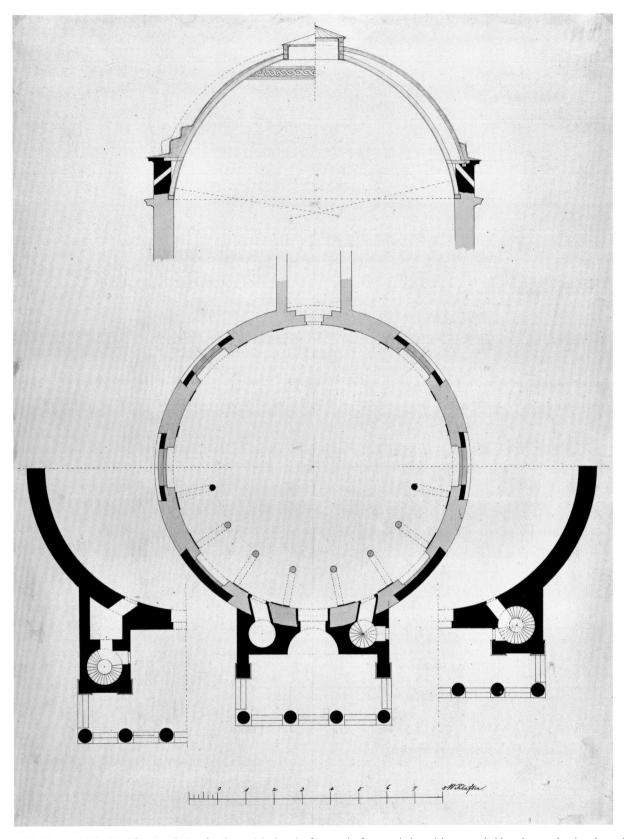

Pl. L Pietro Nobile, Modification design for the parish church of Inzersdorf, ground plan with a remarkable colour code, showing existing structures in pink and new alterations in black, pencil, ink with watercolour, early 1840s, Trieste, SABAP FVG, Fondo Nobile.

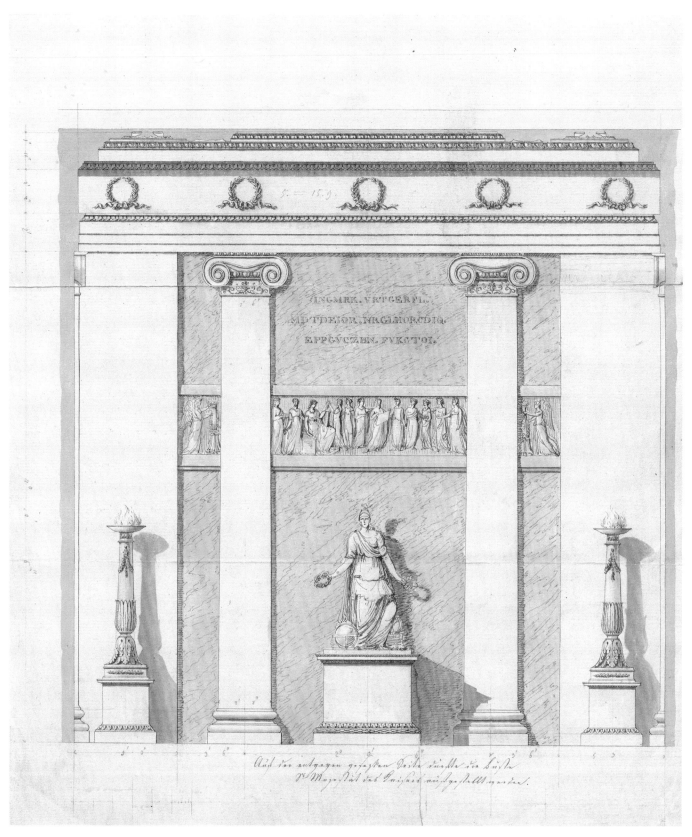

Pl. LI Pietro Nobile, Decoration for the ceremonial hall of the Vienna Polytechnic, elevation of the narrow side of the hall, pencil, ink with watercolour, 1826. Vienna, University Archives of the Vienna Academy of Fine Arts.

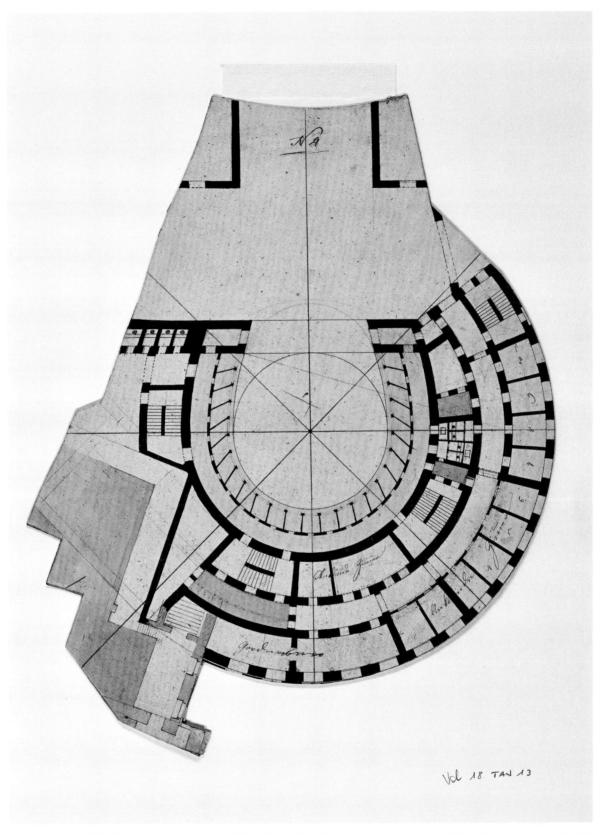

Pl. LII Pietro Nobile, The fourth design for rebuilding the Hofburgtheater, ground plan, pencil, ink with watercolour, 1827/28, Trieste, SABAP FVG, Fondo Nobile.

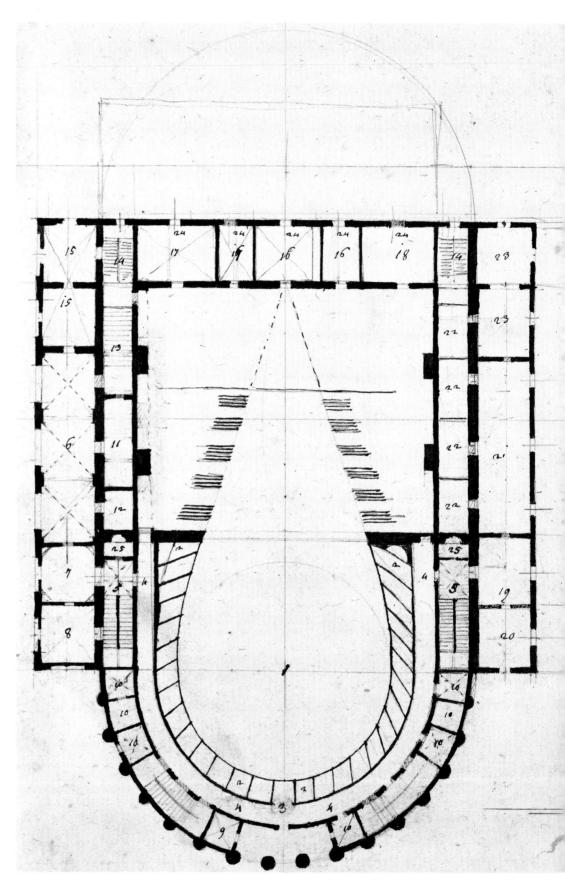

Pl. LIII Pietro Nobile, Design for a theatre with the main façade in a semi-circular shape, pencil, ink with watercolour, around 1827, Trieste, SABAP FVG, Fondo Nobile.

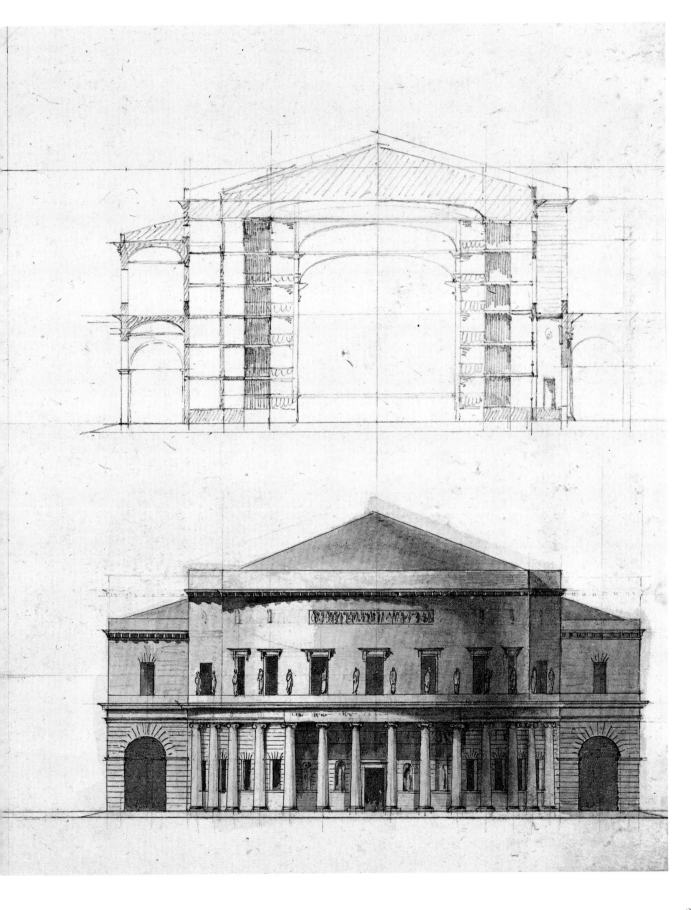

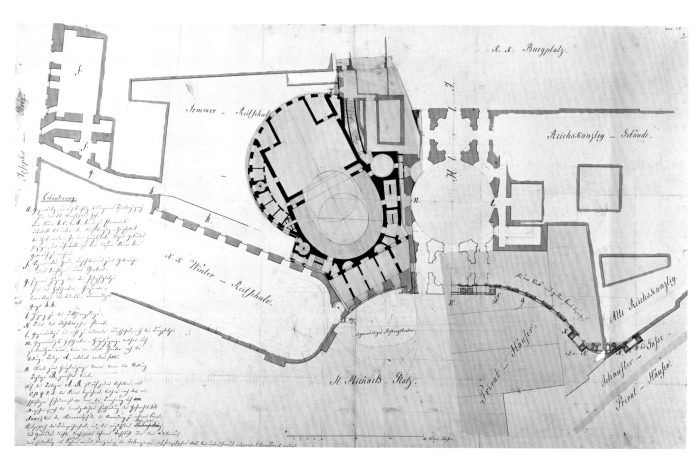

Pl. LIV Pietro Nobile, Final version of the design for rebuilding the Hofburgtheater, ground plan, pencil, ink with watercolour, 1828. Trieste, SABAP FVG, Fondo Nobile.

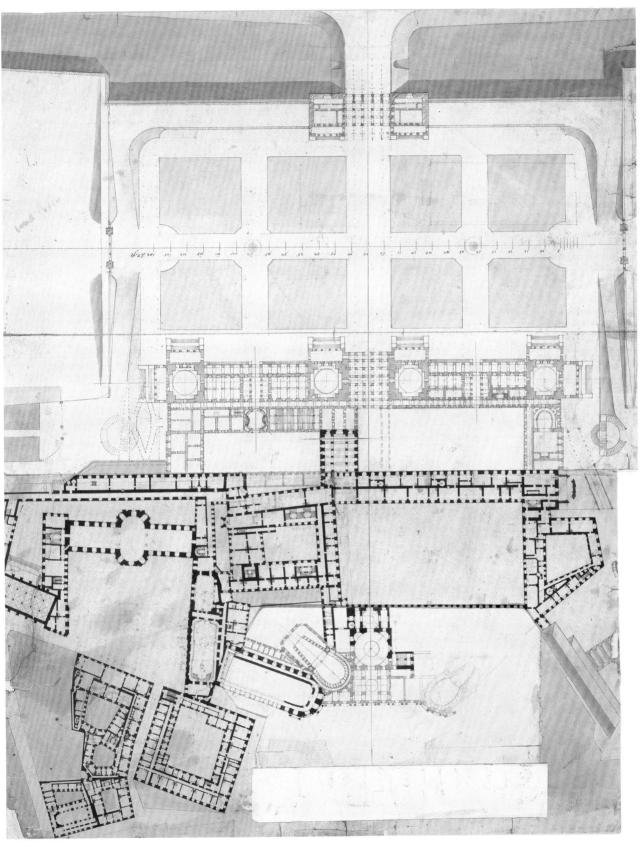

Pl. LV Pietro Nobile, Design for expanding the Hofburg in Vienna, ground plan, pencil, ink with watercolour, 1827. Vienna, Wien Museum.

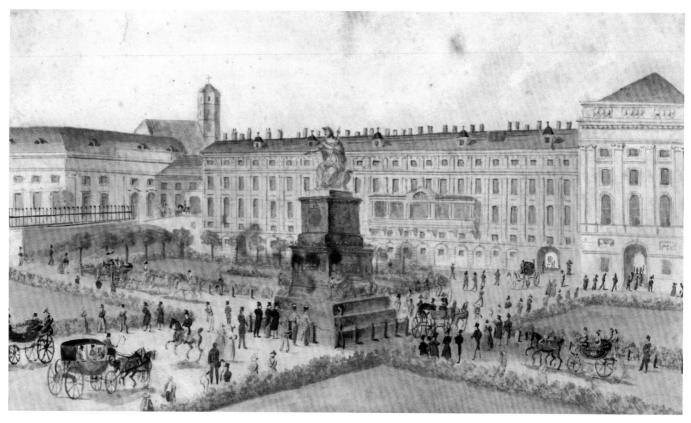

Pl. LVI Pietro Nobile, Life-size model of the monument to Francis I by Luigi Manfredini and Nobile erected on the outer *Burgplatz* in spring 1838 (drawing by Balthasar Wiegand), 1838, pencil, ink with watercolour. Vienna, Wien Museum.

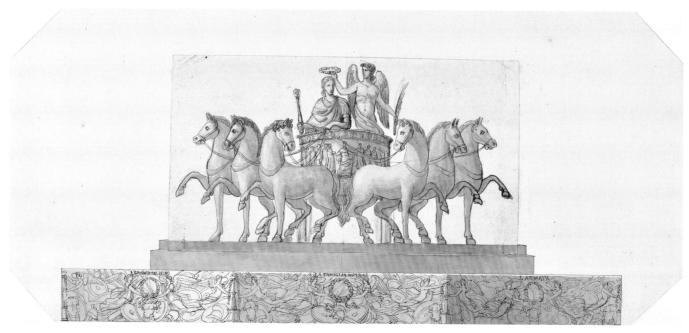

Pl. LVII Pietro Nobile, design for a monumental group crowning the new *Burgtor* with Francis I in the *sestiga*, pencil, ink with watercolour, around 1837, Trieste, SABAP FVG, Fondo Nobile.

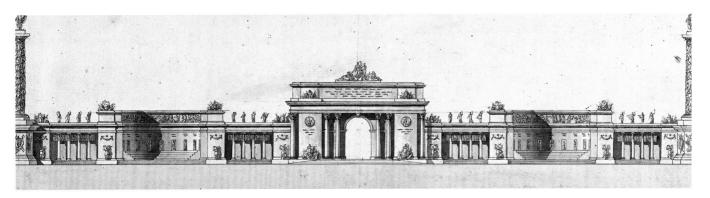

Pl. LVIII Pietro Nobile, Temple of Peace and Unity (Campidoglio), pencil, ink with watercolour, before 1814, Trieste, SABAP FVG, Fondo Nobile.

Pl. LIX Pietro Nobile, Design of a hall in one of Metternich's residences, ink and watercolour, ca. 1826–1829, National Heritage Institute, Regional office in Prague, State château Kynžvart.

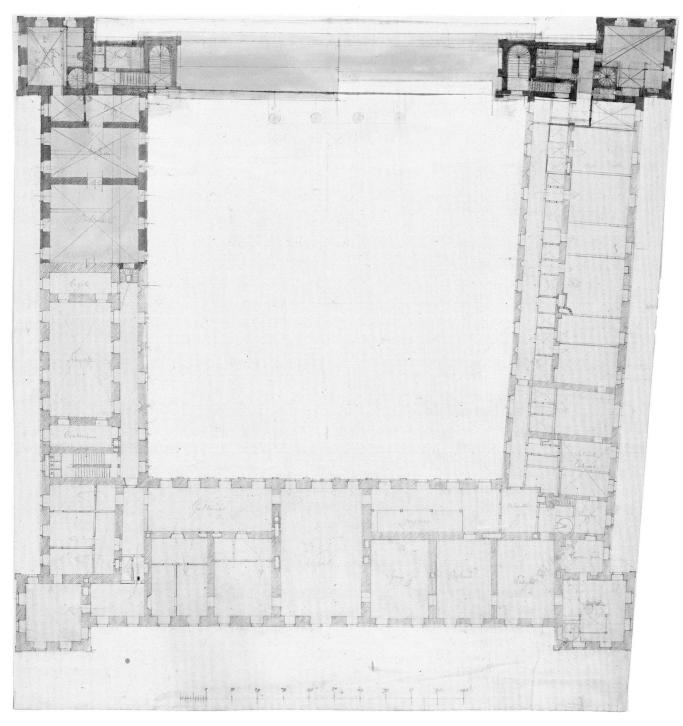

Pl. LX Pietro Nobile, The first variant of floor plan designs of the residence in Kynžvart, pencil, ink with watercolour, ca. 1827, Trieste, SABAP FVG, Fondo Nobile.

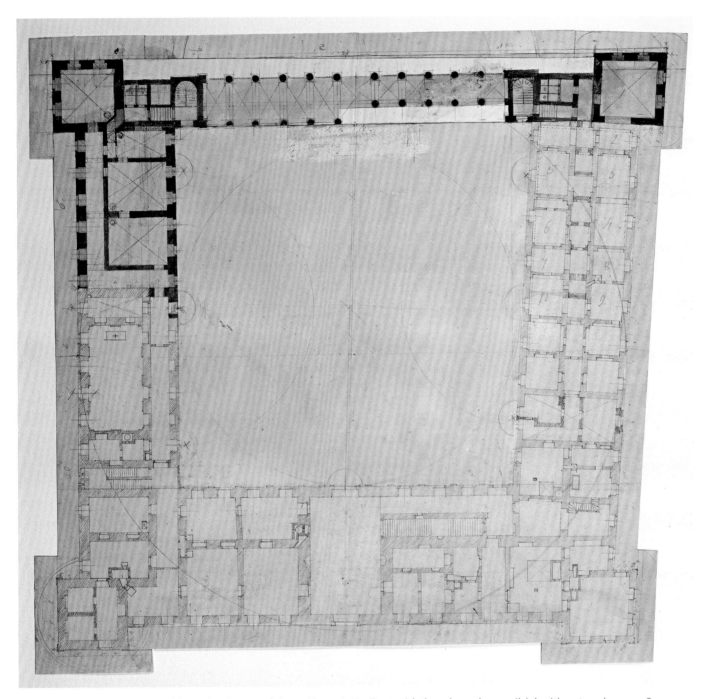

Pl. LXI Pietro Nobile, Variant of floor plan designs of the residence in Kynžvart with the colonnade, pencil, ink with watercolour, ca. 1827, Trieste, SABAP FVG, Fondo Nobile.

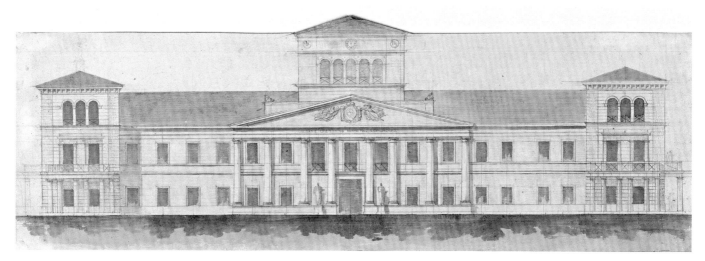

Pl. LXII Pietro Nobile, Design for the garden façade of Kynžvart Château with a roof pavilion, pencil and watercolour, 1827–1833, Trieste, SABAP FVG, Fondo Nobile.

Pl. LXIII Pietro Nobile, Main facade of the château coaching inn, ink and watercolour, ca. 1833–35, Trieste, SABAP FVG, Fondo Nobile.

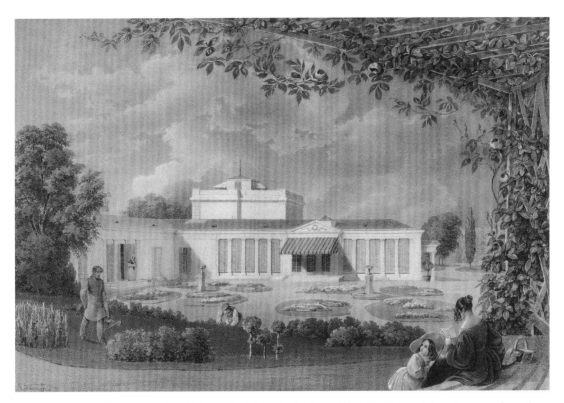

Pl. LXIV Edinger (lithographer) and Eduard Gurk (drawing), View of the Villa Metternich on Rennweg from the south, ca. 1840, Vienna, Austrian National Library.

Pl. LXV Pietro Nobile, Ground plan of the Villa Metternich with an additional southern wing, pencil, ink with watercolour, ca. 1835, Trieste SABAP FVG, Fondo Nobile.

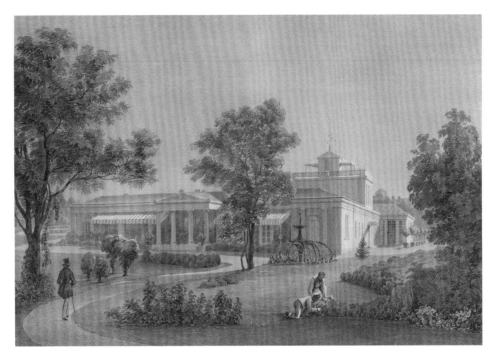

Pl. LXVI Edinger (lithographer) and Eduard Gurk (drawing), View of the Villa Metternich from the north, ca. 1840, Vienna, Austrian National Library.

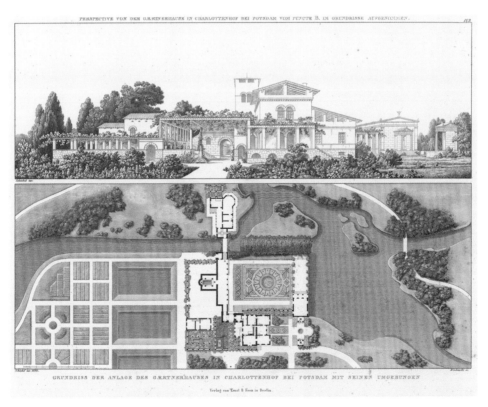

Pl. LXVII Wischneski (engraver) after Karl Friedrich Schinkel: perspective view and ground plan of the Roman Baths of Charlottenhof palace in Potsdam, 1834, Carl Friedrich Schinkel, *Sammlung architektonischer Entwürfe* etc. (Berlin: Ernst & Korn, 1858), plate 169.

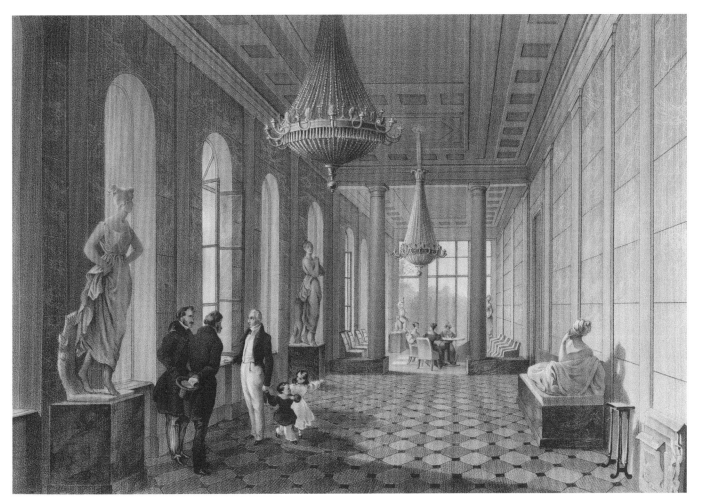

Pl. LXVIII Friedrich Dewehrt (lithographer) and Eduard Gurk (drawing), Interior view of the gallery in the Villa Metternich, looking north, ca. 1840, Vienna, Austrian National Library.

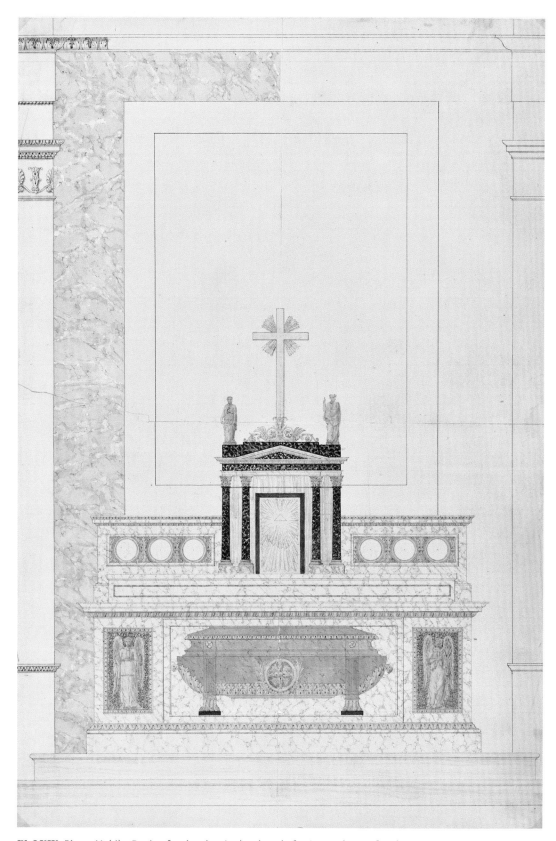

Pl. LXIX Pietro Nobile, Design for the altar in the chapel of Saint Anthony of Padua in Kynžvart Château, pencil, ink with watercolour, before 1834, Trieste, SABAP FVG, Fondo Nobile.

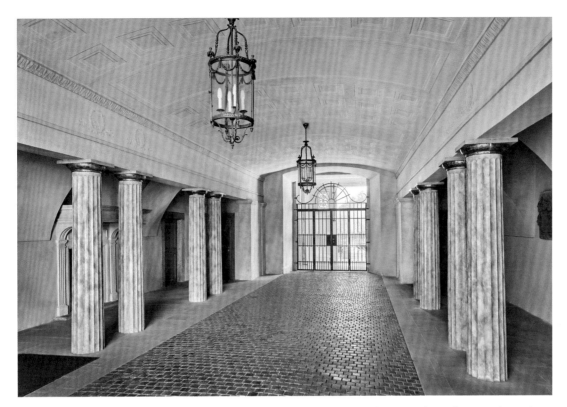

Pl. LXX Pietro Nobile, Château Kynžvart, vestibule with cast iron columns (current colour adjustment), ca. 1833, photo 2018

Pl. LXXI Anton Stöckl, Metternich's foundry in Plasy, coloured aquatint, ca. 1830s–1840s, National Heritage Institute, Regional office in Prague, State château Kynžvart.

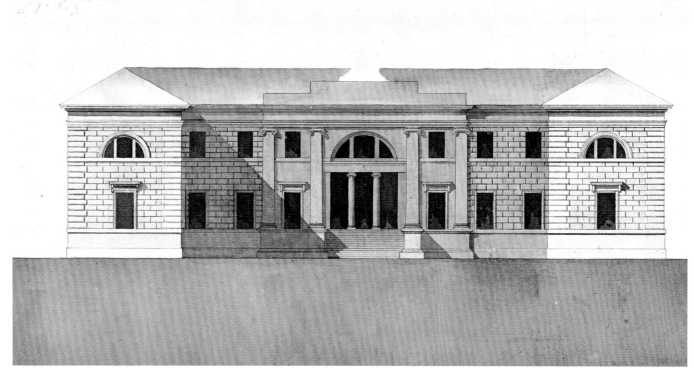

Pl. LXXII Pietro Nobile, Design for the *Ossolineum* in Lviv, pencil, ink with watercolour, 1817, Trieste, SABAP FVG, Fondo Nobile.

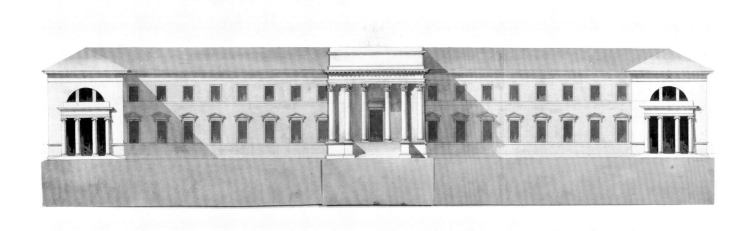

Pl. LXXIII Pietro Nobile, Design for the *Ossolineum* in Lviv, pencil, ink with watercolour, 1817, Trieste, SABAP FVG, Fondo Nobile.

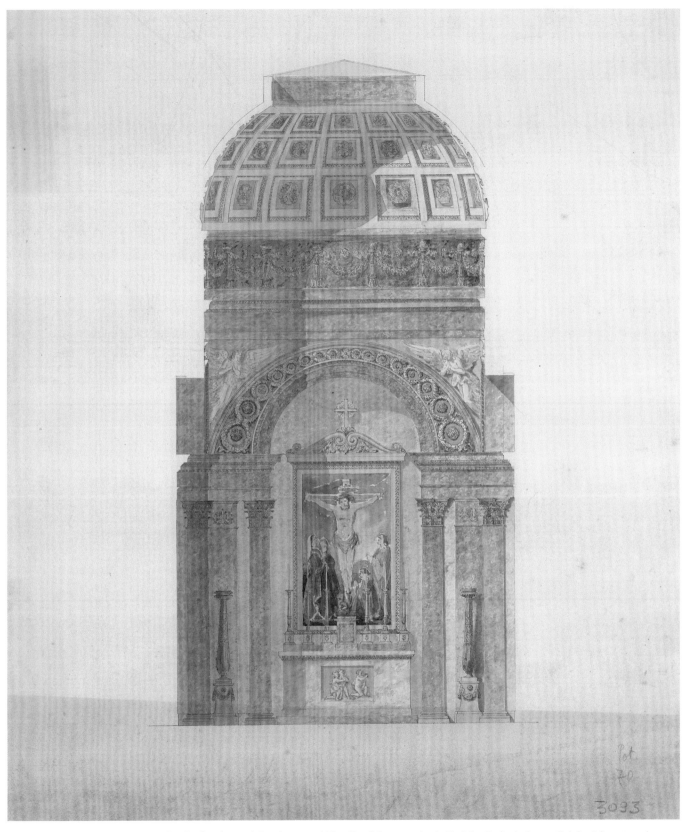

Pl. LXXIV Pietro Nobile, Design for the family tomb for the Potocki family of Krzeszowice in Kraków Cathedral, pencil, ink with watercolour, 1832, Kraków, Archiwum Narodowe w Krakowie.

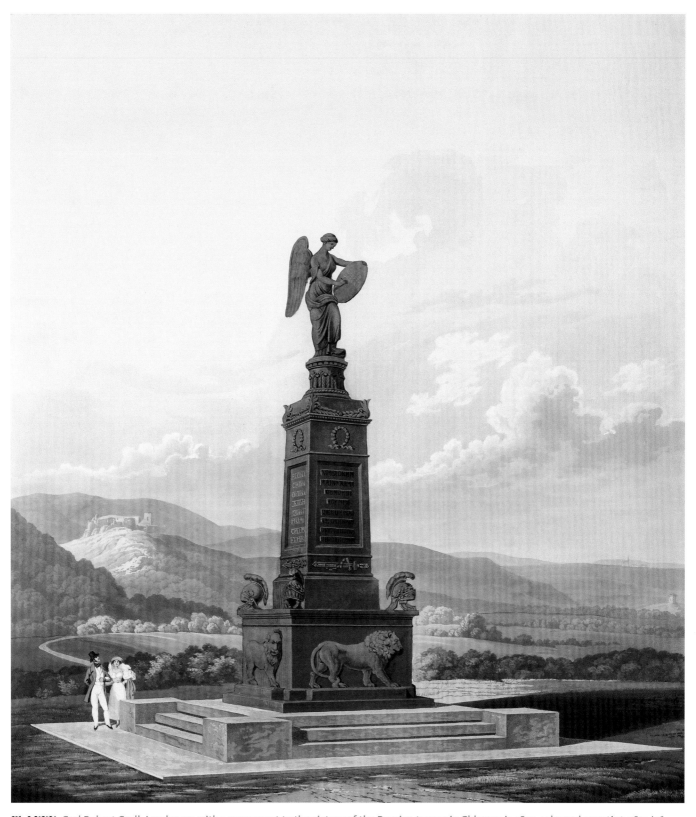

Pl. LXXV Carl Robert Croll, Landscape with a monument to the victory of the Russian troops in Chlumec in 1813, coloured aquatint, 1835/36, National Heritage Institute, Regional office in Prague, State château Kynžvart.

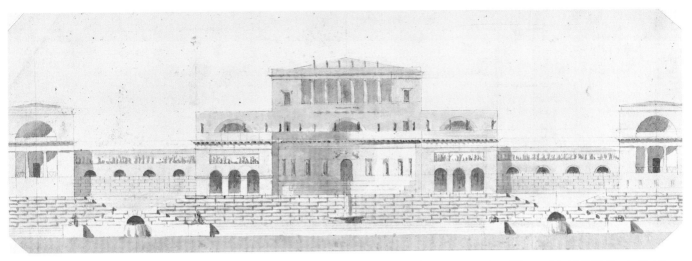

Pl. LXXVI Pietro Nobile, Design for a complex with fountains, pencil, ink with watercolour, ca. 1801–1805, Trieste, SABAP FVG, Fondo Nobile.

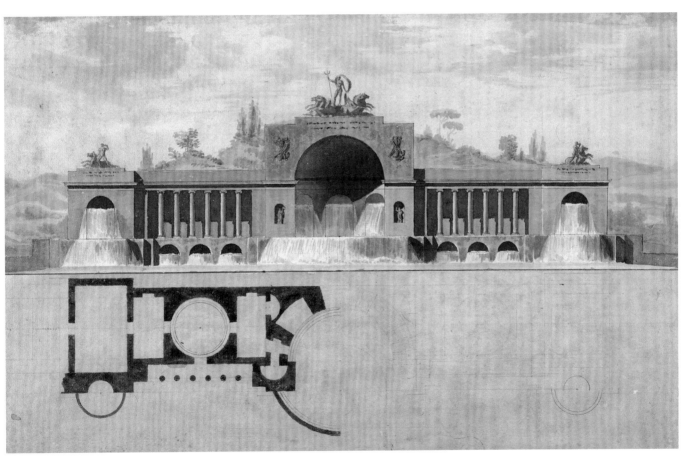

Pl. LXXVII Mario Asprucci the Younger, Design for a fountain, graphit, pen and ink with watercolour, ca. 1800, Museum purchase through given of various donors and Eleanor G. Hewit Fund.

CREDITS

Figures

1 © Archive of National Technical Museum, fond 56, inv. no. 56/78; 2 photo © Richard Biegel; 3 © Kroměříž, Archdiocesan Museum, SK 8550, m1/2; 4 © Vienna, Akademie der bildenden Künste. Kupferstichkabinet, HZ 13.892; 5 © Hungarian National Museum, T.5477; 6 © Vienna, ÖNB, plan collection, ALB Port 186/8; 7 © Franco Firmiani, *Arte neoclassica a Trieste*, Trieste 1989, p. 89; 8 © Trieste, MiC SABAP FVG, Fondo Nobile, vol. 44, no. 112; 9 © photo Taťána Petrasová; 10 © Trieste, CMSA, inv. no. IV/3246; 11 © Vienna, Wien Museum, inv. no. 189.070; 12 © Trieste, MiC SABAP FVG, Fondo Nobile, vol. 4, no. 88; 13, 15 photo © Manfred Seidl, 2011; 14 © Vienna, Austrian Academy of Sciences, Woldan collection, AW-I: OE/Vie 1192; 16 © Vienna, UAABKW, ex 1824/25, Zl. 295 attachment "r"; 17 © Vienna, Wien Museum, inv. no. 10.456; 18 © Trieste, MiC SABAP FVG, Fondo Nobile, vol. 4, no. 113; 19 © Trieste, MiC SABAP FVG, Fondo Nobile, vol. 38, no. 167; 20 © photo Taťána Petrasová; 21 © Trieste, MiC SABAP FVG, Fondo Nobile; 22 © Trieste, MiC SABAP FVG, Fondo Nobile., vol. 3, no. 55; 23 photo © Johannes Stoll, 2020; 24 © Trieste, MiC SABAP FVG, Fondo Nobile, vol. 7, no. 82; 25 © Trieste, MiC SABAP FVG, Fondo Nobile, vol. 49, no. 54; 26 © Trieste, MiC SABAP FVG, Fondo Nobile, vol. 1, no. 29; 27 © Trieste, MiC SABAP FVG, Fondo Nobile, vol. 2, no. 48; 28 © Trieste, MiC SABAP FVG, Fondo Nobile, vol. 2, no. 44; 29 © Trieste, MiC SABAP FVG, Fondo Nobile, vol. 56, no. 2; 30 © Trieste, MiC SABAP FVG, Fondo Nobile, vol. 54, no. 7; 31 © Trieste, MiC SABAP FVG, Fondo Nobile, vol. 54, no. 30; 32 © Trieste, MiC SABAP FVG, Fondo Nobile, vol. 3, no. 95; 33 © Trieste, MiC SABAP FVG, Fondo Nobile, vol. 49, no. 52; 34 © Trieste, MiC SABAP FVG, Fondo Nobile, vol. 5, no. 29; 35 © Trieste, MiC SABAP FVG, Fondo Nobile, vol. 3, no. 89a; 36 © Trieste, MiC SABAP FVG, Fondo Nobile, vol. 5, no. 15; 37 © Trieste, MiC SABAP FVG, Fondo Nobile, vol. 54, no. 17; 38 © Trieste, MiC SABAP FVG, Fondo Nobile, vol. 2, no. 30; 39 © Trieste, MiC SABAP FVG, Fondo Nobile, vol. 7, no. 61; 40 © Trieste, MiC SABAP FVG, Fondo Nobile, vol. 65, no. 52; 41 © Trieste, MiC SABAP FVG, Fondo Nobile, vol. 65, no. 16; 42 © Trieste, MiC SABAP FVG, Fondo Nobile, vol. 21, no. 158; 43 © Trieste, MiC SABAP FVG, Fondo Nobile, vol. 54, no. 9; 44 © Trieste, MiC SABAP FVG, Fondo Nobile, vol. 41, no. 88; 45 © Trieste, MiC SABAP FVG, Fondo Nobile, vol. 70, no. 6/252; 46 © Trieste, MiC SABAP FVG, Fondo Nobile, vol. 70, no. 6/251; 47 © Trieste, MiC SABAP FVG, Fondo Nobile, vol. 70, no. 6/255; 48 © Trieste, MiC SABAP FVG, Fondo Nobile, vol. 70, no. 6/256; 49 © Trieste, MiC SABAP FVG, Fondo Nobile, vol. vol. 49, no. 36; 50 © Vienna, ÖNB, pictures archives, WH 3528E; 51 © Trieste, MiC SABAP FVG, Fondo Nobile, vol. 65, no. 35/15; 52 © Vienna, Academy of Fine Arts, Kupferstichkabinet, Hz. 14.261; 53 *Zeitschrift für praktische Baukunst* (ed. J. Andreas Romberg) 8 (1848), plate 28; 54 © Trieste, MiC SABAP FVG, Fondo Nobile, vol. 16, no. 90; 55 © Trieste, MiC SABAP FVG, Fondo Nobile, vol. 3 no. 52a; 56 Archiv Richard Kurdiovsky; 57 © Vienna, ÖNB, *Allgemeine Bauzeitung* 1 (1836), 91; 58 © wikimedia_Eggersdorf-Pfarrkirche_7281; 59 © Vienna, Albertina, Az. 6263; 60 © Vienna, Albertina, Az. 6264; 61 © Vienna, Albertina, Az. 9790; 62 © Vienna, Albertina, Az. 9789; 63 © Trieste, MiC SABAP FVG, Fondo Nobile, vol. 70, no. 6/244; 64 © Bildarchiv Foto Marburg, anonymous photography from 1976, LA 1.763/33; 65 © Vienna, ÖStA, FHKA, plan collection Rb 712/3; 66 © Vienna, ÖStA, FHKA, plan collection Ra 28/13; 67 © Vienna, ÖStA, FHKA, plan collection Ra 28/15; 68 © Trieste, MiC SABAP FVG, Fondo Nobile, vol. 18, no. 69; 69 © Schönbrunn Kultur- und Betriebsgesellschaft, HG 052 S HP; 70 © Trieste, MiC SABAP FVG, Fondo Nobile, vol. 18, no. 18; 71 © Vienna, ÖNB, Pietro Sangiorgi, *Idea di un teatro adattato al locale detto delle convertite nella strada del Corso di Roma* (Rome: Mordacchini, 1821), plate 1; 72 © Trieste, MiC SABAP FVG, Fondo Nobile, vol. 43, no. 3; 73 © Trieste, MiC SABAP FVG, vol. 1, no. 45; 74 © Trieste, MiC SABAP FVG, vol. 1, no. 53; 75 © Trieste, MiC SABAP FVG, Fondo Nobile vol. 18, no. 46; 76 © Trieste, MiC SABAP FVG, Fondo Nobile vol. 18, no. 43; 77 © *Allgemeine Bauzeitung* 3 (1838): plate 240; 78 © *Allgemeine Bauzeitung* 3 (1838): plate 241; 79 © Archivio di Stato del Cantone Ticino, Bellinzona, Fondo Pietro Nobile, inv. no. 317; 80 © Trieste, MiC SABAP FVG, Fondo Nobile, vol. 17, no. 90; 81 James Stuart and Nicholas Revett, *The Antiquities of Athens*, vol. 2, London 1787, chapt. IV, l. III; 82 © Trieste MiC SABAP FVG, Fondo Nobile, vol. 17, no. 141; 83 Carl Friedrich Schinkel, *Sammlung architektonischer Entwürfe* etc. (Berlin: Ernst & Korn, 1858), plate 169; 84 © Trieste, MiC SABAP FVG, Fondo Nobile, vol. 17, no. 60; 85 a, b photo © Michael Durdis, photo © Taťána Petrasová; 86 photo © IAH, Czech Academy of Sciences – Petr Zinke; 87 © Trieste, MiC SABAP FVG, Fondo Nobile, vol. 39, no. 16; 88 © IAH, Czech Academy of Sciences, Documentation Department, Collection of historical photographs, inv. no. 000585; 89 © Trieste, MiC SABAP FVG, Fondo Nobile, vol. 1 no. 36; 90 © NPÚ, Regional office in Prague, State château Kynžvart, KY 12205; 91 © NPÚ, Regional office in Prague, State château Kynžvart, KY 08500; 92 © Vienna, Albertina, Az7334, M87; 93 © Lugano, Biblioteca cantonale e Libreria Patria, LGC 91 C 821; 94 © Državni arhiv u Rijeci, Zbirka arhiskog gradiva Gradskog muzeja u Puli, k. 8, br. 15, sheet 7.

Plates

I © Vienna, OeStA, KA, Inland C IV. 1/2; II © Eisenstadt, Esterházy Privatstiftung, Eisenstadt Palace – Collection of paintings, B7, photo: Manfred Horvath; III © Scottisch Abbey, Library; IV Wikimedia Commons (gemeinfrei) https://commons.wikimedia.org/wiki/File:Milano,_villa_reale,_prospetto_sul_parco.jpg (14.12.2020); V © Trieste, MiC SABAP FVG, Fondo Nobile, vol. 4, no. 83; VI © Vienna, Albertina, Az. 5315; VII © Trieste, MiC SABAP FVG, Fondo Nobile, vol. 16, no. 33; VIII © Comuna di Trieste, CMSA, inv. 3293; IX © IAH, Czech Academy of Sciences – Petr Zinke; X © Trieste, MiC SABAP FVG, Fondo Nobile, vol. 3, no. 82; XI © Prague, NA, Collection of maps and plans, sign. 60, inv. č. A III 20/3; XII © Trieste, MiC SABAP FVG, Fondo Nobile, vol. 1, no. 38; XIII © IAH Czech Academy of Sciences – Petr Zinke; XIV © Vienna, Albertina, Az7936; XV © Richard Kurdiovsky; XVI © bpk – Photo Agency / Kupferstichkabinett, Staatliche Museen zu Berlin – Preusischer Kulturbesitz, Inv. N. SM 1b.26; XVII © Trieste, MiC SABAP FVG, Fondo Nobile, vol. 7, no. 78; XVIII © Trieste, MiC SABAP FVG, Fondo Nobile, vol. 1, no. 27; XIX © Trieste, MiC SABAP FVG, Fondo Nobile, vol. 1, 78; XX © Trieste, MiC SABAP FVG, Fondo Nobile, vol. 1, no. 79; XXI © Trieste, MiC SABAP FVG, Fondo Nobile, vol. 1, no. 75; XXII © Trieste, MiC SABAP FVG, Fondo Nobile, vol. 1, no. 77; XXIII © Trieste, MiC SABAP FVG, Fondo Nobile, vol. 2, no. 45; XXIV © Trieste, MiC SABAP FVG, Fondo Nobile, vol. 49, no. 3; XXV © Trieste, MiC SABAP FVG, vol. 49, no. 9bis; XXVI © Trieste, MiC SABAP FVG, Fondo Nobile, vol. 51, no. 10; XXVII © Trieste, MiC SABAP FVG, Fondo Nobile, vol. 20, no. 21; XXVIII © Trieste, MiC SABAP FVG, Fondo Nobile, vol. 30, no. 26; XXIX © Trieste, MiC SABAP FVG, Fondo Nobile, vol. 15, no. 26; XXX © Trieste, MiC SABAP FVG, Fondo Nobile, vol. 49, no. 13b; XXXI © Trieste, MiC SABAP FVG, Fondo Nobile, vol. 21, no. 121; XXXII © Trieste, MiC SABAP FVG, Fondo Nobile, vol. 49, no. 10 b; XXXIII © Trieste, MiC SABAP FVG, Fondo Nobile, vol. 9, no. 126; XXXIV © Trieste, MiC SABAP FVG, Fondo Nobile, vol. 38, no. 44; XXXV © Trieste, MiC SABAP FVG, Fondo Nobile, vol. 44, no. 43; XXXVI © Alamy https://www.alamy.it/ (14.12.2020); XXXVII © Trieste tematica: indice delle foto https://sites.google.com/site/triestetematica/home/trieste-tematica-foto-dell-acquedotto-romano-della-val-rosandra?tmpl=%2Fsystem%2Fapp%2Ftemplates%2Fprint%2F&showPrintDialog=1 (14.12.2020); XXXVIII © Vienna, Albertina, Az. 7597; XXXIX © Trieste, MiC SABAP FVG, Fondo Nobile, vol. 36, no. 118; XL © Vienna, Academy of Fine Arts, Kupferstichkabinett, Hz. 14.246; XLI © Vienna, Academy of Fine Arts, Vienna, Kupferstichkabinett, Hz. 14.467; XLII © Vienna, WStLA, Serie 3.1.5.3.A45 - III/45 - Wiener Börse 0/019; XLIII © Vienna, ÖStA, HHStA, PAB, Nr. 1255; XLIV © Vienna, ÖNB, pictures archives, Pk 315/5; XLV © Vienna, ÖNB, pictures archives, Pk 315/6; XLVI © Vienna, Albertina, Az. 6272; XLVII © Vienna, Albertina, Az. 5274; XLVIII © Trieste, MiC SABAP FVG, Fondo Nobile, vol. 16, no. 9, 10; XLIX © Trieste, MiC SABAP FVG, Fondo Nobile, vol. 4, no. 42; L © Trieste, MiC SABAP FVG, Fondo Nobile, vol. 4, no. 40; LI © Vienna, UAABKW, VA ex 1827, Zl. 126; LII © Trieste, MiC SABAP FVG, Fondo Nobile, vol. 18, no. 13; LIII © Trieste, MiC SABAP FVG, Fondo Nobile, vol. 43, no. 2; LIV © Trieste, MiC SABAP FVG, Fondo Nobile, vol. 18, no. 9; LV © Vienna, Wien Museum, inv.-no. 107.056; LVI © Vienna, Wien Museum, inv.-no. 14.005; LVII © Trieste, MiC SABAP FVG, Fondo Nobile, vol. 16, no. 82; LVIII © Trieste, MiC SABAP FVG, Fondo Nobile, vol. 1, no. 31b; LIX © NPÚ, Regional office in Prague, State château Kynžvart, KY 12611; LX © Trieste, MiC SABAP FVG, Fondo Nobile, vol. 17, no. 20a, b; LXI © Trieste, MiC SABAP FVG, Fondo Nobile, vol. 17, no. 20b; LXII © Trieste, MiC SABAP FVG, Fondo Nobile, vol. 17, no. 26b; LXIII © Trieste, MiC SABAP FVG, Fondo Nobile, vol. 17, no. 82; LXIV © Vienna, ÖNB, 260.150-E.Fid.; LXV © Trieste MiC SABAP FVG, Fondo Nobile, vol. 17 no. 125; LXVI © Vienna, ÖNB, 260.150-E.Fid., plate 2; LXVII © Carl Friedrich Schinkel, *Sammlung architektonischer Entwürfe* etc. (Berlin: Ernst & Korn, 1858), plate 169; LXVIII © Vienna, ÖNB, 260.150-E.Fid., plate 1; LXIX © Trieste, MiC SABAP FVG, Fondo Nobile, vol. 17, no. 61; LXX © photo IAH, Czech Academy of Sciences – Petr Zinke; LXXI © NPÚ, Regional office in Prague, State château Kynžvart, KY 11825; LXXII © Trieste, MiC SABAP FVG, Fondo Nobile, vol. 3, no. 47; LXXIII © Trieste, MiC SABAP FVG, Fondo Nobile, vol. 3, no. 34; LXXIV © Kraków, Archiwum Narodowe w Krakowie, sign. AKPot 3093; LXXV © NPÚ, Regional office in Prague, State château Kynžvart, KY 17244; LXXVI © Trieste, MiC SABAP FVG, Fondo Nobile, vol. 41, no. 104; LXXVII © Museum purchase through gift of various donors and from Eleanor G. Hewit Fund; 1938-88-7171.

INDEX

This publication was generously supported by the Czech Sciences Foundation in the grant project 17-19952S "Neoclassicism between Technique and Beauty. Pietro Nobile (1776–1854)", carried out in the Institute of Art History of the Czech Academy of Sciences. The project benefited of the collaboration with the Ministero della cultura, Soprintendenza Archeologia, belle arti e paesaggio del Friuli Venezia Giulia in Trieste and the Institut für die Erforschung der Habsburgermonarchie und des Balkanraumes der Österreichischen Akademie der Wissenschaft.

ISBN 978-3-11-069145-0

Library of Congress Cataloging-in-Publication Data 2021944027

Bibliographic information published by the Deutsche Nationalbibliothek
The Deutsche Nationalbibliothek lists this publication in the Deutsche Nationalbibliografie; detailed bibliographic data are available on the Internet at http://dnb.dnb.de.

© 2021 Walter de Gruyter GmbH, Berlin/Boston
Editor: Taťána Petrasová
Authors: Taťána Petrasová, Rossella Fabiani and Richard Kurdiovsky
Index: Josef Schwarz
Copyediting: Julia Oswald
Cover illustration: Pietro Nobile, Project of the *Salvore* lighthouse in Savudrija, ink and sepia, 1817, Trieste, SABAP FVG
Layout and typesetting: Edgar Endl, bookwise medienproduktion gmbh, München
Printing and binding: Beltz Grafische Betriebe GmbH, Bad Langensalza

www.degruyter.com